W9-CZU-060

The Catholic
Theological Union
LIBRARY
Chicago, Ill.

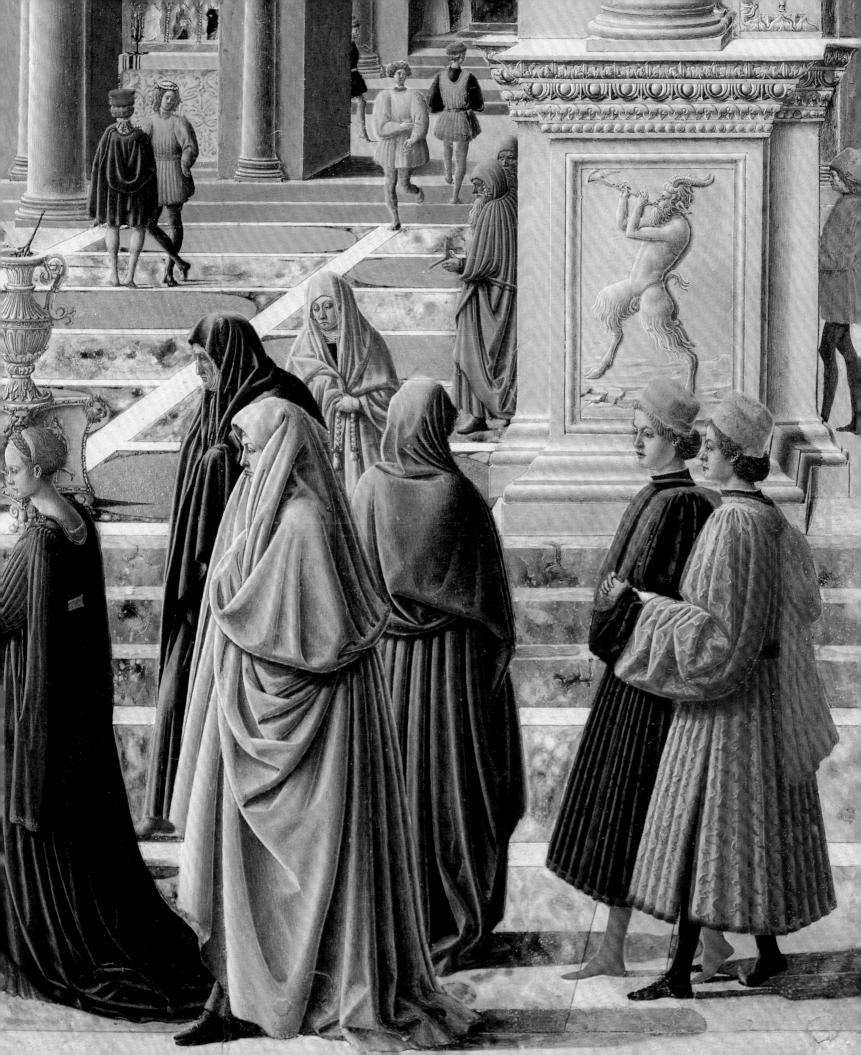

FROM FILIPPO LIPPI TO

WITHDRAWN

PIERO DELLA FRANCESCA

Fra Carnevale and the Making of a Renaissance Master

Edited by Keith Christiansen

The Catholic
Theological Union
LIBRARY
Chicago, Ill.

The Metropolitan Museum of Art, New York

Edizioni Olivares, Milan

Yale University Press, New Haven and London

This volume has been published in conjunction with the exhibition "From Filippo Lippi to Piero della Francesca: Fra Carnevale and the Making of a Renaissance Master" held at the Pinacoteca di Brera, Milan, October 13, 2004– January 9, 2005, and at The Metropolitan Museum of Art, New York, February 1–May 1, 2005.

The exhibition is made possible by BRACCO .

Additional support has been provided by the William Randolph Hearst Foundation and the Gail and Parker Gilbert Fund.

The exhibition catalogue is made possible by Bracco, the Oceanic Heritage Foundation, and the Samuel I. Newhouse Foundation Inc.

The exhibition was organized by The Metropolitan Museum of Art, New York, and the Soprintendenza per il Patrimonio Storico Artistico e Etnoantropologico, Milano.

Published by The Metropolitan Museum of Art, New York

Copyright © 2005 by The Metropolitan Museum of Art, New York
Italian-language edition copyright © 2004 by Edizioni Olivares, Milan

All rights reserved. No part of this publication may be reproduced or transmitted in any form or by any means, electronic or mechanical, including photocopying, recording, or any information storage or retrieval system, without permission in writing from the publishers.

John P. O'Neill, Editor in Chief
Gwen Roginsky, Associate General Manager of Publications
Ellen Shultz, Editor
Bruce Campbell, Designer, after the Italian edition by Edizioni Olivares
Margaret Rennolds Chace, Managing Editor
Paula Torres, Production Manager
Robert Weisberg, Desktop Publishing Manager
Jean Wagner and Judith Calder, Bibliographers

Translations from the Italian by George Bisacca, Frank Dabell, Lawrence Jenkens, Michael Moore, Stephen Sartarelli, David Tabbat.

Cataloging-in-Publication Data is available from the Library of Congress.

ISBN 1-58839-142-6 (hc: The Metropolitan Museum of Art)
ISBN 1-58839-143-4 (pbk: The Metropolitan Museum of Art)
ISBN 0-300-10716-1 (Yale University Press)

Cover/jacket: Fra Carnevale, *The Birth of the Virgin*, detail of catalogue 45 A
Frontispiece: Fra Carnevale, *The Presentation of the Virgin in the Temple (?),* detail of catalogue 45 B
Illustration, page 10: Fra Carnevale, *The Birth of the Virgin*, detail of catalogue 45 A
Illustration, page 20: Fra Carnevale, *Madonna and Child Enthroned with Two Angels*, detail of catalogue 1 B

Printed and bound in Italy

Contents

Sponsor's Statement 9

Directors' Foreword 11

Acknowledgments 15

Lenders to the Exhibition 17

Contributors to the Catalogue 19

In Search of Fra Carnevale, A "Painter of High Repute" 23
Emanuela Daffra

Florence: Filippo Lippi and Fra Carnevale 39
Keith Christiansen

Fra Carnevale, Urbino, and the Marches: An Alternative View 67
of the Renaissance
Andrea De Marchi

Fra Carnevale and the Practice of Architecture 97
Matteo Ceriana

Catalogue 137

Fra Carnevale in Florence 138
Catalogue 1-27

Fra Carnevale in Urbino and the Marches 210
Catalogue 28-47

Biographies 279

Documentary Appendices 289

Documents in the Florentine Archives 290
Andrea Di Lorenzo

Documents in the Urbino Archives 299
Matteo Mazzalupi

Documents in the Barberini Archives 306
Livia Carloni

Technical Essays 309

Observations on the Technique and Artistic Culture 310
of Fra Carnevale
Roberto Bellucci and *Cecilia Frosinini*

Plates 331

Carpentry and Panel Construction 343
Ciro Castelli and *George Bisacca*

Bibliography 364

Index 378

Photograph Credits 384

Sponsor's Statement

There are many factors that drew Bracco to the exhibition "From Filippo Lippi to Piero della Francesca: Fra Carnevale and the Making of a Renaissance Master," but the driving force was the technical investigation employed to elucidate this enormously interesting moment in history. The fact that this project has at its heart the identification of an individual—an artistic personality who has bedeviled scholars for more than a century— holds the greatest fascination for Bracco. In this exhibition, Fra Carnevale emerges from the yellowed pages of archival documents to take possession of an aesthetically complex body of work. By restoring this artist to history's stage, the exhibition recovers yet another part of Italy's enormous patrimony.

Fra Carnevale will now be seen to have played a significant role in the transmission of Renaissance culture from Florence to Urbino. This knowledge heightens our awareness of the Renaissance by presenting works of art that reflect the complexities of a particular place and time. The realization of this project has required a concentration of talents, and Bracco is proud to support The Metropolitan Museum of Art and the Pinacoteca di Brera, the two institutions that have so successfully combined the art of the past with the tools of contemporary life.

The exhibition demonstrates the strong links between Bracco and Italian culture by reaffirming the values, traditions, and innovative knowledge that united science and art in the Renaissance in the form of optics and perspective. However, above all, it was the sophisticated technical analyses—including X-ray and infrared reflectographic technology—that first attracted Bracco. The technical analysis used to get beneath, or rather "inside," these works of art is based on the same kind of non-invasive diagnostic imaging used in medicine: whether analyzing a person or a work of art, the aim is to probe the subject's "inner life." Such is the concept behind Bracco's successful "Life from Inside" corporate identity. The exhibition, which brings together two prestigious institutions, involved the collaboration of the restoration laboratories at a host of international museums.

Bracco believes that a company has the obligation to pass on the values of life and culture to future generations; therefore, we are proud to be a partner in the exhibition. This investigation into the ways in which ideas have been transformed into surpassingly beautiful works of art offers visitors an experience that transcends mere words.

Diana Bracco
President and CEO, Bracco Group

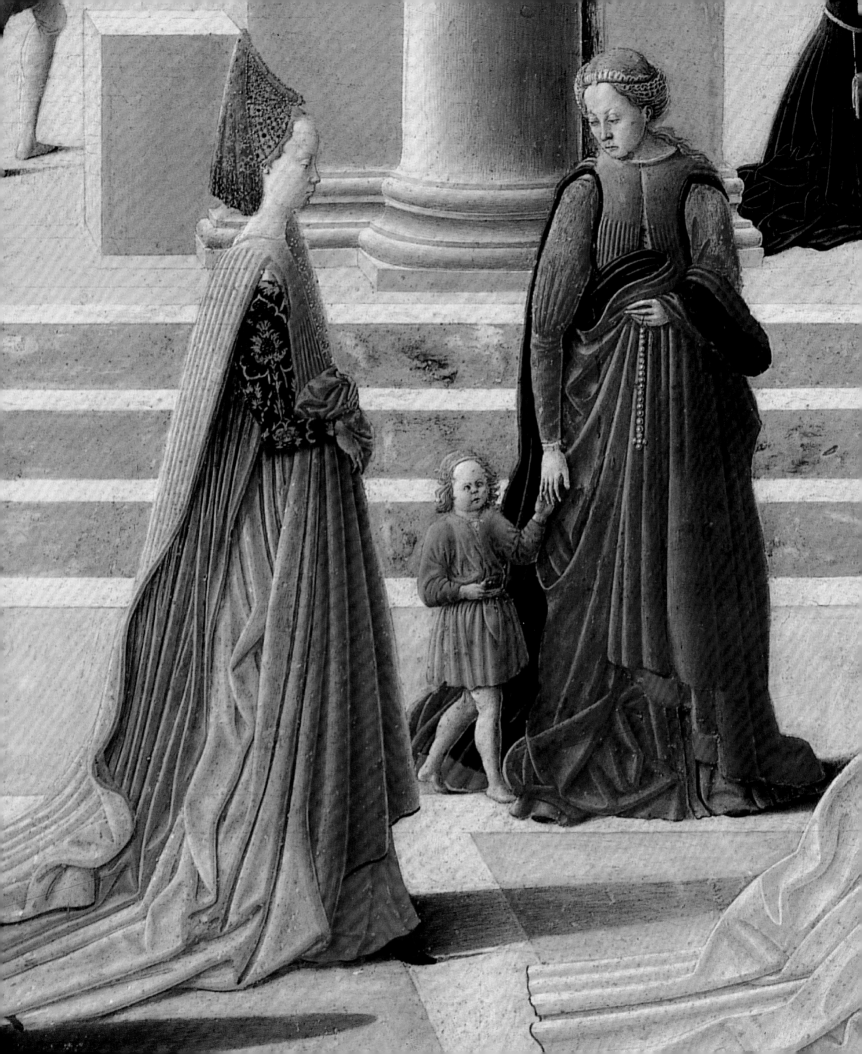

Directors' Foreword

Seventy years have passed since, by royal decree (n. 705), on April 26, 1934, the entail (or *fidecommesso*) on the Barberini Collection was canceled and the possibility of foreign sale granted to the heirs, thereby effectively assuring the dispersal of what had been one of the greatest private collections in Rome, largely formed under the pontificate of Urban VIII Barberini (r. 1623–44). In addition to the masterpieces by Dürer, Caravaggio, Guido Reni, Guercino, and Poussin that would eventually be sold, there were two intriguing fifteenth-century panels of uncertain attribution. They seemed to depict scenes from the life of the Virgin, but in such a peculiarly secular fashion and with such a profusion of architectural detail that their subjects were not obvious. They had begun to attract scholarly attention when, in 1893, Adolfo Venturi had identified their author with the quasi-mythical Urbino painter Bartolomeo di Giovanni Corradini, known as Fra Carnevale, whose works had, according to Vasari, influenced the young Bramante. Venturi later retracted his hypothesis for lack of firm documentation—now brilliantly supplied in this catalogue by the archival discoveries of Andrea Di Lorenzo, Matteo Mazzalupi, and Livia Carloni—but the wheels had been set in motion, and over the course of the next century an astonishing bibliography was to accumulate around these works.

The two panels captured the public's imagination when they were lent by Prince Barberini to the magnificent "Exhibition of Italian Art," held in the galleries of the Royal Academy in London in 1930. There is nothing like a mystery to add allure to an object, and the fact that it was not possible to establish with certainty either the author or the subjects added to the enigma of these marvelous paintings. So it is not surprising that immediately after passage of the 1934 decree a number of agents and dealers set about either to obtain the exclusive rights to sell the two paintings—the centerpiece of the present exhibition—or offered to negotiate with the Barberini heirs. It is perhaps enough to note that no fewer than seven dealers approached The Metropolitan Museum of Art over the next year, sometimes working at cross-purposes and creating a flurry of misinformation. The Metropolitan Museum was not their only prospect. Among the rumored clients were the Museum of Fine Arts, Boston; the National Gallery, London; Baron Thyssen-Bornemisza; and the New York collector Maitland F. Griggs, whose Early Italian paintings later enriched the collections of the Metropolitan Museum and the Yale University Art Gallery. At the center of this contest of competing factions were the heirs: the Corsini family in Florence. Long before the estate had been divided among the various members of the family, dealers were knocking on doors purporting to have an offer in hand, and long before any member of the Corsini family had even decided to sell, the same dealers were contacting prospective buyers with what they declared was the latest asking price. Reading through the missives sent by these competing dealers—on file in the archives of the Metropolitan Museum—one is reminded of those chaotic scenes of Buoso Donati's scheming relatives in Puccini's comic opera *Gianni Schicchi*.

In July 1935 Umberto Gnoli (employed by the Metropolitan Museum as a European representative following his resignation as director of the Perugia art gallery) wrote to the president of the museum, George Blumenthal, who was staying at the Ritz in Paris, to inform him of the madness of the scene: "There [in Florence] I learned that already a crowd of people—authorized or not—had presented themselves to the owners in the name of the Metropolitan Museum. . . . Naturally, being pressed by everyone has gone to the owners' heads . . . and they will demand an exaggerated price." So confused did the matter become that it proved necessary for the director of the Metropolitan, Herbert Winlock, to draw up a chronology of the offers made. Even then, he was not sure that the latest information he had received was correct.

The first to announce their intention to sell were Marchesa Eleanora Corsini Antinori and Baronessa Giuliana Corsini Ricasoli, to whom the *Birth of the Virgin* had at last been assigned. They wisely refused the modest offers made on behalf of the Metropolitan, which, ironically, ultimately acquired the painting from M. Knoedler & Co. for somewhat less than what, initially, it had been rumored the two paintings would fetch together! Prince Tomaso Corsini inherited the *Presentation of the Virgin in the Temple (?),* and after resisting initial advances he sold the painting to the Boston Museum of Fine Arts.

If nothing else, the transport of these fascinating paintings across the Atlantic further stoked interest in them, and in 1939 Richard Offner wrote the first and in some ways the most brilliant of the many articles that have attempted to solve the mystery of their authorship, subject, and function. The article was a work of impeccable connoisseurship, and although Offner preferred to leave the questions of authorship and function open, most of his conclusions have stood the test of time. Following the publication in 1961 of a spellbinding book by Federico Zeri, it was widely believed that the name of the artist—the otherwise obscure Giovanni Angelo d'Antonio (about whom we now know a fair amount)—had been uncovered. That Zeri's conclusions have turned out to be wrong hardly detracts from the brilliance of his many deductions.

In that remarkable study Zeri introduced several new pictures—all but one of which are in this exhibition. Among these was one showing Saint Peter (Pinacoteca di Brera) and another, Saint Francis (Pinacoteca Ambrosiana). Zeri recognized that these panels belonged to the same polyptych as a *Crucifixion,* then in the Cini Collection in Venice and now in the Galleria Nazionale delle Marche, Urbino. Only in the last few years has it been established that the *Crucifixion* was the pinnacle of the altarpiece, placed over the (still-missing) center panel. The dismemberment of what is Fra Carnevale's sole surviving altarpiece is indicative of the fate of his paintings in general and, by extension, of his posthumous fame. That we are able to bring together in this exhibition all four panels known to have belonged to the polyptych (the fourth is a cut-down figure of *Saint John the Baptist,* in Loreto) is emblematic of the act of rehabilitation to which a century of scholarship has been dedicated.

There is little question that Fra Carnevale painted few works, although those that survive give ample evidence of his passion for painting and his meticulous attention to detail. Unfortunately, as noted, his posthumous fame was not sufficient to assure the survival of his paintings. In fact, only one work is preserved in the place for which it was created: Federigo da Montefeltro's painted alcove in the Palazzo Ducale in Urbino. The rest of his refined, subtly eccentric paintings found their way onto the art market and

were dispersed. The panel of *Saint Peter* was donated to the Brera by Casimiro Sipriot in 1904; the Ambrosiana panel passed through two collections before being acquired from the Brivio collection. When published by Offner, the *Crucifixion* now in Urbino belonged to the Roman dealer Simonetti; only in 1987 was it acquired by the Italian state.

That the Pinacoteca di Brera and The Metropolitan Museum of Art should have undertaken this exhibition devoted to the reconstruction of Fra Carnevale's oeuvre and his career, as well as to defining his place in the Renaissance, is, in the true sense, a symbolic act. Had the Brera not, in 1811, received Piero della Francesca's *Montefeltro Altarpiece* as the work of Fra Carnevale and, in 1904, accepted the *Saint Peter* with an attribution to Masaccio?

With this exhibition Fra Carnevale makes his definitive entrance onto the stage of Renaissance painting—not as a name passed down by generations of local chroniclers but as a figure with a historical profile. In order to better understand his achievement, the exhibition has been divided into two parts: the first examines Florence in the 1440s, when Fra Carnevale joined the workshop of Fra Filippo Lippi and established contacts with a wide range of artists. Filippo Lippi, Domenico Veneziano, Pesellino, Luca della Robbia, Maso di Bartolomeo, and a number of fascinating, if anonymous, masters are among our distinguished cast of characters in this incomparable Florentine tableau. In the second half of the exhibition we follow Fra Carnevale from Florence to Urbino, that magical city of the Renaissance, whose ducal palace Baldassare Castiglione, the friend of Raphael and author of *The Book of the Courtier,* did not hesitate to call the most beautiful in Italy (*The Courtier* is set within its rooms). This section travels far less familiar terrain and enlists artists who, for many, will be completely unknown: Giovanni Boccati, Giovanni Angelo d'Antonio (Zeri's candidate for the painter of the Barberini Panels), Benedetto Bonfigli, and Antonio da Fabriano. Like Fra Carnevale, each of these painters had contacts with Florentine art, but they transformed what they learned into a distinctly regional dialect, one lacking the recondite Latinity of Tuscan but possessing some of the most appealing aspects of a highly expressive, local patois. Then there is the magisterial figure of Piero della Francesca, who, hailing from the town of Sansepolcro where Tuscany borders Umbria and the Marches, preceded Fra Carnevale to Florence by six years and eventually displaced him in Urbino, working for the great soldier and patron Federigo da Montefeltro. As in the case of Filippo Lippi in the first half of the exhibition, Piero is the dominant figure in the second half.

Although this exhibition may initially seem recondite, it tackles one of the crucial issues of Renaissance painting: the means by which artists in fifteenth-century Italy created an artistic identity and the ways in which Renaissance style became a symbol of cultural attainment. The works are of a very high order—both aesthetically and historically—and few visitors will come away without having enlarged their understanding of Renaissance art. A deep debt of gratitude is owed the lenders listed in these pages for making it possible to bring together these exceptional works. The Sterling and Francine Clark Art Institute in Williamstown, Massachusetts, deserves special mention for lending its great altarpiece by Piero della Francesca, as does the Boston Museum of Fine Arts for agreeing to allow its panel by Fra Carnevale to travel to Milan so that these two remarkable paintings could be reunited in Italy for the first time since 1935. Equally worthy of mention is the loan by the Accademia Albertina in Turin of two panels, which has enabled the reconstruction of a major altarpiece by Filippo Lippi, as well as

the loan of panels from the Galleria Nazionale delle Marche in Urbino, the Museo del Palazzo Apostolico in Loreto, and the Pinacoteca Ambrosiana and Pinacoteca di Brera in Milan that belong to Fra Carnevale's only known polyptych. These are only some of the pleasures in store for visitors.

This has been a truly collaborative enterprise between the Metropolitan Museum in New York and the Soprintendenza per i Beni Artistici in Milan—one that we trust will inaugurate future exchanges. That it has happened is due in no small measure to the persistent encouragement received from Federica Olivares, whose interest in the project from the time it was first described to her has been nothing short of extraordinary. She put us in touch with Diana Bracco, who has been exceptionally generous in her support of the exhibition, and she guided the Italian edition of the catalogue through publication.

The Pinacoteca di Brera could not have mounted this exhibition without the help of the Amici di Brera. Their support was not unexpected, but it was no less appreciated. Unicredit Broker, Unicredit Private Banking, Xelion, the Fondazione Corriere della Sera, Arteria, Civita Associazione, ATM e Regione Lombardia gave their enthusiastic support to the project. To all of them we owe a debt of gratitude.

The Metropolitan Museum of Art is extremely grateful to Bracco for its generous support of the exhibition, as well as for its extraordinary commitment to this project. We are also deeply indebted to the William Randolph Hearst Foundation and the Gail and Parker Gilbert Fund for their vital assistance toward the realization of this exhibition. We likewise thank Bracco, the Samuel I. Newhouse Foundation Inc., and the Oceanic Heritage Foundation for their invaluable support of the exhibition catalogue.

In conclusion, we would like to express our hope that this intense and remarkably productive collaboration between The Metropolitan Museum of Art and the Soprintendenza per il Patrimonio Storico Artistico e Etnoantropologico, Milano, will be the first of future joint ventures.

Philippe de Montebello
Director
The Metropolitan Museum of Art, New York

Maria Teresa Fiorio
Soprintendente per i Beni Artistici
Pinacoteca di Brera, Milan

Acknowledgments

The organizers of the exhibition and the authors of the catalogue would like to thank the following individuals:

Chiara Angelini
Giorgio Anzani
Adriana Augusti
Ronni Baer
Colin B. Bailey
Carmen Bambach
Clara Baracchini
Gabriele Barucca
Reinhold Baumstark
Luciano Bellosi
Erin Benay
Maria Grazia Benini
Francesca Bewer
Tiziana Biganti
Beatriz Blanco
Julia Blanks
Ursula Bode
Valerio Brambilla
Christopher Brown
David A. Brown
Chezzy Brownen
Rita Bruccolesi Casagrande
Maria Giulia Burresi
Claudia Caldari
Rosane Cass
Alessandro Cecchi
Claudio Cerretelli
Marco Ciatti
Bonita Cleri
Minora Collins
Angelo Colombo
S. E. Angelo Comastri
Michael Conforti
Don Luigi Francesco Conti

Roberto Contini
Frank Dabell
Paolo Dal Poggetto
Daniele Danesi
Rosanna De Benedictis
Amy Dowe
Jill Dunkerton
Lucy Eldridge
Paola Errani
Everett Fahy
Don Renzo Fantappiè
Sylvia Ferino-Pagden
Don Cherubino Ferretti
J. V. Field
Lucia Fornari Schianchi
Elia Fumagalli
Roberto Fumagalli
Cristina Gabrielli
Vittoria Garibaldi
Davide Gasparotto
Marina Geneletti
Maria Giannatiempo López
Don Cherubino Giardini
Paolo Girotto
Carlo Giuliano
Elizabeth Glaeser
George Goldner
Eric Gordon
Paola Grifoni
Mons. Floriano Grimaldi
Melanie Hanan
Gisela Helmkampf
Teri Hensick
Charlotte Hubbard
Ingrid Huber
Frederick Ilchman
Giovanni Ivano
David Jaffé

Yusuke Kawase
Michael Knuth
Monique Le Blanc
Thomas W. Lentz
Theresa Lignelli
Bernd W. Lindemann
Jefe Thomàs Llorens Serra
Angelo Loda
Henri Loyrette
Rhona MacBeth
Michele Maccherini
Toni MacDonald Fein
Claudio Maggini
Dorothy Mahon
Giuseppe Maria Malachiodi
Federica Manoli
Fabio Marcelli
Alessandro Marchi
Luciano Marras
Claudio Martini
Alberto Mazzacchera
Giuseppe Mazzitello
Aldo Mela
Franco Migliaccio
Lucia Monaci
Alessio Monciatti
Philippe de Montebello
Peta Motture
Bruno Munheim
Antonio Natali
Mons. Marco Maria Navoni
Lisa Neal Tice
Don Franco Negroni
Giovanna Nepi Scirè
Alessandro Nova
Elke Oberthaler
Raimondo Orsetti
Maria Amalia Pacia

Giovanni Pagliarulo
Antonio Paolucci
Kim Pashko
Nicholas Penny
Anna Maria Petrioli Tofani
Charles E. Pierce, Jr.
Simona Pizzi
Franco Polcri
Vincent Pomarede
Earl A. Powell III
Richard Rand
Gianfranco Ravasi
Sarah Rimmo-Toure
Valeria Rivola
Roberta Rizzo
Malcolm Rogers
Ashok Roy
Daniele Sanguineti
Lorella Santi
Charles Saumarez Smith
Daniela Savoia

David Scrase
Karl Schütz
Günther Schauerte
Jan Schmidt
Catarina Schmidt Arcangeli
Shannon Schuler
H-Th Schulze Altcappenberg
Ludovica Sebregondi
Carlotta Sembenelli
Tomas Sharman
Don Luigi Silenzi
Kate Silverman
Maria Rita Silvestrelli
Carla Enrica Spantigati
Joaneath Spicer
Eve Straussman
Carl B. Strehlke
Fiorella Superbi
Christine Surtmann
Cornelia Syre
Luke Syson
Patrizia Tarchi

Dominique Thiébaut
Alicia B. Thomas
Rita Toma
Caterina Toso
Francesca Trebbi
Meinolf Trudzinski
Giovanni Valagussa
Rosaria Valazzi
Agnese Vastano
Ernst Vegelin
Françoise Viatte
Elizabeth Walmsley
Ian Wardropper
Stefan Weppelmann
Catherine Whistler
Paul Williamson
Timothy Wilson
Stephan Wolohojian
Martin Wyld
Massimo Zaggia
Annalisa Zanni

Lenders to the Exhibition

Baltimore
The Walters Art Museum: 36

Belforte del Chienti
Church of Sant'Eustachio: 33

Bergamo
Accademia Carrara: 18

Berlin
Staatliche Museen zu Berlin,
Gemäldegalerie: 10

Berlin
Staatliche Museen zu Berlin,
Kupferstichkabinett: 26 A

Boston
Museum of Fine Arts: 45 B

Cambridge, England
The Fitzwilliam Museum: 22 B

Cambridge, Massachusetts
Fogg Art Museum, Harvard University Art
Museums: 11; 15

Cesena
Biblioteca Malatestiana: 37

Florence
Gabinetto Disegni e Stampe degli Uffizi: 16;
26 C

Florence
Galleria degli Uffizi: 28

Hannover
Niedersächsisches Landesmuseum: 7

London
Courtauld Institute of Art Gallery: 21

London
National Gallery: 8 B; 14 A, B

London
Victoria and Albert Museum: 25

Loreto
Museo della Santa Casa: 41 A

Madrid
Museo Thyssen-Bornemisza: 29

Milan
Pinacoteca Ambrosiana: 41 D

Milan
Pinacoteca di Brera: 35; 41 C; 46

Milan
Museo Poldi Pezzoli: 2

Munich
Bayerische Staatsgemäldesammlungen,
Alte Pinakothek: 19

New York
The Frick Collection: 3

New York
The Metropolitan Museum of Art: 1 B; 4;
17; 24; 26 D, E; 39; 45 A

New York
The Pierpont Morgan Library: 13

New York
Collection Julie and Lawrence Salander: 23

Oxford, England
Ashmolean Museum: 5

Paris
Musée du Louvre, Département des Arts
Graphiques: 26 B

Paris
Musée du Louvre, Département des
Peintures: 27

Parma
Fondazione Magnani-Rocca, Corte di
Mamiano: 6

Perugia
Galleria Nazionale dell'Umbria: 30; 32

Pesaro
Museo Civico: 43

Philadelphia
Philadelphia Museum of Art: 8 A, C

Pisa
Museo Nazionale di San Matteo: 9

Prato
Museo dell'Opera del Duomo: 20

Sarnano
Collegiata di Santa Maria di Piazza Alta:
34 A, B

Siena
Biblioteca Comunale degli Intronati: 38

Turin
Accademia Albertina di Belle Arti: 1 A, C

Urbino
Galleria Nazionale delle Marche: 31;
41 B

Varese
Villa Cagnola, Gazzada: 44

Vienna
Kunsthistorisches Museum: 42

Washington, D.C.
National Gallery of Art: 12; 22 A; 40

Williamstown, Massachusetts
The Sterling and Francine Clark Art
Institute: 47

Contributors to the Catalogue

RB Roberto Bellucci

George Bisacca

Livia Carloni

CC Ciro Castelli

MC Matteo Ceriana

KC Keith Christiansen

ED Emanuela Daffra

ADM Andrea De Marchi

ADL Andrea Di Lorenzo

JDD James David Draper

CF Cecilia Frosinini

Matteo Mazzalupi

CBS Carl B. Strehlke

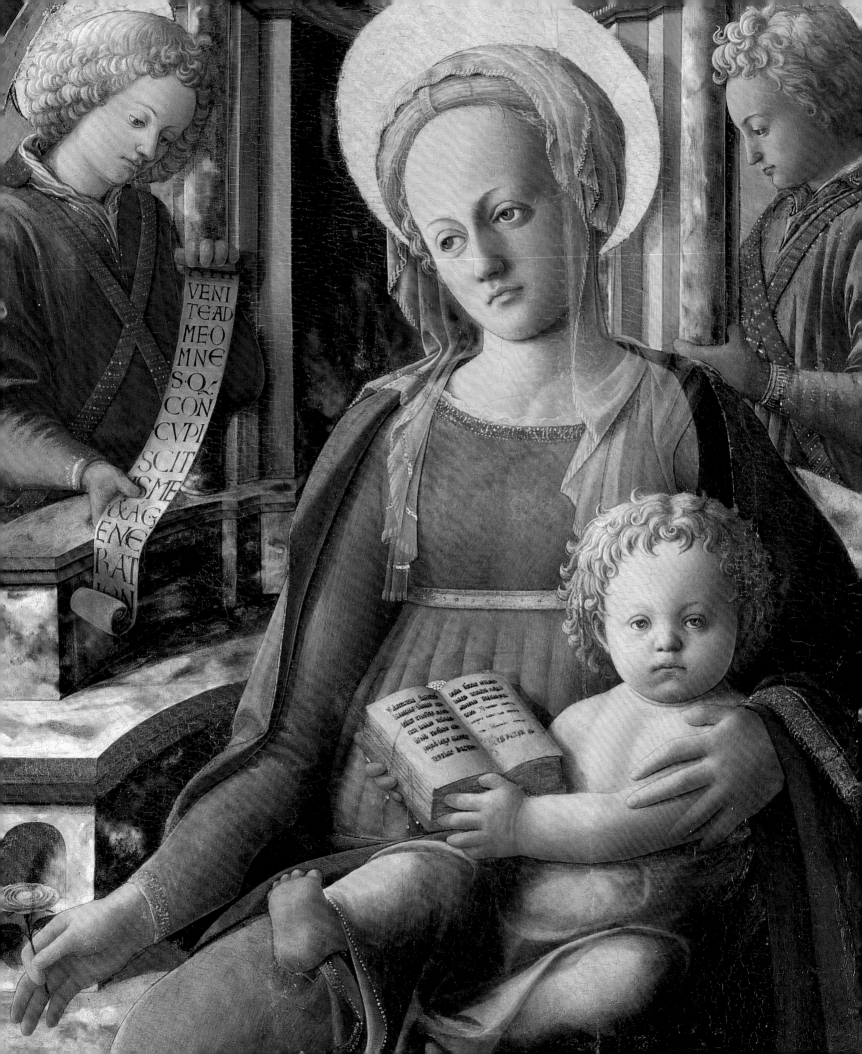

VENI
TE AD
ME O
MNE
S Q̇
CON
CVPI
SCIT
IS ME
ET A G
ENE
RAT ION

From Filippo Lippi to Piero della Francesca

1.
Fra Carnevale, Decoration from the sleeping
alcove, Palazzo Ducale, Urbino, detail.
Galleria Nazionale delle Marche, Urbino

Emanuela Daffra

IN SEARCH OF FRA CARNEVALE, A "PAINTER OF HIGH REPUTE"

T o study Urbino in the second half of the fifteenth century is to stare into the midday sun: an incandescent light that dazzles, captivates, and blurs everything into a luminous but nebulous haze. In this case, the sun is Federigo da Montefeltro and his court, which provided the Marchigian city not only with an unrivaled palace but with a century of splendor recognized throughout Europe. Yet, such magnificence was doomed to gradually fade. With the extinction of the the Della Rovere dynasty and the devolution of Urbino to the Holy See in 1631, the city relapsed into the quiet dullness of a small provincial town, refined but uneventful.

This parabolic trajectory partly explains the anomalous history of Fra Carnevale (born Bartolomeo di Giovanni Corradini), whose complex artistic identity has had to overcome a twofold obstacle: first, the fate of his native city, and second, the fact that his key works, the enchanting but elusive Barberini Panels (cat. 45 A, B), present a fascinating enigma that has totally absorbed his life and art.[1] A brilliant star—in the words of Federico Zeri—although not one of the very first importance, he was incapable of competing with the brilliance of his patron, but as he was the sole indigenous talent in that unparalleled period of Urbino's history, he was destined to survive in the memories of future generations. He was, moreover, the author of a work confiscated by the papal legate Cardinal Antonio Barberini, at the very moment of the duchy's devolution, and was therefore admired with nostalgia—almost as if the work were a tangible fragment of past glory.

The Teacher of Bramante and a Master of Perspective

The artist's legacy begins with the silence of Giovanni Santi in his rhymed chronicle,[2] a fact worth recording because it testifies to another reason for the early oblivion of Bartolomeo Corradini. Giovanni Santi (1440/45–1494) was Raphael's father, and a frequent visitor to the palace of Federigo da Montefeltro, and he certainly knew Fra Carnevale. However, among the artists of the generation preceding his own, he cites only Piero della Francesca in his chronicle, referring to him merely as "*antico*." No doubt to a painter dazzled by the modern Umbrian style of Perugino and steeped in the elegance of Verrocchio, Fra Carnevale must have seemed "*antichissimo*," having flourished but then been superseded by the swift change of taste in the 1470s: unworthy, therefore, of inclusion in an account whose aim was to assign absolute values to contemporary artists.

The first to break this silence was Giorgio Vasari. In the first edition of his *Lives of the Artists* (1550),[3] the Aretine biographer had already granted a few fleeting words to Fra

Carnevale. Brief though they were, they sealed the artist's fate, as they were constantly picked out, repeated, and misunderstood. Describing the youth of the great architect Bramante, Vasari remarked that "his father, who had need that he should earn money, perceiving that he delighted much in drawing, applied him, while still a mere boy, to the art of painting, whereupon Bramante gave much study to the works of Fra Bartolomeo, otherwise called Fra Carnovale da Urbino, who painted the altarpiece of Santa Maria della Bella."

Read objectively, there is little to sustain later interpretions of this passage, which mentions neither Bramante's apprenticeship with the friar[4] nor any specific influence exerted by the altarpiece in Santa Maria della Bella. What the passage attests is that the works of "Fra Bartolomeo," the author of this altarpiece—evidently celebrated enough for Vasari to consider it significant in relation to Bramante—were studied by the future architect-painter. When the altarpiece was brought to Rome by the papal legate Antonio Barberini in 1632,[5] it left nothing but nostalgia in its wake, and the impossibility of direct examination.

Yet, the wheels of historiography had begun to turn: Fra Carnevale's name was now firmly linked to that of one of the greatest architects of the Renaissance, known for the spatial illusionism of his work. It was probably on account of this that Lomazzo (1584) cites Bramante in the category of what may be called architect-designers—that is, inventors of forms rather than pedestrian followers of inflexible artistic canons.[6] It is not for nothing that we find among those Lomazzo lists the names of Girolamo Genga, Andrea Mantegna, Bernardo Zenale, and Bramantino. We do not know whether Lomazzo ever saw works by Fra Carnevale in Urbino (he could have visited the city either before or after his Roman sojourn of 1559–65), but he seems to have had the Barberini Panels in mind when he remarked, "Although there are various paths toward achieving this variety in the composition of the parts and their arrangement, and also those orders, temples, and palaces, this is nothing less than the product of expert designers who, with their ready hands, delineate what in their imagination they devise."

Memory of the painter-friar certainly lived on in Urbino.[7] For all the omissions in Baldinucci's dictionary of masters of "*disegno*"[8] (for example, there is no mention of either Piero della Francesca or Leonardo), Fra Carnevale is present: he is placed about 1520, as a pupil of Raphael, and is described in a paraphrase of Vasari's text,[9] with some secondhand additions, since, according to the declarations of local scholars, he is asserted to have been "*eccellente nelle prospettive.*" It was these scholars who ascribed to Fra Carnevale a work in the church of San Bernardino, just outside Urbino: "to the right of the high altar, a large painting with a beautiful perspective, and other perspectives belonging to other persons." This notice ought to be read alongside the 1599 inventory of the Palazzo Ducale in Urbino, which refers to "an oblong perspective, *anthica ma bella,* by the hand of fra Carnevale"[10]—a citation that determines the second fundamental point of reference in the critical history of our artist: namely, his connection with the church of San Bernardino, and his undoubted skill as a master of perspective.

FRA CARNEVALE AND THE *MONTEFELTRO ALTARPIECE*

To this day, Baldinucci's is the only published reference to the *"grande storia con bella prospettiva"*: we cannot know, therefore, whether to mourn the loss of one of the artist's mature masterpieces (painted for no less a patron than the duke of Urbino, and for the ducal church-*cum*-mausoleum), or to regard the Tuscan biographer's text[11] with suspicion and consider it as a misunderstanding of a local tradition that attributed the painting on the high altar of that church—the celebrated *Montefeltro Altarpiece* by Piero della Francesca now in the Pinacoteca di Brera (cat. 46)—to Corradini.

Perhaps the second hypothesis is closer to the truth, because—like an underground stream that occasionally surfaces—it was taken for granted in the instructions given by Pope Clement XI Albani to assist his envoys Curzio Origo and Giovanni Maria Lancisi in 1703: "The painting on the high altar is much admired for being by Fra Carnevale." The picture's special value lay in its presumed author.[12] Throughout the eighteenth century we hear this attribution repeated, with only a few cases of subtle distinction or deviation.[13]

In the report written by the pope's two envoys, who zealously adhered to the papal directives, we also find the hieratic angels who flank the Madonna identified as the duke's sons, thus transforming this solemn ecclesiastical scene into a family snapshot, as it were. (This curious reading was facilitated by the fact that the wings of the angels are barely visible.) The prelates were evidently following a local tradition that was eventually consolidated in the manuscript *Memorie concernenti la chiesa ed il convento di San Bernardino*, which, by way of its citation by Pungileoni, was still current when the painting entered the Pinacoteca di Brera.[14]

AN INITIAL ASSESSMENT

This first chapter of Fra Carnevale's posthumous fame culminates in Luigi Lanzi's *Storia pittorica della Italia* (1787),[15] which assigned the Dominican friar a minor role in the Roman school of painting by noting that "Bramante and Raphael studied his work, as nothing better could then be found in Urbino," and stating that the altarpiece in San Bernardino was *"difettosa in prospettiva"* (we shall return to this judgment later on) but contained *"bella architettura."*

In the meantime, however, diligent local scholarship—a typically Italian virtue that has enriched the smallest of towns with mines of information yet to be fully exploited—retrieved a handful of documents out of limbo, offering a basis for the reconstruction of the historical Fra Carnevale that lasted through the 1970s.[16] These documents provided a chronology for Bartolomeo Corradini's activity between 1456 and about 1488: a hypothetical apprenticeship with his fellow friar Fra Jacopo Veneto;[17] his abandoning of a commission in 1456 (the altarpiece for the Confraternità del Corpus Domini, later painted by Paolo Uccello and Joos van Ghent); a payment of 1466 (1467, according to the local calendar then in use) for another painting, almost completed (the Santa Maria della Bella altarpiece); his position as curate in the parish church of San Cassiano del Cavallino; and his membership in the Confraternità di Santa Croce.

A small catalogue of paintings was formed: the Santa Maria della Bella altarpiece, not seen after its removal to Rome by the papal legate Cardinal Antonio Barberini in 1632; the *Montefeltro Altarpiece* in San Bernardino; and an oblong panel ("*per traverso*") displayed in the Palazzo Staccoli[18] that has disappeared. A reconstruction of Fra Carnevale's artistic personality was thus (falsely) premised on the only work ascribed to him that was easily accessible.

Fra Carnevale and Piero della Francesca

It is to the eighteenth-century priest Andrea Lazzari, one of the pillars of erudition in Urbino, that we owe a vivid definition of the art of Fra Carnevale, "who, in showing his figures from life, was very accomplished in adapting them from the profane to the sacred" ("*che nel rappresentare al vivo le figure, e da profane ridurle a sagre, è stato assai valente*"). Although often cited, these words are entirely off the mark because they actually constitute an early moment of appreciation, both insightful and sensitive, for the work of Piero della Francesca. When Lazzari wrote these lines, the only work in Urbino considered to be by Fra Carnevale was the great panel in San Bernardino—the *Montefeltro Altarpiece*—in which the figures, thought of as "profane" (that is, showing members of the duke's family), are truly redolent of an introspective and vibrant sacredness. An oeuvre for the friar—really a "pseudo-oeuvre," since it comprised works by Piero and his followers—was gradually built around this work. At its core were the altarpiece now in the Brera and the *Senigallia Madonna* (fig. 2), which Raimondo Antaldi, in a letter cited by Pungileoni, believed to be a sketch ("*abbozzo*") for the altarpiece. There was also the *Flagellation* (Galleria Nazionale delle Marche, Urbino); the *Nativity* (fig. 3); *Saint Michael* (National Gallery, London) and *Saint Nicholas of Tolentino* (Museo Poldi Pezzoli, Milan; then identified as Saint Dominic);[19] the so-called *Villamarina Madonna* (fig. 4); and a *Madonna and Child* (Christ Church, Oxford).

The only authors who, early on, distanced themselves from this shower of attributions were Crowe and Cavalcaselle, who criticized the inconsistencies in Fra Carnevale's historical documentation, since it lacked secure works on which attributions could be based, and who rightly reassigned nearly all the pictures just mentioned to Piero della Francesca.[20] For Cavalcaselle, who studied the Barberini Panels in Rome, the pair of paintings was best situated elsewhere: he did not connect them with the Urbino documents, and rejected the attribution to Botticelli, recorded in the inventory of the Barberini entail (*fidecommisso*),[21] in favor of Marco Zoppo.[22] In the Italian edition of the *History of Painting*,[23] he assigned the two pictures to a follower of Piero influenced by Giovanni Boccati and Matteo da Gualdo, partly recognizing the well-researched studies of Schmarsow and Venturi.[24]

Adolfo Venturi's contributions offer an excellent example of the degree to which the accumulated burden of Piero's paintings weighed down on Fra Carnevale. Indeed, in 1893, the Modena scholar connected the 1466 payment to Bartolomeo Corradini for the altarpiece of Santa Maria della Bella (a document known since the time of Lazzari) with the two panels of the *Birth of the Virgin* and the *Presentation of the Virgin in the Temple (?)* in

2.
Piero della Francesca,
Madonna and Child with Angels
(*Senigallia Madonna*).
Galleria Nazionale delle Marche,
Urbino

3.
Piero della Francesca, *The Nativity.*
National Gallery, London

4.
Follower of Piero della Francesca,
Madonna and Child
(*Villamarina Madonna*).
Museo della Fondazione Cini, Venice

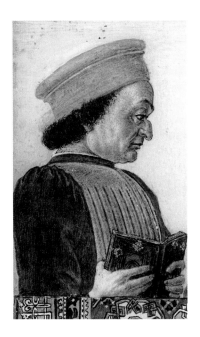

5.
Sandro Botticelli (?),
Federigo da Montefeltro, detail of *Federigo da Montefeltro with Cristoforo Landino*
(cod. Urb. Lat. 504).
Biblioteca Apostolica Vaticana,
Vatican City

the Palazzo Barberini.[25] As a result, he was the first to reject the catalogue of works associated with Fra Carnevale as it had taken shape during the nineteenth century.

Venturi began his analysis with a colorful invective directed at those who write history without the use of objective data, or who use secondhand information. He explicitly affirmed that the works commonly attributed to Fra Carnevale based on their relation to the *Montefeltro Altarpiece* were, in fact, by Piero della Francesca, and that, by the same token, only the Barberini Panels could, on the basis of documents, be assigned to Fra Carnevale: they were in the collection to which the panel from Santa Maria della Bella had been brought, and one of them, the *Birth of the Virgin,* was identical in subject to the altarpiece executed by Claudio Ridolfi as a substitute for the painting removed by the papal legate.[26] However, twenty years later, in his *Storia dell'arte italiana,*[27] Venturi was won over by the objections that were immediately raised to his radical revisions (his argument garnished no substantial following in Italy);[28] he reshuffled his cards and reassigned all of the late works of Piero della Francesca to Fra Carnevale, who, ironically, he defined as a rather pedestrian follower of the great artist—someone given to digressive passages of naturalism in his paintings.[29] As to the pair of pictures in Rome, he created an anonymous "Master of the Barberini Panels"—an artist steeped in the culture of Urbino and aware of Piero's works, but roughhewn and lacking in sophistication.

THE MASTER OF THE BARBERINI PANELS

The first decades of the twentieth century saw the opening of a new chapter in which research on the painter now had to tackle the intrusive presence of the Barberini Panels themselves. Their display at the mammoth exhibition of Italian art held in London in 1930 (fig. 6, 7),[30] followed by the calamitous dispersion of the Barberini Collection; their migration to the United States and their acquisition by public museums (for which, see the Directors' Foreword); and the revival of scholarly interest in peripheral areas of the Italian Quattrocento: all of these factors contributed to studies that gave a far better description of the (now anonymous) painter's culture, even if his historical identification remained a matter of conjecture. One is reminded of the articles by Wehle and Cunningham,[31] who both considered Fra Carnevale's authorship of the panels plausible and were able to discern stylistic evidence pointing to the painter's awareness of Florence, his ties to Piero della Francesca (the source for the elegant dignity of the figures and for the quality of light and color) and Domenico Veneziano, as well as his appreciation for Alberti and a solidly grounded culture of architecture. These ideas were to be articulated in a more structured manner by Richard Offner in a fundamental essay published in 1939.[32] From this point onward, the critical history of the works is so well known (see the relevant catalogue entries)[33] that we shall only touch on its main points.

Offner's essay is a paradigm of scholarly attention to the works themselves and displays as well those traits of pragmatism and clarity Italians associate with Anglo-American scholarship. He identified the key questions to be answered and sought solutions through formal and morphological analysis. This approach enabled him to recognize the same artistic culture in two other works: the *Annunciation* in Washington (cat. 40 and fig. 8) and

the *Crucifixion* in the Galleria Nazionale delle Marche, Urbino (cat. 41 B and fig. 9). What emerged was an artistic profile of the painter: an artist whose earliest training was based on the works of Domenico Veneziano but who was, above all, profoundly influenced and inspired by Fra Filippo Lippi during the late 1440s. He was also aware of Piero della Francesca, whose work he did not fully comprehend but from which he derived his facial types and his formula for perpendicular drapery folds—although not the special relationship between light and color. Those generically North Italian components, seemingly confirmed by the evidence of the altarpieces depicted in the *Presentation of the Virgin in the Temple (?)*—for Offner, typically Emilian and Venetian in form—pointed to someone from north of the Appenines. Offner excluded Fra Carnevale's authorship for lack of documentary evidence that the artist had any contact with Florence.

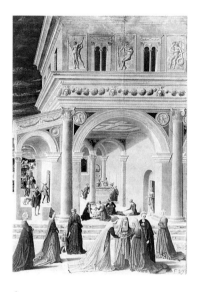

6.
Fra Carnevale,
The Birth of the Virgin (before 1935).
The Metropolitan Museum of Art,
New York

Paradoxically, Offner's weighty essay elicited a diametrically opposed interpretation. Richter,[34] underlining the strong Marchigian element in the Barberini Panels, and, more particularly, their resemblance to the works of Giovanni Boccati, demonstrated how Offner's profile of the artist did not actually rule out an attribution to Fra Carnevale, who, like Boccati, was Marchigian. Richter proposed a slightly different outline, including a sojourn by the master in Padua. He excluded from the artist's oeuvre the Urbino *Crucifixion,* focusing instead on a *Crucifixion* now in the Galleria Sabauda, Turin (fig. 10),[35] followed by the Washington *Annunciation,* the two Barberini Panels (for the first and only time placed in a chronological sequence, with the New York panel coming slightly earlier), and concluding with the *Madonna and Child* in Cambridge (cat. 11), in which he saw strong similarities with the *Presentation of the Virgin in the Temple (?)* in the anomalous architecture, the play of light and shade, and the drapery style.

Offner's reconstruction found little acceptance in Italy. Curiously—perhaps because of their aristocratic, nonchalant quality—the Barberini Panels never captured the attention of the outstanding critic Roberto Longhi, who hastily attributed them to the Perugian painter Bartolomeo Caporali. He may have been irritated by the old confusion between Fra Carnevale and his beloved Piero della Francesca, and he changed the attribution of the *Madonna and Child* in Cambridge to the Pratovecchio Master.[36] Federico Zeri, who was to make a defining contribution, initially rejected the corpus proposed by Offner: only after reflecting on it for over a decade[37] did he agree with the American scholar, expanding the artist's oeuvre with the clear intention of jumping the hurdle Offner had refused to confront—the matching of a historical name to the stylistic data. Thus was born *Due dipinti, la filologia ed un nome. Il Maestro delle Tavole Barberini,* published in 1961.[38]

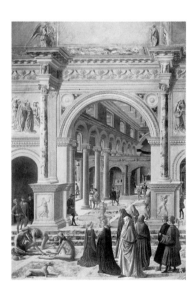

7.
Fra Carnevale,
The Presentation of the Virgin in the Temple (?),
(before 1935).
Museum of Fine Arts, Boston

Zeri further broadened the corpus of the artist's works with three companion panels: *Saint John the Baptist, Saint Peter,* and *Saint Francis* (cat. 41 A, C, D); an *Annunciation* in Munich (cat. 19); and the sleeping alcove in the Palazzo Ducale, Urbino (fig. 41, p. 117).[39] An incomparable connoisseur of Marchigian art, he connected the language of the paintings to their region of origin. He even explained the presence of the Northern Italian idiom—that of the Paduan artist, Squarcione (this much had been perceived by Cavalcaselle)—as the result of a sensibility refracted through the lens of Camerino, whose

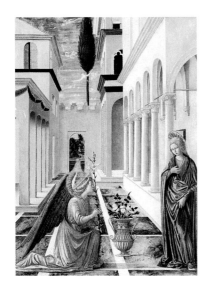

8.
Fra Carnevale, *The Annunciation*.
National Gallery of Art, Washington, D.C.

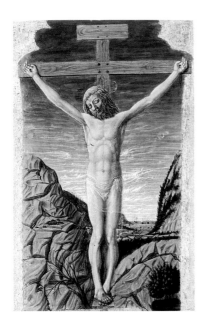

9.
Fra Carnevale, *The Crucifixion*.
Galleria Nazionale delle Marche, Urbino

artists repeatedly visited Padua. Finally, with the attribution of the sleeping alcove, Zeri firmly associated the painter with Urbino, its court culture, and with Giovanni Boccati (who frescoed a room in the palace).

For Fra Carnevale's early career, Zeri offered an interpretation almost exclusively centered on Domenico Veneziano (here one can see the radical difference from Offner's reconstruction) and by a Veneziano-influenced Umbrian culture. He proposed an undocumented period of training by the artist in Perugia—a hypothesis resulting from a nexus of deductions and comparisons, since everything that Domenico Veneziano painted in Perugia is lost. It fit squarely within the hierarchy of mid-Quattrocento painting suggested by Longhi,[40] who in 1952 assigned a crucial role to Domenico Veneziano and his "ornate manner of narration," while diminishing the importance of Filippo Lippi. Yet, as the archival research carried out for this exhibition demonstrates, Lippi's paintings as well as his workshop were inescapable points of reference—and not only for the Master of the Barberini Panels.

Zeri's arguments convinced almost the entire scholarly community, even if the corpus of works he established was not wholly accepted. Specifically, dissenting voices were raised over the Munich *Annunciation* and the panels from the polyptych, which seemed so distant—at least at first glance—from the silent, rarefied world of the Barberini Panels.[41] Parronchi's and Battisti's dissenting opinions regarding the Barberini Panels remained isolated. The former suggested that Leon Battista Alberti had painted them, which was hardly plausible but had the merit of emphasizing their undoubted connection not only with Alberti's buildings but also, and above all, with his literary works and treatises, thereby revealing a richly fertile ground for an understanding of the master.[42] Battisti, on the other hand, in seeking to cast a clearer light on Piero della Francesca's activity in Urbino,[43] returned to Venturi's Fra Carnevale hypothesis, listing the documentation known up to that time.

THE REBIRTH OF FRA CARNEVALE

Battisti's view received confirming evidence in 1975 and 1976 with the publication of documents elucidating two of the problems at the heart of the story. The earliest inventories of the Barberini household indicated Fra Carnevale as the author of the panels now in Boston and in New York, and an account book relating to the *Coronation of the Virgin* by Filippo Lippi (fig. 2, p. 40), recorded that Bartolomeo di Giovanni Corradini, not yet a friar, was a member of Lippi's workshop in 1445.[44] Thus, a record made shortly after the removal of the Barberini Panels from Urbino connected the pair of paintings with the friar, while concrete evidence was found for the Lippesque elements observable in them. This reopened the possibility of identifying the Master of the Barberini Panels as Bartolomeo di Giovanni Corradini, alias Fra Carnevale.[45] Nonetheless, this identification continued to meet with resistance, and Zeri's proposal of Giovanni Angelo d'Antonio da Camerino was favored. Recently discovered documents have now excluded that alternative: Giovanni Angelo turns out to be the artist responsible for the best paintings once ascribed to another Marchigian painter, Girolamo di Giovanni.[46]

Seen from the vantage point of almost thirty years, this one-hundred-and-eighty degree turnaround effectively divided scholars into three camps: critical, cautious, or

convinced,[47] and it once again sharpened the debate about the Barberini Panels themselves. On the one hand, it seemed that only an objective demonstration identifying the panels with the altarpiece from Santa Maria della Bella cited by Vasari could remove the remaining doubts; on the other, the inscrutability of the works themselves made this a difficult challenge—something to be tackled with the most disparate scholarly approaches.[48]

Among the questions raised are the following: Are the Barberini Panels truly identifiable with the Santa Maria della Bella altarpiece? Do they possibly come from the Palazzo Ducale? What sort of object did they form? How do they relate to each other? What are their subjects, and why are they treated in the way that they are? Despite the very considerable efforts expended, there is no satisfactory answer to these questions, and this impediment has perhaps diminished the need to reassess Fra Carnevale's activity, which has in the meantime been enriched by new attributions.

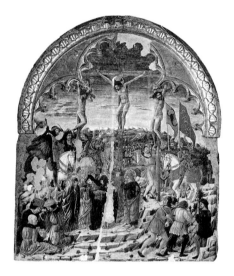

10.
Giovanni di Piermatteo Boccati, *The Crucifixion*. Galleria Sabauda, Turin

AN EXPANDING OEUVRE

Nineteenth-century scholarship underlined the meager output of the friar-painter, despite a documented forty-year career. It explained this by referring to his duties as a parish priest, "which removed the paintbrush from his hand." One can still subscribe to this view today. Just how limited his output was is underscored by the fact that of the nine paintings assembled by Zeri, four belong to one polyptych, just as the two Barberini Panels formed a single complex. A century of scholarship has expanded his oeuvre, but as often as not there has been little consensus regarding these additional attributions. In certain cases—the *Madonna and Child* in Cambridge (cat. 11), the *Crucifixion* (fig. 10), and a lunette with *Saint Jerome* in Turin (Galleria Sabauda)—they have not been accepted by most scholars or have been shown to be erroneous.[49] In other cases, they have rooted themselves firmly within the artist's oeuvre. This has happened with the trenchant portrait of Frederick III in the Uffizi (cat. 28),[50] with its pale, opalescent tones, so close to the palette of Domenico Veneziano; its detailed execution, worthy of a miniaturist's work; and its balance between abstraction and naturalism. Of special interest, too, is a series of drawings (unfortunately not all present in the exhibition for reasons of conservation)[51] that can be classified with the type used on a daily basis in fifteenth-century workshops for establishing a repertory of models (fig. 68, p. 129; ill. p. 202). Their nervous handling and deep shadows, juxtaposed with sudden flashes of light, and their attention to perspectival recession in space seem to represent a translation of Fra Carnevale's own language into another medium. In these works, as in a drawing with figures copied from Lippi's paintings (cat. 16), we find figures depicted in various attitudes (standing, resting, crouching) such as offered ready-made points of reference for future compositions. Some of these figures can be identified—in different garb—in the Barberini Panels, and knowledge of their origin contributes to the artificial, rarefied atmosphere of the paintings: lifted from standard repertories, each group or individual figure is bound to its compositional context by the perspective grid of the picture rather than by collective involvement in a single narrative action.[52]

An awkward portrait in The Metropolitan Museum of Art (cat. 17)[53] was ascribed to the artist on the basis of comparisons that, in fact, tend to disprove the connection with

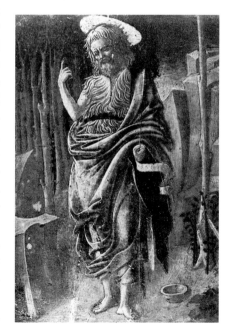

11.
Fra Carnevale (?), *Saint John the Baptist in the Desert*. Musée Condé, Chantilly

12.
Filippo Lippi and Fra Carnevale (?),
The Coronation of the Virgin, detail.
Galleria degli Uffizi, Florence

Fra Carnevale, who is always painstaking, even in the smallest of images. A *Portrait of a Man* in the Kunsthistorisches Museum, Vienna (cat. 42), attributed to Fra Carnevale by Daniele Benati, may acquire a broader consensus.[54]

The most expansive contribution to our understanding of the artist is due to Luciano Bellosi, who investigated the painter's relationship with Domenico Veneziano and recognized in Fra Carnevale's refined pictorial approach to differing nuances of light, brusquely interrupted by pools of shadow cast by drapery, a proponent of a "*pittura di luce.*" Bellosi focused on the artist's early career in Lippi's workshop and he reascribed to him a series of paintings that Berenson believed were by Zanobi Macchiavelli (see cat. 18): paintings characterized by an unconventional interpretation of Lippi's figure types, although deformed, set into ambiguous spatial constructions, and permeated by an existential uneasiness that disturbs their poses (fig. 11).[55]

A partial resurgence of an attribution already discarded is signaled by the suggestion (still without any following) that the *City View* in the Walters Art Museum, Baltimore, should be included in the painter's oeuvre. It has been identified as the picture—"*anthica ma bella*"—listed in the Palazzo Ducale at the end of the sixteenth century.[56] Most recently, Andrea De Marchi has cast light on a study of an allegorical figure in the Cagnola collection (cat. 44) whose past attribution to the Master of the Barberini Panels had gone unnoticed,[57] but which unquestionably is by our painter.

As one can see, these are substantial additions, but they made their appearance one by one, without a corresponding rereading of documents or a review of the artist's career

and the connections among them. One should look with greater scrutiny at Lippi's *Coronation of the Virgin* (fig. 12) in order to identify—beyond what was discerned by Alessandro Conti—the hand of the young assistant, whose presence is now further documented, and who had just arrived from Urbino in 1445. At the same time, it is necessary to consider what this obviously brilliant, restless, and eager youth could have learned in his native region. The body of early works proposed by Bellosi is not notably stylistically coherent and, therefore, is only plausible if it is imagined that the painter joined Filippo Lippi's workshop as a boy, before being fully formed, and thus could totally absorb the Carmelite's lessons. At least, this is what is suggested by the attribution to Fra Carnevale of a *Saint Christopher* (fig. 13).

FRA CARNEVALE THE ARCHITECT

Another field of endeavor—crucial to Urbino—with still-unexplored implications for the identification of Fra Carnevale with the Master of the Barberini Panels is that of the architectural backgrounds of his paintings and his proficiency in architecture. A conspicuous leitmotif in the bibliography on the artist is his interest in his architectural settings, and one wonders whether he might not have been a practicing architect. It is not only a matter of the naïve stress on architectural elements in his two most celebrated paintings, but the way in which these panels display an explicit interest in the tiniest details of ornament and structure.[58] The merits of such consideration are further suggested by the artist's connections with the young Bramante, alluded to by Vasari (albeit only along lines mentioned at the outset of this essay).[59] Perusing the literature on the artist, it will be seen that there is evidence in his architectural backgrounds of an interest extending beyond a purely pictorial training. Motifs can be found in the Barberini Panels and the Washington *Annunciation* that come from a variety of sources: Florence (Michelozzo and Maso di Bartolomeo), Alberti's theoretical writings, Roman architecture, and a profound sympathy for what was evolving in Urbino during the 1450s and 1460s. Direct quotations from architectural projects dating from this time—the portal of San Domenico (fig. 1, p. 96), or the Iole wing of the Palazzo Ducale—demonstrate the painter's familiarity with a refined architectural language. However, with the exception of the careful study by Monica Strauss, in her dissertation, which has not been widely read,[60] no one has seriously considered whether the artist was directly involved in these projects. This is partly because the late date Zeri assigned to the sleeping alcove[61] in the palace shifted this discussion to a period when architectural forms in the palace had radically changed.

However, if we assume that the Master of the Barberini Panels is, indeed, Bartolomeo di Giovanni Corradini, the scene is transformed, for we know that Fra Carnevale was involved—at least as a middleman (this much was already understood by the end of the nineteenth century)[62]—in the building of the portal of San Domenico. He is recorded as an architect by Lomazzo, as we have seen, but also in a notice related to the palace that places him in the company of such important figures as Luciano Laurana and Francesco di Giorgio.[63] Finally, a document of 1455 (recently discovered and transcribed here:

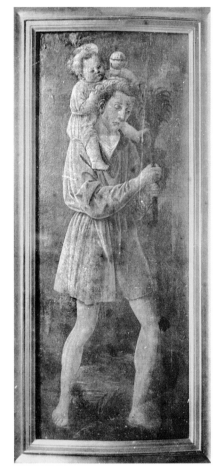

13.
Fra Carnevale (?), *Saint Christopher.*
Formerly, Lanckorónski Collection, Vienna

Mazzalupi, doc. 8) relating to stonework for the new cathedral in Urbino mentions capitals and bases that are to be executed according to Fra Carnevale's designs. Thus, what has been seen as generic comparisons and explained as a shared artistic culture can now be reconsidered as an indication of Bartolomeo Corradini's direct participation in individual architectural projects (on this, see the essay by Matteo Ceriana).

Paralleling the question of Fra Carnevale's practice of architecture is the remarkable fact that his paintings have been consistently regarded as being perspectively inaccurate. Research carried out for the present exhibition (in part addressed in the essay by Roberto Bellucci and Cecilia Frosinini) proves that a tireless, almost obsessive attention was paid to foreshortening, but this deliberate tour-de-force perspective ends up appearing unnatural and "wrong" precisely because some parts of the image appear immune to its laws— above all the figures, which are diligently provided with shadows but are otherwise weightless and seem to be incidental to the independent and overwhelming spatial grid. It is no accident that in the earliest Barberini inventories the panels were described simply as "*prospettive*." The figures within them seemed mere accessories, enabling one "*prospettiva*" to be distinguished from the other. These paintings appear the way they do not for a lack of skill but because of a deliberate, creative intent. As in a work of intarsia, their creation was based on minute planning—at once impressive, antiquarian, and attentive to spatial recession.

PROVISIONAL CONCLUSIONS

In conclusion, we offer a general overview of what has been achieved so far, and what is still needed in our attempt to "find" Fra Carnevale—if, in fact, artists of the past can ever be truly and wholly "found." If we review where we are by following the life and career of our protagonist in chronological order, in light of available documentation,[64] one area that requires investigation is his early training. When he appears in the workshop of Filippo Lippi in 1445, fresh from Urbino, it is as a pupil rather than an apprentice, suggesting that his initial training was in the Marches. Future research will ascertain whether this took place under his fellow friar, the mysterious Jacopo Veneto (although we should recall that Bartolomeo did not take his vows until substantially later on), or in the workshop of Antonio Alberti, with whom one document connects him. In contrast, the role played by Filippo Lippi's workshop as a crucible for artistic experiments by "the 1425 generation," as we might call it, is abundantly clear.

We do not know when Fra Carnevale returned to Urbino, or when exactly he entered the convent of San Domenico, although it was sometime prior to January 1450. At that date the friar was already involved in the creation of what was then the most modern architectural undertaking in Urbino, and he had probably also assumed the mantle of "cultural adviser," summoning to the Marches artists he had met in Florence such as Maso di Bartolomeo and Luca della Robbia. These years of feverish activity could have included a visit to Rome—especially plausible if we accept his authorship of the portrait of *Frederick III* (ascribed here by Andrea De Marchi to the Perugian Benedetto Bonfigli).

The mid-1450s witnessed projects for a new cathedral in Urbino and an altarpiece for the Confraternità del Corpus Domini—a commission Fra Carnevale relinquished in

June 1456 for motives that remain unclear. It is evident by now that he had a multi-faceted personality—one that cannot be pigeonholed, since all facets of the artistic profession were clearly familiar to him. As we admire the exceptionally careful handling of the smallest details in his paintings, we wonder whether he was a miniaturist as well. He was also someone who could assume the role of a low-profile "director," orchestrating other people's work without imposing himself personally in the outcome.[65]

What remains are those traits that make up his social and cultural profile and his identity as a human being. The documents, beyond their particular significance, marshal a group of eminent people around the friar. One of these individuals was Guido Bonclerici, doctor of law in *utriusque juris,* canon of Cagli, secretary to Federigo da Montefeltro, and (from 1470) syndic, proctor, and vicar-general of Bishop Giovanni Battista Mellini. Another was Ottaviano Ubaldini, without any question the most powerful person at the court of Urbino after Federigo himself. Fra Carnevale and Ottaviano were fellow-executors of the will of Matteo de Cataneis, evidently an intimate of the Lords of Urbino;[66] he is cited several times in connection with our protagonist and is for this reason a worthy subject for specific investigation.

The painted works themselves suggest someone with a refined, superior culture—even within the context of his enlightened religious order—revealing an awareness of sources ranging from Alberti's treatises to classical mythology (fig. 14),[67] mingled with a subtle taste for coded language replete with cryptic allusions that disconcert and captivate those who, like ourselves, have lost its interpretive keys. These paintings speak to the heart, stimulate our intelligence, and are a feast for the eyes, conveying a vivid impression of a complex and contradictory personality. Little in them seems to have been left to chance, confined as they are within a finely incised framework in which abandoned compositional plans coexist with definitive solutions. It is almost as if the author had determined not to discard those initial ideas entirely, so that he could recover them at any given moment, at the risk of trapping himself in a maze of perspective lines. However, having arrived at a final solution, he sometimes abandoned its pictorial realization half way through the execution.[68]

Thus, rather than being taken in by cheap psychology, it might be more fruitful to focus on the convent of San Domenico, perhaps starting with the very name by which Bartolomeo Corradini was known—a nickname whose penitential connotations allude to markedly spiritual choices. Contrary to what is generally expressed in historical accounts, which have been misled by the current use of the term, the meaning of "Carnevale," associated with giving up meat, was "Lent," the penitential period preceding Easter.[69]

The Barberini Panels themselves may continue to jealously hold their secret, yet their secure provenance from Santa Maria della Bella strengthens one of the traditional methods of research, which relates to the activity of the confraternity of flagellants who assembled in that church. Although Gilbert's interpretation of the subjects of the Barberini Panels as scenes of hospital life is no doubt exaggerated, one cannot stifle the impression that the sacred episodes represented here are mingled with allusions to the confraternity's business—serving almost as an *exemplum*—and can be read as such, even if archival research has yet to uncover the confraternity's statutes or to document its charitable

14.
Fra Carnevale,
Jupiter and Semele (?), from
the *Birth of the Virgin,* detail.
The Metropolitan Museum
of Art, New York

activities.[70] In addition, we should also examine the meaning of the panels in relation to the series of pictures painted for San Bernardino in Perugia, which herald a new phase in Umbrian painting.

So to Piero: Consigning the confusion between the two artists to a remote past, it is now time to reexamine the works of both of these painters—bearing in mind their obvious artistic differences—as the products of two contemporaries whose paths crossed several times during their lives. In Urbino in the late 1460s, each of them faced the challenge of depicting ornate architecture, and while they produced solutions that were quite different, they shared a secret and enduring bond. Indeed, both artists were fascinated by mathematical certainties and precise shifts of scale. Although Piero created enigmatic spaces, which become more ambiguous as they recede into depth but are perceptible in their complexity through his treatment of light, Fra Carnevale's display of dovetailed space can be easily followed by the eye, its inflexible rigor guided by the compasses and paintbrushes employed by both artists.

The possibility of examining the Barberini Panels and the small picture at Gazzada (cat. 44) alongside Piero's *Montefeltro Altarpiece* and his painting from Williamstown (cat. 47) provides a unique occasion for a lively dialogue centered on issues such as light and color, geometry and perspective, space and time, and antiquity and Christianity: two ways of observing reality and reproposing it in artistic terms. Compared with Piero's eternally transfigured forms,[71] what Fra Carnevale offers us is an elegant but fragile humanity that exists on the edges of obsessively measured spaces, perennially balanced between formal abstraction and painfully concrete detail. However, notwithstanding their differences, the work of both masters expresses variations on a single culture, each destined to be superseded and partly forgotten in the creative turmoil wrought by Federigo da Montefeltro in Urbino.

1. For a complete bibliography, see Bruschi 1983. For more recent scholarship, see Dal Poggetto 1992b and 2003a, and Cleri 1996 and 2004; the last publication—specifically, the essay by A. M. Ambrosini Massari ("L'ambiguo destino del falso Piero: Panoramica delle fonti per Bartolomeo Corradini"), which treats similar issues to those discussed here—was in preparation and could not be fully considered.

2. G. Santi 1985; Varese 1988.

3. Vasari 1991.

4. See Pungileoni 1836, p. 11: "Né pure so a quale fonte abbia atinto il Vasari, che egli desse opera al disegno sotto la disciplina di Fra Borromeo [sic] Corradini."

5. See the documentary appendix by Livia Carloni in this catalogue.

6. Lomazzo 1974, vol. 2, p. 355: chapter XLVI, "Composizioni degli edifici in particolare," deserves to be read in its entirety. See Agosti and Agosti 1997, p. 30.

7. This is proven, moreover, by a portrait of the friar "fra quelli degli uomini illustri di Urbino raccolti dal celebre monsignor Fabretti" (Antaldi [1805], 1996 ed.); the latter can certainly be identified as Monsignor Giuseppe Fabretti (Urbino 1619–Rome 1700), a celebrated collector of ancient and inscribed tablets. His collection was acquired by the cardinal legate Giovan Francesco Stoppani and became part of the lapidary museum that formed the initial nucleus of the Galleria Nazionale delle Marche, Urbino. The fate of his gallery of portraits remains unknown.

8. Baldinucci 1846, vol. 3, p. 178.

9. "Il Vasari dice che nella stessa città dipingesse la tavola per la chiesa di Santa Maria Dolabella. Questi fu quel Bartolomeo di Urbino che insegnò l'arte della pittura a Brammante di Casteldurante." Ibid.

10. Sangiorgi 1976, p. 63.

11. The third volume of the Notizie, with omissions and errors, was not published by the author; edited by his son, it was not issued until 1728.

12. Madiai 1895; Sangiorgi 1992, p. 65. As one might expect in a climate that valued a classical education, the admiration for the Montefeltro Altarpiece was not as great as that for the Saint Sebastian by Timoteo Viti, which also is now in the Brera: "benissimo conservato che pare di Raffaello." The parallel attribution in Padre Vernaccia's letter, cited by Lazzari, is almost contemporaneous.

13. Distinto ragguaglio delle Pitture che si ritrovano nella Città di Urbino sia in pubblico che in privato con i nomi cognomi e patria degli autori che le hanno fatte e la nomina delle chiese, Palazzi e Case dove esistono le più singolari. Ed in fine una breve descrizione del Palazzo Apostolico con il celebre erudito Museo che in esso trovasi. Descritto da Michele Angiolo Dolci Professore di Pittura ed Accademico Clementino nella città di Bologna l'anno 1775, published in Dolci 1933. Combining the two traditional views of Fra Carnevale, the author states that the altarpiece now in San Bernardino is that cited by Vasari as in Santa Maria della Bella. See also the texts in the Biblioteca Universitaria di Urbino

published in Lombardi 1995: for example, the "Nota delli quadri de pittori illustri, che sono nelle chiese della città di Urbino" (Bibl. Univ. Urb., Fondo Comune, vol. 55, fols. 189v–192; copy by A. Corradini, 1705–8), which records a painting in San Bernardino with the Virgin and a portrait of Duke Federigo in armor "ed una prospettiva di mano di Fra Carnevale"; while the "Catalogo delle pitture che si conservano nella città metropoli d'Urbino con la notizia degli autori della medesima MDCCXLIV di Ubaldo Tosi" (BUUF Comune, vol. 93, fols. 219–225v) notes: "nella chiesa di San Bernardino de PP. Zoccolanti, l'altare maggiore, di mano di Fra Carnevale F. Domenicano Urbinate, ed altri dicono di Luca del Borgo." See also Trevisani 1997.

14. The description of the altarpiece appears in a brief account of the convent written in 1793. For a description of the codex and the persistence of the "family" tradition, see Trevisani 1997, p. 73; the identification of the Virgin as the duchess continued up to Ligi 1937.

15. Lanzi 1797 (1824 ed.), pp. 23, 50; Rosini 1841, pp. 168–70; Grossi 1856. Conversely, worth noting is the sensitivity of the highly insightful Abate Lanzi's assessment of Piero della Francesca.

16. Lazzari 1801; Lazzari 1797; Antaldi [1805] 1996 ed., pp. XVIII, XXXII, 23, 34, 42, 43, 44, 116; Pungileoni 1822, reprinted, R. Varese, ed. (Pungileoni 1822 [1994 ed.], pp. 6, 10, 52, 53, 55, 56); Marchese 1845, vol. 1, pp. 350–58.

17. Marchese 1845, vol. 1, pp. 350–58; Alippi 1894; Calzini 1897, pp. 92, 103.

18. Dolci 1933, p. 319: "Palazzo de' Cavalieri Staccoli nell'anticamera prima o sia galleria . . . parete destra: Di Fra Bartolomeo Corradini, detto Fra Carnovale [sic], un quadro per traverso, rappresentante la Gran Vergine con il Bambino e quattro Santi, pittura in tavola." Dolci was probably the source for the later mention in "Diverse notizie riguardanti le Belle Arti di alcuni luoghi delle Marche raccolte da Gaetano Giordani" (1829), Ms. 1799, fol. 26 (Biblioteca Comunale dell'Archiginnasio, Bologna).

19. Frizzoni 1882.

20. Crowe and Cavalcaselle 1864–66, vol. 2, pp. 550–55. A similiar position was adopted by Schmarsow (1886). Prior to that, Dennistoun (1851, vol. 2, pp. 208–11) had attributed the Barberini Panels to Piero, whose oeuvre he had attempted to organize by grouping the painter's works into two stylistic categories: the first was more detailed, typified by small figures and Late Gothic elements; the second, more solemn and grand.

21. Crowe and Cavalcaselle 1864–66, vol. 2, p. 553; Mariotti 1892, pp. 127ff., no. 29, for the transcription of the inventory of the Barberini fidecommisso.

22. Even though Schmarsow (1886, p. 107) clearly connected the panels with the culture of Urbino, he did not associate them with Fra Carnevale, and suggested Luciano Laurana as the author.

23. Cavalcaselle and Crowe 1886–1908, vol. 8, pp. 267–70.

24. See note 25, below.

25. Venturi 1893, pp. 415–17.

26. This Birth of the Virgin by Ridolfi also wound up at the Brera with other works confiscated by Napoleon, and was subsequently assigned to the church in Groppello d'Adda, where it remains to this day. On this, too, see the documentary appendix by Carloni; Leonardi 1970.

27. Venturi 1911, pp. 478–82; 1913, pp. 95–112. In addition to the customarily accepted list of works, he also attributed the small painting on parchment on the inside cover of Cristoforo Landino's Disputationes Camaldulenses (Biblioteca Vaticana, Urb. Lat. 504); see figure 5, page 27.

28. Frizzoni 1895; 1905, p. 393. The criticisms made then are still invoked today: the format of the panels, their incomprehensible subject matter, the markedly secular tone of the narration are all incompatible with an altarpiece. Outside Italy, the situation was different, also because awareness of Piero's late works emerged earlier and with less doubt, particularly among German scholars. See especially Bode, in the notes to the Cicerone (Burckhardt 1884); Borenius in Crowe and Cavalcaselle 1903–14 (vol. 5, p. 29 n. 1); and, for a summary, Di Lorenzo 1996b.

29. Playing on the nickname of the friar, Venturi wrote: "Niuno, perciò, dovrà mai confondere il giocondo arciprete di san Cassiano di Cavallino col solenne maestro di Borgo San Sepolcro. Questi non avrebbe mai osato interrompere la maestà sacra delle composizioni con lo scopiettio improvveduto di qualche trovata naturalistica, con la quale il pievano effondeva il proprio buon umore." On the correct interpretation of the name "Carnevale," see below.

30. London 1930, pp. 84–85. The works appeared as numbers 111 and 114 in the second gallery, dedicated to the art of the fifteenth century; the catalogue listing betrays the uncertain scholarship, since the pictures themselves are attributed to Fra Carnevale, whereas the entry remains uncommitted.

31. Wehle 1936; Cunningham 1937.

32. Offner 1939.

33. See also the texts cited in note 1, above.

34. Richter 1940.

35. See Minardi in De Marchi and Giannatiempo López 2002, pp. 177-78.

36. Longhi 1927 (1963 ed.), p. 204; Longhi 1952a; Fiocco 1955, p. 211.

37. Zeri 1948; Zeri 1953; Zeri 1958, especially p. 38.

38. Zeri 1961.

39. Zeri's chronological reconstruction of the sequence was as follows: the Washington Annunciation came first, followed by one in Munich, the Barberini Panels, and the painted alcove (dated to about 1475), and finally the panels of the polyptych divided at that time between Milan, Loreto, and Venice.

40. Longhi 1952a (1975 ed).

41. See the contributions by Pietro Zampetti, M.G. Ciardi Dupré Dal Poggetto, and P. Dal Poggetto in Ciardi Dupré Dal Poggetto and Dal Poggetto 1983, pp. 34–35, 43–48, 50–55; and Dal Poggetto 1988, pp. 64–68. Quite rightly, however, and on several occasions, Dal Poggetto dates the alcove to the late

1450s, when Federigo married Battista Sforza, contemporary with the decoration of the so-called Camera Picta. Previtali (1970) attributed the panels of the fragmentary polyptych to Giovanni di Piamonte, as he believed that their strongly expressionistic quality was incompatible with the other works in this group.

42. Parronchi 1962; Parronchi 1964a; Parronchi 1974.

43. Battisti 1971 (1992 ed.), especially pp. 248, 386.

44. Lavin 1975; De Angelis and Conti 1976.

45. For the initial, decisive agreement, supported by further attribution within Lippi's oeuvre, see Christiansen 1979.

46. Di Lorenzo 2002; Mazzalupi 2003b.

47. The first group includes Dal Poggetto, Ciardi, and Zampetti; the second, Bruschi; and the third Sangiorgi, Strauss, Bellosi, De Marchi, and Cleri.

48. Gilbert 1993; Gilbert 2000; Borsi 2003; Valeri 1994, 1995, 1999, 2000, and 2004.

49. The last two works are in the Galleria Sabauda, Turin. For the first, see note 1, above; for the second, Zeri 1958, especially p. 38.

50. Meiss 1961a. De Marchi (1992, p. 213; and cat. 28 in this catalogue) believes this is a work by Benedetto Bonfigli. Incidentally, one should note that the three predella panels published by Meiss, in the first part of the same article, as by Giovanni di Consalvo—currently ascribed to the early career of Francesco Botticini (Venturini 1994, pp. 27–28, 99–100)—bear an old inscription on the reverse attributing them to Fra Carnevale.

51. Meller and Hokin 1982; Angelini 1986, no. 27, pp. 43–44; Christiansen 1993.

52. The use of repertory figures also explains the quotations from a wide variety of works, such as the cloaked woman seen from behind in the Boston panel, which recalls not only one of the Virtues on the chariot from Piero della Francesca's portrait of Battista Sforza in the Uffizi, but also a figure in the *Miracle of the Bees*—Lippi's predella in the Gemäldegalerie, Berlin.

53. Joannides 1989.

54. Benati 1996.

55. Bellosi 1990a; Berenson 1950.

56. Ciardi Dupré Dal Poggetto in Dal Poggetto 2001.

57. Ciardi 1965, no. 15, pp. 35–36.

58. Venturi (1893, pp. 417–18): "E la prospettiva accurata, con un minuzioso studio di ogni particolare architettonico, con una finezza stragrande nelle cornici e nella riproduzione dei marmi e di classiche sculture, potrebbe far credere fra Carnevale architetto." One should consider this along with the attributions of the panels to architects such as Laurana (Schmarsow 1886) or Bramante himself (Swarzenski 1939).

59. Borsi 1989, pp. 143–50; Bruschi 1996, especially pp. 264–69; Borsi 1997, pp. 25–31; Bruschi 2002; and, most recently, Bruschi 2004.

60. Strauss 1979; see the essay by Matteo Ceriana in this catalogue.

61. Zeri 1961; Bruschi 1996.

62. Yriarte 1894.

63. Zannoni 1895a; Peruzzi 1986.

64. In light of studies made during the preparation of the present exhibition, further investigation will be carried out in the notarial archives in Urbino—specifically, a thorough examination of pastoral visits.

65. See Bruschi 1996, p. 298.

66. Tommasoli 1978, p. 44 n. 16.

67. One thinks of the *Birth of the Virgin,* where the building is decorated with Dionysiac episodes. Indeed, the first relief, usually identified as a scene with a Triton and a naiad, appears more likely to represent the union of Jupiter, transformed into a snake, and Semele, the result of which was the conception of Dionysus. The iconography of the Urbino *Crucifixion* (cat. 41 B)—specifically, the transparent loincloth and absence of a crown of thorns—is also unusual.

68. This is the case with the architectural friezes in both the *Annunciation* and the *Birth of the Virgin.*

69. Sella 1944.

70. Information on Urbino's confraternities and hospitals can be gleaned from *Relazione* 1933 and Sangiorgi 1992; see also Cleri 1996. These texts also reveal that apart from the hospital there were two "*case*" (homes) for abandoned children (male and female) and one for orphans, while nothing specific is said about Santa Maria della Bella, which was administered by the nuns of the Convertite del Gesù from 1564. The *Relazione* of 1597, which includes a rare brief description of the church, followed the publication of Vasari's *Lives* but predated the transfer of the two panels to Rome; it does not, however, resolve any issues. Specific focus is given to the fact that the church "è adorna di molte reliquie che decorosamente sono chiuse in un armadio a grate di ferro e chiuso a più chiavi," but it is hard to imagine that the Barberini Panels had any connection with this structure.

71. Lanza (1998) speaks, significantly, of a "perennità dell'evento."

Keith Christiansen

FLORENCE: FILIPPO LIPPI AND FRA CARNEVALE

IT IS DIFFICULT to imagine a more modest claim to a place in the history of Renaissance art than that of the Urbino painter Bartolomeo di Giovanni Corradini (about 1420/25–1484), who, after joining the Dominican order about 1449, was sometimes known as Fra Carnevale.[1] Vasari refers to him only in passing in his biography of Bramante, noting that the great architect "studied carefully the works of Fra Bartolomeo, otherwise known as Fra Carnevale of Urbino, who painted the altarpiece in Santa Maria della Bella." Yet, not only was this brief mention sufficient to assure the artist a place in posterity—fame by association—it served as the basis for ascribing to him what are now recognized as some of Piero della Francesca's greatest masterpieces: the *Montefeltro Altarpiece* (cat. 46), the *Senigallia Madonna* (fig. 2, p. 26), and the *Saint Michael* (National Gallery, London).[2] Although today he strikes us as an artist having an altogether different stature from that of Piero, their careers did run along parallel tracks and at important points intersected. We would, moreover, be well advised not to underestimate the originality of Fra Carnevale's art, which to no less a degree than Piero's illuminates some of the salient themes of the Renaissance. He was responsible for two of the most intriguing paintings of the fifteenth century (see cat. 47 A, B)—pictures that remain enigmatic after more than a century of scholarship—and if, as a result of archival research undertaken for this exhibition, it is now possible to lay out the bare bones of his career, much remains to be discovered.[3] His art poses fundamental questions about the meaning of style in the Renaissance and the manner in which artists employed it both to advance their careers and to define an artistic persona—something separate from the social determinants of birth and social condition. It also serves as a paradigm for the ways in which the Renaissance culture of Florence was transported beyond the Apennines and was transformed into a court style—the precondition to its emergence in the sixteenth century as the *lingua franca* of Europe.

Fra Carnevale is first documented in Florence in the spring of 1445, when he joined the busy workshop of Fra Filippo Lippi (about 1406–1469). It is not possible to say whether, in moving from Urbino to Florence, Fra Carnevale was motivated solely by artistic ambitions—a desire to acquire the prestige that attended the mastery of Renaissance style—or whether he had been encouraged in this venture by someone in the entourage of the newly installed young count, Federigo da Montefeltro (1422–1482). Federigo, who succeeded his assassinated half brother, Oddantonio, in July 1444, was at

1.
Filippo Lippi, detail of an angel by Fra Carnevale from *The Coronation of the Virgin*. Pinacoteca Vaticana, Vatican City

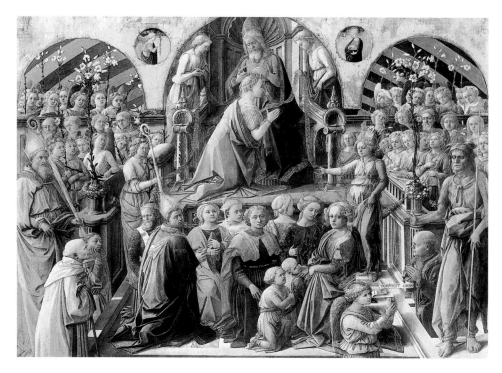

2.
Filippo Lippi, *The Coronation of the Virgin*
(*Sant'Ambrogio Altarpiece*).
Galleria degli Uffizi, Florence

the beginning of what was to be an illustrious military career. Although he was to become one of the great figures of the Renaissance—an outstanding military leader (it was on this that his wealth depended), a proponent of humanist studies, and the patron and friend of Piero della Francesca, Leon Battista Alberti, and Francesco di Giorgio—in 1445 he was only twenty-three and the heir to a small state heavily in debt. His position was far from secure, and artistic patronage cannot have been foremost in his mind. His childhood friend, kinsman, and future adviser, Ottaviano Ubaldini (1423/24–1498), had the sensibility and cultural background necessary to spot Fra Carnevale's promise and to encourage him, but in 1445 Ottaviano was still at the court of Filippo Maria Visconti in Milan, where he had been sent at the age of nine. While there he met one of the foremost artists of the day, Pisanello, whose work he greatly admired—at least to judge from two sonnets composed by the Urbino secretary and poet Angelo Galli.[4] Count Ottaviano was later to befriend Fra Carnevale, but as he did not return to Urbino until 1447 it seems unlikely that in 1445 he had any knowledge of the young, aspiring artist.[5]

It may not be coincidental that financial and military ties linked Federigo with the Medici even before he became the ruler of Urbino: his surviving correspondence with Cosimo de' Medici's son Giovanni (1421–1463)—an almost exact contemporary—begins in 1439, and he was soon referring to Giovanni as a most dear brother ("*Magnifice frater carissime*").[6] In September 1445 Federigo was officially employed by the Florentine commune (negotiations were entrusted to none other than Angelo Galli).[7] Thus, there is a possibility that a Medicean connection played a part in Fra Carnevale's transfer to

Florence. Such a scenario would go far in explaining both Fra Carnevale's association with Lippi—together with Fra Angelico the Medici's favorite painter—and the interest in Medici-funded architectural projects that are reflected in his mature paintings (discussed in the essay by Matteo Ceriana). Indeed, it is difficult to suppress the impression that Fra Carnevale's true goal in Florence was to become conversant with every aspect of Renaissance culture so that it might be introduced into Urbino. If this is so—and it remains no more than a hypothesis based both on the evidence of the paintings and on his later, documented contacts with Florentine architects and sculptors—then he could not have arrived at a better time, for the city was being transformed by the Medici.

FLORENCE: 1434–50

A new chapter in the history of Florence opens in 1434 with the arrival of Pope Eugenius IV (1383–1447) in June and the return of Cosimo de'Medici (1389–1464) from political exile in Venice in September. Eugenius had fled a popular uprising in Rome fomented by the Colonna family, and his temporary residence in Florence meant that for the next nine years the city was the center of Christendom—albeit a Christendom sorely torn apart by contesting parties (in 1439 a rebellious council elected an antipope, Felix V). Eugenius was a man with reforming tendencies and an ascetic character, and his presence in Florence was a matter of considerable prestige. He was given spacious quarters in the Dominican convent of Santa Maria Novella, where his predecessor, Martin V, had also stayed, and he took an active part in the religious and political life of the city. The bookseller and biographer Vespasiano da Bisticci records how Florentines gathered in the piazza below the pontiff's apartments to observe him, "and the reverence felt by them was so great that they stood astonished at the sight of him, silent and turning toward the spot where he stood. . . ." It was partly through Eugenius's mediation that Cosimo was allowed to return from exile—an event that marks the political ascendancy of the Medici and their prominence as patrons of the arts. The Church was the Medici bank's largest client—Eugenius was, indeed, dependent upon its financial backing—and the religious and political ambitions of the pope and his banker intersected in ways that had a profound impact on the city.

Vespasiano da Bisticci enumerates at length the religious establishments in Florence reformed by the pope, emphasizing that it was at Eugenius's urging that Cosimo decided to personally fund the rebuilding of the convent of San Marco for the Dominicans of the Observant movement. For his part, Cosimo lobbied to have the council for the union of the Greek and Latin Churches that Eugenius convened in Ferrara in April 1438 moved to Florence. (The council was financed by Florence and the Greek delegation conveyed by Venetian ships.) The transfer added luster to the city, created commercial opportunities, and brought a contingent of Greek scholars—a potential boost to those humanist studies Cosimo promoted. (The lectures on Plato delivered by the aged George Gemistus Plethon inspired Cosimo, years later, to found the Platonic Academy.) The richly attired

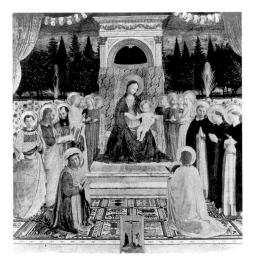

3.
Fra Angelico, *Madonna and Child with Saints*
(*San Marco Altarpiece*). Museo di San Marco, Florence

Greeks, with their elaborate hats and gold-threaded damasks, left an enduring impression on artists. Vespasiano records the belief that "for the last fifteen hundred years and more [the Greeks] have not altered the style of their dress," and from this time forward Byzantine costumes were introduced into Renaissance paintings, most memorably in Piero della Francesca's fresco cycle of the Legend of the True Cross in San Francesco, Arezzo (Piero, as we shall see, arrived in Florence the year of the council).[8] The pomp and splendor of the council certainly confirmed a tendency toward courtly display in the arts—or *magnificenza*—that was openly embraced by Cosimo and his sons Piero and Giovanni, both of whom emerged as important patrons in the 1440s. For Eugenius IV, Ghiberti created a spectacular miter incorporating fifteen pounds of gold and an array of jewels—including "six pearls as large as filberts"—estimated to be worth the astonishing sum of thirty-eight thousand florins.[9] The articles of union between the Greek and Latin Churches, short-lived though it proved to be, were signed amid great ceremony on July 5, 1439, beneath the recently completed dome of the cathedral.

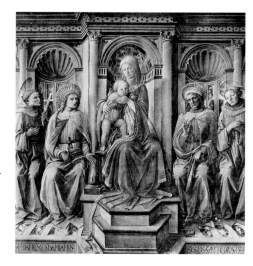

4.
Filippo Lippi, *Madonna and Child with Saints* (altarpiece from the novitiate chapel, Santa Croce). Galleria degli Uffizi, Florence

Both in technological and symbolic terms the completion of Brunelleschi's dome, "vast enough to cover the entire Tuscan population with its shadow, and done without the aid of beams or elaborate wooden supports,"[10] was the great artistic achievement of its time. For the consecration a raised walkway had been built to connect Santa Maria Novella to the cathedral so that the pope's procession could be seen by all. When Eugenius IV consecrated the cathedral on March 25, 1436—the feast day of the Annunciation and the first day of the Florentine new year—it still lacked the lantern, but the choir lofts (*cantorie*) of Luca della Robbia and Donatello were already in place. The next decade saw the decoration of the north sacristy with inlaid wood panels adorned with perspectival scenes (1436–45); Della Robbia's great enameled terracotta lunette of the *Resurrection* (1442–45); and the installation of six enormous circular windows in the drum of the dome (1443–44) designed by Ghiberti, Paolo Uccello, Andrea del Castagno, and Donatello. Uccello's celebrated painted equestrian monument to Sir John Hawkwood was redone following the ceremonies attending the union of the Greek and Latin Churches; he painted the clockface on the interior façade in 1443.

In addition to this great communal monument there was an astonishing array of projects closely associated with the Medici. In 1443—the year the pope returned to Rome—Eugenius attended the consecration of the newly finished convent of San Marco, which had been entirely financed by Cosimo de' Medici. The church, designed by Cosimo's favorite architect, Michelozzo, was furnished with an altarpiece by Fra Angelico that created a new standard for showing the Madonna and Child with saints (see fig. 3); the artist and his assistants had already completed a number of the celebrated frescoes in the chapter house, cloister, and cells of the convent. Eugenius spent the night in the cell that had been built for Cosimo's private use and was decorated with a fresco of the *Adoration of the Magi* (usually ascribed to Benozzo Gozzoli, after Fra Angelico's design). That same year the medieval Franciscan basilica of Santa Croce, begun in 1295, was also consecrated by Eugenius. Donatello's tabernacle of the *Annunciation*—evidently commis-

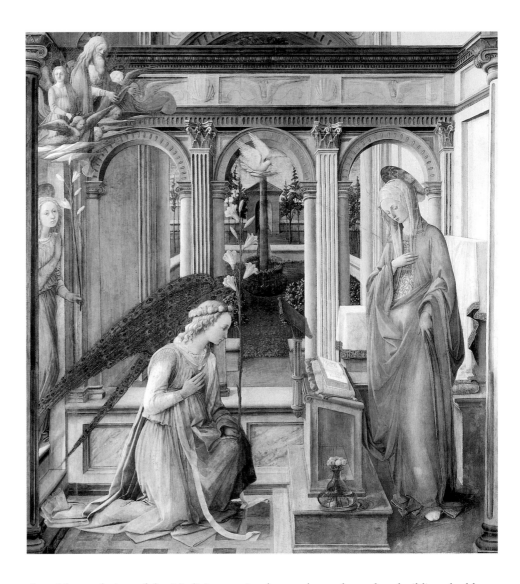

5.
Filippo Lippi, *The Annunciation*
(*Le Murate Altarpiece*).
Alte Pinakothek, Munich

sioned by a relation of the Medici—was in place and two dependent buildings had been added: Brunelleschi's Pazzi Chapel (begun by a Medici supporter, Andrea de'Pazzi, but still unfinished when the pope visited it) and a new chapel for the novices that was funded by Cosimo de'Medici and furnished with an altarpiece by Filippo Lippi (fig. 4). Eugenius was no less active in promoting the reformed Augustinians, transferring the Badia Fiesolana—later rebuilt by Cosimo—from the Benedictines to the Augustinian congregation of Santa Maria di Fregionaia. (Two—or possibly three—altarpieces for Augustinian establishments were painted by Lippi between 1437 and 1440/42—one of them for the archbishop of Florence appointed by Eugenius.)[11] For the general manager of the Medici bank, Giovanni d'Amerigo Benci, Lippi provided two altarpieces for the newly completed Benedictine convent of Le Murate (fig. 5). Eugenius had paved the way

by granting the nuns independence from the neighboring Benedictine establishment of Sant'Ambrogio, for the high altar of which Lippi also painted an altarpiece (fig. 2).[12] It was probably another manager of the Medici bank, Pigello Portinari, who was responsible for hiring Domenico Veneziano to paint a cycle of frescoes of the Life of the Virgin for the church of Sant'Egidio (1439–45; left incomplete by the artist). These same years saw the decoration of Brunelleschi's Old Sacristy at San Lorenzo—yet another Medici project—with Donatello's innovative stucco decorations and two sets of bronze doors (see fig. 6). In 1444 work began on the construction of the Medici palace, again under the guidance of Michelozzo. These various undertakings cannot help but have attracted Fra Carnevale's attention: indeed, as a member of Lippi's workshop he was to be involved in more than one of them. Yet, they represented only a part of the enormous artistic activity in the city, which encompassed Ghiberti's work on the *Gates of Paradise* for the Florence Baptistery (commissioned in 1425 and installed in 1452) and such important private commissions as Uccello's three panels depicting the Battle of San Romano for the Florentine palace of Lionardo di Bartolomeo Bartolini Salimbeni.[13]

Of signal importance for the arts was the presence, among the more than one hundred abbreviators of the papal chancery who accompanied Eugenius IV to Florence, of Leon Battista Alberti; the buildings, sculptures, and paintings that he saw inspired him to write his groundbreaking treatise on painting. Composed in Latin in 1435 and translated into Italian in 1436, with a dedication to Brunelleschi, Alberti's *De pictura* (or *Della pittura*) was to provide the theoretical backbone for Renaissance art and, together with his treatise on architecture—the *De re aedificatoria* (the first draft of which was completed about 1450)—established him as its leading intellectual authority. Alberti's two treatises had a particular significance for the artists in this exhibition, for these erudite works shaped the attitudes and critical language of the rulers of Northern Italy, creating a well-articulated yardstick by which to measure artistic success—one deeply rooted in classical culture, above all in Pliny, Cicero, and Quintillian, but also in Horace and Aristotle. While the Italian edition of the *De pictura* was dedicated to Brunelleschi and lauded the achievements of Donatello, Ghiberti, Luca della Robbia, and Masaccio, a copy of the Latin version was sent with a dedicatory letter to the ruler of Mantua, Gianfrancesco Gonzaga, on the occasion of the Church Council in Ferrara in 1438. In 1423 Gianfrancesco had invited the gifted scholar Vittorino da Feltre to his court at Mantua to set up what soon became the preeminent humanist school in Italy, attended by Ludovico Gonzaga—the patron of Mantegna—and by Federigo da Montefeltro, among many others. Alberti clearly saw the audience for his ideas as well as the possibility of future employment at these North Italian courts: the *De re aedificatoria* was reputedly undertaken at the instigation of Lionello d'Este, the brilliant young Marquis of Ferrara for whom Alberti had made his first essays in architecture; Alberti was to be a frequent visitor to Urbino, and he designed buildings for the Malatesta court at Rimini and the Gonzaga court at Mantua. The effect of these treatises was far greater than the number of surviving copies might suggest, for not only did they provide North Italian rulers with the critical vocabulary

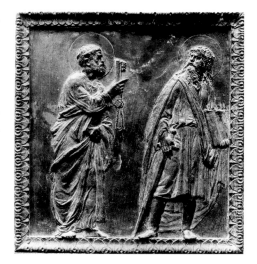

6.
Donatello, *The Apostles Peter and Paul*, detail of a bronze door of the Old Sacristy. San Lorenzo, Florence

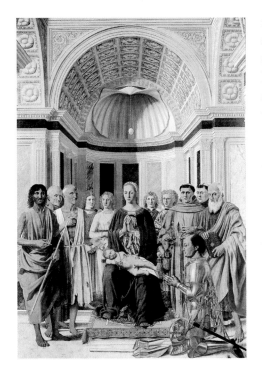

7.
Piero della Francesca, *Madonna and Child with Angels,
Saints, and Federigo da Montefeltro* (*Montefeltro Altarpiece*).
Pinacoteca di Brera, Milan

necessary to appreciate the new art as well as the antiquarian erudition required to sponsor building projects in the revived classical style but they also put the rudiments of that style within the reach of artists. There is much in Fra Carnevale's paintings that attests to his familiarity with the treatises: certainly, the architectural settings of the *Birth of the Virgin* and the *Presentation of the Virgin in the Temple (?)* (cat. 45 A, B) would be inconceivable without the *De re aedificatoria*.

THE PARADIGM OF PIERO DELLA FRANCESCA

It is small wonder that Florence attracted an increasing number of non-Florentine artists and that the Medici were perceived as the arbiters of taste. In 1438 Domenico Veneziano wrote from Perugia, where he had decorated a room in the Baglioni palace, to Piero de'Medici, who was in Ferrara for the Church Council, to request employment.[14] He was familiar with the Florentine scene—he had worked in the city earlier in the decade—and he knew that Fra Angelico and Filippo Lippi had more work in hand than they could reasonably expect to finish (as we have seen, Fra Angelico was employed at San Marco). "If only you knew how much I wish to make some famous work, and especially for you," he wrote, "you would favor this request." Piero de'Medici's response has not survived, but a year later the Venetian was working in Sant'Egidio, assisted by another painter who had been drawn to the city, Piero della Francesca.

Piero della Francesca is one of the protagonists of this exhibition and it is worth pausing over the circumstances surrounding his arrival in Florence. His position in Domenico's workshop is not specified, and, indeed, were it not for the excessive scruples of the bookkeeper recording payments for the fresco cycle in Sant'Egidio, we would have no documentary evidence that he ever visited the city. On September 12, 1439, a disbursement to Domenico of forty-four florins was received by "*Pietro di Benedetto dal Borgho a San Sipolchro sta cho'illui*" ("Piero . . . of Borgo Sansepolcro [who is] staying with him").[15] That we are now able to enlarge upon the significance of this notice is due to the recovered evidence of Piero's prior activity as an artist in his native Sansepolcro and his collaboration with a local artist, Antonio d'Anghiari—memorably characterized by Roberto Longhi as "*un ritardato pittorello goticheggiante*" ("a small-time, *retardataire*, Gothicizing painter").[16]

Piero's training in Sansepolcro cannot have served him well for the kinds of tasks he coveted. At most, he could look forward to a career overshadowed by painters—invariably less gifted than he—imported from Siena and Florence. It is well to remember that as late as 1447, in nearby Arezzo, a mediocrity such as Bicci di Lorenzo was able to command enough prestige as a Florentine painter to receive the outstanding commission to fresco the main chapel of the church of San Francesco. Fortunately for posterity, he died after barely beginning the task, which was turned over to Piero. Perhaps it was in 1437, when the commission for a large, double-sided altarpiece for the church of San Francesco

in Sansepolcro was transferred from Antonio d'Anghiari to the Sienese painter Stefano di Giovanni, better known as Sassetta, that Piero decided to associate himself with an artist who could introduce him to the still-new science of Renaissance painting. (He had assisted Antonio d'Anghiari on the ill-fated altarpiece, which Sassetta was to replace with a *bona fide* masterpiece that would influence the center panel of Piero's first documented work, a polyptych of the *Madonna della Misericordia* commissioned for a lay confraternity in Sansepolcro in 1445.) In 1439—the year he arrived in Florence—Piero was between twenty-six and thirty-two years old, an age by which most artists already had an established artistic identity; this makes his emergence a few years later as a leading exponent of Renaissance style all the more remarkable. It is likely that this relatively late transformation into a Renaissance artist contributed to the impression of sustained intellectual endeavor that Piero's paintings project as well as to his fascination with the mathematical underpinnings of Renaissance art. We can almost hear the nagging voices of the ghosts of his Gothic past when, in his treatise on perspective, the *De prospectiva pingendi*, he attests that "many painters condemn perspective, because they do not understand the power of the lines and the angles produced by it: with which every edge and line can be rendered proportionally. Hence I feel I have to show how necessary this science is to painting."[17] Although Fra Carnevale did not have the subtle intellect of Piero, he, too, embraced perspective as a means of ordering the visual world as well as demonstrating his modernity.

Piero is so often seen as exceptional—not simply in terms of his artistic and intellectual stature but for his cultural itinerary—that it is easy to overlook the fact that his initial provincial training and subsequent refashioning in Florence was not unique. Nor was he alone in further broadening the scope of his art at the highly cultivated courts of Northern Italy—Ferrara, Rimini, and, above all, Urbino. At the court of Urbino he not only found a sympathetic and admiring patron in Federigo but he also met the foremost humanists and architects of the day, including Alberti. Arnaldo Bruschi has argued that we cannot fully understand a work like Piero's *Montefeltro Altarpiece* (fig. 7), which shows the Madonna and Child and attendant figures of saints, angels, and a kneeling Federigo da Montefeltro in a grandiose church interior, without taking into account the various personalities present at the court of Urbino, where it was painted, and the architectural culture nurtured by the duke and his confidant and adviser and kinsman Ottaviano Ubaldini.[18] Similarly, the antiquarianism of Piero's little studied and underappreciated altarpiece (fig. 8 and cat. 47) in Williamstown, Massachusetts, can only be properly evaluated once we learn something about the cultural interests of its Sansepolcro patron and his relationship with the artist—a task that has yet to be undertaken. As demonstrated in the second half of this exhibition, Fra Carnevale played a key role in the creation of the architectural-antiquarian culture of Urbino. He was, indeed, the first to introduce Florentine avant-garde notions to the court, and his art—eccentric and dilettantish, but always fascinating and informed—helps us to appreciate how much Piero's art owed to Urbino.

Two Marchigian Vagabonds

Throughout the fifteenth century aspiring painters ventured from the confines of Tuscany, Umbria, and the Marches to Florence as a means of transforming their art, much as, in the sixteenth and seventeenth centuries, artists traveled to Rome and, in the early twentieth century, to Paris. Some remained, but most returned to their native cities, where they exploited their mastery of the new idioms. (So far as we know, Piero never received an independent commission in Florence, although Vasari reports that he later worked with Domenico Veneziano in Loreto, suggesting that the two artists remained in touch with each other.)[19] Probably in 1443 two other artists who will be of importance to the story we have to tell, Giovanni Boccati and Giovanni Angelo d'Antonio—both from the Marchigian town of Camerino, south of Urbino and east of Perugia and Assisi—made their way to the Tuscan city.[20] In Camerino Giovanni Angelo had married into a mercantile family that had links with the ruling Da Varano and business ties to the Medici.[21] Giovanni Angelo was a clever man who could, and did, do duty as a courtier (we know from one of his letters that he played the lute, which seems to have been a requisite for the role he filled). By 1444 he was a guest in the Medici palace, where he was on familiar terms with Giovanni de'Medici; in 1451 he actually attempted (unsuccessfully) to negotiate a marriage between Giovanni and a cousin of the Da Varano. That was seven years after he had been summoned home, in March 1444, to put his affairs in order; Elisabetta da Varano had even expressed her desire that he accompany the eleven-year-old Rodolfo da Varano to Ferrara on the occasion of the marriage of the marquis Lionello d'Este to Maria d'Aragona. He had traveled to Florence with his compatriot Giovanni Boccati, who—we now know from a newly discovered document—joined the workshop of Filippo Lippi. In January 1443 Boccati received a payment for work on Lippi's altarpiece of the *Coronation of the Virgin* (fig. 2) intended for the church of Sant'Ambrogio.[22] This is the same altarpiece for which Fra Carnevale was to receive payments two and a half years later, and it is interesting to speculate on whether Boccati may have had a hand in directing the Urbino artist to Lippi's shop. Did they know each other at an early date?

By March 1445 Boccati, now on his own, had moved from Florence to Perugia, where in October he became a citizen and undertook to paint a major altarpiece (see fig. 17 and cat. 30). Boccati's intention was to set up a permanent workshop in the city ("*ad exercendem artem pictorum et in eadem civitate habitare et stare continuo intendit et dictam eius artem exercere,*" his petition reads), and it was in view of his expertise ("*in arte pictoria expertissimus*") that citizenship was granted—an indication of the value of having spent time with a widely respected Florentine master.[23] (The prestige of Florentine artists can be judged by the fact that when, in 1454, the local Perugian painter Benedetto Bonfigli was hired to fresco the chapel in the Palazzo dei Priori, it was stipulated that either Filippo Lippi, Domenico Veneziano, or Fra Angelico should do the all-important valuation.) In the event, Boccati left after finishing his altarpiece in 1447: he seems to have accompanied a young Perugian law student to Padua, where it is just conceivable that he was joined by

8.
Piero della Francesca,
Madonna and Child with Angels (detail).
The Sterling and Francine Clark Art Institute,
Williamstown, Massachusetts

Giovanni Angelo as well as by another compatriot, Girolamo di Giovanni, who is documented there in 1450. Both Giovanni Angelo and Giovanni Boccati were back in Camerino by 1451, for we find them in attendance at the wedding of the young ruler Giulio Cesare da Varano to Giovanna Malatesta.²⁴ (It is one of the characteristics of the courts of Renaissance Italy that the ruling families intermarried as part of their politics of expansion and security: Giovanna was the daughter of Sigismondo Malatesta, the lord of Rimini; Giulio Cesare's cousin Rodolfo had married the half sister of Lionello d'Este in 1448; and in 1459 Federigo da Montefeltro married Battista Sforza [1446–1472], the daughter of Costanza da Varano—Rodolfo da Varano's sister—and Alessandro Sforza, brother of the duke of Milan and the ruler of Pesaro.) For painters from small towns an itinerant career was a necessity, even when they were closely associated with cultivated ruling families, as in the case of the Da Varano (Elisabetta da Varano—a Malatesta on her father's side and a Montefeltro on her mother's—had a humanist education and wrote Petrarchan verse).Yet, this should not blind us to the fact that when Giovanni Angelo and Boccati set their horizons on Florence and then Padua, a humanist center where Nicolò Pizzolo and the young Mantegna were establishing their fame, they were motivated by cultural ambitions shared by their prospective patrons and rulers.

9.
Giovanni di Piermatteo Boccati,
detail of the fresco decoration
of the Camera Picta, Palazzo Ducale, Urbino

It is easy to pass a premature, dismissive judgment on the art of Boccati (see cat. 30–33), with its insubstantial figures, high-pitched emotional fervor, and casual attitude toward the science of perspective. Provincial as his art may seem when set against the grave, elevated imagination of Piero, it was nonetheless remarkably attentive to the most innovative ideas in Italian painting. *The Madonna and Child with Music-making Angels* (cat. 32) presents a virtual *curriculum vitae* of the artist's cultural education. The dais of the throne is inspired by Roman pavements, the tabernacle by Florentine and Paduan models (with a classicizing relief intended to appeal to antiquarian tastes), and the steeply foreshortened rose arbor quoted from one of Mantegna's most admired frescoes in the Ovetari Chapel in Padua. The colors and lighting show Boccati to have been no less attentive to the work of Fra Angelico and Benozzo Gozzoli.²⁵ Not surprisingly, then, it was to Boccati that Federigo da Montefeltro turned sometime prior to 1467 for the task of frescoing a room in the new wing of his palace (see fig. 9, 10). Was it on the recommendation of Fra Carnevale, who by then may have been serving as a consultant to Federigo on artistic and architectural matters? There is a temptation to divide Federigo's patronage into successive phases and to associate Fra Carnevale and Boccati with an early, pre-Piero stage (Piero is first documented in Urbino in 1469, although he may have worked there earlier), but this is too simple a schema. To our eyes Boccati's witty and decoratively brilliant frescoes are more Gothic than Renaissance in character. Certainly they lack that grounding in arithmetic and geometry that Federigo prized above all else.²⁶ However, we should not forget that at the same time he was active as Piero's patron and having the walls of his private study covered with astonishing perspective views carried out in wood inlay, Federigo was ordering tapestries from Tournai (1476) that transformed the story of the Trojan War into a Burgundian chivalric romance. Piero's art, in other

10.
Giovanni di Piermatteo Boccati,
Warrior, detail from the fresco cycle
of *Famous Men,* Camera Picta,
Palazzo Ducale, Urbino

11.
Antonio Alberti,
The Miracle of Saint Thomas.
Museo Diocesano "Albani," Urbino

words, gives only a very partial view of Renaissance taste in Urbino; in evaluating the art of Boccati, Giovanni Angelo—and Fra Carnevale—we must remove the blinders of modern taste: tunnel vision has no place here.

FRA CARNEVALE BEFORE FLORENCE

As the examples of Piero della Francesca, Giovanni Angelo, and Giovanni Boccati demonstrate, when, in 1445, Fra Carnevale set out for Florence, he was traveling a well-charted cultural path (although one not so heavily trafficked as it is today by art lovers following the "Piero della Francesca Trail" that, as in Fra Carnevale's day, runs from Florence through Arezzo and Sansepolcro to Urbino). As already noted, mention of Fra Carnevale first occurs among documents relating to the production of Filippo Lippi's landmark altarpiece of the *Coronation of the Virgin*, painted over a period of eight years—between 1439 and 1447—for the Benedictine convent of Sant'Ambrogio in Florence. On April 17, 1445, Fra Carnevale collected a payment for the altarpiece and ten days later, on April 27, another payment was made on Lippi's behalf to a porter for bringing from Urbino the belongings of *Bartolomeo sta chollui*. The epithet *sta chollui*—"is staying with him [Filippo Lippi]"—cannot help but remind us of Piero della Francesca in the workshop of Domenico Veneziano. Fra Carnevale's name recurs repeatedly in the convent's documents for a bit over a year, the last time on September 7, 1446. What his role in the workshop amounted to is a matter of surmise, but that he had a formal arrangement with Lippi is clear enough from the newly transcribed documents (for which, see the appendix by Andrea Di Lorenzo). More unspecified belongings (*chose*) were brought from Urbino in May and June; Lippi had to pay the taxes for importing these items and also bought his new disciple clothes "and other things": a tunic and some linen cloth (*"per fattura d'una giornea e altre chose; per ghuarnello e altre chose"*).[27]

Yet, the relationship was not simply that of apprentice and master, for in November 1445 we find Fra Carnevale described as *"dipintore et disciepolo di frate Philippo"*—that is, someone who already enjoyed the independent status of a painter and had served his apprenticeship. From a document discovered by Franco Negroni and transcribed in this catalogue by Matteo Mazzalupi, we are able to suggest that prior to coming to Florence Fra Carnevale had served his apprenticeship with Antonio Alberti of Ferrara, who had established himself in Urbino at least as early as 1418 and died there sometime between July 1447 and November 1449. Antonio Alberti was no small-time, *retardataire* painter but a Late Gothic artist of notable (if unexceptional) talent, who left a significant body of work in Umbria (in Montone and Città di Castello) and in the Marches (in San Marino, Fossombrone, Talamello, and Urbino). The basis we have for associating Fra Carnevale with Antonio Alberti is an undated payment to the Ferrarese artist made through Fra Carnevale (the exact sort of task he performed repeatedly for Lippi in Florence). The payment was made by Don Sperandeo, a parish priest for whom Alberti painted a trip-

tych in 1436.[28] Fra Carnevale's apprenticeship is thus likely to have taken place in the 1430s, at a time when Alberti had in hand two commissions for institutions that were to be significant in Fra Carnevale's future career. The first was a cycle of frescoes in a chapel at the convent of San Domenico, where Fra Carnevale would take holy orders and where he would be involved with the building of a new portal facing the old palace of the Montefeltro dukes. Although undocumented, the surviving fresco fragments, recovered in 1964 and on deposit in the sacristy of the cathedral of Urbino, are unquestionably by Alberti and have been dated to between about 1437 and 1442.[29] Illustrating episodes from the Story of the True Cross as well as events from the life of Saint Thomas the Apostle (see fig. 11) and of Saint Catherine of Alexandria, the frescoes are carried out in a lively, Late Gothic style that transforms the devout language of *The Golden Legend* into a display of courtly splendor, with every opportunity taken to introduce elaborately costumed bystanders and richly furnished settings. The other commission was for a large *Crucifixion* for the oratory of the Confraternità della Misericordia (Confraternity of Mercy) in Santa Maria della Bella, for which, in 1466, Fra Carnevale was to paint his masterpiece (see cat. 45 A, B). Here again, even more explicitly than in the San Domenico cycle, Antonio Alberti took his inspiration from that most extraordinary of Late Gothic fresco cycles, the Story of Saint John the Baptist, painted by Lorenzo and Jacopo Salimbeni on the interior walls of the Oratorio di San Giovanni in Urbino (1412–16). These rainbow-colored, garrulous, wonderfully captivating works (see fig. 12) must have made a strong impression on the young Fra Carnevale and can, indeed, be seen to have set the stage for the secular, courtly tone still evident beneath the humanist Latin style he cultivated in his own paintings.

12.
Lorenzo and Jacopo Salimbeni,
The Birth of Saint John the Baptist.
Oratorio di San Giovanni Battista, Urbino

THE IMPORTANCE OF FILIPPO LIPPI

For a Gothic-trained artist arriving in Florence in the mid-1440s Filippo Lippi had much to offer. More than any other major painter, he was responsible for reinterpreting Gothic traditions to suit Renaissance sensibilities. It is difficult today to do full justice to the brilliance of his achievement, so essential to defining Medicean taste, for we are conditioned to measure Renaissance art in terms of the grave, grand manner of Masaccio—"*puro sanza ornato*" ("plain and clear") in the words of Cristoforo Landino—or of the dazzlingly expressive antiquarianism of Donatello's sculpture.[30] There would seem to be little room for the winsome, gilded beauty and delicate sensibility Lippi explored. In a highly influential article of 1952, the great Italian critic Roberto Longhi characterized the 1440s as a period of crisis in Florentine art and dismissed what he saw as Lippi's "stubborn descent on a downhill slope of coarse academicism." To Longhi's way of thinking, Lippi had simply not lived up to the promise of his early work, when, according to Vasari, it seemed as though "Masaccio's spirit had entered Fra Filippo's body."

Even allowing for Longhi's love of striking polemical positions and his desire to put Domenico Veneziano at center stage, this judgment seems hard to sustain. Kenneth Clark

described the change observable in Lippi's art of the 1440s more benignly: "Fra Filippo, having attempted the Masacciesque with desperate uncertainty, had recognized that he was gifted for line rather than mass, grace rather than grandeur."[31] This oversimplified and insufficiently probing summation at least has the virtue of characterizing Lippi's art in terms that fifteenth-century critics would recognize. In contrast to these twentieth-century views, we might quote the verdict of one well-informed observer at the close of the fifteenth century, for whom Filippo Lippi was, quite simply, "the most outstanding master of his time" ("*il più singulare maestro di tempo suoi*").[32]

During the 1430s Filippo Lippi had been open to more currents than any other Florentine painter. Quite apart from the firsthand experience of watching Masaccio at work in the Brancacci Chapel of the Carmine, where Lippi took his vows as a Carmelite friar in 1421, he was among the very first artists to respond to Netherlandish painting.[33] His interest in the description of everyday objects, whether the furniture of a domestic interior or an isolated vase half filled with water—as in his *Annunciation* (fig. 13) in the church of San Lorenzo—was directly inspired by a work such as Jan van Eyck's so-called

Detail of figure 13

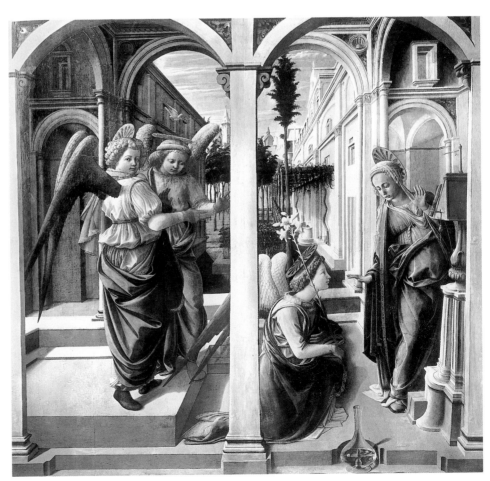

13.
Filippo Lippi, *The Annunciation*.
San Lorenzo, Florence

Lucca Madonna (Städelsches Kunstinstitut und Städtische Galerie, Frankfurt). His land-scapes, such as the one seen through a window in the *Portrait of a Woman and a Man at a Casement* (cat. 4) or the setting of his *Meeting of Joachim and Anna at the Golden Gate* (cat. 5), would be inconceivable without Netherlandish painting, and we need not wonder that they left a lasting impression on Fra Carnevale. No other Florentine artist explored the ways in which cast shadows could be used not simply to create an effect of verisimilitude but to suggest erudite, literary allusions (see cat. 3, 4). He was not a painter of sunlight, a master of pale colors bathed in the light of the early afternoon, in the vein of Domenico Veneziano's *Saint Lucy Altarpiece* (fig. 21 and cat. 22 A, B): a *pittore di luce,* to use Luciano Bellosi's suggestive epithet.[34] Rather, like Leonardo da Vinci, for whom Lippi's paintings of the late 1430s were an important point of reference, he avoided the harshness sunlight confers on forms, preferring the soft light of an interior, since works painted under these conditions "are tender and every kind of face becomes graceful. . . . Too much light gives crudeness; too little prevents our seeing. The medium is best."[35] In works such as the 1437 *Tarquinia Madonna* (Galleria Nazionale d'Arte Antica, Palazzo Barberini, Rome) the *Barbadori Altarpiece* (fig. 14), of 1437–39 (?), and, to a lesser degree, the triptych divided between the Metropolitan Museum and the Accademia Albertina (see cat. 1 A–C), Lippi became the first exponent of a chiaroscuro approach to modeling form, with gold

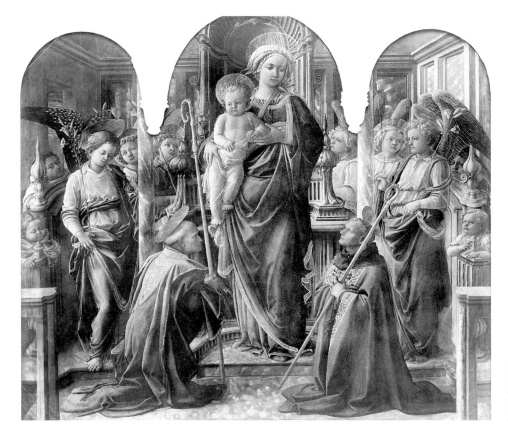

14.
Filippo Lippi,
Madonna and Child with Two Saints
(*Barbadori Altarpiece*).
Musée du Louvre, Paris

reduced to occasional embellishment on the wings of angels or the embroidery of a piece of clothing or the scattered dots of a halo.[36] Yet, he did not have the analytical mind of Leonardo nor the mathematical inclinations of Piero della Francesca. Just as, ultimately, he was unwilling to sacrifice to a nascent concept of tonal unity the medieval artist's association of beauty with pure color, so for him architecture provided the means of imposing an abstract order on a composition rather than of creating a commensurable space. Only rarely did he employ architecture to create a static, Albertian backdrop or stage. This paradoxical outlook made Lippi uniquely receptive to Donatello's unorthodox architectural forms and his brilliant manipulation of space to enhance the emotional impact of his work. It is only one more of the contradictory aspects of Lippi's approach that, occasionally, he was also open to Luca della Robbia's serene classicism as well as to the architectural vocabulary of Brunelleschi.[37]

This imaginatively exploited tension between artifice and naturalistic effects, or between fancy and reason (*fantasia* and *disciplina*),[38] culminates in the great *Coronation of the Virgin* (fig. 2) painted between 1439 and 1447 for the Benedictine convent of Sant'Ambrogio. Documenting a pivotal moment in Lippi's career, the altarpiece brings to a close the more naturalistic experiments of the 1430s and announces the new emphasis on artifice, crucial to understanding his later paintings. In this work a highly compartmentalized space is created by the device of a multi-level throne of extravagantly bizarre architecture: a medley of classically derived motifs is used in a profoundly unclassical manner. The figures, variously scaled according to their iconographical importance—the Virgin, Saint John the Baptist (patron of the donor), and Saint Ambrose (patron saint of the church) being the largest—are packed into their assigned positions in ways that can defy rational analysis, so unexpectedly does the floor level shift throughout the picture. At the same time, the figures are all illuminated by a low-lying light from the left, and the long shadows cast on the marble pavement create the illusion of something experienced rather than imagined. So also does Lippi's attempt to depict the figures as though seen from slightly above, in keeping with the high vanishing point. That these seeming contradictions are intentional rather than accidental is made clear by a number of details that serve to collapse the fiction of spatial recession. A long embroidered band worn by God the Father and held aloft by two angels to either side of the throne extends downward to two additional angels. Yet, the latter are positioned too far forward to realistically perform their duty. Moreover, behind them is suspended a long swag impossibly attached to a projecting architectural element from which giant lilies spiral upward, their flowers seeming to blend with those held by angels in the rearmost row of the stalls. In a similar space-denying way, the scroll unfurled by the foremost angel, who mysteriously emerges from a cavity at the front of the picture—a feature derived from Donatello's stucco roundels in the Old Sacristy—all but touches the folded hands of the donor, shown farther back, kneeling in a curiously sunken area. It is typical of Lippi that a relatively simple, cubic space should be so elaborately deconstructed by decorative details or actions extended across the picture plane rather than receding in depth. Color is sometimes treated in

terms of chiaroscuro to enhance the impression of weight and volume—indeed, few other pictures painted before the 1470s can match the effects Lippi achieves in the standing figures in the foreground that frame the composition. In other places, however, the colors are left saturated. This double use of color can be found even in a number of Lippi's most audaciously composed works of the early 1440s. For example, it has frequently been noted how, in Lippi's *Annunciation* in San Lorenzo (fig. 13), the building at the far end, in deep perspective, is brightly colored so as to relate to the drapery and wings of the angels in the left foreground. In the *Coronation of the Virgin* the rainbow-like bands of blue defining the heavenly spheres add another note of unreality that would have been further enhanced by the frame—alas, lost, as are the frames of all of Lippi's altarpieces, but documented as being remarkably rich in the Gothic panoply of pinnacles. "Fra Filippo Lippi's work possessed grace and was ornate and exceedingly skillful; he was very good at composition and variety, at coloring and creating a relief-like impression and at decorative embellishments of every kind, whether imitated from reality or invented."[39] This apt appraisal by Cristoforo Landino might have been written with the *Coronation of the Virgin* in mind, and it underscores the importance of what Michael Baxandall has called "the period eye" in understanding the complexity of Lippi's art.

The *Coronation of the Virgin* is pivotal precisely because of the ways in which it looks both forward and backward. The issue of naturalistic description first elaborated on in the *Tarquinia Madonna* is brought to a level of extraordinary subtlety, but there are also the seeds of Lippi's most remarkably Gothicizing paintings—such as the *Alessandri Altarpiece* (fig. 15), with its gold background, delicately elongated figures in pink cloaks, and donors shown in miniature. With the single exception of Donatello, no other artist had such an inventive attitude toward the past.[40] Lippi reintroduces gold into his work, but he makes it respond to the logic of uniform illumination: sometimes its shining surface is glazed to obtain shadows, or it may be concentrated in the highlights of a decorative hem; at other times gold dots are combined with white ones and sprinkled judiciously over a form so that they effectively model the surface. The Virgin is sometimes clothed in pale blue and pink—as though she had stepped out of an altarpiece by Fra Angelico. Dark, wooded landscapes are at once suggestive of a specific site and, deprived of sunlight and sky, become as haunting—and symbolically rich—as the *selva oscura* that Dante found himself in at the opening of the *Divina commedia*. In the third book of his treatise on painting, Alberti famously defined the task of the painter as "to so describe with lines and paint with colors on a panel or wall the surfaces of any body that can be seen so that from a fixed distance and fixed central position they will seem to have volume and be very like the actual thing." Lippi was well aware of Alberti's ideas, but he rejected this overly rationalized notion of painting as mimesis, preferring to emphasize artifice as the measure of creativity and the means by which a Gothic past could be reconciled with a newly revived classical present. It was a lesson crucial to his disciples.

Of the art of Filippo Lippi's most famous pupil, Botticelli, Daniel Arasse has written that the coherence of his art resides "in the distance the artist has put between himself

15.
Filippo Lippi, *Saint Lawrence Enthroned with Saints and Donors* (*Alessandri Altarpiece*).
The Metropolitan Museum of Art, New York

16.
Filippo Lippi, *The Coronation of the Virgin* (detail).
Galleria degli Uffizi, Florence

and the search for illusionistic effects through the imitation of nature. . . . Botticelli never dissimulates his art as art; he never camouflages that it is an artifice, that it constructs an artificial representation of the reality it imitates."[41] This modern assessment of Botticelli is perfectly in line with Landino's appraisal of Lippi—"*gratioso et ornato et artificioso sopra modo.*" In understanding the remarkable way in which Lippi adapts his style to various commissions—whether for a splendidly Renaissance *sacra conversazione* for the novitiate chapel in Santa Croce (fig. 4), a Gothicizing altarpiece for the king of Naples (commissioned through Giovanni de'Medici in 1457), or that masterpiece of refined delicacy, the *Annunciation,* for the Benedictine nuns at Le Murate (fig. 5)—it is important to bear in mind the interplay they promote of innate genius (*ingenio* and *fantasia*) manipulating a mastered style (*maniera*).[42]

FILIPPO LIPPI'S WORKSHOP IN THE 1440S

Work on the *Coronation of the Virgin* spanned more than eight years: it was commissioned in 1439, and installed in 1447, but the final payment for the predella was not made until 1458. During this time Lippi had numerous other commissions in hand, and his workshop must have been among the busiest in Florence—although in August 1439 he wrote to Piero de'Medici, "with tears in my eyes" ("*cholle lagrime alli ochi*"), pleading desperate poverty ("*uno de' più poveri frati che sia in firenze sono Io*"). To mention only the most conspicuous paintings that have either survived or of which we have notice, there was the *Annunciation* (fig. 13) for a chapel in San Lorenzo; two altarpieces for Le Murate (only one survives: fig. 5); two more altarpieces for the church of Sant'Egidio (one is certainly documented to 1443–45 and is just possibly the *Annunciation* in the Galleria Nazionale d'Arte Antica, Rome);[43] the altarpiece for the novitiate chapel in Santa Croce (see fig. 4); the *Coronation of the Virgin* (fig. 18) for San Bernardo, Arezzo; and an *Annunciation* for an unknown destination (Galleria Doria Pamphilj, Rome).[44] Then there were the devotional panels, the finest of which is the *Madonna and Child* in the National Gallery of Art, Washington, D.C. Nowhere else could a curious artist have received such a varied and rich training. Certainly, Fra Carnevale's own, later work testifies to an experience based on the full scope of Lippi's endeavors. Two other personalities present in this exhibition—the Master of the Castello Nativity and the Pratovecchio Master—seem also to have been employed in the workshop during this time. Fortunately for us, the *Coronation of the Virgin* is among the best documented of all of Lippi's paintings and it therefore offers a glimpse into the workings of this remarkable studio and the various opportunities it offered.[45]

Construction of the altarpiece was entrusted to Manno de'Cori—a skilled woodworker who had produced choir stalls for Santa Croce, Santa Maria Novella, and Santa Trinità—and to Domenico di Domenico, called "del Brilla." Manno worked on a model for the dome of the cathedral and Brilla was employed by Brunelleschi on the lantern for

the dome.[46] Brilla's work with Brunelleschi assumes considerable interest when we notice that Lippi has taken a number of cues from the cathedral lantern for the extravagantly articulated throne of God the Father: the idea of buttress-like arms with openings (fig. 16). Gilding was subcontracted to two artisans, Bernaba di Giovanni and Stefano di Francesco, who shared a workshop near the church of San Pier Maggiore; Bernaba also painted a curtain to hang in front of the altarpiece.[47]

Much has been made about the identification of the Piero di Lorenzo first cited in a payment received in November 1441: he has sometimes been associated with Piero di Lorenzo di Pratese, who in 1453 formed a partnership (*compagnia*) with the outstanding Florentine painter Pesellino. More importantly for our purposes, the hypothesis has been advanced that this artist is none other than the anonymous Master of the Castello Nativity, who seems not only to have been a member of Lippi's shop during these years but even, on occasion, to have worked to his designs (see cat. 7, 8).[48] The problem is that in 1447 a Piero *dipintore*—possibly but not certainly the same Piero di Lorenzo—is specified as having gilded the piers of the frame of the *Coronation of the Virgin*. Annamaria Bernacchioni has pointed out that since this Piero is listed as in the San Pier Maggiore district, he was basically an artisan, and may well have been a partner of Bernaba di Giovanni and Stefano di Francesco; he cannot be Piero di Lorenzo di Pratese, whose shop was in the Corso degli Adimari.[49] Thus, we are left with a question surrounding the identity of the anonymous master Berenson once characterized as "an artist who never disappoints us."[50]

We have already seen that in 1443 Giovanni Boccati (listed as Giovanni di Matteo da Camerino) was among Lippi's assistants: his name appears only once and the nature of his association must remain a matter of speculation. Until recently, it was supposed that before coming to Florence he worked in Perugia, where he had occasion to study a (now destroyed) fresco cycle by Domenico Veneziano in the Baglioni palace.[51] New evidence suggests that he and Giovanni Angelo da Camerino went directly to Florence and that it was there that they evolved their highly original styles, based in equal measure on those of Lippi and Domenico Veneziano.[52] What emerges with great clarity is the reason the altarpiece Boccati painted in Perugia in 1446–47 (see fig. 17) was patterned so conspicuously on Lippi's *Coronation of the Virgin*.

The artist who was to be Lippi's most faithful assistant, Fra Diamante, is first documented in 1447, when he is listed as a *discepolo di fra filipo*.[53] He was only seventeen, but his broad-faced, round-nosed figures soon begin appearing in Lippi's work, and he may have assisted in some minor capacity in the painting of the *Coronation of the Virgin*. A series of individuals are also named about whom we know nothing. One assistant is cited simply as *lo Spagnuolo*—the Spaniard—in 1445, when Lippi purchased articles of clothing for him. Others mentioned in connection with payments are not specifically identified as painters or apprentices but may have been both: Domenico di Francesco (Domenico di Michelino?),[54] Giovanni, Andreino, Piero di Benedetto,[55] and Benedetto, who repeatedly collected payments in 1442.

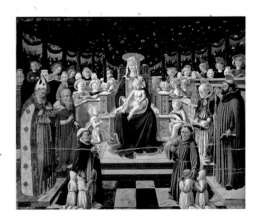

17.
Giovanni di Piermatteo Boccati, *Madonna and Child with Angels and Saints (Pergolato Altarpiece)*. Galleria Nazionale dell'Umbria, Perugia

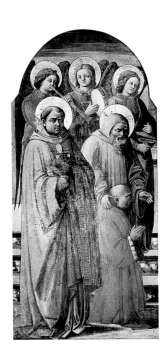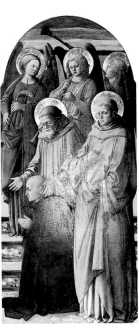

18.
Filippo Lippi, *The Coronation of the Virgin*.
Pinacoteca Vaticana, Vatican City

It should be remembered that the two ledgers we possess—one belonging to the monastery and the other to the banker Giovanni di Stagio Barducci, with whom funds had been deposited for the purpose of financing work (Giovanni's sister was a Benedictine nun)—do not record everyone employed on the altarpiece: they list those to whom payments were made. Lippi may well have paid other assistants directly. From other documents we actually know of one apprentice active in his workshop between 1440 and 1442 named Giovanni di Francesco; through the research of Annamaria Bernacchioni, we can now say that this artist is almost certainly Giovanni di Francesco da Rovezzano, the author of a group of distinguished paintings dating from the 1450s that show affinities with the work of Andrea del Castagno and Alesso Baldovinetti.[56]

Giovanni di Francesco joined Lippi's shop in June 1440: the agreement between the two artists specifies that Giovanni would live with Lippi and remain under contract to do whatever tasks were assigned to him, "like a good disciple" ("*a uso di buono di[s]cepolo*"), but for which he was to be paid. For his part, Lippi agreed to instruct him in all that he knew about painting ("[*Fra Filippo*] *sia tenuto a insegnialli e a mostralli di quello sapessi circha all'arte della dipintura*"). Two years later, Giovanni joined the painters' guild as an independent master; in September 1442, the two artists decided to form a partnership, or *compagnia*—under which artists shared profits from various tasks (the normal term for such associations was two or three years). This arrangement was short-lived: on November 16 the partnership was dissolved. As compensation Giovanni was to receive remuneration for restoring a work by Giotto that had been consigned to Lippi—a reminder that Lippi, like so many artists, took on tasks other than formal commissions for altarpieces or fresco

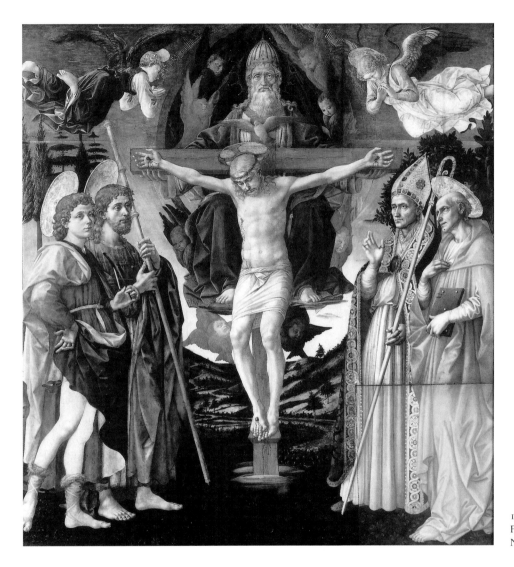

19.
Francesco Pesellino, *The Trinity*.
National Gallery, London

cycles. Lippi did not meet his end of the bargain and the matter eventually went to court.[57] Is this artist the "Giovanni" cited in the Sant'Ambrogio ledgers in 1440?[58] It has been suggested (and denied) that Giovanni di Francesco was the assistant responsible for painting the predella of Lippi's San Lorenzo *Annunciation* (see cat. 15). The matter is of interest because Fra Carnevale has also been credited with this work, although it would seem to have been completed before he joined Lippi's shop (no documents are specifically associated with the altarpiece but its style dates it to about 1440).[59]

A somewhat different case concerns Pesellino (1422–1457). No document associates him with Lippi's workshop, yet he is unquestionably the author of the predella of the altarpiece painted for the novitiate chapel in Santa Croce (see fig. 20).[60] Moreover, it is clear that about 1450 he fell under the spell of Lippi's work. He was an established artist at

20.
Francesco Pesellino, *The Miracle of the Miser's Heart,*
predella of the altarpiece by Filippo Lippi for the
novitiate chapel, Santa Croce

the time and the heir to one of the largest workshops in the Corso degli Adimari,[61] and thus it seems likely that he was subcontracted by Lippi to paint the predella for the novitiate chapel altarpiece. Their relationship—personal as well as artistic—apparently was recognized when, in 1458, Lippi was hired to complete the great altarpiece of the *Trinity* (fig. 19) that Pesellino had left unfinished at his premature death. Pesellino is the paradigm of an artist who refashioned himself under Lippi's tutelage to become one of the most original painters in mid-century Florence. Like Boccati and Fra Carnevale, he already had apprenticed with his grandfather and had worked with another artist, the Angelico-trained painter and miniaturist Zanobi Strozzi (1412–1468).[62] This prior experience gave Pesellino the critical distance necessary to work his way back through Lippi's output of the 1440s and to create the foundations for his own style (see cat. 21). It is in his work that the distinction between an associate of Lippi and someone deeply influenced by his art breaks down.

FRA CARNEVALE IN LIPPI'S WORKSHOP

Of those who worked on the *Coronation of the Virgin*—some as apprentices, some as associates, and some as hired-out specialists—only Fra Carnevale's name occurs with any frequency. Although his role in Lippi's shop is not specified, he must have had a hand in the painting of the altarpiece. Some years back Alessandro Conti attempted to identify an angel in the background of the *Coronation of the Virgin* as Fra Carnevale's contribution.[63] It is a plausible idea, but one that must remain hypothetical. The sole work in which Fra Carnevale's hand can be identified with some confidence is, oddly enough, another *Coronation of the Virgin* (fig. 1). It was commissioned by Carlo Marsuppini (1398–1453), a native of Arezzo and the chancellor of Florence, and painted for the Olivetan monastery of San Bernardo in Arezzo (fig. 18). The date of the commission is not known, but on the basis of the ages and biographies of the donors depicted, it is reasonably thought to have been about 1444, when Carlo Marsuppini's father (included in the altarpiece) died and Carlo was appointed chancellor.[64] An angel in the right-hand panel of the triptych resembles Fra Carnevale's later figures so closely that it must have been painted by him.[65] The attribution is of more than academic interest, for although the figure type is very close to Lippi's, there is a sharper delineation of details. Even more importantly, the figure is not painted in terms of chiaroscuro, but is shown as though bathed in a diffused light. In other words, the angel reveals an artist associated with Lippi but already looking beyond him for inspiration: in this case to that supreme *pittore di luce*, Domenico Veneziano, who during these very years was working on the *Saint Lucy Altarpiece* (fig. 21; cat. 22 A, B) for the Florentine church of Santa Lucia de' Magnoli.[66] It is an indication of Fra Carnevale's independence that his artistic horizons were not limited to the style of the artist whose disciple he had become. With what rapt attention he studied the refined figures and inventive architectural settings of Veneziano's altarpiece—complex and rich in

their expressive impact! Veneziano's frescoes in the church of Sant'Egidio of scenes from the life of the Virgin have not survived, but it is clear from Vasari's description of them that they were a primary source for Fra Carnevale's genre-like approach to his treatment of the birth and marriage of the Virgin. Vasari particularly admired a youth beating on the door of the bedroom chamber with a hammer and a lively dwarf breaking a club in another scene.

The architecture in the Marsuppini *Coronation of the Virgin* is in certain respects unusual for Lippi. Instead of organizing the figures into compartments, it articulates a shallow space, with steps, a bench, and a wall with inlaid marble panels extending continuously across the three panels.[67] The figures are carefully positioned within this outdoor architectural setting. Only two other works by Lippi include comparable architecture: the altarpiece commissioned, as we have seen, by Cosimo de'Medici, for the novitiate chapel in Santa Croce, and the *Annunciation* for Le Murate, commissioned by the Medici associate, Giovanni Benci;[68] both are virtually contemporary with the Marsuppini *Coronation*.[69] The novitiate chapel was designed by Michelozzo, and the architecture in Lippi's altarpiece was self-evidently conceived to complement that of the chapel. The appearance of the Medici emblematic device, the *palle,* in the entablature is typical of Michelozzo's ability to incorporate heraldic devices into his work—it occurs in his church of Bosco ai Frati (a Medici foundation near San Piero a Sieve, north of Florence)—and so also are the Corinthian capitals. The architecture of the Murate *Annunciation* is more idiosyncratic, but the capitals of the columns and pilasters are once again Michelozzan, as is the lozenge-shaped decoration of the green arches of the rood screen (they occur on the architrave of Michelozzo's tabernacle in the Santissima Annunziata [see fig. 5, p. 100]). An attempt has been made to explain the striking differences between the Sant'Ambrogio *Coronation of the Virgin* and the Marsuppini altarpiece by acknowledging the austerity of the Olivetans, for whom the latter work was painted.[70] It is true that the Marsuppini composition is simpler and superficially more conservative in appearance—certainly its form as a triptych seems a throwback to Gothic practice— but it is also the case that the architecture rationalizes the division between the panels. Apart from creating a remarkably coherent space for the figures, it also incorporates veined-marble insets and elegantly carved capitals and could only be considered austere to a viewer unresponsive to the cost of these materials. When we recall the way in which the carefully planned settings in Fra Angelico's *San Marco Altarpiece* complement Michelozzo's work in the convent, it is difficult to avoid the impression that in Lippi's three altarpieces we are dealing with a similar phenomenon: an architectural style associated with Cosimo de'Medici that was consciously adapted for commissions from his close associates. As already noted, Giovanni Benci, the patron of the *Annunciation*, was the general manager of the Medici bank, while Carlo Marsuppini was a close friend of Cosimo.

21.
Domenico Veneziano,
Madonna and Child with Four Saints
(*Saint Lucy Altarpiece*).
Galleria degli Uffizi, Florence

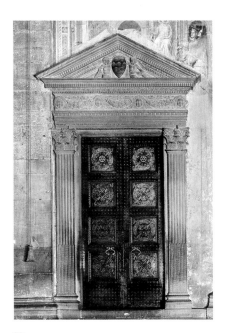

22.
Michelozzo, Door
of the novitiate chapel,
Santa Croce, Florence

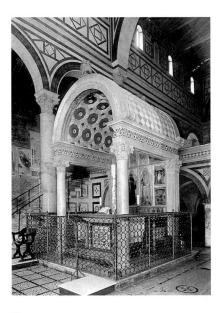

23.
Michelozzo, Maso di Bartolomeo,
and Luca della Robbia, *Tabernacle.*
San Miniato al Monte, Florence

LOOKING BEYOND LIPPI

The Michelozzan features in these three altarpieces are important, for they introduced Fra Carnevale to the work of the leading architect of Medicean Florence. We should not be surprised that motifs derived from Michelozzo's buildings become part of the repertory of the Urbino painter. Especially important for his work was the marble doorway to the novitiate chapel (fig. 22), its architrave decorated with a frieze of cherub heads and swags supported by beautiful Corinthian capitals and fluted pilasters of great elegance. Similarly, the project to decorate the courtyard of the Medici palace with roundels based on classical gems may have provided the germ for the classicizing reliefs that Fra Carnevale introduced into his paintings of the *Birth of the Virgin* and *Presentation of the Virgin in the Temple (?)* (cat. 45 A, B).

Beginning in 1448 Michelozzo was engaged in a number of collaborative projects that included the bronze founder and sculptor Maso di Bartolomeo and also Luca della Robbia. In his marble tabernacles in San Miniato al Monte (fig. 23) and the Santissima Annunziata, both funded by Piero de'Medici, an effect of incomparable richness was created by elaborately carved details or by employing mismatched capitals to suggest the reuse of classical fragments (*spolie*). At San Miniato al Monte, Luca della Robbia provided a glazed-terracotta vault that introduced a further element of polychromy, and he did the same for Piero de'Medici's study in the Medici palace (see cat. 25 A, B). From 1449 to 1451 both Maso and Luca would be involved in the construction of the first example of Renaissance architecture in Urbino: the portal of the church of San Domenico (fig. 1, p. 96), a project that was influenced by these and other Florentine models but attained its own, quite individual, character. Fra Carnevale is cited in several of the relevant documents and may well have played a vital role in that innovative architectural undertaking, conceivably submitting the same kind of drawings he did several years later, in 1455, for the cathedral of Urbino (see the document discovered by Mazzaluppi). Fra Carnevale's ties to Maso di Bartolomeo surely originated during the time he spent in Florence: might he have been responsible for involving Maso and Luca della Robbia in the project?

As Matteo Ceriano demonstrates in his exploratory essay, from the outset Fra Carnevale had a greater intrinsic interest in architecture than did Lippi, just as he was more fascinated with perspective. It is, therefore, not surprising to find him looking further afield than Lippi for inspiration: not just to the work of painters, but to that of architects and sculptors as well. He must have taken the opportunity to study Ghiberti's progress on the *Gates of Paradise,* with their elegant figural style and brilliant use of architectural settings—"buildings done with reason . . . so that standing back from them they appear in relief."[71]

Uccello's extraordinary fresco of the *Flood* (fig. 25) in the cloister of Santa Maria Novella, with its tunneling perspective and figures scattered so as to impart narrative interest through the composition, with witty interpolations to the biblical story, also left an enormous impression on Fra Carnevale, as did the bifocal perspective structure of

Uccello's (detached) fresco of the *Nativity* (Uffizi, Florence) from Santa Maria della Scala.[72] Fra Carnevale employed a similar perspective structure for his two panels of the *Birth of the Virgin* and *Presentation of the Virgin in the Temple (?)* (cat. 45 A, B). By having the orthogonals recede to the left in one and to the right in the other he at once united them conceptually while separating their visual content. It is probably not coincidental that those two panels—the core of this exhibition—were painted in the very years that Uccello was in Urbino at work on the predella of the altarpiece (Galleria Nazionale delle Marche, Urbino) for the Urbino Confraternità del Corpus Domini.

Along with the conceitful art of Uccello, Fra Carnevale was also drawn to the elevated, sacred drama of Fra Angelico's *San Marco Altarpiece* (fig. 3). Fra Angelico left Florence for Rome in 1445, working for both Eugenius IV and Nicholas V, but his absence from the Florentine scene did not diminish the impact of that extraordinary work. The predella, containing scenes from the legends of Saints Cosmas and Damian, established a new level of sophistication in the use of the geometry of perspective and of architecture to articulate a narrative (see fig. 24). Angelico did not share the interest of Domenico Veneziano and Donatello (who was in Padua from 1444 to 1453) in manipulating perspective to establish an emotional tone; he preferred a more normative scheme, with a centralized vanishing point. He then used architecture to give visual emphasis to a composition by providing a geometric scaffolding for the figural content. It was this aspect of Angelico's art that so strongly impressed Piero della Francesca. What seems to have especially attracted Fra Carnevale was Angelico's use of light—a light seemingly filtered through a crystal, acquiring a jewel-like intensity—to give a quality of heightened experience to his depictions of interior spaces. It is this crystalline light that illuminates the chamber behind the Virgin in the *Annunciation* (cat. 19) painted for the wealthy French merchant Jacques Coeur. If we compare that painting with Filippo Lippi's *Annunciation* (fig. 5) for Le Murate, we cannot help but be struck by the way its author—plausibly although by no means certainly identifiable as Fra Carnevale[73]—has transformed the art of his mentor. Architecture and space predominate. The recession of the arcade behind the angel and details such as the bronze gate—patterned on Maso di Bartolomeo's grille in the cathedral of Prato (ill. p. 182)—are described with the care of an amateur architect-designer.

We still know remarkably little of Fra Carnevale's activity in Florence, and the fact that the authors of this catalogue express differing ideas about what he may have painted in the 1440s indicates the speculative nature of the task of its reconstruction. Did he assume the position of senior assistant in Lippi's shop, entrusted with executing devotional works based on the master's design: such as the Lippesque paintings of the Madonna and Child in Baltimore and in Hannover (cat. 7)?[74] Did this activity lead, in turn, to more independent works, such as the *Madonna and Child* in Bergamo (cat. 18)?[75] Was a commission like the one for Jacques Coeur's *Annunciation* placed through Lippi, or did Fra Carnevale (its hypothetical painter) manage to receive independent commissions—despite his never having joined the painters' guild? The *Annunciation* (cat. 40) in

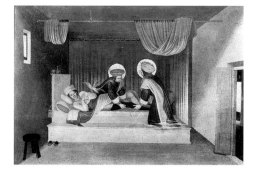

24.
Fra Angelico, *Saints Cosmas and Damian,*
from the predella of the *San Marco Altarpiece.*
Museo di San Marco, Florence

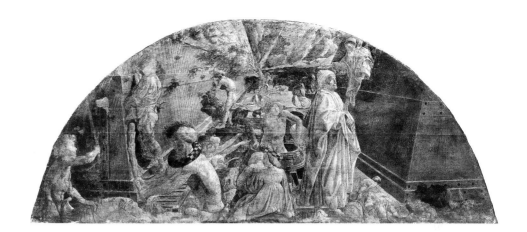

25.
Paolo Uccello, *The Flood*.
Cloister of Santa Maria Novella, Florence

the National Gallery of Art, Washington, D.C., can be traced to the Strozzi collection—albeit only in the nineteenth century—suggesting that Fra Carnevale did, indeed, have Florentine clients. At present we do not know how long he remained with Lippi or whether his initial stay in Florence was reprised later on. There is, indeed, a void between the mention of Fra Carnevale in Lippi's shop on September 7, 1446, and the notice of his presence in Urbino on December 9, 1449, by which time he had taken holy orders at the convent of San Domenico. For the next two decades his career as a friar, priest, painter, and architectural adviser (the order of priority was not necessarily constant) was intimately bound up with the transformation of Urbino into one of the foremost centers of Renaissance culture—a transformation based in no small degree on what Fra Carnevale, like Piero della Francesca before him, had experienced in Florence in the 1440s.

1. The first reference to Bartolomeo Corradini as Fra Carnevale is in a document of 1465 relating to an altarpiece for the Confraternità del Corpus Domini. The name recurs in a number of other documents as well: see Matteo Mazzalupi's contribution to the appendix.

2. See the essay by Emanuela Daffra in this catalogue.

3. See the appendices by Andrea Di Lorenzo and Matteo Mazzalupi.

4. See Michelini Tocci 1986, pp. 304–5.

5. Among the documents discovered by Don Franco Negroni, and transcribed in an appendix to this catalogue by Matteo Mazzalupi, we find Fra Carnevale and Ottaviano Ubaldini appointed as co-executors of a will drawn up in 1471 by the lawyer Matteo Catani. Ottaviano was among the executors of Fra Carnevale's estate.

6. Viti 1986, pp. 471–72, 477.

7. Franceschini 1970, pp. 442–44, 454.

8. On Piero's depiction of Byzantine dress, see Bridgeman 2002, pp. 88–89.

9. *I commentarii*, Ghiberti 1998, p. 94.

10. The description is from the dedication to Brunelleschi of the Italian edition of Alberti's treatise on painting, the *Della pittura*, translated from the Latin in 1436: Alberti 1972, pp. 32–33.

11. See Landucci 1976, p. 55; Carloni 1998.

12. On the convent of Le Murate, see Holmes 2000; Weddle 1997. The principal article on Sant'Ambrogio remains Borsook 1981.

13. For the current scholarship regarding these panels, long thought to have been painted for the Medici palace, see the masterly summary of Gordon 2003, pp. 387–93; they probably date to the late 1430s. Caglioti (2001) identified the Bartolini Salimbeni family as the original patrons.

14. Wohl 1980, pp. 339–40.

15. Ibid., p. 341.

16. Longhi 1927 (1963 ed.), p. 137; Banker 2002, pp. 173–201.

17. The translation is from Gilbert 1980, p. 93.

18. Bruschi (1996, p. 298), urges a much broader consideration of "authorship" than the simple one of identifying the artist who painted a given work: "*Al concetto di 'autore'—unico artista 'creatore'—potra, all'esame dei fatti . . . essere sostituito o affiancato, volta a volta, quello, per cosi dire, di 'regista,' di creativo 'responsabile' o 'organizzatore' del lavoro.*"

19. Piero's and Domenico's work in the sacristy of the great pilgrimage basilica in Loreto has been dated on circumstantial evidence to about 1447 (Wohl 1980, p. 210) or about 1454 (Lightbown 1992, p. 119).

20. Here reference must be made to the fact that earlier scholarship regarding Giovanni Angelo da Camerino has to be discarded in view of the documentary sources published by Di Stefano (2003, pp. 271–78); Di Lorenzo in De Marchi and Giannatiempo López (2002, pp. 196–97); and Di Stefano and Cicconi (2002, pp. 453–56). On the basis of insufficient and, as is now established, wrongly dated documentary information, Zeri (1961, pp. 89–99) identified Giovanni Angelo as the Master of the Barberini

Panels. So brilliantly did he argue this case that this identification was widely accepted—even after documents were discovered that pointed clearly toward Fra Carnevale as the most likely candidate. In the exhibition catalogue *Il Quattrocento a Camerino* (De Marchi and Giannatiempo López 2002), a new profile for Giovanni Angelo was put forward. Confirmation that he was responsible for the finest paintings heretofore ascribed to his fellow Camerino painter (and sometime partner) Girolamo di Giovanni emerged with the discovery of yet another new document (Mazzalupi 2003a). The net result of this is a far clearer basis for understanding the complex cultural exchanges between Florence, Padua, and the Marches in the fifteenth century.

21. See Di Stefano 2003, p. 277.

22. See the appendix by Andrea Di Lorenzo to this catalogue.

23. For the document, see Di Stefano and Cicconi 2002, p. 454.

24. The information occurs in a manuscript in the Biblioteca Valentiniana, Camerino (ms. 144, folios 124v–125r) and has been transcribed by Matteo Mazzalupi: see also Andrea De Marchi's essay in this catalogue.

25. For an analysis of these various currents in Boccati's work, see De Marchi 2002b, pp. 60–62; Minardi 2002, pp. 214–17.

26. In the famous letter patent Federigo issued in 1468 in favor of his architect Luciano Laurana he declared his high esteem for architecture: "*fondata in l'arte dell'aritmetica e geometria, che sono, delle sette arti liberali, et delle principali, perche sono in primo gradu certitudinis.*"

27. For these terms, see Levi Pisetzky 1964, vol. 3, pp. 253–54, 339–41; Herald 1981, pp. 218–20.

28. There is some confusion as to whether Antonio Alberti's altarpiece was painted for the church of San Bartolo or for San Cipriano, outside Urbino. Don Sperandeo is documented as rector of San Cipriano from 1450 to 1456, and it is possible that the saint sometimes identified as Augustine in Alberti's painting is, in fact, Cipriano, and that Don Sperandeo's church was its intended destination. I wish to thank Matteo Mazzalupi for this information; see the appendix by Mazzalupi in this catalogue.

29. See Varese in Dal Poggetto 1992a, pp. 18–19. Andrea De Marchi has informed me that he believes them to be earlier.

30. For Landino's text, see Morisani 1953, p. 270. Baxandall (1974, pp. 143–54) has argued that Landino's judgments closely reflect those of Leon Battista Alberti.

31. Clark 1951, p. 5.

32. The writer was the agent of Lodovico Il Moro in Milan. On these critical terms, see Baxandall 1988, pp. 26, 118–51.

33. Ruda (1993, pp. 126–32) has argued against Lippi's knowledge of and debt to Netherlandish painting. I cannot agree with his conclusions.

34. Bellosi 1990a. However evocative the term, it is misleading in that it suggests that Lippi was less inter-

ested in light than was Veneziano. This is not true; he was concerned with investigating a different balance between light and form. Although Bellosi proposes that Veneziano's was the approach Alberti recommended, the matter is more complicated, as Alberti's notion of black and white as modifiers of color needs to be taken into account. On Alberti's theory of color, see Edgerton 1969. For a review of Bellosi, see Christiansen 1990.

35. From Leonardo's notebooks; see Richter 1883, vol. 1, p. 258.

36. The finest analysis of this approach remains that of Shearman 1962, pp. 36–37.

37. See Del Bravo 1973, pp. 12–13, 23–24; Boskovits in Bellosi 2002, pp. 186–88; De Marchi 1996b, pp. 10–11.

38. For these terms, see Kemp 1977.

39. Morisani 1953, p. 270; see the excellent discussion of the critical terms in Baxandall 1988, pp. 128–39.

40. Pope-Hennessy (1980a, pp. 119–28) brilliantly explored Donatello's reinterpretation of the Late Gothic techniques of Gentile da Fabriano, which parallels some of Lippi's experiments. However, Donatello does not revive Gothic forms the way Lippi does, as, for example, in the painter's triptych for Alfonso of Aragon.

41. Arasse 2004, pp. 20–21.

42. Ibid., pp. 16–17; see also Kemp 1977, p. 390. These categories of artistic genius and style seem to me more important for understanding the variations in Lippi's work than the suggestion of an insufficient training to sustain his artistic ambition, as posited by Holmes 1999, p. 15.

43. In his 1510 guidebook Francesco Albertini cites two paintings by Lippi in the church. One of these was commissioned by the rector of the Arcispedale di Santa Maria Nuova, Michele di Fruosino: payments were made in February 1444 and February 1445. On this, see Merzenich 1997, p. 71; Holmes 1999, pp. 265–66 n. 9. Merzenich speculates—unconvincingly to my way of thinking—that Fruosino's altarpiece is the *Annunciation* now in San Lorenzo. Parronchi (1964) noted that later guidebooks mention an altarpiece of the *Annunciation* by Andrea del Castagno (not referred to by Albertini) that included portraits of two men—such an unusual feature that he felt it worth considering whether the painting might be the *Annunciation* by Lippi now in the Galleria Nazionale d'Arte Antica, Rome. See Ruda 1993, p. 403.

44. To this list should be added a ruinous painting in the Metropolitan Museum—the remains of what must have been a large and impressive altarpiece for a Benedictine establishment. See Ruda 1993, pp. 416–18.

45. See the appendix by Andrea Di Lorenzo for a discussion of the documents.

46. See Borsook 1981, p. 163.

47. De Angelis and Conti 1976, pp. 101–2.

48. See Ruda 1993, pp. 426; Lachi 1995, pp. 21–24.

49. Annamaria Bernacchioni, who kindly checked the documents for this exhibition, has noted in a letter

that Piero di Lorenzo, "*dipintore in Por' san Piero*," was active as an artisan: in 1421 he painted a dossal for the chapel of Ilarione dei Bardi in Santa Lucia de' Magnoli; in 1440 a "*cassettina per deporre le ossa*" for the marchese Ugo di Toscana; and between 1437 and 1443 undertook a number of minor tasks for the Arcispedale di Santa Maria Nuova.

50. Berenson 1932b (1969 ed.), p. 188. As Andrea Di Lorenzo points out in the appendix to this catalogue, the documents may refer to two artists named Piero di Lorenzo, one of whom—the "*Piero di Lorenzo dipintore*"—may in fact be the Master of the Castello Nativity.

51. The significance of Domenico Veneziano's lost fresco cycle in the Baglioni palace in Perugia has perhaps been overstated, to the detriment of the importance of Fra Angelico and Benozzo Gozzoli, both of whom also worked in the city. Zeri (1961, pp. 40–42) placed Veneziano's cycle at the very center of his reconstruction of Umbrian and Marchigian painting, but this was based on the erroneous assumption that the existing letters between Giovanni Angelo and Giovanni de'Medici and between Giovanni Angelo and his Camerino relations dated from 1451, whereas we now know that two of the letters were written in 1443 and 1444: see Di Stefano and Cicconi 2002, pp. 452–53.

52. See, especially, De Marchi in De Marchi and Giannatiempo López 2002, pp. 174–75; De Marchi 2002b, pp. 42–46.

53. Borsook 1981, p. 195 n. 113.

54. This suggestion was made by Annamaria Bernacchioni; see the appendix by Andrea Di Lorenzo.

55. For a possible identification of Andreino with Andrea del Castagno, and Piero di Benedetto with Piero della Francesca, see the appendix by Andrea Di Lorenzo.

56. See the discussion in the biography for the Pratovecchio Master.

57. Ruda 1993, pp. 520–23, 534–36. Holmes (1999, pp. 151–52) provides a good analysis of the relationship, and accepts the traditional identification of Giovanni di Francesco with Giovanni di Francesco da Rovezzano. On this, see the discussion in his biography and in that of the Pratovecchio Master in this catalogue.

58. I owe this suggestion to Annamaria Bernacchioni.

59. Ruda (1993, p. 402) presents a comprehensive account of the attributional history of the predella. The ascription was first made by Pudelko (1936, pp. 61–62), but with the idea that the predella was painted in the late 1440s. We now know that by that time Giovanni di Francesco's association with Lippi had been severed. Bellosi (1990b, pp. 21, 31–42) argued against the attribution, believing the predella to be the work of Fra Carnevale, but he was unaware of the documents indicating that Fra Carnevale only joined the workshop in 1445, and he summarily dismissed the documents associating Giovanni di Francesco with Lippi.

60. See the comments of Procacci 1961, pp. 62–63.

61. Ibid, pp. 30–34.

62. Fahy in Di Lorenzo 2001, pp. 71–72; Angelini in Bellosi 1990a, pp. 125–27.

63. De Angelis and Conti 1976, p. 109.

64. On the date, see Ruda 1993, pp. 419–20. For Marsuppini, see Martines 1963, pp. 127–31.

65. See Christiansen 1979, p. 200.

66. For a discussion of the date of this altarpiece, for which no documents are known, see Wohl 1980, pp. 125–26; Chelazzi Dini in Bellosi 1992a, p. 98.

67. Ruda (1993, p. 419) gives his reasons for believing that the altarpiece was conceived as a trilobed, open-field painting, much like the Sant'Ambrogio *Coronation of the Virgin*. This view is based on an eighteenth-century inventory describing how the three panels had "composed one single [panel]" ("*quali tre quadri sono in tavola, e ne componevano, uno solo*"). Taken in context, the passage says no more than that the three panels, when framed, formed a single altarpiece. The composition, with groups of figures carefully distributed on each of the three panels, would be inconceivable as an open-field painting.

68. For background information on the Murate altarpiece, see Holmes 2000; for the novitiate chapel's altarpiece, see Holmes 1999, pp. 192–99.

69. The date of the novitiate chapel altarpiece is undocumented, but a consensus places it in the early to mid-1440s. A sixteenth-century chronicle of Le Murate states that the church and its paintings were finished in 1443. However, it seems virtually impossible for Lippi to have completed two altarpieces for Le Murate by that date, given the other paintings he

had in hand. The Sant'Ambrogio ledgers record a payment on April 15, 1445, to Lippi's account for the Murate altarpiece. More than likely the chronicle conflates the dedication of the church building with the undertaking of the altarpieces to add luster to the initiative of the abbess, Madonna Scolastica Rondinelli; the chronicle is transcribed in Weddle 1997, p. 379.

70. Ruda 1984. A somewhat different approach to the issue of style is taken by Holmes (1999, pp. 215–40) in an analysis of the Sant'Ambrogio *Coronation of the Virgin* and the Murate *Annunciation*. Curiously, she does not address the issue of chronology but implausibly believes these stylistically divergent altarpieces could have been conceived at about the same time. See note 68, above, for the very little information we possess regarding this painting. The style of the Murate *Annunciation* cannot be reconciled with a date of 1443.

71. *I commentarii,* Ghiberti 1998, p. 95.

72. Angelini (in Bellosi 1990a, pp. 73–77) gives a fine and convincing chronology of Paolo Uccello's work—still a matter of much discussion. See also the remarks of Bellosi (1992b, pp. 25–27), on the affinities of Uccello's fascination with perspective and that of Piero della Francesca.

73. See the contrary view of Andrea De Marchi in his essay in this catalogue. Like him, I, too, had at one time thought this work by the Master of the Castello Nativity.

74. The Baltimore painting could not be lent to the exhibition. This is unfortunate, as the combination of delicacy and flatness and of refinement and lack of anatomical interest is very like what we find in the work of Fra Carnevale. Interestingly, this was one of the pictures Offner illustrated to demonstrate the degree to which certain characteristics in Fra Carnevale's work derive from the work of Filippo Lippi; see Offner 1939, p. 248, as school of Lippi.

75. On this work, see the entry by Andrea De Marchi. While I am in agreement that this painting is by the same artist responsible for the predella of Filippo Lippi's *Annunciation* in San Lorenzo and a small painting of *Saint John the Baptist in the Wilderness* in the Musée Condé, Chantilly, I am not convinced that the person in question is Fra Carnevale. See also note 59, above.

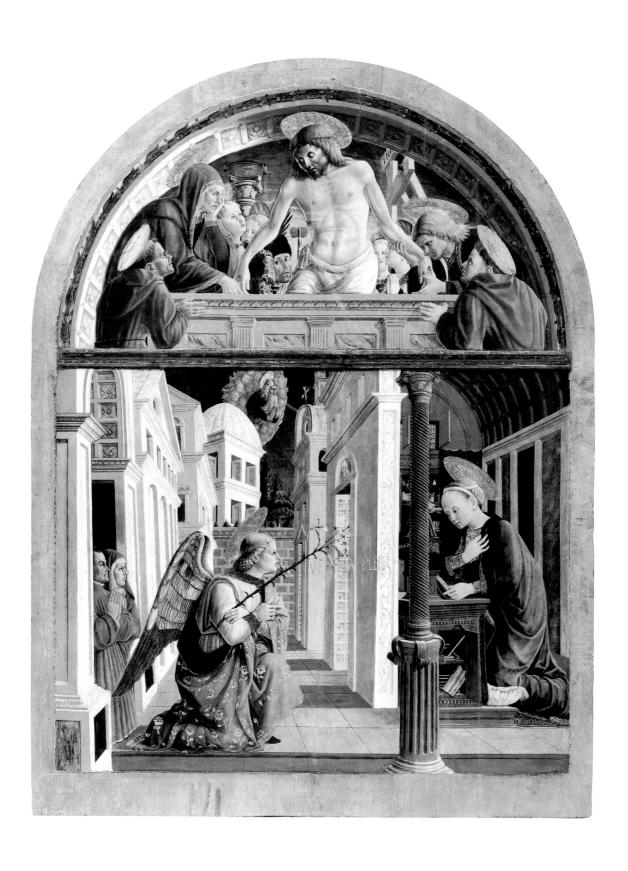

Andrea De Marchi

FRA CARNEVALE, URBINO, AND THE MARCHES: AN ALTERNATIVE VIEW OF THE RENAISSANCE

T A TIME when construction on the Palazzo Ducale in Urbino—begun by Count (from 1474, Duke) Federigo da Montefeltro (1422–1482)—was still ongoing and Piero della Francesca's altarpiece (cat. 46) for the church of San Bernardino had possibly not yet been conceived, the two panels painted about 1466 by Fra Carnevale for the confraternity of Santa Maria della Bella (cat. 45 A, B) already offered a precocious paradigm of *all'antica* architecture, with their depictions of precious inset marbles and carved reliefs, and elegant entablatures and friezes. The architecture in these paintings is perfectly aligned with Alberti's ideas, and is so exemplary as to exceed the limits of the narrative itself—what Alberti referred to as an *istoria*. Indeed, the narrative has the quality of an accessory, as if it were no more than a pretext for the perspectival arrangement of space—a space rendered vast and airy by the gradually diminishing scale of the numerous figures within it. Although the sacred subjects of the paintings are revealed by the complementary reliefs of the *Annunciation* and the *Visitation* in one of the panels, their cultured, humanistic guise has disoriented modern scholars unaccustomed to such an unusual tour de force.[1] That the panels were intended as parts of an altarpiece is supported by their association with a document of December 31, 1466,[2] in which the Santa Maria della Bella altarpiece is described as "*picta pro maiori parte*" ("mostly painted") but still "*perficienda*" ("being completed"), and is further demonstrated by the physical evidence of corbeled arches along the upper border of both panels. These arches are a tangible sign of the kind of compromise framing solution familiar from Piero della Francesca's polyptychs completed during the 1460s for the Augustinians of Sansepolcro and the Poor Clares of Sant'Antonio in Perugia, and they testify to a typology of Gothic altarpieces rather than to that of paintings for a domestic interior—or *spalliere*. That the subjects of these panels have to be deciphered presupposes their direct examination by an unconventional viewer, one capable of appreciating the rarity of the *inventio* and its expression through humanistic *ekphrasis*.

An iconographic program with this degree of cultural sophistication is appropriate to what we can extrapolate from surviving documents about the mysterious Dominican friar of Urbino—a figure who would use Latinisms (writing "Philippo" in Florentine documents, as noted by Andrea Di Lorenzo);[3] who was a member of the inner circle of the court at Urbino and was especially close to Ottaviano Ubaldini della Carda, Federigo's most trusted counselor and possibly his half brother; and who provided in his will for the employment of a learned theologian to preach in the convent of San

1.
Giovanni Angelo d'Antonio,
The Annunciation and *The Lamentation*.
Pinacoteca e Museo Civici
di San Domenico, Camerino

67

Domenico.[4] Halos are all but abolished in these paintings, and their subjects—not imme-diately recognizable—have to be unraveled. Even the Montefeltro eagle is not ostenta-tiously displayed but is placed discreetly on the façade of the palace in the *Birth of the Virgin,* within medallions flanking the great arch that frames the interior view and on a shield decorating one of the biforate windows. The presence of reliefs with classical themes—Dionysiac ones on the façade of the palace and a maenad and Satyr on the plinths of the exterior columns of the temple—is justified, as they allude to the Old Testament world under the Law, not yet transformed by Grace. In the *Presentation of the Virgin in the Temple (?),* the three beggars in the foreground may refer to the charitable activity of the hospital to which the church of Santa Maria della Bella was attached, but they can also stand as an attribute of the Temple of Jerusalem, in keeping with a passage from the Scripture that recalls their presence outside it: for example, the Acts of the Apostles (3: 1–11, especially verses 2 and 10) describes Saints Peter and John encountering and healing a lame man "whom they laid every day at the gate of the temple, which is called Beautiful" ("*ad portam templi quae dicitur Speciosa*"). The beggars thus provide a subtle reminder of the duties of the confraternity. This same intellectual approach inverts the prominence usually accorded the central characters, so that in one panel the newborn Virgin is relegated to the background, and in the other she is shown, almost casually, among her companions.

At the same time, purely quotidian episodes that may seem incidental assume the prominence of ephemeral protagonists. In an idealized scene that is at once implausible and theatrical, details of everyday life appear unexpectedly: affectionate or casual gestures, and figures coming and going, caught as if by surprise. The same ambiguity characterizes, on the one hand, the tireless formalism, the almost crude outlines, and the sculptural con-ception of draperies as though they were low reliefs, and, on the other, the adamantine transparency and the milky luminosity that caresses everything in sight, lightening the half shadows, bathing the pink pavement and plastered walls, and flooding across the landscape and pouring through the windows, which are devoid of either bars or glazing and open onto the sky. In schematic terms, this is the same kind of ambiguity that distinguishes the work of Filippo Lippi from that of Piero della Francesca. The paradoxical ambivalence of the Barberini Panels, suspended between the poles of intellectual abstraction and ordinary life, was perfectly captured by Richard Offner: "the painter has planted the holy person-ages in the midst of the haphazard occurrences of everyday life . . . the scattered activity and interest are like the lazy cadence of waves in a sea. Here people go about their busi-ness in various ways as if there were nothing at any pass or in any part of existence to drive them into decisive action or a dramatic resolution—and as if this existence spread out beyond the limits of the picture in all directions."[5] The expansion of the measurable spaces of the pictures, which are masterpieces of the culture of perspective in the 1460s, contributes—in a manner that would be inconceivable in the work of a contemporary Florentine painter—to the absence of a focal point and to the fragmentation of the nar-rative into everyday events It is in the context of this richly fanciful antiquarian setting that a vibrant "plein-air" quality, both anti-heroic and anti-archaeological, is introduced, in a way similar to what Aby Warburg defined as an alternative to the Florentine approach

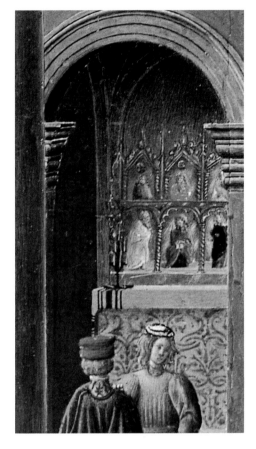

2.
Fra Carnevale, *The Presentation of the Virgin in the Temple (?),* detail. Museum of Fine Arts, Boston

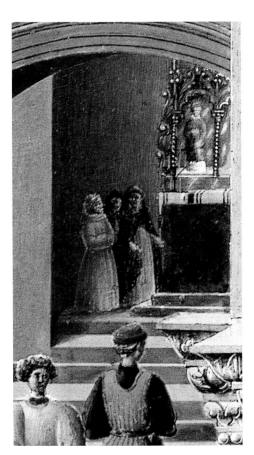

3.
Fra Carnevale, *The Presentation of the Virgin in the Temple (?)*, detail. Museum of Fine Arts, Boston

to narration in Piero della Francesca's *Legend of the True Cross* in San Francesco, Arezzo.[6]

In the *Presentation of the Virgin in the Temple (?)*, beyond the theatrical proscenium, there extends a vast, penumbral interior, closed at the far end by an exedra that recalls the Albertian structure of San Martino a Gangalandi, near Florence: a deliberate re-creation of a Roman basilica whose Ionic colonnades echo those of Santa Maria Maggiore. Benedetto Bonfigli, who is documented as working in the Vatican palace in 1450,[7] was similarly inspired in his grand setting for the *Funeral of Saint Louis of Toulouse,* a fresco (completed by 1461) in the chapel of the Palazzo dei Priori in Perugia. The buildings in both of these works differ from the generic Brunelleschian type adopted by Filippo Lippi in the *Funeral of Saint Stephen* in Prato Cathedral, and dwell on the description of visible roof beams and a high clerestory. Bonfigli, steeped in his aspirations to archaeological accuracy (evident in his use of the Arch of Constantine in the Perugia cycle), paints a continuous architrave, as Fra Angelico does in the Chapel of Nicholas V at the Vatican, and he resolves the problem of depicting architectural elevation by providing a vertical cross section of inner walls, whereas Fra Carnevale's solution is a theatrically ambiguous interior and exterior, rooted in the world of Lippi but also in the Paduan culture of the Ovetari Chapel. Just as Bonfigli grafts a Gothic polygonal apse onto the area beyond his triumphal arch, so Fra Carnevale makes surprise references to contemporary architecture, with the inclusion of the *tramezzo,* or rood screen, which customarily was found in Gothic churches: it divided the interior space between the sanctuary, reserved for the clergy, and the so-called "*parte delle donne,*" reserved for the laity; the openings in the rood screen formed actual chapel spaces facing the congregation (fig. 2). Indeed, this is one of the most evocative depictions in Italian Quattrocento art—prior to Vittore Carpaccio's *Vision of Doge Pietro Ottobon*[8]—of how church interiors appeared before the Counter-Reformation and of the placement of altarpieces and ecclesiastical furnishings. Clearly, Fra Carnevale's descriptive aims were more cerebral than visual, so that although the architecture is specifically religious, it is not entirely consistent: for example, he excludes the wooden choir that would typically appear beyond the screen, thereby facilitating a view of the high altar, beside which two friars (a Franciscan and a Dominican ?) stand (fig. 3).

Yet, because of its almost documentary value, the most curious inclusion is the accurate depiction of altars—the high altar and the two at the left, in recesses in the rood screen—with their textile frontals, Perugia-style cloths draped over their front edge; candelabra; and above all Gothic polyptychs gleaming with gold and intricate carving. An Albertian notion of *varietas* in the re-creation of a vision of antiquity is combined with apparently contradictory but similar contemporary visual references. Offner was captivated by these details and commented on them extensively,[9] pointing out how the foliate ornament carved on and between pinnacles and even on the sides of altars was radically alien to the more sober Tuscan approach, and how parallels could be found in countless Venetian and Emilian polyptychs, since these elements were "luxuriant, extra-architectonic gratuities" proper to the "more conservative tendency in Venetian art."[10] Offner did not yet have a clear idea of the dissemination of these trademark features throughout the Adriatic, beginning with the extremely widespread success in the fourteenth century of polyptychs made in Venice and shipped near and far. With surviving examples from

Emilia in mind, he tended, rather, to think of them as having originated "north of the Apennines," whereas the fundamental dialectic turns on what lies west and east of the Apennines—that is, Tyrrhenian or Adriatic Italy.[11] Zeri then provided instances of the prevalence inland, within the Marches, of these carved lateral crockets, typical of Venetian polyptychs beginning in the second half of the Trecento, citing works of the third quarter of the fifteenth century by Giovanni Antonio da Pesaro (about 1415–1474/78), Paolo da Visso (documented 1438–81), and Nicola di Ulisse da Siena (documented 1442–72).[12]

It is likely that Fra Carnevale's Franciscan altarpiece (cat. 41 A–D), a two-story pentaptych now dispersed among Loreto, Milan, and Urbino, had similar carpentry: the uninterrupted gessoed surface of the panels bears outlines of the arched cusps of an independent frame and is explicit evidence of its manufacture according to traditions current in Venice and the Adriatic (as opposed to Tuscany) from the fourteenth century on: a type well-known in the Marches from the *Valleromita Altarpiece* of Gentile da Fabriano (Brera, Milan) to a polyptych in Belforte del Chienti, near Tolentino (cat. 33) by Giovanni Boccati (ill., p. 20). The surviving framing elements on the *Saint Peter* (cat. 41 C)—particularly, the multiple cusps of the arches and the pierced quatrefoils along the upper horizontal edge—are in keeping with this Adriatic taste. Fra Carnevale's figures achieve a three-dimensional plasticity through the acuity of the drawing and the optical clarity, and the impression they created must have been one of a pulsating, physical presence that contrasted with the traditional framework of a sumptuously Gothic altarpiece—an effect much like that of the polyptychs by Piero della Francesca painted prior to the *Montefeltro Altarpiece* (cat. 46).

Another extraordinary feature indicative of the artist's visual strategies is Fra Carnevale's use of color to simulate the dazzling brilliance of the gold-leaf backgrounds of the polyptychs. He takes into account the viewing conditions to which they would have been subject, as well, by highlighting their gold surfaces, much as Konrad Witz does in his *Saint Mary Magdalene and Saint Catherine of Alexandria* (Musée de l'Oeuvre Notre-Dame, Strasbourg), of about 1440,[13] where the artist depicts the reflections of a candle on the burnished-gold surface of the altarpiece. This display of mimetic virtuosity, evoking Pliny's "splendor," was a particularly appreciated challenge during the mid-fifteenth century,[14] first attempted by Flemish painters. Leon Battista Alberti was well aware of it, and in his *Della pittura* (1436) heaps praise on effects of gleaming light as "*l'ultimo lustro di una forbitissima spada*" ("the highest luster of the most highly polished sword"), although he advises the utmost frugality when it comes to using the black and pure white on which these effects depend ("it would please me if white were sold to painters at a price higher than the most precious gems").[15]

The ability to convey the appearance of metal through the medium of paint ("*miracolo della pittura,*" Alberti would have said) is displayed in Fra Carnevale's Franciscan polyptych, in the studs and clasps of the books held by Saints Francis and Peter, in the latter's keys, and in the slender cross held by the Baptist. The stimulus for such a Flemish-inspired degree of attention, at this particular moment in his career, could also have come, as we shall see, from his occasional contact with Antonio da Fabriano, who had been trained in the Flemish-influenced Genoa of Donato de'Bardi (documented 1426–50).

4.
Nicolò Pizzolo, *Saint Gregory,* detail.
Formerly, Ovetari Chapel, Church of the Eremitani, Padua

5.
Bartolomeo Caporali
(based on a drawing by Benozzo Gozzoli),
The Annunciation, detail.
Musée du Petit Palais, Avignon

6.
Giovanni Angelo d'Antonio,
The Annunciation, detail.
Pinacoteca e Museo Civici di
San Domenico, Camerino

Similar details also abound in the work of the Paduans in the circle of Nicolò Pizzolo (about 1421–1453), Francesco Squarcione (about 1394/97–1468), and the young Mantegna, and, by extension, in the paintings of the Camerino artists Giovanni Boccati and Giovanni Angelo di Antonio, who began their productive relationship with painters in this circle in about 1450—not to mention the Perugian masters, including Bartolomeo Caporali (documented 1442–92) (fig. 4-6).

There is, however, a more intellectual element in the specific challenge of expressing the inimitable effect of gold by pictorial means, as can be seen in the luminous shine on the tiny fictive polyptychs painted by Fra Carnevale. The *Baptist* in Loreto, strikingly fore-shortened as though seen from below, and the *Crucified Christ* in Urbino, both from the upper register of the Franciscan polyptych mentioned above, do not have gilded halos, unlike the other figures, but golden yellow ones, whose varied luminescence and trans-parency are set off against the atmospheric sky. Surprisingly, in the *Madonna of the Orchestra* by Boccati (cat. 32), painted on his return from Padua to Perugia in about 1455, there is not one grain of gold; the way he renders its fictive effect in halos and in sumptu-ous damask is programmatic. Padua, too, in the 1450s, abounds with similar examples in the works of the young Mantegna, Marco Zoppo (1433–1478), and Giorgio Schiavone (about 1436–1504). The words of Leon Battista Alberti, written twenty years or so earlier, come to mind here: "There are some who use much gold in their *istorie*. They think it gives majesty. I do not praise it. Even though one should paint Virgil's Dido, whose quiver was of gold, her golden hair knotted with gold, and her purple robe girdled with pure gold, the reins of the horse and everything of gold, I should not wish gold to be used, for there is more admiration and praise for the painter who imitates the rays of gold with colors."[16]

Passages from Alberti's treatise have been repeatedly used to explain the Barberini Panels and their systematic display of varied poses—"the copiousness and variety of things"—so much so that Parronchi attributed them to Alberti's youthful activity as a painter,[17] which conflicts with the considerably later dating of these works. The compari-son is no less striking for the close interest, in the panels, in the phenomena of the "recep-tion of light" ("*ricezione de' lumi*"), of which they are among the finest examples in Florentine painting. The basic source is found in the art of Domenico Veneziano of about 1440–50, and in works by proponents of what Bellosi has called "*pittura di luce,*" which figured in the memorable exhibition he organized at the Casa Buonarroti in 1990.[18] Toward the middle of the century we find in the work of Fra Carnevale and other Marchigian painters, far more than among the Florentines—with the sole exception, per-haps, of Giovanni di Francesco da Rovezzano (1412/28?–59) and the Pratovecchio Master—an almost fanatical interest in light reflected in shadow; this even extends to the outlining of profiles in light to achieve an effect of expressive pathos, as in the case of the right arm of the *Baptist* in Loreto, or in Giovanni Angelo d'Antonio's *Crucifixion* of 1452 in Castel San Venanzio. Alberti speaks extensively of the effects of reverberation, wherein "the rays of light" once they are interrupted by the shadow of a body, "either return from whence they came or are directed elsewhere" ("*o ritornano onde vennono, o s'adirizzano altrove*"), as in the reflection of water on a ceiling; or "carry with themselves the color

they find on the plane" ("*seco portano quel colore quale essi trovano alla superficie*"), so that "anyone who walks through a meadow in the sun appears greenish in the face" ("*chi passeggia su pe' prati al sole pare nel viso verzoso*"). In Giovanni Angelo d'Antonio's *Saint Jerome* (cat. 35), the figure's priestly amice is boldly tinged with a pink shadow from the reflection of the cardinal's robe worn over it.

The semantic ambiguity of the two Barberini Panels, further induced by their spectacular display of marbles, bas-reliefs, and classical entablatures, cannot have failed to evoke the disdain of the politically wary Aeneas Sylvius Piccolomini, Pope Pius II (1405–1464). Yet, in his *Commentarii,* in discussing the temple-like church of San Francesco (the Tempio Malatestiano) in Rimini built by his detested enemy Sigismondo Malatesta, he nevertheless lets slip a few words of admiration because the structure is objectively "a splendid church . . . though he filled it so full of pagan works of art that it seemed less a Christian sanctuary than a temple of heathen devil-worshippers. In it he erected for his mistress a tomb of magnificent marble and exquisite workmanship." [19] Even Alberti's Tempio Malatestiano, its façade worthy of a Roman triumphal arch, was balanced within by elements of Gothic architecture, its chapels, decorated with marbles and reliefs framed by ogival arches, pierced by tall Gothic windows. Similarly, the chapels in the temple in Fra Carnevale's *Presentation of the Virgin (?)* for Santa Maria della Bella contain altarpieces with Late Gothic carpentry. The impression that must have been made by the antiquarian transformation of San Francesco in Rimini, and the repercussions in Urbino itself in building projects in which our Dominican painter was more or less directly involved, underlie his growing interest in a resonant architectural setting and in the sophisticated choice of fictive reliefs and ornamental motifs to adorn it.

In the Marches, an interest in painted architecture—albeit in a radically different idiom—was encouraged by the repeated visits to Padua of a handful of painters from Camerino, including, for example, Giovanni Boccati in 1448 and Girolamo di Giovanni in 1450. An idealized, *all'antica* urban setting serves as the backdrop in the scenes from the life of Saint James and Saint Christopher in the Ovetari Chapel of the Church of the Eremitani in Padua, painted in the early 1450s by Andrea Mantegna and Ansuino da Forlì (documented in Padua in 1451). Earlier, Nicolò Pizzolo (died 1453; documented in connection with Boccati in 1448) [20] had experimented with something of this kind when he provided the cartoon (as I believe he did) for the mosaic of the *Dormition of the Virgin* in the Mascoli Chapel in San Marco, Venice, [21] where an iconographically gratuitous extension of the scene occurs in a series of receding buildings framed by a grand arch. The fact that these scenic inventions had their roots in the work of Donatello and of Filippo Lippi does not belie the influence of the dazzling Paduan frescoes on the painters of Camerino, who borrowed precise elements of their architectural vocabulary from Pizzolo and from Mantegna—not to mention the initial inspiration for the *all'antica* street that opens out in the background of the Spermento *Annunciation* by Giovanni Angelo d'Antonio, painted about 1455 (fig. 1, p. 66). [22]

The *Annunciation* was revolutionary for the Marches—a manifesto that anticipated by twenty to thirty years the diffusion of the new, Paduan-type of Renaissance altarpiece, with an arched lunette and a spectacular, almost excessive display of radical perspectival

7.
Fra Carnevale,
The Birth of the Virgin, detail.
The Metropolitan Museum of Art,
New York

8.
Justus von Ravensburg,
The Annunciation, detail.
Cloister of Santa Maria di Castello,
Genoa

9.
Antonio da Fabriano,
Saint Jerome in His Study, detail.
The Walters Art Museum, Baltimore

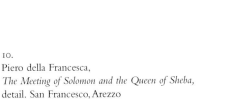

10.
Piero della Francesca,
The Meeting of Solomon and the Queen of Sheba,
detail. San Francesco, Arezzo

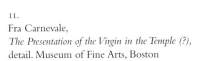

11.
Fra Carnevale,
The Presentation of the Virgin in the Temple (?),
detail. Museum of Fine Arts, Boston

foreshortenings and acrobatic *di sotto in su* views. Perfectly in tune with the world of Nicolò Pizzolo, Giovanni d'Antonio's *Annunciation* exhibits a willful ambiguity between interior and exterior, and between elegant marble pediments and furtive glimpses of domestic furnishings, all described with the optical precision of a Flemish painting. The concept underlying the Barberini Panels, expressed by means of a different sense of space and amplitude, is nonetheless not unlike that seen here. The unexpected veracity of certain details in the Barberini Panels—a bronze candelabrum with its spent taper, a glass flask, a piece of fruit, a tightly sealed jar, pewter platters stacked on a shelf in a wall cupboard in Saint Anne's room (fig. 7)—would be unthinkable without the sort of stimulus derived, on the one hand, from Antonio da Fabriano and his Ligurian-Flemish sources (for example, the beautiful works of Justus von Ravensburg),[23] and on the other from Giovanni Angelo da Camerino and his revival of Pizzolo's startlingly descriptive domestic interiors (fig. 8, 9).[24]

The perspectival and compositional standards established by the Barberini Panels, markedly superior to those of an experimental and challenging work such as the Spermento *Annunciation,* presuppose a direct association on the part of the artist with the architectural and sculptural projects in Rimini and in Urbino itself, but also a dialogue with the peerless, mathematically informed oeuvre of Piero della Francesca, with whom Fra Carnevale probably became acquainted in 1451, when the master of Borgo Sansepolcro created his solemn votive image of Sigismondo Malatesta in the Tempio Malatestiano in Rimini. The plan there was not for painted altarpieces but for "*lapideae tabulae*" (sculpted reliefs), and yet Piero's fresco resembles a polychrome relief, made more natural by its illusionistic, continuous framing and by the round aperture through which the clear sky and the Castel Sismondo are visible. In the *Birth of the Virgin* and the

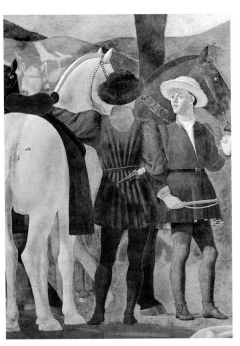

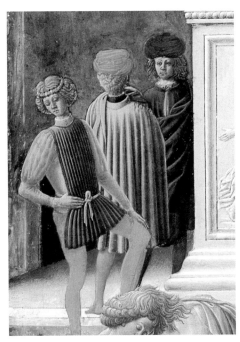

10

11

73

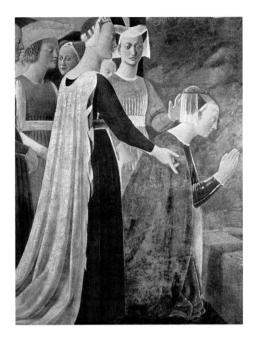

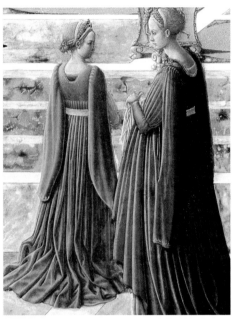

12.
Piero della Francesca,
The Meeting of Soloman and the Queen of Sheba,
detail. San Francesco, Arezzo

13.
Fra Carnevale,
The Presentation of the Virgin in the Temple (?),
detail. Museum of Fine Arts, Boston

Presentation of the Virgin in the Temple (?), too, the figures resemble fictive reliefs that appear realistic only because of their coloration, their dress, and the landscape setting, imbued with light from the shining sun: everything is dominated by clear, almost monochromatic tonalities and intense blues, as if transposed from an antique cameo.

The focus of the compositional devices in the Barberini Panels corresponds with that of the Rimini fresco: studied pauses between solids and voids and an uninterrupted arrangement of figures and architectural elements that interact with a calibrated spatial depth, diagonally connecting the two dogs, the kneeling despot, and his patron saint. On the left in the *Birth of the Virgin,* three women occupy the foreground in a diagonal arrangement, and the juxtaposition of one woman, seen from behind, with another, in a frontal view, along the painting's orthogonals—their poses repeated by the pairs of young men who encircle the temple in the *Presentation of the Virgin (?)*—recalls the forward- and backward-looking squires in the *Meeting of Solomon and the Queen of Sheba* in Piero's Arezzo cycle (fig. 10, 11). The young Virgin, barely turning as she walks solemnly away, the folds of her dress falling as straight as the fluting on a column and the nape of her neck revealed by the curve of the neckline of her robe, cannot fail to bring to mind the women who accompany the Queen of Sheba in the Arezzo fresco (fig. 12, 13). The white greyhound in the foreground of the Boston panel is another obvious tribute to the fresco painted by Piero for Sigisimondo in 1451 (fig. 14, 15). The foreshortened view of the pilasters and capitals in the exterior loggia in the New York panel, one of the greatest virtuoso passages in these paintings, seems to consciously compete with Piero's sophisticated rendering of architectural space: beyond passages in the Arezzo cycle or the Urbino *Flagellation,* we are reminded of the right side of the cloistered portico in the *Annunciation* from the polyptych for Sant'Antonio, Perugia, a project also under way in these same years (fig. 16, 17).

14.
Fra Carnevale,
The Presentation of the Virgin in the Temple (?), detail.
Museum of Fine Arts, Boston

However, the first decisive Renaissance influence on the Master of the Barberini Panels occurred in Florence during the 1440s, in a striking parallel with the careers of the two Camerino painters Giovanni di Piermatteo Boccati and Giovanni Angelo d'Antonio. The latter, the son of Antonio "*lu pazu*" of Bolognola, a tiny hamlet perched above the valley of the Fiastrone, among the Sibilline Mountains, south of Camerino, had been identified by Federico Zeri, in his well-known study of 1961,[25] as the possible author of the Barberini Panels. On the other hand, research during the 1970s, particularly by Alessandro Conti[26] and Keith Christiansen,[27] uncovered increasingly strong evidence for identifying this master as Fra Carnevale of Urbino, born Bartolomeo di Giovanni Corradini. On the occasion of the 2002 exhibition "Il Quattrocento a Camerino. Luce e Prospettiva nel Cuore della Marca,"[28] and as a result of new archival research by Emanuela Di Stefano, it has been possible to establish that Giovanni Angelo was the author of a group of paintings of the highest quality. Bernard Berenson's pioneering article of 1907[29] had attributed these works to another painter from Camerino, Girolamo di Giovanni di Marano (documented from 1450; died 1503), recorded in Padua in 1450,[30] who appears, instead, to have been something of an alter ego and a lesser colleague of the master from Bolognola—the latter being a friend and correspondent of Giovanni di Cosimo de'Medici (1421–1463), who signed himself as "*il dipintore da Camerino, qual son-ava de lioto*" ("the painter from Camerino, who played the lute"). This identification, while not definitively proven at the time of the 2002 exhibition, nevertheless strengthened the case for an Urbino-based Master of the Barberini Panels—someone whose presence in Camerino has never been documented, although that of Giovanni Angelo is recorded extensively between 1443 and 1476. Finally, the discovery by Matteo Mazzalupi of the record of a payment to Giovanni Angelo on November 12, 1452, for a *Crucifixion* in Castel San Venanzio, one of the masterpieces Berenson attributed to Girolamo di Giovanni, has confirmed that current research is, indeed, on the right track.[31]

Andrea Di Lorenzo's careful reexamination of Giovanni Angelo d'Antonio's Medicean correspondence[32] has established that the surviving letters, in fact, belong to three distinct periods between 1443 and 1451, and do not all date to 1451, as Zeri had thought. They reveal the evolution of the painter's relationship with Giovanni di Cosimo—at first formal, then more intimate, and, in a final letter, taking on a nostalgic tone, when the artist brings up a possible marriage with a member of the Da Varano family, the lords of Camerino. This new information reinforces the notion that the influence of Florence was at its peak about 1443 and shortly thereafter, while in 1451 the Camerino painters were looking to Padua, which they had visited on a number of occasions, for inspiration.[33] Altogether, what emerges from this web of documents and stylistic evidence suggests that artists were far more mobile than usually imagined.[34]

It was on the basis of this data that, during the Camerino exhibition in 2002, we reconstructed the early activity of Giovanni Boccati and Giovanni Angelo d'Antonio, focusing on the period before Bocatti's sojourn in Perugia in 1445, and his *Adoration of the Magi* in Helsinki,[35] and Giovanni Angelo's Bolognola altarpiece (Museo di Palazzo Venezia, Rome; presently on loan to the Pinacoteca e Museo Civici, Camerino).[36] In so doing, we arrived at two different views of Florentine culture in the early 1440s, which

15.
Piero della Francesca,
Saint Sigismond and Sigismondo Malatesta, detail.
Tempio Malatestiano, Rimini

was dominated by Fra Filippo Lippi, Domenico Veneziano, and Fra Angelico, the painters most favored by the Medici (who, in fact, seem to have welcomed Giovanni Angelo as a guest, given that their palace was the address used by his father-in-law, Ansovino, probably in 1444 ["*Zuvanni dipintore da Camerino, in Fiorenza in casa di Cosimo*"]).[37] Their two paintings are emblematic of the differences between these Camerino artists, who, although of distinct character, had been traveling companions since their youth (thus, Ansovino's scolding of his son-in-law: "*quando ve parteste de qua, tu et Iohanni Bocchaccio, ce diceste avevate el modo avere de multi denari. Non so que guadangio ne v'abbiate facto*") and who were colleagues later on, as indicated by a Camerino document of 1452 discovered by Matteo Mazzalupi (relating to a loan they had jointly incurred) and by their collaboration on the Raggiano *Crucifixion* in the 1460s. The Florentine sojourn of Bartolomeo di Giovanni (Fra Carnevale) would follow the same path as that taken by the two older and more worldly painters from Camerino.

While carrying out archival research in preparation for this exhibition, Andrea Di Lorenzo discovered the record of a payment on January 31, 1443, to "Giovanni di Matteo da Camerino" (Giovanni di Piermatteo Boccati) in the account book of a farm known as La Piacentina, which had been bequeathed by Francesco Maringhi to finance the cost of an altarpiece for the high altar of Sant'Ambrogio in Florence, commissioned from Filippo Lippi by 1439 (fig. 2, p. 40).[38] Thus, we finally have not only a secure documentation of Boccati's presence in Florence but also evidence for his relationship of trust with Filippo Lippi, since the money Boccati collected (two lire and four soldi) was intended for the Carmelite painter. Lippi's influence is particularly evident in Boccati's *Pergolato Altarpiece,* a work executed for San Domenico, Perugia, between 1445 and 1447 (fig. 17, p. 56). Two years later, beginning on April 17, 1445, and in the context of work connected with Maringhi's altarpiece—the most complex and impressive of those painted by Lippi—there appears the name of Bartolomeo di Giovanni da Urbino, who functioned as a go-between in transmitting payments to the painter, as well as a definite collaborator.[39] One can only strongly suspect that the two Marchigians already knew one another, and that it was Boccati who brought the future Fra Carnevale to the attention of Lippi.

Further evidence of direct contacts between Boccati and Fra Carnevale is suggested by the fact that it was the painter from Camerino who was summoned by Federigo da Montefeltro to decorate the Camera Picta in his new apartments—the room where he received his second wife-to-be, Battista Sforza, in 1459—with a series of frescoes of *Famous Men* (fig. 9, 10, p. 48). A slightly later date has also been proposed for the cycle, but it is likely that the decorations[40] would have been readied in time for the marriage of Federigo and Battista, celebrated in Pesaro on November 13, 1459. Fabio Marcelli has suggested that the inspiration for the frescoes was the pairs of *Famous Men* painted by Bonifacio Bembo (documented 1444–77) in the Cortile dell'Arengo in Milan in 1456—an appropriate homage by Federigo to his Sforza spouse.[41] This dating can also be confirmed by the stylistic similarity of these frescoes with the *Saint John the Baptist* and *Saint Sebastian* (Oberlin, Ohio), from the polyptych that Boccati painted between 1458 and 1461 for San Francesco in Tolentino.[42] This was a turning point in his career: compared to the *Madonna of the Orchestra* in Perugia (cat. 32)—a work that resounds with

16.
Piero della Francesca,
The Annunciation
(from the Sant'Antonio Altarpiece),
detail. Galleria Nazionale
dell'Umbria, Perugia

17.
Fra Carnevale,
The Birth of the Virgin, detail.
The Metropolitan Museum of Art,
New York

mature echoes of Padua and Mantegna (the sculpted altarpiece in the Ovetari Chapel in Padua and even of the *Martyrdom of Saint Christopher*) and employs the latest techniques to indicate perspective—the Ajaccio *Madonna,* once the center of the Tolentino altarpiece, displays an increasingly decorative Renaissance vocabulary in which spatial definition suddenly becomes uncertain and confused. Yet, albeit with uneven results, Boccati had produced ingenious examples of illusionistic painting in Urbino, such as the foreshortened parallelepiped trusses from which the fictive tapestry, with its depictions of Heroes, is suspended, or the passages of drapery in the vaulting, attached with bands and ribbons by the putti in the pendentives.

Boccati doubtless possessed a certain self-esteem and must have been particularly skillful in promoting himself, as shown by the emphatic wording used in the document that granted him citizenship in Perugia in 1445—"*in arte pictoria expertissimus*"[43]—as well as by his inflated payment of 250 florins[44] for the *Pergolato Altarpiece* (cat. 30), completed in 1447, and perhaps also by the bitter struggle he had with the Franciscans of Tolentino regarding his fee and their assessment of his work.[45] His resumé was impressive—activity in Florence, Perugia, and Padua—so the high regard in which he was held by Federigo at the end of the 1450s is therefore not surprising. Even if the count's Camera Picta appears to be a stylistic compromise between different worlds, so was the sculptural decoration of the Jole apartments in the Palazzo Ducale—a fascinating example of the so-called "*rinascimento umbratile,*" with its classical architraves; overlapping cornucopias; still slightly Gothic scrolls replete with birds, as in the margins of an illuminated miniature; caricature-like heads and other elements that seem borrowed from Luca della Robbia; and adaptations from Roman sarcophagi, although perhaps filtered through an intermediary drawing from the circle of Pisanello, such as Matteo de'Pasti could have devised in Rimini. In fact, Giovanni Angelo d'Antonio, not Giovanni di Piermatteo Boccati, was the favorite Camerino painter at the court of the Da Varano. When Boccati returned to Camerino, he occupied himself with lucrative but provincial commissions for country churches, such as the Belforte polyptych of 1468 (cat. 33), although in the intense physicality of the *Blessed Guardato* from that altarpiece there are still traces of his past contact with Fra Carnevale and the masters in Lippi's circle in Florence.

It is rather remarkable that ten years or so before this, the most prestigious painting commission in Urbino had been given to Boccati, while Fra Carnevale limited himself to painting monochrome swags and small putti heads on the upper frieze of Federigo's sleeping alcove—assuming, as I believe, that it was also executed on the occasion of the count's marriage to Battista Sforza.[46] There are, however, reasons for suspecting that early on in his association with the count of Urbino, Fra Carnevale might have served as artistic adviser, perhaps believing that that role carried more prestige than executing actual works. It was during these years that Fra Carnevale was awarded the task of painting the altarpiece for the powerful confraternity of Corpus Domini, but on June 25, 1456, he changed his mind and returned the advance he had received.[47] This important commission subsequently involved Paolo Uccello, who would paint the predella (1465–68) of the altarpiece; Piero della Francesca (1469), who did nothing; and finally Joos van Ghent (1473–74). Surviving documents reveal the prominent social position and prosperity

attained by our Dominican friar, the parish priest of San Cassiano di Cavallino, and make us wonder whether, in fact, Fra Carnevale was merely a "dilettante artist"—the term coined by Ulrich Middeldorf[48] to justify the absence of a substantial body of works in a period of activity lasting virtually forty years and ending with the friar's death in 1484.

Fra Carnevale's involvement in architecture and sculpture (discussed in the present catalogue by Matteo Ceriana) is revealed in a document of December 30, 1455, discovered by Matteo Mazzalupi, in which the friar is recorded as having been paid for designing the bases of columns, capitals, and other stonework elements for Urbino Cathedral.[49] It is notable that in 1449, Bartolomeo's return to Urbino and his admission into the Dominican order[50] coincided with his initial work on the portal and marble decoration (later left unfinished) of the church of San Domenico itself. This structure was to be the very first Renaissance building in Urbino, financed in part by Federigo, no doubt in emulation of his bitter rival Sigismondo Malatesta (1417–1468), whose Tempio Malatestiano was being built in Rimini. The account book of Maso di Bartolomeo, transcribed here in its entirety by Andrea Di Lorenzo,[51] clearly demonstrates the central role played by Fra Carnevale as financial mediator between the official representatives of the convent of San Domenico and the artists in following up and evaluating the work in progress. He was evidently on familiar terms with Maso di Bartolomeo and his brother Giovanni, for it is known that he advanced money to them in 1451 so they could hire a young assistant in Florence to serve as a gilder.[52] In addition, our friar seems to have mediated, and perhaps offered initial advice, on the decision to summon to Urbino, Maso, Giovanni di Bartolomeo, and Luca della Robbia—artists admired by the Medici and who were responsible for the most modern advances in Florentine art. The first painting created for a private collector that we can connect with a commission by Federigo outside of Urbino—leaving aside the problem of Piero's *Flagellation*—is an unusually long *spalliera* panel with scenes of a boar and deer hunt, now in the Musée des Augustins, Toulouse (fig. 18, 19),[53] a subject that would have been unthinkable in Florence, for its adaptation

18.
Giovanni di Francesco da Rovezzano,
The Hunt, detail. Musée des Augustins, Toulouse

19.
Giovanni di Francesco da Rovezzano,
The Hunt, detail. Musée des Augustins, Toulouse

of courtly life was designed to please the count, who also purchased Flemish tapestries with hunting themes. The city in the background, outlined against an unforgettably fiery sky, is Florence, and the Florentine painter who executed this hunting scene, probably shortly before he died in September 1459, was Giovanni di Francesco. Giovanni's eccentric style falls somewhere between that of Andrea del Castagno and Domenico Veneziano; a painter of "*istorie,*" he was also an exponent of the so-called *pittura di luce,* and his emphatically graphic style led both Schmarsow[54] and Berenson[55] to mistakenly identify him as the author of the Barberini Panels. In fact, Giovanni di Francesco and Fra Carnevale could easily have known each other in Florence.

Too often, we associate the art produced in Urbino with the culture of perspective, even though the court of Federigo da Montefeltro was an extraordinary and insatiable crucible for the latest and most disparate artistic movements. Furthermore, all too frequently we misjudge historical events in hindsight, as in the case of the count's residence, for in the 1450s, the Palazzo Ducale had yet to become a grand Renaissance palace. It is difficult to imagine the extraordinary impact and novelty of the façade of San Domenico, in a small town that would shortly become the exemplar of the city-as-palace, controlled by a particularly enterprising and successful *condottiere*-prince. At the time, Urbino still resembled many other small, even more rich and prosperous cities in the Marches, whose culture was still steeped in Late Gothic taste and would remain so for years to come. Apart from the presence in Urbino of the 1416 masterpiece by the Salimbeni, Lorenzo (documented 1400–1416) and Jacopo (1400–1427), in the Oratorio di San Giovanni (fig. 12, p. 50), and the paintings of Ottaviano Nelli (documented 1400–1444), two highly proficient Late Gothic artists worked in the city during the respective reigns of Antonio (died 1404) and his son Guidantonio (died 1443) da Montefeltro: the first of these artists, whose style was still rooted in the Trecento manner of the Catalan-Marchigian Master of the Bellpuig Coronation, was the author of the San Bartolomeo triptych of about 1408;[56] the second, Antonio Alberti (documented 1418–47), a native of Badia Polesine, between Ferrara and Padua, was probably trained by the Salimbeni but was later influenced by Gentile da Fabriano and Emilian painting (fig. 11, p. 49). Alberti's long career, including an Umbrian period before 1424, when he worked for Braccio da Montone, extends from the late 1410s until his death in 1447/49.[57]

As a young man, too, Bartolomeo di Giovanni Corradini was associated with Antonio Alberti. Alberti had been paid in 1442 by Fra Carnevale's patrons, the confraternity of Santa Maria della Bella, and twenty or so years earlier, he had painted a fresco of the *Crucifixion* (Galleria Nazionale delle Marche, Urbino), for the oratory, its ceiling modeled after that of the Oratorio di San Giovanni mentioned above).[58] A document discovered by Don Franco Negroni, unfortunately not dated, reveals that Bartolomeo Corradini was the recipient of thirty-five *bolognini* on behalf of Antonio Alberti, which suggests that his first apprenticeship was with this master.[59] The payment was from Sperandeo di Giovanni, the parish priest of San Cipriano near Urbino, and, as Matteo Mazzalupi has noted, he was also the patron whose name is inscribed on Alberti's triptych of 1436 (Galleria Nazionale delle Marche, Urbino)[60]—which would confirm a fairly early date for Corradini's association with the Ferrarese master. It is difficult to imagine that the

earliest works by the future Fra Carnevale undoubtedly reflected the Late Gothic style of Antonio Alberti, but it suggests that when he joined Filippo Lippi's workshop, he had already received initial training in Urbino.

The experience of the Sansepolcro painter Piero della Francesca was somewhat the same. Piero was trained in the workshop of Antonio di Giovanni da Anghiari (documented 1430–70), to whom he had been entrusted by his father, Benedetto, by 1431.[61] In 1439, he worked alongside Domenico Veneziano on the scaffolding of the Florentine church of Sant'Egidio, more as a colleague than as a pupil, and it is thus significant that the documents use the same wording—"*sta cho' llui*"—in the references to payments to Bartolomeo di Giovanni on behalf of Filippo Lippi.[62] Boccati and Giovanni Angelo d'Antonio were not trained in Florence, but they went there as journeymen to seek their fortune. The attempt to attribute to Giovanni d'Antonio the mysterious fresco of *Saint Ansanus* in San Niccolò Oltrarno[63] is justified by imagining his early style as combining elements from his training in his native region with features of the Late Gothic.

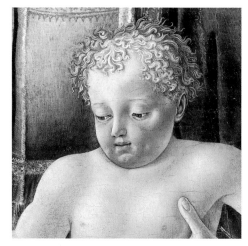

20.

If Piero della Francesca traveled to Florence, it was perhaps with the encouragement of his mediocre master Anghiari, for the latter must have absorbed some of the latest trends in Florence during the 1420s, when he was part of the circle of minor painters such as Francesco d'Antonio or Paolo Schiavo; this influence is further suggested by a fresco attributed to Antonio, recently discovered in Falcigiano, in the upper Tiber Valley.[64] Bartolomeo di Giovanni Corradini probably maintained a friendship with Giovanni Boccati and moved in the same circles, for the two shared certain stylistic traits that connect their early works to the youthful output of such hard-to-classify painters as the Pratovecchio Master. In the mid-1440s, a sort of "gang" of unorthodox Lippi followers emerged, composed of Florentine "outsiders" as well as Marchigians.[65]

In the absence of other secure information, the documents linking Boccati (1443) and Bartolomeo di Giovanni (1445–46) to Filippo Lippi in Florence serve the useful function of dating the earliest, still-debated works by the anonymous artist called by Roberto Longhi the Pratovecchio Master. His identification, first with young Giovanni di Francesco and then with the Lippi-Pesellino imitator Jacopo d'Antonio[66]—who was documented in 1451 as the painter of seraphim in the reframed Badia altarpiece by Giotto—is not at all satisfactory.[67]

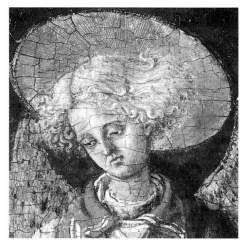

21.

His earliest paintings, and in particular the enchanting little panel with the *Three Archangels* in Berlin (cat. 10), which first inspired Longhi to give this anonymous artist a name, seem rather to elucidate themselves through a close association with the Marchigian painter Fra Carnevale, active in Florence in 1445–46 in the workshop of Filippo Lippi. There is a similar response to the art of Lippi, evident in the head of the archangel Gabriel, a response engendered by the new world of Domenico Veneziano, subtly deformed and softened by handling that seems composed of congealed brushstrokes of light. The full heads of bright, blond, disheveled hair of the *Three Archangels*, and their melancholy facial features, recur in the *Virgin and Child with Angels* in the Pierpont Morgan Library (cat. 13) and the *Madonna* in the Fogg Art Museum (cat. 11), works that, before Longhi's essay, were all attributed to the Marchigian painter Giovanni Boccati, whose training should in fact be understood as parallel to that of

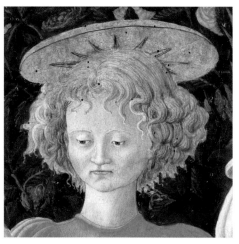

22.

20.
The Pratovecchio Master,
Madonna and Child, detail.
Fogg Art Museum,
Harvard University Art Museums,
Cambridge, Massachusetts

21.
The Pratovecchio Master,
The Three Archangels, detail.
Staatliche Museen, Berlin

22.
Giovanni di Piermatteo Boccati,
*Madonna and Child with Angels
and Saints (Pergolato Altarpiece),* detail.
Galleria Nazionale dell'Umbria, Perugia

Fra Carnevale (fig. 20–22). Fredericksen fully endorsed these works as by the latter, following the attribution of the *Madonna* at Cambridge already proposed by Richter[68] and Ragghianti.[69]

The stylistic affinities between Boccati and Fra Carnevale are also clear in their treatment of landscape (fig. 23, 24). The early work of the former—the *Adoration of the Magi* in Helsinki and the predella of the *Pergolato Altarpiece* (cat. 30), in which the aerial views of field-dotted hills and bays with sailing ships are borrowed variously from Domenico Veneziano and Jan van Eyck—are especially relevant for the vivid passages of landscape by Fra Carnevale in the *Crucified Christ* (cat. 41 B), the *Annunciation* (cat. 40), and even the *Birth of the Virgin* (cat. 45 A). A separate element, the streaked cirrus clouds, is taken directly from Piero and then intricately and imaginatively reworked.

The connection with the two painters from Camerino may also help to explain more plausibly that generically "Paduan" quality invoked by several scholars in discussing the work of the Master of the Barberini Panels. Offner saw the master's sculptural obsession as a slightly vague North Italian quality, evoking the Padua of Mantegna and the Ferrara of Francesco del Cossa, and he remarked on the assimilation of natural phenomena—on the fidelity "to some ideal and type of durability, like stone or metal"[70]—in terms similar to those used earlier by Berenson and Longhi on the subject of the Ferrarese school. The Master of the Barberini Panels, who for Offner was literally "more than an eclectic; he was a nomad," had no specific or known contact with Padua and Ferrara—notwithstanding the fact that the Barberini Panels had been attributed to

23.
Giovanni de Piermatteo Boccati,
The Road to Calvary (predella from
the *Pergolato Altarpiece*), detail.
Galleria Nazionale dell'Umbria, Perugia

24.
Fra Carnevale,
The Birth of the Virgin, detail.
The Metropolitan Museum of Art, New York

Marco Zoppo by Cavalcaselle,[71] who also had ascribed to Zoppo Fra Carnevale's *Portrait of a Man* in Vienna (later restored to him by Benati)[72]—a work that recalls the powerful realism of Cossa. As ably pointed out by Zeri, the Master of the Barberini Panels was not unaware of the extraordinary culture that emerged about 1450 in the Venetian city—with the art of Donatello, Pizzolo, and Mantegna—but he experienced it indirectly, through his connections with the slightly older Camerino painters Giovanni Boccati and Giovanni Angelo d'Antonio.

Thus, while Fra Carnevale did not experience Paduan art at firsthand, his return to the Marches between 1446 and 1449, when he took his vows and entered the Dominican convent in Urbino, did, indeed, play a decisive role in the development of his pictorial language, in a way that was considerably different from how it would have evolved in Florence had he remained in the close circle of Filippo Lippi. The expressionism of the saints and of the crucified Christ in the Franciscan polyptych (cat. 41 A, D) represents a disconcerting facet of his career, but a crucial one in attempting to define his anomalous artistic personality. The impetuously sculptural approach responsible for the deeply hollowed eye sockets of the Baptist and of Saint Peter, and for the treatment of the flesh, whose surfaces are outlined by the light reflected in shadow, cannot be explained as the achievement of Domenico Veneziano alone. It also reflects Giovanni Angelo d'Antonio's works from his Paduan period, when he was strongly influenced by the painter and modeler Nicolò Pizzolo, as in the harsh and troubling *Crucifixion* in Castel San Venanzio, for which Giovanni received payment in 1452.[73] The agitated suffering registered on the face of Fra Carnevale's *Saint Francis* echoes the pained expressions of the figures crowded in the lunette of the Spermento altarpiece (fig. 25, 26), their skin drawn tautly over their bony features, as in that of the Virgin, whose anxiety is revealed by her fleshy lips, half open like those of the little angels. Before Offner and Zeri restored these expressive, almost overworked, and strange works to the Master of the Barberini Panels, the later Marchigian painters Ludovico Urbani and Nicola di Maestro Antonio were also considered as their author.

The treatment of the draperies, consisting of deep folds and cavities, as though they were conceived as embossed metal sheets, is the same as in the Barberini Panels, but there one would be hard pressed to find passages of such raw and pitiless realism. The composition, too—for all the sophistication of the figures set against slender molded niches and marble floors (echoes of Filippo Lippi)—displays little regard for perspective, especially as these same figures appear almost crushed between the wall and the foreground. Despite the suggestion of a marine background behind the solitary figure of Christ, the painted rocks against which he stands are unquestionably two dimensional, their spatial irregularities accentuated by the two trees, representing good and evil and symbolic of Redemption in the Middle Ages. Zeri attempted to justify the anomalous character of these panels by placing them at the end of the painter's career, after the execution of the Barberini Panels. The rediscovery of an unfinished but fundamental work—the mythological picture in the Cagnola collection at Gazzada (cat. 44), with its ambitious rendering of architecture and sculpture—should, however, demonstrate that Fra Carnevale was moving in quite another direction during the 1470s, and that a plausible context for the

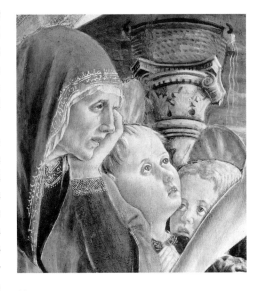

25.
Giovanni Angelo d'Antonio,
The Lamentation, detail. Pinacoteca e Museo
Civici di San Domenico, Camerino

26.
Fra Carnevale,
Saint Francis, detail.
Pinacoteca Ambrosiana, Milan

27.
Antonio da Fabriano,
Saint Jerome in His Study, detail.
The Walters Art Museum, Baltimore

28.
Fra Carnevale,
Saint Francis, detail.
Pinacoteca Ambrosiana, Milan

29.
Fra Carnevale,
Saint John the Baptist, detail.
Museo della Santa Casa, Loreto

30.
Fra Carnevale,
Saint Peter, detail.
Pinacoteca di Brera, Milan

Franciscan polyptych in the Marches only existed during the 1450s. We have already discussed similarities with the most powerful works by Giovanni Angelo d'Antonio, whose painting becomes more majestic and refined toward 1460 after increasing exposure to the luminous, geometric style of Piero della Francesca, its development perfectly paralleling the course followed by Fra Carnevale. Previtali suggested as an alternative an attribution of these panels to Giovanni di Piamonte, who assisted Piero on the fresco cycle of the *Legend of the True Cross* in Arezzo and is the author of an altarpiece in Santa Maria delle Grazie, in Città di Castello, dated 1456.[74] This proposal, based on a comparison of the angularity of the drapery and the peasant-like veracity of the figures' veiny hands, was simply wrong, but it did recognize a common point of departure.

A far more persuasive connection can be established with a painting by Antonio da Fabriano: his unsurpassed masterpiece, the *Saint Jerome in His Study* (cat. 36) in Baltimore, dated to 1451. The compositional idiom of this picture may be traced back to van Eyck, just as Fra Carnevale's saints are grounded in the pictorial language of Filippo Lippi—as is proven merely by a consideration of the contrasting style of drapery. Proof of the innovations that Antonio encountered when he returned to the Marches is found in the emphasis on spatial construction, with rooms receding in depth, despite the use of two,

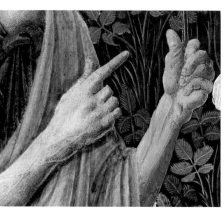

27.

28.

29.

30.

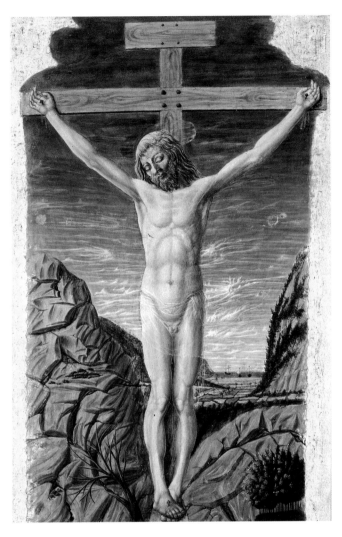

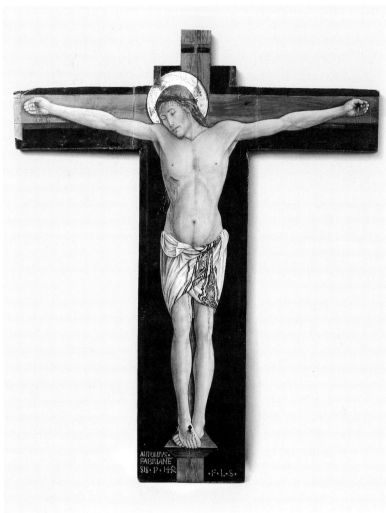

31.
Fra Carnevale,
The Crucifixion.
Galleria Nazionale delle Marche, Urbino

32.
Antonio da Fabriano,
Crucifix.
Museo Piersanti, Matelica

mutually contradictory vanishing points. Antonio had assimilated a taste for soft light from Flemish painting and from Donato de' Bardi—it quietly pervades his interiors, revealing even the most humble objects—but also for surface truth: his *Saint Jerome,* a forbidding, wrinkled old man is a worthy companion to the startled *Saint Peter* in the Brera. The delicate sheen of Antonio's grayish flesh tones is not to be found in Fra Carnevale's work, nor is the subdued and hesitant demeanor of his figures; possessed of a different approach to expressivity and his own sense of form, he was governed by altogether independent ambitions. His style is all the more striking for the strong contrast that emerged in the works of the two painters about 1451, when Fra Carnevale was certainly in Urbino and the influences were no doubt reciprocal. One need look no further for evidence of this than in the unforgettable depictions of arthritic hands by both artists (fig. 27–30).

Contact between Antonio da Fabriano and Fra Carnevale would not be implausible if one could demonstrate that the Franciscan polyptych were painted for Cagli, not far from Gubbio and Fabriano—especially since Antonio, who usually confined his work to the towns of Matelica, Genga, or Gualdo Tadino, was active in Urbino as well. It was for the church of Sant'Angiolino in Altavilla, a suburb of the city, that he painted the recently discovered crucifix (Museo Diocesano "Albani," Urbino), dating to the 1450s.[75] Antonio depicts the loincloth as a transparent veil, but does not go so far as to describe the genitals, as in the remarkable panel by Fra Carnevale.[76] A comparison for the figure type and for the unusual way in which the body is aligned is provided by another painted cross by Antonio in Matelica (in far better condition), which bears the date 1452 (fig. 31, 32). Here, the Fabriano master must have had in mind the noble, erect figure painted by Donato de' Bardi in Savona—a work also cited by Offner,[77] who could not have suspected the existence of a possibly mediating influence from the Marches. All three artists employ the neo-Giottesque motif of showing Christ with one foot crossed over the other and pointing inward.

The Franciscan polyptych and the Washington *Annunciation* (cat. 40) obviously represent two quite distinct moments in Fra Carnevale's development. The homage to Lippi is clear in the archangel and in the tall stem of lilies, and Fra Carnevale seems to have had precise knowledge as well of the *Annunciation* (fig. 5, p. 43) originally painted for the convent of Le Murate—a work recorded in the same Sant'Ambrogio account book with the mention of a payment on April 16, 1445. Further homage is evinced by the pose of the Virgin and by the angel's outspread blue wings edged in gold, even if the painter forsakes the charming peacock's eyes. In contrast to the complicated treatment of space in Lippi's painting, where the composition becomes fragmented by the competing planes, the proscenium, the *hortus conclusus,* and the various arches, enclosures, parapets, and architraves, Fra Carnevale's figures stand out against a serene city composed of pure, neatly arranged volumes enclosed within stuccoed walls, with precipitously foreshortened façades, arcades resting on simple piers without moldings or capitals, needle-like projections of shadow, and a tessellated pavement that recedes into space with the clarity of a perspective grid—evoking the actual, earlier and more Piero-like inlaid wood flooring by the brothers Cristoforo and Lorenzo Canozi da Lendinara (documented 1449-88),[78] renowned from Padua to Lucca, for their skill in this field.

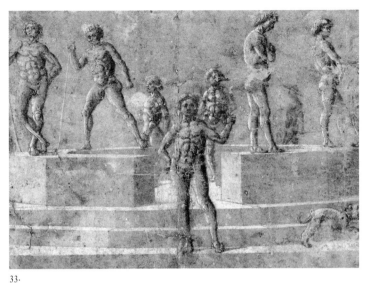

33.

34.

That Fra Carnevale was indulging his infatuation with the culture of perspective—inspired specifically by Piero—is proven by the study for the base of a hexagonal well-head, incised into the ground of the painting at the level of the archangel's shoulder but subsequently left incomplete (fig. 33).[79] The artist probably intended to depict the divine messenger and the Virgin in close proximity, as in Lippi's *Annunciation* in San Lorenzo, but then revised the composition, moving the archangel to the left and filling the void with the vase of roses.[80] The sharply foreshortened hexagonal form would have stood out in the telescoped space leading beyond the city gate out into the distant landscape, evoking the *Annunciation* (The Fitzwilliam Museum, Cambridge) by Domenico Veneziano from the predella of the *Saint Lucy Altarpiece*, but for similar studies of polyhedra one immediately thinks of Piero—an association that would be unthinkable for the Franciscan polyptych. Such motifs were explored by Piero in drawings for his treatise *De prospectiva pingendi* (fig. 37)[81] and were subsequently popularized in the inlaid woodwork of the Canozi (fig. 36) as well as in illuminated miniatures, such as the 1458 illustration (fig. 35)—for a codex of works by Euclid and Ptolemy—of a city scene with a polygonal well in the middle (the volume belonged to a fellow citizen from Piero's native Sansepolcro, the architect Francesco del Borgo).[82] Offner, who was the first to remark that the same hand was responsible for the Washington *Annunciation* and the Barberini Panels, recognized the extent of Lippi's influence in the former while noting the "increasing infiltration of north-Italian elements" in the latter. He therefore dated the *Annunciation* to about 1450, believing it was executed in Florence. This interpretation had a certain validity for both Meiss and Zeri, which prompted the Italian scholar to add to the artist's oeuvre yet another *Annunciation,* painted for Jacques Coeur (cat. 19), which, although it does not resemble the Washington picture in any detail, must date to about 1450 as well.

I believe that, notwithstanding its nineteenth-century Strozzi provenance (and in contrast to the conclusions reached by other authors in this catalogue), the Washington

33.
Fra Carnevale,
Allegorical Scene, detail.
Nationalmuseum, Stockholm

34.
Fra Carnevale,
The Annunciation, detail.
National Gallery of Art, Washington, D.C.

35.
Miniaturist from the circle of
Piero della Francesca,
City View with Well (Euclid, *Optica;*
Ptolemy, *Libellus de iis quae in caelo
aspiciuntur; De algebra et almuchabala),*
folio 1 r. Biblioteca Apostolica Vaticana,
Vatican City, ms. Urb. lat. 1329

36.
Cristoforo Canozi da Lendinara,
Fountain. Intarsia panel from the
choir stalls, Parma Cathedral

37.
Piero della Francesca,
De prospectiva pingendi,
Book II, §VI. Biblioteca Palatina,
Parma, ms. 1576

Annunciation was not painted in Florence, and that not only is it closer to the Barberini Panels than they are to the Franciscan polyptych, it is more likely to date to about 1460. The spatial recession in this perspective view of the countryside, with a winding river and the path that crosses it, is rendered with loose but precisely orchestrated brushwork, and displays an awareness of Piero's *Saint Jerome* of 1450, in Berlin—a painting well known in the Marches, as it was freely copied by Nicola di Maestro Antonio da Ancona in a lunette now in the Galleria Sabauda, Turin. The homage to Lippi is obvious, as in the pair of panels from Santa Maria della Bella. It is to Offner's credit that he was perceptive enough to recognize that the specific detail of the profile and headdress of the woman at the extreme left in the *Birth of the Virgin* came twenty years after the crowned Virgin in the Sant'Ambrogio altarpiece (fig. 38, 39), and that its source undoubtedly was a drawing.[83] Yet Offner was unaware that the artist was a documented participant in that very work by Lippi! Conversely, the architectural and city views that Fra Carnevale included in the backgrounds of his works were completely unrelated to Lippi's pictorial language and, instead, took as their point of departure the idealized worlds of Alberti and of Piero; this can best be explained by the gradual maturation of his artistic style after his return to Urbino. Engaged in significant building and sculptural projects arising from Federigo's rivalry with the Tempio Malatestiano in Rimini, such as the construction of the marble façade of San Domenico and the decoration of the Sala della Iole, Fra Carnevale responded directly to Piero's influence, which peaked during the 1460s, and also affected other Marchigians such as Giovanni Boccati and, above all, Giovanni Angelo d'Antonio da Camerino.

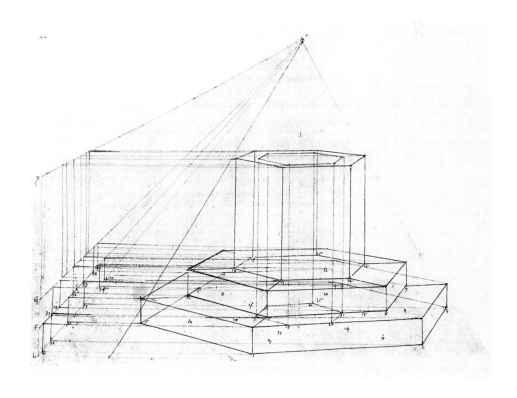

I have focused on the impact of Marchigian painting in order to explain the expression-
ism and harsh physicality of the saints in Fra Carnevale's Franciscan polyptych, invoking the
artist's contacts with Antonio da Fabriano and Giovanni Angelo da Camerino, but the pro-
found influence of Filippo Lippi on the *Saint Peter* (fig. 43)—specifically, on the impetuous
drawing of the figure's prominent features—should not be underestimated. Also comparable,
for example, is an acutely foreshortened *Head of a Monk* (fig. 42)—his face, with its tightly
pursed lips and sharp nose drawn in silverpoint and white lead on yellow ocher prepared
paper—which I believe should be attributed to Lippi, contemporary with his Prato fres-
coes.[84] Another Florentine source, secondary but no less important, for the saints in the
Franciscan polyptych is Domenico Veneziano's *Saint Lucy Altarpiece* of the mid-1440s: the
way in which the high cheekbones and the eye sockets are delineated under the skin, so
striking in the Loreto *Baptist,* implies a knowledge of Donatello as filtered through
Domenico Veneziano (fig. 40, 41). Not only did Lippi and Veneziano leave their mark on
Giovanni Angelo d'Antonio and Giovanni Boccati but contact with these eccentric
Marchigians can also probably help to explain the individuality of the evolving style of the
Pratovecchio Master, who must have crossed paths with Boccati as well as with Fra
Carnevale.

Another painter who seems to have encountered Bartolomeo di Giovanni at the
time that he frequented Lippi's workshop in Florence in 1445–46 was the Master of the
Castello Nativity. This artist was trained in Lippi's circle, and for a number of years
codified an attractively decorative idiom, somewhat stereoptypical, but with subtle linear
qualities and a diffused light, indicating that his style, too, was evolving in the same direc-
tion as those of Fra Carnevale and the Pratovecchio Master during the mid-1440s.[85]
Problems are posed by some paintings that might represent the early phase of the Master
of the Castello Nativity but that also have been attributed to the Master of the Barberini
Panels or, in any case, display strong affinities with his style. Such a work is the Munich
Annunciation (cat. 19), rich in details, its figures set among sumptuous marble inlays and
wood carvings, bronze grates, carpets, and green and crimson velvets, but whose domestic
interiors and landscape are redolent of Fra Angelico. In the secure works by the Master of
the Barberini Panels, to whom the Munich *Annunciation* was attributed by Zeri,[86] as an
example of his possible Florentine beginnings, there is not a trace, however, of Angelico's
distinctive style. This altarpiece was commissioned by Jacques Coeur—an intimate of
King Charles VII of France—who was disgraced in 1454 and then exiled to the island of
Chios. If, as Christiansen once suggested, the commission dates to Jacques Coeur's jour-
ney to Rome in 1448,[87] it is likely that the work was painted by a Florentine artist con-
nected with Angelico, who was working for Pope Nicholas V (but see the different dating
suggested in the catalogue entry). The picture's presence in the current exhibition along-
side the paintings of Fra Carnevale will provide an opportunity to consider the validity of
this attribution. The relationship with the Master of the Castello Nativity is even more
clearly demonstrable in the *Madonna and Child* in Hannover (cat. 7), where the draperies—
devoid of the metallic embossing typical of Corradini—consist of gently gathered folds
of material and transparent veils, with gilded and dotted borders (a Lippi motif not found
in the work of Fra Carnevale). The melancholy expression of the Christ Child's plump

38.
Filippo Lippi,
The Coronation of the Virgin, detail.
Galleria degli Uffizi, Florence

39.
Fra Carnevale,
The Birth of the Virgin, detail.
The Metropolitan Museum of Art, New York

40.
Fra Carnevale,
Saint John the Baptist, detail.
Museo della Santa Casa, Loreto

41.
Domenico Veneziano,
Saint John the Baptist, from the
Saint Lucy Altarpiece, detail.
Galleria degli Uffizi, Florence

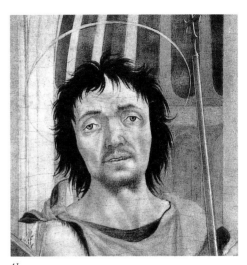

40. 41.

face and the angled eyebrows recall those of the putti in the Faltugnano altarpiece (ill., p. 160), the Master of the Castello Nativity's masterpiece in Prato.[88]

If we begin with the Franciscan polyptych in reconstructing Bartolomeo di Giovanni's Florentine, Lippesque phase, I continue to believe that a more persuasive proposal for his early work is that of Bellosi,[89] who supported the attribution of the predella of Lippi's *Annunciation* in the Martelli Chapel in San Lorenzo, with its scenes from the life of Saint Nicholas, and of two panels in the Musée Condé, Chantilly, to the Urbino painter. In particular, I am convinced that his Florentine output included the Uffizi drawing on reddish-colored prepared paper of *A Woman and a Kneeling Monk* (cat. 16), which could further such a comparison. The monk is taken from the Sant'Ambrogio *Coronation of the Virgin,* on which Fra Carnevale was a documented collaborator, but is reworked as a kneeling figure: Lippi's skillfully nuanced drapery folds here become complicated by the depiction of hooked loops and indentations, carved out by the light entering from the side, flattening the surface, and producing a metallic effect exactly like that seen in the drapery of the *Saint Peter* in the Brera and the *Saint Francis* in the Ambrosiana. The monk and the female figure in profile, wearing a long, trailing robe, make for an intriguing combination; she is the prototype for the woman solemnly advancing, her hands folded in front of her, at the extreme right of the *Birth of the Virgin* in the Metropolitan Museum.

There is a similar sensitivity in rendering bodies under the *"piegar de' panni,"* as if they were shallow reliefs, in three studies on blue-tinted paper in the Nationalmuseum, Stockholm (fig. 44), which Vasari believed were by Paolo Uccello and Christiansen has correctly attributed to Fra Carnevale.[90] The drawings represent an impudent-looking youth posing as David; another more hesitant one, his right arm akimbo; and a third seated on a stool, leaning his elbow on a parapet. These studies were all taken from life, in the workshop, and adhere to a genre that flourished in Florence—notably, in the versatile pen-and-ink and wash drawings by Maso Finiguerra. To these studies, which show how deeply rooted Bartolomeo di Giovanni's Florentine culture was, we can relate a closely connected fourth, also in Stockholm, representing an Eros about to shoot an arrow and a

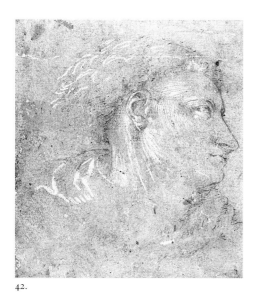

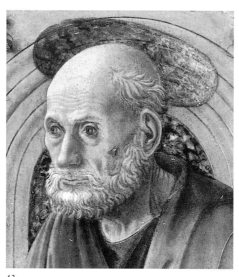

42.

43.

42.
Attributed to Filippo Lippi,
Head of a Monk.
Gabinetto Disegni e Stampe,
Galleria degli Uffizi, Florence

43.
Fra Carnevale,
Saint Peter, detail.
Pinacoteca di Brera, Milan

putto holding festoons (fig. 45);[91] it was also collected by Vasari and mounted in his album, under the name of Paolo Uccello. The pen-and-ink and wash technique is different, but the dry treatment of anatomy and the nervous line can easily be compared with those of the fictive reliefs in the Barberini Panels, while the sharp features of the plump face and the unruly head of hair of the putto with festoons are rather like the winged masks along the frieze in the *Birth of the Virgin.* This little sprite stands on an upturned mollusk shell and is flanked by two baluster volutes, one of Lippi's favored motifs that was also imitated by Giovanni Angelo d'Antonio in his earliest works, and which reappears, likewise coupled with a shell, on the arms of the throne in the Maringhi *Coronation of the Virgin* (fig. 46), on which the young painter from Urbino collaborated. Conversely, the fluttering cloak seems to presuppose a not-uninspired archaeological model (as in the bacchic reliefs in the New York panel), and it is possible that Fra Carnevale was freely inspired by the putti in the *Throne of Neptune,* then in San Vitale, Ravenna—an ancient work well known to many artists of the Quattrocento, from Pisanello to Donatello.

No less interesting is another sheet in the Swedish national collection: a study of figures variously arranged around a dodecagonal polyhedron (fig. 33).Vasari ascribed the work to Dello Delli, but it has now rightly been attributed to the Master of the Barberini Panels by Peter Meller and Jeanne Hokin.[92] Here, too, the strongly lateral light source is emphasized by the white lead on the sky-blue tinted paper, with the modeling in shallow relief.This drawing is helpful in reading the Barberini Panels themselves: the latter underscore "the principles for variety and antithesis which characterize the drawing in Stockholm."[93] An advanced exercise in formalism, it seems to unite the Florentine tradition of figure studies with a strictly perspectival approach to composition.With regard to the first of these aspects, the sensitive treatment of light specifically evokes a series of drawings (see cat. 26 A–C) once believed to be by Domenico Veneziano but that Bellosi has instead ascribed to Luca della Robbia—an artist whom Fra Carnevale knew well, as indicated by his significant involvement in the work on the portal of San Domenico in Urbino.

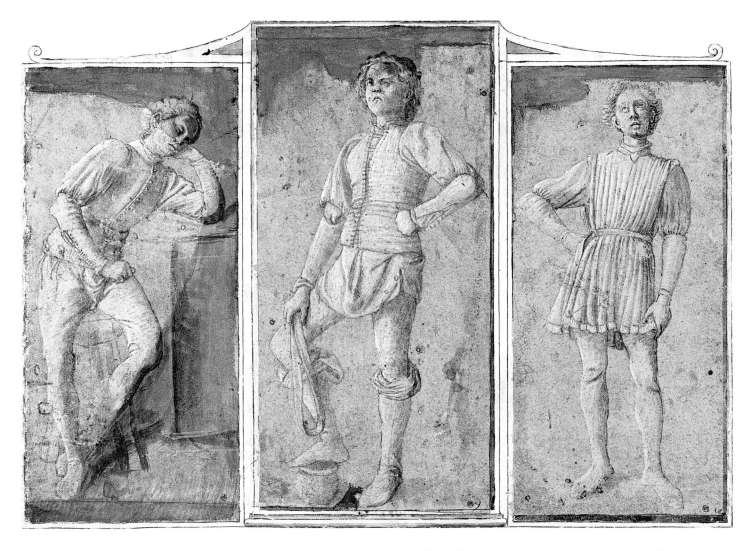

44.
Fra Carnevale,
Study of David (center) and
Two Figure Studies (left and right).
Nationalmuseum, Stockholm

As to the second quality, an unlikely feature in any Florentine painter other than Domenico Veneziano, one has to presume an association with the investigations carried out by Piero della Francesca, fully realized in the drawings for the *De prospectiva pingendi,* and that connection may be established with the unfinished wellhead incised in the ground of the Washington *Annunciation.*

The *Heroic Figure Against an Architectural Backdrop* in the Cagnola collection at Gazzada (cat. 44)—unfairly underrated until now, when it has been restored for the present exhibition, and is discussed here by Matteo Ceriana—presents even more intricate problems in the wake of such works as the drawing of polyhedra and figures in Stockholm, and touches on the thorny question of Donato Bramante (1444–1514) and his putative study with Fra Carnevale, mentioned by Vasari.[94] Like the London *Nativity* by Piero della Francesca (fig. 3, p. 26), this mysteriously incomplete panel is emblematic. About 1480 Fra Carnevale seems to have faded into the background in an Urbino dominated by

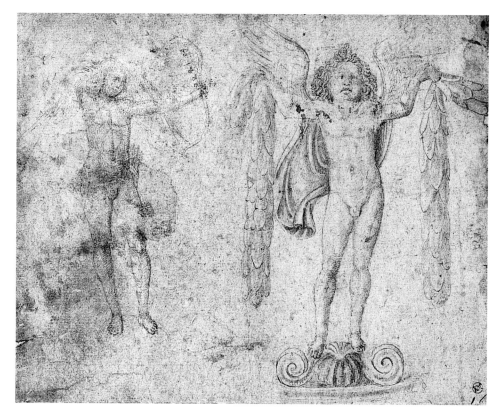

45.
Fra Carnevale,
Studies of Cupid and a Putto.
Nationalmuseum, Stockholm

46.
Filippo Lippi,
The Coronation of the Virgin, detail.
Galleria degli Uffizi, Florence

the Sienese Francesco di Giorgio, just as the great Sansepolcro master withdrew from the scene in his final years. The so-called "ideal cities," now divided between Urbino, Berlin, and Baltimore, no longer have anything to do with his world or with the idea of a "*pittura di luce,*" in which the architecture is never an end in itself but a constituent element of the variety of motifs that comprise the Albertian "*istoria.*" Even if these panels are its heirs, in one sense, and if, in the Urbino palace inventory of 1599, one of them was ascribed to Fra Carnevale,[95] it is only evidence of the birth of an Urbino myth—as outlined in this catalogue by Emanuela Daffra. In light of a work of such notably high quality as the processional standard for the confraternity of Saint John the Baptist, with the *Baptism of Christ* and *Saint John Preaching*—which I believe should be attributed to Giovanni Santi (about 1440/45–194) at the beginning of his career—we can see that Fra Carnevale may still have had something to communicate to a resourceful young man in Urbino in the artistically tumultuous 1470s. Santi was the son of a gilder, who had moved into town from the *contado,* and who accompanied Piero della Francesca to Urbino in 1469. However, he made no mention of the Dominican painter in his *Cronaca rimata,* and, instead, fell under the influence of the sparkling formal elegance and the material preciosity epitomized by Verrocchio's Umbrian legacy—a style of painting that developed around the irresistibly charismatic Pietro Perugino and the scenes from the life of Saint Bernardino, of 1473 (Galleria Nazionale dell'Umbria, Perugia).

1. Some idea of this appears in the slightly paradoxical essays by Creighton Gilbert (1993; 2000), who interprets these as scenes of hospital life; see also the doubts raised by Alessandro Conti (in De Angelis and Conti 1976).

2. See the documentary appendix by Mazzalupi, doc. 20.

3. See the documentary appendix by Di Lorenzo.

4. See the documentary appendix by Mazzalupi, doc. 39.

5. Offner 1939, pp. 209–10.

6. See Warburg 1914 (1966 ed.), pp. 286, 290–92, for an unpublished assessment of Piero, who opposed "un'invincibile resistenza all'irruzione dello stile patetico," applied himself to the study of light like the Northern masters, and struggled "contro la retorica romana della mimica." Warburg (1922) perceives behind the Constantine of the Arezzo frescoes John VIII Paleologus, who, however, "parla senza gesti archeologico-eroici"; see Agosti and Farinella 1984, pp. 435–37.

7. Bonfigli drew a regular salary of seven ducats a month as an employee of Pope Nicholas V between January 18 and May 14, 1450 (Mazzerioli in Mancini 1992, p. 151, docs. 7–9).

8. Venice, Galleria dell'Accademia, no. 91.

9. Offner 1939, pp. 234–36.

10. Ibid. While the foliate motif is strictly Venetian in origin, there are numerous surviving examples from the second half of the fourteenth century especially among works created for a provincial setting beyond Venice (as at Sant'Arcangelo di Romagna, Velo d'Astico). It is significant that by 1444 or thereabouts the crockets of the polyptych by Antonio Vivarini and Giovanni d'Alemagna for the Venetian church of San Zaccaria were not pierced but carved in relief. In the Marches lateral foliate crockets were superseded—as, for example, in Boccati's polyptych of 1468 for Belforte sul Chienti—by structures that could be fitted into a *capsa* within the chapel, and therefore had unfinished sides.

11. See Braudel 1949 (1953 ed.), p. 127.

12. Zeri 1961 (2000 ed.), pp. 157, 164. Respectively, the triptych by Giovanni Antonio da Pesaro in the Museo di Palazzo Venezia, Rome (Berardi 1988, pp. 142–44), the altarpiece by Paolo da Visso for San Domenico, Ascoli Piceno and now in the Pinacoteca Civica there (Venanzangeli 1993, pp. 112–15), and the polyptych from the Abbey of Sant'Eutizio, Preci, now in the Pinacoteca Comunale, Spoleto, subsequently recognized by Bellosi as a work by Nicola di Ulisse da Siena, the attribution of which was confirmed by a later transcription of the signature "*opus Nicolai*" and the date 1472 (Cordella 1992).

13. Inv. MBA 97.

14. See Gombrich 1976, pp. 3–35.

15. Alberti 1435, vol. 2, p. 46; 1975 ed., p. 82.

16. Ibid., p. 49; 1975 ed., p. 88.

17. Parronchi 1962.

18. Bellosi 1990a.

19. Pius II [prior to 1464], 1984 ed., pp. 366–67.

20. See Di Stefano and Cicconi 2002, p. 455, doc. 71.

21. See De Marchi 1996a, pp. 62–66; Franco 1998, p. 120; Rearick 2002.

22. See Di Lorenzo 2002, pp. 309–19.

23. See De Marchi 2002b, pp. 95–96 n. 242.

24. For a discussion of the relationship between Giovanni Angelo d'Antonio and Nicolò Pizzolo, which also involved Ansuino da Forlì, see ibid., pp. 52–59 (and fig. 50–59), as well as the photographic comparisons in Mazzalupi 2003b, fig. 39–40. To this group of "Flemish-style" still-life details by Justus von Ravensburg, Antonio da Fabriano, Nicolò Pizzolo, Giovanni Angelo, and Bartolomeo Corradini, I would add a startling detail from the *Annunciation* in the Musée du Petit Palais, Paris (Laclotte and Mognetti 1976, no. 48; the fictive paper unfortunately bears only a simulated inscription), a work almost entirely ignored in Perugian bibliographies of the last decades but that represents the absolute masterpiece of a painter usually identified (with good reason, I believe) as the young Bartolomeo Caporali. The painting, listed in the Campana collection catalogue of 1858 as by Benedetto Bonfigli, was reassigned to the young Caporali by Roberto Longhi. In contrast, Bellosi attributes the picture to Benozzo Gozzoli, which has its share of truth: while the execution is perfectly consistent with such works as the *Saint Jerome* in the Museo Nazionale di Capodimonte, Naples, and the *Virgin and Child with Angels* in the Galleria Nazionale dell'Umbria, Perugia, it is nonetheless true that the composition and design—obvious, in the drapery of the angel—are too close to Benozzo not to be based on a cartoon by him; this would suggest a date of about 1456 for the *Annunciation,* when Benozzo was working in Perugia on the Sapienza Nuova altarpiece and also provided a drawing (still extant) that was used by Bonfigli for his fresco of *Attila Taking Perugia* in the Palazzo dei Priori, Perugia, painted immediately after 1461 (Melli 2000).

25. Zeri 1961.

26. Conti in De Angelis and Conti 1976.

27. Christiansen 1979.

28. *De Marchi* and Giannatiempo López 2002.

29. Berenson 1907.

30. See Di Stefano and Cicconi 2002, p. 455, doc. 77.

31. See Mazzalupi 2003b.

32. Di Lorenzo 2002, pp. 294–98.

33. For example, in order to paint his *Madonna of the Orchestra,* Giovanni Boccati must have seen Mantegna's *Martyrdom of Saint Christopher* (Minardi 2002, p. 216), and yet we now know that both he and Giovanni Angelo d'Antonio were present at the wedding of Giulio Cesare da Varano and Giovanna Malatesta on May 12, 1451, as attested by a manuscript cited by Lilii as well (Biblioteca Valentiniana, Camerino, ms. 144, folios 124v, 125r, where, among those mentioned in the "lista de homini da convitare del terzero di Mezzo" are "magistro Io[anni] da Bolognola" and "Io[anni] di Piermattheo d'Antonio d'Andruccio"; this reference, identified

by Matteo Mazzalupi, is in addition to the documents assembled in Di Stefano and Cicconi 2002). The activity dates for Boccati used in this catalogue (April 19, 1440–June 2, 1486) are based on recent archival findings by Cicconi and Mazzalupi (Archivio di Stato di Camerino, natarile: *notaio* Vannucci di Matteuccio, fols. 161v–162r; *notaio* Antonio di Pascuccio, fols. 72r–74v.

34. This is instructive, too, in the case of the Lucchese painter Michele Ciampanti, the so-called Stratonice Master, whose trips to Siena and Florence, proven by specific works and not merely by obvious points of stylistic influence, have to be considered along with his documented presence in his native Lucca in 1463, 1464, 1467 (in Pisa), 1469, 1470, 1472, 1473, 1474, 1476, 1478, and so on.

35. See De Marchi in *De Marchi* 2002a, pp. 230–33.

36. Ibid., pp. 302–3.

37. See Di Stefano and Cicconi 2002, p. 453, doc. 56 (transcribed by Andrea Di Lorenzo).

38. See the documentary appendix by Di Lorenzo.

39. Ibid. Subsequent payments on April 29, May 29, and June 18, 1445, are for transportation costs and customs charges imposed on items Bartolomeo brought from Urbino, evidently indicating that the artist had just moved and was intending to remain in Florence for some time.

40. See Dal Poggetto 1991 (although he erroneously identifies the married couple in the series of Heroes).

41. Caglioti 1994; Marcelli in De Marchi 2002a, p. 262. Moreover, Marcelli favors a slightly later dating, immediately after 1462, arguing that 1460–62 is less likely because of Federigo's constant travels. As is known, it was in the Camera Picta that the contention between Francesco Laurana and Giorgio da Como was resolved in 1467.

42. For documentation see Di Stefano and Cicconi 2002, pp. 457, 459, docs. 106, 107, 122; Coltrinari 2004, pp. 88–91, 135–37, doc. 37. As clarified by Mazzalupi (2003, p. 28), the Vincenzo di Pasqua documented in relation to this altarpiece in 1458 was, in fact, a woodworker. On these paintings see Minardi in De Marchi 2002a, pp. 245–56, with an earlier dating of about 1450–56. The connection with the later polyptych for Tolentino (De Marchi 2002b, pp. 61–62) has been confirmed by Matteo Mazzalupi (2003, p. 28) as a result of the identification of the Blessed Tommaso da Tolentino with the spuriously named "Giovanni de Prato" of the panel in the Pinacoteca Vaticana, and also supported by a reference in a 1748 inventory of the church of San Francesco.

43. See Di Stefano and Cicconi 2002, p. 454, doc. 64 (transcribed by Minardi).

44. Ibid., p. 455, doc. 68.

45. Ibid. p. 459, doc. 122 (called to my attention by G. Semmoloni).

46. For an early dating, see Rotondi 1950, p. 403; Dal Poggetto in Dal Poggetto 1992a, pp. 309–13; and the conclusions by Matteo Ceriana in the present catalogue.

47. See the documentary appendix by Mazzalupi, doc. 9.

48. Middeldorf 1978.

49. See the documentary appendix by Mazzalupi, doc. 8.

50. The earliest secure record of this occurs on December 9, 1449, when Maso di Bartolomeo declares that he has paid the stonecutter Antonio di Simone da Montecorvo "in ciella di frate Bartolomeo in San Domenicho" (see the documentary appendix by Di Lorenzo).

51. Ibid.

52. Giovanni di Bartolomeo left Urbino for Florence on February 23 and returned on March 31, "e doveva menare un garzone che mettessi d'oro," but the assistant refused the job and on June 12 Giovanni had yet to reimburse Fra Bartolomeo for the money set aside by the convent for hiring him (see the documentary appendix by Di Lorenzo). The extensive gilded decoration in the Tempio Malatestiano and in the Sala della Iole in Urbino suggests that something similar was being considered for the portal of San Domenico as well, but with unusual ostentation, given that it was for the outside of a building. See the essay by Matteo Ceriana in this catalogue.

53. Inv.D.1959.1 (M.N.R. 850), 27 x 236 cm: see Laclotte 1978 (listed as Circle of Giovanni di Francesco, Pesellino, and Baldovinetti). Callmann (1991) correctly identifies it with the "quadro uno di tavola lunga pinto di caccie uno di cervo e l'altro del porco cinghiale, in mezzo vi è un ponte," described in the Urbino palace inventory of 1631, published by Sangiorgi (1976, p. 272), and attributes it to Giovanni di Francesco, as proposed to her by Everett Fahy in 1985. See Hémery 2003, pp. 130–31 (with splendid color details). The attribution to Giovanni di Francesco, which is perfectly convincing, implies a date prior to his death in September 1459 and therefore places this work among the first paintings commissioned by Federigo from Florence, perhaps with his marriage to Battista in mind (November 13, 1459)—given, in any case, that it seems to be one of Giovanni di Francesco's most mature works.

54. Schmarsow 1912, pp. 207–10.

55. Berenson 1932a, p. 342; Berenson 1936, pp. 278–79.

56. See Dal Poggetto 2003b, p. 91. The date comes from a document of September 13, 1408 (ten lire from the sale of a plot of land are to be paid "pro tabulis dictae ecclesiae Sancti Bartoli nuperrime factis"), discovered by Don Franco Negroni (2002, p. 55), but regrettably lacking the name of the painter. It should be noted that the indication in the plural of the "magistris dictas tabulas facientibus et pincentibus" is to be understood as a reference to the woodworker and to the painter. I hope soon to complete a proper study of this remarkable artist, who painted the frescoes in the chapel *a cornu evangelii* (to the left of the chancel) in San Francesco, Urbino (these are now detached and mounted on the walls, but others have come to light in the area below the roof, implying that the artist decorated the apse, too); a *Madonna of Humility* on canvas, formerly in the cathedral of Urbino (now in the Galleria Nazionale delle Marche, Urbino); and other frescoes in Fossombrone and Gabicce Monte, whose impact parallels that of Bitino da Faenza in Rimini and Pietro di Domenico da Montepulciano in Ancona; for now, see De Marchi 2002b, p. 89 n. 37. As Andrea Di Lorenzo has pointed out, the existence in Urbino of traditional Gothic altarpieces such as the one in San Bartolomeo, with extensive narratives in the lateral panels, may be of interest in connection with the specific typology of the Santa Maria della Bella altarpiece, where the two Marian stories seems to have flanked an image, painted or carved, of the Virgin and Child.

57. For the still-open debate about the Marchigian aspects of Alberti's style and an unrelated group of panels and frescoes grounded in the culture of the Este—which were, in fact, painted by the Master G. Z.—see, most recently, De Marchi 2002b, pp. 90–91 n. 67. The commendable archival research of Don Franco Negroni (2002) has uncovered that artist's full name (Antonio di Guido di Giovanni Recchi), the place where his family came from, Badia Polesine, and also an indication of how deeply rooted he was in Urbino, where he is recorded from August 31, 1418, on. A document of 1437 significantly refers to him as "magistero Antonio de Recchis de Ferraria pictore de Urbino": evidently Ferrarese origins were considered prestigious. Another painter active in Urbino during the 1420s, confused with both Alberti and Nelli but of inferior talent, continued the fresco cycle of scenes from the life of Saint John the Baptist on the inner façade of the Oratorio di San Giovanni and painted a *Virgin Nursing the Child, with Two Angels,* in San Sergio as well as a *Madonna of Humility,* dated 1423, in the Oratorio della Santa Croce (De Marchi 1992, p. 132 n. 51).

58. Associating the payment of 1442 with the fresco has practically become commonplace, but the date clashes with the style of the work, one of Alberti's earliest, which still reveals the influence of the Salimbeni, and probably was painted before his Umbrian phase in Perugia, Montone, and Città di Castello (for this, see Padovani 1975, p. 50 n. 33; De Marchi 1993, p. 89).

59. Negroni 2002, p. 57; see the documentary appendix by Mazzalupi, doc. 2.

60. See Rossi in Urbino 1968, pp. 32–33; Dal Poggetto 2003b, p. 71. The attribution to Antonio Alberti dates back to Longhi 1934 (1956 ed) p. 12. Its supposed provenance from San Bartolomeo, first proposed by Serra (1921, p. 41; 1930, pp. 72–74), could derive from confusion with the San Bartolomeo triptych, of about 1408 (for which, see note 56, above), unless, as Andrea Di Lorenzo has suggested, it actually came to the church of San Bartolo during the period of the suppressions. Matteo Mazzalupi is responsible for the correct transcription of the epigraph "hoc opus fatu[m] fuit te[m]pore do[mi]ni Sperandei an[n]o D[omi]ni 1436," for the connection with the document relating to Bartolomeo di Giovanni, and thus for the alternative hypothesis of a provenance from the church of San Cipriano; Cipriano could be the bishop depicted to the Virgin's left, as a pendant to Saint Crescentino.

61. See Banker 1993.

62. The payment of April 27, 1445, was to the porter who had brought Bartolomeo di Giovanni's belongings from Urbino to Florence; furthermore, in a payment of November 28, 1445, Bartolomeo is explicitly called "discepolo di frate Philippo" (see the documentary appendix by Di Lorenzo).

63. De Marchi 2002, pp. 48–49.

64. In anticipation of a more comprehensive publication, which I am preparing together with Franco Polcri and Annamaria Bernacchioni, see De Marchi and Polcri 2003. On Antonio da Anghiari, see also Dabell 1984; De Marchi 2002b, p. 63.

65. In this context, where Lippi's workshop seems truly to have been a cultural crossroads and an open schoolroom of sorts, it would be fascinating to see whether there is any truth to Andrea Di Lorenzo's proposal (see the documentary appendix) to identify the Piero di Benedetto who received money on behalf of Fra Filippo on April 12, 1442, as Piero della Francesca; the latter certainly did not share stylistic affinities of any kind with Lippi. No less significant is the association of a payment of October 15, 1442, thus far either unnoticed or misinterpreted, with money owed by Lippi to Donatello.

66. These proposals were put forward respectively by Fredericksen (1974) and Padua Rizzo (1992a). To the last works of the Pratovecchio Master one might add a *Virgin and Child with Saint Anthony of Padua and Saint Sebastian* (Musée Jacquemart-André, Paris; inv. P 1385), ascribed to Pier Francesco Fiorentino (Sainte Fare Garnot in Babelon et al. 2000, p. 158, no. 52).

67. This passage is quoted from De Marchi in Bellosi 1990a, p. 149.

68. Richter 1940, p. 320.

69. Ragghianti 1949, p. 299.

70. Offner 1939, p. 214.

71. Crowe and Cavalcaselle 1871, p. 350.

72. Benati 1996. I believe that this is the portrait most convincingly attributed to Fra Carnevale. I have strong reservations about the authenticity of the *Portrait of a Woman* in the Metropolitan Museum (cat. 17), ascribed to him by Joannides (1989); for the portrait of *Frederick III* in the Uffizi (cat. 28), see my entry.

73. See Di Lorenzo in De Marchi 2002a, pp. 306–9; Mazzalupi 2003.

74. Previtali (1970, p. 106 n. 6), followed by Conti (in De Angelis and Conti 1976, p. 108 n. 30). Bellosi (1987) disagreed with this, proposing instead a Florentine period for Giovanni di Piamonte, in a minor key but not lacking in his characteristic rustic expressiveness. I find this persuasive, with the sole exception of the frescoes in Santa Maria del Morrocco (which still await proper attribution), the

Gualino *Saint Jerome in the Desert* (Galleria Sabauda, Turin), and the Berlin altarpiece, dated 1471, formerly erroneously ascribed to Cosimo Rosselli and now correctly regarded as Lucchese by Boskovits—a work that certainly echoes the late style of Domenico Veneziano, but with greater emphasis on draftsmanship; I suspect that it might be the only substantially autograph painting by Matteo Civitali (on this fascinating problem, see the essays and catalogue entries in Barrachini et al. 2004). One could add some works to the corpus of the mature Giovanni di Piamonte that would demonstrate a direction contrary to that taken by Bartolomeo Corradini—an invaluable formative experience alongside Piero della Francesca, a migration from the provinces to an artistic center, and then a regression toward a more modest pictorial language, although one not unresponsive to those of Baldovinetti and Pollaiuolo. These works include (1) a *Female Franciscan Blessed,* a cuspidal panel with a gold ground (Staatliche Museen, Berlin; inv. 1421); (2) a *Virgin and Child* (Lanckoronski Bequest, Wawel, Kraków; see Skubiszewska in Kuczman 1998, pp. 66–68); and (3) a *Saint Roch* (formerly De Boer collection, Amsterdam; see Martini 1960, fig. 8, listed as by Bartolomeo della Gatta).

75. Cleri (1997a, pp. 108–9) dates this cross to 1451, between the fresco of *Saint Bernardino* in San Francesco, Gualdo Tadino, and the *Saint Jerome* in the Walters Art Museum, Baltimore, both also dated to that year. However, I would date the crucifix to 1460, because the rendering of the loincloth, with its two crossed folds of material, is less complex than that of the Matelica crucifix of 1452, and anticipates Antonio's solution on the cross, dated 1479, in the Jesuit Congregation, Lyons (published by Laclotte 2003) and in the fresco, which probably dates to 1480, in the convent of San Domenico, Fabriano.

76. Here, one recalls Alberti's words in the *Della pittura* (1435, vol. 2, § 36; 1975 ed., p. 62): "before dressing a man, we first draw him nude, then we enfold him in draperies" ("*a vestire l'uomo prima si disegna ignudo, poi il circondiamo di panni*"). Infrared reflectography of the *Three Archangels* in Berlin (cat. 10), an early work by the Pratovecchio Master, has revealed a remarkable drawing of nude figures with male genitals. Reflectography has also shown that the Virtues on triumphal chariots on the verso of Piero's portraits of Federigo da Montefeltro and Battista Sforza were drawn as nude figures.

77. Offner 1939, p. 249.

78. See Bagatin 1987.

79. These incisions were first pointed out by De Marchi (1993, pp. 89–91, fig. 7).

80. As observed by Boskovits in Boskovits et al. 2003, p. 184.

81. See, especially, plate VI of Book II of Piero della Francesca's *De prospectiva pingendi:* ("Nel piano degradato un pozzo de sei faccie equali degradare, et con eschalini atorno, seguitando i lati, circondare." (1942, pp.106–9, pl. XIV, fig. XXXVII). Analogous polyhedrons are depicted in a drawing in Stockholm (fig. 33) and the *Heroic Figure* (cat. 44), perhaps one of Fra Carnevale's last works.

82. This is a manuscript from Urbino containing Euclid's *Optica,* Ptolemy's *Libellus de iis quae in caelo aspiciuntur,* and the *De algebra et almuchabala* attributed to Mahomet, dated October 23, 1458, in Rome in the *explicit* by the French scribe Michel Foresius. The illumination in question is on the external margin of the inner frontispiece, on folio 1r: (Biblioteca Apostolica Vaticana, Rome, ms. Urb.lat.1329; see Bartola and Stabile in Buonocore 1996, pp. 380–82, no. 97). The codex was not lent to the present exhibition.

83. Offner 1939, p. 217, fig. 8–9.

84. Florence, Gabinetto Disegni e Stampe degli Uffizi, inv. 201F, listed as by Lorenzo di Credi.

85. On this painter see Lachi (1995), who suggests an interesting identification with Piero di Lorenzo Pratese (later a colleague of Pesellino and of Zanobi del Migliore), even if this is not based on any concrete evidence. The numerous attributions to his early, Lippesque phase, proposed by Lachi, are extremely heterogeneous, and his book is generally vitiated by a certain dilettantism with regard to attributions (for example, the Berenson *Madonna of Humility* illustrated on p. 94 is a typical work by Apollonio di Giovanni, not Pesellino, and the *Annunciation* in Notre-Dame, illustrated on p. 102 as by Baldovinetti is a forgery). A "*Piero di Lorenzo dipintore*" received payments on behalf of Filippo Lippi on November 10, 1440, for the Maringhi altarpiece (Di Lorenzo, documentary appendix), and we should not rule out the possibility that this is the Pietro di Lorenzo paid in 1447 for gilding the frame. Conversely, as Bernacchioni points out, he is an artisan of secondary importance, traceable through documents to 1421, and distinct from Piero di Lorenzo Pratese. See the essay by Keith Christiansen in this catalogue.

86. Zeri 1961.

87. Christiansen (1979, p. 201 n. 8) at that time expressed reservations about the attribution to the Master of the Barberini Panels but later (1993, p. 367 n. 14) retracted his doubts. A decidedly negative opinion of this authorship is expressed by Boskovits (in Boskovits et al. 2003, p. 186 n. 25: "this work is very different indeed from the rest of the artist's oeuvre, and in any case its execution by the same hand and almost contemporaneously with the Washington *Annunciation* can be excluded").

88. The Hannover *Madonna* had already been attributed to the Master of the Castello Nativity by Berenson (1932a, p. 343), whereas recently a direct attribution to Fra Carnevale was proposed by Boskovits (in Boskovits et al. 2003, p. 184). The same problem is posed by an apparently heavily reworked *Madonna and Child,* sold at auction in New York in 1950, which Berenson believed was closely connected with the Hannover *Madonna,* although he reattributed it to Zanobi Macchiavelli (Berenson 1950, fig. 16). Everett Fahy has called my attention to a *Madonna and Child* (formerly Bühler, Munich; negative in the Institute of Fine Arts, New York), the setting of which is an interior with an exedra and a window to the left, and where the child clings to his mother, reaching for her neck with his right hand and with his left hand points to her mouth. Apparently an unpublished work, it is clearly by the Master of the Castello Nativity, as Fahy has shown, and it provides an interesting link between the two paintings of the *Madonna and Child* cited above.

89. Bellosi (1990b, p. 37). See also the entry on the Bergamo *Madonna and Child* (cat. 18) in the present catalogue.

90. Inv. NM 47/1863: Christiansen (1993, p. 367 n. 11), in fact, only gave an unequivocal attribution to Fra Carnevale of the drawing with the David, nonetheless recognizing that "Vasari certainly thought that the various drawings he mounted together were by the same hand, and he may have been right." See also Bjurström 2001, no. 1049, 1050, 1051. (It is unfortunate that the drawings from Stockholm will not be lent to the present exhibition. See Petrioli Tofani [in Petrioli Tofani 1992, pp. 154–55, no. 7.9]; Melli [in Brandt et al. 1999, pp. 390–91, no. 66].)

91. Inv. NM 45c / 1863; see Bjurström 2001, no. 1070.

92. Inv. NM 11 / 1863; see Meller and Hokin 1982; Bjurström 2001, no. 1063.

93. Meller and Hokin 1982, p. 241.

94. "Ma il padre, che aveva bisogno che e' guadagnasse, vedendo che egli si dilettava molto del disegno, lo indirizzò, ancora fanciulletto, all'arte della pittura; nella quale studiò egli molto le cose di Fra Bartolomeo, altrimenti Fra Carnovale da Urbino, che fece la tavola di Santa Maria della Bella in Urbino" (Vasari 1568 [1906 ed.], vol. 4, pp. 147–48).

95. See Sangiorgi 1976, p. 63: "un quadro longo d'una prospettiva anticha ma bella di mano di fra' Carnevale"; "anticha ma bella" is a sign of the appreciation for the work, notwithstanding the fact that it belonged to a remote period in which pictorial tastes differed, and is certainly not a reference to the depiction of ancient Roman monuments, as inferred by Ciardi Dupré Dal Poggetto (in Dal Poggetto 2001, pp. 73–85), in order to argue for its identification as the panel in Baltimore.

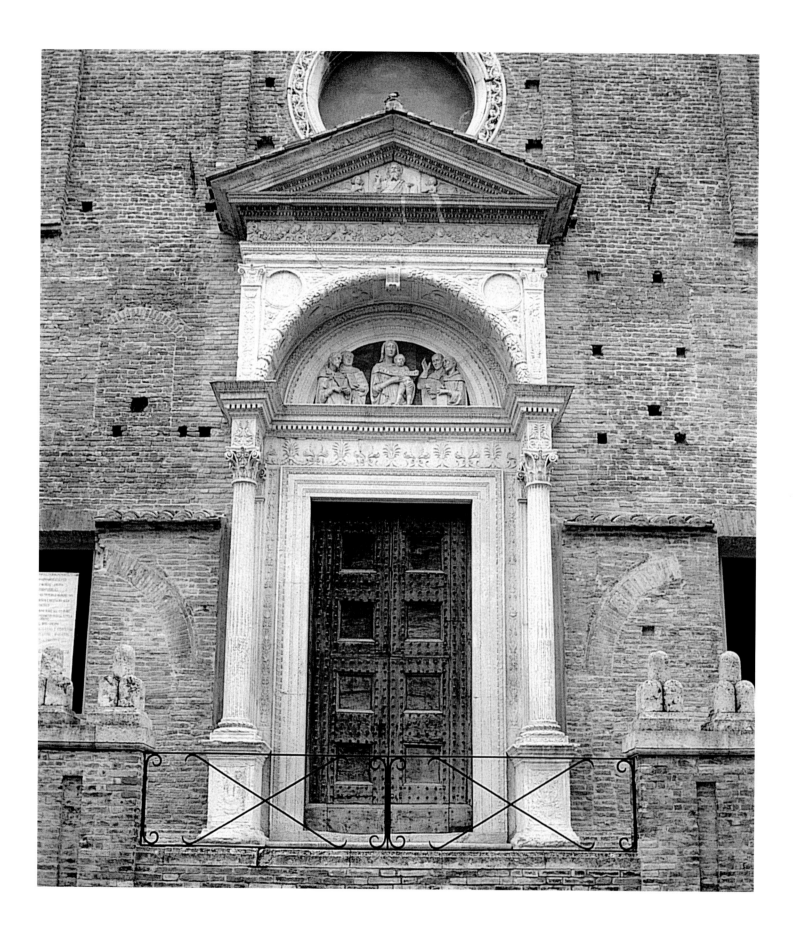

Matteo Ceriana

FRA CARNEVALE AND THE PRACTICE OF ARCHITECTURE

FLORENCE, 1445

BARTOLOMEO DI GIOVANNI Corradini, later known as Fra Carnevale, arrived in Florence in the spring of 1445, and the impression the city made on him can be traced in all his works: works as excellent as they are rare. It should not surprise us that the young artist from Urbino was quite breathless when faced with the immense construction sites (above all, that of the cathedral of Santa Maria del Fiore), as well as with the quality and quantity of new projects, masters, and workshops. Still rather inexperienced, if no longer a rank beginner, he had been trained in Urbino in the workshop of Antonio Alberti—perhaps already associated with the modest Apennine court of Guidantonio da Montefeltro (1378–1443).[1] Alberti's shop, while certainly noteworthy, persisted in catering to the taste for Gothic art typical of the regions of Northern Italy and along the slopes of the Apennines.

As Keith Christiansen argues in his essay, between the fourth and fifth decades of the fifteenth century Florence was an indispensable stopping place for an artist wishing to keep abreast of the innovations of Fra Angelico, Filippo Lippi, and Domenico Veneziano.[2] So far as architecture and decorative sculpture were concerned, the presence of Brunelleschi, Michelozzo, and Donatello, as well as the lucid and brilliant intelligence of Leon Battista Alberti, made Florence the only place an artist could study the *res aedificatoria,* or manner of building. Whether Fra Carnevale's arrival in Florence was encouraged, if not actually organized, by the new—and young—Count Federigo da Montefeltro (1422–1482), who was then in the service of the Florentine government, or *Signoria,* or by Federigo's elder half brother, Ottaviano Ubaldini, it is reasonable to suppose that, at the moment of his departure the young artist would have been advised to fill his notebooks with drawings of buildings and architectural models, to copy their ornamental features, to jot down the names of masters and their best assistants, and also to pay attention to more practical questions: the advancements in engineering that were so dear to Federigo's heart, construction costs, and the price of materials (Tuscan marble in particular). Twenty years later, Federigo, by then Duke of Urbino, was to write that Tuscany, where he had for many years been wont to seek his artists, had always been the "fountain of architects."[3] Even after the duke's death, the new supervisor of work on the Palazzo Ducale at Urbino, the Lombard Ambrogio Barocci, went to Florence to buy some of the marble needed to finish facing the façade of the palace, although the building was not strictly Florentine in style.[4] In any event, what the young Federigo wanted in those first years of government was certainly not paintings. After all, the residences of the

1.
Maso di Bartolomeo and Workshop, and Luca della Robbia. Portal, San Domenico, Urbino

97

Montefeltro in the center of Urbino were already decorated with many square meters of highly colored illusionistic frescoes showing wood paneling or tapestries (obsessively adorned with mottoes and heraldic symbols) from the Late Gothic workshops of the Salimbeni and of Antonio Alberti.[5]

Beyond any precise chronological computation, there is considerable significance in the information provided by the seventeenth-century historian Cesare Clementini[6] to the effect that Federigo began the rebuilding of the Palazzo Ducale in Urbino as early as 1447—a date that, perhaps not by chance, coincides with Fra Carnevale's hasty and otherwise unexplained return home—in order to keep pace with the architectural projects of the count's hated enemy, Sigismondo Pandolfo Malatesta. Federigo must have had in mind the antique marble mass of Sigismondo's dynastic church, the Tempio Malatestiano at Rimini (but of this, we shall have more to say later on).[7]

Fra Carnevale's decision to frequent the studio of Filippo Lippi—the leading painter in Florence in the mid-1440s, not only in terms of the quality of his works but also because he was Cosimo de'Medici's favorite—and thus to establish many contacts in artistic circles both within and outside the city walls (contacts spelled out in the documentation transcribed by Andrea di Lorenzo in the appendix)[8] was in a certain sense an inevitable one. It was the way to learn the language of the new painting, but also that of the new architecture. In fact, as Leon Battista Alberti had written a few years earlier, "unless I am mistaken, the architect took from the painter his architraves, capitals, bases, columns, pediments, and all other similar things."[9] That painting allowed for the freedom of invention necessary to elaborate on a new, *all'antica* architectural language is demonstrated by Masaccio's fresco of the *Trinity* in Santa Maria Novella, with its illusionistic architectural setting.

Filippo Lippi's works from the late 1440s are, from this standpoint, paradigmatic. Although he did not have a mind for architecture as a conceptual system, or a rigorous methodology for approaching design and space, Lippi was perfectly capable of freely manipulating its language,[10] using its various inflections with an aplomb verging on cynicism. There is a Brunelleschian severity in the small *Sacra Conversazione* in the Fondazione Cini, Venice; in the austere setting of the Marsuppini *Coronation of the Virgin* of the mid-1440s (fig. 18, p. 57); or in the ornate throne, with its luxuriant neo-Gothic floral motifs, of the *Barbadori Altarpiece,* commissioned in 1437 (fig. 14, p. 52). There is also a geometric abstraction and a programmatic proliferation of sharply foreshortened walls in the *Tarquinia Madonna* of 1437 (Galleria d'Arte Antica, Rome), and in the San Lorenzo *Annunciation* (fig. 13, p. 5), as well as in the wild, hybrid fantasy of the Maringhi *Coronation of the Virgin,* begun in 1439 (fig. 2, p. 40), which demonstrates the influence of Donatello's pyrotechnical antiquarian assemblages (especially the elongated volute of the throne combined with a shell, which recalls the bronze capital of Donatello's pulpit at Prato).[11] The visual evidence of a relationship between Donatello and Lippi in a workshop where the careers of many artists crossed paths has now received documentary support through the discovery of a payment made to Donatello on Lippi's behalf in 1443.[12] Lastly, the altarpiece for the Medici novitiate chapel in Santa Croce (fig. 3) reveals a debt to Michelozzo's decorative vocabulary. The frieze, punctuated with the Medici *palle* (balls),

2.
Fra Carnevale,
The Presentation of the Virgin in the Temple (?),
detail. Museum of Fine Arts, Boston

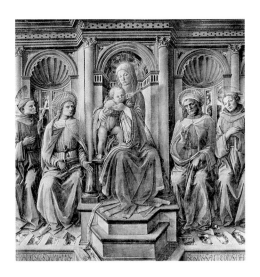

3.
Filippo Lippi,
Madonna and Child with Saints
(altarpiece for the novitiate chapel, Santa Croce),
detail. Galleria degli Uffizi, Florence

derives from those designed by Michelozzo for the church at Bosco ai Frati (begun 1427) and for the doors of the rood screen of San Marco (1440–41; certainly before 1443).[13] Moreover, as Massimo Bulgarelli has pointed out to me, the marble backdrop that imposes an architectural order on the image is the first known example in Florence of the use of a series of arches framed by columns with architraves, in accordance with a scheme derived from ancient theaters: a device in keeping with the ideas of Leon Batista Alberti himself. This clever architectural invention was the source of Fra Carnevale's rood screen in the *Presentation of the Virgin in the Temple (?)* (fig. 2, 3, pp. 68, 69)—an exquisitely "modern" element translated into a form that would allow its insertion into the nave of an "antique" basilica.[14]

Evidence of Fra Carnevale's apprenticeship with Lippi, proudly declared in numerous, easily identifiable quotations, turns up in his painted architecture as well: the prevalence of feigned polychrome marbles, painted with freely brushed, multi-colored patterns; or the steps extending from one to the other of the Barberini Panels that are used to unify the space, as in the Marsuppini *Coronation of the Virgin* (fig. 18, p. 57). These motifs are no less Lippesque than the subtle profiles of the women, with their extremely varied headgear. The first impact of Lippi's somewhat erratic spatial logic, which is often guided more by theatrical or devotional concerns than by geometrical ones, may possibly be read in the disoriented placement of the figures in the *Madonna and Child* in the Accademia Carrara, Bergamo (cat. 18), in which the figures occupy a shaky, irrational space and the small capital in the corner, elongated as in the work of Ghiberti,[15] has the quaint liveliness of a lettuce leaf. In one of his late works, Fra Carnevale, with touching faithfulness to his master, adapts the building in Lippi's late *Annunciation* in the apse of the cathedral of Spoleto for the *Birth of the Virgin* (cat. 45 A),[16] but he replaces Lippi's antiquarian quotations from a local source—a capital from the venerable church of San Salvatore[17]—with moldings possessing a more abstract character and perhaps already exhibiting the decorative severity Luciano Laurana imposed on the Palazzo Ducale at Urbino.

To return to Florence during those years, a fundamental source for interpreting the young Urbino artist's apprenticeship are the entries in Maso di Bartolomeo's account books for 1449 to 1451. These testify to Fra Carnevale's association with that sculptor and with his younger brother, Giovanni di Bartolomeo, Maso's close and faithful collaborator.[18] Maso—who may well be the "Masaccio" mentioned by Leon Battista Alberti in the dedication of the *Della pittura*[19] and the one praised, years later, by Filarete in his treatise on architecture[20]—was certainly the most important bronze sculptor in Florence after Donatello's departure in 1444 (all the more so as Michelozzo had turned his attention to architecture). Access to such a shop must have meant that Fra Carnevale suddenly found himself at the intersection of an extraordinary network of contacts and relationships, in a place from which he might observe some of the most recent and innovative sculptural and architectural creations in Florence.[21] We must imagine that, among the models in the workshop—both graphic and sculptural—there undoubtedly were those for the pulpit on the exterior of the cathedral of Prato (1433–38), on which Maso had collaborated with Donatello and Michelozzo,[22] as well as for Maso's own works in the same building: the grille (fig. 4) and balcony for the Chapel of the Virgin's Girdle (the Cappella del Sacro

Cingolo).²³ At the time of Fra Carnevale's arrival in Florence in 1445, Maso is documented in a partnership with Michelozzo and with Luca della Robbia to execute the commission for a set of bronze doors for the north sacristy of the cathedral of Florence.²⁴ During the months when he seems to have frequented the sculptor's shop, work was proceeding—perhaps based on the reelaboration of a design by Donatello²⁵—on the cornice for those doors: a richly decorated molding with quatrefoils from which small heads protrude. The design was a faithful version, only slightly more severe and restrained, of a motif used by Ghiberti on his first set of doors for the Florence Baptistery—on which, in fact, Michelozzo had worked as a youth.²⁶ It is fascinating to think that in the sacristy of Florence Cathedral the young artist from Urbino had a chance to see a spectacular example—probably the very first—of that illusionistic and perspective intarsia decoration that was to typify Federigo's *studioli,* or private studios, in his palaces in Urbino and Gubbio.

Beginning in February 1447, Michelozzo and Maso were collaborating on a bronze grille, or *graticola,* for the Altar of Santo Stefano in Florence Cathedral;²⁷ Maso's workshop also was engaged on a Medici project in the Florentine church of San Lorenzo in 1448–49.²⁸ With Michelozzo and Luca, Maso was involved in the decorations for the Cappella del Crocifisso in San Miniato al Monte (fig. 23, p. 61), drawings for which must have been available in 1446–47.²⁹ Again with Michelozzo and also with Pagno di Lapo Portigiani, Maso participated in the execution of the bronze furnishings for the extraordinary aedicula of the Annunciate Virgin in the Servite church of the Santissima Annunziata in Florence—already substantially complete in 1448, even if not consecrated, according to the solemn inscription on the monument, until 1452.³⁰ These last two projects employ an exuberant decorative vocabulary and an unprecedented variety of materials—marble, bronze, mosaic (real and feigned), glazed majolica—and pursue an ideal of magnificence

4.
Maso di Bartolomeo, Grille of the Cappella del Sacro Cingolo, Prato Cathedral

5.
Pagno di Lapo Portigiani, Tabernacle, Santissima Annunziata, Florence

6.
Fra Carnevale, *The Birth of the Virgin,* detail. The Metropolitan Museum of Art, New York

7.
Bernardo Rossellino,
Baptismal font, Collegiata, Empoli

8.
Fra Carnevale,
The Presentation of the Virgin in the Temple (?), detail.
Museum of Fine Arts, Boston

transmitted not only by means of heraldic symbols and epigraphs but also (and primarily) through a lofty antiquarian style. They are paradigmatic of the prevailing tendencies at the time: not just of the personal taste of Piero di Cosimo de'Medici but also of the definitive rupture with the Brunelleschian ideals of the preceding decades.[31] It is not surprising that these architectural projects left a recognizable mark on Fra Carnevale's artistic career: in his delight—both in his paintings and in his later undertakings for Federigo—in an architecture that is always ornate, marmoreal, and adorned with numerous narrative reliefs with connotations of classical antiquity.

The complex and magnificent marble frieze of the aedicula, or *tempietto,* of the Annunziata, for example, decorated with Medusa heads within medallions and garlands tied with fluttering ribbons (fig. 5), appears, just slightly simplified,[32] in the palace shown in the *Birth of the Virgin* (fig. 6), while the large marble vase in the *Presentation of the Virgin in the Temple (?),* from which a laurel branch protrudes (and which we may imagine being used for aspersion), echoes those designed by Maso for his candelabra or by Pagno di Lapo to support the altar of the *tempietto* of the Santissima Annunziata (fig. 8).[33] The vase takes up an antiquarian idea that is Albertian in character.[34] It may, indeed, be inspired by a project of Leon Battista's follower, Bernardo Rossellino, who in 1447 executed for the Florentine canon of the Collegiata at Empoli, Antonio di Giovanni Giachini, a baptismal font in the form of a wonderful antique krater, which was isolated in the center of the chapel (fig. 7).[35] A frieze of cherub heads and garlands is certainly not a rarity in the mid-Quattrocento, but it is highly probable that Fra Carnevale, who used the motif to adorn a sleeping alcove in the Palazzo Ducale, Urbino (fig. 41), recalled the "antique"-style frieze on the door of the novitiate chapel in Santa Croce (fig. 22, p. 61) or that on the lavabo in the sacristy of the basilica (the attribution of the lavabo, usually assigned to Pagno di Lapo Portigiani, should perhaps be carefully reconsidered).[36] Of particular importance for Fra Carnevale must have been his encounter with Michelozzo in Maso's shop and his study of Michelozzo's works of the late 1430s and early 1440s, such as the novitiate chapel and the decorative furnishings for the Pazzi Chapel, both in Santa Croce, or for the Florentine church and convent of San Marco, which belonged to the Dominican order the Urbino artist was soon to join.[37] The importance of this encounter would seem to be proven by the extraordinarily beautiful *Annunciation* painted for Jacques Coeur (cat. 19), in which, as Christiansen notes, echoes of Maso's work are apparent in the grille, while the decorative motifs of the capitals of the steeply foreshortened portico, composed of four volutes with a carved leaf emerging between them and reaching as far as the little stone flower on the abacus, are borrowed, instead (although in a more naïve way), from those Michelozzo designed for the atrium of the Santissima Annunziata in the early 1440s.[38] In the lunette of the door leading from the loggia into the magnificent orchard of vines and cypresses, two Herculean putti bear a cartouche similar to those embedded by Michelozzo in the tympanum of the door of the novitiate chapel.

In much the same fashion, Fra Carnevale's "workshop companions"—Giovanni di Francesco and the Pratovecchio Master—were also testing their abilities with the evocative power of architecture, each to the extent that his individual nature inclined him. In the latter's *Madonna and Child* at Harvard (cat. 11), the drafted stone—of the same type as

that Michelozzo had probably conceived from the outset for Cosimo de'Medici's palace in the via Larga,[39] but that was also used by Donatello on the base of his equestrian statue of *Gattamelata* in Padua—is pierced by a tabernacle window with heavy carved moldings very similar to those preferred by Fra Carnevale, while the Ionic columns, afterward rendered smooth, were initially designed to be spiraled, like those on Donatello's Parte Guelfa tabernacle on the exterior of Orsanmichele in Florence,[40] or on the magnificent tabernacles installed by Bernardo Rossellino on the façade of the Fraternità di Santa Maria della Misericordia at Arezzo (commissioned in 1434–35). Both the moldings and the capitals are practically identical to Fra Carnevale's painted architecture, the former chiseled with a slightly naïve meticulousness that forces the sculptor to sacrifice the colored marble frieze to the delineation of every detail of the architrave, and the latter having a flared collar and hollowed-out volutes no less curled than Michelozzo's on the Brancacci tomb in Sant'Angelo a Nilo, Naples. In constructing the throne in the *Carrand Triptych* of about 1454 (fig. 9),[41] Giovanni di Francesco, another artist who probably worked in Urbino,[42] recycled the Michelozzan idea of the barrel vault supported on free-standing columns—taken over from the Cappella del Crocifisso in San Miniato al Monte. However, he framed this motif in a trabeated order of pilasters, an example of which appears in Masaccio's *Trinity* in Santa Maria Novella, Florence. The optical sharpness of Giovanni di Francesco's hard-edged, fictive architecture is increased by the cleanly "carved" surfaces, whether fluted, cabled, or even strigilated.

9.
Giovanni di Francesco,
Madonna and Child with Saints
(*Carrand Altarpiece*),
detail. Museo Nazionale del Bargello,
Florence

10.
Maso di Bartolomeo and Workshop,
Portal, detail.
San Domenico, Urbino

11.
Fra Carnevale,
*The Presentation of the Virgin in the
Temple (?),* detail. Museum of Fine Arts,
Boston

URBINO: SAN DOMENICO AND THE PALAZZO DUCALE

It was very probably in Florence, most likely in the setting of the Dominican monastery of San Marco—where at least one of Fra Carnevale's artistic mentors, Michelozzo, worked assiduously—that our artist decided to take religious orders. We may certainly give the new friar credit for authentically spiritual motivations, but we cannot fail to note the obvious advantages such a social position held for someone with a tendency toward an intellectual approach to art and who had no desire to manage a flourishing and hard-working shop. In Urbino itself, a member of the Franciscan order offered just such an example of a man with a similar approach to the artistic profession. This was Fra Gaspare da Urbino, who, along with Fra Giovanni da Urbino, had been sent to Constantinople by Saint Bernardino of Siena to build a Franciscan monastery there.[43] One would like to recognize our two friar-architects in the two monks (a Franciscan and a Dominican with his assistant?) in conversation at the foot of the altar in the apse of the temple in the *Presentation of the Virgin in the Temple (?)* (fig. 2) intent upon discussing the building, but there is nothing to support such a supposition.

What we may, indeed, imagine without fear of overspeculation is that contacts within the preaching order must have made it easier for Fra Carnevale to become involved in the creation of the new portal on the façade of San Domenico in Urbino (fig. 1,)[44]—this, despite the fact that it has not yet been possible to establish whether the monastery in Urbino followed the same Observant rule as San Marco in Florence. Some slender evidence nonetheless suggests that this may have been the case.[45]

At any rate, it can be no coincidence that Fra Carnevale's return to Urbino marked a decisive turning point in the work on the façade of the Dominican church, which had been dragging on since the early years of the century, all the while adhering to outdated, local conventions. We need only look at the oculus of the façade, with its undulating, Late Gothic botanical traceries, to imagine what the local stonecutters would have produced with the generous legacies of the local citizenry.[46] Upon the arrival of the new friar and, no doubt, with the support of his Florentine brethren from San Marco, it suddenly became possible to call upon the busiest and best-paid artists of Florence—the same ones who had worked for Cosimo de' Medici and who were now in the employ of his son Piero. Maso di Bartolomeo was not only Florence's best-known craftsman in his specific field—bronze sculpture—but he must have had a solid international reputation for, immediately after working in Urbino, he was summoned to Rimini by Sigismondo Malatesta, then to Faenza by Astorre Manfredi, and lastly to Dalmatia.[47] The young and ambitious Count of Urbino could not but become an enthusiastic supporter of a project that he would have had some difficulty in financing at the time. Nor could Federigo let slip the opportunity of entrusting Maso with the task of producing the weapons he needed,[48] and of trying out the team of stone carvers who would afterward be called upon to work on his new palace.

To tell the truth, the triumphal portal, raised on a podium reached by a staircase, with freestanding columns on pedestals, a barrel vault, and a tympanum, forces itself rather violently onto the preexisting façade of San Domenico, so completely upsetting the scale of

the structure that the tympanum interrupts the oculus. Perhaps the project was meant to recover some coherence upon completion with the creation of a new façade at least partially faced in stone, as suggested by those portions of the structure where the surfaces were left rough since they were to have disappeared beneath a stone revetment.[49] Once finished, the façade would have regained a unified, monumental form. However, this result would have reduced the portal's isolation: an isolation that, as matters stand, renders the portal most impressive, conferring upon it the power of an inescapable manifesto of the new Renaissance style in an Urbino still under the spell of the magnificent and courtly Late Gothic.

Maso di Bartolomeo's *Libro di Ricordi,*[50] of which the parts that are of interest to us have finally been transcribed by Andrea di Lorenzo (see the appendix), gives us the most important information regarding the construction. Under the careful guidance of Fra Carnevale, Maso di Bartolomeo and the members of his shop arrived in the spring of 1449—enabling them to prepare the construction site in good weather; the first payments date to August.[51] Maso kept track of the work at every step, beginning with the excavation of stone at Piobbico—a delicate operation that was monitored by the experienced Pasquino di Matteo da Montepulciano. At Federigo's request, the bronze sculptor soon devoted himself to the more urgent task of producing cannons (specifically, *bombarde* and *cerbottane*).[52] Meanwhile, stonecutters from Settignano, in Tuscany, joined by others from Montefeltro (including Antonio da Montecorvi), Northern Europe, and Dalmatia,[53] continued to prepare and carve the stone, very probably under the supervision of Fra Carnevale. Thus, in 1451, Maso was able to write, "the whole task is about two-thirds done" (*"n'è fatta circha a due terzi di tuta l'opera"*).[54] The leading role among the stonecutters and carvers was assumed by Pasquino da Montepulciano, who would put in place the last parts of the portal in October and November of 1454 (Pasquino also assembled Maso's grille for the Cappella del Sacro Cingolo at Prato)[55], in collaboration with another of Maso's most faithful partners, Michele di Giovanni *di Bartolo,* known as Il Greco. As early as January 2, 1450, Fra Carnevale assisted with the payments, and it is natural to assume that he also had formal and artistic control of the monument. After the important discovery by Matteo Mazzalupi of the friar's involvement in the reconstruction of the cathedral of Urbino in 1455, this supervisory role can now be supported with the documentary weight of a proven technical competence, even on the construction site.[56]

Thus, when, on the temple façade in the *Presentation of the Virgin in the Temple (?),* Fra Carnevale clearly depicted the capitals of the columns and pilasters of San Domenico (fig. 10, 11),[57] or, when, in the loggia in the *Birth of the Virgin* (fig. 6), he painted a capital from the attic of the portal or the motif of a frieze decorated with cherub heads and garlands, he is simply returning nostalgically to his old inventions and reusing his own graphic models.

Studying the portal, one cannot understand how it ever could have been considered close to Bernardo Rossellino's tomb of Leonardo Bruni in Santa Croce (after 1445):[58] the difference could not be greater, whether in general syntax or in proportions. The San Domenico portal, with freestanding columns reiterated by pilasters, cannot be compared with what is a far less complex tomb, despite the use in the latter of pilasters—especially

12.
Workshop of Maso di Bartolomeo, Tribune of the Sacro Cingolo, Prato Cathedral

13.
Workshop of Maso di Bartolomeo, Portal, detail. San Domenico

14.
Pasquino da Montepulciano,
Frieze, detail.
Portal, San Domenico,
Urbino

if we acknowledge the rarity in mid-Quattrocento Florence of such a key element of Fra Carnevale's plan as fluted columns.[59] To this it should be added that the decorative grammar of the Bruni tomb is much more carefully conceived and possesses a stronger architectural coherence, both in the proportions of the socle and the pilasters and in their relationship with the arched lintel of the archivolt. Here, the distribution of the ornamental features is also much more consistent. The models for the San Domenico portal are, instead, to be found in the works of Michelozzo: the Brancacci tomb in Sant'Angelo a Nilo, Naples (1427), and the later aedicula of the Cappella del Crocifisso in San Miniato (fig. 23, p. 61). The compositional scheme is undoubtedly closer to the former than to the latter, on account of the general proportions and the elongation of the columns.[60] Indeed, the connection is so close that one might wonder whether the crowning element of the portal, for which Luca della Robbia was to have prepared a roundel depicting God the Father, was not initially a mixtilinear Gothic gable, as on Michelozzo's monument in Naples, where, in fact, there is a roundel that includes an image of God the Father in the act of blessing, or at Montepulciano, on the façade of Sant'Agostino (also by Michelozzo); perhaps the transformation at Urbino was only carried out later. Even Bernardo Rossellino had not disdained a mixtilinear pediment on the façade he designed at Arezzo, flanked though it was by austere classical tabernacles. As originally planned, with only three figures instead of five, the sculptural group by Luca della Robbia in the lunette (fig. 20),[61] would have had an even closer resemblance to that of Sant'Agostino at Montepulciano, apparently executed and installed by Michelozzo between 1438 and 1439.[62]

A project by the architect of old Cosimo de'Medici—who was, during the period under discussion, Federigo's political, financial, and cultural patron—was thus carried out by Florentine artists and craftsmen[63] as well as by Fra Carnevale, who had served his apprenticeship in the Tuscan city. This was the same procedure followed at Rimini by Sigismondo Malatesta and later at Mantua by the Gonzaga, and it produced at Urbino a less rustic result than that of the Franciscan library at Cesena (dedicated in 1452),[64] where, at the behest of Malatesta Novello, Matteo Nuti interpreted to the best of his abilities yet another of Michelozzo's designs—that for the door of the novitiate chapel in Santa Croce. It is nonetheless quite likely that in working on the portal of his convent, the young Fra Carnevale contributed some of his own excellent ideas—perhaps the very ones pointed out by Bruschi:[65] the classical plinths derived from triumphal arches, such as the one at Ancona, or from the Temple of Minerva at Assisi. However, these ideas must also have been known to Pasquino, since they were present in Filarete's *Martyrdom of Saint Peter* on the bronze doors of Saint Peter's in Rome:[66] the trabeation without an architrave; the capitals in the form of a double *s* of a startling and elegant complexity, which reappear in the Barberini Panels; and the substitution of a garland for an arched lintel, as adapted by Domenico Veneziano[67]—a transcription of an invention of Donatello. In particular, the use of plinths beneath the columns, unknown in Florence in the early 1440s but constantly employed by Fra Carnevale in his later, certain works—in the alcove in the Palazzo Ducale; in the *Presentation of the Virgin in the Temple (?)*; and in his allegorical figure in the Cagnolo Collection (cat. 44)—confirms that the model was, indeed, the celebrated Temple of Minerva in Assisi, also well known to Pasquino, because such plinths

can be seen on the Vatican doors by Filarete.[68] As on Leon Battista Alberti's Santa Maria Novella in Florence (or in the interior of the Tempio Malatestiano), the plinths are used in Urbino to extend the columns and to connect the different portions of the various architectural styles. It is also probably a result of the period Pasquino spent in in Filarete's workshop in Rome that we also owe the unusual corner effigy of Jupiter Ammon (fig. 14).[69] As for the triangular tympanum of the San Domenico portal, for which the projected terracotta by Luca della Robbia never arrived, a carved God the Father[70] flanked by praying angels was produced (fig. 15)—as on the Pazzi Chapel in Florence.[71]

The pervasive and subtle ornamentation of the entire portal is an immediate response to Florentine architecture of the late 1440s and early 1450s: the plinths and the short dadoes are decorated with very delicate carving, similar to what we find on the Tempio Malatestiano or, even more so, on Bernardo Rossellino's sepulchral monument to Leonardo Bruni in Santa Croce, Florence.[72] The execution of the frieze with palmettes (fig. 17) is no less detailed.[73] Only certain parts, such as the pilasters, conserve, in the vegetal decorations, a slightly smug naturalism similar to that on the framing elements of Maso's grille for the Cappella del Sacro Cingolo in Prato Cathedral (fig. 12).[74] On the other hand, the palmettes on the frieze—quite classical in their design—forecast the incisive clarity of the bronze palmettes and the lupine patterns by Pasquino that he would add to that same grille to complete the design of his teacher, Maso. The cherubs on the frieze beneath the pediment and under the arch as well as the God the Father on the tympanum are the work of Pasquino (who, in any event, was the principal carver through 1451)—either by him or done under his direct control—as is abundantly demonstrated by a comparison with the sphinxes that he executed at least a decade later, and that therefore are stylistically more mature and more fully realized, on the pulpit at Prato (fig. 16).[75] Now that Francesco Caglioti has discovered a document linking Pasquino and Desiderio da Settignano,[76] all the stylistic details that recall those of the great sculptor—the pudginess of the cherubs, the softness of the plumage, the delicate rendering of the festoons and the ribbons—have definitively been confirmed. As was recognized long ago by Clarence Kennedy, the two adoring infant-angels to either side of God the Father on the tympanum (fig. 19) are, instead, by the hand of Michele di Giovanni and were probably sculpted in the fall of 1454.[77] A documentary reference to a request by Fra Carnevale for a gilder from Florence—expedited through the good offices of Maso's brother, Giovanni—should probably be associated with putting the finishing touches on the portal. That the portal received gilding may be deduced from the traces of color still present on the most sheltered parts (the sculptures for Count Federigo's new apartments were likewise gilded).[78] The portal no doubt produced its intended effect, since both its decorative motifs and its compositional syntax were imitated shortly afterward: a stone carver—perhaps a Dalmatian, educated in a Late Gothic style—reproduced the decorative candelabra in the Palazzo Ducale at Pesaro, while on the door of the church of Sant'Agostino at Ancona Giorgio da Sebenico juxtaposed a frieze of leaves, folded into the most bizarre shapes, with classically fluted columns (1460).[79]

The triumphal portal of San Domenico—which, we must imagine, was red, blue, and gold, enhanced by the gleaming azure and white of the glazed terracotta—faces

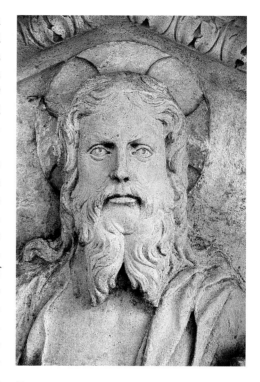

15.
Pasquino da Montepulciano, *God the Father*, from the tympanum of the portal, San Domenico, Urbino

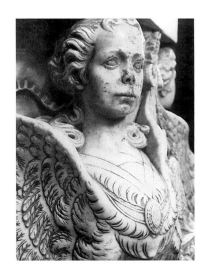

16.
Pasquino da Montepulciano,
Sphinx, from the base of the pulpit,
detail. Prato Cathedral

17.
Maso di Bartolomeo and Workshop,
Frieze, detail.
Portal, San Domenico, Urbino

Count Federigo's first architectural commission: his new apartments in the rebuilt Palazzetto della Iole. When we stop to think about it, the project for the Palazzetto is hardly unexpected. From many standpoints, the seizure of power in 1444 by Count Antonio's young, illegitimate son—Federigo—marked a decisive turning point for the modest capital. Even in fixing his place of residence, Federigo decided in favor of altogether new solutions. Abandoning the traditional apartments of the Montefeltro counts, whose rooms were covered with the emblems of the old lords and images of their courtly way of life, he opted instead for a space constructed *ex novo,* decorated in an antiquarian figurative language that is restrained yet modern, capable of embodying the renewed ideals of the Montefeltro, as it had those of the Malatesta, the Manfredi, and the Gonzaga. It may seem superfluous to evoke the passage in Leon Battista Alberti's *De re aedificatoria* in which the great theorist states that the house of the lord, if it is not to be confused with that of the tyrant, must be "accessible and richly ornamented, distinguishing itself more for its elegance than for its grandeur"[80]—words that were, perhaps, less a suggestion than a confirmation of decisions that Federigo had already made.

All else aside, however, the very location of the new apartments is extremely suggestive, since it cannot help but bring to mind the planning process that led to Cosimo de'Medici's new palace in the via Larga in Florence. When Fra Carnevale arrived in Florence in 1445, the site on which the gigantic stone mass of the Medici palace was to rise was occupied by an enormous void left by demolitions: a rupture in the urban fabric that, even before construction began, impressed contemporaries by its vastness.[81] Certainly, to anyone who frequented the studio of Maso and Michelozzo the building plan must have been well known, even in its successive modifications: especially the close relationship that was to be established between the palace and the Medici parish church of San Lorenzo, both of which, according to Vasari's account, Brunelleschi would have liked to situate facing and overlooking the same public piazza. It cannot fail to strike us that this is the identical relationship of the Dominican church and the rebuilt Iole wing of Federigo's new residence: palace and temple face-to-face in the center of the city.[82] Federigo's desire to adhere to the Florentine model was to have a logical sequel: just as soon as he had consolidated his own financial situation, he called upon Luciano Laurana to build the central courtyard with monolithic columns—the distinguishing characteristic of the Medici courtyard as well—and to create a façade faced in stone. In fact, in 1466, Federigo Galli, who had succeeded his father, Angelo, in the role of secretary to the count, was in a position to sing the praises of the palace and its owner, employing Vitruvian hyperbole.[83] The stages of the construction of the Iole wing have been convincingly described by Pasquale Rotondi and reiterated with new precision by Janos Höfler.[84] They involved restructuring and increasing the height of partly preexisting buildings so as to obtain apartments consonant with Federigo's elevated status. One reached these new apartments by means of a staircase located to the north—more or less on the site of the present one by Laurana—which, if it was external, would have had the appearance of many such staircases in Northern Italy, precisely documented in the drawings of Jacopo Bellini, as well as in the still extant staircase in the Corte Vecchia in Ferrara.[85] The plans appear to have been implemented rather slowly, beginning toward the

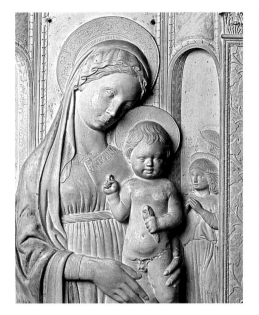

18.
Michele di Giovanni, called Il Greco,
Madonna and Child, detail.
Galleria Nazionale delle Marche,
Urbino

19.
Michele di Giovanni, called Il Greco,
Angel, from the tympanum of the
portal, San Domenico, Urbino

end of the 1440s—for Federigo fatiguing years marked by frequent military campaigns—but came to a preliminary conclusion during the 1450s, so that we may, perhaps, take seriously the traditionally accepted date of 1454 for the foundation of the palace[86]—all the more so in that this date coincides perfectly with the termination of work on the portal of San Domenico and the presence of Pasquino and of Michele di Giovanni (Il Greco) in Urbino (by 1457, both stone carvers were far from the city of the Montefeltro: Pasquino had returned to Florence and Michele was in Dalmatia, further suggesting that work probably had been concluded).[87] Overriding evidence for recognizing Il Greco as the author of the sculptures in the Iole wing was put forward by Kennedy, and despite the reservations expressed by Rotondi, this hypothesis is now confirmed by some works in Dubrovnik that can be attributed to the sculptor.[88]

To confer something innovative upon those bare walls, where the crenellation was the only noble aspect of the old palace, biforate windows (fig. 21)[89]—which Baldi still found *"alquanto del gotico"* (quite Gothic)[90]—were borrowed from Florentine sources: they are clearly derived from drawings by Michelozzo's shop, if not from the direct example of the Palazzo Medici, as demonstrated by the lateral pilasters supporting the arches, indicating a superior, rational approach. (It is very hard to distinguish these pilasters from below, but they testify to an undeniable architectural logic.) The festoon of small arches—a motif used by Michelozzo at Santa Croce on the windows of the novitiate chapel, displaying unrestrained taste for the archaic and the neo-Gothic—is quite similar to that on the frame of Fra Carnevale's polyptych (cat. 41 C), where their juxtaposition with the fictive marble backgrounds of the paintings—of Rossellinian derivation—shows the same sort of old-fashioned solution.[91] Despite the presence of such elegant touches, nothing would have led one to suspect, in the early 1450s, that the palace in Urbino could equal the magnificence of the Palazzo Medici in Florence. Among other reasons, at the

20.
Luca della Robbia,
Madonna and Child with Saints
(lunette from the portal of San Domenico).
Galleria Nazionale delle Marche, Urbino

time the count could not justify a lavish expenditure on stone. It is very probable that the plans called for a plastered façade, either painted or covered with incised decoration (sgraffito). This would have conferred greater coherence on the façade and eliminated the effect of the windows' seeming to be perched on a slender, continuous stone stringcourse —a white line that is too thin to leave any real mark on the great mass of wall. It is also possible that the plan was to execute false ashlar facing of cornices and architraves in sgraffito. Or a more festive façade might have been planned, in the North Italian tradition, such as the count could have seen in Venice, Mantua, or Ferrara, and like that depicted by Piero della Francesca on the building in the background in the *Flagellation* (Galleria Nazionale delle Marche, Urbino):[92] consisting of marble intarsia in geometric patterns with heraldic devices and, perhaps, some finishing details in gilded stucco.

The most innovative aspects of the new apartments are to be found, however, in the interior decoration, where the beautiful limestone from Piobbico was employed along with the even finer, if more fragile, stone from Cesane, offering a material as dense and white as ivory for the extensive carved ornament.[93] In the sixteenth century, Baldi described the rooms of the Iole wing, situating them stylistically and chronologically within the palace as a whole: "The fireplaces . . . of the old rooms, although they have been diligently worked, still have much about them that is barbarous, as may be seen in the room of the apartment where, in the guise of caryatids, stone figures of Hercules and Deianira support the moldings [of the fireplace]."[94] The densely carved frames of the secondary doors and the windows were probably made before the fireplace. The doors have a continuous cornice with a return at the base and a triangular pediment above, as in the Pazzi Chapel at Santa Croce. Among the other doors, the one opening into the room frescoed by Giovanni Boccati with the cycle of *Famous Men* (*uomini famosi*) repeats the Donatellian motif of a series of seashells, such as Maso would later carve on a window of the Palazzo dei Rettori at Dubrovnik,[95] while on the pediment two putti support Federigo's device of an exploding grenade, or flaming petard—cousins to the cherubs on

21.
Window, from the
Iole wing of the
Palazzo Ducale, Urbino

the door of the novitiate chapel in Santa Croce. In the tympanum of the door leading from the Camera Picta, with frescoes of *Famous Men,* into the so-called Sala dell'Alcova (named after Fra Carnevale's painted sleeping alcove), there are, instead, three heads of adolescents that resemble enlarged, slightly rustic transcriptions of certain Ghibertian figures on the north door of the Baptistery in Florence. The most complex decorations, however, are those on the window frames, with their deep, stone embrasures; their borders decorated with strips of vegetal motifs; and cordons, or geometric elements, interspersed with roundels containing heads and rosettes (fig. 24, 28, 29). This motif, of classical origin,[96] took on new, autonomous life in the Middle Ages and was fashionable in Florence in the 1440s, in painting[97] as well as in sculpture. The most pertinent example, albeit far coarser than that at Urbino, is provided by the frames of the doors and windows of the Pazzi Chapel (fig. 25),[98] or (as Massimo Bulgarelli has reminded me), the architraves of the tabernacle at San Miniato al Monte, where heads appear to burst from their corolla-like rosettes in accordance with a Tuscan decorative tradition dating back to the thirteenth century (fig. 27). The interlacing of ornamental and vegetal motifs in a style at once geometric and naturalistic was part of Maso's repertory from the time that he worked on the Cappella del Sacro Cingolo (fig. 12). The window seats rest on double balusters[99] decorated with scales or leaves that are bound at the center by a leather lace with a buckle, recalling again a motif employed by Maso in his grille at Prato (fig. 4), as well as the indomitable lily-like branches of his candlesticks at Prato and Pistoia. Yet, amid these Florentine motifs, so typical of Maso's workshop, there appear within the arched lintels of the windows of the Sala della Iole elements that unexpectedly digress. The acanthus leaves, succulent and gathered in bunches as though harvested from the same plants as the coarser ones on Filarete's bronze doors for Saint Peter's (on which Pasquino had collaborated), testify to an altogether different ornamental rhythm. Then there are features that, although certainly characteristic of the decorative repertory of Gothic stoneworkers, also belong to that of illuminated manuscripts, where they appear as *bas-de-page* drolleries: motifs such as a carved head with a leaf entering an ear and emerging from the figure's mouth, or emblematic details from fables involving animals, such as a bird doing battle with a snake (fig. 23)—an invention drawn from the workshop's repertory and reused by Pasquino in his portions of the grille at Prato (fig. 22). To these must be added some very beautiful little heads, carved with a pungent truthfulness—near portraits that, in a display of skill, protrude, in perspective, from stone roundels (fig. 28, 29). How can we fail to recognize that they derive from Ghiberti's Baptistery doors; from those by Maso, Luca, and Michelozzo for the sacristy of Florence Cathedral; or, even from Paolo Uccello's majestic painted clock (fig. 30), for that same building (1443), which so impressed Giovanni di Francesco, among others, and still merited special mention from Vasari a century later?[100] This wealth of diverse motifs required an authoritative mind—for a task of coordination and assembly—and the imagination necessary to combine such different repertories leads us to suppose that the personality in question was one less conditioned by the workshop traditions of a stoneworker and more like that of Fra Carnevale, who—now that we know that he provided drawings for the stone carvers of the cathedral in 1455—becomes a credible candidate as overseer of the decoration of Federigo's apartments. His role seems

22.
Pasquino da Montepulciano,
Grille of the Cappella del Sacro
Cingolo, detail. Prato Cathedral

23.
Michele di Giovanni, called Il Greco,
and Workshop, Cornice of a window
in the Sala della Iole, Palazzo Ducale,
Urbino

24.
Michele di Giovanni, called Il Greco,
and Workshop, Decoration on a window
in the Sala della Iole,
Palazzo Ducale, Urbino

25.
Workshop of Michelozzo (?),
Decoration on a window in the Pazzi Chapel,
Santa Croce, Florence

26.
Luca della Robbia,
Cherub, from the tomb of
Bishop Federighi,
Santa Trinita, Florence

27.
Thirteenth-century sculptor (Lapo?),
Pluteo. Museo dell'Opera
del Duomo, Siena

24. 25.

confirmed by the manner in which ornamental motifs were composed: extrapolating them from their context and bringing them together as though they were the tesserae of a mosaic, emptying them of their iconographic significance and emphasizing instead their formal values. This is the same mind at work in the Barberini Panels.[101] The figures of maenads, Satyrs, or of dancing nudes, derived from ancient sarcophagi or friezes, are used to decorate the architecture with little heed to their original context or sequence. Yet, if we compare them closely with the figures painted—not to say carved—in the background of Fra Carnevale's pictures (fig. 34), we find the same pungent draftsmanship (perhaps somewhat forced, from an expressive standpoint), lanky bodies, and piecemeal approach to composition, as in the frieze of the fireplace in the Sala della Iole (fig. 31, 35). What is at issue here is a use of ancient motifs, each one enclosed within its own pictorial field and outlined by moldings—as on a sarcophagus or the front of an altar. This treatment does not diminish the prestigious, if somewhat melancholic, status of these motifs as *spolia* (reutilized archaeological fragments). The parts are reproduced with an attention to the material beauty of the marble and the way it is carved as well as to the nobility of the individual forms, but there is little interest in either the syntax or the meaning of the classical language as a whole. This approach is very close to the one we find in the interior of the Tempio Malatestiano in Rimini, and it is not by chance that the best contemporary comparison for the bas-reliefs in Fra Carnevale's paintings is offered by the marble reliefs decorating the chapels dedicated to the Planets and to the Liberal Arts in Sigismondo Malatesta's "temple" in Rimini.[102] The mentality behind these projects corresponds with

28.

29.

28 and 29.
Michele di Giovanni, called Il Greco,
and Workshop, Decorations on windows.
details. Sala della Iole, Palazzo Ducale, Urbino

rare precision to that vade mecum of antiquarian knowledge that was prepared for Filarete in 1459–60 at the latest[103] by Porcellio Pandoni, a humanist who was in constant contact with Urbino. Recently rediscovered in the Vatican Library, Porcellio's text gives us a unique, accurate, and very useful gauge of the antiquarian foundation of an artist and architect of the uncommon cultural attainments of Filarete. Brief citations, literary quotations, ekphrastic fragments (descriptions of famous statues and pictures, mostly drawn from Pliny), and bits of mythological and antiquarian erudition are juxtaposed, one next to the other, in no particular order and according to no cultural hierarchies, structured according to some tenuous logic of classification, like the badly organized entries in some pocket encyclopedia.

Fra Carnevale's firm guidance, his constant control, and the utilization of his precise drawings for the figures and outlines of the ornamental parts of the architecture may explain how it was that the hand of Michele di Giovanni (Il Greco) and his workshop produced results so much more felicitous than usual (their customary level of achievement is seen in the two angels on the portal of San Domenico and in the relief of the *Madonna and Child* in the Galleria Nazionale delle Marche in Urbino [fig. 18]). In the palace decorations there is no trace of the far more highly developed manner of Pasquino, characterized by more complicated and expressive draperies, a rendering of the figures that alternates a continuous modulation of those planes carved in depth with foreshortened profiles in low relief, achieved by means of a *stiacciato* technique derived from Donatello, and a soft and tremulous treatment of flesh areas. This is quite distinct from the relief style of Il Greco: rounded and puffy forms, with sharply delineated contours. In the smiling faces carved by the latter, the irises of the eyes are always outlined and the pupils

30.
Paolo Uccello, *Head of a Prophet,*
from the clockface. Florence Cathedral

31.
Michele di Giovanni, called Il Greco,
and Workshop, Fireplace.
Sala della Iole,
Palazzo Ducale, Urbino

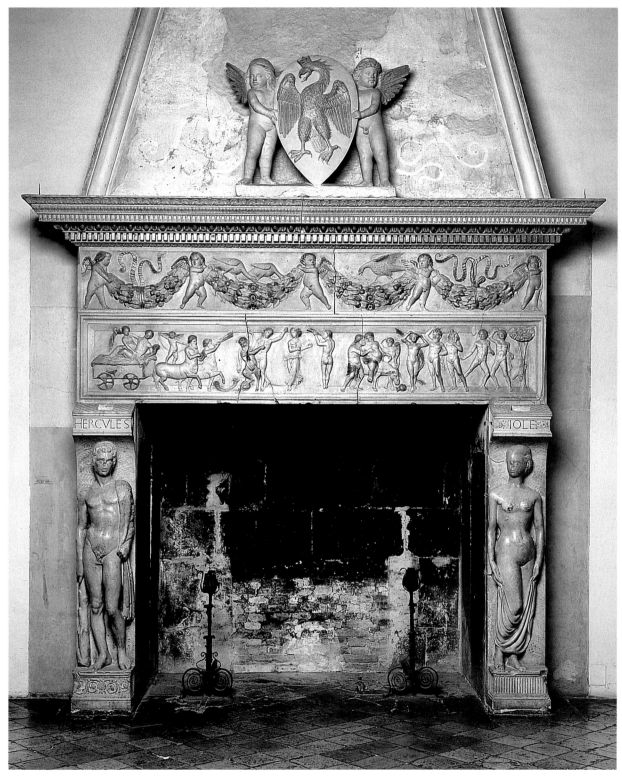

31.

are indicated by a small hole made with a drill (fig. 24), the profiles are always topped by curly ringlets, and the physiognomies are always a little child-like. One sees, in these faces, elements of the sculpture of Luca della Robbia (fig. 26), with whose shop Michele was in contact as a result of the dealings of his own master, Maso.[104]

In seeking to establish a chronology of the work in the apartments of the Iole wing of the Palazzo Ducale, it is necessary to begin with the corbels whose volutes take the form of a double *S*. Michelozzian in character, they are not easily found in this particular form even in Florence and conceivably were designed specifically for this site by Fra Carnevale.[105] We then move on to the fireplaces and the frame of the door that gave access to the rooms from the staircase (fig. 31, 39, 40). The large fireplace in the principal room, supported by caryatids representing Hercules and Iole, is the earliest known example of this type, and incorporates as well the literal imitation of an ancient sarcopaghus with a Dionysiac and amorous theme—another "first."[106] In fact, if the figures of the two demigods—nude, as befits representations of ancient heroes[107]—are borrowed from the precocious mythological figures of Hercules and Abundance on the Porta della Mandorla of the cathedral of Florence (fig. 32),[108] and if the pitched-and-tiled canopy over them[109] resembles Late Gothic goldsmiths' work rather than an ancient structure, the two bas-reliefs that form the lintel not only reprise ancient motifs, but their juxtaposition imitates the coffin-like effect and sloped lid of a sarcophagus, implying that the artist was able to study his model at firsthand; this, far more than the faithful reproduction of the figural composition, may be the proof that Fra Carnevale made a trip to Rome. The figures have been taken from a Dionysiac sarcophagus, one of the most celebrated of which was in Santa Maria Maggiore in Rome,[110] although another version, in the Camposanto at Pisa, was perhaps the example studied by Lorenzo Ghiberti.[111]

What is certain, at any rate, is that the literary praise penned by Porcellio[112] of this kind of Dionysiac sarcophagus would hardly have been a sufficient source for the design

32.
Early fifteenth-century Florentine sculptor, *Abundance.*
Porta della Mandorla, Florence Cathedral

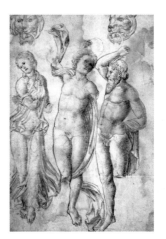

33.
Lombard master (?), Figures copied from an antique sarcophagus.
Biblioteca Ambrosiana, Milan

34.
Fra Carnevale, *The Presentation of the Virgin in the Temple (?),* detail.
Museum of Fine Arts, Boston

35.
Michele di Giovanni, called Il Greco, and Workshop. Fireplace, detail.
Palazzo Ducale, Urbino

36.
Fra Carnevale, *Study of Putti*,
Nationalmuseum, Stockholm

37.
Michele di Giovanni, called Il Greco,
and Workshop, Doorway into the
Iole apartments, detail.
Palazzo Ducale, Urbino

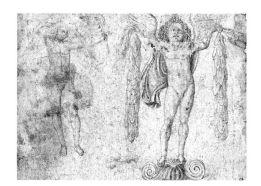

38.
Giovanni di Piermatteo Boccati,
Camera Picta, detail.
Palazzo Ducale, Urbino

of the lintel of the Iole fireplace: what was needed were faithful drawings that interpreted and reelaborated the sarcophagus's individual components (fig. 33).[113] Equally certain is that Michele di Giovanni, on his own, could not have recomposed the texts of these stories, or decided how to integrate the missing archaeological parts or to interpret the timeworn and corrupted subject matter, let alone put the whole thing together. Similarly, it was surely not the stone carver who had the idea of inserting into the fireplace of the Camera Picta the learned quotation from an ancient architectural feature—the frieze of the Basilica Aemilia—much admired by Alberti, or the putti playing instruments, derived from Donatello.[114] The rare subject matter of these fireplaces somewhat exceeds the norm of courtly taste. Although the presence of Hercules and Iole has been taken for granted, it should not be: the inclusion of this pair implies a certain erudite pretension at work, perhaps that of the old, courtly secretary and poet Angelo Galli, who, not coincidentally, died in 1459:[115] one must have the patience to follow the thread of ancient tradition from antiquity to Dante and Boccaccio.[116]

Such faithful antiquarian images cannot help but recall the example of the Palazzo Medici, in the late 1450s and early 1460s, during the last years of Cosimo's rule and the first of Piero's: specifically, the garden where ancient statues of *Priapus* and of *Marsyas*—the latter restored by Mino da Fiesole—were displayed, and the courtyard decorated with roundels of mythological scenes copied from antique sources.[117] Although the apartments in Urbino were perhaps finished before work on the Palazzo Medici was concluded, the Florentine palace probably had provided Federigo with a fitting example.

Some idea of Fra Carnevale's numerous drawings for these works is evident from a sheet in Stockholm assigned to him by Andrea De Marchi (fig. 36)[118] showing one putto with a bow and another on a shell-shaped acroterion holding garlands—an echo of Donatello's putti on the baptismal font in Siena. Similar figures are found on the frieze of battling putti decorating the door in the Sala della Iole (fig. 37);[119] that the drawing is of the same date is demonstrated by the elongated and shapely grace of the figures, whose proportions are not far from those of Maso's bronze sprites on his grille at Prato. The typology of this door (fig. 39), which will become absolutely canonical in the palace in Urbino, is conspicuously copied from Michelozzo's in the novitiate chapel in Florence (fig. 22)—a model that was also repeated by Matteo Nuti at Cesena in 1452[120] and, with a greater architectural understanding, by Luca Fancelli at the Gonzaga palace in Revere.[121]

This is not surprising, since the prototype had a strong, evocative power, as Vasari testified, when he remarked that it "was so very rare at that time for works to imitate the good style of ancient monuments, as this one does."[122]

That Fra Carnevale was the general director of the decorative program for the new apartments seems to be further borne out by the unexpected architectural complexity of Giovanni Boccati's cycle of frescoes of *Famous Men* (fig. 9, 10, p. 48), which seems to have been executed for the wedding of Federigo and Battista Sforza in 1459.[123] The painter, perhaps summoned by Fra Carnevale himself in consideration of their shared Florentine apprenticeship, never created a more resolved and complex architectural scheme: every element is rationally worked out in a measurably believable manner to create the illusion of an open loggia (whether it terminated in a simple attic with quadrangular balusters, as in Andrea del Castagno's cycle at Legnaia (1449–50), or was supported by quadrangular piers, as in Mantegna's *Baptism of Hermogenes* in the Eremitani in Padua,[124] is impossible to say, given its poor state of preservation): the loggia, from which hang brocaded cloths (fig. 38), their lacing carefully described, is surmounted by a curtain held by putti—seemingly the first invention of this kind. The brocade pattern is the same as that on the ceiling of the count's alcove, which was conceived by Fra Carnevale. The putti in the lunettes, who bustle about amid large bronze kraters, even lifting them with a complicated system of pulleys, are inspired by those on ancient sarcophagi dedicated to the seasons.[125] The preparation of the apartments for the new countess—whose fortunes and family connections were far superior to those of Federigo's first wife, Gentile Brancaleoni—seems to have concluded with the alcove (fig. 41); a genuine work of architecture, it is similar to a large architectural model and in every way is worthy of Federigo, of whom Vespasiano de'Bisticci recounts, not without the inevitable courtly adulation, that "to hear people talk, it seemed that the most important matter to which he had ever devoted himself was architecture."[126] This element of furniture, which enclosed the count's bed as though it were in a small room, has been dismantled and reassembled several times; its present appearance is the fruit of a reassembly—in part arbitrary—resulting from the extensive replacement of the lower portion.[127] Frequently dated after 1459, the alcove becomes entirely comprehensible if assigned a date no later that that.[128] The Gothic initials—if, indeed, they may be read as *FD* (Federicus Dux)[129]—were certainly easier to modify than the many initials carved in stone on the doors and windows of the palace. Those inscriptions were altered following Federigo's investiture as duke in 1474 by adjusting some of the paint. The architectural structure is perfectly explicable in terms of the treatment of the ground floor of Alberti's Palazzo Rucellai in Florence (fig. 43, 44).[130] The Doric order[131]—austere, virile, yet also elegant—would have struck the count as increasingly desirable once Leon Battista Alberti[132] had explained to him, during his visits to Urbino, the rationale for its proportions and the reason for the plinth. Fra Carnevale, working up the notes that he would have taken on such an occasion, eliminated the celebrated ancient-style rustication of the wall in the Palazzo Rucellai, justifiable only on an exterior, and replaced it—since this was a question of interior decoration—with renderings of the most luxurious polychrome marbles, which he had learned to paint while in Lippi's workshop and in which, with a subtle sense of space, he incorporated the count's

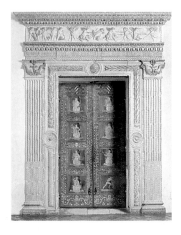

39.
Michele di Giovanni, called Il Greco, and Workshop, Doorway in the Iole apartments, Palazzo Ducale, Urbino

40.
Michele di Giovanni, called Il Greco, and Workshop, Fireplace in the Camera Picta, Palazzo Ducale, Urbino

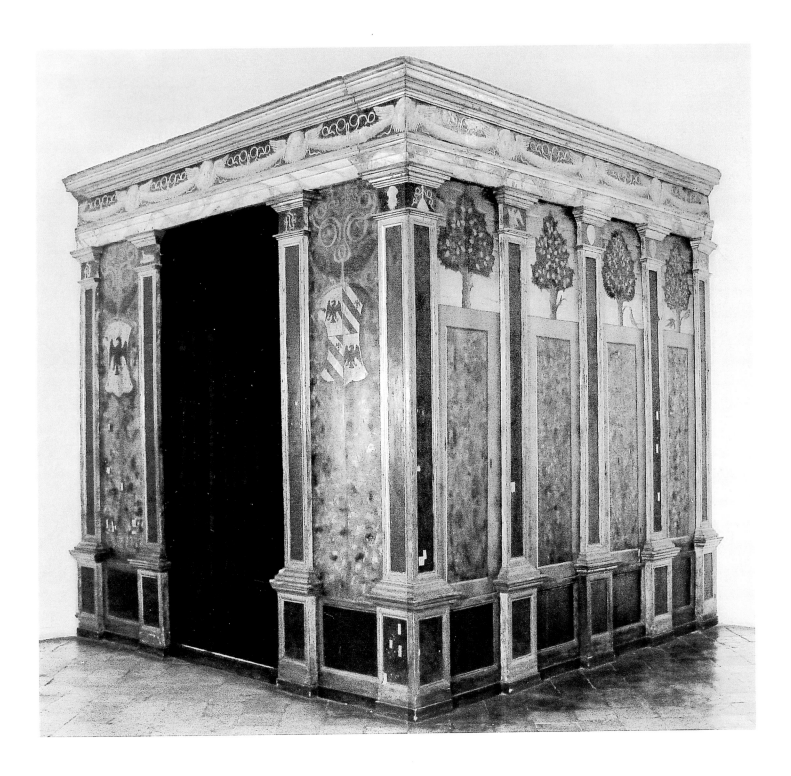

41.
Fra Carnevale, Sleeping alcove.
Palazzo Ducale, Urbino

heraldic symbols (fig. 42). The magnificent ceiling of brocaded cloth is entirely worthy of the cope worn by Saint Zenobius in Domenico Veneziano's *Saint Lucy Altarpiece* and Giovanni di Francesco's altar frontal at Petriolo.[133] Lastly, there are the garlands with putti heads—of pure, Florentine-Michelozzian ancestry (fig. 1, p. 22). In contrast to this refined decoration are the little trees that an heir to Antonio Alberti's shop must have executed: composed like a collage, they still exhibit the craftsman-like grace of a flowering field in the Late Gothic tradition. During the cold winters of Urbino this type of decoration must have provided the illusion of a garden in bloom, but it probably also reminded the count of a wall in one of the bedrooms in the villa of Pliny the Younger, which had been similarly decorated with frescoes of marble and of a garden visible beyond.[134]

42.
Fra Carnevale,
Armorial device, from the
sleeping alcove, detail.
Palazzo Ducale, Urbino

The Two "Perspectives"

In 1455 Fra Carnevale was directing the work on the cathedral of Urbino. The crucial, newly discovered document that establishes this fact also provides a context for the two Barberini Panels by proving that the author of these two enigmatic and solitary masterpieces had a talent for architectural design and the kind of practical background that derives from working on a construction site itself. The document relates to the furnishing of stone for the cathedral, and it throws light on the progress at the work site, noting that in 1453 and 1455, property belonging to the Ospedale di Santi Spirito e Lazzaro was sold to finance ongoing construction work.[135] In this document, Bartolomeo di Cristoforo, a supervisor (*operaio*), contracts the stonecutter Francesco di Matteo di Monte Corvi[136] to carve the bases of columns and pilasters as well as the keystones of the arches using material already on site;[137] Corvi would also be responsible for procuring more stone for capitals to be made according to drawings provided by Bartolomeo di Cristoforo himself or by Fra Carnevale, who witnessed the contract. The document was drawn up in the house of the legal scholar Matteo Catanei,[138] who, in 1471, left a large sum of money to be spent on the cathedral when work resumed. These documents must relate to a building project begun in 1437—following a papal bull issued by Eugenius IV—for which the first stone was laid in 1439.[139] However, so slowly did work proceed that by the time Fra Carnevale was appointed to superintend the architectural decoration, the material for the pilasters and columns had just been brought to the site. It would seem that the plans were for a vaulted structure with a nave and at least two side aisles, conceived along Gothic lines. However, the 1430s were not a propitious period for building in the region and it is difficult to find analogies for the structure (which does not survive). Nor is it easy to speculate on Fra Carnevale's intervention. Perhaps he intended to give an essentially Gothic building an antique veneer, along the lines of Michelozzo's creations, such as the Medicean church at Bosco ai Frati. Or it might have prefigured the stylistic compromise of Bernardo Rossellino's cathedral in Pienza for Pope Pius II. At any rate, the earthquake of December 1456[140] must have interrupted work for the umpteenth time, and possibly also drew attention to the structural difficulties involved in building the church on an unsound, steeply sloping terrain subject to landslides. In the event, the matter was resolved in a radical fashion some years later by Francesco di Giorgio. Initially, he was

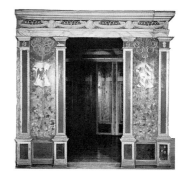

43.
Fra Carnevale,
Sleeping alcove,
Palazzo Ducale, Urbino

44.
Leon Battista Alberti, Façade of the
Palazzo Rucellai, detail. Florence

45.
Florentine goldsmiths' work, from a
design by Leon Battista Alberti,
Healing of a Man Possessed by Demons,
plaquette. Musée du Louvre, Paris

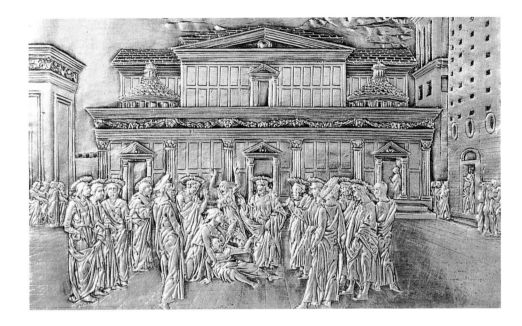

summoned to solve problems of stability and engineering, but in the end he planned a
new, grand and impressive cathedral (now destroyed).[141]

Fra Carnevale's involvement with the actual construction was to supply the foreman
with drawings. There is an analogy here—although we must be careful to maintain a
sense of relative merit and proportion—with Alberti, who had the habit of directing con-
struction projects by providing drawings and of working through talented foremen such
as Matteo de'Pasti or Luca Fancelli.

If, on the cathedral project, our artist-friar was called upon to "ornament" a building
for which plans already were substantially under way, in painting he was able to deal with
the Albertian theme of the Christian temple without the constraints of a preexisting
structure. From an architectural standpoint, the problem consisted of adapting what was
seen as the "universal" constructive and decorative language of classical antiquity—the
"classical" idiom—to a type of building that, in a manner of speaking, had risen from the
ashes of the Vitruvian universe. Even when judged in purely figurative terms, the
significance of the architecture in the two "perspectives"—as the Barberini Panels were
called in seventeenth-century inventories[142]—was to recontextualize Christian stories
within a prestigious cultural code: one that, given the intellectual climate of the day, espe-
cially in Urbino, was necessarily "antique."[143]

In the panel in Boston (fig. 50 and cat. 45 B) the problem is faced head on, for the
subject of the *Presentation of the Virgin in the Temple (?)* required the portrayal of a building
not merely to provide a setting but also, and above all, to suggest in visual terms the pas-
sage from the Old to the New dispensation. In depicting an ancient "temple," the friar
proudly displays, for those who are able to perceive it, his awareness of the extreme
difficulty and crucial importance of a consummate Albertian problem.[144] "No aspect of
building requires more ingenuity, care, industry, and diligence than the establishment and

ornament of the temple," wrote Alberti.[145] So it is not surprising that, in looking for the antecedents of Fra Carnevale's depiction of architecture, the most interesting comparison is found in a small silver plaque in the Louvre (fig. 45), from the late 1430s or early 1440s, which probably repeats an architectural invention of Alberti.[146] In the scene from the Gospel story of Christ liberating a man possessed by a demon, the dominating presence is that of a large temple—at once ancient and modern—which occupies the background, rising up on a podium reached by stairs. The temple's entire structure, not just its façade, is clearly emphasized. The episode takes place in a large piazza populated with groups of bystanders who are more or less involved in the narrative. If, as Massimo Bulgarelli has demonstrated, the ecclesiastical structure shown on the plaque is a reworking of the Venetian basilica of San Marco, Fra Carnevale offers, instead, a Late Antique basilica,[147] perhaps studied in Rome, where he must have gone between autumn 1451 and early 1452.[148] It is also possible that he made a brief trip to Rome during the Jubilee of 1450, possibly with Angelo Galli, or maybe at some other time in the 1450s for reasons related to his position in his religious order.[149] What would seem to clinch the point is that his painting of a basilica bears a strong resemblance to the church of Santa Sabina on the Aventine Hill, an important Dominican center in the Quattrocento. Beside the arches on plinthless columns, there is the apse, conceived as independent of the colonnade, as well as the clerestory windows, which, in the fifteenth century, numbered five on each side of the nave and differed from those we see today.[150] The friar's apprenticeship in Florence is revealed in the way that, almost through a process of stylistic automatism, the order in the nave of Santa Sabina becomes Ionic (fig. 46), like that in the Dominican library of San Marco in Florence built by Michelozzo. In accordance with a practice current in Florence in the 1430s and 1440s, the capitals are rotated ninety degrees and are thus seen head on rather than aligned with the arcade. This liberty in the use of the Ionic order was probably due to Brunelleschi, who, in the Barbadori Chapel in Santa Felicità, Florence, oriented the capitals both orthogonally and longitudinally.[151] In any event, in the loggia in the *Annunciation* (cat. 40), Fra Carnevale had already adopted a very brilliant Michelozzian model[152] for the Ionic order together with an orthogonal orientation (fig. 47). An Ionic order, rotated, may be seen in Paolo Uccello's frescoes in Prato Cathedral[153] and in those he executed in *terra verde* at San Miniato al Monte (fig. 48), as well as in the work of Pesellino (cat. 21) and in actual buildings in those same years—even in a palazzo sometimes ascribed to the young Alberti.[154] If it could be proven that the loggia of the Arcangeli-Odasi house in Urbino was erected according to a plan Fra Carnevale made in the early 1460s—a few years earlier than the Barberini Panels for Santa Maria della Bella—we would have further confirmation that the friar knew perfectly well how to handle the Ionic order, since there the capitals are oriented parallel with the trabeation. The inversion in the *Presentation of the Virgin in the Temple (?)* would then have to be understood as a nostalgic evocation of the Florentine style—like the female heads borrowed from works by Filippo Lippi of the 1440s.[155]

The ceiling of the temple in the *Presentation* is constructed with antiquarian precision using beams, as in ancient basilicas, instead of the handsome vaulting of the cathedral of Urbino on which the friar was in charge of the work. The pavement repeats that of the

46.
Fra Carnevale, *The Presentation of the Virgin in the Temple (?)*, detail.
Museum of Fine Arts, Boston

47.
Fra Carnevale, *The Annunciation*.
National Gallery of Art, Washington, D.C.

48.
Paolo Uccello, Frescoes, detail.
Cloister, San Miniato, Florence

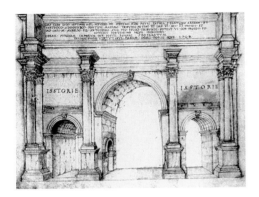

49.
Giuliano da Sangallo, *Arch of Septimus Severus,*
drawing from the *Codex Barberiniano.* Biblioteca
Apostolica Vaticana, Vatican City

Pantheon in Rome, where large marble disks (*rotae*) alternate with colored marble squares.[156] Just as extraordinary as the temple interior is the perspective structure, which we must imagine as disappearing beneath the gilded arches of a Gothic frame, constructed to suit the tastes of the confraternity brothers who commissioned the work. This frame also formed an Albertian "window," which, in its divergence in style from the painted scene thus became "modern": a diaphragm between the real world and the fictive realm of the painting, it was precisely because of its stylistic divergence that it underscored the ancient world depicted in the narrative. This kind of contrast between the universes of frame and picture had already been experimented with by Fra Carnevale's teacher, Filippo Lippi, especially in those works where the setting was consciously and conspicuously perspectival.[157]

The façade of the Christian temple—how, on the one hand, it should appear to grow structurally out of the building, closing off its space, but, on the other hand, also embody the meaning of the building itself and the aspect of it presented to the urban community—is one of Alberti's most important themes, pursued in the Tempio Malatestiano in Rimini, at Santa Maria Novella in Florence, and in his churches in Mantua.[158] The simplest solution was to adapt one of the most impressive and eloquent architectural forms from antiquity—the triumphal arch, erected to honor pagan emperors—to a new use, to represent the triumph of Christianity. Thus, taking as his point of departure the Arch of Septimius Severus, as restored in a drawing by Giuliano da Sangallo (fig. 49),[159] the friar constructed a marble-encrusted façade, consonant with what Pandoni had noted in his excellent dictionary of ancient art:[160] a façade ornamented with sculptures, as the Roman arches had been—but also like the interior of the Tempio Malatestiano.[161] At first glance, this would not appear to be a very novel solution, but there is a substantial difference between Fra Carnevale's design and the contemporary representations of façades in the manner of triumphal arches often mentioned by art historians, such as those by Jacopo Bellini—whose large canvases were used to stage an independent central scene[162]—or that by Vecchietta in the *Dream of the Blessed Sorore* (of 1441) in the Spedale di Santa Maria della Scala in Siena (fig. 51).[163] Vecchietta's fresco nonetheless offers numerous analogies in the decoration and in its composition with that by Fra Carnevale, who may well have had a chance to study the fresco in person,[164] given the interchange between the Montefeltro court and Siena. Vecchietta's structure lacks architectural solidity: it is less a façade than a clever means of closing off the nave and aisles of a grandiose church that is little more than an "ideal" version of Siena Cathedral.

By contrast, Fra Carnevale's façade, with its giant order of freestanding columns, is, if anything, too faithfully copied from its ancient model. Nonetheless, it is an architectural organism possessing an autonomous solidity, as demonstrated by the artist's care in rendering the thickness of the walls and extending the plinths of the columns around the door and, we may well imagine, onto the interior wall. It is almost as though in "planning" his building, the friar recalled Leon Battista Alberti telling how, at Rimini, he had solved the tricky problem of grafting a façade governed by the proportions of a classical order onto a Gothic church, patiently explaining to Matteo de'Pasti that "this façade had best be an independent work,"[165] since the roofing would, in any case, be incompatible

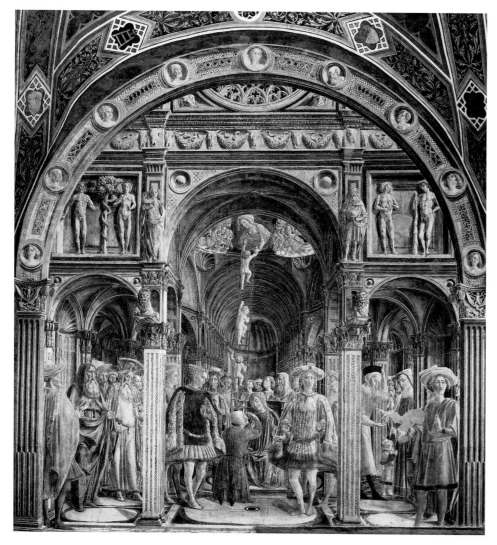

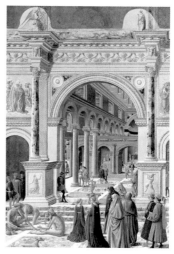

50.
Fra Carnevale, *The Presentation of the Virgin in the Temple (?)*.
Museum of Fine Arts, Boston

51.
Lorenzo di Pietro, called Il Vecchietta,
Dream of the Blessed Sorore.
Pilgrims' Hospice of the
Spedale di Santa Maria della Scala, Siena

52.
Fra Carnevale, *The Presentation of the Virgin in the Temple (?)*, detail.
Museum of Fine Arts, Boston

with the highest point of the façade. One of the details indicating that Fra Carnevale had the Tempio Malatestiano as well as its ancient model, the Arch of Augustus, in mind is the pier of the central arch, which is not marked by a pilaster but only by the wall, and where the cornice of the arch is supported by a trabeation inserted into that wall: a seemingly insignificant detail, but painted with care and meant to be a clue for those capable of recognizing its derivation.

As might have been expected, the dialogue with the urban setting of Urbino intensifies in the representation of the palace in the *Birth of the Virgin* (fig. 53 and cat. 45 A). If, as already mentioned, the prototype for the open arch derives from Lippi, much of the ornamentation is linked to the Palazzo Ducale. Not only the eagles (the count's device) but also the capitals derive from models from the friar's studio (fig. 63, 64), used, as we have noted, on the portal of San Domenico and also in the apartment of the Iole wing (note the dolphin motif on one of the capitals).[166] Even the Composite order, in which

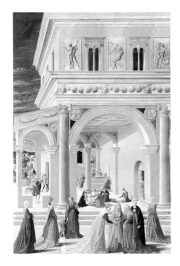

53.
Fra Carnevale, *The Birth of the Virgin*.
The Metropolitan Museum of Art,
New York

54.
Lazzaro Bastiani,
The Communion of Saint Jerome.
Galleria dell'Accademia, Venice

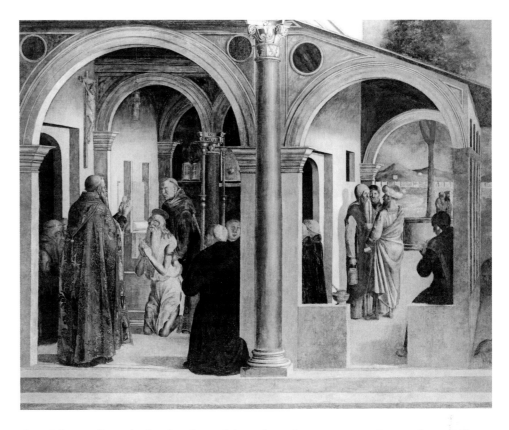

sheep's horns (fig. 56) take the place of the volutes, is a response to Laurana's magnificent capitals in the courtyard, or to the later ones in the wood paneling of the *studiolo*. It seems pointless to remark on the frequently noted return to biforate windows, now, however, set within a more modern "tabernacle" framework (fig. 65).[167] As already noted, the painter did not complete the carved decoration of the moldings, in keeping with the new style of the palace.

The concept of splendor proposed by Fra Carnevale—a palace decorated with large bas-reliefs with ancient themes, in accordance with a fashion set by the Medici, and in which the various phases of work on the Palazzo Ducale coexist rather than compete, thereby creating a new, ornate style—is something that was destined to remain the exclusive universe of the two extraordinary Barberini Panels. Laurana, and, after him, the Sienese Francesco di Giorgio, took a different course, and in the decade following the completion of Fra Carnevale's two panels for the altar of Santa Maria della Bella, the Palazzo Ducale would be covered with a magnificent but abstract veneer of drafted stones punctuated by doors and windows in the form of austere tabernacles. By some mysterious route, Fra Carnevale's palace in the Barberini Panels found an echo not in Urbino but in Venetian painting.[168] In Lazzaro Bastiani's canvas of the *Communion of Saint Jerome* (fig. 54)—painted for the *scuola* or confraternity devoted to that saint[169]—the architectural setting for the story is derived in such a blatantly obvious manner from that of the panel with the *Birth of the Virgin* as to make the problem inescapable: just note the detail

of the wall articulated by pillars on which fragments of trabeation serve as capitals. To explain these architectural forms, it is not enough to cite models in the albums of drawings by Jacopo Bellini, further elaborated by the latter's sons Gentile and Giovanni, with both of whom Bastiani collaborated. Rather, it is necessary to presume that Bastiani knew Fra Carnevale's picture—how, is difficult to say, except by evoking the web of dealings and relationships that linked Urbino with Venice. What is certain is that Bastiani's *Saint Jerome in His Study, Adored by a Patron* (Palazzo Arcivescovile, Monopoli, Puglia) also becomes easier to understand if we presuppose his knowledge of the panels of the *Liberal Arts* that decorated the *studiolo* in the Palazzo Ducale in Urbino. (This is especially evident if we observe the donor, posed obliquely but with his hands nonetheless visible and open in a devout sign of homage.) We might say that the spirit of Fra Carnevale's two famous "perspectives" was passed along, perhaps through Bastiani, to Carpaccio,[170] and then to other Venetian painters active at the turn of the fifteenth century. It is in Venice that the sober and expansive, luminous and color-filled, secular and novelesque narrative style of the Barberini Panels came to a definitive fulfillment: that succession of spaces peopled with figures contingently related to the story, and that manner of developing the narrative so that it does not neglect the sheer pleasure of "reading" the tale—of instructing while at the same time enchanting the viewer.

55.
Maso di Bartolomeo and Workshop,
Frieze, detail.
Portal, San Domenico, Urbino

ATRIA AND ARCHES IN RUIN

The presence in Urbino during the 1460s of works by Piero della Francesca was a fact that could not be ignored by those who, like Fra Carnevale, devoted themselves—even

56.
Fra Carnevale, *The Presentation of the Virgin in the Temple (?)*, detail.
Museum of Fine Arts, Boston

57.
Piero della Francesca,
Montefeltro Altarpiece, detail.
Pinacoteca di Brera, Milano

58.
Giuliano da Sangallo,
Courtyard, Santa Maria
Maddalena de' Pazzi
(Cestello), Florence

59.
Piero della Francesca,
Madonna and Child Attended by Angels,
detail. The Sterling and Francine
Clark Art Institute, Williamstown,
Massachusetts

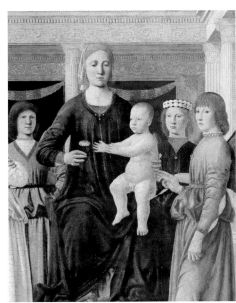

60.
Piero della Francesca,
Madonna and Child Attended by Angels,
detail. The Sterling and Francine
Clark Art Institute, Williamstown,
Massachusetts

61.
Piero della Francesca,
Montefeltro Altarpiece, detail.
Pinacoteca di Brera, Milano

intermittently—to painting. In the Barberini Panels he had introduced a number of motifs derived from the works of the great master from Sansepolcro: the architectural frieze with cornucopias and the greyhound are borrowed from Piero's votive fresco of Sigismondo Malatesta in Rimini (fig. 14, 15, pp. 74, 75), while the meditative nudes in the *Presentation of the Virgin in the Temple (?)* are from the *Death of Adam* in the Arezzo cycle. These citations have something of the quality of cultural emblems. However, the true point of correspondence between the two artists is found in the degree of stylistic and technical strictness—one might almost say ethical rigor—with which the architecture in their paintings is laid in and painted. A rich network of incised lines, incorporating detailed calculations, both in Piero's *Montefeltro Altarpiece* (cat. 46) and in the Barberini Panels, testifies to a long and complex process of preparation. Similar, too, is the precision in the application of paint, often leaving only a very thin border between one field of color and another, or between a darker and a lighter glaze. An almost imperceptible tonal gradation is employed to render the fullness of those elements shown in shadow, where the lighting is weak but, paradoxically, the richness of textures is more complex than in those parts seen in direct light, since the light is reflected from one surface to another, touching projecting areas but also encouraging a gentle fading of tone or sudden shifts into deep shadows. We also find in both painters a similar treatment of ornamental carving—unlike the subtle and near-maniacal graphic emphasis of Florentine masters (fig. 9)—in which the dentils, convex moldings (ovoli), and acanthus decoration are, wherever possible, rendered without drawings: simply by means of the paintbrush describing a dense shadow to define the concavities (fig. 60, 61). Precisely because of these similarities in approach, we must allow that in 1466, when we know the Santa Maria della Bella altarpiece was under way, something of Piero's temple-like church in the *Montefeltro Altarpiece* must have been available to be inspected: perhaps not only the preparatory drawings but

also parts of the painted background. It is, indeed, tempting to imagine Fra Carnevale looking over Piero's shoulder as he worked.

For his part, Piero had a keen sense of the *genius loci,* and in the *Montefeltro Altarpiece* he paid homage to the San Domenico portal, the friar's most important architectural work, borrowing various details (fig. 55, 57), such as the peculiar form of the frieze with palmettes and acanthus volutes, or the exquisitely antiquarian conception of the little pinecones at the corners, between the dentils of the cornice.[171] Then there is the altarpiece at Williamstown (cat. 47), in which the painter—a subtle connoisseur of architecture and therefore attentive to even the most minor details of the buildings that he wanted to represent—adopted from the San Domenico portal the idea of a contraction of the frieze and the architrave in the trabeation of his great classical atrium (fig. 59).[172] As noted in the catalogue entry, the architecture in this painting is not without difficulties, for although it is worked out with Piero's accustomed attention to every detail—even to the point of suggesting those portions not visible—and although the building could be reconstructed, rationally,[173] nonetheless the atrium remains somehow distant and even intangible. The eccentric placement of the Madonna and Child emphasizes the relationship of the column of the colonnade to the Virgin, weakening the sense of a central axis. The courtyard-exedra that surrounds the figures and introduces the theme of the Madonna as the Church (*Ecclesia*), is derived from Roman examples of entablature (the now destroyed Arco del Portogallo) and appears as a sort of polemical response to Luciano Laurana's celebrated courtyard in the Palazzo Ducale: a trabeated space ornamented with marble panels decorated with inlaid garlands;[174] it does not lack a certain elegant grace, but seems somewhat slight when compared with the ponderous sobriety of Laurana's arcade. Conceptually, it derives from the courtyard-exedra of the *Saint Lucy Altarpiece* (fig. 21, p. 60)[175] by Piero's earlier master, Domenico Veneziano. Looking beyond that work, the most immediate comparison that comes to mind is the fresco decoration of the Bibliotheca Graeca in the Vatican. This is a key monument in the history of painting in Rome. It has been dated to the papacy of Nicholas V, in the first half of the 1450s, or to that of Sixtus IV, in the 1470s. The fact that it may have been carried out under Nicholas V justifies mentioning it here, for the decoration consists of a courtyard on trabeated columns, paradoxically crowned by a still-Gothic balustrade on which are posed vases of flowers, exotic birds, cartouches, and rather foppish figures (it is hard to imagine the latter as the least bit competent in Greek!).[176] It is possible that Alberti suggested a peristyle as appropriate to an ancient-style place of study, and it is certain that when he was in Rome, Piero himself must have examined the library with interest. Nevertheless, the closest comparisons are with later structures, such as the courtyard of Santa Maria Maddalena de'Pazzi (Cestello) in Florence, designed by Giuliano da Sangallo at the end of the 1480s (fig. 58).[177] Despite this reassuring progeny, the atrium in Piero's altarpiece remains an enigmatic space that the Virgin and her angelic guard prevent us from experiencing fully and rationally. At the same time, it invites our admiration for the way in which light plays on the marble dais (fig. 60), producing an impalpable chiaroscuro, or for the opalescent effects of the shining marble in the shadowed background, beneath the portico. No better comparison for this spatial quality can be found than in the rearmost

62.
Piero della Francesca,
Madonna and Child with Angels
(*Senigallia Madonna*), detail.
Galleria Nazionale
delle Marche, Urbino

63 and 64.
Fra Carnevale,
The Birth of the Virgin, details.
The Metropolitan Museum of Art, New York

room Piero depicts in the *Senigallia Madonna,* in which rich marble and *all'antica* decoration are eliminated and an effect of space is achieved by the shaft of light passing through the glazed, bottle-glass windows (fig. 61). The space is again intangible and incomprehensible in terms of layout and distance, and it is experienced with a sense of otherness. The very late *Nativity* in the National Gallery, London (fig. 3, p. 26), makes much the same impression since the background landscape on the left and the cityscape on the right appear, without a middle ground, behind a sharp slope and the ancient ruin that serves as a shed.

In his last years, Piero was dictating his treatise on perspective, in which he solemnly declared that "the intellect is unable to judge on its own, their measure [that of the dimensions of things seen by the eye], that is to say, what is nearest and what farthest, for this reason I declare that perspective is necessary, since it distinguishes all quantities proportionally, as befits a true science."[178] Paradoxically, having attained a mastery of pictorial perspective, Piero went on to take a different approach in his paintings, working toward more elaborate and complex visual effects by rendering space through light and color. In a certain sense, this same tendency is found in the last, deeply moving phase of Fra Carnevale's development. In the 1460s, the Dominican had to yield control over the construction site of the Palazzo Ducale to Luciano Laurana, perhaps not without a certain sense of relief.[179] He had supplied drawings and models for the handsome doors, the windows, and the magnificent, classicizing fireplaces, and he had embellished the duke's rooms; now, however, it was a question of rotating the plan of the palace itself and extending it on the steep and treacherous slopes above Valbona, transporting from Piobbico the monolithic columns for the courtyard, working out the complicated relationships between the various stories, and building the vaults of the throne room. Fra Carnevale belonged to the generation of Florentine painters that, through the medium of drawing, had created the new lexicon of Renaissance architecture, imagining two-dimensional buildings richly ornamented with stones and decorations. Yet, he probably felt uncomfortable with actual and complex engineering problems, and was even less inclined to tackle the military architecture so important to Federigo's political and military practice, as it was essential to the duke's profession as a soldier. Fra Carnevale was probably just as happy to devote himself to the restoration of his parish church at Cavallino—of which, however, nothing remains.[180]

There are clues in his paintings that testify to the curiosity with which he followed the construction of the Palazzo Ducale: In the *Birth of the Virgin,* he took note of its new tabernacle windows and turreted façade, with its frieze decorated with festoons. He registered the differences between the heraldic eagles of the 1450s (as painted in the left-hand roundel; see fig. 63)[181] and those in motion, with spread wings, in the duke's apartments (as painted in the right-hand roundel; see fig. 64). His emphasis upon the base moldings of the piers of the palace and those of the engaged columns has notable affinities with the treatment of the pilasters in the corners of the courtyard of the Palazzo Ducale. Moreover, just as, in the celebrated interior pier of the courtyard, there is no engaged column and no base molding, so a base molding is absent in the room where the Virgin is being bathed.

It is not impossible that the friar continued to design elements of the Palazzo Ducale. Indeed, the *Heroic Figure* in the Cagnola collection (fig. 69 and cat. 44) provides a good

index of this possibility. The picture was evidently a door for a piece of furniture, as the reverse side is decorated with a fictive geometric intarsia constructed with a complicated web of incised lines; the classical theme of the recto suggests the furnishings of a small room or *studiolo,* a private space such as the later Tempietto delle Muse. The plans for the Tempietto date to the 1470s, although progress was slow and may have been interrupted, despite the fact that Fra Carnevale (if he was involved) was still active and even had assistants.[182] Precisely on account of this rupture in the work on the Tempietto, the fact that the *Heroic Figure* is not finished seems poignant.

The figure of an ancient god or hero stands upon a decahedron. Studies by Sara Scatragli of the incised lines and the compass holes have made it possible to determine the method of construction behind this decahedron, which corresponds exactly to the geometric precepts set down by Piero della Francesca in his treatise *De prospectiva pingendi* (fig. 37, p. 87).[183] Beyond the perfectly foreshortened polygonal podium there rises the Roman Arch of the Argentari, pictured from the same viewpoint as that in a drawing in Giuliano da Sangallo's *Codex Barberiniano* or in the *Codex Coner.* The arch is not only seen fully restored rather than in its actual state—in the Quattrocento it was partly incorporated into the church of San Giorgio al Velabro—but it is completed with a pediment, like that of the Arch of Augustus at Rimini, or like Alberti's recent rereading of such a model on the façade of Sant'Andrea in Mantua (begun in 1472). Yet, the sumptuous arch, decorated with bas-reliefs, is fissured, as though to demonstrate that the significance of Rome cannot be recovered if we do not take into account its decadence and the irremediable loss of a glorious past, lest we succumb to the gilded, fairy-tale decoration of the famous Flemish tapestries woven for the Urbino court, or of those *cassoni* panels with exemplary paintings of "Roman life." What Fra Carnevale gives us are ruins like those first made popular by Donatello (cat. 12): actual monuments, historically eloquent, capable of conveying information because they were measured and studied by the friar himself in Rome, utilizing the method employed first by Alberti and then by Francesco di Giorgio (the latter was just about to arrive in Urbino or perhaps was already there). Nor should we forget the accounts of Fra Carnevale's friend Giovanni Boccati regarding Padua and the activities of Mantegna, or the news that arrived from a friendly court such as that at Mantua.

In the Cagnola panel there is, nonetheless, a radical change in the composition of the space. Unlike the *Annunciation* in the National Gallery of Art, Washington (cat. 40), which unfolds in depth with an abstract, programmatic logic and the unified, ironclad constructive spirit[184] of a perspective intarsia, in the Barberini Panels space is complex and multidirectional, yet perfectly traversable, even to the farthest recesses—beyond the doors and windows and into the landscape. Although in the Cagnola panel the vanishing point is placed in an area hidden from view and so low as to do away with any intermediary plane, there is no gradual passage from the foreground to the urban background. The young god seems to tower upward and to almost overwhelm the historic buildings, were it not for the brilliant light that caresses everything.

As we near the conclusion of this brief history, we are left with the enigmatic drawing formerly in one of Vasari's albums (fig. 68)[185] that possibly is connected with the artist's preliminary planning for the Cagnola panel—or perhaps it is all that is left of a

65.
Fra Carnevale, *The Birth of the Virgin,* detail. The Metropolitan Museum of Art, New York

66.
Fra Carnevale, *The Birth of the Virgin,* detail. The Metropolitan Museum of Art, New York

67.
Capital from the courtyard of the Palazzo Ducale, Urbino

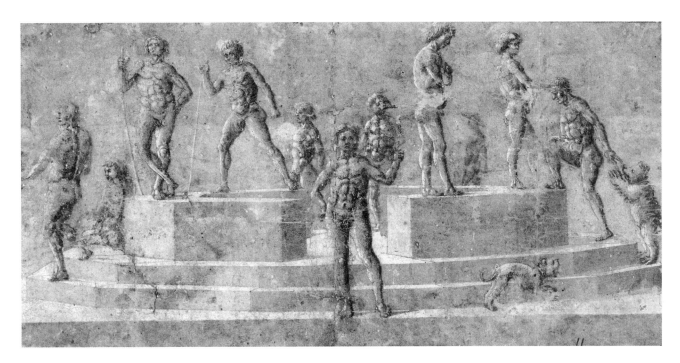

68.
Fra Carnevale,
Allegorical Scene, drawing.
Nationalmuseum, Stockholm

more ambitious scheme. Whatever can the friar have intended with these male nudes, posed variously on a podium copied with precision from an illustration in Piero's treatise?[186] *"At sunt quidem . . . in theatro deorum omnium simulacra"*: can the drawing be a study for the theater of the divine simulacra described by Alberti in the fourth book of the *Momus,* completed by the end of the 1450s, in which the proud and conceited gods take the places of their effigies in order to enjoy the adoration of the populace, but instead fall victim to the mockery and insults of men and the winds?[187] In this same passage on the sacred statues, we find the angry proclamation: *"Demum inutile istud aes, cui nihil invenias quod probet praeter artifici manus, Iovis istar venerabimus,"*[188] substituting the figures' artistic value—and this is no small feat—for their devotional significance.

If the conversations between Alberti, Federigo, and Fra Carnevale were not merely about artistic theory (for example, the way artistic images sometimes occur in nature, as in clouds),[189] but also dealt with religion and philosophy, we should not be surprised that in the end, our painter set aside his brush: he was a potent illustrator of magnificent stories who was, however, only lukewarm in his devoutness, and a skeptical painter of antique simulacra. Federigo was certainly a man to whom Alberti could read his greatest philosophical composition with no fear of being misunderstood, though it is a work as mocking as it is difficult and enigmatic, and pitiless to the point of being cutting. For like Alberti, the illegitimate Federigo, on account of his precarious social position, had, in his youth, been at the mercy of the whims of the powerful.

69.
Fra Carnevale, *Heroic Figure Against
an Architectural Backdrop.*
Villa Cagnola, Gazzada (Varese)

The writing of this essay was greatly facilitated by the collective efforts, made in the course of preparing the accompanying exhibition, by my colleagues Roberto Bellucci, Ciro Castelli, Keith Christiansen, Emanuela Daffra, Andrea De Marchi, Andrea Di Lorenzo, Cecilia Frosinini, and Matteo Mazzalupi. Our common purpose, as well as our constant, frank discussions of our differing opinions, was the most exciting aspect of this experience. Likewise, for their unflagging assistance, suggestions, readings, and archival research, I must also thank Annalisa Bristot, Massimo Bulgarelli, Fabio Marcelli, Alessandro Marchi, Don Franco Negroni, Cristina Quattrini, Richard Schofield, Samo Stefanac, Rosaria Valazzi, Massimo Zaggia—and Bonita Cleri, who kindly rushed the minutes of the conference on Fra Carnevale to me posthaste.

1. Negroni 2002; Negroni 2004, p. 18.
2. For an overall view, see Bellosi 1992a; for an extensive documentary exploration of the subject, complete with statistics and an impressive body of archival references, see Jacobsen 2001.
3. Federigo da Montefeltro 1978, p. 20. Among Federigo's architects, the one about whom little is known as yet, is Pippo da Firenze, mentioned in a list of members of the court compiled in the early sixteenth century; see Fontebuoni 1985, p. 376. On Pippo di Antonio da Firenze, who is probably the same man, see Ceriana 2002b, p. 290.
4. Fabriczy 1907, p. 253.
5. Compare the recent discoveries made by Maria Giannatiempo López (2004) in the course of restoring various rooms on the ground floor of the Palazzo Ducale.
6. Clementini 1627 (1969 ed.), vol. 2, p. 354. The text is cited in Rotondi 1950, vol. 1, p. 82.
7. On the relationship between the two noblemen, rivals in military acumen as well as in the control of the territory, see Pernis and Adams 1996; see also Turchini 2004, whose findings are perhaps more solid.
8. In the present catalogue.
9. Alberti 1973, p. 46.
10. For a comparison of the Maringhi and the Marsuppini *Coronation of the Virgin* of the 1440s, see Ruda 1984.
11. The double colonnette sheathed in bronze foliage supporting the armrest of the throne is conceptually reminiscent of the pairing in the niche of the (formerly) Loeser *Madonna* (now in a private collection), where the two colonnettes, together rest on a single krater-shaped base, and are joined by a single, extended Ionic capital. I am unable to situate this painting, perhaps less damaged than commonly believed, in the painter's Paduan period with the same assurance as Andrea De Marchi (1996b, pp. 14, 21 n. 53, 22 n. 59), regardless of the fact that Giovanni Boccati borrows the bizarre architecture of the throne in his Ajaccio altarpiece (Minardi in De Marchi 2002a, pp. 245–46), nor can I see a connection with the quite different, Donatellian *Madonna* in the Cassa di Risparmio, Prato. The two

paintings were shown together in the exhibition "Filippino Lippi. Un bellissimo ingegno. Origini ed eredità nel territorio di Prato," but the entries by Mannini on the first painting, and by Casini on the second, take into account only part of the earlier bibliography (Mannini 2004, pp. 40–41).
12. See the documentary appendix by Di Lorenzo.
13. See Caplow 1977, vol. 2, pp. 537–38, 590–93, for a discussion of the Franciscan church at Bosco ai Frati; see also Chieli 1998, despite the few serious errors such as the comparison of the carvings in the Cappella dell'Annunziata with the altarpiece in San Domenico, Fiesole, by Fra Angelico but with additions by Lorenzo di Credi.
14. On the Florentine origin of the rood screen, see Borsi (1997, pp. 33–34), who compares, by way of typology, Carnevale's screen with its counterpart in Lippi's Munich *Annunciation,* although the latter is, in fact, very different in its general structure.
15. See, for example, the well-known sacristy door in the church of Santa Trinita, by Ghiberti, with the assistance of none other than Michelozzo.
16. See Offner 1939, p. 220. Lippi was in Spoleto in May 1466 to examine the apse that he was engaged to fresco, but the Opera del Duomo had already begun investing the large sums required for the paint and the gold leaf in February (see Fausti 1915, pp. 5, 9). In 1469 Antonio and Piero del Pollaiuolo (ibid., p. 14) were guests of Lippi, which raises the possibility that Fra Carnevale may very well have met the two artists for the first time on this occasion. No documentation exists of Fra Carnevale's possible presence in Urbino from October 1467 to March 1471 (see the documentary appendix by Matteo Mazzalupi in the present catalogue).
17. Toscano 1961, p. 91.
18. See Andrea di Lorenzo's transcription in the present catalogue of the notations in Maso's account books and his summary of the literature relating to the documents. On Maso's workshop and the participation of his brother Giovanni, see Caplow 1998. Giovanni was six years younger than Maso (see Höfler 1988, pp. 538–39).
19. Alberti 1973, p. 7. The names of Alberti's artist friends are listed in the preface to the Italian edition of his treatise; Masaccio—that is, Maso di Bartolomeo—is mentioned together with a homogeneous group of living sculptors. Janitschek (1877, pp. 227, 257–61) was the first to correctly identify Masaccio with Maso, a fact that has been acknowledged by Höfler 2004, p. 74.
20. Averlino 1972, vol. 1, pp. 170–71.
21. On the vast amount of literature on Maso di Bartolomeo and the organization of his workshop, see the studies by Giuseppe Marchini (1952; 1968a); for a careful review of his biography, see Höfler 1984; 1988; 1996.
22. See Lisner 1958–59, among others.
23. Scalini 1995.
24. Caplow 1974, pp. 165–66; for illustrations, see Marquand 1914, pp. 79–84.
25. Herzner (1976, pp. 53–54), reexamines the docu-

ments of February 1437 in which the Opera del Duomo's engagement of Donatello to execute the doors to the two sacristies is recorded. The project was left unfinished, and was later completed by followers of Michelozzo.
26. Caplow 1977, vol. 1, pp. 68–72.
27. Ibid., pp. 434–37.
28. Hyman 1977, p. 404.
29. Caplow (1977, vol. 1, pp. 444–50) attributed the tabernacle to Michelozzo, in collaboration with Bernardo Rossellino—who during the same period was engaged in the rebuilding of the presbytery of the church; Bulgarelli (1998, p. 101) more correctly ascribed it to Rossellino alone.
30. Caplow 1977, vol. 1, pp. 450–52. On the dating of the aedicula of the Annunciate Virgin before 1448 (1449 according to the Florentine calendar), see Saalman 1977, vol. 1, pp. 226–27; see Liebenwein 1993 for the role assumed by Cosimo's son; see also Caglioti 2000, vol. 1, p. 95 n. 59.
31. See the useful observations in this connection in the expanded essay by Morolli (1998); see also Canali 1992. The elaborate transennae devised by Maso for the Annunziata were also apparently an Albertian quotation from antiquity: see Canali 1999, pp. 10–11.
32. The comparison was made by Parronchi (1964a, p. 446), who discusses the Florentine sources of the architecural decorations in the two Barberini Panels; see also Strauss 1979, p. 105 n. 85. Morolli (1998, p. 151) notes the mentions in documents relating to the aedicula of the Annunziata, of Giovanni di Bertino [Bettino] as the "*maestro di disegni*" who implemented Alberti's designs for the marble façade of Santa Maria Novella; this mention was first documented in sources published in 1461, but it could even predate that year ([Tonini] 1876, pp. 296–97, coc. LIII).
33. Bartoli (2004, p. 220) recently suggested a connection with a page in the *Destailleur Codex*—the so-called *Mantegna Codex*—in Berlin, which is, however, a collection of images from another area and another period.
34. Parronchi (1964a, pp. 447–48) cites a passage in the *De re aedificatoria* (VII, 10; 1966 ed., pp. 610–11) that describes, among other objects, the gold cup, containing a cinnamon plant, that Augustus had placed in the great temple on the Palatine.
35. Giglioli 1906, pp. 41–42. An attribution to Pasquino da Montepulciano can be found in the 1904 edition of *Cicerone* (Burckhardt 1904, vol. 2, pp. 1–2, 187). The vase has been convincingly attributed to Bernardo Rossellino—although only if one compares the cherubs on the handles (*anse*) with the contemporary sculpture of the *Virgin Annunciate* in the same church. It has yet to be determined, however, whether Rossellino executed these works at Empoli, rather than his Florentine workshop. See Paolucci 1985, pp. 100–103. On Rossellino, see Bulgarelli 1999; Schulz 1977, pp. 123–24.
36. Lunghi 1996b, p. 480.
37. For the works in Santa Croce, see Caplow 1977, vol. 2, pp. 577–86; for those in San Marco, see ibid.,

pp. 534–43.

38. Gosebruch 1958, p. 142. A similar type of capital was employed earlier by Maso di Bartolomeo for the balcony of the Chapel of the Virgin's Girdle in the interior of Prato Cathedral: see Cerretelli 1995, pp. 103–4.

39. On the rustication of the Palazzo Medici, see Eckert 2000, pp. 103–4; on the significance of rustication in Florence—as, for example, the restrained rustication of the Palazzo Rucellai—see Belli (1996, p. 23), who notes that it was in the twenty-year period from 1446 to 1466 that the prevalence of rustication became widespread.

40. For the architecture of the tabernacle, see Lisner 1958–59, pp. 74–77.

41. See Ferro in Bellosi 1990a, pp. 48–49.

42. As in the vertical panel with hunting scenes by Giovanni di Francesco (now in the Musée des Augustins, Toulouse), and documented in inventories housed in Urbino; see Callmann 1991.

43. Gattucci 1981, p. 353 n. 4.

44. See, most recently, Höfler 2004, pp. 73–82, and also Höfler 1998; Höfler 1988. For a thorough discussion of the architectural features of the door, see Bruschi 1996, pp. 265–71.

45. In the 1470s, Elzèar de Garnier, protégé of King René d'Anjou and aide to the renowned reformer general Leonardo de' Mansueti of Perugia, stayed at the Urbino monastery; see Mortier 1909, pp. 534–35 n. 1.

46. From 1408 until 1453 there are records of donations and bequests for the construction of the church and the portal: see Negroni 1993, pp. 34–35 n. 7.

47. Höfler 1988.

48. From Maso di Bartolomeo's account book, one may infer that the artist executed weapons for Federigo during part of 1449 through 1450.

49. Ceriana 1997, p. 137.

50. "Libro di conti e ricordi di Maso e Giovanni figlioli di Bartolomeo da Firenze dell'anno 1449, scarpellatori di pietre, scultori di marmo, fonditori di metallo, e orefici" (Biblioteca Nazionale Centrale, Florence, ms. Baldovinetti 70). This important document was published in Chiesa di S. Domenico 1874 and Yriarte 1894; the commentary by Fabriczy (1895) appears in the latter source; see, more recently, Strauss 1979, pp. 152–54, which includes a partly annotated excerpt of the text by Harriet McNeal Caplow (in preparation for many years).

51. "Libro di conti e ricordi," fol. 21r.

52. The first direct payment by Federigo for the cannons noted in the journal was made on March 3, 1450 ("Libro di conti e ricordi," fol. 13), although in September 1449 the count seems to have paid for the transferral of Maso's luggage; see also Höfler 1988, p. 538.

53. Höfler 2004, pp. 75–76.

54. "Libro di conti e ricordi," fol. 9r.

55. Höfler 1988, p. 541; on Pasquino di Matteo da Montepulciano, see Fabriczy 1906; on Michele di Matteo the best source remains Kennedy 1932–34.

56. See the documentary appendix by Mazzalupi.

57. Already pointed out by Parronchi 1964a, p. 466, and shown in detail in the illustrations, 162b and 162c.

58. Schulz 1977, pp. 33–34; the connection was later made again by Höfler (1998, p. 249; 2004, p. 78).

59. Canali 1999.

60. The comparison with Michelozzo, however obvious, was made by Strauss 1979, pp. 126–48; in a chapter devoted to Fra Carnevale as architect (pp. 129–30), Strauss also cited the portal of Sant'Agostino, Montepulciano, and the Bruni tomb; see also Bruschi 1996. On the architecture of the Brancacci tomb, see the perceptive comments of Lisner (1958–59, pp. 77–79); Caplow 1977, vol. 1, pp. 164–80; and Lightbown 1980, vol. 1, pp. 52–127: the discussion of the tomb with the most copious information

61. The "Libro di conti e ricordi," fol. 25v, records a payment made to Luca della Robbia for a "*Nostra Donna*" with Saint Peter Martyr and Saint Dominic, and a tondo of God the Father in the "*frontone*"; see Pope-Hennessy 1980a, pp. 251–52; Padoa Rizzo in Dal Poggetto 1992a, pp. 80–81.

62. Martini in Sigillo 1994, pp. 62–63; Pizzinelli in Scarpelli et al. 2003, pp. 64–65. Luca's sculptural group represents a decisive step forward from the magnificent crouching figures on Michelozzo's cornice: underlying the semicircular disposition of Luca's stark white figures—which recede in space— is a decade's experience of Florentine *sacre conversazioni* by Fra Angelico and, later, Lippi, including the *Madonna and Child Enthroned with Two Angels,* and *Saints Augustine and Amarose* and *Saints Gregory and Jerome* (cat. 1 A–C). On this subject, see Meiss 1963, pp. 123–45, especially pp. 139–43.

63. Aside from Maso himself, most of the carvers working for him were on familiar terms with Michelozzo, especially Pasquino, Michele di Giovanni, and Giovanni di Bartolomeo; see Caplow 1998, p. 135. On the collaborations with Michelozzo on the project for the door, see Bruschi 1996, p. 267.

64. Volpe 1989.

65. Bruschi 1996. Strauss (1979, pp. 134–36) erroneously attributed the project for the portal solely to Corradini.

66. See Stöckhert 1997, pp. 42–44. On the antiquarian tastes of Filarete and his workshop, see Parlato 1988.

67. Wohl 1980, pp. 134–37, dates Domenico's fresco of *Saint John the Baptist and Saint Francis* between 1450 and 1453.

68. Averlino 1972, vol. 1, pp. 199–200; Alberti 1966, vol. 2, pp. 560–61. On the type of plinths used by Alberti, see Syndikus 1996, pp. 157–71. The example chronologically closest to the Urbino door is the order employed in the interior of the Tempio Malatestiano, although the latter is a few years later in date. Maso himself was in Rimini in 1452 (Höfler 1988, p. 538). Strauss (1979, pp. 131–32) earlier had associated these plinths with the architectural vocabulary of Alberti. Stefano Borsi's 2003 article presents some useful hypotheses.

69. The Donatellian heads are those on the sides of the base of the Parte Guelfa tabernacle; busts of Jupiter

Ammon, consisting of a human face with a goat's horns, are found on various ancient altars, such as the altar of Rodone, formerly at Santi Quirico e Giulitta, Rome; that of the Orocento (Uffizi, Florence; see Mansuelli 1958, p. 214); and that of Zethus Corinthus at the Camposanto in Pisa (see Parra in Settis 1984, pp. 220–24). Another model might have been the Ara Grimani: see Bober and Rubinstein 1986, p. 121 n. 89. The possibility that the motif might derive from an antique prototype from the Urbino area cannot be confirmed; the altar with the heads of Ammon at the corners—a recent gift to the archaeological museum at the Palazzo Ducale—seems to be Roman in origin. Gori in Luni and Gori 1986, p. 128); on antiquities in Urbino, see Luni 1992, pp. 41–45.

70. The monetary transactions with Luca della Robbia are recorded on folios 25v and 27 of Maso's account book, but it is clear that the sculptor made the payments in Florence with money given to him by Corradini. It is unlikely, however, that Luca would have gone to Urbino to engage in such a complex work so far from his workshop; see Bartoli 2004, pp. 217–18. One of the salient characteristics of Della Robbia's ceramic sculptures was their transportability.

71. The figure on the Florentine tympanum is, however, Saint Andrew represented between two angels; regarding the chapel, see Saalman 1993, pp. 211–85, especially p. 227, for the date (1439), and also p. 247. The Pazzi Chapel has generated a great deal of discussion; the positions taken by Guillaume (1990) were contradicted by Trachtenberg (1996; 1997; 1998) in favor of Michelozzo. It is very possible that Cosimo's favorite architect, together with skilled helpers, could have realized the project first begun by Brunelleschi for Andrea Pazzi—the sort of collaboration, which appears to have been common practice, that is documented among different artists and workshops in Florence.

72. Syndikus 1996, p. 152.

73. The Urbino decorations met with immediate success, and, as Marchini (1968b) noted, were adapted, in somewhat more rustic form, in the Palazzo Sforzesco, Pesaro.

74. Marchini 1952; Scalini 1995.

75. On the pulpit in Prato Cathedral, see Nuti 1939. The mature style of the frieze on the bronze grille of the Cappella del Sacro Cingolo and of the sculptural decoration of the pulpit—dating between 1469 and 1471—led Busignani (1962) to propose that the young Verrocchio may have served an apprenticeship in Pasquino's workshop in Prato. This hypothesis was taken up again by Pope-Hennessy (1988, p. 21) and by Natali (1990, p. 60 n. 52). Pasquino's autograph painting of *God the Father* is discussed by Marchini (1952, p. 122) and by Rotondi (1950, pp. 166–67).

76. Contacts between Pasquino and Desiderio were documented in 1459—although it is possible that they met before then—as suggested by the fact that the composition on the base of the Prato pulpit is derived from that of Donatello's *David* in the

Palazzo Medici; see Caglioti 2000, vol. 1, pp. 128–30 n. 110.

77. Kennedy 1932–34.

78. See the documentary appendix by Di Lorenzo, under the date 1451 ("Libro di conti e ricordi," fol. 23v). It is possible that, once in Urbino, the gilder worked on more than one project; obviously, if it was a question of gilding only one panel, a member of Antonio Alberti's workshop could have undertaken the task. Gilding the stone on the outside is another matter. (I am indebted to Rosaria Valazzi, who directed the restoration of the Urbino doors, for having brought to my attention the final report of November 2003 on the scientific research conducted on the door by Amadori, Gramegna, Maione, and Schillaci of the Facoltà di Scienze Ambientali dell'Università degli Studi di Urbino "Carlo Bo." Over the course of their investigations, traces of blue and red coloration were discovered on the frieze, which would suggest that there must certainly have been gilding as well. The capitals and the decoration of the balcony of the Chapel of the Virgin's Girdle in Prato Cathedral were gilded by Pietro Chelini before 1441 at the behest of Maso; see Cerretelli 1995, p. 103.)

79. The first imitations were noted by Marchini 1968b, pp. 213–14. On Giorgio da Sebenico's Ancona workshops, see Mariano 1993' Ercolino 2000.

80. The passage from *De re aedificatoria* (V, 3; 1966 ed., vol. 1, p. 347) is as follows: "*Nam regum quidem aedes in media urbe aditu facilis, ornatu venusta, lautitie elegans magis quam superba sit*"; quoted in Londei 1989, p. 93.

81. Kent and Kent (1979) pointed out that the demolition necessary to clear the site for the future palazzo had already been completed by March 1445. For a more recent study of the palazzo, see Cherubini and Fanelli 1990.

82. Vasari 1971, pp. 185–86. See also Hyman (1977, pp. 98–127), who discusses Vasari's traditionally held account that a first, more magnificent—perhaps too magnificent—project by Brunelleschi, rejected by Cosimo, had included the construction of a piazza between the Palazzo Medici and the church.

83. Marchini 1958, pp. 44–47; Marchini 1960, p. 78. Marchini's hypothesis that the columns originally carved for Urbino were later finished in the palazzo at Casteldurante (present-day Urbania) seems untenable. It is more likely that the laudatory text alluded to an as-yet unrealized project, and that the sandstone columns are by Laurana. Galli's text, as well as historical information about the man himself, was discussed and analyzed by Michelini Tocci 1958–59; on the courtyard of the Palazzo Medici and the columns, see Hyman 1977, pp. 186–205. The idea that Federigo was involved from the start on the layout of the palazzo, or that, in any case, an already elaborated design existed as of the 1450s—since Pius II is known to have made use of the same model for Pienza, beginning in 1458—was advanced by Heydenreich (1967).

84. Rotondi 1950, pp. 81–167; Höfler 1998, p. 253; Höfler 2004, pp. 83–101.

85. Höfler (2004, p. 89) does not, however, mention contemporaneous typologies similar to those employed in the Urbino area.

86. The date is often cited without mention of the discovery made by Michelini Tocci (1958–59, p. 236 n. 1): an original document printed in 1723 in Amsterdam, *Memorie istoriche concernenti la devoluzione dello Stato di Urbino alla Sede Apostolica forse di monsignor Sartorio,* which records that Federigo "constructed and expanded the Royal Court of Urbino by laying the foundations on Saint Jerome's day (September 30) in the year 1454." For this same conclusion, see Höfler 2004, pp. 98–99.

87. Höfler 2004, p. 99.

88. Kennedy 1932–34; Rotondi 1950, pp. 143–48; Höfler 1999.

89. See, most recently, Höfler 2004, p. 92; on the windows of the Palazzo Medici, see Preyer (1990, p. 62), who rightly regards them as a reinterpretation, through a Brunelleschian sensibility, of such traditionally Florentine elements as the arched windows of the Palazzo Vecchio and of Orsanmichele.

90. Baldi 1859, p. 572.

91. The niches on the façade of the Fraternità della Misericordia in Arezzo terminate in rounded arches that seem somewhat incongruous in that context.

92. Londei (1991) identifies this—perhaps forcing the issue—as the palazzo of Count Antonio. Bertelli (1991, pp. 124–25) interprets the frieze of roses as a heraldic emblem of the Malatesta and discusses the painting's origin and its date, even though the form of the corolla in Piero's picture does not correspond to that of the Malatesta flower.

93. Amadori 1985. Contrary to what Ciardi Dupré Dal Poggetto asserts (2003, p. 201), these are different varieties of limestone. I thank Rosaria Valazzi for confirming this for me.

94. Baldi (1859, p. 572) correctly identifies the figure as Deianira rather than Iole, which is understandable for a scholar of sixteenth-century art.

95. Höfler 1996, pp. 92–93.

96. The motif of decorative vegetal bands interrupted by roundels was itself an adaptation of the ornamentation on the inner surfaces of the architraves, where panels in the spaces between columns and capitals coincided with the positions of the roundels.

97. One of the most spectacular examples is the fresco by Neri di Bicci of the *Glory of San Giovanni Gualberto* of 1455 in Santa Trinita, Florence (originally from San Pancrazio), which presents some problems of interpretation because of the quality of the painting and the extravagant originality of the composition and execution. Santi 1987, p. 140; Longhi (1952a [1975 ed.], p. 120 n. 14 suspects the influence of Alberti, given the complexity of the layout and the fact that the fresco is located in the same complex as one of the architect's greatest achievements.

98. Strauss 1979, p. 137; see also note 65.

99. For a general view, see Heydenreich 1977. See also Davies and Hemsoll (1983), who propose

Brunelleschi as the author of the double balusters (ibid., pp. 4–5). Caglioti (1995, pp. 37, 54–55 nn. 158, 161) quite reasonably favors Donatello, instead.

100. Bellosi 1990b, p. 21; Vasari 1971, p. 68.

101. Zeri 1961, pp. 81–82.

102. Ibid., pp. 69–70; see, most recently, Bartoli 2004, p. 217.

103. Pfisterer 2002b; on Porcellio's relationship with Federigo, see Zannoni 1895b, p. 122, and, more recently, Londei 1989.

104. Illustrated here is one of the angels from the intrados of the tomb of Bishop Federighi (died 1450) in Santa Trinita, the contract for which was drawn up in 1454: see Pope-Hennessy 1980a, pp. 242–44. For the date that the work was finished, see Glasser 1969; the cherubs should have been completed before 1458.

105. The corbels of the Sala degli Uomini Famosi were attributed to Maso by Marchini (1968a, p. 243), who likens them to those at the Palazzo Quaratesi in Florence. Marchini (1960, p. 77) also cites the corbels at the Oratorio del Corpus Domini at Urbania, which nevertheless seem to be slightly later copies made by local sculptors. See also Rotondi 1950, p. 149, and, most recently, Höfler 2004, p. 105.

106. See Turcan 1966, pp. 155, 474–84, for the iconography of the Triumph and the bacchic wedding feast. The most extensive discussion is found in Matz 1968–75. Kennedy (1932–34, p. 36) associated the imagery of the fireplace with the count's future wedding.

107. Baxandall 1963, pp. 314–15 n. 34.

108. Rotondi 1950, pp. 133–34; Strauss 1979, pp. 138–39. The precocious grace of the figures led Marchini (1960, p. 76) to attribute them to Giorgio da Sebenico, whom he had risked identifying (p. 78) as the "Giorgio schiavo" ("Giorgio the Slav") working for Federigo in Gubbio in 1466.

109. Two small statues are now missing from the niches carved specifically for them: see Rotondi 1950, p. 134.

110. On the famous sarcophagus now in the British Museum, London, see Rubinstein 1975, p. 117; Scalabroni in Cavallaro and Parlato 1988, pp. 161–63; and Salis 1947, pp. 118–20, concerning its long-standing influence as a model. See also Middeldorf (1956 [1980 ed.], pp. 246–47), who cites two other examples of the type, in Pisa and Lucca, which might have been seen by Donatello, who appears to refer to them in letters from 1428–29. On the possibility that Fra Carnevale visited Rome, based on the knowledge of ancient sculpture revealed in his works, see Zannoni 1895b, p. 491; and, most recently, Bartoli 2004.

111. For the sketch of the three sarcophagi in Pisa, London, and Berlin, which are considered to have served as models for the fireplace, see Rotondi 1950, p. 135; for the most complete discussion of the motif of cherubs and garlands, see Herdejürgen 1996. A well-known example of a work that utilized an antique model in Pisa was that with the coats of arms of Azzopardi Tortini: see Arias, Gabba, and Cristiani 1977, p. 101, A 7 int.

112. "Many marvelous and beautiful figures without authors have been found, especially the four satyrs, one of which is shielding Bacchus, another carrying him on his shoulders, the third crying like a child, and the fourth drinking from his companion's krater. Then there are two nymphs who are covering him with their clothes so that others may not see him": see Pfisterer 2002b, p. 134.

113. Some poorly preserved and reworked drawings of this sarcophagus, now in the Biblioteca Ambrosiana, Milan, from a much-worn and reassembled notebook (Romano in Agosti, Natale, and Romano 2003, pp. 138–39), are nevertheless important because they indicate what the work originally looked like, with all the missing parts and lacunae in place. In their lengthy bibliography, the drawings have been variously attributed: Degenhart (1950) ascribed them to Pisanello's workshop, claiming that they were later reworked by a Mantegnesque draftsman, but this hypothesis was corrected by Middeldorf (1956 [1980 ed.]). The drawings were again ascribed to an anonymous North Italian artist of about 1460 by Cavallaro and Scalabroni (Cavallaro in Cavallaro and Parlato 1988, pp. 155–60; Scalabroni in ibid., pp. 167–71), and Bober and Rubinstein (1986, p. 65). Romano (1981, p. 13) considered them North Italian and strongly Mantegnesque. See also Agosti 2001, p. 37 n. 109; Romano in Agosti, Natale, and Romano 2003. Dacos (1961, pp. 145–46) assigned F214 inf. 2 r, a study of draped figures and a Satyr straddling a young man, to Michele da Giovanni, although it was strengthened by a Mantegnesque hand. The figures on the sides, indicated in pink and blue, are of high quality, although heavily retouched, and are executed in a technique utilizing delicate highlights in white lead (biacca), reminiscent of that employed in drawings of antiquities by Central Italian artists such as those in the circle of Benozzo Gozzoli. The custom of drawing archaeological antiquities, regardless of their condition, was common in Pisanello's circle, only to be adopted by Matteo de'Pasti in his workshop in Rimini, from where it caught on elsewhere in the Marches. On the drawing of antiquities, see Cordellier in Marini 1996, pp. 84–85, 181–84.

114. This is the frieze of palmettes also employed by Rossellino on the Bruni tomb; see Schulz 1977, p. 39 n. 35. On Alberti's studies of the monument, see Syndikus 1994. The small panels with cherubs playing musical instruments, flanking the frieze, are obvious quotations from Donatello—for example, from the baptismal font in Siena or the putti on the altar of Sant'Antonio in Padua. The decoration of the frescoed niches in the nave of the church of Morrocco at Tavernelle Val di Pesa (founded in February 1460) contains echoes of the antique, although in the upper parts of the cornices—conceived as actual stone architectural elements inserted into the plaster of the nave—are panels with cherubs quite similar to those in Urbino. The frescoes on the right wall, facing the ones attributed by Bellosi (1987, p. 21) to

Giovanni di Piamonte, are stylistically similar to those by Fra Carnevale from the 1450s, while the shepherds in the Nativity scene recall comparable figures in Baldovinetti's Medici Nativity in the small cloister of the Annunziata. In the past, Berenson (1932a, p. 342) ascribed them to Giovanni di Francesco; Giovannozzi (1934, pp. 362–64), to a pupil of Castagno; and Fredericksen (1974, p. 26) pointed out similarities to the style of Cervelliera. The church appears to have been rebuilt with a bequest from Giovanni Sernisi (or Sernigi), whose epitaph, accompanied by a life-like portrait by Andrea della Robbia, still survives (Marquand 1922, vol. 2, pp. 192–93).

115. On Galli, see Nonni 1998. With regard to the identification of Federigo with Hercules, see Clough 1973, p. 134. It is quite likely, in any case, that Angelo Galli provided instructions for the iconographic program to be followed in the Iole apartments, as romantic poetry appears to have been his specialty, judging from the books of works that survive. See Nonni 1986; Santagata 1986. On ideals of feminine courtly behavior as found in the Petrarchian love poetry of Urbino—and of Angelo Galli in particular—see Quaglio 1986; on the persistence of the myth of Hercules, see Gaeta 1954. In the Ovide moralisé of Chrétien le Gouyas, it is Iole who prefigures the Christian Church—as opposed to Deianira, who personifies the Jewish people—and is presented as the wife of Hercules, who symbolizes Christ; see Gaeta 1954, pp. 243–45. On the role of fortune in courtly society, see Tissoni Benvenuti 1993. In Bassi's poem, Iole is the seducer of Hercules. There is a study on the Labors of Hercules (p. 776) by a Venetian from the Corner family who perhaps encountered the young Federigo in Venice; see also Tissoni Benvenuti 1994. The Late Gothic apartments in the palace of the Este were also decorated with a fresco cycle of the legend of Hercules; see Fratucello 1999. For the story of Hercules in Florentine works, see Hessert 1991.

116. The amorous passion between Hercules and Iole is cited as a canonical example in Canto IX (ll. 101–102) of Dante's Paradiso by Folchetto di Marsiglia, in the sky of Venus: the story of Hercules and Deianira falling in love was already treated before in lines 68–69 of Canto XII of the Inferno (Torri 1827–29, vol. 1, p. 225). Dante's verses were based on Ovid (Kraus 1971): the Heroides (Book IX) and the Metamorphoses (Book IX, ll. 134–140), in which Iole is the adulterous lover of Hercules. Petrarch's treatment of the story of Hercules in one of the versions of the De Viris illustribus is largely fragmentary; see Gaeta (1954, p. 253 n. 1), who does not, however, remark about the Dante quotation. Other important texts that deal with the Herculean legend are the Latin works of Boccaccio (Genealogiae deorum gentilium), even though Iole does not figure prominently in them, and is confused with Omphale—an error to which Boccaccio himself alerts the reader in Book XIII (Zaccaria ed., vols. VII–VIII of the complete works; Boccaccio

1998, p. 1277). Federigo owned a copy of the Latin works of Boccaccio (Vespasiano de' Bisticci 1892–93, vol. 1, ch. XXIX, p. 299) as we know from the inventory of his library; see Guasti 1862; Guasti 1863, p. 145 n. 533. The reading by Coluccio Salutati (1951) is too allegorical and moralistic to be subject of an amorous stanza. A lengthy chapter in Giovan Mario Filelfo's Martiados (before 1464) is devoted to the deeds of Hercules, which Zannoni (1894, p. 651) and Pignatti (1995, p. 628) present as metaphors for the prowess of Federigo.

117. On Cosimo the Elder's and Piero's antiquarian tastes, see Caglioti 2000, vol. 1, pp. 381–94, 392–93 n. 48, who presents a credible chronology of the project and hypothesizes that the 1452 addition by Maso to the courtyard involved a frieze with festoons that was later destroyed, and was not what we see today; see Wester (1965, pp. 15–49), who dates the roundels to 1460. On the chronology of the palazzo, see Hyman 1977, pp. 186–205.

118. Bjurström 2001, no. 1070.

119. See Cieri Via 1996, pp. 48–49 n. 5; the scene in the frieze on the door apparently depicts a battle between Eros and Anteros (Stuveras 1969, pp. 99–100). For a "history" of amorini, see Dempsey 2001, pp. 63–106. Compared to the masterful frieze on the fireplace, the one on the door appears to be something of a parody not unlike those found on ancient sarcophagi, where along the front of the lid the main scene occurs and is repeated, with grotesque imagery, enacted by erotes. One example is the Capitoline sarcophagus depicting the hunt of Meleager: see Koch 1975, pp. 89–90. On a cassone by Apollonio di Giovanni and Marco di Buono (Indiana University Art Museum, Bloomington), made about 1463 on the occasion of the marriage of Giovanni di Antonio Pazzi and Beatrice di Giovanni Borromei, putti astride dolphins wave banners with the armorial bearings of the wedding couple. The pair of dolphins on the capitals are perhaps derived from the type of frieze on the Camposanto at Pisa, used as a pluteus in the Middle Ages: see Arias, Gabba, and Cristiani 1977, p. 116, B 3 est. The architectural decorations in the Iole apartments consisting of alveolate ovoli moldings alternating with large notched lancets date to about the late 1430s, as can be shown by a comparison with Donatello's Cavalcanti Annunciation (1435) in Santa Croce, Florence.

120. On the resemblance of the door in Urbino to the one at Cesena, see Rotondi 1950, p. 133; this type of tabernacle-like door, which imitates an invention by Michelozzo—with its fluted engaged pilasters topped by Composite capitals—is found in the Malatestiana at Cesena inaugurated by Malatesta Novello in 1452 (Volpe 1989) but is much more rustic than examples in Urbino.

121. The Revere door—called to my attention by Massimo Bulgarelli, with its fluted, engaged pilasters and interior cornice adorned with heraldic blazons—was completed in 1457, except for the tympanum, which was added soon afterward at the behest of the marchese Ludovico; see Lawson 1979, vol. 1, p. 108.

133

122. Barocchi 1958, p. 227.

123. Rotondi 1950, vol. 1, pp. 155–66. Dal Poggetto (in Dal Poggetto 1992a, pp. 280–83) suggests a date no later than 1459, the year of the count's marriage to Battista Sforza; the painted coats of arms unite the image of a lion with that of a quince—the Sforza arms—with those of the Montefeltro. On the fresco cycle of *Famous Men* see, most recently, Marcelli (in De Marchi 2002a, pp. 257–63), who dates the series between 1460 and 1465 because of Federigo's prolonged absences from Urbino in the preceding years. The argument does not appear to be definitive, however, because, as noted, it was almost certainly Fra Carnevale who supervised the fresco decoration of the Iole apartments.

124. On Boccati in Padua, see, most recently, Minardi 2002, pp. 212–17.

125. Concerning the putti on the base of Donatello's *Judith,* which allude to the role of wine in the death of Holofernes, see Dempsey 2001, pp. 56–61; Bober and Rubinstein 1986, p. 91 n. 53. Sarcophagi of this kind, with cupids and bacchic imagery, probably existed in Pisa and Florence as well.

126. Vespasiano de' Bisticci, quoted in Rotondi 1950, vol. 1, pp. 412–13 n. 46. Heydenreich (1967) presents some informed speculation on Federigo as architect.

127. On its state of conservation and for a proposed reconstruction of the alcove, see the dissertation by Filippini (1984): the sides of the panels with the garden imagery were on the inside of the structure, although in all likelihood its position against the wall is original.

128. Dal Poggetto in Ciardi Dupré Dal Poggetto and Dal Poggetto 1983, pp. 50–55; Dal Poggetto in Dal Poggetto 1992a, pp. 309–13; Bruschi 1996, pp. 285–86. Bruschi (2002, pp. 47–49), in considering the completion of the alcove to parallel chronologically the duke's election, assumes Fra Carnevale to have been its sole decorator, and Bramante its architect. At first I had erroneulsy discounted the reasons for an earlier dating: see Ceriana 1997, p. 138.

129. Nardini (1912) reads the two letters as *F*s and attributes the alcove to Paolo Uccello. On the Montefeltro emblems, see Lombardi 1992. The reading of the monogram as *FD* is questionable, since the second letter does not typically arch to either the right or left but has two small lines, an upper one in the shape of a rhombus and a lower one in the shape of an Acanthus leaf. The ends of the two *F*s should curl forward, but, instead, the second one is bent upward and to the left. In the alphabets published by Champ Fleury (1529), for the *lettre de forme* and the *lettre bastarde,* Geofroy Tory drew an *F* with the upper line in rhomboid, form—exactly as if it were made with a quill pen, as in the second letter of the Urbino monogram; the *F* of the *lettre tourneure,* on the other hand, is closed in front like the first of the two by Fra Carnevale (Tory 1927 [1967 ed.], pp. 176–78). The *D* has an unmistakable eyelet-like projection that closes with an independent stroke of the pen (on the right) or with a continuation of the vertical stroke (on the left). It is

130. Syndikus 1996, pp. 30–35; Burns 1999, pp. 136–37 notes 19–20. The models were ancient theaters.

131. See Tavernor 1994, pp. 368–70, and, more recently, Ronen (1998), who suggests that the model for the sequence of pilasters on a plinth connected by a base (*zoccolatura*), and for the specific placement of the doors, was the arrangement of the second order in the ancient Pantheon; the rotonda was one of the antique architectural forms most studied by Alberti. The Lippesque marble paneling is interrupted by Doric engaged pilasters on plinths united by a base; these pilasters, adapted from the Baptistery in Florence, are reminiscent of those on the ground floor of the Palazzo Rucellai. In Piero della Francesca's altarpiece, he depicts engaged pilasters on plinths, joined together by a base, across the entire façade of the building (Ceriana 1997, p. 138).

132. Syndikus 1996, pp. 104–17. On Alberti's presence at the Urbino court—certainly a determining factor in the design of the Palazzo Ducale, see Burns 1998, p. 143; Bruschi 2001, p. 367 n. 43; Biermann 2002; and, most recently, Calzona 2004.

133. The altar frontal in the church of San Biagio, Petriolo (near Florence), dates to 1453; see Ferro in Bellosi 1990a, pp. 50–51.

134. "*Est et aliud cubiculum a proxima platano viride et umbrosum, marmore excultum podio tenus, nec cedit gratiae marmoris ramos inidentesque ramis aves imitata pictura*" ("There is also [in my villa] another bedroom shaded by a nearby plane-tree and decorated in marble all the way to the ceiling and in a fresco, no less attractive than the marble, of leafy fronds peopled with birds." [Pliny the Younger, *Epistolae*, Book V, VI, 22; Pliny 1972, pp. 344–45]). There was a copy of Pliny the Younger's letter in Federigo's library; see Guasti 1863, vol. 3, p. 439 n. 445; Michelini Tocci 1958–59.

135. Negroni 1993, pp. 48–49.

136. As brought to my attention by Matteo Mazzalupi, the name "Francesco di Matteo di Tura da Montecorbe" appears among those of stonecutters active in Urbino at the time; see Calzini 1899, p. 132 n. 2.

137. Some *"nodelli"* are mentioned in connection with "*lapidipus feminis*" in a contract dated February 11, 1382 (1383 in the Florentine calendar), for the Loggia dei Lanzi; these must have been pins or pegs for connecting the stone blocks. See Frey 1885, p. 299.

138. Negroni 1993, p. 52. Catanei must have been a person of some importance, since as soon as Federigo assumed power, he was given an estate: see Tommasoli 1978, p. 44 n. 16.

139. Negroni 1993, pp. 43–46.

140. Ibid., p. 49. Matteo Mazzalupi informs me that, among the papers of the same notary, Simone Vanni, he has found records of many bequests to the cathedral from 1455 to 1457.

141. Tafuri 1993.

142. See the documentary appendix by Livia Carloni.

143. There are many perceptive observations on the architecture in the indispensable article by Offner (1939, pp. 229–33), including numerous references to Florentine, Montefeltrian, and Albertian sources. For further discussions, see Strauss 1979, pp. 95–106; Bruschi 1996, pp. 277–85; Borsi 1997, pp. 11–72, with some valuable arguments; Borsi 2003; Bruschi 2002, pp. 37–39; Cieri Via 1999, pp. 237–42; and most recently, Bruschi 2004.

144. On Alberti's religion, see the concise but rich discussion in Tenenti 1999.

145. "There is nothing in the entire discipline of architecture that requires greater use of intelligence, attention, ability, and diligence than the construction and decoration of a temple" (Alberti 1966, vol. 2, Book VII, 3, pp. 542–43).

146. Bulgarelli in Bellosi 2002, pp. 218–21.

147. Bruschi (1996, p. 281) reconstructs the building's plan in figure 13 in his essay.

148. Bartolomeo di Giovanni Corradini is last documented in Urbino in August 1451, but he is not mentioned in Maso's account book after June of that year. The next reference to the friar in Urbino is in 1454, at which time he certainly must have taken part in the final installation of the portal of San Domenico: see the documentary appendix in this catalogue.

149. The date ascribed to the portrait of *Frederick III* (cat. 28) by Meiss (1961a, pp. 61–66), no longer appears certain. The painting, which was probably executed in Rome in 1457, has been attributed by Andrea De Marchi to Benedetto Bonfigli.

150. Four windows of the church depicted in the painting are visible, but, logically, there must have been a fifth one in the part of the clerestory obscured by the façade. On the nave windows, which were modified and restored several times, see Berthier 1910, p. 533. In the 1450s the titular cardinal of the church was Aeneas Silvius Piccolomini (ibid., p. 518). On the membership of the convent in the observant Dominican congregation, see Berthier 1912, pp. 411–29.

151. Saalman 1958; Saalman 1993, pp. 82–105.

152. This was pointed out by Parronchi 1964a, p. 466, ill. 154a–b.

153. Perhaps in homage to the model established by Uccello, in Lippi's late frescoes at Prato the Ionic capitals of the trompe l'oeil niches are also rotated to show the volute instead of the echinus.

154. This is the loggia of the palazzo of Pietro Lunense, who was in Viterbo in the early 1450s; see Burns 1998, pp. 118–20.

155. The loggia is part of a palazzo that belonged to Federigo in 1465 and was sold later that year to Pietro di Arcangelo dei Bonaventura; see Londei 1991, pp. 37–38 nn. 82–83, pp. 57–58. Since the decoration features the exploits of the house of Montefeltro, the loggia must have been executed before 1465. The attribution of the project to Fra Carnevale has been proposed by Fabio Marcelli (in a forthcoming paper from a conference on the wood ceilings that was held in Pavia). The borrow-

ings from Lippi in the Barberini Panels were pointed out by Offner (1939, pp. 216–17). Unfortunately, the attribution must be made more by the process of elimination than because of any stylistic analogy between the capitals of the loggia and the Ionic capitals painted by Corradini. The perspectival views on the (later) wood door leading from the Sala degli Angeli into the Salone del Trono in the Palazzo Ducale incorporate the Arcangeli-Odasi loggia. None of the buildings represented, however, recalls the architectural style of Fra Carnevale, who nevertheless might well have been asked to provide a cartoon of an urban view. See the rather persuasive argument advanced by Raggio (1999, pp. 4, 10, 157) and by Benzi (2002) for attributing the inlays in the duke's *studiolo* in Urbino to Baccio Pontelli.

156. Lucchini 1996, p. 81.

157. Lippi's *Vitelleschi Altarpiece,* painted for the church of San Marco in Tarquinia in 1437 and depicting an almost programmatically spacious architectural setting, retains its original fine carved and gilded frame; see Carloni 1998, pls. vii, viii.

158. Among the flood of bibliographical material on Alberti, that by Lorenz (1976) remains a useful and clear introduction to the subject. A thorough overview is provided by Lorch (1990), who discusses all known works by Alberti as well as those variously attributed to him—especially the type of the double, superimposed façade; see, most recently, Bulgarelli 2003a.

159. See the *Codex Barberiniano* by Giuliano da Sangallo, fol. 21; Strauss 1979, p. 105; Bruschi 1996, p. 281; Borsi 1997, p. 43. For a well-organized exploration of the subject see Deiseroth 1970. The most famous arch in the area, certainly familiar to Fra Carnevale, was that in Fano, which Giuliano da Sangallo (fol. 61) restored with freestanding columns that it never actually did have. The clear disproportion between the central arch and the smaller side arches of the façade depicted in the *Presentation of the Virgin in the Temple (?)* might have been a deliberate attempt by the friar to make the perspective compatible with an oblique viewing point in the nave, as suggested by the situation of the marble arch in a colonnaded street in the center of the city of Fano; see Luni 2000, pp. 165–229.

160. See Pfisterer 2002b, p. 136: the entry reads: "The forum of Augustus Divus Octavianus was so sumptuous and beautiful with its columns, statues and marbles from every region, that one could hardly fail to do the same," and so on in this vein.

161. For association of the passages from Alberti's treatise with the revetment of the temple's walls see Cieri Via (1999, pp. 238–39), whose attempt to liken the figural style of the friar in these bas-reliefs to Francesco di Giorgio's entirely different approach seems somewhat erroneous.

162. The comparison was first made by Offner 1939, p. 211 n. 16.

163. Borsi 1997, pp. 91–93. On the architecture in the Sienese painter's works, and on that in the *Dream of the Blessed Sorore,* see Bonaiti 2000–2001.

164. Note the stories in low relief under the side arches; the bucrania in the relief on the trabeation; the paterae, with enhanced central spherical decorations, in the base of the arch, the statues on the attic, and the fluted pilasters.

165. Grayson 1957, p. 17.

166. The fine capital with dolphins, which has been compared with that on the main door of the Sala della Iole (Strauss 1979, p. 123), has a central shoot from which two floral corollas issue that is quite similar to one on a capital on the attic of the central portal of San Domenico. The capital, with its rampant dolphins, resembles a medieval transcription of an ancient typology—a form that Fra Carnevale might have encountered in Romanesque art in Umbria and in the Marches; for some very fine examples in the cathedral of Viterbo, see Watterson 1979, pp. 47–60.

167. Strauss 1979, p. 123.

168. Ibid., pp. 100–101.

169. Humfrey (1985) suggests a date in the 1470s; Casu (1996, p. 85 n. 63), one in the next decade; and a date "at the close of the eighth decade" has been been proposed by Sartor (1997, p. 39).

170. The comparison of the Palazzo della Nascita della Vergine with some of the architecture in Carpaccio's cycle of scenes from the life of Saint Ursula, and the suggestion that the Codussian rood screen (?) in San Michele in Isola might originally be from Urbino—because of its similarity to that seen in the Boston panel—were made by Andrea Guerra at a conference on architecture in Carpaccio's paintings at the IUAV in 2003.

171. Ceriana 1997, p. 137.

172. Bruschi 1996, p. 268 n. 7.

173. Ceriana 1997, p. 138; in the Williamstown painting it is also possible to reconstruct the style of the column bases through what can be seen to the left and right of the figures: they consist of classical bases on low, quadrangular plinths.

174. Bruschi 2002, pp. 46–47. In a not entirely positive assessment of the painting—which was supposedly executed "mainly with the help of assistants"—Bruschi suggests that the architecture was conceived with the help of the young Bramante.

175. For a comparison of the architecture shown in the paintings of Domenico Veneziano and Piero, see Ceriana 1997, pp. 128–31.

176. See the lucid exploration of the question in Tumidei 1994, pp. 48, 77–78 n. 154: Yuen 1970; Boyle 1991; and also Horster 1980, pp. 41–44. The payment made by the Vatican *fabbrica* to master Andreino da Firenze (that is, Andrea del Castagno) occurred

in 1454 (see the documentary appendix by Di Lorenzo). The appearance of the architecture and the decorative vocabulary of the Sala Graeca are not in tune with the style that prevailed during the reign of Sixtus IV, beginning with the fresco by Melozzo for the pope's library, whose marble and imperial monumentality is light years away from the immature, antiquarian, slightly naïve and flowery decoration of the spacious loggia. The bucrania in the painted architecture in the projecting part of the frieze are reminiscent of those by Fra Carnevale in the Barberini *Presentation of the Virgin in the Temple (?).*

177. Luchs 1977, pp. 22–28. The corner pilasters are not square columns but are fluted. Giuliano was paid for a model—probably for a cloister—in February 1491. The idea of putting a four-sided arcade in this space, however, must have arisen after the laying of the foundation of the church in 1481. This connection was already made by Pacciani in Cieri Via 1996, pp. 316–17.

178. Piero della Francesca 1984, pp. 128–29.

179. See Lutz 1995; Höfler 2004, pp. 123–48.

180. See Serra 1932, pp. 236–37; and, most recently, Fucini Bartolucci in Cleri 2004, pp. 25–44.

181. See the one published in Rotondi 1950, vol. 2, n. 59: the eagle is from the room adjacent to the sleeping alcove in the Iole apartments.

182. In 1476, Fra Nicola Hanna (the name seems like a mistranscription of *de Lanne*) of Fano was given permission to leave the monastery to work with Fra Carnevale; see Marchese 1878–79, vol. 2, p. 529. See the documentary appendix by Mazzalupi.

183. See Piero della Francesca 1984, pp. 79–81, for the multisided polygons viewed in perspective.

184. See the essay by Roberto Bellucci and Cecilia Frosinini.

185. Bjurström 2001, n. 1063 (n.p.).

186. Piero della Francesca (1984, pp. 106–9) dealt with question in problem VI of Book II, which involves rendering a polygonal wellhead on a two-stepped podium into perspective.

187. See the currently available edition of Alberti (1986, pp. 230–91, especially p. 242). On the *Momus,* see Vasali in Alberti 1986, pp. 443–63. On the "theater of the gods," see Rinaldi 2002, pp. 143–59. For a perceptive reading of Alberti's ideas on art, as viewed through the hermeneutical lens of the *Momus,* see Bulgarelli 2003a.

188. "In short, we must venerate, as if it were Jupiter himself, this piece of incoherent bronze that has nothing good about it except for its workmanship" (Alberti 1986, pp. 240–41). See, on this sensitive topic, the excellent article by Tenenti 1998.

189. One must not forget the dolphin-shaped clouds in the *Birth of the Virgin*: on possible sources in Alberti, found in a passage from the *De statua,* see Janson 1961.

Catalogue

[1]

FRA FILIPPO LIPPI

A. *Saints Augustine and Ambrose*

B. *Madonna and Child Enthroned with Two Angels*

Tempera and gold on wood (transferred from wood): overall, 122.6 x 62.9 cm; painted surface, 120 x 61 cm
The Metropolitan Museum of Art, New York.
The Jules S. Bache Collection, 1949 (49.7.9)

C. *Saints Gregory and Jerome*

A and C: Tempera and gold on wood: overall (each), 129 x 65 cm; painted surface (each), 121 x 57 cm
Accademia Albertina di Belle Arti, Turin
(inv. 140, 141)

The main components of this major altarpiece by Filippo Lippi are reunited here for the first time since 1935, when the three panels were shown in Paris at the Petit Palais. Although it has sometimes been contested that they formed a single altarpiece (Marchini), there really can be no doubt of the matter: the box-like enclosure runs continuously through all three panels, as does the gold background, and despite the unexpected projection of the pavement in front of the Virgin into the viewer's space, devices of this sort are common in Lippi's work. (The rounded protrusion was a revision that Lippi painted over a straight edge.) It is possible to reconstruct the picture's impact of a continuous space—albeit viewed through a tripartite frame—from Pesellino's altarpiece with the Madonna and Child and four saints (Louvre, Paris), which is heavily indebted to Lippi's work of the 1430s but was painted in the mid-1450s. Pesellino's figure of Saint Zenobius (?) looking over his shoulder at the viewer, with his cope falling in heavy vertical folds and the hem rising in a sharp diagonal, clearly derives from Lippi's Saint Augustine, as does the enclosure (given a more modern aspect by the replacement of the gold with trees and sky) and the stepped pavement (jogging in rather than projecting out). Despite the continuous architectural

enclosure used to unify the space in Lippi's triptych, the panels do not make a completely homogenous impression. This is due partly to a stylistic divergence among the panels and partly to the condition of the Metropolitan Museum's painting, which has been transferred from one panel to another. The grayish pink dress of the Virgin has become transparent with age, revealing some of the preparatory underdrawing as well as a pentimento in the book held by the Christ Child. There is, however, no reason to posit the presence of workshop collaboration, as do Ruda and Rowlands. A measure of the quite exceptional quality of the ensemble is provided by the Turin panels, which have been cleaned prior to this exhibition. The colors in the left-hand panel especially have an almost enamel-like brilliance that emphasizes the inherently sculptural conception of the figures, yet there are some of the same defects in anatomical description that are typical of Lippi's work of the 1430s.

Lippi's key pictures of the 1430s are his *Madonna and Child* (known as the *Tarquinia Madonna;* Galleria Nazionale d'Arte Antica, Rome), painted in 1437 for Giovanni Vitelleschi for an Augustinian church in Tarquinia, and the *Barbadori Altarpiece* (fig. 14, p. 52) of 1437–39 (?), executed for a chapel in the Augustinian church of Santo Spirito in Florence. Berenson, who is responsible for establishing the basis for our understanding of Lippi's early chronology, thought the Metropolitan's panel later in date than the *Tarquinia Madonna,* adding, "Only one feels at the same time a veering toward the Louvre masterpiece [the *Barbadori Altarpiece*]." Interestingly, of the Turin panels he remarked, "The panel with Jerome and Gregory has something about it which may have inspired the *Veneti.* The attitude and draperies recall Mantegna and Giovanni Bellini." He was, of course, well aware that Lippi is documented in Padua in 1434 and that later sources record some works he left there. Perhaps it is not surprising that Rowlands and Humfrey have suggested that the New York–Turin triptych was painted for a Paduan church and had a formative impact on Nicolò Pizzolo, Andrea Mantegna, and Antonio Vivarini and Giovanni d'Alemagna.

There is no doubt that the work Lippi carried out in Padua was crucial to Paduan painting prior to the arrival in the city of Donatello in 1444. Moreover, the altarpiece painted by

Antonio Vivarini and Giovanni d'Alemagna in 1446 for the Scuola Grande della Carità in Venice (Galleria dell'Accademia, Venice) could derive from a work by Lippi similar in format to this one. However, De Marchi (1996b) has clarified the style of Lippi's Paduan paintings, and it can be said with some confidence that Lippi painted the New York–Turin triptych in Florence, where, as we have seen, it was studied by Pesellino. (Rowlands has argued that the altarpiece was painted in Florence in the 1440s, in part by Pesellino, and then sent to Padua, but this rather elaborate scenario is unconvincing.)

The years from 1435 to 1440 represent a period of intense experimentation by Lippi, and there is not a simple progression from one work to the other. Documents prove him to have been a slow, even dilatory worker, who was constantly revising and adding to his initial conceptions. In a well-known letter to Piero de' Medici in 1438, Domenico Veneziano expressed his conviction that Lippi would require at least five years to complete the *Barbadori Altarpiece* (an estimate that perhaps demands more attention than it has received: we know that Lippi took eight years to paint the *Coronation of the Virgin* for the convent of Sant'Ambrogio). He often had several commissions in hand, and there are sometimes stylistic disparities, or variances, within a single work. This is, for example, the case with the *Annunciation* (fig. 13, p. 51) in San Lorenzo, Florence, in which there is a notable difference in the treatment of color in the right- and left-hand panels (the altarpiece seems to have been painted on two supports that were only joined together subsequently, thus explaining why the moldings of the center pier do not exactly align and the colors do not completely match: see Ruda 1993, p. 400). The figures in the right-hand panel are painted in what might be called a chiaroscuro mode that emphasizes delicate transitions between lit and shaded areas, while in the left-hand panel the drapery is brilliantly colored, with sharply delineated folds that underscore their sculptural solidity. This is essentially the same division we find between the New York and Turin panels, suggesting that the triptych was possibly begun in the late 1430s but only brought to completion about 1440, or even somewhat later. It is worth pointing out that the flat halos of the saints, with their incised, radiating lines, imitate those by Fra Angelico and are characteristic of Filippo Lippi's work of the 1440s—not of the 1430s.

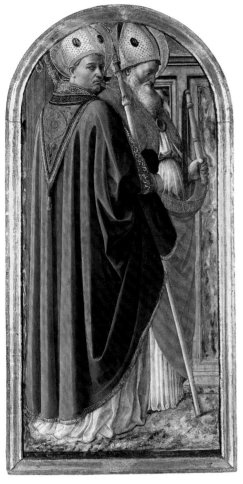

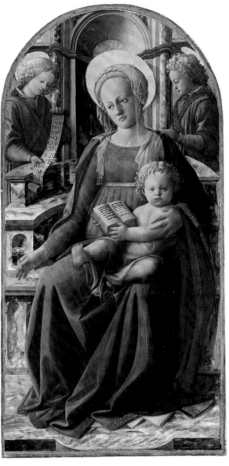

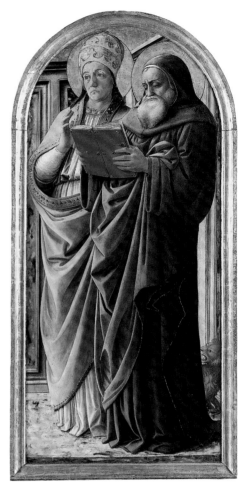

A

B

C

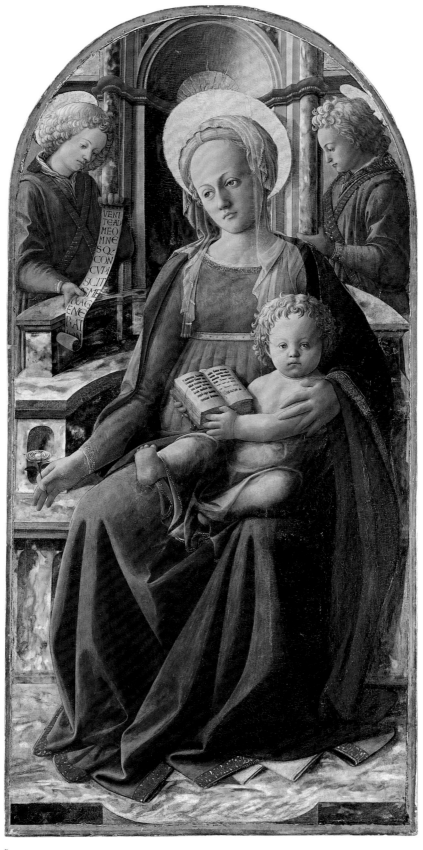

The text on the scroll reads:
VENI
TEAD
MEO
MNE
SQ
CON
CVPI
SCIT
IS ME
FAGE
NER
RAT
...

B

Opposite: Detail of c

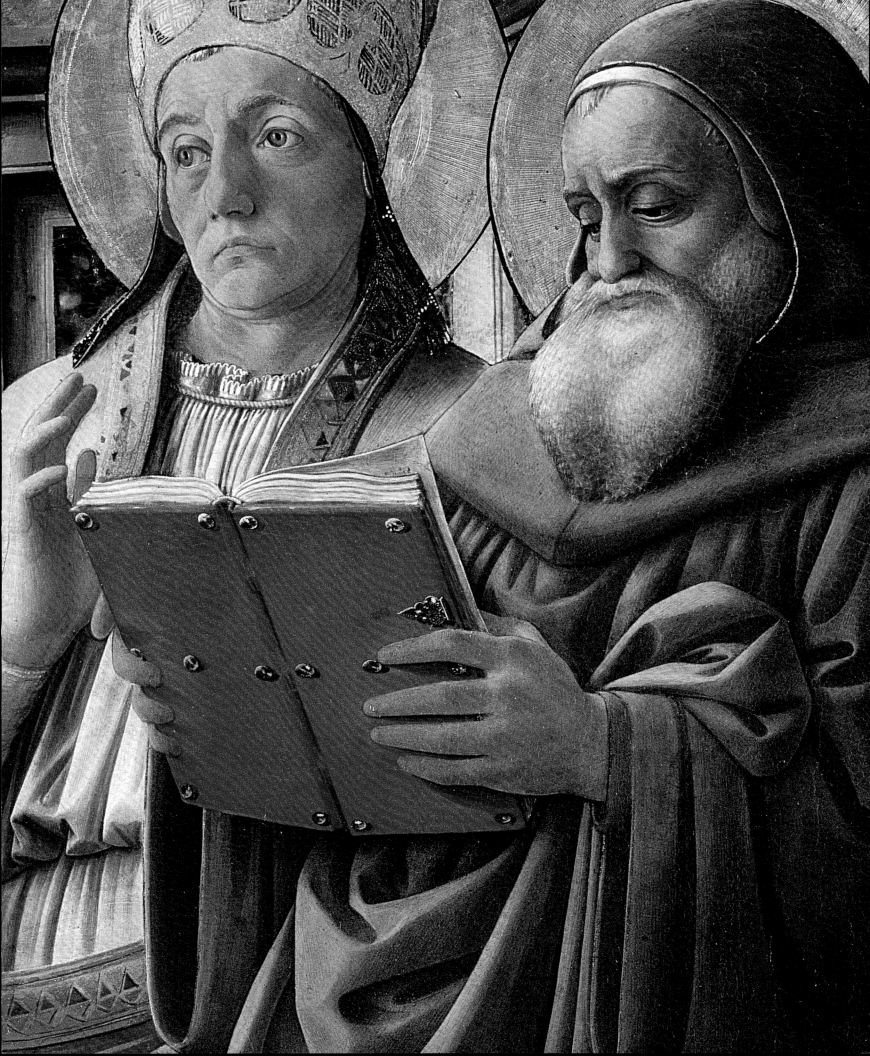

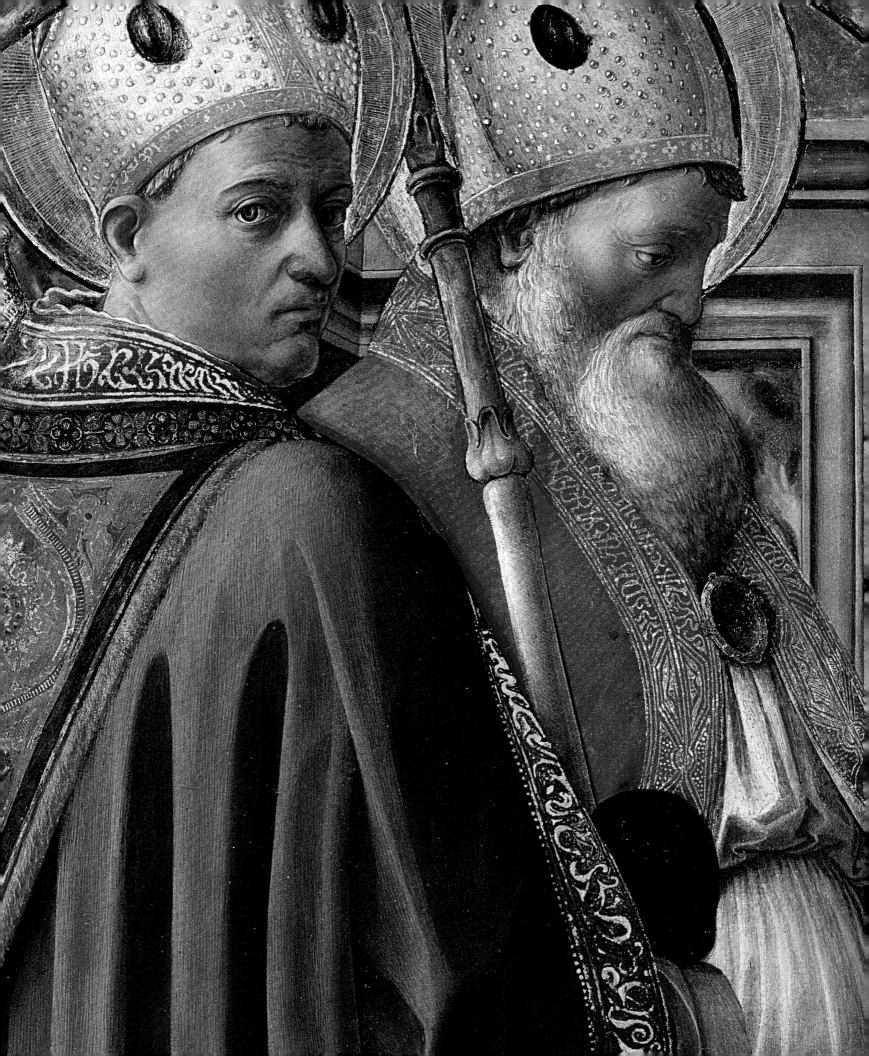

Here again, the contrast with the perspectival halos of the Madonna and Child suggests a protracted execution.

The San Lorenzo *Annunciation* is unusual in Lippi's oeuvre for the emphatic perspective view beyond the Virgin's chamber into a garden flanked by steeply receding buildings, with the vanishing point at the height of the Virgin's head. The narrative is developed in terms of contrasts of pose and gesture—*affezione* or *affetti*—as set down by Alberti, and there can be little doubt that the angel at the left, who looks out of the picture toward the viewer, is a nod to Alberti's recommendation in his treatise on painting that there "be someone in the narrative who admonishes and indicates what is happening or beckons with the hand to observe" (II.42). This same role is fulfilled in the Metropolitan–Turin panels by the figure of Saint Augustine, who is posed remarkably like the angel in the *Annunciation*. We might also note the attempt, in the panel with Saints Jerome and Gregory, to use gesture and pose to suggest an ongoing discussion that centers on the Virgin. She is shown seated on the Throne of Wisdom (the *Sedes Sapientiae*) holding a rose ("the rose of Sharon" [Song of Solomon 2: 1]; a "rose plant in Jericho" [Ecclesiasticus 24: 18]), identifying her as the bride of Christ and the Church. The verse inscribed on the scroll held by one of the angels is taken from Ecclesiasticus (24: 26)— "VENITE AD ME OMNES [QUI] CONCUPISCITIS ME & GENERTION[IBUS] M[EI IMPLEMINI]" ("Come over to me, all ye that desire me, and be filled with my fruits")—a text on Divine Wisdom commonly associated with the Virgin (see Schiller 1971–72, vol. 1, pp. 23–25; Rosand 1982, p. 107). Jerome was, in fact, devoted to Mary, and his writings were used by proponents of the doctrine of the Immaculate Conception. In other words, this is a work in which Lippi has refashioned the terms of the *sacra conversazione* with strong Marian overtones along Albertian lines. For the depiction of the saints in dialogue he perhaps derived inspiration from Donatello's large stucco reliefs of Saints Cosmas and Damian in the Old Sacristy of San Lorenzo. Saint Gregory especially has a powerful, Donatellesque physiognomy reminiscent of the heads Uccello

painted in the frame of the clockface on the interior façade of the cathedral of Florence (1443). However, one of the salient aspects of the New York–Turin triptych is the rejection of the clinging, "wet" drapery style of Donatello for one of large, simplified folds that only occasionally—as in the figure of Saint Jerome —form a web-like pattern. Here again the analogies are with the San Lorenzo *Annunciation* and thus mark a specific moment in Lippi's career: a turn from his experimentation with a chiaroscuro light effect to one in which color reacquires a more symbolic as well as a decorative function. The curiously diminutive niche behind the Virgin is typical of the way Lippi manipulates architecture to create a scaffolding for the figures.

Romano points out that the habit worn by Saint Jerome probably indicates that the triptych was commissioned for a convent or monastery, as Jerome would normally be shown dressed as a cardinal when in the company of the three other Fathers of the Church. One possibility is the Gesuati, who followed the Augustinian rule and held Saint Jerome in special veneration; their primary establishment in Florence was San Girolamo delle Poverine (see Paatz 1940-54, vol. 2, pp. 350ff.). Another possibility is that the altarpiece was painted for the Augustinians, for whom, as Carloni (1998, pp. 210–12) has noted, Lippi executed the *Barbadori Altarpiece* in addition to the *Tarquinia Madonna*. Carloni has called attention to the fact that Pope Eugenius IV was himself an Augustinian and promoted the reform of the order: in 1439 he transferred the Badia Fiesolana to the jurisdiction of the Augustinian Canons of Santa Maria di Fregionaia, near Lucca (Cosimo de'Medici was later to rebuild the church). The Augustinians were strong supporters of Marian devotions. However, as there is no record of this altarpiece in a Florentine church, the work may have been intended for a foundation outside the city. Marchini mistakenly took the floral decoration on the cope of Saint Augustine for a Medici heraldic device (the *palle*), and Ruda noted that the work could be the one Lippi refers to in a letter of 1439 addressed to Piero de'Medici.

Since the Metropolitan Museum's *Madonna and Child* has been transferred from its original support, any reconstruction of the triptych must necessarily be based on the physical evidence of the two Turin panels, which have come down to us intact. They have not been thinned and are only minimally trimmed along their vertical and curved edges. The moldings are original, although partly regilded. This is an unusual feature for an altarpiece of this date, as is the fact that there is no sign on the reverse sides of the Turin panels of a batten; it is not out of the question that they were inserted into some sort of tabernacle with marble moldings.

Although the condition of the Turin panels is very good, the halos of Saints Augustine and Ambrose have been regilded and much of the decorative gilding on the vestments of the figures and the tiara of Saint Gregory is gone. A vertical split runs through Saint Ambrose's right shoulder. For a full report on the condition and restoration of the panels, see Mahon, Nicola, and Parodi in Giuliano and Sanguinetti 2004, pp. 29–32, 41–56.

K C

PROVENANCE (A, C): Msgr. Vincenzo Maria Mossi di Morano; gift of Msgr. Mossi di Morano to the Accademia Albertina, 1828; (B): Johann Baptist Ciolina-Zanoli, Cologne (until 1837); Franz Anton Zanoli, Cologne (until 1850); Max Clavé von Bouhaben, Cologne (by 1854); Franzisk Clavé von Bouhaben, Cologne (sale, Cologne, J. M. Heberle, June 4–5, 1894, no. 67); Dr. Ludwig Mond, London; Dr. Adolphe Schaeffer, Frankfurt am Main (until 1921); Duveen Brothers, Inc., New York, 1921–28; Jules S. Bache, New York (1928–43), who bequeathed the panel to The Metropolitan Museum of Art, New York.

REFERENCES: Mendelsohn 1909, pp. 108–10; Berenson 1932c, p. 21 (1969 ed., pp. 215–16); Pudelko 1936, p. 58; Oertel 1942, pp. 22, 66; Pittaluga 1949, pp. 47, 210–11; Zeri and Gardner 1971, pp. 63–64; Marchini 1975, pp. 26, 97, 200, 205; Levi d'Ancona 1977, pp. 336–37; Ames-Lewis 1979, p. 269; Fusco 1982, pp. 8–9; Rowlands 1983, pp. 16–17, 38–42, 96–98; Boskovits 1986, p. 249 n. 41; Romano in Dalmasso, Galante Garrone, and Romano 1993, p. 34; Ruda 1993, pp. 71, 84–85, 387–89; Humfrey 1994, pp. 146–47; De Marchi 1996b, pp. 7–8, 13, 15 n. 2; Carloni 1998, pp. 207, 211; Giuliano and Sanguinetti 2004.

Opposite: Detail of A

[2]

FRA FILIPPO LIPPI

The Pietà

Tempera on wood, 57.5 x 32 cm
Museo Poldi Pezzoli, Milan (inv. 1569)

This painting, executed on an arched panel, is an extraordinarily refined *Imago Pietatis*: the dead Christ, the expression on his face noble and intense and his flesh livid, appears to rise from a sarcophagus attended by the Virgin and Saint John the Evangelist. Christ's body is wrapped in a shroud that leaves his torso exposed; his mother holds his head with her left arm, as the Evangelist supports Christ at the waist. The composition has been carefully considered and achieves some very sophisticated effects, such as the detail of Christ's right hand resting on his mother's right shoulder although his arm remains hidden behind her. The Virgin's face, turned toward the viewer, expresses strong emotion, while Saint John, his head inclined and his gaze cast downward, seems to internalize his sorrow. The composition is not perfectly aligned with the central axis; instead, the figures and the sarcophagus are shifted slightly to the right. A large, barren and rocky mountain looms up in the background, at the center of which is a cave—likely a reference to the tomb where, according to the Gospel accounts, Joseph of Arimathaea placed the body of Christ (Matthew 27: 57–60; Mark 15: 43–46; Luke 23: 50–53); at the lower left is another open tomb.

This work comes from the collection of Gian Giacomo Poldi Pezzoli (1822–1879), although there is no record of when or where he acquired it. The painting first appears in an inventory compiled by the notary Rinaldo Dell'Oro in 1879, after Poldi Pezzoli's death. The *Pietà* is listed among the works in the first room of the Gallery: "4803/52. Unknown. The *Pietà* having a rock in the background. Painted on a panel with a carved, gilt frame. Value one thousand lire." Later, in the first published catalogue of the Poldi Pezzoli collection, edited by Giuseppe Bertini (1881, no. 148, p. 39), the work was ascribed to the school of Murano (the Vivarini). Berenson (1900, p. 130; 1909, p. 163; 1932a, p. 443) assigned it instead to Francesco Pesellino. The correct attribution to Lippi, later universally accepted, was first suggested in 1901

(Schmarsow, Bayersdorfer, and von Lützow 1901, pl. 7). Indeed, despite its imperfect condition, "the high quality of the painting in its best preserved passages (including the drapery that covers the body of Christ and some of the rocky landscape) makes any uncertainty that it is an autograph work [by Lippi] impossible" (Natale 1982, no. 182, p. 147). The picture, more likely a refined, portable altarpiece for private devotion rather than the upper panel of a polyptych, as has been suggested, should be dated early in Lippi's career (Berenson 1936, p. 247; Volpe 1956, p. 44). This is confirmed by its style, which "demonstates the undeniable influence of Masaccio in the facial types and handling of the lights and darks as well as a knowledge of Fra Angelico in the fluent line that dominates the composition" (Natale 1982, no. 182, p. 147). The pointed form of the arched panel also suggests an early date (Rowlands 1983, p. 9; De Marchi 1996a, p. 74 n. 81). More precisely, the panel must have been painted in the second half of the 1430s, after Filippo Lippi returned from his visit to Padua (Boskovits 1986, p. 249 n. 41; De Marchi 1996a, pp. 74–75; De Marchi 1996b, pp. 7, 10, 17 n. 24), and at the same time that he was executing some of his more important altarpieces: the 1437 *Tarquinia Madonna* (Galleria Nazionale d'Arte Antica, Rome), the *Barbadori Altarpiece* (Musée du Louvre, Paris), of 1437–39 (fig. 14, p. 52), and the triptych now divided between the Accademia Albertina in Turin and The Metropolitan Museum of Art in New York (cat. 1 A–C). De Marchi has pointed out that the composition reflects a lost prototype by Donatello, especially apparent in the off-center placement of the sarcophagus and the position of Christ's left hand, which is folded backward. Donatello's model enjoyed widespread popularity in the Veneto, perhaps because of the artist's long sojourn in Padua, and there remain several series of copies of the prototype in plaster and terracotta (De Marchi 1996a, pp. 71–76; De Marchi 1996b, pp. 10, 19 n. 35). However, the Poldi Pezzoli *Pietà* is the earliest reflection we have of this lost prototype. Lippi's personal contribution consists of the wrapping of the shroud around Christ's head, a motif that reappears in a superb, although much damaged *Pietà* in the Keresztény Múzeum in Esztergom, Hungary—the work is dated by De Marchi (1996b) to the period of Lippi's stay in Padua, where he is documented in 1434—as well as in a later *Pietà with Saints Francis and Jerome* (Palazzo Arcivescovile,

Florence), which was produced by the artist's shop (De Marchi 1996b, p. 7).

However, the Poldi Pezzoli *Pietà* is much closer in style to another small painting dating from the same moment: a splendid panel of *The Penitent Saint Jerome and Another Monk Pulling a Thorn from the Lion's Foot* (Staatliches Lindenau-Museum, Altenburg, Germany), which can be identified with an item in the 1492 inventory of the Medici Collection ("A painting with a gilded frame with the figures of Saint Jerome and Saint Francis painted by Pesello and Fra Filippo, f. 10": see Müntz 1888, p. 64; Spallanzani and Gaeta Bertelà 1992, p. 33). It was also described in the 1560–70 inventory ("A panel with an old, gilded frame with a Saint Jerome and Saint Francis, from the hand of Fra Filippo, small": see Beck 1974, no. 3, p. 66, no. 5, p. 62, respectively; Barocchi and Gaeta Bertelà 2002, p. 203), although the monk in the foreground was mistaken for Saint Francis. Giorgio Vasari also remarked (Vasari [1568] 1971, p. 338) on the picture's exceptional quality when he saw it in Cosimo I's *guardaroba* ("Even better is a S. Jerome in Penitence of the same size in the *guardaroba* of Duke Cosimo . . .").

As Oertel (1942, p. 73, pl. 90) has noted, the Poldi Pezzoli *Pietà* and the *Penitent Saint Jerome* in Altenburg are essentially pendants, conceived and executed at the same time. Close in both style and dimensions, they have the same rocky landscape, the stones arranged like steps to suggest a sense of ascent. It is not impossible that this particular type of landscape, which is such an important component of each painting, had some mystical significance in the religious meditations of the cultured patrons for whom the images were intended. It is also worth noting that the profile of the Altenburg *Saint Jerome* is almost identical to that of Saint John the Evangelist in the Poldi Pezzzoli *Pietà*, and that, anatomically, the nude torso of the penitent saint is very close to, although thinner than, that of Christ at the center of the Milan painting. The format of the two panels is different: the Poldi Pezzoli picture has a pointed arch while the Altenburg painting is rectangular and was intended to have a more modern, Renaissance frame. Yet, each painting is a very refined example of private devotional art executed with extraordinary care; they must have been intended for patrons at the highest cultural and social level. The *Penitent Saint Jerome* has been identified with the panel mentioned by Fra Filippo in a letter, dated August 13, 1439, to

Piero de'Medici, for which, he complained, he had not yet been paid (Ruda 1993, pp. 283, 520 doc. 6). It is also possible, however, that its patron was Cosimo *il Vecchio,* himself; Vasari notes that he was a close friend of the Carmelite painter and had commissioned several pictures from him (see Vasari [1568] 1971, pp. 330–32).

We do not know who the first owner of the Poldi Pezzoli panel was. However, given its probable date and its relationship to the Altenburg painting, which has a Medici provenance, there is the temptation to associate the panel with the small picture Fra Filippo made for Cosimo to present to Eugenius IV, presumably during the pope's stay in Florence (1434–36; 1439–43): "he painted some little scenes that were sent by Cosimo as a gift to Pope Eugenius IV, the Venetian; wherefore Fra Filippo acquired great favor with that Pope by reason of this work" (Vasari [1568] 1971, p. 331). Given that Vasari did not identify the subject of the small panel, there is little basis for its identification, although it must certainly have had a religious subject, since it was intended for the pope. It is undeniable, too, that the exquisite Poldi Pezzoli *Pietà* corresponds perfectly to the kind of devotional painting we would expect Lippi to have made for an extremely important patron. When one compares the pictures from Altenburg and from Milan, one sees that they are, indeed, among the very finest small-format paintings by Fra Filippo. As Vasari's own acute critical judgment confirms, Fra Filippo's greatest talent lay in this kind of picture: "for if Fra Filippo was a rare master in all his pictures, he surpassed himself in the small ones, to which he gave such grace and beauty that nothing could be better, as may be seen in the predelle of all the panels he painted" (Vasari [1568] 1971, p. 338).

The *Pietà* unfortunately has suffered from earlier, drastic cleanings. The gold of the halos has disappeared, leaving the bole preparation exposed, and even the gilding that decorated the draperies of the Virgin and Saint John is almost completely gone. A strip of bare wood a

Infrared reflectograph (detail)

centimeter and a half wide extends around the panel, indicating where the original—now, sadly, lost—frame would have been attached. The panel itself was planed down by about a half centimeter and cradled. The pointed shape of the arch is original, but in the distant past a fragment of the panel was eliminated by removing a piece; the original profile was restored, probably at the end of the nineteenth century (De Marchi 1996a, p. 74 n. 81; De Marchi 1996b, p. 17 n. 24). The panel was given its neo-Gothic frame at the same time. A photograph (Brogi no. 15497) shows the panel as restored in the nineteenth century. The intervention by Mauro Pellicioli in 1951 is the only one documented: he removed the visible retouchings and the regilded halos and filled in the losses in a more discreet manner, giving the work its present

appearance; the cradling was probably added at this time as well.

Infrared reflectography carried out by Gianluca Poldi and Giovanni C. F. Villa clearly reveals the abrasions and lacunae on the surface of the painting, along the edges and in the central area (ill.). Especially affected are the two sarcophagi, the head and drapery of Saint John, Christ's torso and arm, and the right hand of the Virgin. The best-preserved passages are the faces and drapery of the Virgin and Christ and the rocky landscape in the upper half of the picture. The delicate preparatory drawing, executed in brush, probably with a brown or gray medium, is also visible in the reflectography, especially in the mantle of the Virgin and the garments of Saint John. The artist initially painted in Saint John's legs before deciding to conceal them behind the sarcophagus (this change, which did not include the legs of the Virgin or of Christ, is also apparent in normal light, and was noted by Ruda [1993, pp. 377–78]). It seems, then, that Lippi did not originally plan to put the sarcophagus in the foreground. Once he began painting in John's legs, however, he decided—perhaps because he was not satisfied with the foreshortening—to alter the composition and cut the figure off at the knees. It is possible that the second sarcophagus, placed off-center and to the left, originally was intended as Christ's tomb, since its presence is otherwise not easy to explain.

A D L

PROVENANCE: Gian Giacomo Poldi Pezzoli, Milan (before 1879).

REFERENCES: Bertini 1881, no. 148, p. 39; Berenson 1900, p. 130; Schmarsow, Bayersdorfer, and von Lützow 1901, pl. 7; Berenson 1909, p. 163; Berenson 1932a, p. 443; Berenson 1936, p. 247; Oertel 1942, p. 73, pl. 90; Pittaluga 1949, p. 182, fig. 136; Volpe 1956, p. 44; Berenson 1963, vol. 1, p. 112; Marchini 1975, pp. 102, 172, 211, no. 47, fig. 143; Natale 1982, no. 182, pp. 147 (with earlier bibliography), 384, pl. 327; Rowlands 1983, p. 9; Boskovits 1986, p. 249 n. 41; Ruda 1993, no. 11, pp. 377–78; De Marchi 1996a, pp. 74–75; De Marchi 1996b, pp. 7, 10, 17 n. 24; Mannini and Fagioli 1997, no. 9, p. 90.

[3]

FRA FILIPPO LIPPI

The Annunciation

Tempera on wood: each panel, 64 x 23 cm
The Frick Collection, New York (inv. no. 24.1.85)

Virtually nothing is known about the origin and function of this haunting depiction of the Annunciation, in which the young Gabriel moves toward the Virgin with a silent and reverential grace, gathering up his cloak with his left hand, while with the other he holds a long stem of lilies. The Virgin, who has just entered the room, responds with a gesture of humble acceptance and modest salutation. The room itself is defined simply and efficaciously by a steeply foreshortened molding and corbels supporting the cross vault. The splayed lines of the molding are a recurrent feature of Lippi's work (see cat. 1 A–C). The colors of the floor and the wall are not treated uniformly but differ in the two halves of the room, making it clear that the panels were not joined. (Only the left edge of the left panel and the right edge of the right panel are intact; Berenson reproduces a photo of them falsely joined, before they were reseparated sometime prior to 1924.)

Are the two panels the exterior wings of a small devotional altarpiece, as Venturi conjectured? Or were they intended to be framed more or less as we see them today? Throughout his career Lippi was interested in elaborate, highly imaginative framing solutions, so the second possibility should not be excluded. As late as 1457 he proposed a Gothic frame for an altarpiece to be sent to King Alfonso of Naples. His great *Barbadori Altarpiece* (fig. 14, p. 52) of 1437–39 has a tripartite form, and its Renaissance architectural setting must have been set off by an anachronistically Gothic frame with crockets and spires. Even the *Annunciation* (fig. 13, p. 51) in San Lorenzo, Florence, which today is enclosed within a reproduction Brunelleschian frame with a unified, square picture field, originally must have been divided in two by some

sort of framing element, for the color of the pilaster Lippi painted to divide the composition is not uniform: it differs on either side of a vertical join (see Ruda 1993, pp. 399–403). The same sort of solution may have been adopted here.

Although Ruda has argued for a date of about 1435–36, the picture is usually—and rightly—regarded as more or less contemporary with the *Barbadori Altarpiece,* which was newly under way in March 1437 and was perhaps completed in 1439. The same young Virgin appears in both, wearing a closely similar headdress, with the hem of her garment and cloak decorated in gold. As in the *Barbadori Altarpiece,* so, too, here the feathers of the angel's wings are picked out in gold.

Crucial to the dating of the picture is the handling of light. During the 1430s Filippo Lippi was the most innovative Florentine artist in his exploration of novel solutions to the problem of the interaction of light and color. He worked within the aesthetic of medieval painting, which prized color for its intrinsic beauty, but experimented with chiaroscuro effects in a way that was not taken up again before Leonardo da Vinci (see Shearman 1962, p. 36). The most radical of these experiments occurs in the *Barbadori Altarpiece* (it was the kneeling saint at the left in that work that provided Leonardo with a model for the angel he painted in Verrocchio's *Baptism of Christ* [Uffizi, Florence]). Lippi did not have the analytical mind of Leonardo, and in his paintings there is always a tension between art as an imitation of visual experience and art as an abstract language with pronounced symbolic content. The first approach derives from his study of the work of Masaccio and is based on his awareness of Renaissance optics; the second stems from his deep appreciation of the traditions of medieval religious painting. The same sort of ambiguity or tension characterizes his handling of space, which was never rigorously perspectival.

Chiaroscuro effects are not pronounced in this picture. Indeed, the emphasis on beauty of color is scarcely inferior to what we would expect to find in a work by Lorenzo Monaco. Yet, if allowance is made for the abrasion to the paint surface and the loss of glazes as well as

for the desire to create a precious object of devotion, the suggestion of a controlled, directed light falling in a diagonal shaft from the left is notable. Lippi's insistence on an interior space is in keeping with this desire to control the illumination: the sunlit world of Domenico Veneziano was antithetical to the novel kind of atmospheric unity he sought.

The depiction of the Virgin's shadow against the wall is as astonishing as that cast by the intruding male head in the Metropolitan's *Portrait of a Woman and a Man at a Casement* (cat. 4). If, in the portrait, there is a suggestion of Lippi's awareness of Pliny's story about painting having its origins in the act of tracing a man's shadow (*Natural History* XXXV.5), here the impetus must be the desire to affirm the Annunciation as a physically real event, for at this date it was still unusual in Florence to show a sacred figure casting such a precisely delineated shadow (see, for example, cat. 8 B, in which no shadows are cast by the sacred figures but only by the animals). Lippi may well have intended the shadow to have a semeiological function similar to that of the astonishingly veristic depiction of a vase of water in his altarpieces of the *Annunciation* in San Lorenzo and for the convent of Le Murate (fig. 5, p. 43). In those works Lippi alluded to the idea of the Virgin as the inviolate vessel of God, while here he seems to give optical meaning to the biblical salutation of the angel —"The Holy Ghost shall come upon thee, and the power of the Highest shall overshadow thee" ("*Spiritus Santus superveniet in te et virtus Altissimi odumbrabit tibi*") (Luke 1: 35). Precisely such a formula for understanding the mystery of the Incarnation occurs in the *Summa Theologica* of Saint Antoninus (1389–1459), the fifteenth-century archbishop of Florence. He explains the passage as signifying that "the body of humanity raised up in [Mary] the incorporeal light of God. The shadow results from a body in light" ("*corpus humanitatis in* [*Mariam*] *suscipiet incorporem lumen deitatis. Umbra enim a lumine formatur et corpore*"; see Edgerton 1987, pp. 46, 52 n. 10).

The figure of the Virgin offers a fine comparison to her counterpart in Fra Carnevale's *Annunciation* in Washington (cat. 40) and underscores both the Urbino painter's debt

to the artist to whom he apprenticed himself and the degree to which he looked beyond Lippi—especially to Domenico Veneziano—for inspiration and guidance toward a more coherent and complex perspectival vision. The colors, figure types, and interest in light that characterize this phase of Lippi's activity were particularly important for the author of the *Madonna and Child* in Massachusetts (cat. 11).　　K C

PROVENANCE: Calcagno family, Palermo (until 1924); Langton Douglas, London (1924); The Frick Collection, New York.

REFERENCES: Venturi 1924, pp. 167–68; Berenson 1932b (1969 ed.), p. 168; Oertel 1942, p. 67; Pittaluga 1949, pp. 72, 213; Frick Collection 1968, pp. 228–31; Marchini 1975, p. 203; Boskovits 1986, p. 249 n. 41; Steinberg 1987, p. 32; Ruda 1993, pp. 80–84, 381–82; Holmes 1999, p. 257 n. 11.

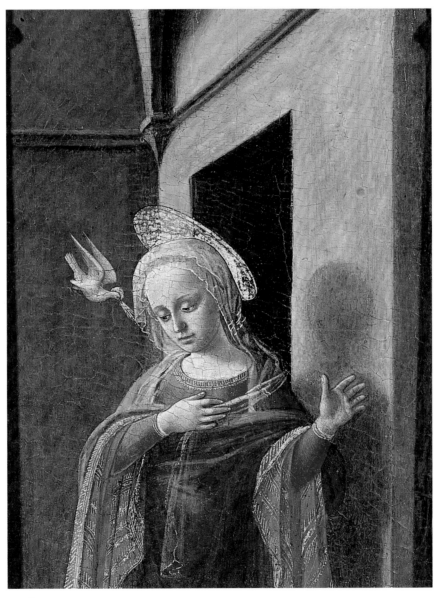

Detail

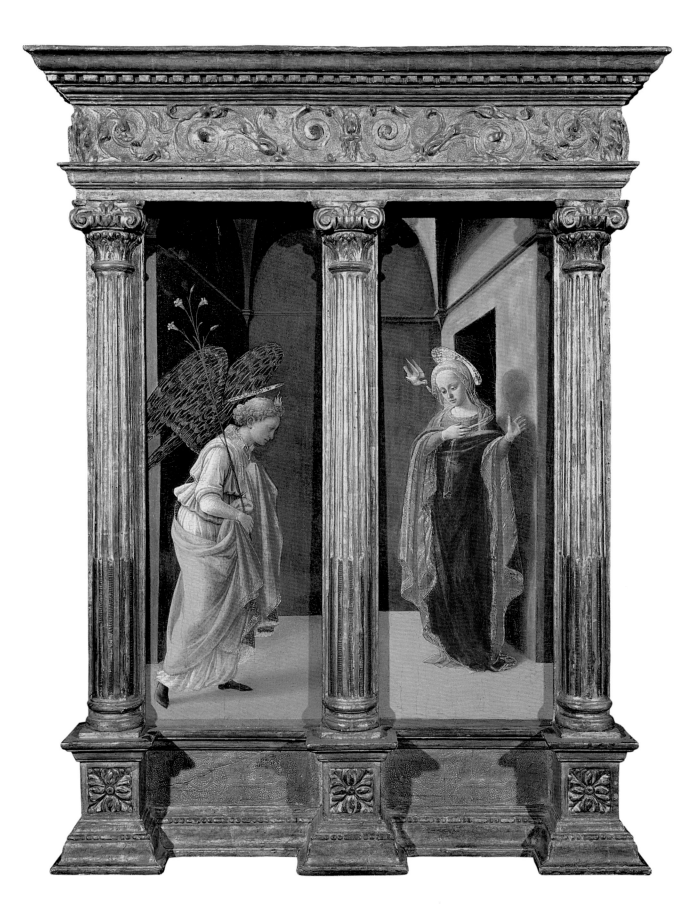

[4]

FRA FILIPPO LIPPI

Portrait of a Woman and a Man at a Casement

Tempera on wood, 64.1 x 41.9 cm
The Metropolitan Museum of Art, New York.
Marquand Collection, Gift of Henry G. Marquand,
1889 (89.15.19)

This is one of only two independent por-
traits by Filippo Lippi; the other, in the
Gemäldegalerie, Berlin, shows a woman viewed
in profile before a window embrasure with a
view onto a blue sky and a shoreline enveloped
in haze. The Metropolitan's portrait is, by com-
mon agreement, the earlier of the two and by
far the more innovative. It is, indeed, the first
surviving Italian portrait with an interior
setting, the first Italian portrait with a landscape
background, and the first double portrait in
Italian art. On the basis of the coat of arms
displayed by the male sitter the couple has been
tentatively identified by Breck as Lorenzo di
Ranieri Scolari and Angiola di Bernardo Sapiti,
who were married in 1436. The Scolari arms
were originally *argent, three bends azure* (that is,
blue bands on a silver field), but by Ranieri's
time they had been altered to *or, three bends sable*
(black bands on a gold or yellow field). A dark
blue pigment (now much altered), not black, is
used by Lippi, so the identification remains
hypothetical. Alternatively, Jensen has proposed
that the male is Giacomo Ferrero of Piedmont
(1438–1519). The coat of arms of the Ormea
branch of the Ferrero was also *or, three bends
sable* (see Spreti 1928–35, vol. 3, p. 150). This
identification requires dating the picture in the
1460s and is based on a tendentious reading of
the costumes.

An approximate date for this portrait may
be established by a comparison with the donor
figures that appear in some of Lippi's altar-
pieces. These range from the astonishingly nat-
uralistic portraits Lippi inserted in the *Barbadori
Altarpiece* (fig. 14, p. 52), of 1437–39 (?) and in
the *Coronation of the Virgin* (fig. 2, p. 40), begun
in 1439 but only completed in 1447; to the
sturdy, generalized features of the two men who
appear in an *Annunciation* (Galleria Nazionale

d'Arte Antica, Rome), a work usually dated
to the early 1440s; the delicately descriptive
depictions of the Alessandri sons in a cut-down
altarpiece in the Metropolitan Museum, of
about 1450 (fig. 15, p. 54); and the incisively
characterized likenesses of four members of the
Ospedale del Ceppo in Prato included his
Madonna del Ceppo (Galleria Comunale, Prato),
of 1452–53. On this basis the Metropolitan's
double portrait can be convincingly dated to
about 1440–44, while the Berlin *Portrait of a
Woman* would seem to date from about 1450 (the
pale palette and use of dots of gold as highlights
in the Berlin portrait are characteristic of Lippi's
work of about 1450). The Scolari had their first
child in 1444, and it is not impossible that the
double portrait commemorates this event.

Much has been read into the prominence of
the female sitter in the double portrait, the way
in which her husband's head intrudes into the
interior space, and the meaning of their gazes,
which never meet. Baldwin has emphasized the
importance of the gaze in amatory poetry and
suggests the pertinence of a verse from the Song
of Solomon (2:9) in which the bridegroom—in
biblical exegeses, understood to be Christ—
"standeth behind our wall, looking through the
windows, looking through the lattices." It also has
been suggested that the different placement in
space of the couple and their lack of interaction
imply a hierarchy in social position, or gender
roles; the possibility that one or the other is
dead; or that the woman—sumptuously dressed,
with the word *lealt*[à] (faithful) embroidered
on her sleeve—is being presented as a prized
possession. (On these various interpretations,
see Ruda.) It is therefore important to under-
score the degree to which the ambivalent space
of the picture is characteristic of Lippi's work of
the 1440s.

In the *Annunciation* to which this picture
bears the closest stylistic affinity, the space has
the superficial appearance of being laid out
according to a perspective grid, with the
orthogonals receding to an area to the left of
the Virgin's head. Yet, the expectation of a
commensurable space is denied by the surface
patterns created by the various pieces of furni-
ture and the placement of the figures within
the room. The angel is well in front of the Virgin
and could not hand her the lily without turning
inward—which he does not do. Similarly,
the gazes of the two donors, who are shown
kneeling behind a wall—like spectators at a

Giovanni di Ser Giovanni (called Scheggia),
Madonna and Child. Museo Horne, Florence

mystery play—are directed parallel to rather than toward the action. Just as there is no indication in the double portrait where the male sitter is standing to obtain his view into the room, so in the *Annunciation* it is left to the imagination how the two donors have arranged the lower half of their bodies. Under these circumstances we might well doubt that Lippi intended the ambiguities of his spatial construction to be freighted with the kinds of readings that have been proposed. The fact that the female sitter's hat is cropped off and would not fit into the room has led to the notion that the picture has been cut down (in fact, its edges are intact) or even that the picture is not by Lippi. What bears emphasizing is that the picture proposes a fiction, not a counterfeit of reality, and that it subverts the geometry of perspectival space in favor of a subjective realm shaped by creative artifice.

If the box-like space of the portrait, with its steeply foreshortened ceiling, recalls Donatello's so-called *Pazzi Madonna* (Staatliche Museen, Berlin) or Scheggia's painting of the *Madonna and Child* (see ill.), Wright is surely correct that the sharply defined shadow cast by the male

sitter onto the back wall relates to Pliny's well-known account of the origin of painting in the tracing of the contours of a cast shadow (*Natural History* XXXV.5). Quintillian, too, alludes to this story (*Institutio oratoria* X.7)—referred to by Alberti in his *Della pittura*—but as a criticism of art as imitation: "Shall we follow the example of those painters whose sole aim is to be able to copy pictures by using the ruler and the measuring rod?" The shadow thus can be understood not only as a means of recording the features of the beloved (Pliny, *Natural History* XXXV.43) but as an invitation to read the picture as a poetic conceit. "*Artificioso sopra modo*"—"artful beyond measure"—is how Cristoforo Landino described Lippi in his 1480 commentary to the *Divine Comedy,* while the duke of Milan's agent in Florence called him simply the most singular master of his day ("[*il*] *più singulare maestro di tempi suoi*").

The landscape in the double portrait, as in the *Annunciation,* is conceived in fairly naturalistic terms. There is, indeed, the possibility that Lippi's inspiration was a Netherlandish painting. The viewer's glance travels through the window and down a country road past some houses and

villas to a distant range of mountains. This wonderfully atmospheric and suggestive rendering of landscape left an indelible impression on Fra Carnevale's style. We recognize an echo of it in the *Annunciation* in Washington (cat. 40) and, most especially, in the *Birth of the Virgin* (cat. 45 A), where Fra Carnevale's familiarity with the present portrait is suggested by the presence of a woman dressed very similarly in the distinctive horned hat, known as a *scella,* which remained in fashion in Northern Italy until about 1470 (see Benati in Mottola Molfino and Natale 1991, pp. 305–6). K C

PROVENANCE: Private collection, Florence (until about 1829); Reverend John Sanford, Nynehead Court, Wellington, Somerset, and London (about 1829–55); Lord Methuen, Corsham Court, Chippenham, Wiltshire (1855–83); Henry G. Marquand, New York (1883–89).

REFERENCES: Breck 1913, pp. 44–55; Oertel 1942, p. 48; Pittaluga 1949, p. 209; Zeri and Gardner 1971, p. 85; Pope-Hennessy and Christiansen 1980, pp. 56–59; Baldwin 1986a, pp. 30–34; Baldwin 1986b, pp. 7–12; Jansen 1987–88, pp. 97–121; Tietzel 1991, pp. 17–38; Simons 1992, pp. 43, 50; Ruda 1993, pp. 85–88, 385–86; Mannini in Mannini and Fagioli 1997, pp. 92–93; Holmes 1999, pp. 129–30; Dalli Regoli 2000, pp. 28–29; Wright 2000, p. 96; Brown 2001, pp. 106–7.

Opposite: Detail of cat. 4

[5]

FRA FILIPPO LIPPI

The Meeting of Joachim and Anna at the Golden Gate

Tempera on wood, 20.5 x 47.9 cm
Ashmolean Museum, Oxford (inv. A81)

The subject, treated in the second-century *Protoevangelium,* is recounted in *The Golden Legend.* Instructed by an angel, the outcast Joachim meets his wife, Anna, at the Golden Gate of Jerusalem in recognition of the good news that, although barren for twenty years, she has conceived and will bear a daughter, Mary. Lippi shows the couple united by the angelic messenger. Behind Anna is a handmaiden, and at the far right paired deer and storks, or herons, inhabit the landscape, which is divided by a stream. This enchanting picture, with one of Lippi's most panoramic landscapes, doubtless formed part of a predella recounting the life of the Virgin. Oertel identified the altarpiece with the *Annunciation* in Munich (fig. 5, p. 43), and Pittaluga proposed as an additional scene a *Nativity* in the National Gallery of Art, Washington, D.C. Although both hypotheses have been questioned, they may well be correct. The subject and style of the Ashmolean panel make the connection with the Munich *Annunciation* logical. As for its association with the *Nativity,* it has been wrongly inferred, from incisions on either end of the *Meeting of Joachim and Anna at the Golden Gate,* that it was conceived with rounded edges, whereas the *Nativity* is rectangular. On that basis the two pictures were thought to be incompatible (Lloyd). However, the incisions have proven to be later—probably made for framing after the panel was separated from its predella. The paint in the upper corners is continuous with the rest of the paint surface and largely original. The panel thus was initially rectangular and, like the *Nativity,* was framed with a fictive molding, partly preserved on the bottom. Ruda dated the *Nativity* to the 1430s, but, like the *Meeting at the Golden Gate,* it is a characteristic work of the mid-1440s. Although the *Nativity* and the *Meeting at the Golden Gate* have similar landscape settings, the Ashmolean panel is the more refined of the two (both are

damaged; the *Meeting at the Golden Gate* has been cleaned for this exhibition). As Boskovits has noted, the figure scale in the *Nativity* is larger and the drapery is treated in a more linear fashion, but similar differences can be found as well in Lippi's predella for the *Barbardori Altarpiece* (fig. 14, p. 52).

In the eighteenth century Richa (1754–59, vol. 2, p. 109) described an *Annunciation* by Lippi in the Benedictine convent of Le Murate in Florence (suppressed 1808) that he particularly admired for the inclusion of a second angel that "behind the entrance to the room looks on with astonishment at the Archangel who salutes the Virgin." This description is usually associated with the Munich painting.

The Murate *Annunciation* was one of three altarpieces financed by the wealthy Florentine merchant Giovanni d'Amerigo Benci. According to a 1597 chronicle, construction of the east end of the convent began in 1439 and the three altars and their altarpieces, two of which were painted by Lippi, were completed in 1443 (Holmes 2000, pp. 115–16; Weddle 1997, p. 379). A seventeenth-century diary also states that the construction of the church commenced in 1439 but that in 1443 Benci erected three altars, thus suggesting a later date for the commission of Lippi's two altarpieces (Ruda 1993, p. 411). The only contemporary document is a transfer of payment on April 16, 1445, "for Giovanni Benci's altarpiece" ("*per la tavola di Giovanni Benci per resto di ragione . . .*") (see Andrea Di Lorenzo's documentary appendix). This debt occurs in an account book covering expenses for Lippi's altarpiece of the *Coronation of the Virgin* (fig. 2, p. 40) for the nearby church of Sant'Ambrogio, which also belonged to a convent of Benedictine nuns. The history of the *Coronation* is instructive, for although a seventeenth-century source records that it was painted in 1441, we know from contemporary documents that it was commissioned from Lippi in 1439 but only delivered in 1447, with most payments concentrated in the years from 1445 to 1447 (Borsook 1981, pp. 159–64). Lippi's involvement with that altarpiece—among his most ambitious—may have inspired Benci to hire him for Le Murate. In any event, given the amount of work Lippi had in hand in the early 1440s, it is highly unlikely that two altarpieces for Le Murate were finished by 1443. The style of the Munich *Annunciation* seems more in keeping with Lippi's paintings of the mid- to late 1440s;

certainly, it cannot be contemporary with the *Annunciation* in San Lorenzo, Florence, or with that in the Galleria Nazionale d'Arte Antica, Rome—both datable to the early 1440s. Rather, it is closer in style to the altarpiece (fig. 4, p. 42) for the novitiate chapel in Santa Croce, Florence, and to the *Coronation of the Virgin* (fig. 18, p. 57) for an Olivetan convent in Arezzo, both of which are dated on circumstantial evidence to the mid-1440s. We might imagine that the altarpiece was commissioned in 1443 but only completed several years later. Alternatively, the identification of the Murate altarpiece with the Munich *Annunciation* should be dropped; that the Munich *Annunciation* had a narrative predella is probable but not provable, as its frame does not survive.

The predella to which the Ashmolean *Meeting at the Golden Gate* and the National Gallery *Nativity* belonged would most likely have included a third scene showing the Birth of the Virgin. It is unfortunate that this scene—together with most of Lippi's predella panels—has not survived, for it must have made a strong impression on Fra Carnevale, who was then a "*discepolo*" in Lippi's workshop. Clearly, the reduced scale of the figures and the landscape setting in the *Meeting at the Golden Gate* forecast features of Fra Carnevale's work. The ingenious way that the city gate, plank bridge, and river recede to a vanishing point over Anna's head, with a network of paths used to articulate the transition from the pebbly foreground to the atmospheric distance—with, on the right, a cloud-scudded sky and birds hovering over a walled city and, on the left, receding hills—is echoed in Fra Carnevale's *Annunciation* in Washington (cat. 40) and in the background of the *Birth of the Virgin* (cat. 45 A). There is a temptation to consider this remarkable experiment in Lippi's art as a response to Fra Angelico and Domenico Veneziano (Wohl). Given the exceptional character of this exquisite predella panel, it is curious that it has received such cursory and even dismissive treatment in the recent literature (Ruda). K C

PROVENANCE: Fox-Strangeway Collection; Ashmolean Museum, Oxford (from 1850).

REFERENCES: Cavalcaselle and Crowe 1886-1908, vol. 5 (1892), p. 239; Pudelko 1936, p. 56; Pittaluga 1949, p. 205; Marchini 1975, p. 168; Lloyd 1977, pp. 100–102; Wohl 1980, pp. 18–19; Ruda 1993, pp. 174, 244, 410–11; Holmes 1999, p. 274 n. 24; Boskovits in Boskovits et al. 2003, p. 408.

[6]

FRA FILIPPO LIPPI

Madonna and Child

Tempera and gold on wood, 80 x 52.5 cm
Fondazione Magnani-Rocca, Corte di Mamiano
(Parma)

Unlike his pupil Botticelli, Lippi painted remarkably few devotional panels of the Madonna and Child; scarcely a dozen may be ascribed to him with confidence, yet each is a landmark in the genre. Perhaps the earliest, dating from the 1430s, is the small, badly abraded *Madonna and Child* in the Turini collection that combines the Brunelleschian architecture of Masaccio's fresco of the *Trinity* (Santa Maria Novella, Florence) and of Donatello's niche on Orsanmichele for the Parte Guelfa as the setting for a diminutive standing Madonna and her sleeping child (Marchini 1975, pp. 19–20). The beautiful *Madonna and Child* in the National Gallery of Art, Washington, D.C.—among Lippi's most harmonious creations of the 1440s—is unusual less for the manner in which the architectural niche enhances the three-dimensionality of the figures than for the way the gaze of the Virgin establishes a direct psychological relationship with the viewer-worshiper. Both features are common to a number of Luca della Robbia's glazed terracotta reliefs, and the picture may document a fruitful exchange between the two artists. Lippi's great tondo of the *Madonna and Child* in the Galleria Palatina, Palazzo Pitti, Florence, introduces an unprecedentedly elaborate architectural background with scenes from the life of the Virgin, for which the nearest equivalent is Ghiberti's gilt-bronze relief with the story of Isaac on the *Gates of Paradise* of the Baptistery in Florence. By contrast, the panels in the Uffizi, Florence, and in the Alte Pinakothek, Munich, present the softly lit figures of the mother and child—in three-quarter rather than frontal view—against an atmospheric landscape background of Leonardesque fantasy. Pope-Hennessy (1980b, pp. 150–52) has emphasized the importance of Lippi's paintings for sculptors, especially Antonio Rossellino. However, the influence ran both ways. There can be no doubt that in the Uffizi panel Lippi consciously set out to vie with the delicate, shallow modeling and

sharp undercutting of Desiderio da Settignano's low-relief, or *stiacciato,* marble sculpture (the arrangement of the figures along converging diagonals is a recurrent sculptural device employed to increase the notional depth of the relief). Unusually, the genesis of the Uffizi picture and the progressive flattening of the forms can be followed in a preliminary drawing in white gouache on prepared paper (Gabinetto dei Disegni e Stampe, Uffizi, Florence). The transparent halos and the distant view through the window, which must have been conceived as a challenge to sculptors, introduced a theme that was to become a staple of sixteenth-century critical theory: the relative merits of painting and sculpture. "If I am not wrong," Alberti wrote, in his 1435 treatise on painting (III.58), "sculpture involves more certainty than painting . . . and it is easier to create a quality of relief in sculpture than in painting."

Compared to these innovative pictures the Magnani *Madonna and Child* might at first seem slightly inconsequential and conservative—a throwback to Gothic practice in its flat, gilt halos and elaborately tooled gold cloth of honor. Yet, the composition is based on a terracotta relief by Luca della Robbia (De Marchi 1996b, p. 11; De Marchi 1998, p. 19: what relation there may be between Luca's composition and a *Madonna and Child* by Jacopo Bellini, formerly in the Walter Burns collection, North Mimms, is difficult to say). The parapet in front of the exquisitely refined (but unfortunately abraded) figures, together with the shallow rectangular recess behind the gilt cloth, establishes the subtle and endlessly varied terms of Lippi's continuous dialogue between sculpture and painting on the one hand and between the illusionism of Renaissance painting and the ornamental qualities of Late Gothic painting on the other.

The picture must be more or less contemporary with the very beautiful *Annunciation* in the Galleria Doria Pamphilj, Rome, and the badly damaged and fragmentary *Alessandri Altarpiece* (fig. 15, p. 54). In both of these works Lippi employs the type of halo seen in the Magnani *Madonna and Child*—one notably similar to those favored by Fra Angelico throughout the 1440s. In the Doria *Annunciation* the gold curtain hanging over the Virgin's bed is tooled with a flat, repeat pattern, its broad folds modeled in glazes. This essentially ornamental device is willfully played against the receding lines of the bench on which the Virgin sits and the nat-

uralistic shadows on the back wall. The same sort of conceitful contrasts are found in the Magnani painting, in which the arabesques of the hem of the gold cloth are set off against the subtle lighting on the Virgin's cloak and the modulated shadows in the rectangular recess. Like the *Alessandri Altarpiece,* the *Madonna and Child* must date to the late 1440s or very early 1450s, but, in any case, prior to the more purely sculptural *Madonna del Ceppo* (Galleria Comunale, Palazzo Pretorio, Prato), which is documented to 1452–53. It is approximately contemporary with a *Madonna and Child* in the Walters Art Museum, Baltimore, that was designed by Lippi but—in this writer's view—painted by a talented pupil who was unable to fully exploit the kinds of contrasts inherent in this sort of image (Zeri 1976, vol. 1, p. 73). There is a possibility that the pupil in question was Fra Carnevale, as the curiously flat body of the Christ Child would suggest. It was, in any event, from that picture that Fra Carnevale derived his female figure types, as Offner (1939, p. 243) was the first to observe.

Lippi was not alone in reviving the ornamental use of gold leaf in his mid-century paintings. (Unlike Fra Angelico, who never abandoned gold as a means of reinforcing the heavenly setting of his *sacre conversazioni,* Fra Filippo had all but eliminated gold from his paintings in the late 1430s.) The same is true of Domenico Veneziano's *Madonna and Child* at Villa I Tatti, Settignano, in which the aristocratic Virgin wears a tooled-gold dress and is silhouetted against a flat, painted-and-gilded brocade cloth. There is no doubt that in mid-fifteenth-century Florence, Gothic altarpieces continued to enjoy a vogue among conservative patrons, but it is no less clear that sophisticated individuals like Piero de'Medici enjoyed the rich, courtly aspects of Gothic art but nonetheless wanted pictures carried out in a distinctly more modern style. In the Magnani *Madonna and Child* Lippi has imaginatively and consciously appropriated elements from a Gothic past to enhance the painting's affective power. K C

PROVENANCE: Contessa Foglietti, Castello di Montauto, Florence; Private collection, Nice (by 1932); Magnani collection, Corte di Mamiano.

REFERENCES: Toesca 1932, pp. 104–9; Pudelko 1936, p. 68; Pittaluga 1949, p. 195; Marchini 1975, p. 208; Sgarbi 1984, p. 50; Ruda 1993, p. 436; De Marchi 1996b, pp. 11, 20 n. 39; Mannini and Fagioli 1997, p. 113; De Marchi 1998, p. 19.

[7]

MASTER OF THE CASTELLO NATIVITY

Madonna and Child

Oil on wood, 69.5 x 47 cm
Niedersächsisches Landesmuseum, Hannover
(KM 83)

This engaging picture takes its point of departure from two kinds of images. The delicately featured Virgin is shown standing in front of a marble niche, reading from a devotional book. Her pose and attitude are those of an Annunciate Virgin and must have been taken from an altarpiece very like that painted by Filippo Lippi for convent of Le Murate in Florence (fig. 5, p. 43) between about 1443 and 1445 (Holmes 2000, pp. 114–34). Indeed, the artist has been at some pains to create a support for the lively child the Virgin balances on her arm, which he does by gathering up the drapery behind the child and implausibly raising the Virgin's right leg. The child mischievously slips his right hand into his mother's dress while in his left hand he holds a pomegranate (symbolic of the Church). His active engagement of the viewer and the manner in which he raises one leg, pushing against his mother's arm, are motifs that belong to the repertory of Luca della Robbia: especially pertinent is a terracotta relief known in a number of versions (including examples in The Detroit Institute of Arts and in the Louvre, Paris) as well as another terracotta of the standing Madonna holding her child (Victoria and Albert Museum, London)— works that have been convincingly dated to the late 1420s (Gentilini 1992, vol. 1, pp. 22–23). It has long been recognized that there was a close and fruitful exchange of ideas between Luca

della Robbia and Filippo Lippi—one that goes back at least to the 1430s—but Luca's sculpture provided a mine of ideas for other painters, too, and we should not be surprised that someone working in Lippi's workshop and perhaps under his guidance should have turned for inspiration to his sculpture.

Although Berenson's attribution of the picture to the Master of the Castello Nativity is now widely accepted, there are also close affinities with the presumed early work of Fra Carnevale (to whom Boskovits ascribes it), and we are reminded of the fact that both artists were associated with Lippi's shop and may have served as assistants on some of the same paintings. Yet another artist has been brought into this discussion, and that is Pesellino, who also worked for Lippi—in the late 1440s or early 1450s he painted the predella of Fra Filippo's altarpiece for the novitiate chapel in Santa Croce, Florence (fig. 20, p. 59). A brightly veined marble niche is a standard feature in Pesellino's devotional paintings, which, however, invariably evince an impeccable command of figural construction quite unlike what is found here. A small, damaged painting in the Johnson Collection at the Philadelphia Museum of Art, of the Madonna and Child enthroned with Saints Jerome and John the Baptist, gives a clear idea both of Pesellino's debt to Lippi and of his greater feeling for structural cohesiveness. Pesellino's Madonna and Child compositions perhaps show an even closer affinity to those of Luca della Robbia than do Lippi's, but they are thought out with a sculptor's sense of weight and volume.

Ursula Schlegel ascribed the Hannover *Madonna and Child* to Pesellino, and Chiara Lachi has not excluded his participation in the picture, which she dates to the early 1450s. For this reason it is important to insist on the fundamentally Lippesque character of the Hannover painting. The elaborately bunched drapery of the Virgin's cloak, delicately modeled to suggest a soft light playing over the forms, reflects Lippi's concerns

in the mid-1440s, as does the refined use of gold dots to highlight the edge of the Virgin's transparent veil. The closest analogy for the facial types and the emphasis on contour at the expense of volume is the Master of the Castello Nativity's *Faltugnano Altarpiece* (especially the putti-caryatids), which may have been completed shortly before 1450 (see cat. 8 A–C). In his 1993 monograph on Filippo Lippi, Ruda suggested that the design of the *Faltugnano Altarpiece*—of remarkable sophistication and clearly related to Lippi's altarpiece for the novitiate chapel in Santa Croce—must be based on a drawing by Filippo Lippi, and we may well wonder if a drawing by Lippi was not employed here: if the picture was not, in some sense, viewed by its first owner as a product of Lippi's shop. It is, in any event, likely to have been painted in the late 1440s.

The picture is generally in good condition, but shows some wear—particularly in the hair and the shaded portion of the Virgin's face and neck and in the middle tones of the child's torso. Curiously, the panel has a horizontal rather than a vertical grain, but the picture surface has not been cut and the cropping of the top of the niche is intentional.

The panel came to the Landesmuseum in 1884 as part of the Kestner Collection and may have been acquired by August Kestner (1777–1853), who began collecting Italian paintings as early as 1819 (see Aschoff and Siebert 2003). He was closely associated with the German artistic community in Rome, where between 1825 and 1849 he was the Hannoverian minister to the Vatican. KC

PROVENANCE: Possibly August Kestner, Rome (d. 1853); his nephew Hermann Kestner, Hannover (1853–84); Städtische Galerie (now Niedersächsisches Landesmuseum), Hannover (from 1884).

REFERENCES: Berenson 1932a, p. 343; Schlegel 1962, pp. 172–78; Grohn 1995, pp. 131–32; Lachi 1995, pp. 26, 106–7, no. 20; Boskovits in Boskovits et al. 2003, p. 184.

[8]

MASTER OF THE CASTELLO NATIVITY

A. *Saints Justus and Clement Praying for Deliverance from the Vandals*

Tempera and gold on wood, 21.8 x 46.5 cm
Philadelphia Museum of Art. The John G.
Johnson Collection

B. *The Nativity*

Tempera and gold on wood, 21.6 x 65.7 cm
National Gallery, London (3648)

C. *Saints Justus and Clement Multiplying the Grain of Volterra*

Tempera and gold on wood, 21.8 x 46.5 cm
Philadelphia Museum of Art. The John G.
Johnson Collection

These three panels come from an altarpiece once in the small parish church of Santi Giusto e Clemente in Faltugnano in the hills north of Prato; the main panel (see ill.) is now on deposit in the Museo dell'Opera del Duomo, Prato. The two panels in the Johnson Collection depict the legend of Justus and Clement. The two saints escaped the Goths in North Africa and settled in Volterra, which they helped save from the invading Vandals by having the grain remaining in the city multiplied and then thrown at the invaders, who dispersed in confusion.

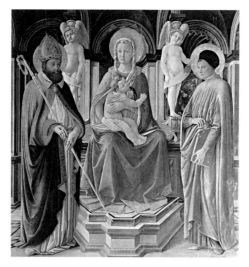

Master of the Castello Nativity, *Madonna and Child with Saints Justus and Clement* (*Faltugnano Altarpiece,* main panel). Museo dell'Opera del Duomo, Prato

The saints were venerated throughout Tuscany, but by the mid-fifteenth century some doubts seem to have developed about their legend. Despite this, devotion to Justus and Clement was revived in Volterra when their relics were reinstalled in 1469.

The direction of the wood grain indicates that the two panels relating to the saints, which flanked the *Nativity,* reversed the narrative sequence, and the loaves of bread that caused the Vandals to break ranks are not depicted in either predella scene.

The Master of the Castello Nativity must have worked closely with Filippo Lippi, as many of his paintings are direct copies of Lippi's compositions of the late 1450s. Indeed, Ruda proposed that the altarpiece, the anonymous painter's masterpiece, was actually designed by Lippi. This analysis depends on assigning a date of about 1450 to the work. The church from which it comes seems, in fact, to have been undergoing a renovation in 1450, when a small

sum of money was donated to the priest for "*una tavola rifatta*" (Archivio di Stato, Prato, Ceppi 306, no. 73: Mannini in Cerretelli 1998, no. 21). *Tavola* can mean either an altar table or an altarpiece: given the small sum of money involved and the term "*rifatta*" (redone), an altar table is probably what was meant. It is possible that a large altarpiece had been newly made or was being painted and that it required remaking the altar table, but this is no more than speculation. In 1469 Pope Paul II granted the patronage of the church to Gino di Lando Bonamici (Archivio di Stato, Florence, Diplomatico 79, March 7, 1468 [modern style 1469]), specifically stating in the bull that Gino already had increased the wealth of the church and made improvements to the building. The 1459 tax return of Gino's father reveals that by that date he owned considerable property in the surrounding area, which, in turn, suggests that the Bonamici may have had an interest in the church for over a decade. The family's coat of arms is still on the façade, but may have been placed there after the papal bull was issued. Although the altarpiece must have been painted sometime between 1450 and 1469, it seems to this writer that a date in the middle part of this range conforms better to the painter's generally conservative, provincial style and to his place as a purveyor of popular Lippesque compositions for patrons in Florence and such outlying areas as Prato. However, elsewhere in this catalogue the date of about 1450 is sustained.

CBS

PROVENANCE (A): Luigi Grassi, Florence (before 1912); John G. Johnson, Philadelphia (from 1912); (B): Sir Henry Howorth (by 1907–1922); National Gallery, London.

REFERENCES: Ruda 1993, p. 491; Lachi 1995, pp. 31–35; Mannini in Cerretelli 1998, no. 21; Strehlke 2004, pp. 176–80.

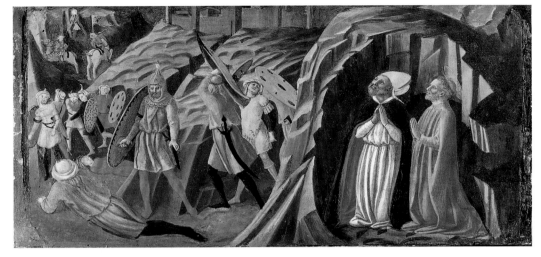

A

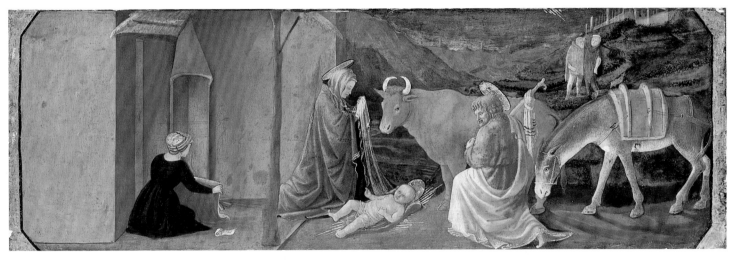

B

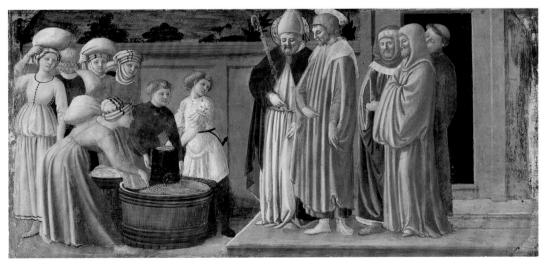

C

[9]

MASTER OF THE CASTELLO

NATIVITY

Madonna and Child with Two Angels (Madonna of Humility)

Tempera and gold on wood, 126 x 72 cm
Museo Nazionale di San Matteo, Pisa (inv. 4919)

Devotional images of the Madonna seated on the ground, in a position of humility, trace their origin to fourteenth-century Sienese painting. They continued to enjoy widespread popularity throughout Italy in the first half of the fifteenth century. In Florence notable examples were painted by Masaccio (National Gallery of Art, Washington, D.C.), Masolino (Kunsthalle Bremen; Alte Pinakothek, Munich), and Filippo Lippi (Castello Sforzesco, Milan), but the largest and most important corpus is that of Fra Angelico (the earliest examples, dating from the 1420s, are those in The State Hermitage Museum, Saint Petersburg; the Johnson collection, Princeton; and the Galleria Nazionale, Parma). Especially relevant for the Master of the Castello Nativity are those paintings by Fra Angelico of the 1430s and 1440s in which the Madonna sits on a raised marble dais with a cloth of honor suspended behind her, so that her humility is exalted (in the words of the Magnificat: "*Deposuit potentes de sede, et exaltavit humiles*"—"He hath put down the mighty from their seats, and exalted them of low degree"). This formula enjoyed enormous popularity among Angelico's followers, and the resulting images, especially those by the painter-miniaturist Zanobi Strozzi, are of notable decorative richness (see Di Lorenzo 2001, pp. 22–26, 46–49).

That the Master of the Castello Nativity studied the work of Fra Angelico is clear not only from the general iconographic features of the painting but from certain motifs, such as the gold embellishment on the sleeve of the angel at the right. Yet, the primary stylistic debt is to Filippo Lippi. The broad-faced figure types and chubby baby belong to Lippi's repertory, as does the manner in which the drapery of the Virgin is conceived in broad, flat folds. The form of the veined-marble steps on which she is elevated is taken from Filippo Lippi's altarpiece for the novitiate chapel in Santa Croce, Florence (fig. 4, p. 42), and from his *Coronation of the Virgin* (fig. 18, p. 57) for the Benedictine monastery of San Bernardo, Arezzo. There are no documents relating to these works, but they are datable to the mid-1440s. On the other hand, the prominently placed vase of roses is less reminiscent of those glass flasks Lippi includes in his altarpieces (see fig. 5, p. 43, fig. 13, p. 51), with the astonishing and precocious interest they demonstrate in reflection and refraction, than of the vase of lilies in the *Annunciation* in the Galleria Doria Pamphilj, Rome. That picture, with its exquisitely ornamental style, seems to date from the very late 1440s (see Ruda 1993, pp. 428–29), and it is this moment in Lippi's career that the Pisa *Madonna and Child* seems to echo.

Lachi (1995, pp. 18–20) has argued that the Pisa painting is the first independent work by the Master of the Castello Nativity and dates to the 1440s. Yet, if we compare it with the *Madonna and Child* in Hannover (cat. 7) and the *Faltugnano Altarpiece* (see cat. 8 A–C)—both so closely related to Lippi's paintings of the late 1440s that he might be thought to have had a hand in their design—it will be seen that the Master of the Castello Nativity has abandoned the Carmelite painter's diluted pinks, blues, and greens accented with rich corals and has embraced instead the luminous colors of Domenico Veneziano's *Saint Lucy Altarpiece* (Uffizi, Florence) and Fra Angelico's Santissima Annunziata silver chest panels and *Bosco ai Frati Altarpiece* (Museo di San Marco, Florence), with their rich blues, saffron yellows, and greens brought into jewel-like sharpness by a focused light. Coupled with this emphasis on rich colors viewed under a strong light there is a greater emphasis on elegant accessories: the jeweled brooch worn by the Virgin, whose hair is pulled away from her face so as to give prominence to her forehead, or the necklace worn by one of the angels. Henceforth these will be recurring features in the Castello Master's work, bringing it in line with the fashions of mid-century Florence. (One thinks, for example, of Domenico Veneziano's sublimely aristocratic *Madonna and Child* at Villa I Tatti, Settignano.) The painting is thus likely to date from the very early 1450s.

The picture, which in the nineteenth century was in the Conservatorio di Sant'Anna in Pisa, is no less notable for its dense assemblage of attributes of the Madonna. She is portrayed as the Virgin of the Annunciation, interrupted in her devotions by the dove of the Holy Spirit surrounded by rays of gold. Her gesture of plucking a flower declares her to be the rose without thorns, while the decoration on the shoulder of her mantle denotes her as the star of the sea—associations familiar from medieval hymns: "*Salve sine spina / rosa flos purpureus*" ("Hail, rose without thorns, crimson flower"); "*Ave maris stella, dei Mater alma*" ("Hail star of the sea, dear mother of God"). The Christ Child holds a pomegranate, a symbol of the Church.

K C

PROVENANCE: Conservatorio di Sant'Anna, Pisa (before 1884).

REFERENCES: Crowe and Cavalcaselle 1864–66, vol. 2, p. 515; Berenson 1932a, p. 343; Lachi 1995, pp. 16–19, 59–62, 93–94, no. 5.

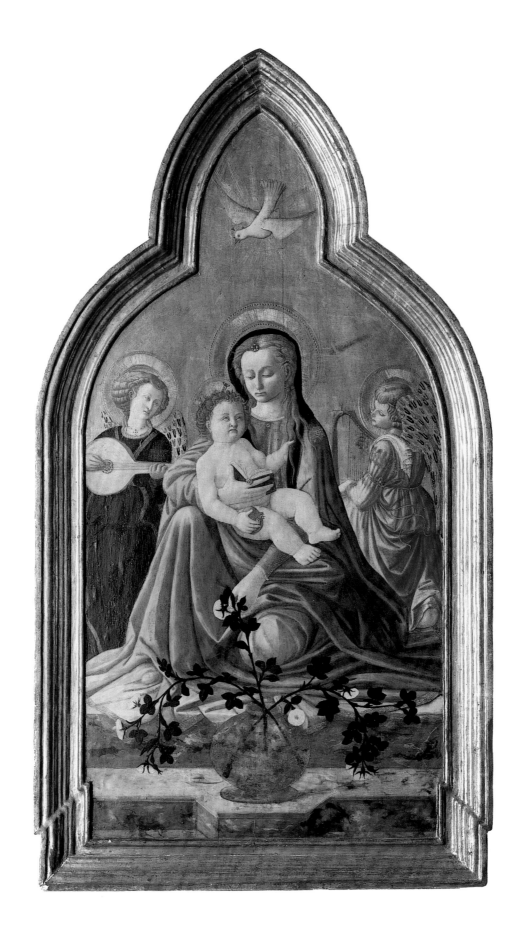

[10]

THE PRATOVECCHIO MASTER

The Three Archangels

Tempera and gold on wood: overall, 38.8 x 27 cm;
painted surface, 37.3 x 25.5 cm
Inscribed (along the bottom edge): ANGELVS
Gemäldegalerie, Berlin (inv. 1616)

This small painting shows Michael holding the sword with which he slew Satan; Raphael with his young ward, Tobias; and Gabriel holding a banderole that was once inscribed with the opening words of his salutation to the Virgin on the occasion of the Annunciation. The panel thus invokes the angel who is the protector of travelers combined with the savior of souls and the angel of redemption. Devotion to the archangels was particularly popular in Florence. In about 1470, members of a society dedicated to the archangel Raphael hired Francesco Botticini (1445/46–1497) to decorate the altar in their quarters in Santo Spirito, with a painting (Uffizi, Florence) of all three. Filippino Lippi (1457–1504) also treated the subject (Galleria Sabauda, Turin). Neri di Bicci (1419–1491), as a sideline, produced small images of the archangel Raphael with Tobias—by far the most popular subject—or of all three angels (including an altarpiece of 1462 for Santo Spirito, Florence: see Gombrich 1972, pp. 26–30; Pope-Hennessy and Kanter 1987, pp. 179–82).

The painting shown here is among the earliest representations of the theme. The richly colored ecclesiastical vestments, with a stole crossed over the breast, together with the delicately delineated features of the figures, their fashionably blond hair, and their halos foreshortened at various angles, suggest a world of courtly refinement. Although Longhi did not hesitate to ascribe the work to the Pratovecchio Master—in 1940 he made it the master's eponymous work, dating it no later than about 1440—both Fredericksen and Zeri (comment made in 1976 as reported in the 1978 Gemäldegalerie catalogue of paintings) considered it possibly by the Master of the Barberini Panels (Fra Carnevale).

The earliest record of the painting is in Ferrara at the beginning of the twentieth century, when it was ascribed to Piero della Francesca. It was subsequently attributed by Berenson to Giovanni Boccati. Longhi rightly insisted that it was executed in Florence by a painter closely studying Domenico Veneziano's art, yet there is something distinctly un-Florentine in the curiously weightless bodies and feminine, refined facial features and hands; something different from the more solidly constructed and broadly featured figures of the Pratovecchio Master's *Madonna and Child with Six Angels* (cat. 13) and reminiscent of the work of Boccati. As recently noted by Minardi and emphasized by De Marchi (see his essay in this catalogue), at the very least the *Three Archangels* testifies to a moment of rare confluence of artists and interests. If it is, indeed, by the Pratovecchio Master—as I, too, believe—then it marks his closest approximation of what we presume was the young Fra Carnevale's style as a disciple of Lippi and a close observer of Domenico Veneziano—but at a date in the late 1430s or very early 1440s, prior to Carnevale's documented presence in Lippi's workshop.

A better understanding of the picture—a work of rhapsodic, if eccentric, beauty and fascination—will doubtless result from its being seen in this exhibition alongside other works by artists associated with Lippi's workshop. Yet, it is important to emphasize that our ideas about these artists and what they painted remain entirely conjectural. Moreover, some works key to making judgments could not be lent. It would, for example, have been instructive to see the *Three Archangels* together with a small panel of Saint John the Baptist in the wilderness (fig. 11, p. 30)—a work at one time ascribed to Giovanni di Francesco and, more recently, to Fra Carnevale (see de Boissard 1988, pp. 62–63, no. 19). However, the Musée Condé is prohibited from lending.

Certainly the comparison with Jacques Coeur's *Annunciation* (cat. 19) will prove instructive, for while the composition of that work derives from Lippi, space, light, and color are treated with the heightened lyrical sense of Domenico Veneziano. The face of Saint Michael, with its high forehead and heavy-lidded, slightly somnambulant expression, is echoed in that of Gabriel in the *Annunciation,* and the fastidious attention given to the crinkled banderole that Gabriel holds is directly analogous to the string that extends from the key in the lock of the grille to the prie-dieu of the Annunciate Virgin. The spidery fingers of Raphael and the delicate patterning of drapery folds seem in some respects closer to the style of Fra Carnevale than to that of the Pratovecchio Master. Moreover, the underdrawing of the archangel Raphael—partly visible to the naked eye (see ill.)—displays remarkable analogies with the work of Fra Carnevale, especially his Bacchic reliefs in the *Birth of the Virgin* (cat. 45 A). The figure was sketched in nude and the genitals were included, recalling Alberti's insistence (*Della pittura,* II.36) that it is necessary first to draw a figure nude and then apply the drapery. It is not easy to explain these similarities. Did Fra Carnevale, like his Marchigian compatriots Giovanni Boccati and Giovanni Angelo da Camerino, make a trip to Florence prior to 1445? (On the documents relating to the trip, see the documentary appendix.) Although no more than conjecture, this would explain some of the traits the *Three Archangels* shares with his work as well as with Boccati's earliest paintings.

K C

PROVENANCE: Private collection, Ferrara; von Bode (until 1929); Staatliche Museen, Berlin.

REFERENCES: Berenson 1932a, p. 90; Longhi 1940, p. 100; Longhi 1952a, pp. 21–22, 35; Fredericksen 1974, p. 29; De Marchi in Bellosi 1990a, pp. 149–50; Minardi 2002, p. 211.

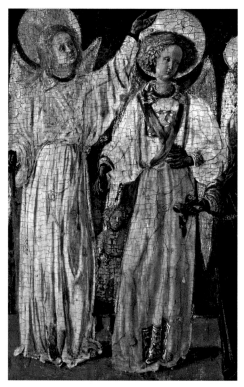

Infrared reflectograph (detail) showing the preparatory drawing beneath the angel's garments

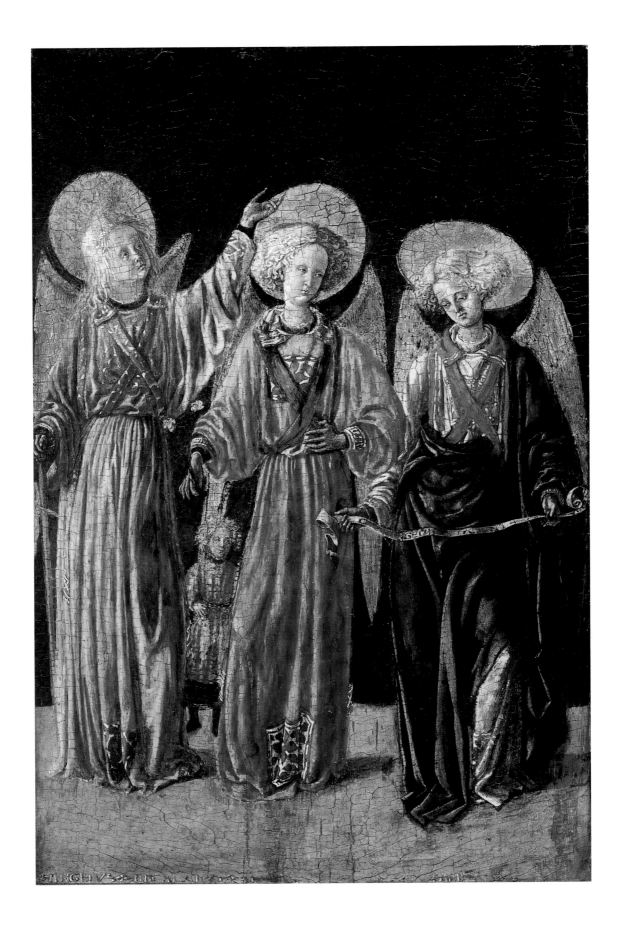

[11]

THE PRATOVECCHIO MASTER

Madonna and Child

Tempera on wood, 98.7 x 69.8 cm
Fogg Art Museum, Harvard University Art
Museums, Cambridge, Massachusetts. Gift of Mr.
and Mrs. Arthur Lehman (1927.66)

The Virgin is shown standing at the window of a patrician palace, the opening of which is framed by splendid Ionic columns and an elaborate entablature. Her expression is tinged with the melancholic foreknowledge of her son's future Passion. By contrast, the Infant Christ is actively posed, his gaze directed downward, suggesting an ideal viewing point slightly to the left and below the center of the picture.

In the 1440s Filippo Lippi explored a variety of solutions for showing the Madonna and Child within or against an architectural niche, with the child resting on a parapet—the finest example is that in the National Gallery of Art, Washington, D.C., dating from perhaps 1442/45—but in none of these is there a similar illusionistic intent, with the parapet and tabernacle window conceived as though projecting into the viewer's space. Lippi's badly damaged painting of the Madonna and Child appearing behind a window embrasure (Utah Museum of Fine Arts, Salt Lake City)—a work of the mid-1430s—offers some analogies, although that picture seems to have been designed as a lunette to be placed over a door and it traces its lineage to illusionistic frescoes, not devotional paintings. A large processional banner painted on silk by Benozzo Gozzoli (Cappella del Rosario, Santa Maria sopra Minerva, Rome) and dating from 1449 displays a like concern with illusionism (Ahl 1996, pp. 252–53, no. 68). Yet, the motivation behind that work was doubtless its function as a cult object—not as a work of private devotion. More germane is Gentile da Fabriano's Madonna and Child (Yale University Art Gallery, New Haven) of about 1424–25. Gentile took his inspiration from the stiacciato reliefs of Donatello, and there can be little doubt that sculpture provided the model for the author of this picture as well.

Perhaps the most interesting comparison is with a gilt-bronze plaquette by an artist in the circle of Donatello showing the Madonna and Child at an arched window (see cat. 12). That

work is usually dated to about 1450, when Donatello was in Padua, but it may well be earlier, as there are also compelling analogies with his bronze relief of the Feast of Herod of about 1425 for the Siena Baptistery (Luchs in Darr 1985, pp. 139–40, no. 33). In any case, sculptors rather than painters most thoroughly investigated the ways in which an architectural setting—actual or fictive—could be used to confer greater immediacy on this time-worn theme. Thus, a painting by Masaccio's brother, Scheggia (ill., p. 150), in which the Madonna is viewed in a niche-like room of Brunelleschian design, must owe its invention to Donatello, whose Pazzi Madonna (Staatliche Museen, Berlin) first explored this idea.

That Donatello's work was the point of reference for the author of this picture is demonstrated by the Ionic columns and entablature that frame the window. They are taken fairly directly from Donatello's architectural niche for the tabernacle of the Parte Guelfa on the façade of Orsanmichele in Florence. Smooth columns have been substituted for Donatello's spiral fluted ones, although an examination of the picture reveals that spiral columns were partly laid in and then painted out. Also eliminated is the frieze of putti from the entablature (a motif closely studied by Fra Carnevale), but in other respects the model has been carefully copied—right down to the rope-like molding of the echinus that replaces a more orthodox bead-and-reel design. The result is a tabernacle window of rare architectural refinement—far more sophisticated than can be found in comparable Florentine paintings—although with details such as the capitals and bases rendered with a notable awkwardness in foreshortening. This combination of architectural sophistication with peculiar lapses in foreshortening is typical of the work of Fra Carnevale: one thinks of the Ionic colonnade of the basilica in the Presentation of the Virgin (?) (cat. 45 B). No less characteristic of his work is the delight taken in the conceit of the sharply delineated shadow here, cast by the tabernacle onto the stone wall. Again, the Presentation of the Virgin (?) offers analogies. There can be little question that Fra Carnevale was introduced to this sophisticated use of naturalistic details by Fra Filippo Lippi: the shadow cast by the male sitter onto the back wall in the Portrait of a Woman and a Man at a Casement (cat. 4) is a perfect example.

It is hardly surprising, then, that the Harvard Madonna and Child occasionally has been

ascribed to the Master of the Barberini Panels—that is, Fra Carnevale—by Richter and by Fredericksen, as well as to his Marchigian compatriot Giovanni Boccati (by Berenson). Indeed, were we to judge the picture by its architecture alone, there would be little reason to doubt Fra Carnevale's authorship. Longhi was the first to attribute the painting to the Pratovecchio Master, followed by Zeri and Bellosi, inter alios, and their attribution is not usually questioned. However, nowhere in the Pratovecchio Master's certain works do we find the transparency of color that characterizes this picture or a like interest in effects of reflected light. Rather, the attribution to the Pratovecchio Master rests on morphological comparisons. This exhibition offers a unique opportunity to confirm the attribution of the panel as well as to reevaluate the relationship of the Pratovecchio Master—whatever his historic identity—to Fra Carnevale.

The artist of this picture certainly spent time in the workshop of Filippo Lippi: the spherical heads and curiously boneless hands relate to Lippi's work of the late 1430s—especially the so-called Tarquinia Madonna of 1437 (Galleria Nazionale, Rome) and the Barbadori Altarpiece (fig. 14, p. 52) of about 1437–39—and the active pose of the child is no less indicative of Lippi's interests in this period. It is well known that the child in the Tarquinia Madonna derives from Donatello's bronze candle-holding putti (or spiritelli) for the choir lofts (cantorie) in Florence Cathedral (Musée Jacquemart-André, Paris). Furthermore, it is recognized that during the second half of the 1430s the sculptural decoration of Donatello's and Luca della Robbia's twin choir lofts in the cathedral became a reference point for all the leading painters of Florence, from Lippi to Domenico Veneziano (the Christ Child in his Madonna and Child in the Muzeul National de Arta, Bucharest) and Uccello (the child in his Madonna and Child in the National Gallery of Ireland, Dublin). The Harvard panel is therefore unlikely to date much after about 1440.

K C

PROVENANCE: Hans Schwarz, Vienna (sale, Lepke, Berlin, November 8–9, 1910, no. 22); Mr. and Mrs. Arthur Lehman, Cambridge, Massachusetts (1910–27); Harvard University Art Museums.

REFERENCES: Berenson 1932a, p. 90; Richter 1940, pp. 314, 320; Longhi 1952a, (1975 ed.), pp. 109–10; Zeri 1961, p. 54; Fredericksen 1974, pp. 28–29; De Marchi in Bellosi 1990a, p. 149; Minardi 2002, p. 226 n. 36.

[12]

CIRCLE OF DONATELLO

Madonna and Child

Gilt bronze, 20.3 x 15.2 cm
National Gallery of Art, Washington, D.C. Samuel H.
Kress Collection (1957.14.131)

This exceptionally fine relief, as notable for its engaging conception as for its exquisite facture, seems to have enjoyed widespread popularity. It is known in at least four casts, in stucco squeezes, and in three marble variants (see Pope-Hennessy; Luchs). The most interesting of the stucco squeezes, in the Victoria and Albert Museum, London, is painted and framed, effectively transforming the relief into a painting (Pope-Hennessy 1964, pp. 90–91). The pose of the Christ Child was adapted in a drawing by Mantegna and in several North Italian paintings (Ekserdjian in Martineau 1992, p. 229).

What makes the relief so remarkable is the way the architectural setting is employed illusionistically to enhance the devotional affect of the figures. The arch is shown in steep perspective, so that its inner surface recedes from the viewer and the supporting columns are cut off by the forward edge of the parapet on which the child is posed. Visible at the back is a shell niche, creating a particularly dense visual surface. Both the Virgin and the child turn to the left with their right hands extended toward the fictive worshiper, establishing a directional axis for viewing the relief. A stone has slipped from its position, adding an unsettling note (it was eliminated from the stucco squeeze in the Victoria and Albert Museum). This sort of interest in activating the fictive space of the relief so as to heighten the psychological impact of the figures and to indicate their relation to the real space of the viewer is typical of Donatello. In the 1420s he exploited the effect in an unforgettable fashion in the so-called *Pazzi Madonna* (Staatliche Museen,

Berlin), in which the compressed space of the rectangular niche intensifies the mood of tragic foreboding. It is no less memorable in Donatello's bronze roundel (Victoria and Albert Museum, London), showing a maternally protective Madonna with the child and four angels behind a projecting balustrade, a work given by the sculptor to his physician Giovanni Chellini in 1456, or in the great marble relief for the cathedral of Siena (Museo dell'Opera del Duomo, Siena), in which a commanding figure of the Madonna, gazing pensively at her vulnerable child, is projected in front of a deep oculus inset with marble squares. An activated, perspective setting is the leitmotif of Donatello's stucco roundels for the Old Sacristy of San Lorenzo in Florence as well as of his bronze reliefs for the high altar of the Santo in Padua. The present relief, too, must depend from a design by Donatello, to whom it was ascribed by Molinier, and, indeed, it typifies his persistent interest in breaking down the distinctions between painting and sculpture. Without a relief very like this one the Pratovecchio Master's *Madonna and Child* (cat. 11) would be inconceivable, and that of Uccello (National Gallery of Ireland, Dublin) probably would have been less inventive.

The relief has been associated by Pope-Hennessy with Donatello's activity in Padua between 1444 and 1453, as the Madonna's outstretched hand has been thought to derive from his statue of Saint Justina for the Santo altar. In fact, the same rhetorical gesture was employed by Donatello for a life-size pigmented stucco relief of Saints Cosmas and Damian in the Old Sacristy of San Lorenzo, in which the figures are shown disputing, as well as for one of the terracotta putti atop the Cavalcanti Tabernacle in Santa Croce who directs the viewer's attention to the scene of the Annunciation below. Here we might imagine the Christ Child as recommending the worshiper to his mother and she, in turn, to God: hence, the gaze of the child toward the viewer and that of the Virgin heavenward.

The architecture, too, has been related to that of the Padua reliefs. However, even closer

Workshop of Pisanello, Studies for the *Madonna and Child*. Musée Condé, Chantilly

analogies can be found in Donatello's Florentine sculpture prior to his departure for Padua, especially the gilt-bronze relief of the *Feast of Herod* for the Siena Baptistery font (1423–27) and a marble relief with the same theme of perhaps a decade later (Musée des Beaux-Arts, Lille). The *Madonna and Child* relief was certainly known to someone in the circle of Pisanello—possibly Matteo de'Pasti—for it is included in an album put together about 1440 following its owner's trip from Tuscany to Rome (see Cordellier in Marini 1996, pp. 491–92; see also ill.). It thus dates from the 1430s.

K C

PROVENANCE: Gustave Dreyfus, Paris (before 1886–1914); Duveen Brothers, Inc., London (1930); Samuel H. Kress Foundation (1945–57).

REFERENCES: Molinier 1886, p. 34, no. 64; De Ricci 1931, p. 10, no. 7; Pope-Hennessy 1965, pp. 21–22; Luchs in Darr 1985, pp. 139–40; Christiansen in Martineau 1992, p. 97.

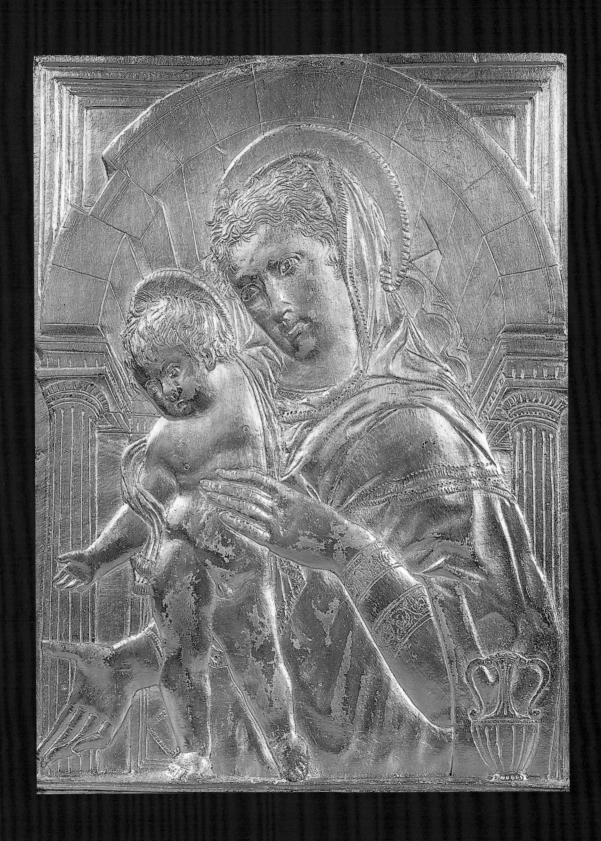

[13]

THE PRATOVECCHIO MASTER

Madonna and Child with Six Angels

Tempera on wood, 64.8 x 43.2 cm
The Pierpont Morgan Library, New York. Purchased
by J. Pierpont Morgan, 1907 (acc. no. AZ146)

In Florence in the first half of the fifteenth century the market for devotional images of the Madonna and Child was dominated by sculpture, not painting, and the replication of these in stucco, terracotta, or papier-mâché (*cartapesta*) constituted a large part of the commercial activity of workshops throughout the city. Many of the works were polychromed in painters' studios and were as much the products of a painter as of a sculptor. A well-known case in which the artist can be identified is a *cartapesta* squeeze of a Donatello-inspired bronze plaquette of the Madonna and Child that was set into a tabernacle frame and painted by Paolo Schiavo, perhaps about 1440 (Victoria and Albert Museum, London, inv. A.45-1926). Similarly, Giovanni di Francesco embellished a tondo of the Madonna and Child (formerly Staatliche Museen, Berlin) by painting heads of prophets in the spandrels between the circular relief and its square frame. It is hardly surprising that sculptural reliefs should have exerted a profound influence on painted compositions of the Madonna and Child. Filippo Lippi's early painting of the Madonna and Child with saints, angels, and a donor (Cini Collection, Venice) takes its inspiration from a marble relief from the workshop of Donatello (Victoria and Albert Museum, London, inv. A.98-1956) that also exists in molded versions, and Mantegna's sublime *Madonna and Child* (Gemäldegalerie, Berlin) would be inconceivable without Donatello's so-called *Verona Madonna,* known exclusively in molded versions in stucco or terracotta.

What is unusual about this charming painting by the Pratovecchio Master is that, as De Marchi has noted, it so faithfully repeats the features of a terracotta relief by the sculptor Michele da Firenze (see ill.), who worked on Ghiberti's first set of doors for the Florence Baptistery. It must have been in Ghiberti's workshop that Michele became familiar with the new technique

of modeling compositions in clay and firing them (see Gentilini 1992, vol. 1, pp. 27–30). He was open to the innovations of both Ghiberti and Donatello, but translated them into a dense, highly decorative style that was especially appreciated in Northern Italy, where he gained employment in Ferrara (1427; 1439–40), Verona (1433–38), Modena (1440–41), and Reggio Emilia (1443).

The composition of the relief on which this painting is based has a strongly Gothic flavor, with the Virgin seated beneath a tent-like canopy, from the apex of which a half-length figure of God the Father emerges, with angels piled up at the sides. It is a composition that results from an essentially additive approach, and why the Pratovecchio Master should have turned to such a source is puzzling. Appropriately, he has further embellished the scene by adding a flowering meadow—a reference to the Virgin's *hortus conclusus*—similar to that in Domenico Veneziano's (now ruined) fresco (National Gallery, London) from a tabernacle on the Canto de' Carnesecchi in Florence, perhaps Domenico's most North Italian composition. One of the Pratovecchio Master's few departures from the terracotta compositional model is the angel at the upper right who, in the relief, places his left hand on his chest, mirroring the action of his companion.

Yet, for all his fidelity to his source, the Pratovecchio Master has eliminated the residual, overcrowded, Gothic flavor of the relief. Gone is the curved picture field and elaborate Gothic tracery, replaced by a simple, fictive molding. The figures are more animated and volumetric, the heaviness of their drapery conveyed by deep corrugated folds. Space is opened up between the angels and their size is diminished so as to create a sense of depth—an effect that must have been more conspicuous when the blue azurite background, now damaged and overpainted, was intact. The Virgin's podium is also foreshortened to suggest depth. It is as though the charming but congested, piled-up forms of the terracotta relief had been filtered through the lens of both Domenico Veneziano and Filippo Lippi.

The heavy drapery—in particular that of the Virgin—is curiously reminiscent of Lippi's paintings of the late 1420s and early 1430s, especially his small devotional altarpieces in the Museo della Collegiata, Empoli, and the Cini Collection, Venice. However, the rich, jewel-like colors have more to do with the courtly world of Domenico Veneziano's earliest works: a tondo of the *Adoration of the Magi* (Gemäldegalerie, Berlin), a

full-length *Madonna and Child* with a rose hedge in the background (Muzeul National de Arta, Bucharest), and the *Carnesecchi Tabernacle.* As noted above, the fragmented, much-damaged, and, alas, only partially legible *Carnesecchi Tabernacle* seems to have provided a point of reference for the transformation of the terracotta relief into a painting. The date of that work remains controversial, but it was certainly painted prior to about 1445 (indeed, it may date to the mid-1430s); the Morgan painting, too, is unlikely to date much after 1440/45. Certainly, there is no hint of those pale, sun-bleached colors or of the acerbic, descriptive line that characterize Domenico's *Saint Lucy Altarpiece* (Uffizi, Florence; see cat. 22 A–B)—features that the Pratovecchio Master was to use to brilliant effect in his own two altarpieces (see cat. 14).

Although the painting occasionally has been ascribed to the Master of the Barberini Panels (Fra Carnevale), there really can be no doubt that it is by the Pratovecchio Master: the figure of God the Father and the drawing of the angels' hands—especially those of the second angel on the left—are characteristic of his work. There is in this painting none of that sense of a light-filled space that is one of the signal qualities of Fra Carnevale's style. Rather, light is employed to emphasize the three-dimensionality of the forms, as with Castagno. Moreover, whereas in the work of Fra Carnevale the figures are ancillary to an abstract, perspectival space, with the Pratovecchio Master the perspective is invariably rudimentary: he creates space by convincing us of the physical density of his figures. From the outset, then, the paths of the two masters diverged. KC

PROVENANCE: Godefroy Brauer, Florence and Paris (until 1907); J. Pierpont Morgan, New York (from 1907).

REFERENCES: Berenson 1932a, p. 90; Longhi 1952a, (1975 ed.), p. 110; Fredericksen 1974, p. 28; De Marchi in Bellosi 1990a, p. 149; Minardi 2002, p. 226 n. 36.

Michele da Firenze,
*Madonna and Child,
God the Father, and
Six Angels.*
Victoria and Albert
Museum, London

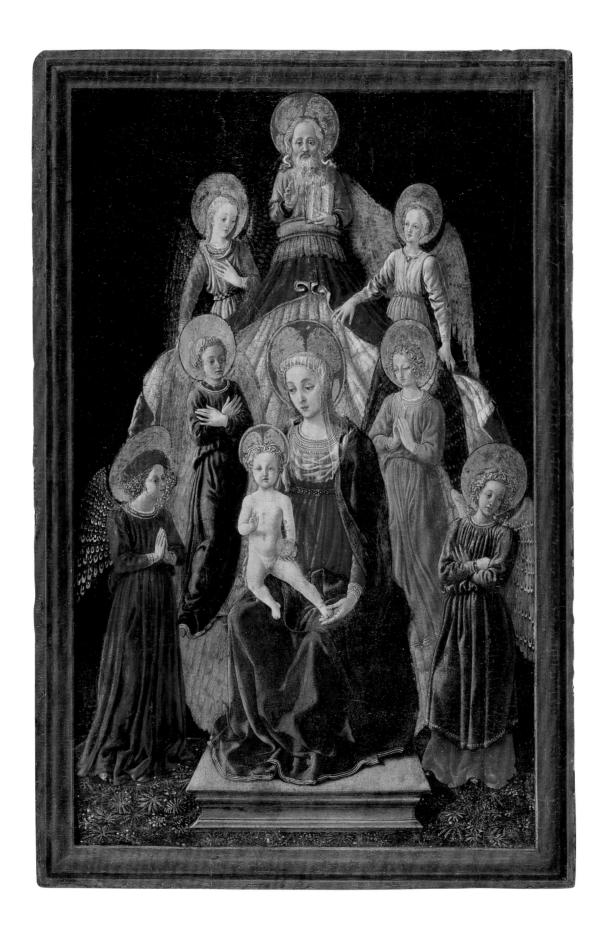

[14]

THE PRATOVECCHIO MASTER

Pinnacles to an Altarpiece

A. *The Virgin*

Tempera on wood
57 x 27.5 cm

B. *Saint John*

Tempera on wood
57 x 28 cm

National Gallery, London (NG 584)

The crowning achievement of the Prato-vecchio Master is an elaborate Gothic altarpiece painted for the Camaldolese nunnery of San Giovanni Evangelista at Pratovecchio. The triptych had at its center an *Assumption of the Virgin* (see ill.) and side panels of Saints Michael and John the Baptist, and a bishop saint, possibly Donatus of Arezzo, and a virgin martyr, possibly Antilla (National Gallery, London; see Gordon 2003, pp. 122–23). The lateral panels are basically intact, although their frames were regilded and in part reconstructed in 1858. They are flanked by piers decorated on their front and outer surfaces with standing figures of saints. Above them are roundels with the angel and the Annunciate Virgin. The two present works are pinnacles and would have flanked a panel of the crucified Christ, now lost. This type of multistoried, Late Gothic altarpiece remained popular in provincial areas of Tuscany well into the middle years of the fifteenth century, but in this case there was doubtless the intention to complement a similar, earlier altarpiece painted by Giovanni dal Ponte for the same Camaldolese nunnery (Gordon 2003, pp. 104–17). The convent of San Giovanni Evangelista was subject to Santa Maria degli Angeli in Florence, the high altar of which was adorned by Lorenzo Monaco's great 1413 *Coronation of the Virgin* (Uffizi, Florence), and that extravagent work must have established the standard of taste in its Camaldolese dependencies.

In contrast to the *retardataire,* Gothic structure of the altarpiece is the insistently modern figurative content. The Pratovecchio Master has not only absorbed the lesson of Domenico Veneziano—that synthesis of light and color that makes the *Saint Lucy Altarpiece* one of the landmarks of Italian painting—and been deeply impressed by the brooding, psychological intensity of Andrea del Castagno's saints and apostles but he has also looked with fascination at the sculptural reliefs of Donatello. Gone are any traces of the master's presumed tutelage by Filippo Lippi.

It is widely agreed that the center panel of the *Assumption of the Virgin* is a response to the 1449 altarpiece by Castagno (Gemäldegalerie, Berlin) for San Miniato fra le Torre, Florence, and that, in consequence, the polyptych must date to the mid-1450s. This would make it more or less contemporary with Domenico Veneziano's fresco of *Saints John the Baptist and Francis* (see ill., p. 245), in which that great Florentine-by-adoption moves beyond the radiantly sunny world of the *Saint Lucy Altarpiece* to probe an ascetic religiosity tinged with a melancholy bordering on the tragic. Only Donatello went further in this direction—especially in the work he carried out following his return to Florence in 1453, after a ten-year absence in Padua. We particularly sense the Pratovecchio Master's debt to Domenico

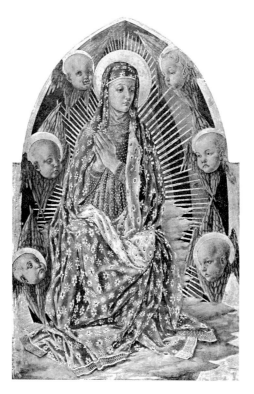

The Pratovecchio Master, *The Assumption of the Virgin.* San Giovanni Evangelista, Pratovecchio

Veneziano in the way the drapery of both the Virgin and Saint John reads like shards of shattered glass, its pale colors (obfuscated by a yellowed varnish) glinting in the sun. The dark blue backgrounds are overpainted and may have been azurite.

It is Donatello's bronze doors for the Old Sacristy in San Lorenzo that provided the Prato-vecchio Master with his model for the rhetorical poses and gestures of the Virgin and Saint John (fig. 6, p. 44). In certain respects, these are the altarpiece's most extraordinary figures, and, as Longhi saw so clearly, they look ahead to the work of Pollaiuolo. Completely original is the pose of the Virgin, who turns away from her crucified son, stepping forward like an actor on a stage to address her audience and extending one hand in a demonstrative gesture of despair (similar to that employed by Donatello in his stucco relief of Saints Cosmas and Damian in the Old Sacristy). Her attitude—"*di oratrice disperata, di profetessa viandante,*" in the words of Longhi—contrasts with the pathetic, inner-directed expression of Saint John. This sort of intentional contrast of emotional states, conveyed through stance and gesture and the play of illusionistic space, also characterizes the paired figures of saints and apostles on Donatello's bronze doors, which in the course of the 1450s and 1460s were to become the object of renewed study. Apart from the obvious impact they had on the young Pollaiuolo, they were studied by the Bolognese painter Tommaso Garelli in a series of drawings now in the Uffizi, Florence (see Angelini 1986, pp. 57–63). (The athletic poses of Donatello's apostles were famously censored by the timid-minded gold-smith-sculptor Filarete in his treatise on architecture of about 1461–62 for looking too much like fencers.) It was a world Fra Carnevale did not explore and that clearly distinguishes his work from that of this still-anonymous painter.

K C

PROVENANCE: Probably Camaldolese nunnery of San Giovanni Evangelista, Pratovecchio (until 1808/10); Lombardi-Baldi Collection, Florence (probably by 1845–57); National Gallery, London.

REFERENCES: Longhi 1952a, (1975 ed.), pp. 111–14; Fredericksen 1974, pp. 16–17; De Marchi in Bellosi 1990a, pp. 150–52; Gordon 2003, pp. 122–33.

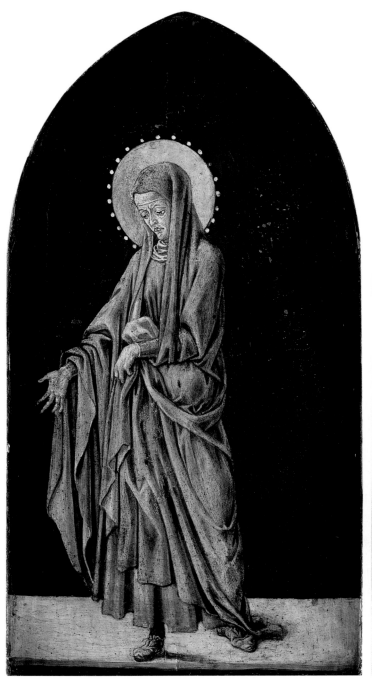

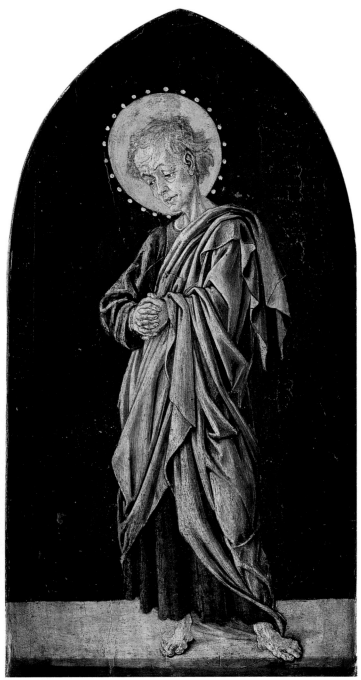

A

B

[15]

WORKSHOP OF FRA FILIPPO LIPPI

Female Figure (Prophetess?)

Pen and ink, heightened with white gouache, on
blue paper, 25.1 x 11.4 cm
Harvard University Art Museums, Cambridge,
Massachusetts (inv. 1936.118)

It is not certain who the female is or what
significance should be attached to her
upward-pointing hand. As she is dressed in a
tunic, there would seem to have been a classi-
cizing intent. Marchini makes a comparison
with Michelozzo's statues from the Aragazzi
tomb in the cathedral of Montepulciano
(Victoria and Albert Museum, London), and
this has the merit of reminding us of the
importance of Donatellesque sculpture as a
source of inspiration for Lippi. However, the
closest analogies for the dress and pose of the
figure are with a statuette variously identified as
the Virgin, a sibyl, or a prophetess, mounted on
Ghiberti's niche for the Arte del Cambio on
Orsanmichele or with a figure of a prophetess
from the doorframe of the *Gates of Paradise,*
to the left of a scene with Cain and Abel
(Krautheimer 1956 [1982 ed.], pp. 87–88 n. 5,
172–74). The object the figure stands next
to, draped with a garland of leaves, is best
compared not to a classical sarcophagus but to
the marble balustrades in Lippi's *Coronation
of the Virgin* (fig. 2, p. 40).

Berenson did not hesitate to ascribe the
drawing to Lippi, dating it to about 1440 and
comparing the figure with the Virgin in Lippi's
Annunciation (fig. 13, p. 51) in San Lorenzo,
Florence. Conversely, Marchini and Ruda dis-
cerned weaknesses in the anatomy and in the
perspective of the lectern or sarcophagus. Ruda
considered the drawing possibly a copy of a lost
study by Lippi dating from the late 1430s. The
schematized folds below the figure's left arm
and the rather mechanical parallel hatching
exclude the likelihood that the drawing could
be by Lippi. Nonetheless, Berenson's indications
were correct, except that the best analogy for the
angular folds of the drapery, the spindly legs,
and the weak wrists is to be found in the predella
to the San Lorenzo *Annunciation,* especially the
scene of Saint Nicholas halting an unjust exe-
cution. This is a problematic work. Apart from
the fact that some scholars have gone so far as
to question whether it was part of the original
conception of the altarpiece (why include,
beneath an *Annunciation,* a predella dedicated to
Saint Nicholas?), the authorship of the various
panels has been much debated. For the scene of
Saint Nicholas halting the execution, attributions
have ranged from Lippi to Giovanni di Francesco
(documented in Lippi's workshop between
1440 and 1442) and Fra Carnevale, among others
(for these various suggestions see Ruda 1993,
p. 402; De Marchi's essay in this catalogue). The
same assistant may have been responsible for a
small panel showing Saint John the Baptist in
the wilderness (fig. 11, p. 30) that also has been
ascribed to Giovanni di Francesco and to Fra
Carnevale (de Boissard 1988, pp. 62–63).
Interestingly, that figure's standing pose is very
like that of the woman in the drawing and dis-
plays some of the same weaknesses. Yet another
work apparently by the same artist—but later in
date—is the *Madonna and Child* in the
Accademia Carrara, Bergamo (cat. 18).

One of the problems with an attribution of
these works to Fra Carnevale is that although
the predella would seem to date from about
1440–42, Fra Carnevale only joined Lippi's
workshop in the spring of 1445, having arrived
in Florence shortly before (on April 28, 1445, a
porter was paid for bringing Carnevale's
belongings from Urbino). It is, of course, per-
fectly possible that Fra Carnevale had already
been to Florence prior to that date and worked
with Lippi, but on balance this does not seem
likely. The other problem is that the stylistic
connection of these works with the *Annunciation*
in Washington (cat. 40)—considered by most
scholars to be Fra Carnevale's earliest certain
painting—is far from obvious. We would thus
seem to be dealing with one of Lippi's assistants
whose work cannot be traced with certainty
beyond the mid- to late 1440s (see Wohl 1980,
p. 62 n. 52). Another closely related but—I
believe—distinct assistant to Lippi was respon-
sible for a *Madonna and Child with Saints and
Angels,* also at the Musée Condé, Chantilly (de
Boissard 1988, pp. 115–17).

K C

PROVENANCE: Henry Oppenheimer (sold, Christie's,
London, July 24, 1936, lot 60).

REFERENCES: Berenson 1938, p. 156, no. 1384A;
Mongan and Sachs 1940, p. 10; Dallí Regoli 1960, p. 201;
Degenhart and Schmitt 1968, vol. 2, p. 435; Marchini 1975,
p. 217; Ruda 1993, p. 502.

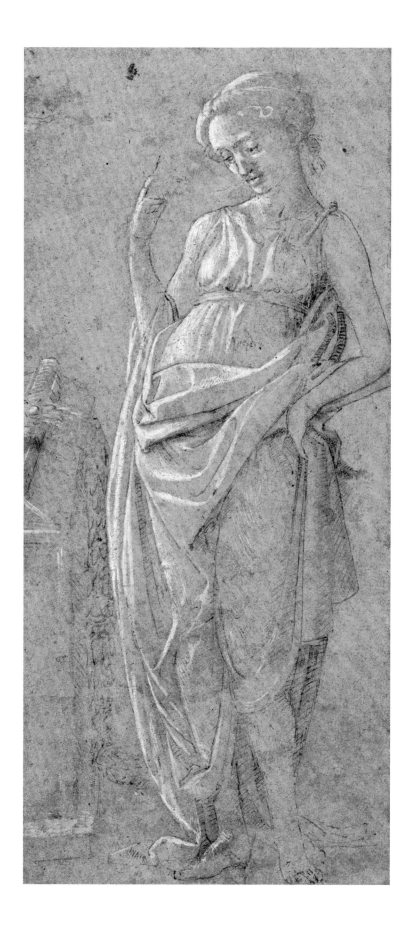

[16] ★

Fra Carnevale (?)

A Woman and a Kneeling Monk

Pen, with brown and white wash, on reddish-
colored paper, 163 x 139 mm
Gabinetto Disegni e Stampe degli Uffizi, Florence
(inv. 121E)

Filippo Lippi's *Coronation of the Virgin* (fig. 2, p. 40), commissioned in 1439 by Francesco Maringhi for the high altar of the Benedictine convent of Sant'Ambrogio in Florence, is one of the landmark altarpieces of the Renaissance (Ruda 1993, pp. 139–47, 422–26). Its innovative, multi-tiered space, packed with an assembly of sacred figures of varying sizes viewed from an elevated vantage point under rigorously controlled lighting, was unprecedented. Production continued over a period of eight years, with a concentration of activity between 1442 and 1446; the predella was only paid for in 1458 (see Borsook 1981, pp. 159–64). Surviving documents mention the names of a number of assistants, including Fra Carnevale, whose name occurs in relevant payments from April 1445 to September 1446 (see the appendix by Di Lorenzo). Not surprisingly, a number of drawings by Lippi's circle survive that copy parts of this great work (Degenhart and Schmitt 1968, vol. 2, pp. 530–38, treat these as a uniform group, although they are clearly by different hands). Most of these studies relate to what was almost certainly one of the predella scenes: a small panel showing a *Miracle of the Infant Saint*

Ambrose (Gemäldegalerie, Berlin) that, in its interpretation of the miracle as a domestic event, must have left a lasting impression on Fra Carnevale. The kneeling monk in the drawing exhibited here relates, instead, to the figure of Saint Anthony Abbot (?) in the left foreground of the *Coronation*. Interestingly, the figure is shown in profile and full length rather than cut off, as he is in the altarpiece, and his head is not viewed from above. There is, then, the possibility that the drawing copies a lost study by Lippi for the altarpiece, which would seem to be borne out by the fact that the two figures—taken from two different sources—overlap as they would in a model book, in which motifs are gathered together to form a repertory.

Berenson, followed by Degenhart and Schmitt, ascribed the drawing to Pesellino, on the highly problematic assumption that he worked in Lippi's shop in the mid-1440s. In fact, in style the study bears little relation to Pesellino's certain drawings. More recently Angelini (1986), following a suggestion of Bellosi, has ascribed the drawing to Fra Carnevale—not only because we know he was a member of Lippi's shop but because it displays stylistic affinities with his work in "the incisive line of the drapery, the terse crystalline luminosity, obtained with a dense use of white." Certainly, the quality is very high and the use of washes remarkably varied.

Angelini arrived at the attribution to Fra Carnevale by an admittedly circuitous line of reasoning: he saw affinities between the style of the drawing and that of the predella of Lippi's *Annunciation* in San Lorenzo, Florence. The attribution of that predella to Fra Carnevale remains uncertain (for an argument in its favor,

see the essay by De Marchi), and there is no obvious relation between its strongly linear traits and the solid, almost prismatic forms of the Uffizi drawing, in which light becomes a key feature. In the absence of any certain paintings—let alone drawings—from this moment in Fra Carnevale's career, the authorship must remain conjectural. (The only certain drawings by Carnevale date to later in his career: see Meller and Hokin 1982; Christiansen 1993.) The standing woman does bear a striking resemblance to some of the figures in the ex-Barberini panels (cat. 45 A–B), both in pose and in the geometric clarity of the folds of drapery.

Although the monk derives from Lippi's *Coronation,* the drapery style in the drawing is a good deal tidier. The female figure conceivably was inspired by Domenico Veneziano's (destroyed) fresco of *The Birth of the Virgin* in Sant'Egidio, Florence. Domenico's frescoes were on the west wall of the choir and, like the drawing, were lit from the left; from the vivid description of them left by Vasari, they were unquestionably a major influence on Fra Carnevale's *Birth of the Virgin*. If the present drawing is by Fra Carnevale, it would reveal an artist studying Veneziano's work even while in Lippi's shop: indeed, interpreting Lippi's figure style through the lens of Veneziano.

K C

REFERENCES: Berenson 1903, vol. 2, p. 129; Van Marle 1928, vol. 10, p. 424 n.; Berenson 1938, vol. 2, p. 254; Degenhart and Schmitt 1968, vol. 2, pp. 530–31, no. 521; Angelini 1986, pp. 43–44; Angelini in Bellosi 1990a, p. 136; Ruda 1993, pp. 509–10.

★ Shown only in Milan

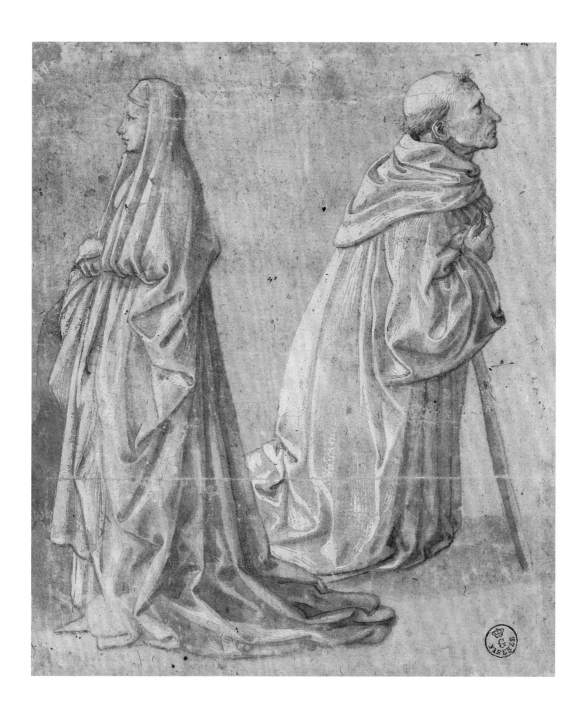

[17]

CIRCLE OF PAOLO UCCELLO

Portrait of a Woman

Tempera on wood, 41.3 x 31.1 cm
The Metropolitan Museum of Art, New York. The
Friedsam Collection, Bequest of Michael Friedsam,
1931 (32.100.98)

Few fifteenth-century portraits present such a conundrum as this one showing a remarkably plain-faced woman, her elaborately bound hair wrapped, helmet-fashion, around her head, and her harsh profile set implacably against a curious architectural niche brightly illuminated by a diagonal shaft of light (the sky is largely repainted, but the rest of the picture is in relatively good condition). Since an architectural setting was a rarity in early-fifteenth-century Italian portraiture, one might well wonder what it means here. Was it intended to have funerary connotations, establishing a commemorative function for the portrait, or is the purpose of the pronounced perspective and the cast shadow to assert the illusionistic "presence" of the sitter? "Through painting, the faces of the dead go on living for a very long time" Alberti wrote, in a suggestive passage in the *Della pittura* (II.25). It is perhaps worth noting that Ghirlandaio's superb posthumous portrait of Giovanna degli Albizzi Tornabuoni, of 1488 (Museo Thyssen-Bornemisza, Madrid), would seem only a little less claustrophobic were it not for the niche-like cupboard behind the sitter stocked with a variety of precious objects and a piece of paper with an epigram by the Latin poet Martial.

The profile format was de rigueur in mid-fifteenth-century Florence, especially for female portraits, but why does this sitter stare so fixedly? Is she to be imagined as though looking through an opening, as in Lippi's *Portrait of a Woman and a Man at a Casement* (cat. 4)? If that is the case, why is the lighting so emphatically from above, causing the sitter's ear to cast a long, diagonal shadow across her neck and the shadow of the head to be projected low, against the lateral wall? At a time when female portraits tended toward the formulaic, in order to bring a woman's features into conformity with an ideal of beauty, why is this likeness so notably unflattering? These are not merely rhetorical questions but indications of the parameters of our understanding of Early Renaissance portraiture and of the conventions and functions that informed it.

No less enigmatic is the matter of authorship. (The suggestion that the picture is a fake—occasionally expressed orally—is not borne out by a technical examination.) Initially catalogued as a work by Filippo Lippi, the picture has been ascribed to his pupil Fra Diamante (Berenson), to Giovanni di Francesco (Longhi; Zeri; and Benati), to a follower of Paolo Uccello (Pope-Hennessy and Christiansen; and Jansen), and to Fra Carnevale (Joannides [1989] and Volpe [in Boskovits 1997]). The only agreement is that the picture must date from between about 1440 and 1450. It has some of Giovanni di Francesco's dryness of handling and tendency toward abstraction, as seen, for example, in the terminal figures of his magnificent Crucifix in Sant'Andrea, Brozzi (Cavazzini in Bellosi 1992a, pp. 126–30). However, the color has a greater transparency and the figure is less lapidary and harshly linear than are those in Giovanni di Francesco's more typical works. By the same token, the picture lacks the jewel-like brilliance and miniature-like delicacy of Fra Carnevale's paintings. The closest analogies for the stereometric treatment of the head and bust, and for the transformation of the ruff and the lappets of the sleeve into decorative patterns, may be seen in the work of Uccello. His *Madonna and Child* (National Gallery of Ireland, Dublin) and the fragmentary *Saint Monica and Two Youths* (Uffizi, Florence) offer some parallels for the way the volumetric figure is silhouetted against a perspective setting, while the border decorations of Uccello's frescoes in the cathedral of Prato reveal the same decorative instinct that informs the costume details in this portrait. A similar fascination with the play of cast shadows on an irregular surface is found in Uccello's celebrated fresco of the Flood (fig. 25, p. 63). Like the *Portrait of a Woman,* the *Saint Monica* initially was ascribed to Giovanni di Francesco. It also has been considered the work of a follower of Uccello, but is now widely regarded as by Uccello himself (see Angelini in Bellosi 2002, pp. 200–202), thus echoing the critical history of this portrait. Despite, or even because of, recent research, Uccello's career remains problematic and open to conflicting interpretations; his authorship of the fresco cycle in Prato Cathedral of scenes from the life of the Virgin has long been a divisive issue among specialists, but the series is now generally accepted and dated to the early 1430s. This writer would date the Dublin and Uffizi pictures to the late 1430s—after the Prato frescoes and more or less contemporary with the three celebrated scenes of episodes from the Battle of San Romano, in which Uccello's multi-interests in perspective, pattern, and naturalistic observation are most memorably combined (see Caglioti 2001, pp. 37–54; Gordon 2003, pp. 378–97). As an aside, it is perhaps worth noting that the female sitter's large, fleshy ear is almost identical to those of the cherubs in the Pratovecchio Master's *Assumption of the Virgin* (San Giovanni Evangelista, Pratovecchio); this artist, too, has connections with both Lippi and Uccello, as well as with Domenico Veneziano and Andrea del Castagno.

We seem, then, to be dealing with a painter who, taking as his point of departure Lippi's landmark *Portrait of a Woman and a Man at a Casement,* was deeply sympathetic to Uccello's fascination with geometry, on the one hand, and, on the other, no less influenced by that artist's peculiar interest in uningratiating, homely female types of distinctly middle-class status. It is a culture parallel to that of Fra Carnevale, although the end results are lacking in that artist's essential refinement.

K C

PROVENANCE: Alexander Casella, London (1884); Édouard Aynard, Lyons (until 1913); sale, Galerie Georges Petit, Paris, December 1–4, 1913, no. 53 (as by Filippo Lippi); Seymour de Ricci, Paris (1913); F. Kleinberger, Paris and New York (1922); Michael Friedsam, New York (1923–32).

REFERENCES: Lelarge-Desar 1913, p. 392; Berenson 1932a, p. 169; Lipman 1936, p. 76; Ragghianti 1938, p. XXII; Pittaluga 1949, pp. 221–22; Longhi 1952b, p. 43; Zeri and Gardner 1971, pp. 113–14; Fredericksen 1974, p. 29; Pope-Hennessy and Christiansen 1980, p. 56; Jansen 1987–88, p. 97; Joannides 1989, pp. 7–10; Benati 1996, p. 27 n. 4; Boskovits 1997, p. 255.

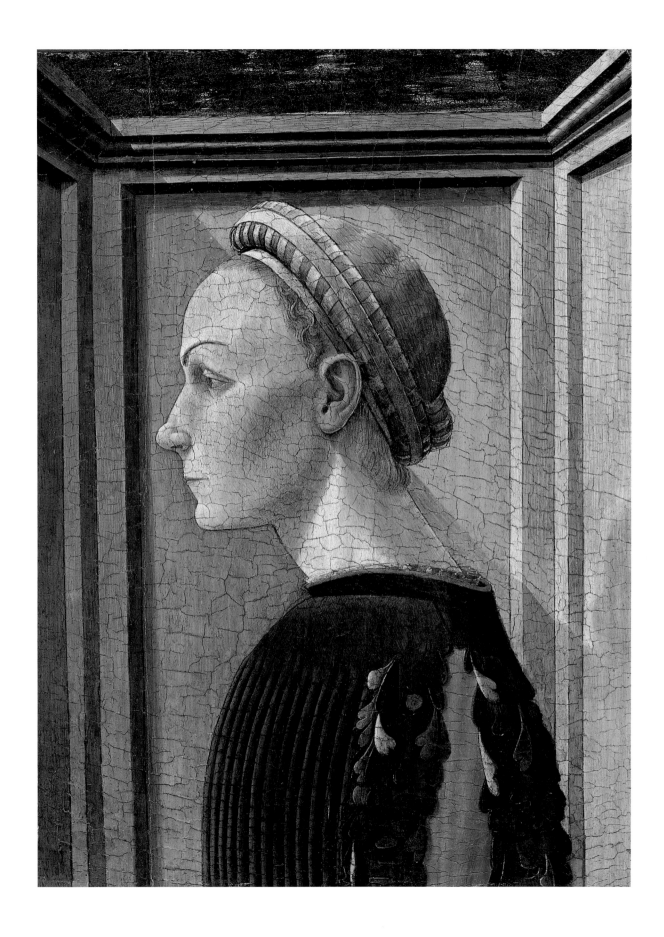

[18]

FRA CARNEVALE (?)

Madonna and Child

Tempera on wood, 49.7 x 30.6 cm
Accademia Carrara, Bergamo (inv. 510)

This *Madonna and Child,* bequeathed to the Accademia Carrara by Guglielmo Lochis in 1859, is by a close follower of Filippo Lippi (although Lochis himself believed it was an autograph work), and is distinguished by its rather unorthodox composition. In Lippi's paintings of the Madonna and Child of the 1430s and 1440s, the Madonna is generally shown in melancholic thought while supporting the Christ Child on a parapet, and she is usually presented frontally, conveying a sense of calm composure. Those qualities are rather dramatically altered here by the windowsill, which is distorted by its oblique placement, as well as by the proximity of the figures to the picture plane and by the cropping of the image (especially the halo of the Virgin; the panel has also been thinned). The Madonna appears trapped between non-orthogonal planes, perceived in fragments that are not even consistent with one another. There is, however, a precedent for this type of composition in the *Madonna and Child* (the *Tarquinia Madonna*) that Lippi painted for Cardinal Giovanni Vitelleschi (Galleria Nazionale d'Arte Antica, Rome). That picture is also dominated by large figures in a domestic interior conspicuous for its many angles and for a minimally foreshortened window on the left that opens onto a landscape, exactly as in the present *Madonna and Child.* The bizarre architectural forms, colored in violet, seem to have been influenced by Lippi—for example, the indication of a window with a trilobate arch cut off by an architrave, through which one can see clay-colored hills and blue skies even more luminous than Lippi's. The bouncing vitality of the precariously balanced Child is frozen in a split second: gestures such as the spontaneous movement of the Child's hand toward his mouth recall the naturalism of Fra Filippo's sublime works, such as his *Madonna and Child* in the National Gallery of Art in Washington, which features the tickling of the Child's chin. The effect here, however, is different, since what is conveyed is an improbable sense of precari-

ousness rather than an intimacy suffused with sentimentality. The metallic sharpness of the bodies and the excavated folds of the Virgin's blue robe recall the most sculptural of Lippi's work—that of his second period, beginning with the *Tarquinia Madonna* of 1437 and ending with the Sant'Ambrogio *Coronation of the Virgin* (fig. 2, p. 40), on which, from 1445–46, he was assisted by Fra Carnevale. The shadows—liquid and dense, with edges that seem almost to vibrate—cast by the Child's foot, the Madonna's fingers, and the column and capital in the right background, are Lippesque. The gilded decoration that normally pervades Lippi's work is here limited to the now faded golden thread that traces the hems of the robes, while the metallic brilliance of the three-dimensional halos is rendered entirely by paint—but with an intention similar to the specks of gold in Saint Augustine's halo in the *Barbadori Altarpiece* (fig. 14, p. 52) of 1437–39. The Virgin's red robe is executed with a subtle pointillism that offers a distant echo of the work of Gentile da Fabriano. However, the closest similarities are with the *Annunciation* in the Martelli Chapel in San Lorenzo (ill. and fig. 13, p. 51); indeed, no face in Lippi's oeuvre bears a stronger similarity to that of the Bergamo *Madonna* than the face of the Virgin in the Martelli *Annunciation.* It is as though the same cartoon had been used, even if the Bergamo Virgin lacks the

Filippo Lippi, *The Annunciation* (detail).
San Lorenzo, Florence

slightly opened lips of the latter as she answers the angel with "*Ecce ancilla Domini*" ("Behold the handmaiden of the Lord"). The coiled braid that encircles her head is also similar, although Fra Filippo further complicates it in his picture by adding the transparent veil and the wispy locks that escape the braid. In the Bergamo panel, the Virgin's blond hair is springy, as if made of threads of gilded metal, demonstrating a taste for a descriptive accuracy that differs from the essentially pictorial quality of Lippi's work of the 1440s.

Such accurate visual description, combined with a diffused luminosity—à la Domenico Veneziano—is found in the Florentine work of such heterodox painters as Giovanni di Francesco (to whom Berenson [1932a] first attributed the Bergamo *Madonna*), the Pratovecchio Master (to whom the picture was attributed by Wohl [1980]), or the Marchigian Fra Carnevale. Bellosi (1990b) associated the Bergamo panel with Fra Carnevale, citing Previtali's concurring opinion (according to Benati, Volpe had the same idea); Bellosi dated the panel to the artist's youthful period spent in Florence. He also suggested that several other works—a *Madonna and Child with Saints and Angels* and a *Saint John the Baptist* (both, Musée Condé, Chantilly; fig. 11, p. 30), as well as three scenes from the life of Saint Nicholas on the predella of Lippi's Martelli *Annunciation*—might also be assigned to the young Fra Carnevale. Berenson (1950 and 1963; Rossi 1988) attributed the panel to Zanobi Macchiavelli, correcting earlier, tentative attributions to Alesso Baldovinetti (see Morelli, handwritten notes of 1864 to Lochis 1858) and to Domenico di Bartolo (in Van Marle 1934). Boskovits (in Boskovits et al. 2003) accepted Bellosi's attribution of the Bergamo *Madonna and Child* to Fra Carnevale, whom he suspected might have had "an earlier, possibly Paduan-Squarcionesque training," but he rejected the attribution to him of the Chantilly panels and the predella of the *Annunciation,* which he ascribed to Lippi himself. Paduan stylistic traits are never explicit or direct in the work of Fra Carnevale, and they seem to turn up only after the 1440s—in accord with what we know of his fellow Marchigian painters from Camerino (Giovanni Boccati, Giovanni Angelo, and Girolamo di Giovanni). It is interesting that, from the beginning, Berenson (1932a and 1936), followed by Van Marle (1934), flirted with the notion that the Bergamo picture was painted by the young Boccati under

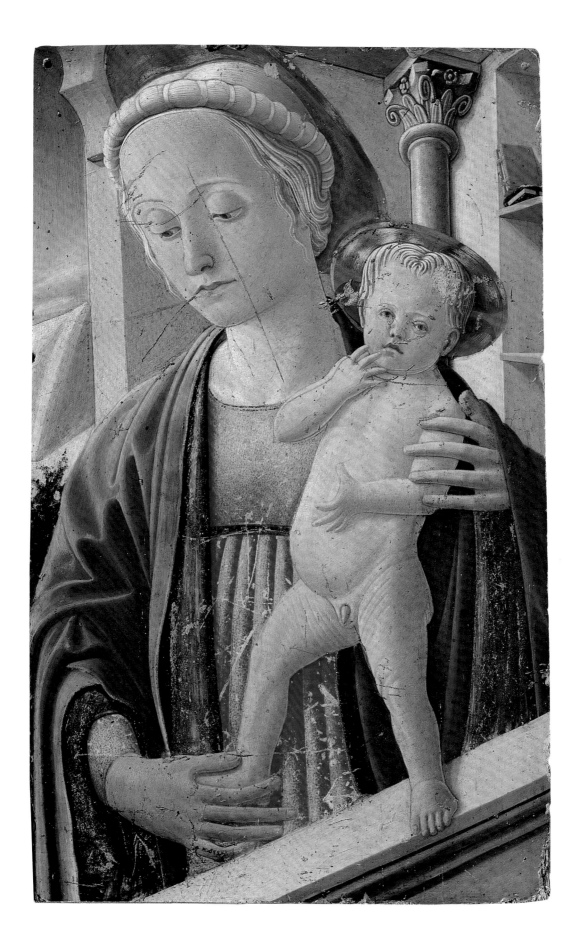

the influence of Fra Filippo (early on, Berenson had listed the picture as by Giovanni di Francesco). Until then, the panel was not immediately identified as a Florentine work; indeed, it was thought to be Paduan, as attested by the collector's note on the back ascribing it to "*Squarcione Francesco / di Andrea Mantegna.*"

The calculated quality of the composition of the Lochis picture makes it almost inseparable from the small panel of the *Madonna and Child with Saints and Angels* in Chantilly (and thus also from the *Scenes from the Life of Saint Nicholas*); one should compare especially the broad forehead and low brow of the two Madonnas, the elastic line that almost deforms their profiles, and the identical braid around the head of each. Also comparable are the deeply cut folds of the two blue mantles, incised by the sharply angled light and painted with distinct brushstrokes rather than in Filippo's softer and more impalpable manner. The same effects are found in a drawing in the Uffizi of a woman and a kneeling monk (cat. 16), which Bellosi also associated with the young Fra Carnevale, and they can be detected in the Marchigian master's Franciscan polyptych (cat. 41 A–D) as well as in the Barberini Panels (cat. 45 A–B). One can also point out the similarity of the Christ Child's face, with its soft and somewhat timid pout, to that of the Child who grabs Saint Christopher's hair in a panel that Bellosi (1990b, p. 36, fig. 30) attributed to Fra Carnevale and that perhaps originally was part of the same Franciscan polyptych (fig. 13, p. 32). The shiny three-dimensional halo is illuminated with tiny flecks of yellowish gold, like those in the Gothic polyptychs seen in the Boston *Presentation of the Virgin in the Temple (?)* (cat. 45 B). In the absence of more substantial evidence, this proposal remains merely a hypothesis—and one that is not without problems (see, for example, the entry for cat. 15). This exhibition presents an occasion to examine the matter at close hand. It should nonetheless be noted that the transparent shadows and sunlit tones, which relate to Fra Carnevale's probable contacts with Florentine proponents of a "*pittura di luce*" (the Pratovecchio Master, the early work of the Master of the Castello Nativity, and Giovanni di Francesco, among others), do not coincide with the denser, sfumato effects proper to Lippesque painting or to the muted tones of the Chantilly panels and of the *Scenes from the Life of Saint Nicholas*. The spatial irrationality of the Bergamo panel is also somewhat disconcerting if we

recall Fra Carnevale's systematic assimilation of Piero della Francesca's perspective constructions in his later works. If the Lochis *Madonna* is really one of Bartolomeo Corradini's first autonomous paintings after leaving Filippo Lippi's shop, then it is necessary to radically postulate that his mastery of perspective, so foreign to Lippi's style, matured in Urbino rather than in Florence in the 1440s. A D M

PROVENANCE: Guglielmo Lochis, Mozzo (before 1859); bequeathed to the Accademia Carrara, Bergamo (1859).

REFERENCES: Lochis 1858, p. 247; Berenson 1932a, pp. 90, 341; Van Marle 1934, p. 17; Berenson 1936, p. 77; Berenson 1950, p. 346; Ottino Della Chiesa 1955, p. 26; Wohl 1980, pp. 194–95; Rossi 1988, p. 181; Bellosi 1990b, p. 37; Lachi 1995, p. 26; Benati 1996, p. 25; De Marchi 2002b, p. 50; Minardi 2002, p. 217; Boskovits in Boskovits et al. 2003, p. 184.

[1 9]

FRA CARNEVALE (?)

The Annunciation

Tempera and gold on wood, 69.9 x 78 cm
Inscribed (along the bottom of the grille): HOC ERAT
IN [P]RENCIPIO ("In the beginning was
the word . . ." John 1: 1)
Alte Pinakothek, Munich (inv. no. 645)

The Annunciation is shown taking place in an open court before the Virgin's house. Her bedchamber (the *thalamus virginis*), luxuriously decorated with ermine hangings, curtains, and a small, open cupboard, is seen through a marble door at the right. Behind the Virgin a green curtain has been drawn back to reveal the view through another door into a dining room, where a table, stool, and bench are arranged in front of a staircase leading up past an open window. An elaborate bronze grille bearing an inscription relating to the Incarnation is shown unlocked, with a key in its open gate. It provides symbolic as well as visual access to an area paved with inlaid marble slabs in front of an altar set up against the exterior wall of the house (the yellowish altar cloth is only partially visible). Beyond this sanctified area is a deep, colonnaded portico, at the end of which is a door surmounted by an escutcheon supported by two winged putti that leads to an arbor and

a closed gate (commonly referring to Mary's virginity: Ezekiel 44: 1–2). The walled garden (the *hortus conclusus* of the Song of Songs 4: 12) to the left of the colonnade is surrounded by the arbor and contains cyprus trees (symbols of the Virgin), a well (the *fons hortorum* of the Song of Songs 4: 15), a thatched structure of some sort, and peacocks (symbols of immortality).

It would be difficult to cite another fifteenth-century *Annunciation* in which a comparable number of familiar symbols of the Virgin—first described by Syre—have been used to evoke the life of a patrician Florentine. We are left in no doubt who the palace belongs to: the arms of Jacques Coeur (about 1395–1456), the wealthy merchant and finance minister of Charles VII, are prominently displayed in the tympanum of the door behind the Virgin, who is shown kneeling at a prie-dieu, a prayer book in her hand, her velvet-cushioned faldstool behind her. That Jacques Coeur should have commissioned such a work would not be surprising, for he had a special devotion to the Annunciation: the subject is carved over the door to the chapel of his residence in Bourges (begun 1443: see Favière 1992), and it is depicted in a magnificent stained-glass window illuminating his family chapel in Bourges Cathedral (1447–50: see Grodecki 1975). Moreover, the prolific use of Marian emblems in the *Annunciation* is perfectly in keeping with the surviving decoration of Jacques Coeur's palace chapel, the ceiling of which is embellished with flying angels holding scrolls inscribed with verses relating to the Virgin, many taken from the Song of Songs. Certainly, the carpet on which the angel genuflects would have been appreciated by someone who, like Coeur, had

Maso di Bartolomeo, Grille (detail).
Cappella della Cintola, Prato Cathedral

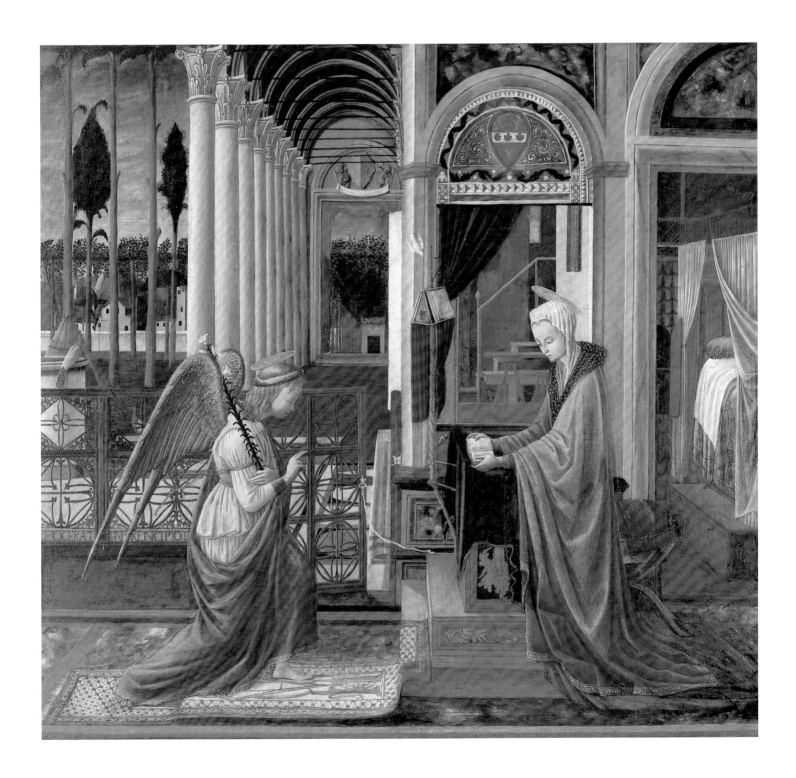

trade relations with the Levant (he made a trip to Damascus in 1432). Does the intensely descriptive character of the picture reflect Coeur's Northern tastes and his patronage of an artist such as the Fleming Jacob de Litemont? (See Lorentz 2003, pp. 38–49.)

In the past it has been assumed that the picture was commissioned by Jacques Coeur either during a diplomatic mission to Rome that he undertook for the king in 1448, or when, disgraced, he fled from France in 1454, making his way to Rome by mid-March of 1455. However, it is unlikely that Coeur commissioned anything after his arrest in Taillebourg in 1451, when work on his palace in Bourges came to a halt. On the other hand, his mercantile involvement with Florence began much earlier than either of these dates would suggest (see Mollat 1957; Mollat 1988, pp. 91–97). In 1443 he had established a partnership with the silk merchants Niccolò di Piero di Bonaccorso and Zanobi and Guglielmo Martini. In 1446 he joined (by proxy) the powerful silk guild, the Arte della Seta; his son Ravard became a member the following year and another partner, Guillaume de Varye, joined in 1450. Jacques's brother, Nicolas, was the king's representative to Pope Eugenius IV and was in Florence during the ecumenical council held there from 1439 to 1443. There was thus no shortage of individuals who could have commissioned the work for Coeur—but for what locale? We know that the chapel in Jacques Coeur's palace in Bourges was decorated with a triptych, reported by visiting Florentine ambassadors in 1461 to have been by "a very great master," with portraits of Coeur and of Charles VII (see Avril 2003, pp. 158–59). However, he also had residences in Montpellier, Lyon, and Pézenas, and his chapel in Bourges Cathedral was furnished with a private oratory. If the picture had ever been sent to France, Coeur must have taken it with him when he left for Italy: it was purchased in Florence in 1808 from the dealer Abbate Rivanni, who supplied the Bavarian royal collections with a number of Early Italian pictures. (The mistaken idea, often repeated, that the panel might be from Santa Maria Primerana in Fiesole originated in Strutt 1901, p. 33.) It is not out of the question that from the outset the painting was intended to decorate the Florentine palace of one of Coeur's associates.

The picture was acquired as a work by Masolino. Since then it has been ascribed to a variety of artists: Filippo Lippi "in the spirit of [Fra] Angelico" (Cavalcaselle); Jacopo del Sellaio (Mackowsky); a French painter (Voll); school of Lippi (1911 museum catalogue); the Master of the Castello Nativity (Berenson); the Master of the Barberini Panels (Zeri); and, more cautiously, to a still anonymous Marchigian painter (Syre). Like Meiss, Strauss, Syre, and Boskovits, the present writer initially doubted Zeri's attribution of the picture to the artist we now know as Fra Carnevale and considered the possibility that it was by the Master of the Castello Nativity. I no longer feel this is a viable alternative for the simple reason that the picture is quite beyond that artist's capabilities. Part of the difficulty resides in the curiously elongated, overly delicate figures of the angel and the Virgin, with their broad foreheads and small chins. It is important to recall that they were patterned on one of Filippo Lippi's most singular works, the altarpiece of the *Annunciation* (fig. 5, p. 43), dating from 1443–45 (see cat. 5), for the convent of Le Murate in Florence. Lippi's figures, too, are strangely elongated, almost ethereal in appearance. What our artist was uninterested in was Lippi's imaginative creation of a church-like space that opens onto a walled garden: an exercise in sacred allegory that the artist of the present *Annunciation* has rendered in prosaic terms of intimate domesticity.

It is in the domestication of the religious theme and in the fastidious attention given to the architecture that Fra Carnevale reveals his authorship. The grille was quite clearly inspired by the one Maso di Bartolomeo created for the Cappella della Cintola in the cathedral of Prato (1438–42; see ill.), while the capitals of the colonnade—still semi-Gothic in character—bear comparison to those in the atrium (or *chiostro dei voti*) of the Santissima Annunziata in Florence, presumably designed by Michelozzo and ready for installation by 1450 (see Casalini 1995, p. 94). The marble paving beyond the grille is Michelozzan in its reference to Roman models and is perhaps inspired by the pavement beneath the tabernacle in the Santissima Annunziata (completed 1448). The work of these two sculptor-architects runs like a thread through Fra Carnevale's work.

No less characteristic of Fra Carnevale is the system of perspective. Although not as rigorous as that found in the *Annunciation* in Washington (cat. 40), it is based on the same principles. The vanishing point is high in the picture field, located on the vertical molding, below and to the left of the tiny dove, 7.7 centimeters from the base of the door. There is a diagonal incision with paired compass points that was used to determine the ribs of the vaulting. Other incisions occur throughout, perhaps the most revealing of which are those employed to establish both the foreshortening and the intervals of the stairs and the railing in the room behind the Virgin. Not all architectural features recede to a single vanishing point: the background arbor, for example, has been foreshortened empirically, but throughout the picture there was an evident effort to create a commensurable space and to provide openings that invite the viewer to explore it. The other element that is typical of Fra Carnevale is his miniaturist's eye for details: the key in the grille, with a string that extends to the prie-dieu; the lamp hanging in front of the open window; or the key in the chest by the bed (infrared reflectography reveals that, initially, the other chest also had a key in its lock that subsequently was painted out).

Zeri (1961, p. 99) did not so much argue for an attribution to Fra Carnevale as assert it, noting that in the picture "the admirable reflection of Domenico Veneziano . . . is brought into harmony with Filippo Lippi and Piero della Francesca: not yet the Piero of Urbino, but already the Piero of Arezzo, which suggests a date [for the *Annunciation*] around 1455 [that is, when Jacques Coeur fled from France]." This seems to me a curious formulation, in which an attempt is made to match the style of the picture to a significant date in the life of Jacques Coeur. However, as we have seen, the picture could have been painted any time after about 1444 and is unlikely to postdate 1451. Indeed, the style— exquisite though it may be—is less mature than that of the Washington *Annunciation* (cat. 40). Certainly, there is no hint of Fra Carnevale's awareness of Piero's frescoes. Rather, the color harmonies and the treatment of light—especially that pearly light playing on the tidy folds of the bed curtain—recall the work not only of Domenico Veneziano but of Fra Angelico (see fig. 24, p. 62). While the engaging patois of Fra Carnevale is as far removed from the elevated sacred discourse of Angelico's *San Marco Altarpiece* (fig. 3, p. 41) as it is from the courtly diction of Veneziano's *Saint Lucy Altarpiece* (fig. 21, p. 60), he has conspicuously borrowed from the predella of the latter work a simple, illusionistic molding of lavender gray to create the effect of observing the Annunciation through an Albertian window.

The vertically grained panel is intact, with

evidence of two battens along the top and bottom of the reverse side. Old repaints were removed in 1884, the sky was scumbled over at that time, and the gold of the halos and on the angel's wings was largely renewed. KC

PROVENANCE: Abbate Rivanni, Florence (until 1808); Crown Prince Ludwig of Bavaria, later King Ludwig I (r. 1808–26); Bayerische Staatsgemäldesammlungen, Munich.

REFERENCES: Crowe and Cavalcaselle 1864–66, vol. 2, p. 349; Mackowsky 1899a, p. 276; Strutt 1901, p. 33; Voll 1907, pp. 41–42; Berenson 1932a, p. 343; De Man 1950, pp. 225–26; Zeri 1953, p. 131; Meiss 1961a, p. 66 n. 40; Zeri 1961, pp. 21, 99; Christiansen 1979, p. 201 n. 8; Strauss 1979, p. 35; Ciardi Dupré Dal Poggetto in Ciardi Dupré Dal Poggetto and Dal Poggetto 1983, p. 43; Zampetti 1988, p. 395; Syre 1990, pp. 86–91; Boskovits in Boskovits et al. 2003, p. 186 n. 25.

[20]

MASO DI BARTOLOMEO

Reliquary for the Holy Girdle of the Virgin

Embossed copper, engraved and gilded; wood; panels of horn, ivory, and fabric,
15.5 x 21 x 14.5 cm
Museo dell'Opera del Duomo, Prato

This reliquary box consists of a wood core sheathed with a blackened horn veneer that creates the backdrop for sixteen dancing putti carved in ivory. Only six of the putti are original; the others, copied from those that remained, were added during a restoration in the nineteenth century. The box is inserted into a gilded-copper framework that is embossed and engraved and to which the base and cover are connected by ten small columns with Corinthian bases and capitals. From a structural point of view these elements function as braces that hold the various parts together. The cover is crowned with a double volute and has, on its interior, the coat of arms of Niccolozzo Milanesi, which is only visible when the box is opened for display of the relic (Cerretelli 1995, p. 122). The coat of arms is surrounded by a winged garland with ribbons and an inscription, written in beautifully proportioned Roman-style letters, with only a single abbreviation at the end: CINGENO/S VIRGO O DEI / VAS MISERICORD/IA TVA SICVTI HO /C VASCVLVM / CING VLVM / CINGIT T / VVM ("Cover us with your mercy, O Virgin,

vessel of God, as this small container holds your girdle"). The ribbons of the garland are inscribed MATER DEI MEMENTO MEI. The wings are decorated with a very subtle stippling to suggest the delicate texture of feathers.

Baldanzi (1846, pp. 265–66) published the contract for this reliquary, but without paying attention to the importance of the object itself. It was commissioned in 1446 from Maso di Bartolomeo, "*magistro et peroptime doctor de dictiis laboreriis*"—that is, "a master skilled in the production of this sort of work [bronze]." The contract required the sculptor to make "*unus capsettinus de bronzo pulcherrimus et decorus bene ornatus compositus et ordinatus . . . cum suo capsettino eburneo et fregiis,*" and then it spelled out the appearance of the reliquary's clasp and the mechanism for removing the relic itself from its tabernacle. The contract also makes it clear that this box was to replace one that already existed. The reliquary was rediscovered in the nineteenth century, and it became more widely known through an article by Middeldorf (1935) and after its inclusion in the large exhibition of Italian goldsmiths' work held in Milan in 1937; in the exhibition's catalogue by Morassi, however, it was mistakenly dated to 1466.

The reliquary contained the most important civic relic in Prato and was to be the sacred fulcrum of the area in the cathedral dedicated to the Virgin's girdle. At the end of the fourteenth century the chapel, located against the interior façade of the church, to the left as one entered (*a cornu evangelii*), was decorated by the workshop of Agnolo Gaddi (1392–95) with scenes from the life of the Virgin. In July 1428 a contract was drafted for a new pulpit on the exterior of the church that was to be constructed according to an approved model. This pulpit was to be reached by means of a passage excavated within the façade itself and was intended as a place to display the relic to the whole city, gathered together in prayer in the piazza in front of the cathedral. The pulpit was the work of Donatello and Michelozzo, assisted by Maso di Bartolomeo. A gallery was later added (1434) on the interior façade, above the main portal, to display the relic inside the church; it was executed by Maso, working alone but under the influence of Michelozzo's style. The ensemble was completed by a bronze grille, also commissioned from Maso, in 1438, but not finished until some decades later, and after many vicissitudes, by his assistant Pasquino di Matteo da Montepulciano (fig. 5, p. 100; ill.

p. 182); the grille enclosed the entire area of the Altar of the Holy Girdle and the access to the pulpit. The tabernacle for the relic itself had a small bronze door, also commissioned in 1446 but now lost, which was decorated with the not uncommon scene of the Virgin giving her girdle to Saint Thomas—the act that constituted the origin of the relic itself (Baldanzi 1846, p. 265).

In its exceptional design, the reliquary is, in fact, a small architectural object. Marchini (1968a) acutely underscored the extraordinary fact that Maso created a precious object of gold employing an architectural and decorative vocabulary derived entirely from monumental forms and abandoning the usual formal, and especially technical, characteristics of the gold-smith's art, in which, for decades to come, Gothic elements would be combined with a nascent repertory of antiquarian motifs.

Maso conceived of the reliquary in terms of a small Renaissance altar, recalling, for example, the one erected by Andrea di Lazzaro Cavalcanti, called Buggiano, in Brunelleschi's Old Sacristy at San Lorenzo (1432), itself derived from the Romanesque altar in the Florentine Baptistery (Morolli 1979, pp. 184–92; see also ill.). The reliquary box was also intended to evoke the sarcophagus from which the Virgin ascended into heaven, leaving behind her girdle as a gift to the apostles. Antique sarcophagi in Pisa, Rome, and Florence offered ready models that were often slavishly imitated, as demonstrated by a contemporary Florentine chest included by Middeldorf (1935 [1979–80 ed.], pp. 213–14) in his publication of the Prato reliquary.

In designing this object, Maso must have had in mind Donatello's project for the *Cantoria* in Florence Cathedral (1433–39). There, a band of dancing angels, some of them also playing musical instruments, form a procession behind a screen of columns. It is not surprising that, in exploiting the contrast between the rhythm of the architectural elements and the movement of the dancing putti, Maso tried to imitate the frenzied drama of Donatello's choir loft (Museo dell'Opera del Duomo, Florence) to create an effect of divine, bacchic joy. Maso was so faithful to Donatello's concept that he even attempted to reproduce the chromatic effect of the Florentine *Cantoria* (Bonsanti 1986: in the Prato pulpit the putti are also placed against a gold mosaic ground). Yet, Maso diluted Donatello's sense of rhythm by reducing the columns on the long sides of the reliquary box: six were originally planned (the attachments were already prepared), but only four were ultimately employed.

Maso also turned to Donatello for some of the features of his decorative vocabulary. The motif of the winged garland, for example, can be found in Donatello's tabernacles of both the Parte Guelfa on Orsanmichele and the Cavalcanti *Annunciation* in Santa Croce, Florence (Trudzinski 1986, pp. 91–95). On the other hand, Maso also introduced motifs (such as the tondi flanked by foliage, grape leaves, and palmettes interspersed with rosettes) that became part of his repertory. He used the last-mentioned motif in a more developed form on the piers of the portal at San Domenico in Urbino. The quality of the engraving, which is less fine than what is found in most Late Gothic objects carried out by professional goldsmiths, is compensated for by the inventiveness of the formal motifs. One might note, for example, the two volutes, elegantly trimmed with moldings and foliage, which make up the top of the reliquary's cover. This motif certainly derives from the upper acroteria on ancient altars such as the one recorded at the end of the sixteenth century at San Giovanni in Laterano, Rome, by Giovan Battista Montano (Album in Sir John Soane's Museum, London, vol. 123, fol. 74v; Fairbairn 1998, vol. 2, pp. 722–23). M C

PROVENANCE: Prato Cathedral.

REFERENCES: Baldanzi 1846, pp. 87–88, 264–68, doc. X; Middeldorf 1935, pp. 279–82 (1979–80 ed., vol. 1, pp. 211–15, especially p. 212); Morassi 1936, p. 37; Marchini 1952, p. 126; Marchini 1958, p. 43; Marchini 1963, pp. 19–20, 77; Marchini 1968a, p. 238; Bonsanti in Darr and Bonsanti 1986, pp. 189–91; Cerretelli 1995, pp. 122–25; Pfisterer 2002a, pp. 350–51.

Marble altar, 13th century (reconstructed). Baptistery, Florence

[21]

FRANCESCO PESELLINO

The Annunciation

Tempera on wood: left-hand panel, 18.9 x 13.5 cm;
right-hand panel, 19 x 13.1 cm
Courtauld Institute Gallery, London
(inv. P.1966.GP.313)

Of Pesellino's small-scale devotional works—a genre that he specialized in—the Courtauld *Annunciation* is certainly among the finest. Seldom did the gifted young artist achieve a like impression of domestic intimacy, owing not simply to the mirrored attitudes of the figures, shown humbly kneeling with their heads inclined, or to the detailed description of the Virgin's house, but to the poetic effects of a soft morning light that pervades the scene. Gone are the bright, decorative colors that distinguish his miniatures for a manuscript of Silius Italicus's *Bellum Poenicum* (now divided between the Biblioteca Nazionale Marciana, Venice, and The State Hermitage Museum, Saint Petersburg) and the elegant figures, in their neatly pressed costumes, of the cassone panels depicting Petrarch's *Triumphs* (Isabella Stewart Gardner Museum, Boston). In those works it is Fra Angelico's preference for sharply lit, crisply defined forms that dominates.

Angelico would have been the obvious model for a prodigiously gifted youth trained by a Late Gothic master. Pesellino's teacher had been his grandfather Giuliano d'Arrigo, known as Pesello (1367–1446), who is probably identifiable with the charming artist we know as the Master of the Bargello Judgment of Paris (Neri Lusanna 1989). Apparently after his grandfather's death in 1446 Pesellino established some sort of working relationship first with Zanobi Strozzi, with whom he collaborated on a series of panels depicting the Journey of the Magi (see Fahy in Di Lorenzo 2001, pp. 71–74), and then with Filippo Lippi, painting the predella of Lippi's altarpiece for the novitiate chapel in Santa Croce (fig. 20, p. 59). The circumstances that led to the painting of that predella are still unclear, as documents are lacking. All that can be said is that Lippi is known to have employed other artists to help carry out the many commissions he had in hand.

The predella to the novitiate chapel altarpiece reveals Pesellino still working in an Angelico-inspired style, although tempering his palette by emphasizing earth tones. He was no longer what Bellosi (1990a) has termed a *pittore di luce*—a painter of sunlit scenes—but was beginning to explore the more subtle, chiaroscuro effects of Lippi's art. In the Courtauld *Annunciation* he is a recognizable disciple of Filippo Lippi—so much so that the picture was ascribed to Lippi prior to Berenson's recognition of it as a characteristic work by Pesellino. Surprisingly, its model was not a contemporary picture by Lippi but an *Annunciation* (National Gallery of Art, Washington, D.C.) painted perhaps two decades earlier (Boskovits in Boskovits et al. 2003, pp. 395–98). Despite the Washington picture's ruinous condition, it must have been remarkable both for its complex architectural space, with interconnected rooms, and its subdued interior lighting. As in Pesellino's little masterpiece, Lippi shows the figures caught in a diagonal shaft of light that falls across the back of the angel and illuminates the Virgin by passing through an open door notionally located behind a pilaster with engaged columns (this bilateral division of the *Annunciation* by a prominent architectural feature is a hallmark of Lippi's early work). Pesellino has further elaborated upon this ingenious idea by contrasting the brightly lit exterior loggia and its Michelozzan arcade with the more softly lit interior of the Virgin's room. As Shearman (1962, p. 36) has noted, it was in Lippi's works of the late 1430s that the interaction of light and color was explored in ways that were crucial to later Florentine painting, especially to that of the young Leonardo da Vinci. Pesellino was the first artist to begin the process of exploring Lippi's oeuvre, proceeding from the recent work back to those innovative experiments in a chiaroscuro system of modeling, which were inspired in part by Lippi's awareness of Netherlandish painting. Pesellino's conscious reappraisal of those groundbreaking pictures of the late 1430s and early 1440s is apparent in his altarpiece, now in the Louvre, in which the figure of Saint Zenobius is taken over more or less directly from Lippi's Saint Augustine in the panel now in the Accademia Albertina di Belle Arti, Turin (cat. 1 A), while the box-like enclosure, with window openings providing controlled light, was inspired by Fra Filippo's *Barbadori Altarpiece* (fig. 14, p. 52). The culmina-

tion of this process of retrospective reassessment—so crucial to the great generation of painters who came of age in the 1460s and 1470s (Verrocchio, Pollaiuolo, Botticelli, Leonardo da Vinci)—was Pesellino's truly revolutionary altarpiece of the *Trinity* (fig. 19, p. 58), commissioned in 1455 and completed after the artist's death in 1457 by Filippo Lippi (see Gordon 2003, pp. 273–78). The Courtauld *Annunciation* is a prelude to this great work. Like Fra Carnevale, Pesellino was no passive disciple of Lippi: he mined the wealth of Lippi's art for what he needed to construct his own personal style—one far more naturalistically grounded than anything Lippi himself had conceived.

A precise dating of the panel is likely to remain controversial, given the paucity of documents associated with Pesellino's activity (for a cogent review see Angelini in Bellosi 1990a, pp. 125–27). However, Pesellino's collaboration with Zanobi Strozzi and his illuminations of the *Bellum Poenicum* may be situated in the years 1446–49 (Ferro in Bellosi 1990a, pp. 128–32). In 1453 Pesellino entered into partnership with Zanobi di Migliore and Piero di Lorenzo. Although his formation of a *compagnia* did not preclude taking on independent work, his association with Lippi most likely took place between about 1450 and 1453. The *Annunciation* probably dates from the very early 1450s; it is painted on two panels and was either intended to be framed as it is today or perhaps formed the folding wings to a small, portable altarpiece.

On the reverse of the two panels is a coat of arms and a scroll that are said to have been added in the nineteenth century—an assertion not yet put to the test of a technical examination.

K C

PROVENANCE: W. B. Spence (sale, Christie's, London, April 9, 1859); Thomas Gambier-Parry, Highnam Court, Gloucester (1859–88); Sir Hubert Parry, Highnam Court (1888–1918); Ernest Gambier-Parry, Highnam Court (1918–36); Mark Gambier-Parry, Highnam Court (1936–66); Courtauld Institute Gallery, London.

REFERENCES: Berenson 1905, pp. 42–43; Fry 1930, p. 130; Berenson 1932c (1969 ed.), p. 223; Angelini in Bellosi 1990a, p. 127; Ruda 1993, pp. 398, 490.

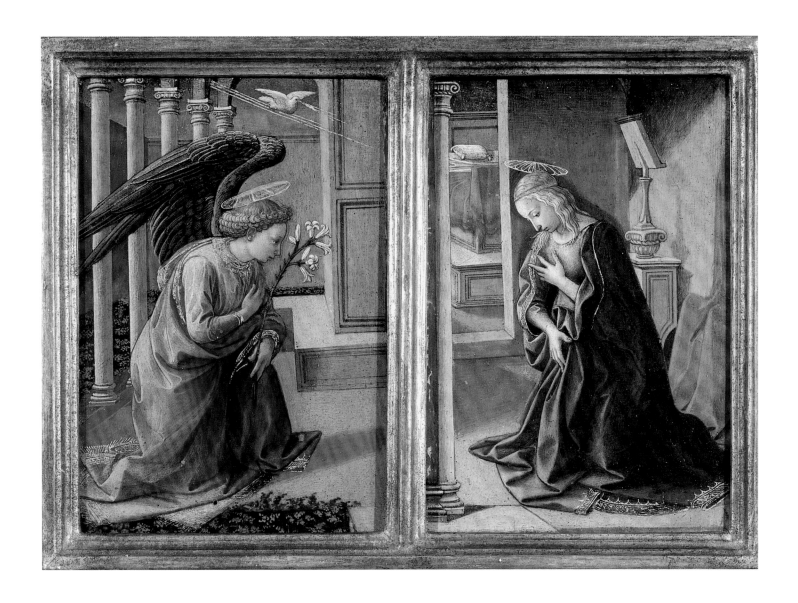

[22]

DOMENICO VENEZIANO

A. *Saint John in the Desert*

Tempera on wood, 28.4 x 31.8 cm
National Gallery of Art, Washington, D.C.
Samuel H. Kress Collection (1943.4.48)

B. *A Miracle of Saint Zenobius*

Tempera on wood, 28.6 x 32.5 cm
The Fitzwilliam Museum, Cambridge (inv. no. 1107)

The two panels are from the predella of Domenico Veneziano's *Saint Lucy Altarpiece* (fig. 21, p. 60), which—together with Fra Angelico's *San Marco Altarpiece* (fig. 3, p. 41) and Filippo Lippi's *Barbadori Altarpiece* (fig. 14, p. 52) for Santo Spirito, Florence, and his *Coronation of the Virgin* (fig. 2, p. 40) for Sant'Ambrogio—remains one of the defining works of religious art of the first half of the fifteenth century. Remarkably, we know practically nothing about the circumstances behind the commissioning of this great work, which stood on the high altar of the small Olivetan church of Santa Lucia de'Magnoli in the via de'Bardi in Florence (see Wohl 1980, pp. 123–26). The main chapel, under the patronage of the rich merchants (and brothers) Agnolo and Niccolò da Uzzano, was decorated with a cycle of frescoes of scenes from the life of Saint Lucy by Bicci di Lorenzo (before 1428); Domenico Veneziano's altarpiece is generally dated to the mid- to late 1440s. The predella was separated from the main panels at an unknown date (Lanzi 1795-96, vol. 1, p. 58, mentions the predella as still intact), and they are now dispersed as follows (listed in their original order, left to right): *The Stigmatization of Saint Francis* and *Saint John the Baptist in the Desert* (National Gallery of Art, Washington, D.C.); *The Annunciation* and *A Miracle of Saint Zenobius* (The Fitzwilliam Musem, Cambridge); and *The Martyrdom of Saint Lucy* (Gemäldegalerie, Berlin). Only when the various parts were brought together in the Uffizi in 1992 was it possible to appreciate the degree to which the altarpiece is a *summa* of Veneziano's art.

The serene, sunlit architecture of the main panel—inspired in part by the shell-niche tribunes on Brunelleschi's dome for the cathedral of Florence, but with Michelozzan detailing—is occupied by figures of aristocratic bearing that are realized with a mastery of anatomical structure unprecedented in Renaissance painting. When framed and in situ, a compelling effect was achieved of the *sacra conversazione* as an extension of the worshiper's own experience. The low vanishing point—located between the legs of the Virgin rather than at the height of the saints—suggested a spatial continuum with the viewer that was further enhanced by the notional source of light, which coincided with the primary source of illumination in the choir of the church. The harmony achieved between figure and setting as well as between color and light was the prerequisite for Piero della Francesca's altarpieces (in Milan and in Williamstown; cat. 46, 47), painted more than two decades later. It is, however, important to remember that the original chromatic qualities of the main panel were greatly impoverished as a result of a severe cleaning undertaken in 1862 that was heavily criticized at the time by Cavalcaselle. The justice of Cavalcaselle's assessment was made abundantly clear when the predella scenes were shown with the main panel in 1992. The well-preserved scenes exhibited here, with their saturated colors and rich, tonal effects, give an idea of what has been lost in the main panel.

Among the novelties of the main panel is the use of architecture to refashion the sacred field of a Gothic polyptych by simultaneously dividing the surface of the picture and creating a deep, commensurable space (on the perspective see Welliver 1975, pp. 5–17; Battisti 1971, pp. 35–40). By contrast, in the predella Domenico had the opportunity to display those narrative gifts that, to judge from Vasari's description, also characterized his (destroyed) fresco cycle in Sant'Egidio in Florence—a cycle on which the young Piero worked in 1439 and that was closely studied by Fra Carnevale.

Each of the predella scenes is illusionistically framed by a simple pink molding lit from the upper right (only the two scenes shown here preserve the molding more or less intact). On the left side of the predella, beneath the appropriate saints in the main panel, were placed two outdoor scenes: Saint Francis receiving the stigmata and the young Saint John the Baptist shedding his worldly garments and donning a camel's skin as he prepares to enter the wilderness (for the literary sources of the latter subject see Lavin, but also the comments of Boskovits). By contrast, the two right-hand scenes had urban settings. One takes place in front of the palace of the governor of Syracuse, who is shown on a balcony, ordering Saint Lucy's execution; the other concerned one of the patron saints of Florence, the fourth-century bishop Zenobius, and the setting is an imaginative recreation of the Borgo degli Albizzi, near the church of San Piero Maggiore, where the miracle was reputed to have occurred. (A woman from Gaul making a pilgrimage to Rome had entrusted her ailing child to Saint Zenobius. The child died just prior to his mother's return; she brought the body to Zenobius, who restored the boy to life.) At the center was the Annunciation, set in a cloister-like Renaissance courtyard. In each scene, perspective, landscape, and architecture are imaginatively manipulated in the interest of narration.

In the *Annunciation* (Fitzwilliam Museum, Cambridge) the horizon is level with the Virgin's bowed head, and the symmetrical disposition of the colonnaded courtyard and the idyllic beauty of the garden visible through an arched opening (aligned on the central axis before the panel was cut on its left side) enhance the quality of stilled action. So important was the division of the scene into sunlit and shaded areas for achieving an effect of serenity that the diagonal angle of the shadow across the pavement was incised into the surface of the gesso. The center axis was also incised, with the vanishing point located in the locked door (the *porta clausa*). (As in Fra Carnevale's *Annunciation* in Washington, the crenellated wall is colored pink, although in the case of Fra Carnevale's picture the door offers a vista onto a distant landscape.)

Saint John the Baptist's rejection of worldly comfort for a life of asceticism is underscored by contrasting the nude body of the youthful saint—of Apollonian beauty (for its classical sources see Wohl 1980, pp. 43–44)—to the shard-like facets of the rocky desert terrain, the jagged peaks of which gleam threateningly against an idyllic sky. This is not the naturalistically

descriptive landscape of Domenico's earlier tondo of *The Adoration of the Magi* (Gemäldegalerie, Berlin) but a brilliantly conceptualized landscape of renunciation. Even the bushes and mountain stream that will provide the saint food and drink add to the aura of desolation. The perspective structure underlying this landscape is projected diagonally from the right, so that the vanishing point indicates the saint's destination.

Of the five scenes, the most memorable is perhaps the one showing Saint Zenobius resuscitating a dead child, in which an unsurpassed effect of dramatic urgency is obtained by aligning the foreshortened façades of austere Florentine palaces along two plunging diagonals that converge behind the anguished figure of the child's mother. In the *Chronicon,* Saint Antoninus (1389–1459) described the scene as follows: "[The mother] laid down the dead body of her son at [Saint Zenobius's] feet, and full of tears, rending her garments, and tearing her hair with grief, cried aloud that her only son, whom she had entrusted to his care, had rendered up his spirit, never to return again to his own. Moved by her tears, the holy man of God, after he had offered up a prayer and made the sign of the cross over him, restored him to his mother, brought back from the dead" (see Horne 1908, p. 311). Domenico established a purposeful contrast between the grieving gesture of the mother, clothed in black, her headdress billowing out behind her, and the calm, prayerful pose of the saint. As often happens in the narrative reliefs of Donatello, a good deal of license has been taken with the perspective system in order to enhance the dramatic effect, but the key diagonal—extending through the child's lifeless body and his mother's torso—has been incised into the gessoed surface. There could be no greater contrast than that between Domenico Veneziano's emotionally charged scene and the elegant, spatially serene, and dramatically restrained interpretation on Ghiberti's shrine of Saint Zenobius in the cathedral of Florence, modeled about 1435 and completed by 1442 (see Krautheimer 1956 [1982 ed.], pp. 141–43, 154–55). Tellingly, it was Ghiberti's, not Veneziano's, depiction that the more timid and decoratively inclined Benozzo Gozzoli turned to for inspiration when, on two occasions, he depicted the same miracle (Gemäldegalerie, Berlin; The Metropolitan Museum of Art, New York).

Veneziano was unquestionably the most attentive student of Donatello's audacious experiments in narrative composition, as exemplified by the stucco reliefs of scenes from the life of Saint John the Evangelist in the Old Sacristy of San Lorenzo (completed before the sculptor's departure for Padua in 1444). As is the case there, so, too, in the scenes of Veneziano's predella "the space content seems to have been determined throughout by the nature of the subjects depicted, not by optical considerations" (Pope-Hennessy 1993, p. 182). This overriding interest in the dramatic aspect of the narrative was not taken up by either Piero della Francesca, with his sublime emotional detachment, or by Fra Carnevale, with his fascination for architectural settings in and of themselves. Although critics have rightly insisted upon the novelty of Veneziano's color—"high-pitched and delicate" (Offner 1939, p. 224)—what was of utmost importance for Piero and Fra Carnevale was Veneziano's self-fashioning as the artist envisioned by Alberti in the *Della pittura*—the poet-painter with a complete mastery of geometry. K C

PROVENANCE: (A) Santa Lucia de'Magnoli, Florence (probably until the early nineteenth century, although the altarpiece had been removed from the high altar by 1728); Bernard Berenson, Settignano (before 1919); Carl Hamilton, New York (1919–42); Samuel H. Kress Foundation, New York (1942); National Gallery of Art, Washington, D.C.; (B) Santa Lucia de'Magnoli, Florence (probably until the early eighteenth century); purchased in Florence by Joseph Fuller, Chelsea (London) (1815); his son, Professor Frederick Fuller (until 1909); The Fitzwilliam Museum, Cambridge.

REFERENCES: Pudelko 1934, pp. 154–58, 160–63; Salmi 1936, pp. 71–74, 126–27; Offner 1939, pp. 244–46; Lavin 1955, p. 89 n. 27; Lavin 1961, pp. 321–23; Goodison and Robertson 1967, pp. 46–49; Battisti 1971, pp. 35–40; Shapley 1979, pp. 159–62; Wohl 1980, pp. 32–63, 123–32; Christiansen 1981, p. 66; Agosti in Bellosi 1990a, p. 70; Bellosi 1992b, pp. 19–23; Chelazzi Dini in Bellosi 1992a, pp. 94–98; De Marchi 1994b, pp. 33–37; Christiansen 1996, pp. 100–102; Boskovits in Boskovits et al. 2003, pp. 241–50.

A

B

[2 3]

L UCA DELLA R OBBIA

Madonna and Child

Painted and gilded terracotta and wood,
37 cm (diameter)
Collection Julie and Lawrence Salander, New York

To judge from the number of surviving examples, this was among Luca della Robbia's most popular compositions. Marquand (1914, pp. 239–43) lists nine versions, one of which, in the Corsini Collection in Florence, is enameled in an uncharacteristically brilliant array of colors (see Scudieri in Gentilini 1998, pp. 164–66). Although the Corsini version has given its name to the composition, it may actually be later than some of the examples in terracotta, stucco, and papier-mâché (*cartapesta*). This is also true of the blue-and-white glazed *Madonna and Child* in the Philbrook Museum of Art in Tulsa (Middeldorf 1976, pp. 34–35). The earliest certain enameled terracottas by Della Robbia are the tabernacle (1441–43) for Sant'Egidio in Florence and the great *Resurrection* (1442–45) over the door of the North Sacristy in Florence Cathedral; only in the 1440s does his activity center on the use of enameled terracotta. Prior to that time the majority of his sculptures of the Madonna and Child were pigmented, sometimes with naturalistic tints and sometimes—as here—with white on a blue background (see Gentilini 1992, vol. 1, pp. 36–39). The model on which the Corsini *Madonna and Child* derives is generally dated to about 1440 (Pope-Hennessy 1980a, p. 251; Gentilini 1992, vol.1, p. 48).

The technique of terracotta sculpture had been explored by both Ghiberti and Donatello in the second and third decades of the fifteenth century (see Bellosi and Gentilini 1998) and became a mainstay of most studios. In some instances the sculpture was modeled and was intended to be unique; in other cases, however, a mold was used with a view to replication. All the examples of the Corsini composition are molded: whether there was ever an "original" version, in the modern sense of the word, is doubtful. Yet, we should not confuse replication

with quality, for the success of these images turned as much on their formal invention and the emotional qualities conveyed as on their availability. It is one of the paradoxes of Renaissance painting in Florence that the most innovative and emotionally complex devotional images of the Madonna and Child were sculptures (see cat. 12, 24). Only one painted composition by Filippo Lippi (cat. 6) demonstrably replicates a compositional formula created by Luca della Robbia, but the expressive range and rich formal inventiveness of Luca's terracotta sculpture established the norm by which painted images were judged.

An indication of the wide admiration the Corsini composition enjoyed is the inclusion of a version in the carved doorframe of the hospital of Santa Maria Nuova, Florence, as well as in the vault of a cloister of Santa Maria di Castello, Genoa. An example in *cartapesta,* formerly in the Kaiser-Friedrich-Museum, Berlin, seems to have been made for a Knight of the Order of the Crescent, while another had a frame carved to resemble the celebrated Medici diamond ring—one of Piero de'Medici's favorite armorial devices (Bode 1889, p. 7; Marquand 1914, p. 242, nos. 91, 92). The present example is unique in being set into a wood salver with a gilt rim, the inside of which is painted blue with red rays. The spatial play between the projecting figures and the concave surface into which they are set greatly enlivens the composition, although it required eliminating the Virgin's halo.

A sticker on the reverse side of the wood salver identifies the work as coming from the distinguished Hainauer collection. At the time of its publication by Marquand (1914, no. 88) it had been completely overpainted, possibly to cover the minor damage in the Virgin's neck (there are still minute traces of blue in the Virgin's left sleeve).

K C

P ROVENANCE : Oscar Hainauer, Berlin (until 1894); Julie Hainauer, Berlin (1894–1906; 1897 cat., no. 15, p. 11); Duveen Brothers, New York (from 1906); Carlo de Carlo, Florence (sale, Venice, Semenzato, October 19, 2000, lot 169); Salander-O'Reilly, New York (2000–2003).

R EFERENCES : Marquand 1914, p. 241, no. 88; Pope-Hennessy 1993, p. 251; Butterfield and Radcliffe 2002, p. 42.

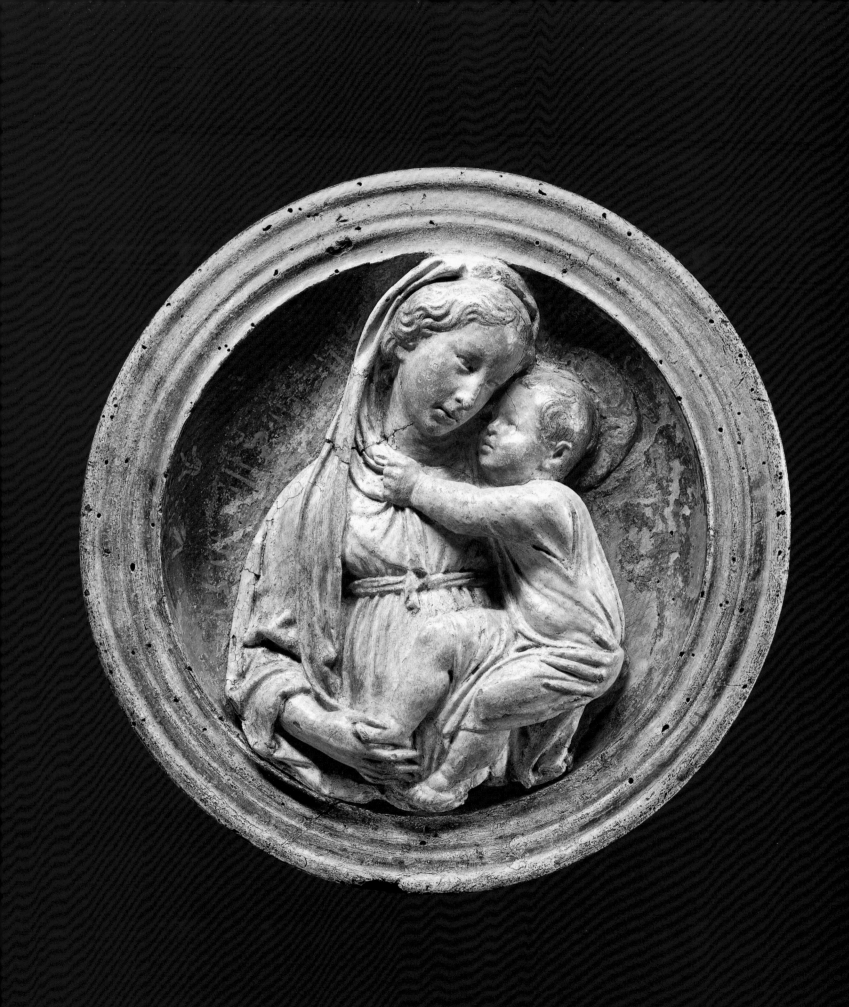

[2 4]

LUCA DELLA ROBBIA

Madonna and Child ("Bliss Madonna")

Glazed terracotta, partially gilt, 48.3 x 38.7 cm
The Metropolitan Museum of Art, New York.
Bequest of Susan Dwight Bliss, 1966 (67.55.98)

Luca della Robbia was much involved in promulgating an illusionistic, windowlike presentation of the Madonna, shown within an arched niche behind whose ledge she seems to stand. The type became especially familiar in painting, as in the picture by the Master of the Lanckorónski Annunciation in The Metropolitan Museum of Art. Luca's curvaceous child toddles on the ledge, steadied by his solicitous young mother. Of all niche-and-ledge Madonna paintings, Fra Filippo Lippi's *Medici Madonna* (Palazzo Medici-Riccardi, Florence) is closest to the "*Bliss Madonna*" in the strong similarities of the Christ Child's open pose, but Gentilini suspects that in this instance it was Luca who may have influenced Fra Filippo, and, indeed, current thinking finds the impact of sculpture on painting flowing well into the 1440s. Gentilini dates Luca's work to about 1445–50, earlier than most scholars, although he is seconded by Gaborit (in Gaborit and Bormand 2002, p. 17), who detects a relationship to Luca's *Resurrection* lunette (1442–44) in Florence Cathedral, a monumental relief in which Luca remains paradoxically something of a miniaturist, elegantly paring down shapes and sparing no effort in his tender characterization of drapery folds, much as here.

The *Bliss Madonna* stands out among Luca's domestic-scaled Madonnas for several reasons: the composition itself is a rare union of elegance, rigor, and warmth; the pale turquoise-blue ground is unusual; and the largely intact oil gilding, again uncommon, provides an exquisite tracery to define the architecture of the niche and the circles around the coats of arms, which Marquand (1914) tentatively identified as those of the Bartorelli and Baldi families. This example is superior to one cast from the same mold: the *Shaw Madonna* in the Museum of Fine Arts, Boston, glazed in a rather discordant blue-and-green combination and now in rather poor condition. The back of the *Bliss Madonna* is completely filled with clay, so that no mold marks are visible. In 1979, a small twist of drapery that had been glazed and attached with glue, forming a most peculiar loincloth, was found to be a late addition and was removed from the child's midsection. This would have gratified Marquand (1914, p. 158), who had been at pains to defend the *Bliss Madonna* against Schubring's accusation that the bit of cloth was "invented as a concession to American standards of modesty." In fact, Marquand could point out that the offending loincloth was visible in a photo made when the relief belonged to the Parisian Gavet.

Finally, a word about the psychology of the relief. Darr (in Darr 1985, p. 157) finds the sideward glance of the Virgin "coy" in relation to the *Shaw Madonna*'s forward gaze, whereas in reality the rubbing of the *Shaw Madonna* has caused the personae to lose most of their gilding except for traces in the hair. The eyes of the *Shaw Madonna* stare straight ahead with relative hardness, while, in the present relief, the Virgin searches outside herself as she contemplates her son's destiny, with a dreamy look that simultaneously captures the viewer's attention.

JDD

PROVENANCE: Émile Gavet, Paris (before 1895); Henry G. Marquand, New York (sale, New York, American Art Galleries, January 30, 1903, no. 1198); Mrs. George T. Bliss (from 1903); by descent to Susan Dwight Bliss.

REFERENCES: Bode 1892–1905, p. 74, pl. 227; Schubring 1905, pp. 79, 81; Marquand 1912, pp. 7, 8, 15; Marquand 1914, no. 42; Pope-Hennessy 1980a, pp. 51, 65, 76, 255, 268; Darr in Darr 1985, no. 44; Gentilini 1992, vol. 1, pp. 41–45, 60, 102, 157 n. 74, 163 n. 6; Gaborit and Bormand 2002.

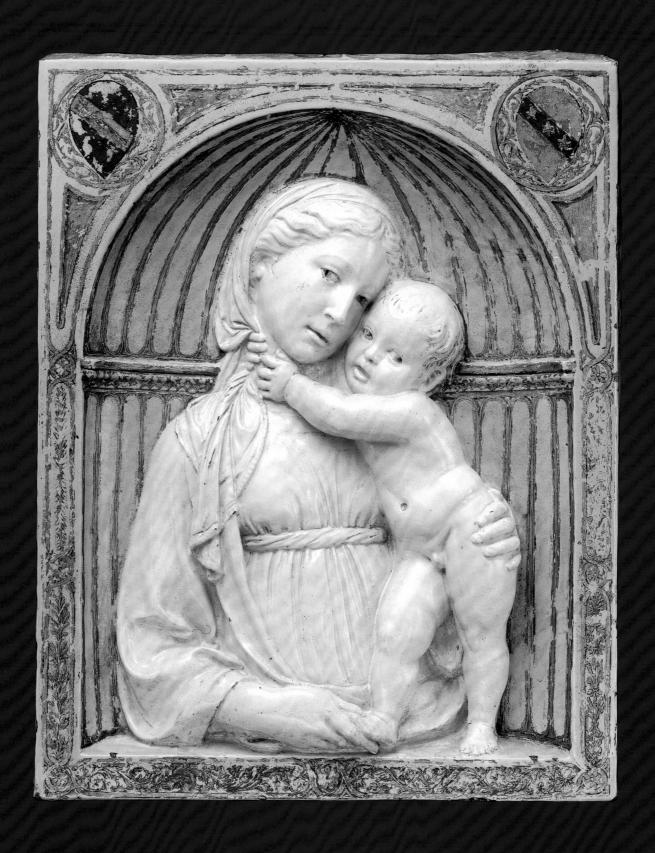

[2 5]

LUCA DELLA ROBBIA

The Labors of the Months
A. *January* and B. *June*

Glazed terracotta: diameter, 59.7 and 56.5 cm
Victoria and Albert Museum, London
(inv. 7632-1861, 7637-1861)

These two magnificent roundels depict *January* and *June* and belong to a series of twelve Labors of the Months—the sole remnants of a much-admired room in the Palazzo Medici on the via Larga (today via Cavour) in Florence. Destroyed in 1659, when the Palazzo Medici was enlarged, the room was a private study, or *studiolo*, for Piero de'Medici. No documents can be associated with the commission, but the room is presumed to have been designed in the early 1450s. The first description occurs in the architectural treatise of the goldsmith-architect Antonio Filarete, who visited Florence for the last time in 1456. He noted the many books and "other worthy objects" that filled the *studiolo* (for some of these see Ciardi Dupré dal Poggetto and Dal Poggetto 1996, pp. 149–51) and then commented on "the floor as well as the ceiling enameled with most worthy figures, so that whoever enters is filled with admiration. The master of this enameling was Luca della Robbia." The walls evidently had a revetment of inlaid wood with architectural perspectives (see Liebenwein 1977 [1988 ed.], pp. 56–57).

The roundels decorated the barrel vault and must have been set into a framework of architectural moldings, much as in the enameled Cappella del Crocifisso in San Miniato al Monte, Florence (fig. 23, p. 61), commissioned in 1447 (see Pope-Hennessy 1980a, pp. 239–40). Each roundel is of a single piece, framed by a water leaf and dart molding, with the corners alternately glazed in purple, for porphyry, and green, for serpentine (only fragments of this decoration remain). The curvature of the roundels has made it possible to establish their arrangement—in three rows of four—and to suggest the room's dimensions, 3 x 4.8 or 4 x 5.5 meters. In each, a male figure performs an activity appropriate to the month. The border indicates the amount of daylight, and a flaming

sun—the notional source of light in each scene —is shown with the proper astrological sign. The imagery is based, in part, on the treatise by the first-century Spanish writer Columella, the *De re rustica*; for example, it is Columella who describes January as a fitting time "for cutting down trees for building" (Pope-Hennessy 1980a, pp. 240–42).

Virtually every other ceiling or vault decoration executed by Della Robbia—for the Cappella del Crocifisso and the vault of the Chapel of the Cardinal of Portugal in San Miniato, the tabernacles at Impruneta, and the cupola of the portico of the Pazzi Chapel— employs either molded architectural forms or figurative sculptural decoration. The ceiling of Piero de'Medici's *studiolo* is unique in that Della Robbia adopted a pictorial solution, making it extremely difficult to compare its style with the rest of his work. The notional depth of the scenes is greater and the compositions are more loosely organized than is true of his sculpted reliefs of 1437–39, for the campanile of the cathedral of Florence (Museo dell'Opera del Duomo, Florence), or of his unfinished altar decorations of 1439 for the cathedral showing Saint Peter's deliverance and subsequent crucifixion (Museo Nazionale del Bargello, Florence). Moreover, although the figure style is well within the parameters of Luca's naturalistic vocabulary, there is no precise parallel for their morphology or tall proportions. For these reasons Cruttwell rejected the roundels as having come from the *studiolo,* while Marquand found it impossible to recognize Luca's hand in "the flat-headed, long-limbed, stiffly draped figures." He suggested that the sculptor merely "furnished the enamel and supervised the baking of these delicately constructed, architectural medallions."

Critical appraisals have changed dramatically since Cruttwell and Marquand expressed their reservations about the roundels. Salmi, for example, praised their "concise clarity, with a sense of movement and a spirit of observation of the world," but he, too, found it difficult to draw any comparisons with Luca's sculpture. To him, the closest analogies seemed to be with the predella scenes of Domenico Veneziano's *Saint Lucy Altarpiece* (cat. 22 A–B), thereby introducing the possibility of Luca having collaborated with a painter. Salmi suggested that the artist in question was the same Veneziano-influenced draftsman responsible for a series of drawings that depict casually posed models ren-

dered with white heightening on blue paper (see cat. 26 A–E).

That the technique of the roundels resembles the one used in making informal studies of studio assistants posed as models seems obvious. Gentilini described the roundels as "practically drawings highlighted in white gouache on blue paper." We have it from Vasari that Luca made drawings of precisely this type (*lumeggiate di biacca*), although the examples he mounted in his *Libro de' disegni* under the sculptor's name are by an artist of a later generation (see Ragghianti Collobi 1974, p. 45). Given this line of reasoning, we should hardly be surprised that some scholars (Bellosi; De Marchi) ascribe to Luca the finest of the drawings alluded to by Salmi. However, drawings of this sort were not Luca's only source of inspiration: the interior of the cupola of Brunelleschi's Old Sacristy at San Lorenzo was painted (possibly by Pesello) with astrological signs in white on a blue background (Parronchi 1984a). While there can be no doubt that about 1450 Luca became interested in the possibility of using glazes to imitate the appearance of painting, the actual technique was quite different, since it involved the vastly more complex application of vitreous glazes and the sometimes unpredictable effects that occurred during firing.

This new interest in simulating painting is most clearly apparent in the border of the Federighi tomb in Santa Trinita (1454–56), in which glazed tiles representing bunches of flowers, pomegranates, and pinecones linked together by a continuous, knotted rope are inserted into a marble surround. Such is the pictorial effect of the border that Vasari justly declared that it "would not be done better had it been painted in oil." It is in comparison with the Federighi tomb that the roundels of the *studiolo* appear uneven and experimental. There is, indeed, evidence that Luca had difficulties both in maintaining a consistency in the appearance of the various scenes—the white is thicker and more opaque in some roundels and more transparent in others—and in the firing. Especially in *July,* the glaze has crawled, while in the border and the sun of *June* a second firing seems to have been necessary to correct defects. The very fact that Luca never again repeated this type of simulated chiaroscuro drawing suggests that he viewed the result as an equivocal success. (Vasari tells us that late in life Luca attempted to imitate painted compositions on a flat surface, but none of these works has survived.)

Even allowing for the experimental character of the roundels, the differences seem too great to be accounted for merely on a technical basis. As Wohl recognized, Luca must have employed assistants. To convince ourselves of this, we need only compare the poorly drawn, doll-like figure of *May*, set against a flat, ill-defined frieze of trees and shrubs—so unlike Luca's work as a sculptor in the relief of Orpheus-Poetry from the campanile of Florence Cathedral—with the consummately accomplished figure of *January*, his vigorous pose described by deft brushstrokes and the space brilliantly defined by the receding lines of a grove of trees on one side, and stacked wood on the other. In one, the white glaze is thick and uniform; in the other, it is at once bold and controlled and wonderfully varied. Similar differences can be found in the other roundels and must be ascribed not simply to technical issues—the consistency of the white and dark blue glazes and variations in firing—but to the competence of the person wielding the brush.

The roundel of *January* is in every respect exceptional. The active pose has been rendered with an anatomical understanding and representational mastery for which there are few parallels prior to Pollaiuolo. In none of the other roundels is the descriptive means at once so pictorial and concise, with contour lines almost eliminated and volume suggested by contrasting brushstrokes of white and dark blue. It is *January* that seems closest to the character of the best drawings Salmi associated with the roundels. In *March, April, November,* and *December,* a delicate contour line is used to set the figures off from the background and liquid whites and dark blue are employed not only to model the forms but to convey a real sense of light. In *February* and *October* the somewhat labored use of a second blue to rework the areas of white may signal a particularly recalcitrant glazing medium, but the coarse effect of *May, July,* and *August* cannot be so easily dismissed: the design has been trivialized by an inability to foreshorten forms, let alone suggest recession by varying the intensity of the white glaze. The most straightforward way of explaining these differences is to suggest the use of compositional drawings and possibly even cartoons, which were transposed onto the roundels by Luca and one or more assistants. Only in this way can we account for the overall uniformity in design principles (best analyzed by Pope-Hennessy) and the very great range in quality of execution.

Was the person responsible for the preliminary drawings or cartoons a professional painter—as Salmi suggested—or Luca himself? In formulating an answer to this question we ought to recall that collaboration was the norm among fifteenth-century artists. This was not only true of architectural projects involving mixed media, such as the construction of the Cappella del Crocifisso at San Miniato, which combined the talents of the architect Michelozzo, the sculptor-bronze founder Maso di Bartolomo, and Luca della Robbia; it was true as well of virtually every aspect of artistic production. When, to cite one well-documented case, Giuliano da Maiano was commissioned in 1463 to complete the intarsia decoration for the main sacristy of the cathedral of Florence, he solicited cartoons for the larger figurative portions from his brother-in-law Maso Finiguerra, who was widely admired as a "*maestro di disegno,*" and had the heads of these cartoons colored by Alesso Baldovinetti for their translation into wood inlay. A recognized master in perspective, Giuliano designed the elaborate architectural settings (Haines 1983, pp. 161–65). It was this collaborative practice that led Ruth Wedgwood Kennedy (1938, pp. 81–87) to propose that the exquisitely enameled frieze of plants and flowers on the Federighi tomb was designed by Baldovinetti. Her proposal has been dismissed by Della Robbia specialists, although perhaps without sufficient consideration for the very great disparity between coloring wreaths of fruit and flowers modeled in relief and painting complex bunches of flowers, pomegranates, and pinecones on a flat surface. Of the fact that cartoons were created for the Federighi tomb there can be no doubt, as the bunches of fruit and floral elements are repeated. Moreover, as in intarsia, the border is composed of many individually fired pieces that are fitted together. It takes nothing away from Luca's ingenuity to suggest that he may have turned to a painter to draw the necessarily complicated cartoons for this undertaking. On the other hand, it is highly improbable that he would have allowed a painter to participate in his secret glazing process.

Unlike the border of the Federighi tomb, the roundels of the *studiolo* are painted on a single piece of molded terracotta: in this respect their production is more analogous to painting than to intarsia. Such is the technical and formal mastery of *January* that there is a temptation to ascribe the design and execution to the same artist. This really can only be Luca himself, for not even Domenico Veneziano had such a firm grasp of anatomical structure coupled with a naturalism that is almost Attic in feeling. However, in some of the roundels, especially in *September* and *November,* we seem to be dealing with designs created by a more delicate, less audacious imagination, while in others, for example, *May* and *August,* a maladroit assistant has spoiled whatever design he was provided with. In these cases it is at least possible that Luca employed a draftsman to translate his compositional ideas into cartoons that could be transposed by his assistants onto the roundels. Salmi noted that the foreshortened mule in *September* is strikingly similar to one in Pesellino's *spalliera* panels with the story of David (National Gallery, London). There is also a suggestive resemblance between the lanky, loose-limbed figures in *April, November,* and *December,* and three drawings Vasari mounted in his *Libro de'disegni* under the name of Uccello (see ill. p. 202): one of these is unquestionably by Fra Carnevale (see Christiansen 1993). Fra Carnevale almost certainly had established ties with Michelozzo, Maso di Bartolomeo, and Luca della Robbia during his years in Florence, and beginning in 1450 he was involved with the last two artists in Urbino on the construction of the Renaissance portal of San Domenico, for which Luca provided an enameled lunette (see especially the analysis of Strauss 1979, pp. 126–35). There is thus no a priori reason for eliminating the possible participation of Fra Carnevale in this project.

K C

PROVENANCE: Palazzo Medici, Florence (by 1456–1659); Riccardi family (from 1659); Gigli-Campana Collection, Rome (until 1859).

REFERENCES: Cruttwell 1902, pp. 129–30; Marquand 1914, pp. 89–94; Salmi 1936, pp. 75, 129; Longhi 1952a (1975 ed.), p. 118 n. 11; Pope-Hennessy 1964, pp. 104–12; Bellosi 1978, p. xxv; Pope-Hennessy 1980a, pp. 43–45, 240–42; Gentilini 1992, vol. I, pp. 110–12; De Marchi 1998, p. 22.

Overleaf, p. 200: cat. 25 A; p. 201: cat. 25 B

[26A–E]

FLORENTINE, MID-FIFTEENTH

CENTURY

Figure Studies

A. Two Females and a Male Saint

Brush and gray wash, heightened with white
gouache, and black chalk (?), on blue paper,
201 x 313 mm
Kupferstichkabinett, Staatliche Museen, Berlin
(inv. no. 5047)

B. Three Males

Brush and gray-brown wash, heightened with white
gouache, and pen and ink, on blue paper (stained),
183 x 324 mm
Musée du Louvre, Paris (inv. 2688)

C. Two Male Nudes

Brush and brown wash, heightened with white
gouache, over traces of metalpoint, on blue paper,
231 x 255 mm
Gabinetto Disegni e Stampe degli Uffizi, Florence
(n. 1107 E)

D. Standing Male Nude Leaning on a Staff
(recto only exhibited)

Brush and gray wash, heightened with white
gouache, on (faded) blue paper, 211 x 110 mm
The Metropolitan Museum of Art, New York. Gift
of Cornelius Vanderbilt, 1880 (80.3.114)

E. Standing Male Nude with a Club
(recto only exhibited)

Brush and gray wash, heightened with white
gouache, on (faded) blue paper, 210 x 97 mm
The Metropolitan Museum of Art, New York. Gift
of Cornelius Vanderbilt, 1880 (80.3.113)

By the mid-fifteenth century it had become standard workshop practice in Florence to work from posed models; for the most part they were young, male studio assistants (*garzoni*), although studies of females are also occasionally encountered (invariably dressed). Those drawings that survive are either in pen and ink with brown wash on white paper and have a predominantly linear quality, or are in the more pictorial technique of brown or gray wash heightened with white gouache on blue paper. By far the largest and most accomplished drawings of the first kind are by the goldsmith Maso Finiguerra (1426–1464); their formal resolution situates them between the tradition of model and pattern books and the newly emerging practice of keeping sketchbooks, and suggests that they had a practical function in the creation of *nielli,* Finiguerra's specialty (see Angelini 1986, pp. 72–80; Melli 1995, pp. 34–38). The second type have the character of relatively spontaneous workshop exercises, the object of which was to increase representational skills through the study of reality (*imitatione dal vero*).

The use of white gouache highlights on colored paper was not new—Cennino Cennini describes the technique in his handbook on painting (chap. XXXI–XXXII)—but in these drawings it is employed in an innovative way, at once to transcribe the effects of light and to create a quality of three-dimensionality (*rilievo,* in the critical language of the day: on these terms see Baxandall 1972 [1988 ed.], pp. 119–23). The technique is closely allied to what Alberti, in his 1435 treatise (I.8), referred to as "*ricevere il lume*"—the reception of light (a topic that was later to obsess Leonardo da Vinci). Quickness of hand (what Alberti called *prestezza da fare*) rather than finish (*diligenza*) is emphasized. This type of drawing thus can be seen to complement working from sculpted models or from stiffened drapery arranged over a lathe figure (for the relationship of the two, see Forlani Tempesti 1994, pp. 5–11), and is a step beyond copying from the work of other masters (see cat. 16).

Not surprisingly, casually posed figures are the most frequent subject of these works,

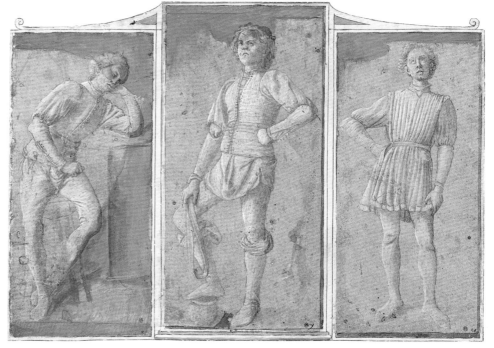

Fra Carnevale, *Study of David* (center)
and *Two Figure Studies* (left and right).
Nationalmuseum, Stockholm

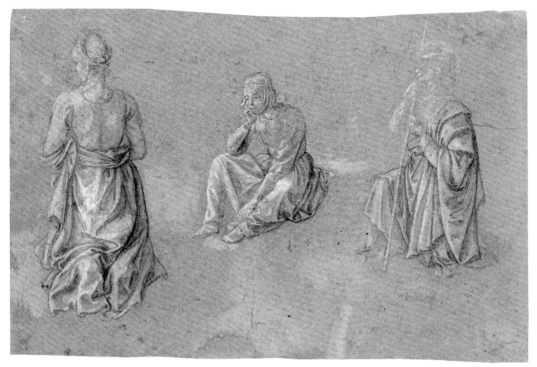

A

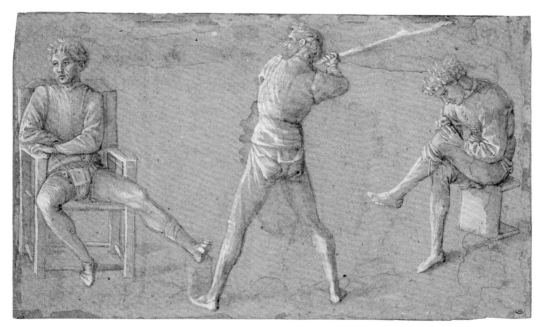

B

although in a few cases we encounter a studio model striking a pose that might be useful in working out a formal composition. For example, the kneeling male figure in the Berlin drawing exhibited here (A) would be appropriate for a scene of the Adoration of the Shepherds (indeed, the figure has been provided with a halo and may have been thought of as a study for Saint Joseph). The kneeling female would have been appropriate for someone attending the birth of the Virgin, and it would not take much imagination to transpose to a Flagellation scene the youth who wields a stick in the Paris drawing. Yet, the casual arrangement of these figures on the page suggests studies done with no particular task at

hand. The practice of making such informal studies inevitably had a profound impact on the ways in which painters reconceived traditional scenes: we need only think of the beggars and young men that Fra Carnevale depicts in the *Presentation of the Virgin in the Temple* (?), sitting in the marble-paved square and loitering about within the temple (cat. 45 B).

Presumably Fra Carnevale executed drawings such as these in the workshop of Filippo Lippi, for although no such drawings by Lippi survive, his son Filippino is the author of the largest and most accomplished corpus that has come down to us—despite the fact that they are invariably in silverpoint with white gouache and have a more pronounced linear quality. Vasari believed that

Uccello produced numerous figure studies ("*assai cose di figura*"), and we find one of the very few drawings in this vein that can, with certainty, be ascribed to Fra Carnevale mounted on a page of Vasari's celebrated *Libro de' disegni* under Uccello's name (Christiansen 1993, pp. 363–67). The drawing (see ill.) is more formal than those exhibited here, but the figure—identifiable as a David with the head of Goliath—is clearly taken from a posed model making do with a chamber pot for Goliath's head.

With the exception of the two examples from the Metropolitan Museum—(D) and (E), cut from a single sheet—the present drawings were catalogued by Berenson under the rubric "School of Paolo Uccello," although, as he

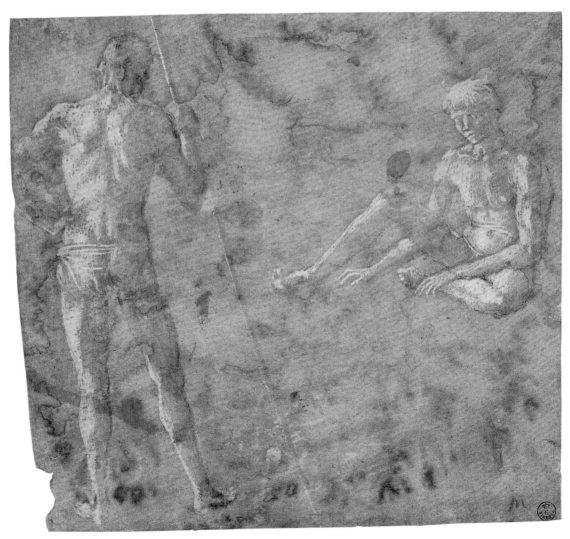

C

noted, they bear little real relationship to the artist's painted work. Salmi first pointed out stylistic affinities with the paintings of Domenico Veneziano, who Degenhart subsequently proposed as their author. Arguing authorship on the basis of what are really idiosyncrasies of technique and practice, Degenhart further expanded the group with related but inferior drawings—including the two in the Metropolitan—that are clearly by different hands; some are mere copies done as exercises by workshop apprentices.

Underlying Salmi's observations was the relation he saw between the drawings and the "luminous, enameled beauty" ("*bellezza lucente di smalto*") of Luca della Robbia's roundels now in the Victoria and Albert Museum (cat. 25 A–B)—all that remains of Piero de'Medici's celebrated study, or *studiolo*, in the Palazzo Medici. The figural compositions of the roundels, he declared, were inspired by the work of Domenico Veneziano but were executed by the author of the drawings. It is hardly surprising, then, that Luca himself should be proposed as the artist responsible for the studies—or at least for the finest of them (Bellosi; De Marchi). Had not Vasari declared that the sculptor (Luca) was a fine and graceful draftsman who did precisely this sort of drawing? ("*Ebbe Luca bonissimo disegno e grazioso, come si puo vedere in alcune carte nel nostro libro lumeggiate di biacca.*") Unfortunately, those examples Vasari ascribed to Luca in his *Libro de'disegni* are by an artist from the circle of Filippino Lippi (see Ragghianti Collobi 1974, p. 45). Indeed, as with Domenico Veneziano, so with Luca della Robbia we possess no certain drawings as reference points. Given these circumstances, it is hardly surprising that the author of the standard monograph on Domenico Veneziano (Wohl 1980, p. 163) finds that the drawings have hardly any relationship to that artist's work but could have been done in Luca della Robbia's shop, while, in his book on Luca della Robbia, Pope-Hennessy has declared that they are only superficially related to the roundels, which he argues are by Luca himself, although influenced by Veneziano. Yet another, recent proposal (Bambach) is that Fra

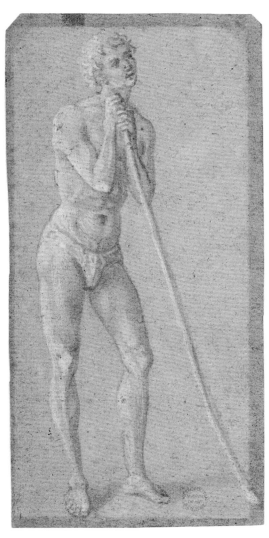

D

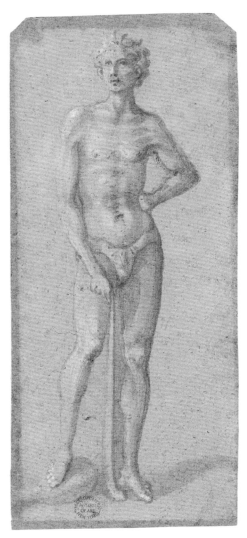

E

Carnevale, whose dealings with Luca della Robbia are documented, and who was deeply influenced by the art of Domenico Veneziano, should be considered as providing a general point of reference for rethinking the attribution. This exhibition provides the first occasion for these various possibilities to be put to the test.

What needs to be emphasized is, first, that just as the roundels vary in quality and show the intervention of more than one artist (see cat. 25 A-B), so the drawings exhibited here—the finest of the group assembled by Degenhart and Schmitt—were produced by more than one hand. Those in the Metropolitan Museum, with their elongated figures rendered in an altogether more tentative fashion, are self-evidently not by the artist responsible for the drawings in Florence, Berlin, and Paris. (There are sixteenth-century drawings on the versos of the Metropolitan sheets, but these were the product of a later artist/owner and have nothing to do with the date of execution of the drawings on the rectos.) Second, it must be stressed that the criteria of judgment reside not in the refinement of the compositional solutions or anatomical correctness but in the handling of the gray or brown washes and the white gouache heightening, for these drawings are about the rendering of form viewed in light. In the *Della pittura* (II.46) Alberti had pointedly declared, "I would consider anyone a mediocre painter who did not properly understand the effect every kind of light and shade has on all surfaces." What is remarkable about the seated female figure in the Berlin drawing is not the lack of definition in rendering the right foot or the inadequate articulation of the figure's left wrist and hand but the way, through the mere application of white, the foreshortening of the left knee is convincingly established. The head and the right arm and hand of the kneeling male figure are conveyed entirely by deftly brushed-on strokes of white. The same is true of the rendering of the seated male nude in the drawing in Florence (cat. 28), in which the projection of the left knee and calf is established by the varied intensity of the whites. At the same time, the Berlin study (A) remains apart from those in Paris (B) and Florence (C) by its greater concern with sculptural form. Not only is the wash gray rather than brownish but it is used to obtain a wider value range. Similarly, the white gouache is employed to

achieve a more varied effect than is true of the Paris sheet. There is a concern with middle tones and continuity of surface that sets this drawing apart from the others and could suggest a sculptor's approach. A contour line—the very basis of Florentine *disegno*—plays no role here. Paradoxically, it is the lack of attention to anatomical detail that defines the goals of the artist and the brilliance of the drawing. This is the work that has the closest affinities to the roundels and deserves to be considered as possibly by Luca della Robbia.

Taken by itself, the seated figure who, in the Paris drawing, with focused concentration studies a small book balanced on his knee may be fruitfully compared to the figures in the predella scenes of Domenico Veneziano (cat. 22 A-B). Domenico's manner of employing dots and dashes for hair is found here, and the variation of the effects of light in the face is quite remarkable. True, the drapery folds are not as carefully organized as in Domenico's painted work, and the face of the boy seated in a chair is somewhat schematic, but these are informal studies that allowed for no real corrections. In any event, studies very like the Paris drawing surely preceded Domenico Veneziano's accomplishment in the predella of the *Saint Lucy Altarpiece*. Perhaps the closest analogy is in the fluttering headdress of the grieving mother in the *Miracle of Saint Zenobius* (cat. 22 B), yet precisely because of the formal nature of the altarpiece and the fact that it is painted in colors and not monochrome, the stylistic connections may seem somewhat generic.

Whether or not the Uffizi drawing is by the same hand as those in Berlin and Paris and what relationship the Metropolitan's drawings have to these will best be judged in the exhibition itself. However, we should not allow a discussion of attribution to obfuscate a key issue, which is the shared practice of painters and sculptors in drawing from life. It is now widely accepted that sculptors sometimes supplied painters with sculpted models to work from. Here, the influence moves in the other direction, for what distinguishes Luca della Robbia's enameled roundels is the adoption by a sculptor of a painter's solution to his task. This resolution is the clearest evidence of an exchange between Della Robbia and Veneziano, and possibly even of the enlisting of artists from Veneziano's circle (including Fra Carnevale: see cat. 22 A-B) to work on the roundels for Piero de'Medici's

study. This sort of exchange was actually much broader. Filippo Lippi's *Madonna and Child* in the Fondazione Magnani-Rocca (cat. 6) is based on a terracotta sculpture by Luca, while the Madonna and Child in Luca della Robbia's roundel on Orsanmichele, Florence, for the Arte dei Medici e Speziali is self-evidently inspired by Domenico Veneziano's *Saint Lucy Altarpiece*. It was this constant give-and-take among painters, sculptors, architects, and goldsmiths that underlies so many innovative works of Renaissance art and that provided foreign artists such as Fra Carnevale with such a rich experience during the years he spent in Florence.

KC

PROVENANCES: (A) Adolf von Beckerath, Berlin (Lugt 1612 and 1504); acquired 1902; (B) Filippo Baldinucci, Florence (until 1696; vol. I of drawing collection, p. 27, as by Masaccio); Pandolfo Pandofini, Florence; Filippo Strozzi, Florence (until 1806); (D, E) James Jackson Jarves; Cornelius Vanderbilt (until 1880).

REFERENCES: Berenson 1903, vol. 2, p. 178; Marquand 1914, pp. 89–92; Salmi 1936, pp. 75, 129–30; Berenson 1938, vol. 2, pp. 357–58; Degenhart 1959, pp. 100–113; Degenhart and Schmitt 1968, vol. 4, pp. 417–21; Pope-Hennessy 1969, p. 174; Bellosi 1978, p. xxv; Pope-Hennessy 1980a, pp. 45, 241; Ames-Lewis 1981 (2000 ed.), pp. 60, 94; Bean 1982, p. 80; Sisi in Petrioli Tofani 1992, p. 42; Schulze Altcappenberg 1995, pp. 132–34; De Marchi 1998, p. 22; Bambach 1999, pp. 58–59.

[27]

GIOVANNI DI FRANCESCO DA

ROVEZZANO

The Nativity and The Adoration of the Magi

Tempera on wood, 21 x 117 cm
Musée du Louvre, Paris (inv. MI 523)

There are lacunae along the bottom of the panel, in the stable, and at various points along the upper edge—all visibly inpainted during the 1981–82 restoration—but none of these affects the primary areas. The panel does not appear to have been reduced in size, as the lipped edge where the frame was attached remains on all sides.

In the nineteenth century the picture belonged to Giovan Pietro Campana, a Roman banker, who assembled a remarkable number of Florentine "primitives" (Pianazza 1993). Information on its provenance may eventually come to light through research in the unpublished archives of Ottavio Gigli, Campana's erudite friend and agent in Florence.

The distinctive style of the picture makes it fairly simple to associate it with a group of mid-fifteenth-century Florentine paintings first identified by Weisbach (1899, pp. 76–77; 1901a, pp. 43–44; 1901b, p. 8). The keystone of the group is a triptych formerly in the Carrand Collection (since 1888, in the Museo Nazionale del Bargello, Florence)—hence the name given initially to the painter, the Master of the Carrand Triptych (for this artist's critical reception, see Fredericksen 1974, p. 36 n. 104). The sharp outlines and bright colors of the triptych initially led scholars to identify its author with Pesellino (Cavalcaselle and Crowe 1886–1908, vol. 6, p. 30; Logan 1895, p. 396; Berenson 1909, p. 130), or with Pesellino's grandfather—Vasari's mysterious Giuliano d'Arrigo, also known as "Pesello" (Mackowsky 1899b, p. 83; Weisbach 1901b, p. 8; Venturi 1911, p. 384, despite many doubts). Berenson, as early as 1913 (p. 34) felt that the Master of the Carrand Triptych must have belonged to the generation of artists that came after the 1430s and 1440s. He regarded the anonymous master as a link between Alesso Baldovinetti and Cosimo Rosselli, which thus would have made him active in the 1460s.

Without hesitation, Adolfo Venturi (1927, pp. 31–34) identified him with Baldovinetti.

In 1917 Pietro Toesca established a connection between this group of paintings and a document published by Horne, according to which a Giovanni di Francesco dipintore received a payment in December 1458 for a lunette above the left door of the Ospedale degli Innocenti—a fresco stylistically identical to the work of the Master of the Carrand Triptych. From Gaetano Milanesi's notes to his classic edition of Vasari's Lives (1906, vol. 2, p. 682 n. 2, which confuses two different painters; vol. 3, p. 490), it did not take much to realize that there was a perfect correlation between this group of pictures and Giovanni di Francesco del Cervelliera da Rovezzano, whom Vasari describes as a pupil of Andrea del Castagno and who is noted for having been involved in a litigation with Filippo Lippi.

This identification has never been questioned, although there is some documentary confusion about the master (for which, see the biographies of Giovanni di Francesco and the Pratovecchio Master in this volume). Aside from an altar frontal dated January 1453 (or 1454 modern style) in the church of San Biagio a Petriolo, and the Innocenti fresco, none of Giovanni di Francesco's works is precisely datable, despite the fact that their stylistic consistency suggests that they were all painted in the 1450s, in the period leading up to his premature death in 1459 (Offner 1933, p. 177 n. 34; Bellosi 1990b, p. 17). From a chronological point of view, little is gained by recognizing Giovanni's hand in the remarkable fresco (see ill.) that served as the backdrop to Michelozzo's statue

Giovanni di Francesco da Rovezzano (?), fresco backdrop for a statue by Michelozzo, detail. Santissima Annunziata, Florence

of Saint John the Baptist in the Santissima Annunziata, Florence, probably commissioned after 1450 by Antonio da Rabatta, a banker in the circle of Cosimo de'Medici (the chapel is adjacent to those in the left aisle decorated by Andrea del Castagno). The dove, the wonderful palm tree with the individual fronds drawn in perspective, and the dense clouds—like the soft, ricotta-white curls in the Madonna and Child in the Philadelphia Museum of Art (Johnson Collection)—are characteristic of Giovanni. As in the case of the polychromed terracotta Madonna and Child (formerly in the Kaiser-Friedrich-Museum, Berlin), the fresco was executed in collaboration with the workshop of Michelozzo, the Medici's official sculptor and architect. Like the young Baldovinetti, Giovanni must have attracted the attention of those in Piero de'Medici's circle.

The chronological data are consistent with the painter's style, for if we were to define the artistic coordinates of Giovanni di Francesco they would be Andrea del Castagno, Piero della Francesca, Domenico Veneziano, and Alesso Baldovinetti. From Castagno he almost literally took over certain figurative inflections, such as the straining muscles of the body of the crucified Christ in his fresco in Santa Maria Maggiore, Florence, and in Sant'Andrea a Brozzi. He studied the compositions of Piero della Francesca, while his bright colors and crystalline light are indebted to Domenico Veneziano. As for Alesso Baldovinetti, he was more a traveling companion with whom to exchange ideas about art and technique, since he possessed neither the requisite age nor the temperament to be a teacher.

Giovannozzi (1934, p. 346) situated the Louvre panel in the late 1450s, precisely because of its relation to the work of Baldovinetti: specifically, in certain of its silvery chromatic tones; the facial expressions of the courtiers; and the tall, thin cypresses. The pose of Saint Joseph, seated on the ground with his hands clasped around one knee, echoes the saint in Baldovinetti's fresco in the forecourt of the Santissima Annunziata (Weisbach 1901a, p. 44). The headdress of the dwarf—a figure also present in Boccati's Adoration of the Magi (Ulkomaisen Taiteen Museo, Sinebrychoff, Helsinki)—is similar to the cap worn by a guest in Baldovinetti's scene of the Wedding at Cana (Museo di San Marco, Florence) from the Silver Chest Panels (Armadio degli Argenti) painted for Piero de'Medici's chapel in the Santissima Annunziata. Vasari (1966–76, vol. 3, 1, p. 359) praises the

figure of a dwarf in Domenico Veneziano's scene of the *Marriage of the Virgin* in the (destroyed) fresco cycle Domenico painted (with Piero) in the church of Sant'Egidio, Florence. In short, it was no accident that both Giovanni di Francesco and Alesso Baldovinetti were invited to decorate the framed lunettes beneath the loggia of Brunelleschi's Ospedale degli Innocenti with a fresco: Giovanni painted *God the Father Blessing* and Alesso an *Annunciation* (destroyed). Giovanni di Francesco's lucid composition, sharply outlined figures, and (once) brilliant color must have competed with Andrea della Robbia's glazed roundels with infants on the façade of the Ospedale, and these stylistic traits surely characterized Baldovinetti's contribution as well.

The first thing one notices about the Louvre panel is that it seems too large to have functioned as a predella, for it would not fit below an individual section of a polyptych—not even the center panel. However, it could have served as the lower part of a single-field altarpiece, much like Giovanni di Francesco's scenes from the life of Saint Nicholas of Bari (Casa Buonarroti, Florence), painted to be placed below Donatello's *Annunciation* in Santa Croce, Florence. It should be recalled that this type of altarpiece is not characteristic of the oeuvre of Giovanni di Francesco; he seems always to have worked within a more traditional format, which raises the possibility that the panel may have decorated the back of a bench or some other piece of furniture for private use (as suggested by Weisbach 1901a, pp.

43–44). Such a purpose would not be contradicted by the fact that the Magi have halos. It is true that artists in Florence in the 1430s and 1440s, beginning with Fra Angelico, sometimes depicted the Three Kings without halos. There is, for example, Domenico Veneziano's tondo in Berlin (Gemäldegalerie), the two panels of the *Journey of the Magi* on which Pesellino and Zanobi Strozzi collaborated (The Sterling and Francine Clark Art Institute, Williamstown, Massachusetts; Musée des Beaux-Arts, Strasbourg), or the celebrated frescoes by Benozzo Gozzoli in the chapel of the Palazzo Medici. Nevertheless, some paintings connected with the Medici, such as the *Adoration of the Magi* (the so-called *Cook Tondo*) painted by Fra Angelico and Filippo Lippi (National Gallery of Art, Washington, D.C.), which may have been in the Medici family's collection, and the fresco in a cell (no. 39) at San Marco that Cosimo de'Medici used for his private retreats, depict the Magi with halos. It is tempting to imagine that Giovanni di Francesco's panel may have been commissioned by someone in the Medici circle.

Whatever the case may be, the subject lent itself both to bold narrative and decorative effects and was very popular in Florence—and not only among members of the Confraternity of the Magi. The Signoria commissioned Francesco Pesellino to paint a *Story of the Magi* to decorate the staircase of the Palazzo Vecchio (Vasari 1966–76, vol. 3, p. 372), and images of the Magi adorned several rooms of the Medici

palace (Müntz 1888, pp. 60, 62, 64, 85, 88, 90; Hatfield 1970, p. 137 n. 143).

We wished to include a narrative painting by Giovanni di Francesco in the exhibition to evoke the beautiful panel of the *Hunt* (fig. 18 and 19, pp. 78–79), which is identifiable with a picture listed in inventories of the Palazzo Ducale in Urbino. The first scholarly articles on the *Hunt* appeared after World War II, when the picture was acquired by the Louvre. It did not readily fit into the oeuvre of any of the three main contenders for its authorship: Francesco Pesellino, Alesso Baldovinetti, and Giovanni di Francesco (Laclotte 1978; Bartolini in Bellosi 1990a, p. 159; Hémery 2003, pp. 130–31). This beautiful painting, whose bright colors are hard to reconcile with the pearly tones Alesso used in his scenes on the Silver Chest Panels, is probably the work of Giovanni di Francesco, as Andrea De Marchi argues elsewhere in this catalogue. To determine its author, one must allow that the saturated color of the rocks, the blazing sunset, and the rendering of the greenery as sharply outlined bouquets set against the dark mass of the trees are perhaps decorative conventions, while the mythological stories—courtly, ancient, and interwoven with shimmering gold effects—show a reluctance to abjure the flat, ornamental world of millefleurs tapestries and gilt *pastiglia* decorations. These stylistic features certainly stand out when compared with Giovanni di Francesco's extraordinary work on the Casa Buonarroti and Louvre panels, although in those, too, the harnesses of the horses shine (or, rather, shone) with gold and glazes. In

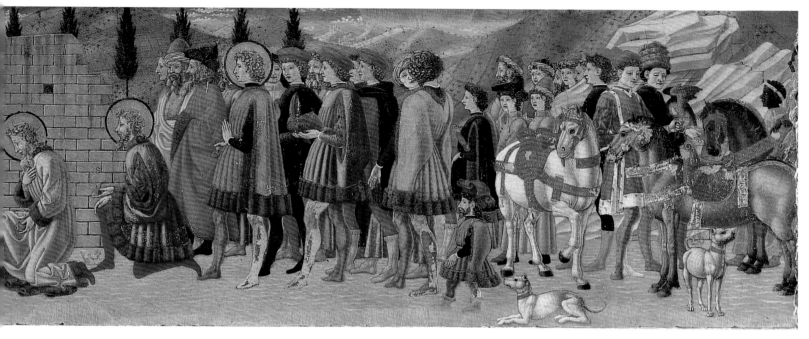

the two panels the transitions between colors always aim for spatial effects, while the various forms are drawn with a dedication and care that attempts to describe structure. What we are dealing with is a mental attitude or intellectual approach that seeks to analyze the stones and leaves of the grapevines, the fig tree, and the quince one by one, as they reveal their tridimensionality through the play of light and shadow.

Although the composition of the *Hunt* is finely orchestrated, with the two scenes separated by the visual caesura of a bridge and the unexpected respite of a distant city in the background, it is less sophisticated than that of the *Nativity* and of the *Adoration of the Magi,* despite certain similarities. In the last work, the placement of the walls at an angle and the use of this background to divide the two scenes; the alternation of figures in frontal and profile view; and the contrast of fully lit and penumbral areas attest to a strict spatial logic deployed to create a unified stage setting. The imposing wall is rendered with an obsession for architectural detail and measured by the grid formed by the scaffolding holes. Breaches in the wall enliven the scene by providing views onto a landscape, while elsewhere the wall remains intact and serves as a backdrop for the figures. Although this type of background was inspired by the *Cook Tondo,* its figurative weight anticipates Baldovinetti's *Nativity* in the forecourt of the Santissima Annunziata (1460–62) and the later paintings of the Nativity by Fra Filippo Lippi (Spoleto Cathedral) and Fra Diamante (Louvre,

Paris)—not to mention the wall, constructed stone by stone, in Piero della Francesca's *Nativity* in London (fig. 3, p. 26). Through the architecture of the wall the composition is articulated as a diptych, since the figurative frieze of courtiers and servants provides a perfect balance to the centripetal scene of the *Nativity* on the left. The center of the panel coincides roughly with a rarefied spot in the composition—namely, the kneeling figure of the oldest king. This feature also characterizes the scenes from the life of Saint Nicholas of Bari, which has at its center the kneeling figure of the innkeeper's first victim to be resuscitated by the saint.

There is no need to reiterate the resemblance between the sharp, slender grace of the Madonna and the Virgin in Domenico Veneziano's tondo of the *Adoration of the Magi* (Gemäldegalerie, Berlin), which is also the source of some of the pages and footmen and their distinctive tunics and cloaks. There would not seem to be any further debt to Andrea del Castagno, whose influence is apparent in the harsh brutality of the Brozzi Crucifix (Bellosi 1990b, p. 20) and the appearance of some of the saints in the Carrand Triptych. In the Louvre panel, Giovanni waivers between Andrea del Castagno and Domenico Veneziano as his model, but the conflict is fully resolved in Domenico's favor.

Yet, what is truly miraculous is the artist's handling of light. The rays of the morning sun illuminate in amazing detail the thatched straw wall at the back of the stable—the interior of

which is enveloped in a soft penumbra—and beat down on the hewn stone wall at the right, marking it with sharp, dense shadows. On the other side of the wall, the lingering shade provides the painter with the opportunity to passionately investigate the reverberations and play of light on the edges of the stones. The viewer witnesses the glory of a clear winter dawn behind the stone wall, with wisps of scattered clouds in the sky and a golden light illuminating the slopes of the hills, reawakening them with a fresh clarity that Bellosi (1990b, p. 18) does not hesitate to compare to Piero della Francesca's *Baptism of Christ* (fig. 3, p. 26).

M C

PROVENANCE: Giovan Pietro Campana, Rome (before 1858–61); Musée Napoléon III, Paris (1861); Musée du Louvre, Paris (1862–76); Musée Fabre, Montpellier (1876–1981); Musée du Louvre, Paris.

REFERENCES: Logan 1895, p. 396; Cavalcaselle and Crowe 1886–1908, vol. 6, p. 30; Schmarsow 1899, p. 139; Weisbach 1899, pp. 76–77; Weisbach 1901a, pp. 43–44; Weisbach 1901b, p. 8; Berenson 1909, p. 130; Langton Douglas in Crowe and Cavalcaselle 1903–14, vol. 4 (1911), p. 201; Venturi 1911, p. 384; Berenson 1913, p. 34; D'Albenas 1914, p. 208 n. 247; Toesca 1917, pp. 1–4; Venturi 1927, p. 28; Longhi 1928 (1968 ed.), p. 27; Van Marle 1928, p. 386; Berenson 1932a, p. 342; Offner 1933, p. 177 n. 34; Giovannozzi 1934, p. 346; Ragghianti 1935, p. 122; Faré and Baderou 1939, p. 78; Longhi 1952 (1975 ed.), p. 115; Laclotte 1956, pp. 56–57 n. 80; Fredericksen 1974, p. 22; Bellosi 1990b.

[2 8]

BENEDETTO BONFIGLI (?)

Frederick III

Tempera and gold on paper, mounted on wood,
22.5 x 16 cm
Galleria degli Uffizi, Florence
(Miniature, inv. 1890 no. 841)

Despite minor tearing along the edges, especially at the bottom, on the whole the miniature is exceptionally well preserved. The color, as kindly pointed out to me by Alessandro Cecchi, is applied on a paper—not a parchment—support that has been glued onto a small wood panel. This is the same type of support used, for example, for the celebrated *Portrait of Louis II d'Anjou* (Bibliothèque Nationale de France, Paris), which, moreover, is the same size (22 x 17 cm). Two strips—one along the top and the other on the right of the panel—are not covered by the paper and contain an inscription in capital letters somewhat hybrid and indecisive in form (for example, the *D* and *P* are uncial letters and the *C* and *E* are Roman). Applied in gold leaf and retraced on one side in black so as to create the illusion of three-dimensionality, the inscription reads: FEDERICVS TERTIVS ROMANOR[VM] / REX DIVVS AC SEEMPER [*sic*] AVGVSTVS ("The divine and always august king of the Romans, Frederick III"). That the inscription and miniature are contemporary is demonstrated by the uniform blue and gold—the latter unfortunately is mostly gone and is legible only as an imprint. In imitation of miniatures, gilding was used for the floral motifs that surrounded the portrait bust.

The sitter is shown in perfect profile, facing to the left—in order to include his chest and bent arm—and wears a white garment under a crimson tunic stippled to look like fine fabric, with a fur lining and a high, starched collar. His head, and the thick mane of blond hair falling on his shoulders, are uncovered, while Frederick III's physiognomy is strongly characterized by a long, tapering nose, easily recognizable from another portrait of him, by an Austrian painter (Landesgalerie, Graz; see Meiss 1961a, fig. 23). As exemplified by the trapezoidal shape of the eyelids, the planes of the face are a bit schematic, but there is a notable effort to confer a lifelike quality on the portrait with the inclusion of such details as the barely open mouth—the sitter appears about to speak—the

rendition of the stubble of the beard, and the double chin, with the collar pressing against it. Compared to other portraits of Frederick III, this likeness seems more intentionally mannered than naturalistic. The artist probably did not portray the sitter from life, but was provided with a model or a sketch to work from.

In 1451 (in all likelihood the year the painting was executed), Frederick was thirty-six years old. The youthful, dashing quality of the miniature—not overly official, except in the sumptuous dress and regal bearing—is perfectly in keeping with its probable function, as reconstructed by Meiss on the basis of historical documentation. As Suida (1931a) noted, the wording of the inscription ("*romanorum rex ac semper augustus*" rather than "*romanorum imperator*") implies that Frederick had not yet been invested with imperial rank, but that it was probably imminent. The painting's context is, therefore, the preparation for his journey to Italy in early 1452, culminating on March 19 with his coronation by Pope Nicholas V at Saint Peter's. En route, in Siena on February 7, he met his future bride, Eleanor of Portugal—an event immortalized by Pinturicchio in the Piccolomini Library of the cathedral of Siena. Eleanor was the sister of Alfonso V of Portugal and the niece of Alfonso the Magnanimous, King of Naples, and her engagement was sponsored by her uncle in the Jubilee year of 1450. At that time, the future Pius II, Aeneas Silvius Piccolomini—then Bishop of Trieste, papal legate to Germany, and apostolic protonotary to Frederick—together with Michael of Pfullendorf, was charged with conducting the matrimonial negotiations, a task that took him to Naples, where, after forty days, the agreement was concluded on December 10, 1450 (see Pius II *I Commentarii*, 1984 ed., pp. 102–4). Aeneas Silvius then returned to Rome, "*circa finem Iubilaei,*" to pursue the matter, sending a first legation to Lisbon in March 1451 to ratify the contract (Pastor 1944–60, vol. 1, p. 489), then a second one in August to arrange the marriage by proxy (Lankman, 1721–25), and finally organizing the official ceremony in Rome on the same day as the imperial coronation, March 19, 1452. It is intriguing to consider that this small, precious portrait might be a *pièce de reception* sent to Eleanor with the legation in March 1451, and that it was commissioned in Rome by the future Pius II between December 1450 and February 1451.

Before the article by Meiss (1961a), which is the most elaborate study of the work and an indispensable reference for both the historical

Benedetto Bonfigli, *Saint Louis of Toulouse Receives the Habit,* detail. Cappella dei Priori, Perugia

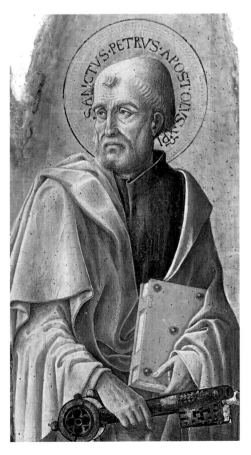

Benedetto Bonfigli, *Saint Peter,* detail. Galleria Nazionale dell'Umbria, Perugia

context and the iconographical tradition of representations of Frederick III, the predominant tendency was to ascribe the painting to a Sienese artist (Weisbach 1913), perhaps Vecchietta (Edgell 1932) or Domenico di Bartolo (Ragghianti 1938), or to attribute it to a Paduan artist from the circle of Squarcione (Suida 1931a; Fiocco 1937; Pope-Hennessy 1944), based on the future emperor's celebrated visit to Francesco Squarcione's studio in January 1452, as recorded a century later by Berdardino Scardeone (1560, p. 370).

Meiss's article appeared the same year as Zeri's book on the Barberini Panels, and it made a rather sophisticated argument for ascribing the painting to the Master of the Barberini Panels, providing a valuable chronological anchoring as well. This attribution was later accepted by Christiansen (1979). However, Daniele Benati's attribution to Fra Carnevale of a densely colored and forcefully incisive *Portrait of a Man* (cat. 42)—an attribution that I find completely convincing—seems incompatible with the miniature of Frederick III. To support his attribution, Meiss illustrated the head of the veiled woman in cerulean blue in the foreground of the *Presentation of the Virgin in the Temple (?)* (cat. 45 B). Yet, in comparison the profile of Frederick III looks hopelessly flat and two-dimensional, utterly lacking the relief-like volumes, with their Lippiesque accents, that characterize even the most mannered heads by Fra Carnevale, such as those in his Franciscan polyptych (cat. 41 A–D), where the skin is never delicately dotted to suggest a shaven beard—a detail still somewhat reminiscent of the work of Gentile da Fabriano. For some time now I have suggested an alternative attribution to the Perugian painter Benedetto Bonfigli, for whom this work would represent an exceptional tour de force, in keeping with the importance of the commission. Few painters are as dramatically uneven as Bonfigli or so subject to alternations of mood and circumstance. However, his finest efforts, indeed, show truly great potential—as demonstrated, for example, by the murals in the Cappella dei Priori in Perugia (the veritable incubus of his life), the San Domenico polyptych of 1467–68 (see ill.), or even the *Annunciation* (cat. 29) in the present exhibition. When he wanted to, Bonfigli certainly knew how to paint: he could spin out precious, illusionistic details with the tip of his brush, build up intense flesh tones, and intertwine fabrics with radiant light, as in the *Frederick III*. Even when they are meant to be imposing, his figures always betray a certain structural frailty. Whether

shown in profile or foreshortened, the contours of the faces are often sharp or rippled: compare the face of Boniface VIII in the *Saint Louis of Toulouse Receives the Habit* in the Cappella dei Priori (see ill.), executed not long after 1455, with its sharp lines to denote his thin lips; the salient, bulbous nose; the saturated, reddened flesh tones; and the fringing of the eyebrows to suggest individual hairs. Of course, mural technique—for the most part "a calce"—is one thing and the delicate touch of miniature painting (as in this portrait) quite another, for it requires a greater finish for close viewing. Even the signature, trapezoidal treatment of the eyelids is a recurrent feature of Bonfigli's paintings—as, for example, in his *Adoration of the Magi* of 1467 (Galleria Nazionale dell'Umbria, Perugia), the execution of which is admittedly somewhat weak. Yet, the effect of

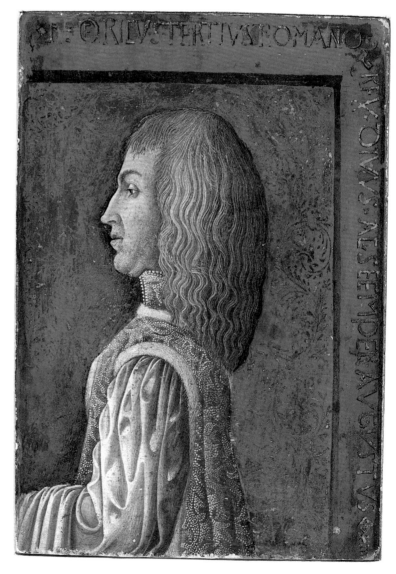

Melchior's double chin, in the latter, pressing against his high, starched collar is similar to that in the little Uffizi portrait of the aspiring emperor. The quality of Bonfigli's achievement again rises in the lateral panels with saints in his altarpiece for San Domenico of 1467–68 (see ill.). Here, despite the later date and a treatment of light that is decidedly freer and more mature, like that in Flemish painting, the comparison with the present work seems to me very intriguing. One should, for example, note the bony frailty of the faces, the graceful dotting of the braids on Saint Catherine's epaulets (as on Frederick's tunic and collar), the stiffly broken drapery folds on Saint Peter's right arm (like the even stiffer folds on Frederick's left arm), and the nervous line that twists the fabric into overly artificial hollows and honeycombs and

deprives the figure of solidity. If Bonfigli really is the author of this miniature, there is no reason to puzzle over his connection with the Roman Curia, since from January 18 to May 14, 1450, the Perugian master was paid by Nicholas V for unspecified work, and is described in documents as "*dipintore*" in the Vatican palaces (see Mazzerioli in Mancini 1992, p. 151, docs. 7–9).

ADM

PROVENANCE: Galleria degli Uffizi, Florence.

REFERENCES: Weisbach 1913; Suida 1931a; Edgell 1932, p. 209; Fiocco 1937, pp. 17, 178 n. 12; Ragghianti 1938, p. xxiii; Pope-Hennessy 1944, p. 113 n. 14; Meiss 1961a; Christiansen 1979, p. 199; De Marchi 1992, p. 213 n. 64; Benati 1996, p. 27 n. 4; De Marchi 2002b, p. 95 n. 224.

[29]

BENEDETTO BONFIGLI

The Annunciation

Tempera and gold on panel, 51 x 36.5 cm
Museo Thyssen-Bornemisza, Madrid (inv. 1977.23)

This panel has been cut down on the left and slightly at the top, and it has also been thinned. The faces of both figures have been damaged, although these areas have been skillfully and painstakingly restored. Originally, the dimensions of the panel were probably the same as those of Bonfigli's *Nativity* in the Berenson Collection (53 x 41 cm; Villa I Tatti, Settignano)—which is also very similar in style but slightly later in date. The two panels are not, however, part of a series, as the halos and the decorative border of the Virgin's mantle differ in each. Both do demonstrate the best of Bonfigli's qualities and his strong propensity for evocative settings. The Perugian painter was essentially a contemporary of Giovanni Boccati and Giovanni Angelo d'Antonio, both from Camerino, and presumably was a little older than Fra Carnevale. Boccati's predella for the *Pergolato Altarpiece* (cat. 30) introduced to a Perugian public those panoramic landscapes inspired by the example of Netherlandish painting and the work of Domenico Veneziano. The common denominator is the distant vista, framed in Bonfigli's *Annunciation* by barren hillsides and a lake dotted with sailing vessels. The inclusion of an all-embracing background—impossible without the example of Domenico Veneziano and of

Giovanni Boccati—also interested Fra Carnevale in the 1450s and 1460s. What is unusual in the Berenson *Nativity* is the telescopic view of a rugged mountain range, not unlike the Apennines in Umbria and the Marches. The upper half of the composition of the *Annunciation* establishes a contrast with the colored marbles and sculpted reliefs of the richly furnished enclosure in the foreground. Bonfigli was certainly very familiar with the cloistered and discrete settings in Fra Angelico's paintings of the Annunciation—sited between a monastic cell and a walled garden (the *hortus conclusus*)—but he includes instead the view of a city set against a wide horizon: it is a strategy that, through the *di sotto in sù* perspective, expands the scene beyond its intimate plein-air setting (despite the gold sky) toward an open horizon. Bonfigli may have discovered this motif in 1455 while he was working on the historical scenes in the chapel of the Palazzo dei Priori in Perugia, probably the most important civic commission a painter from that city could hope to receive. Nonetheless, the Thyssen *Annunciation* has been dated much earlier than that cycle—to 1440–45 (Zeri 1978) or about 1445 (Mancini 1992)—a period when Bonfigli's art still retained Gothic elements (as can be seen in some of the frescoes carried out by his shop in 1445 in the church of San Cristoforo, near Passignano, on Lago di Trasimeno). It is likely, then, that the date of about 1455 proposed by Boskovits (1990) is more accurate.

The high wall, rhythmically punctuated by classicizing pilasters that support a frieze of garlands and with inset marble panels that alternate between porphyry and serpentine, is impossible to imagine without the painter's awareness of the chapel Fra Angelico frescoed for Nicholas V in Rome. Bonfigli is documented in the Eternal City in 1450. More generally, this motif was probably also influenced by Benozzo Gozzoli, who was in Umbria competing with local artists from 1450 to 1456: examples in his work there include the wall in the background of the *Annunciation* on the predella of the altarpiece from San Fortunato, Montefalco (now in the Pinacoteca Vaticana). The varied urban and rural settings in the murals in the Franciscan church at Montefalco must have inspired Bonfigli to use similar backgrounds, although his frescoes of scenes from the life of Saint Louis of Toulouse in the Palazzo dei Priori (between 1455 and 1461) are more rigorously perspectival and offer a more analytical description of the architectural setting (see Mancini 1992, pp. 86–105).

If the city in the Thyssen panel is examined

in isolation, its similarities with the fantastical view of Marseilles—an interpretation of Perugia, as seen from the hill of San Pietro—in one of the scenes in the Palazzo dei Priori cycle become apparent; that scene, showing Saint Louis retrieving money from a fish, was probably painted about 1456–57. As Longhi noted in his reevaluation of Bonfigli's work (1952a), the deviations from Gozzoli's models must almost have been a point of pride for the Perugian painter. In 1461, for example, Bonfigli was required to use a drawing by the Florentine artist for his scene in the Palazzo dei Priori of *Attila Taking Perugia* (see Melli 2000), but he reinterpreted it, as evidenced by the extraordinary device of the shaft of golden light that cuts across the medieval towers, the palace roofs, and the high balcony, with the clarity of sunset. This handling of light gives the sacred scene, solemnly enacted in the foreground, an unexpected emotional charge that is foreign to Benozzo's work. In 1456, just before receiving the commission to fresco the chapel in the Palazzo Medici, Florence, with his celebrated *Journey of the Magi*, Gozzoli had returned to Perugia to paint an altarpiece for the Sapienza Nuova, also leaving drawings for an ambitious altarpiece with an *Annunciation* (Musée du Petit Palais, Avignon) that was executed by Bartolomeo Caporali, Bonfigli's friend and partner, in the following decade. (The bench with inlaid marble panels recurs in several of Caporali's youthful works, including a *Madonna and Child* in Berlin and a predella in the State Hermitage Museum, Saint Petersburg, and is found, as well, in Giovanni Boccati's *Madonna of the Orchestra* [cat. 32], painted for Perugia.)

The pose of the Virgin in the Thyssen *Annunciation*, kneeling on a *prie-dieu* and draped in an ample mantle that is tucked under her left arm, in a formulaic manner typical of Gothic painting, disguises a paraphrase of a Virgin Annunciate in Gozzoli's altarpiece formerly in San Domenico, Narni (now in the Pinacoteca Civica, Narni) of about 1450. Bonfigli also had a fragmentary but certain knowledge of the masterpieces to be seen in the churches of Florence. He was, for example, influenced by the work of Filippo Lippi, from whom he borrowed more explicitly in the 1460s (the Carmelite painter came to Perugia in 1461 to evaluate his frescoes in the Palazzo dei Priori and then went on to work in Spoleto). The glass vase with a rope-like neck recalls similar details in Lippi's *Annunciation* for San Lorenzo (fig. 13, p. 51) and that for the convent of the Murate (fig. 5, p. 43), in which there is also a bouquet of red and white roses instead of the more usual lilies. (A similar vase

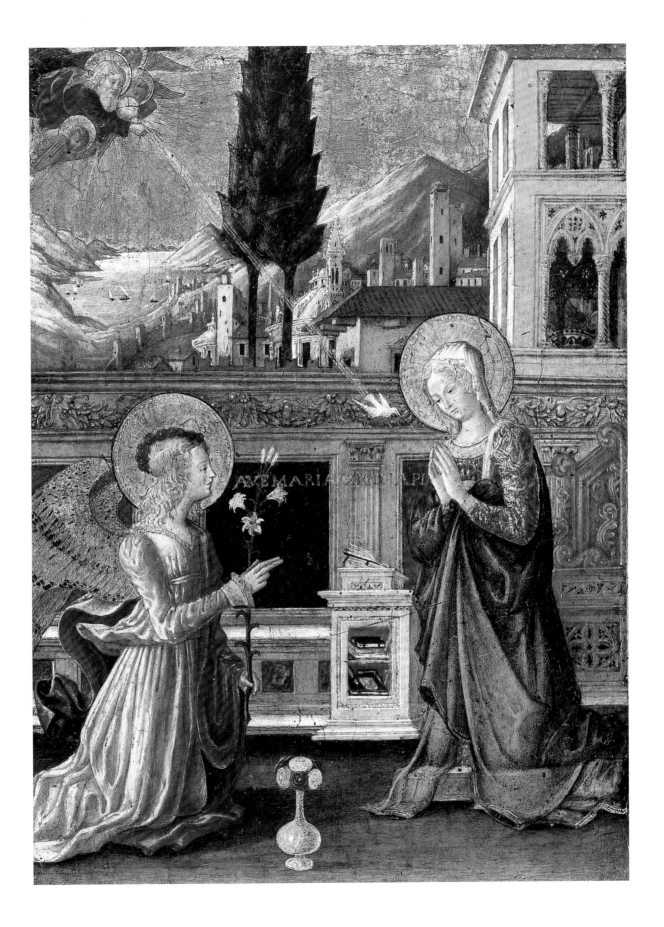

can be found in Vecchietta's altarpiece for San Niccolò at Spedaletto, near Pienza, dating to about 1462.) The ambitious foreshortening of the cityscape, which recedes behind the domestic enclosure where the Virgin kneels, recalls the dizzying foreshortenings in the third scene in the Palazzo dei Priori cycle of stories from the life of Saint Louis. This sharp angle of vision forced the painter to use contradictory angles in foreshortening some of the details in the foreground, such as the bookstand and the back of the bench. In its rich decorative motifs, which reflect the Gothic style of the Adriatic region, the bench is not unlike the choir stalls carved in the same years in Perugia by Paolino da San Ginesio and Giovanni di Stefano da Montelparo. These elements of Bonfigli's panel coexist with the Renaissance pilasters and polychromed marble in a hybrid creation that nicely characterizes the artist's unique cultural position in the 1450s. He was also still sensitive to Gothic traditions as far back as Gentile da Fabriano and, in the background, used gold on gold to indicate a ray of divine light. The archangel's wings are built up using a thin layer of gold leaf, which Bonfigli then incised and glazed. The fluttering red drapery behind Gabriel is again a Gothic touch, but the two figures also convey a strong physical presence and composure through the sensitive, Donatellesque modeling of the yellow-ocher drapery, highlighted by the glow emanating from the divine messenger. This handling recalls some of the works by the Pratovecchio Master.

The challenge of achieving an ever-greater monumentality explains the profoundly different character of Bonfigli's work in the following decade, and it is useful, by way of contrast, to examine his *Annunciation of the Notaries,* probably commissioned in 1464 (Galleria Nazionale dell'Umbria, Perugia), in which the casual realism of the city at sunset and the lateral shaft of light so prominent in the earlier panel give way to a scene that is both more courtly and a little rhetorical.

ADM

PROVENANCE: Thomas Pelham Hood, Springmount (Ulster) (19th century); Baron Hans Heinrich Thyssen-Bornemisza, Lugano (from 1977); Museo Thyssen-Bornemisza, Madrid.

REFERENCES: Zeri 1978, pp. 394–95; Pope-Hennessy 1983, pp. 14–15; Toscano 1987, p. 368; Boskovits 1990, pp. 38–41, no. 5; Freuler 1991, pp. 253–54; Mancini 1992, pp. 46–47, no. 6; Lunghi 1996a, p. 45.

[30]

GIOVANNI DI PIERMATTEO BOCCATI

The Arrest of Christ

Tempera on wood, 40.3 x 65.5 cm
Galleria Nazionale dell'Umbria, Perugia (inv. 151)

Giovanni Boccati rarely displayed his ability as a narrative painter better than here, but our appreciation of the qualities of this work should not be affected by the lack of compositional and perspectival rigor or fine draftsmanship. No one else in Perugia could have conceived such a lively narrative, set in a broad and evocative landscape, with that variety and richness (*varietas* and *historia copiosissima*) lauded by Alberti in his treatise on painting of 1435. To appreciate this we need only compare Boccati's scene with the restricted and artificial spaces of the predella panels of Domenico di Bartolo's 1438 polyptych for the church of Santa Giuliana in Perugia (Galleria Nazionale dell'Umbria, Perugia). There is also the possible influence of Domenico Veneziano's frescoes (completed by 1438; now destroyed) in the Baglioni palace in Perugia, but it is likely that the importance of this cycle has been overstated. Rather, the really decisive experience for Boccati, as for Piero della Francesca and other artists from Umbria and the Marches during the 1440s and 1450s, was a firsthand knowledge of Florence—attested by documents and by the stylistic details in their paintings. The absolute novelty of Boccati's impressively large predella scenes and his audacious attempt to import to Perugia the new, rectangular *all'antica* altarpiece—as opposed to the Gothic polyptych that Fra Angelico painted for the same church—make his exorbitant fee a bit less incredible (the 250 florins probably included the cost of constructing the wood structure).

In the *Arrest of Christ,* the first of three scenes from the predella of the *Pergolato Altarpiece* (fig. 17, p. 56), the procession of figures proceeds along a diagonal from the left, veering in the foreground to enter the middle distance on the right, creating a sort of "fish-eye" view such as might have pleased the great French painter Jean Fouquet. The suggestively confused climax of the action takes place at the right side of the panel, in an enclosed, wooded Garden of Gethsemane. Soldiers have battered

down the garden's wattle fence, while three apostles flee in terror through the trees. No less violent is the scene of Saint Peter throwing himself upon Malchus, the High Priest's servant, to cut off his ear. The slender figure of Christ all but disappears in the melee. In the center foreground are two armed figures, one of whom strides decisively, his red-and-blue cloak billowing in the breeze, while the other breaks into a run. A group of hurrying soldiers emerges from behind a rock on the left, their numbers suggested by the densely packed helmets, picturesque hats, and tilted lances and halberds they carry (there is a large loss in this area, as well as others in the sea and near the face of Judas).

In the companion scenes of the *Way to Calvary* and the *Crucifixion,* Boccati also created impetuous and eventful narratives, full of emotionally charged episodes—as though he were attempting to re-create, albeit in a more anecdotal fashion, the spirit of Pietro Lorenzetti's frescoes with scenes from the Passion of Christ in the lower church of the basilica of San Francesco at Assisi. Key to the success of Boccati's scenes are the expansive landscape settings, which are impossible to imagine without a work such as Domenico Veneziano's *Adoration of the Magi* (Gemäldegalerie, Berlin), painted for the Palazzo Medici in Florence—which our Camerino artist frequented before his move to Perugia, where he became a citizen in 1445. (That Boccati knew Veneziano's work is evident from his youthful masterpiece, an *Adoration of the Magi* in Helsinki, which may also have been a Medici commission: see De Marchi in De Marchi 2002a, pp. 230–33). It seems that Boccati had also seen works by Jan van Eyck or his circle, as suggested some time ago by Zeri (1961; on this issue, see also Minardi in De Marchi 2002a, pp. 206–8). In the *Arrest of Christ* Boccati's attempt to represent meteorological phenomena reaches its apogee: the coral disk of the sun slips into the sea at sunset, veiled by clouds; the sky becomes pale along the curved horizon—for an effect of cosmic illusionism—creating a counterpoint to the tree trunks, while at the left the composition broadens to include a view of a port, a fortified city, and a stretch of countryside marked by plots of land divided by hedges. This sort of veristic description would be unusual in Florentine painting, but it is also found in Fra Carnevale's *Crucifixion* (cat. 41 B). A somewhat older Sienese painter, Pietro di Giovanni Ambrosi (docu-

mented 1428–49), experimented with a similar type of "birds-eye" view landscape in his *Nativity* (Museo Diocesano, Asciano) and in a miniature of the *Madonna of Humility* on the frontispiece of Martino di Andreolo de' Garati's *Tractatus de principatu* (Biblioteca Trivulziana, Milan, ms. 138), commissioned by Filippo Maria Visconti and datable between 1445 and 1447. There are other similarities in the work of Boccati and Ambrosi: an almost abstract luminosity and a sharp rendering of some of the faces—such as that of the Madonna. It seems likely that there was some contact between the two artists, perhaps during their sojourns in Florence or during the visits the Medici paid to the baths at Petriolo, south of Siena, as mentioned in the letters of Giovanni Angelo d'Antonio, a contemporary and companion of Boccati.

The issue of the influence on Boccati of Fra Angelico's polyptych (now divided between the Galleria Nazionale dell'Umbria, Perugia, and the Pinacoteca Vaticana) for the Guidalotti Chapel in San Domenico is complex (see Scarpellini 1988; De Marchi in Bellosi 1990a; Sartore and Scarpellini 1998). Boccati seems to have borrowed many ideas, probably on the spur of the moment, as the two works seem to be virtually contemporary. We know that Boccati's altarpiece was commissioned by a certain "messer Angniolo," who can be identified as Angelo Geraldini da Amelia (Mancini 1992, pp. 30–31 n. 82; see also Minardi in De Marchi 2002a, pp. 209, 226 n. 22; Marcelli 2002). The altarpiece was perhaps intended for the Sapienza Nuova, or Collegio di San Girolamo, of which Geraldini served as rector until 1446 (and for which Benozzo Gozzoli painted a smaller altarpiece in 1456). Geraldini refused the painting sometime between October 26, 1446, and March 4, 1447, and he then passed it along to the *disciplinati* of San Domenico, who are represented in the main panel at the feet of Saints Dominic and Francis. The large altarpiece was not finished until 1447, as attested by the date painted on the first step of the dais (and by the record of a very small payment of three florins made on May 3, 1447). The interruption of the preparatory incisions corresponds exactly to the area with the group of *disciplinati,* indicating that the work was still not complete when they took over the commission.

ADM

PROVENANCE: Oratorio dei Disciplinati, San Domenico, Perugia; Galleria Nazionale dell'Umbria, Perugia (from 1863).

REFERENCES: Orsini 1784, pp. 70–71; Siepi 1822, p. 490; Crowe and Cavalcaselle 1864–66, vol. 3, pp. 114–15; Destrée 1900, pp. 22–28; Feliciangeli 1906, pp. 3–4, 9; Bombe 1912, pp. 83–85; Longhi 1952a, p. 18; Meiss 1961b, p. 299; Zeri 1961, pp. 55–56, 68; Vitalini Sacconi 1968, pp. 125–29, 238–39; Bacci 1969a, pp. 24–27; Zampetti 1971, pp. 26–29, 190; F. Santi 1985, pp. 22–24; Toscano 1987, p. 368; Scarpellini 1988, pp. 111–12; De Marchi in Bellosi 1990a, pp. 94–96; Mancini 1992, pp. 20–22, 30–31; Delogu in Garibaldi 1996, pp. 58–59; Lunghi 1998, pp. 88–89; Sartore and Scarpellini 1998, pp. 90, 96–97; De Marchi 2002b, pp. 45–47, 50, 68; Marcelli 2002, pp. 12–15; Minardi in De Marchi 2002a, pp. 209–11, 235–45.

[31]

GIOVANNI DI PIERMATTEO BOCCATI

The Crucifixion

Tempera, gold, and silver on wood, 33 x 24.5 cm
Galleria Nazionale delle Marche, Urbino

The earliest of Giovanni Boccati's paintings for private devotion is an *Adoration of the Magi* in Helsinki (for which, see De Marchi in De Marchi 2002a, pp. 230–33), painted in the early 1440s, perhaps for the Medici, and possibly in Florence, where we now know the artist was staying in January 1443 (see the documentary appendix by Di Lorenzo). He later successfully introduced this type of painting into Umbria and the Marches, specializing in images of the *Crucifixion*; aside from the present example, four others survive (Galleria G. Franchetti alla Ca' d'Oro, Venice: 71 x 52 cm; Private collection, Milan: 41.5 x 27 cm; Kérésztény Múzeum, Esztergom: 75.8 x 49.7 cm; and Robert Lehman Collection, The Metropolitan Museum of Art, New York: [largely repainted] 49.3 x 43.4 cm).

Boccati's interest in narrative painting—what Alberti called *istoria*—distinguishes him from Giovanni Angelo d'Antonio, his companion and associate first in Florence and then in Padua. Giovanni Angelo was more interested in large-scale representations; narrative scenes, whether independent or part of a predella, are relatively rare. This *Crucifixion*, like the *Arrest of Christ* from the predella of the *Pergolato Altarpiece* (cat. 30), documents an approach to painting that Fra Carnevale, in brilliant and inimitable counterpoint, completely reinvented in the Barberini Panels (cat. 45 A–B). The highly intellectual and anti-canonical dimension of Fra Carnevale's work testifies to the very different and more up-to-date pictorial direction espoused at Federigo da Montefeltro's court following the building of the Iole wing of the Palazzo Ducale.

Boccati's scenic approach—the expansive settings and illusionistic croppings—was intended to create a profoundly empathetic impact, as if these works were highly colored, miniature *sacre rappresentazioni,* or *tableaux vivants.* Even before Niccolò di Liberatore, Boccati was the heir to the so-called *Passione degli umbri*—the passionate style in the figurative arts that arose in Umbria, to the east of the Tiber, in the thirteenth and fourteenth centuries. Boccati's representations of *Calvary*—untiring variations on a theme—are obliquely foreshortened, and they fade away at the edges, as if they had been swallowed by a panopticon of almost cosmic proportions. Zeri (1961) quite rightly presumed at least an indirect knowledge on the artist's part of some painting by Jan van Eyck, although Boccati's image of the horizon is not fixed but curves, as it does in Gentile da Fabriano's first polyptych for San Niccolò Oltrarno of 1424–25 (Gallerie Fiorentine) and in the paintings of many Sienese artists such as Pietro di Giovanni Ambrosi, Sano di Pietro, and Giovanni di Paolo. Boccati's images of the *Crucifixion* are like stills from a sacred theatrical event in which the torment of the mourners takes on an ever more unpredictable form—as in the Urbino panel, where the figures seem almost to disappear, hiding behind Golgotha. This panel is the smallest as well as his earliest version of the *Crucifixion.* The painting in the Ca' d'Oro in Venice, which also expands into a broad landscape with a distant sea, seems almost a continuation of the predella panel from the *Pergolato Altarpiece* of 1446–47 (cat. 30); neither bears any obvious evidence of the artist's documented sojourn in Padua in 1448. There is some prominent use of gold leaf—lightly incised and then glazed, in the manner of Gentile da Fabriano, as in the trappings of the horse in the foreground—as well as the use of silver leaf (now completely tarnished), in the armor of the sol-diers circling Mount Golgotha on horseback as though in a festive joust (indeed, they seem to be the true protagonists in the scene). Christ and the two thieves are relegated to the middle ground and placed curiously off-center, to the left. These elements, as well as some technical characteristics that link the painting to the earlier Helsinki *Adoration of the Magi,* would undergo a transformation after the artist's stay in Padua: here, the figures are still malleable and a little inconsistent. Christ, who is pressed up against the cross, is reminiscent of those moving figures in the work of the Late Gothic artist Arcangelo di Cola da Camerino, and even of those of the Master of the 1454 Triptych, who was also active in Perugia from 1444 to 1450 (see Marcelli in De Marchi 2002a, pp. 188–203). Although conjectural, it has recently been proposed that this anonymous master might be identified with Ansovino di Vanni da Bolognola, who was documented in Tolentino in the 1450s and in touch with both Giovanni Angelo d'Antonio and Girolamo di Giovanni da Camerino (Coltrinari 2004).

It would be interesting to know the intended destination (possibly Perugia) of the Urbino *Crucifixion,* so that we might compare the city view at the right with the more carefully detailed ones (also on a slope) in Benedetto Bonfigli's work in the next decade—for example, in his *Annunciation* discussed in catalogue 29 above.

ADM

PROVENANCE: Richard Mayer, Zurich; Vittorio Cini, Venice (until 1987); acquired by the Italian state, 1987; Galleria Nazionale delle Marche, Urbino.

REFERENCES: Meiss 1961b, p. 299; Zeri 1961, pp. 57–61; Vitalini Sacconi 1968, pp. 124–25; Bacci 1969a, pp. 22, 27; Zampetti 1971, pp. 26, 28, 190–91; Dal Poggetto in Dal Poggetto 1988, pp. 62–63; De Marchi 2002b, p. 44; De Marchi 2002c, pp. 53–54; Minardi 2002b, pp. 31–32; Minardi in De Marchi 2002a, pp. 208, 211, 233; Minardi in De Marchi and Giannatiempo López 2002, pp. 179–81.

[32]

GIOVANNI DI PIERMATTEO BOCCATI

Madonna and Child Enthroned with Music-Making Angels (Madonna of the Orchestra)

Tempera on wood, 131 x 96 cm
Galleria Nazionale dell'Umbria, Perugia (inv. 147)

As early as 1446–47, Giovanni Boccati had created an altarpiece in which the assembly of saints and angels surrounding the Virgin are placed under a pergola—hence the name given to the work: the *Pergolato Altarpiece* (fig. 17, p. 56). The back of the Virgin's throne is replaced by a leafy exedra, but the throne itself is of wood, decorated with certosina intarsia; the lateral walls and benches are marble, rendered in a uniform pink typical of the palette of Filippo Lippi. Ideas that are at once similar yet different emerge in this smaller altarpiece, which was painted in Perugia about a decade later. The expressive *di sotto in sù* perspective lends a sort of monumentality to the blond, music-making angels playing a variety of instruments—including a lute, tambourine, cymbals, rebec, reed pipe, and harp—as they stand on a high, semicircular podium around the Virgin's throne; together with two additional angels in the foreground, playing a portable organ and a zither, they give the painting its traditional name: the *Madonna of the Orchestra*. A steeply foreshortened pergola of roses, probably inspired by Mantegna's *Martyrdom of Saint Christopher* in the Ovetari Chapel of the Church of the Eremitani in Padua, painted about 1454–55 (Minardi in De Marchi 2002a), creates a perspective grid. Boccati must have returned to Padua (where he is recorded in 1848), perhaps after having been documented in Camerino in 1451 and 1452 and then in Spoleto in 1454. What is striking here with respect to the *Pergolato Altarpiece* is the new, systematic insistence on a marble revetment, although the effect is tempered by the meadow in the foreground, emphasized by the two little angels who kneel to pick flowers. A familiarity with the Florentine works of Domenico Veneziano and his circle, any more than with the painting of Filippo Lippi, is not enough to explain this; the possible stimulus of

Alberti appears more likely by the fact that work on the Tempio Malatestiano in Rimini was ongoing. Beyond that, Boccati was influenced by the consciously *all'antica* narrative style that became fashionable in Padua about 1450 with Donatello's altar in the Santo and the fresco cycle in the Ovetari Chapel. The frieze showing a battle of nudes on the trabeation of the throne—not unlike a cameo on a blue ground—testifies to the unmistakable impact of Paduan art, as in no other painting by Boccati, and recalls the stucco predella and frieze with music-making putti on the sculptural altarpiece in the Ovetari Chapel—the work of Giovanni da Pisa and Nicolò Pizzolo (Boccati was in touch with Pizzolo in 1448). It is interesting to note how differently Boccati and Giovanni Angelo respond to these Paduan novelties: both are documented in Camerino for the wedding of Giulio Cesare da Varano and Giovanna Malatesta on May 12, 1451, as well as for a financial obligation they assumed together on July 4, 1452 (Mazzalupi 2003b, pp. 27–28). The closest parallel in Giovanni Angelo's work is his *Annunciation* (fig. 1, p. 66), where there is a greater articulated assimilation of the architectural vocabulary and expressive Paduan language of Pizzolo and the young Mantegna. Boccati, on the other hand, seems to have been attracted by more superficial elements, attesting to a fantastic and fancifully decorative sensibility.

Boccati's incredible popularity at the end of the nineteenth and the beginning of the twentieth century (see Dabell 2003) soared on the unhistorical notion that he was the forerunner of the "Umbrian school" and foreshadowed the "graceful" style of Perugino, and was based on paintings such as this one (on view at the Galleria Nazionale dell'Umbria), after Cavalcaselle (Crowe and Cavalcaselle 1864–66, vol. 3) attributed it to its proper author, removing it from the more generic category of School of Perugino. Paradoxically, this distorted interpretation of Boccati's place had a negative effect on later evaluations of the painter, even by scholars of the stature of Berenson, and Boccati suffered a rather ungenerous devaluation. However, once this picture is restored to its original historical context, it can be understood as one of the best works of this uneven artist, and among the first full, if somewhat whimsical, interpretations of Padua's innovative style to be found in Central Italy in the 1450s. Boccati painted the altarpiece at more or less the same time as his cycle of

Famous Men (fig. 9–10, p. 48) in the apartments of Federigo da Montefeltro and his consort Battista Sforza in the Iole wing of the Palazzo Ducale in Urbino (see Marcelli in De Marchi 2002a, pp. 257–63). The fact that Fra Carnevale was likely in Urbino in this period, together with the powerful influence of Boccati's experience in Padua, where he had lived in 1448, might well explain his tendency toward a lighter tonality and a more assured and ambitious monumentality in this composition, when compared with that of *Pergolato Altarpiece* of 1446–47. These qualities also make the altarpiece something of a high point in the artist's career—albeit one without any true sequel.

It is useful to compare this work with the *Madonna and Child with Angels* in the Musée Fesch in Ajaccio, although the latter panel—the center of a polyptych created for a Franciscan church—is not nearly as well preserved (see Minardi in De Marchi 2002a, pp. 245–50, who argues for a different chronology for these two works). The comparison highlights a sudden slackening in the taut perspective and scenographic character of Boccati's work, despite the persistence of Paduan ornamental motifs. The possibility that the polyptych was intended for San Francesco at Tolentino (Mazzalupi 2003b, p. 28) offers a probable *terminus ante quem* for dating the *Madonna of the Orchestra,* for the work was commissioned from Vincenzo di Pasqua, who withdrew from the project in 1458; it was not completed until 1461 by Boccati, who then demanded a more adequate compensation. The Fesch *Madonna,* also rectangular in shape, is only slightly larger (148 x 103 cm); however, unlike the altarpiece in Perugia, it is not an autonomous work but rather the central panel of a polyptych peculiarly hybrid in appearance. As can be seen from the surviving lateral panels of saints (Allen Memorial Art Museum, Oberlin, Ohio), these were the same height as the central section, which is unusual. An eighteenth-century inventory that describes the panels in San Francesco (except for the *Madonna and Child,* which evidently had already been removed from the altarpiece) suggests that further panels ("*mezzi ovati*") were situated above the lateral ones—a format not unusual in the Adriatic region and similar to that of Boccati's polyptych at Belforte del Chienti of 1468 (cat. 33). The upper panels (divided between the Pinacoteca Vaticana, Vatican City, and the Galleria Sabauda, Turin) still preserve their original Gothic framing ele-

ments and small arches. It is a pity that the original frame of the *Madonna of the Orchestra*—gessoed at the same time as the panel, as is demonstrated by the raised lip of paint along the edges (Delogu in Garibaldi 1996)—has not survived. It is also safe to say that in this case the frame was classicizing—*more patavino*—and had a trabeated cornice. The particular character of the work is further revealed by the systematic elimination of gold (in fact, there is not even any shell gold, despite the accounts in the literature: see De Marchi in De Marchi 2002, p. 61). This contrasts with the presence of gold throughout the *Pergolato Altarpiece;* here the illusion of gold is created by color, whether in the foreshortened halos or in the precious damask of the Virgin's blue mantle—almost as if Boccati were responding to Leon Battista Alberti's exhortations in his treatise on painting. That the work was intended for a particularly cultivated and sophisticated audience finds support in Marcelli's hypothesis (2003) that the altarpiece was intended for Santa Maria del Mercato, where members of the Perugian *studium* assembled (Ermini 1971, p. 306). When the church was demolished in 1545, its functions were assumed by San Simone e Guida al Carmine, built in about 1570; the altarpiece comes from the latter church.

ADM

PROVENANCE: possibly Santa Maria al Mercato (before 1545); San Simone e Giuda al Carmine, Company of the Holy Sacrament (until 1822); Galleria Nazionale dell'Umbria, Perugia (from 1822).

REFERENCES: Siepi 1822, vol. 1, p. 323; Crowe and Cavalcaselle 1864–66, vol. 3, p. 116; Destrée 1900, p. 21; Feliciangeli 1906, pp. 16, 36; Bombe 1912, p. 85; Rotondi 1950, p. 163; Vitalini Sacconi 1968, pp. 139–42; Bacci 1969 b, pp. 4, 15; Zampetti 1971, pp. 32, 195; Cionini Visani 1973, p. 323; Santi 1985, pp. 24–26; Delogu in Garibaldi 1996, pp. 62–63; Ceriana 2002a, p. 107; De Marchi 2002b, pp. 61–62; Minardi 2002a, pp. 214–17, 250–56; Marcelli 2002, p. 16; Marcelli 2003, p. 323.

[33]

GIOVANNI DI PIERMATTEO BOCCATI

The Blessed Guardato

Tempera and gold on wood: (overall) 138 x 47 cm; (painted surface) 96 x 44 cm
Church of Sant'Eustachio, Belforte del Chienti

This pinnacle from Boccati's altarpiece in Sant'Eustachio in Belforte del Chienti (see ill.), the largest fifteenth-century polyptych in the Marches (it measures 483 x 323 cm), is also one of the most notable because of its complex structure, the richness of its carved frame, and the fact that it has survived almost intact. The restoration now under way in Urbino (by Romeo Bigini under the guidance of Maria Giannatiempo López), which has involved the dismantling of the polyptych, has provided a unique opportunity to study the altarpiece and its wood structure while also making it possible to include the panel of the *Blessed Guardato* in this exhibition. Fortunately, the figure's relatively minor iconographic importance has spared the panel the overzealous cleaning that has damaged the paint surface of many of the principal panels of the altarpiece. The pulsating physical realism of the figure, the result of a pictorial approach that concentrates on surface effects, and the intensely characterized face, still very well preserved, can be compared with the elegantly affecting visual language of the Master of the Barberini Panels, although the artistic intent of the latter was very different in formulation.

The Belforte polyptych is an excellent example of Boccati's mature style. It is dated 1468, when the artist was probably forty-five or fifty years old and had been back in his native Camerino for some ten years (although he would shortly return to Perugia to try his luck there again). Despite the fact that the altarpiece was intended for a rural locale, the painting is an ambitious one. The individual who commissioned it for the high altar of Sant'Eustachio was Taliano di Lippo, an important figure in Belforte. Situated high above the Chienti Valley, Belforte is on the road from Tolentino to Camerino, and to Umbria, Visso, and Foligno. Other local figures were associated with the enterprise—the prior Ugolino da Nunzio and a local notary named Ansovino di Pietro (for information about them, see Armellini 1989)—

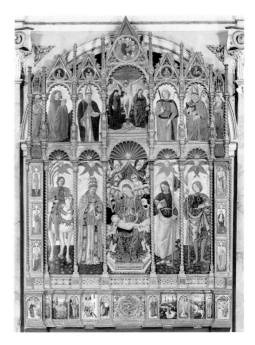

Giovanni di Piermatteo Boccati, *Belforte Altarpiece.* Church of Sant'Eustachio, Belforte del Chienti

so that the work, in effect, represented the efforts of the entire community.

The Belforte polyptych is typically Adriatic in construction. The frame is not engaged but was produced separately—the contours of the small, perforated arches; spiral colonnettes; and, in the upper register, the censer-shaped bases of these columns are incised into the surface of the individual panels. The Gothic-style carving, with perforated pediments and spandrels, pinnacles, and foliate decoration along the cusps, is also typical of Adriatic frames. (The pinnacles and foliate decoration were partially reworked, probably when the polyptych was adapted to fit within an arched recess: the perforated pediments above the figures of Gabriel and the Virgin were substantially lowered, obscuring part of the original, gilded pointed arches.) On the reverse of the panel of *Saint Eleutherius* is a curved compass line with small arches inscribed along its length; it probably served as a guide for the carved arches on the frame. The panels have not been thinned (they are about five centimeters thick), and there are no traces of any battens on the back to hold them together. Most probably the complete structure was encased and anchored within some sort of *capsa,* or enclosed framework. Because there is

no foliate decoration on the sides of the altarpiece (the wood there is unfinished), it seems likely that the pilasters and spiral colonnettes were anchored to a framing device placed perpendicular to the panels themselves. A *capsa* was commonly found on Venetian and Adriatic polyptychs, but what is new here is that it was incorporated into the carpentry of the altarpiece itself.

The inscription identifying the figure in the exhibited panel—B[EATUS] GUARDATUS—occurs on the separate segment of frame below the panel that includes a shell, a traditional decorative element on Adriatic polyptychs of the late fourteenth and early fifteenth centuries, which originated in thirteenth-century classicistic art in San Marco, Venice. This framing element also lends the altarpiece a greater sense of height—a desired effect to which the extreme elongation of the individual panels contributes. Boccati resolved any awkwardness by adding cherubim and seraphim above each saint as well as by depicting the figures in the upper register in three-quarter length, with the sole exception of Guardato: he is represented kneeling, and thus appears larger and more prominent than his companions, Saints Nicholas, Sebastian, and Eleutherius. Guardato was a patron of Belforte, like Saint Eustace, to whom the predella is dedicated, and who is represented on horseback, just below him. Both holy figures occupy a place of honor to the Madonna's right. The dedicatory inscription on the altarpiece, below the main register of panels, includes the name of its principal patron, Taliano di Lippo; it begins between the figure of Saint Eleutherius (?) and the center panel with the Madonna and Child and angels. Guardato's intense and pious attitude—he fingers his prayer beads as, with an open mouth, he looks toward the rays of light incised in the gold ground and at the crucified Christ in the center panel—takes on the explicit significance of intercession.

Biographical information about this local holy figure is only sketchy at best. According to Iacobilli (1638, vol. 1, pp. 133–34), Guardato was born about 1360 in Visso to the Riguardati family, originally from Norcia. He was a follower of the Blessed Placido da Recanati, the leader of the spiritual movement of the Apostolini at the end of the fourteenth century, and he died in Belforte while passing through the town on January 25, 1425. The rocky hills in the background are allusions to his reputation as a devout traveler. His sober habit is nonethe-

less clearly secular: he wears a *lucco*—a long robe—and a hood (in the illustration in Iacobilli's text, however, he is dressed in a generic monastic habit). Another Apostolino, the Blessed Filippo da Fermo, was depicted in the simple habit of the Observant Franciscans, known as the Zoccolanti, by Olivuccio da Ciccarello (Museo Diocesano, Ancona; see Marchi in De Marchi 2002a, pp. 144–46). It may be that there was some latitude in representations of such recently beatified figures. Matteo Mazzalupi has pointed out to me the similarities between this sitter and several images of bearded and penitent *beati* with hoods and prayer beads that are found in the area around Camerino. Each of them could also be linked with other contemporary figures—in particular, the Blessed Ugolino da Fiegni—as is the case with a figure of this type in a fresco in San Martino at Vestignano di Caldarola that has been identified, rather fantastically, as Nicodemus. Other such figures include the one at the far right of the predella of Carlo Crivelli's triptych for San Domenico at Camerino, and one in a panel in the Portland Art Museum from a pilaster on Crivelli's altarpiece in the cathedral of Camerino (Pinacoteca di Brera, Milan), who, just as arbitrarily, has been interpreted as the Sienese Blessed Andrea Gallerani (see Daffra in De Marchi 2002a, pp. 433–39, 442, who records the hypothesis in favor of Blessed Guardato).

ADM

PROVENANCE: Church of Sant' Eustachio, Belforte del Chienti.

REFERENCES: Servanzi Collio 1869; Destrée 1900, pp. 21–22; Bombe 1912, pp. 86–87; Zeri 1961, p. 49; Vitalini Sacconi 1968, pp. 133–35, 239–40; Bacci 1969b, pp. 8–9; Zampetti 1971, pp. 35–36; Armellini 1989; De Marchi 2002b, pp. 72–73; Minardi 2002a, pp. 221–22, 267–78; Minardi 2003, pp. 337–38.

[34]

GIOVANNI ANGELO D'ANTONIO

DA CAMERINO

A. *The Annunciation*

B. *The Crucifixion*

Tempera and gold on wood (painted on both sides),
126 x 76 cm
Inscribed (on the scroll in *The Annunciation*): ANUTI-ATA [SIC] GRATIARUM; (in gold letters issuing from the angel's mouth): AVE G[RATIA] PLENA; (in *The Crucifixion*): I[ESUS]. N[AZARENUS]. R[EX]. I[UDEORUM].
Collegiata di Santa Maria di Piazza Alta, Sarnano

This work, painted on both sides of a single (now badly warped) panel, has sustained significant losses. The largest are in the *Annunciation,* although in the *Crucifixion* there are lacunae in Saint John's red mantle, the skull at the foot of the cross, and Christ's body; his left side and leg are especially abraded. The damage to the painting's surface was noted as early as the middle of the nineteenth century (Cavalcaselle and Morelli 1896, p. 216; Cavalcaselle and Crowe 1886–1908, vol. 9, p. 98 n. 2). According to a letter in the parish archive at Santa Maria di Piazza Alta in Sarnano, the painting was restored by the Soprintendenza of Urbino between October 1960 and February 1961.

The work is a portable standard, meant to be mounted atop a pole and carried in public processions on important religious feast days. This type of double-sided panel painting was very popular in the Marches in the fourteenth and fifteenth centuries (Schmidt 2003), and some examples were extremely refined in their execution. The most famous such painting, by Gentile da Fabriano, was made for a Franciscan convent in Fabriano in the first half of the 1420s (today the work is divided between the J. Paul Getty Museum, Los Angeles, and the Fondazione Magnani–Rocca, Corte di Mamiano, near Parma). Gentile's standard was copied by Antonio da Fabriano in 1452, but only one side of the copy survives (Gemälde-galerie der Akademie, Vienna: see De Marchi in Dal Poggetto 1988, pp. 194–97, nos. 67–68, and Cleri, ibid., pp. 198–99, no. 69).

The subjects of the Sarnano standard, as well as the inscription ANUTIATA GRATIARUM displayed

so prominently in the *Annunciation,* suggest that this work was intended especially for the procession on March 25 in honor of the annunciation of the birth of Christ. Pictures of this type, when they were not being carried in processions, might be displayed in churches in specially prepared niches—in which, evidently, only one side of the panel would be visible—or they might simply have been stored in the sacristy.

The archangel Gabriel in the *Annunciation* has just arrived to deliver his message to the Virgin: he raises his right hand in a gesture of greeting while holding a lily, a symbol of purity, in his left hand. He is dressed in a sumptuous robe with brocaded-velvet sleeves, his red mantle is decorated with gilded lozenges, and his wings are painted in red and green, also with gilding. Gabriel's crown of flowers is similar to those worn by the angels in the *Madonna and Child* (formerly, Cini Collection; now, Galleria Nazionale delle Marche, Urbino: see Di Lorenzo in De Marchi 2002a, pp. 319–21, no. 5), and the words AVE GRATIA PLENA, traced in gold, issue from his mouth. The Virgin stands in front of him, her arms crossed on her chest in a gesture that is both timid and surprised. The dove of the Holy Spirit flies toward her on a ray of light.

The narrative is set in a complex architectural space. A fluted column on a tall base occupies the foreground, just beyond the space defined by a thin platform on which the Virgin and angel are posed; the column separates the two figures from one another and, by hiding part of both the lily and the dove, it helps to create the sense of a deeper space. The scroll that bears the title of this sacred narrative is affixed to the foreshortened base. The scene is framed by a double arch; at the top, now almost entirely obliterated, are the sill and jamb of a window. The ceiling has flat coffers, and a plethora of architectural features fill the background: moldings decorated with *rinceaux* motifs, pilasters, cornices, narrow arched windows, and beamed ceilings—all of which are contained within a very small space. The vanishing point is not situated on the central axis but is to the left, and directs the viewer's gaze through a barrel-vaulted arch that opens onto a broad landscape.

On the other side of the panel is the *Crucifixion,* painted on a gold ground. Christ, his eyes closed and his head hanging down, bleeds copiously from his wounds. Wracked by grief, the Virgin points to her son with her right hand while she holds her left hand to her

head. John the Evangelist, dressed in a red mantle, clasps his hands to his chest in a gesture of anguish and desperation. One of the most fascinating aspects of the painting is the bird's-eye view behind the figures of a luminous landscape extending deep into space and dotted with villages, farms, monasteries, castles, roads, and pathways.

The processional standard is in the Collegiata di Santa Maria di Piazza Alta in Sarnano, southeast of Camerino, and this most likely was also its original location. The rural town of Sarnano was founded in the thirteenth century on a high and easily defensible point of land by some of the inhabitants of five nearby castles—Brunforte, Castelvecchio, Poggio, Piobbico, and Bisio—who wanted to free themselves from the yoke of the local feudal lords (Feliciangeli 1920, pp. 27–29). The church of Santa Maria di Piazza Alta traces its origins to an oratory founded in the late thirteenth century by the monks of the Benedictine Abbey of Santa Maria di Piobbico in the center of the new town on land granted by the bishop of Camerino. From its beginnings, the church was the most important gathering point for the commune of Sarnano, and it was overseen by the abbot of Piobbico. The present structure was built at the end of the fourteenth century (Pagnani 1995, pp. 61–63). Antonio de Bosis, an energetic character with a charismatic personality, became Abbot of Piobbico and of Santa Maria di Piazza Alta in Sarnano in 1456 (Feliciangeli 1920, pp. 12–13; Pagnani 1995, pp. 95–101; Paciaroni 2001, pp. 59–60). He began his career as a simple priest, and by 1455 was the vicar of the bishop of Camerino at Sarnano and the surrounding territory. De Bosis, who died in 1490, is referred to in documents as "lettered," although there is no trace of anything he wrote. He must also have been interested in music since in 1456 he paid a Maestro Giovanni Guglielmo d'Inghilterra to give him music lessons. His name survives, too, in the dedicatory inscription of a fresco cycle painted in 1483 by Lorenzo d'Alessandro da Sanseverino in the church at Sarnano in which De Bosis is shown as a kneeling donor. He was responsible as well for the erection, in 1456, of the funerary monument to his predecessor, the pious abbot Agostino Marinelli, in the abbey at Piobbico. The under arch of that monument has painted decorations by a mediocre artist who, in addition, was likely the author of other frescoes on the inside right wall of the abbey (probably

executed at the same time as those on the under side of the arch), including an *Annunciation* that faithfully quotes Giovanni Angelo's most accomplished work—an *Annunciation* (fig. 1, p. 66) formerly in the small Franciscan monastery of Spermento (see Di Lorenzo in De Marchi 2002 a, pp. 309–19, no. 4). It seems quite plausible that we also owe the commission for the standard to the active and enthusiastic De Bosis, and that he ordered it for the church of Santa Maria di Piazza during his first years as abbot. The standard is recorded in the sacristy of the Collegiata in Sarnano in the inventory of works of art in the Marches and Umbria compiled by Cavalcaselle and Morelli in 1861–62 (Cavalcaselle and Morelli 1896, p. 216); they dated it to the second half of the fifteenth century, assigning it a value of eight hundred lire, noting that it "has suffered greatly." At the time the inventory was published, Francesco Gatti (in Cavalcaselle and Morelli 1896, p. 191) added that the painting had been moved to the public picture gallery in Macerata. Sometime before he died in 1897, Cavalcaselle (in Cavalcaselle and Crowe 1886–1908, vol. 9, p. 98) attributed the panel to Girolamo di Giovanni. However, wider appreciation for the work is due to its having been included in the important exhibition in Macerata in 1905, with the tentative attribution, "*Scuola di Urbino, Fra Carnevale?*," as proposed by Adolfo Venturi (in "*Esposizione regionale Marchigiana*" 1905, pp. 53–54). In a review of the exhibition, Corrado Ricci (1906, pp. 209–12) attributed the standard from Sarnano to the same artist who painted the *Annunciation* at Spermento, stating that in it one could catch glimpses of the influence of Piero della Francesca. He rejected the idea, however, that it was by the same hand as the Barberini Panels, which Venturi (1893, pp. 415–18) had attributed to Fra Carnevale. Berenson (1907, p. 130) returned to Cavalcaselle's suggestion, and in the first important, monographic article dedicated to Girolamo di Giovanni, he firmly restated the attribution of the Sarnano standard to the artist, underscoring with great acumen its reflections of Paduan art, and noted that the *Annunciation*'s "most interesting aspect is the Renaissance architecture with its Squarcionesque and delicate refinement and elegance." The attribution to Girolamo di Giovanni was never questioned again until 2002, when research undertaken for the exhibition "Il Quattrocento a Camerino" led to the reassigning of Girolamo di Giovanni's most

significant works to the master of the Spermento *Annunciation*, who was subsequently securely identified as Giovanni Angelo d'Antonio da Camerino; this has instigated a reevaluation of the attribution of the Sarnano standard as well (see De Marchi 2002b, pp. 42–43; De Marchi 2002c, pp. 54–62; Mazzalupi 2003b).

As has already been observed, the *Annunciation* on the Sarnano standard (the architecture of which is replete with motifs that derive from the frescoes in the Ovetari Chapel in Padua) depends directly on the Spermento *Annunciation*, especially in the use of the column with a high base that, placed in front of the narrow platform on which the sacred story takes place, contributes to the illusion of depth. The pilaster with a *rinceaux* motif (borrowed from Mantegna's *Martyrdom of Saint James* in the Ovetari Chapel) also appears in the Spermento *Annunciation*, and the same is true of the barrel-vaulted arch with coffers and a foliate cornice. In the Sarnano *Annunciation*, however, the figures are less harmoniously placed in the scene and the architectural space is more contracted and congested—as though conceived in graphic terms and therefore lacking that powerful three-dimensionality and deep spatial illusion that is one of the salient characteristics of the Spermento altarpiece. Even the shimmering, luministic character of the Spermento *Annunciation*, in which a strong southern light is reflected in the polished marble of the architecture, creating areas of strongly contrasting highlights and shadows, seems attenuated in the Sarnano panel (in part because of its less-than-perfect state of conservation), as evident in the faintly indicated shadow of the angel. The Sarnano panel does have some extraordinary passages: the flesh tones, modeled in the light falling from the left, as well as the exquisite handling of the draperies and of the wings of the angel.

The *Crucifixion*, too, reveals strong links to Giovanni Angelo's earlier works, especially to his bold *Crucifixion* in Castel San Venanzio, the source for the Sarnano panel's arrangement of the body of Christ, which hangs in front of the cross, his head resting on his right shoulder. Yet, the physical quality—a certain heaviness—that is conveyed in the Castel San Venanzio work by the suspended figure of Christ, the muscles of his arms stretched taut, seems more attenuated in the Sarnano panel. The shadow that defines Christ's side and leg appears less clean and vigorous in the Sarnano picture, and the filmy

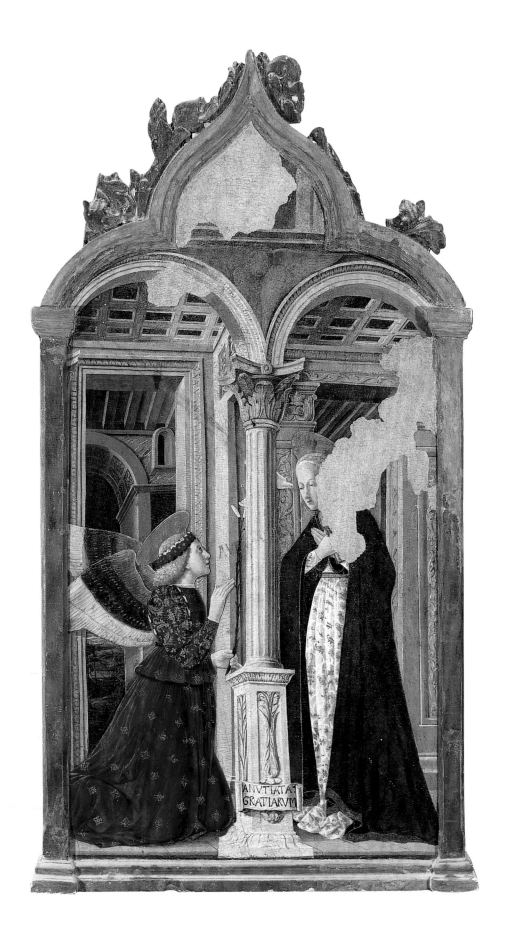

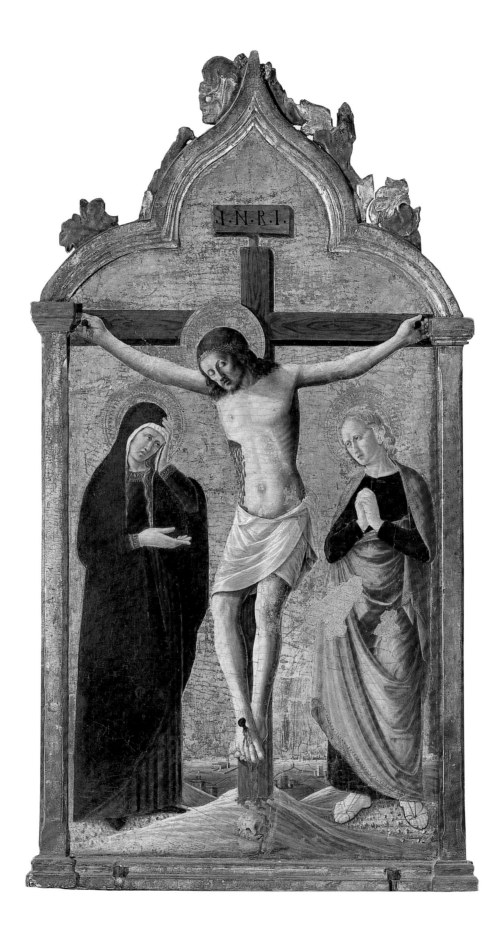

material of the loincloth, the folds of which glisten in the light, is not as convoluted or deeply cut as it is in the painting in Castel San Venanzio. The loveliest part of the panel in question here is the moving aerial view of the broad, luminous landscape that opens behind Mount Calvary.

The fact that the double-sided panel in Sarnano contains extraordinary inventions but was executed with a skill not always on a par with the strong sense of modeling and light typical of Giovanni Angelo d'Antonio's most intense works raises the suspicion that it may well have been the result of a close collaboration between that artist and Girolamo di Giovanni. These two painters are documented in both 1461 and 1463 as having formed a partnership (see Di Stefano and Cicconi 2002, pp. 458, 460, documents 119, 120, 130).

A later work with the same subject, noted by Minardi (1998, p. 19, fig. 6, pp. 23, 36 n. 29, 37 n. 54), and now in a private collection in Scotland, derives directly from the Sarnano *Crucifixion*. I have recently attributed this picture to Girolamo di Giovanni (at the time of the Camerino exhibition, still referred to as the Master of the Macchie), based on its pronounced graphic qualities, which are also apparent in another *Crucifixion*, now in Urbino but originally in the church of Sant'Agostino at Monte San Martino (see Marcelli in De Marchi 2002 a, pp. 381–82 nos. 5–6).

The most plausible date for the Sarnano standard is about 1456–58—that is, not much later than the Spermento altarpiece from which it derives. This would seem to further corroborate the suggestion that the work was commissioned by Antonio de Bosis during his first years as Abbot at Piobbico.

ADL

PROVENANCE: Collegiata di Santa Maria di Piazza Alta, Sarnano (described as in the sacristy by 1861–72); Pinacoteca, Macerata (1872–about 1905; *Esposizione di Macerata* 1905, p. 54); Collegiata di Santa Maria di Piazza, Sarnano (after 1905).

REFERENCES: Cavalcaselle and Morelli 1896, p. 216; Cavalcaselle and Crowe 1886–1908, vol. 9, pp. 97–98; "Esposizione regionale marchigiana" 1905, pp. 53–54; Ricci 1906, pp. 211–12; Berenson 1907, p. 130; Gnoli 1908, pp. 41–42; Berenson 1909, p. 184; Feliciangeli 1910b, pp. 3–5, 25, 27 n. 1; Venturi 1911, p. 524; Feliciangeli 1912, p. 9; Serra 1924–25a, p. 157; Serra 1924–25b, pp. 424–25; Serra 1929–30, p. 247; Berenson 1932a, p. 258; Van Marle 1934, pp. 34–35 n. 2; Berenson 1936, p. 222; Zampetti in Zampetti 1961, p. 203; Zeri 1961, p. 78; Cardona 1965, pp. 50–51, 74; Berenson 1968, vol. 1, p. 194; Vitalini Sacconi 1968, pp. 153, 171, 182–84, 248 nn. 394–95; Zampetti [1969], p. 95; Paolucci 1970, pp. 32–33, 40 n. 12; Battistini 1987, p. 396; Curzi 1987, p. 650; Zampetti 1988, pp. 390, 398; Daffra and Di Lorenzo in Zeri 1992, pp. 143–44; De Marchi 1996a, p. 63; Minardi 1998, pp. 22–23, 37 n. 53; Mercurelli Salari 2001, p. 563; De Marchi 2002b, p. 49; De Marchi 2002c, p. 61; Di Lorenzo in De Marchi 2002a, pp. 326–29, no. 10; Di Lorenzo in De Marchi and Giannatiempo López 2002, pp. 216–18, no. 48; De Marchi 2003, p. 375; Laclotte 2003, p. 800; Minardi 2003, pp. 330, 333; Schmidt 2003, pp. 555, 559, 566.

[35]

GIOVANNI ANGELO D'ANTONIO

DA CAMERINO

Saint Jerome

Tempera and gold on panel, 154 x 43 cm
Inscribed (on the frieze of the parapet):
S[ANCTVS]·IERONIMVS·
Pinacoteca di Brera, Milano (on deposit from the
Museo Poldi Pezzoli, inv. 62)

This panel is from the upper register of a reconstituted polyptych in the Pinacoteca di Brera (see ill.); the companion panels show, left to right, Saints Sebastian and Peter, the Crucifixion, and Saint Lawrence. The main panels with which the upper register has been framed since 1925 represent the Madonna and Child with angels, flanked by, on the left, Saints Augustine and Catherine of Alexandria and, on the right, Saints Apollonia and Nicholas of Tolentino. A 1991 cleaning of the reconstructed altarpiece by Paola Zanolini revealed the panels of the upper register to be in reasonably good condition. The gold, although worn in places, is original, and so also is the foliate carved frame. However, the twisted colonnettes and their capitals were made in 1925, when the altarpiece, as we know it today, was reassembled, having entered the collection of the Pinacoteca di Brera three years earlier. It has been suggested, if only tentatively, that the frame was the work of Giovanni di Stefano da Montelparo, a wood-carver who made the frame for a polyptych by Niccolò di Liberatore (Niccolò da Foligno) in San Francesco, Gualdo Tadino (Crocetti 1990, p. 25). Photographs of the upper register of the altarpiece, taken on the occasion of the "Mostra d'antica arte umbra" in Perugia, show the original spiral colonnettes (Berenson 1907, p. 132; Perkins 1907, p. 95, ill.; Gnoli 1908, pl. 85; Bairati 2000, p. 50, ill.; Bairati 2003, p. 783, fig. 4), which were slightly larger than the present ones. The lily-shaped terminals crowning the frames of Saints Peter and Lawrence, which had been broken, were made up in 1925, together with the rest of the frame for the altarpiece. In these old photographs, the panels are arranged in a sequence that is probably not the original one. Nonetheless, they do establish that the springing of the arches of the panels was aligned, whereas in 1925 the *Crucifixion* was incorrectly placed at a higher level than that of the flanking panels.

The *Saint Jerome* is the most moving of the figural panels in the upper register. He is shown with his symbol, the lion, placing its paws on the saint while licking him as would a dog. Jerome is scrutinizing the text of the Vulgate, which he holds in front of him. Staring at the text through gilded pince-nez, his brows knitted in concentration, he reads aloud, his mouth half open, revealing white teeth. The saint is shown in three-quarter length, behind a balcony, the cornice of which is decorated with foliate and astragal motifs similar to the painted architecture in other works by Giovanni Angelo d'Antonio. The saint's name is inscribed on the cornice, framed by two hanging tassels. The balcony increases the verticality of the panel, and the artist has taken advantage of the space above Saint Jerome to include a seraph. The *Saint Jerome* and its companion panels forming the upper register of the Brera altarpiece come from the Benedictine abbey (after 1848, Collegiata di San Benedetto) in Gualdo Tadino, which must have been the original location of the altarpiece to which they belonged. An inventory of the works of art in the churches of Gualdo Tadino, dated October 28, 1888, records the panels, then attributed to Matteo da Gualdo, in the sacristy of San Francesco, noting, however, that they came from San Benedetto; they had been moved to San Francesco about 1875 and were returned to their original location in 1896, when San Benedetto was reopened, following ongoing construction (Bairati 2000, pp. 47–49). The 1888 inventory describes the paintings as: "Christ crucified, flanked by the Virgin and Saint John," and, to either side, "half-length figures of Saint Peter the Apostle, Saint Lawrence the Martyr, Saint Facondino and Saint Jerome" ("Regesto," in DeVecchi 2000, p. 168 n. 7). In the 1907 "Mostra d'antica arte umbra," in Perugia, the panels were judged to be among the most interesting works in the exhibition; they were displayed next to a polyptych from San Pellegrino, near Gualdo Tadino (Perugia 1907, pp. 59–60), and scholars immediately recognized that the two altarpieces were by the same artist (Perkins 1907, p. 95). Guido Cagnola (in Perkins 1907, p. 95 n. 2) was the first to suggest that this artist might be Girolamo di Giovanni, who was known to have been in Padua in 1450 and to have signed a polyptych from Monte San Martino that, in

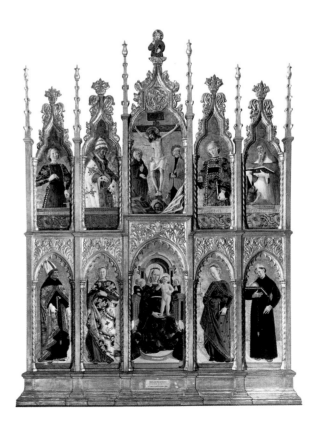

1905, was shown in an exhibition at Macerata ("Esposizione regionale marchigiana" 1905, pp. 45–46, no. 12). In a seminal article Berenson (1907, pp. 131–33) went on to reconstruct the artistic personality and corpus of Girolamo di Giovanni for the first time, claiming that the main register of the Gualdo Tadino altarpiece could be identified with a *Madonna and Child* in the Museo Poldi Pezzoli, Milan, as well as with panels of four saints, owned by the London-based dealer Dowdeswell & Dowdeswell. The Poldi Pezzoli museum took up Berenson's suggestion with enthusiasm and within a few years was able to reunite the various parts of the altarpiece. The museum acquired the four saints from Dowdeswell & Dowdeswell in 1910, thanks in part to a contribution from Cagnola, and in 1914, after long negotiations with officials at San Benedetto conducted by Ettore Modigliani, the *soprintendente* of Milan, the Poldi Pezzoli also obtained the upper register (Dragoni 2003). However, the reconstructed altarpiece proved to be too large for the museum, and in 1922 the reassembled polyptych was deposited at the Brera in exchange for the loan of a famous Persian carpet with hunting scenes (Daffra and Di Lorenzo in Zeri 1992, pp. 138–39). The polyptych's neo-Gothic frame was made in 1925 to display the altarpiece at the Brera (Salmi 1925–26, pp. 90, 95, fig. 12); as mentioned above, however, it is likely that, as reassembled, the order of the panels and their original alignment are incorrect. More recently we have also come to understand that Berenson's reconstruction of the altarpiece as a whole is probably wrong. For instance, it is highly unlikely that a work intended for a Benedictine church would include Augustinian saints in the main register. The handling of light, too, is inconsistent: it falls from the right in the main panels and from the left in the upper register, creating a contradiction difficult to reconcile for an artist who was a follower of Piero della Francesca. Finally, the saints below are slightly but perceptibly smaller than those above (Di Lorenzo 1998). Thus, it seems that the upper and lower registers of the Brera altarpiece must come from different polyptychs. The lower register, with its representation of Augustinian saints, might have been intended originally for the high altar of the basilica of San Nicola at Tolentino (Di Lorenzo in De Marchi 2002 a, p. 336; Coltrinari 2004, pp. 76–100). The upper register is from a polyptych made for the Benedictine abbey at Gualdo

Tadino that is still missing its lower register, although a splendid fragment of a *Madonna and Child* (in a private collection in Rome when Carlo Volpe called it to the attention of Antonio Paolucci in 1970; it had been sold at Galerie Fischer, Lucerne, December 3–7, 1963, lot 1117: the auction catalogue gives its dimensions as 56 x 38.5 cm) may have been its center panel (Paolucci 1970, p. 36, Mazzalupi in De Marchi 2002 a, p. 339, no. 15). The light in this painting enters from the left, and the figures exhibit stylistic characteristics similar to those of the upper register. One can only hope that the missing panels from the main register will some day be located. They may have represented Benedictine saints such as Benedict, his sister Monica, or perhaps Mauro, Placido, or Flavia.

Ever since Berenson (1907) first reconstructed the artistic personality of Girolamo di Giovanni, the panels of the Brera polyptych have been considered among that artist's most emblematic works, together with a fresco of 1449 (Pinacoteca e Museo Civici, Camerino), a *Crucifixion* at Castel San Venanzio, the *Annunciation* from Spermento (fig. 1, p. 66), a *Madonna* formerly in the Cini Collection and now in Urbino (Galleria Nazionale delle Marche), the standard of Sarnano (cat. 34), and a fresco of 1462 (Pinacoteca e Museo Civici, Camerino). Research undertaken for both the 2002 exhibition "Il Quattrocento a Camerino. Luce e Prospectiva nel Cuore della Marca" and the book *Pittori a Camerino nel Quattrocento* led these works to be reattributed to an anonymous master of the Spermento *Annunciation*, who was tentatively identified with Giovanni Angelo d'Antonio da Camerino, known to have worked with Girolamo di Giovanni (see De Marchi 2002b, pp. 42–43; De Marchi 2002c, pp. 54–62; Di Lorenzo 2002, pp. 294–301). Matteo Mazzalupi's discovery of a receipt, dated 1452, for a payment to Giovanni Angelo d'Antonio for the *Crucifixion* at Castel San Venanzio (Mazzalupi 2003 a; Mazzalupi 2003 b) has now confirmed this hypothetical identification. In addition to the altarpiece for the Benedictine abbey, Giovanni Angelo produced another work for a church in the area around Gualdo Tadino—a polyptych still in San Pellegrino, just outside that Umbrian town; its inscription dates it to 1465: T[EM]P[O]RE DO[MI]NI AGNELI FRANCISCI DE GUALDO. The polyptych was commissioned by Cardinal Filippo Calandrini, from Sarnano, the bishop of

Bologna, who held the abbey of Santa Maria di Sitria at the Scheggia Pass—of which the church of San Pellegrino was a dependency—in commendatory (Bairati 2003, p. 770). Mazzalupi has noted that the coat of arms shown in the polyptych of San Pellegrino is that of Calandrini and that the presence of the apostle Philip to the right of the Madonna, in the place of honor, is an allusion to the cardinal (Mazzalupi 2003–2004, p. 121 n. 69). At his death in 1476, Filippo Calandrini left vacant his positions at the abbey of Sitria and at San Benedetto in Gualdo Tadino (Eubel 1901, p. 11 n. 5); he was therefore probably the patron of both polyptychs by Giovanni Angelo d'Antonio. Calandri was half brother of Nicholas V and was likely nominated commendatory Abbot of Sitria and San Benedetto by the pope, perhaps on the occasion of a papal visit to Gualdo Tadino in 1449 or 1450 (Guerrieri 1933, pp. 132–33). Perhaps the success of the polyptych for the Benedictine church led to the commission granted to Giovanni Angelo for the San Pellegrino altarpiece. The two works are certainly similar in style, although the San Pellegrino altarpiece is more rustic—perhaps not unexpected for an altarpiece destined for a country church. Giovanni Angelo was an artist accustomed to adjusting his style, whether to suit the more refined Da Varano court at Camerino or the devout parishioners in the countryside. A date just before the middle of the 1460s would explain the close stylistic ties that can be observed between the upper register of the Brera polyptych and the fresco from San Francesco, dated 1462 (Di Lorenzo in De Marchi 2002a, pp. 329–30, no. 12). Indeed, the San Benedetto polyptych from Gualdo Tadino fits perfectly among the works Giovanni Angelo executed in the 1460s—not only the 1462 fresco, but the lower register of the Brera altarpiece, which, as we have seen, comes from the basilica of San Nicola at Tolentino; the recently discovered, lovely *Madonna and Child,* dated 1465, in Serravalle; the San Pellegrino polyptych; the *Saint John the Baptist* in Avignon (Musée du Petit Palais); the fragment of a *Madonna della Misericordia* at San Francesco in Pontelatrave; the *Madonna della Misericordia,* dated 1468, for the church at Villa a Cessapalombo; and the Valle San Martino fresco (see De Marchi, Di Lorenzo, and Mazzalupi in De Marchi 2002a, pp. 329–50, nos. 12, 13, 18, 19, 20, 22–24). These works come from an extraordinarily felicitous period in this master's

career, when Giovanni Angelo moved beyond his enthusiasm for Paduan art and embraced the example of Piero della Francesca in his handling of perspective and light, even as he added intensely naturalistic passages and endowed his figures with a genial humanity. These characteristics are particularly apparent in the detail of the child who turns toward the spectator in the Villa a Cessapalombo *Madonna della Misericordia* as well as in the engrossed, introspective *Saint Jerome* exhibited here.

ADL

PROVENANCE: Abbey of San Benedetto, Gualdo Tadino (until 1875); sacristy of the church of San Francesco, Gualdo Tadino (1875–96); San Benedetto, Gualdo Tadino (1896–1914); Museo Poldi Pezzoli, Milan (1914–22); Pinacoteca di Brera, Milan (on deposit, from 1922).

REFERENCES: Berenson 1907a, pp. 131–33; Cagnola in Perkins 1907, p. 95 n. 2; Labò 1907, pp. 11–13; Nazzari 1907, pp. 41–42; Perkins 1907, p. 95; Perugia 1907, pp. 59–60; Gnoli 1908, pp. 41–42, 135; Berenson 1909, p. 183; Feliciangeli 1910b, pp. 14–16, 25; Frizzoni 1910, pp. 46–48; Venturi 1911, p. 524; Feliciangeli 1912, p. 9; Modigliani 1914, p. 35; Museo Poldi Pezzoli 1914, p. 25; Venturi 1915, p. 190; Museo Poldi Pezzoli 1920, p. 25; Salmi 1925–26, pp. 90, 95, fig. 12; Berenson 1932a, p. 257; Colasanti 1932, p. 49; Colasanti 1933, p. 286; Van Marle 1934, pp. 27–28, 36; Berenson 1936, p. 221; Berenson 1968, vol. 1, p. 194; Vitalini Sacconi 1968, pp. 91, 153, 186, 195–98, 242 n. 322, 249 nn. 408–11; Bacci 1969b, pp. 10–11; Zampetti [1969], pp. 94–95; Paolucci 1970, pp. 35–36, 41 n. 19; Donnini 1972, pp. 6–8; Vitalini Sacconi 1972, pp. 162–66, Mottola Molfino 1982, pp. 38, 59 n. 110; De Benedictis in Scalia and De Benedictis 1984, no. 10, p. 232; Vitalini Sacconi 1985, p. 66; Zampetti 1988, pp. 390, 398; Crocetti 1990, p. 25; Daffra and Di Lorenzo in Zeri 1992, no. 56, pp. 138–45; Di Lorenzo 1996 b, p. 131 n. 63; Di Lorenzo 1998; Minardi 1998, pp. 20, 22–27, 37 nn. 57–58, 62–64, p. 38 n. 88, figs. 12, 15, 18; Bairati 2000, pp. 49–50, 63 nn. 35–36; "Regesto" in De Vecchi 2000, p. 168; Mercurelli Salari 2001, pp. 562–63; De Marchi 2002b, pp. 68–69; De Marchi 2002c, p. 61; Di Lorenzo 2002, p. 295; Di Lorenzo in De Marchi and Giannatiempo 2002, pp. 223–25, no. 51; Di Lorenzo in De Marchi 2002a, pp. 337–39, no. 14; Bairati 2003; Dragoni 2003; Minardi 2003, pp. 334–38; Tambini 2003, p. 828; Coltrinari 2004, pp. 67–100.

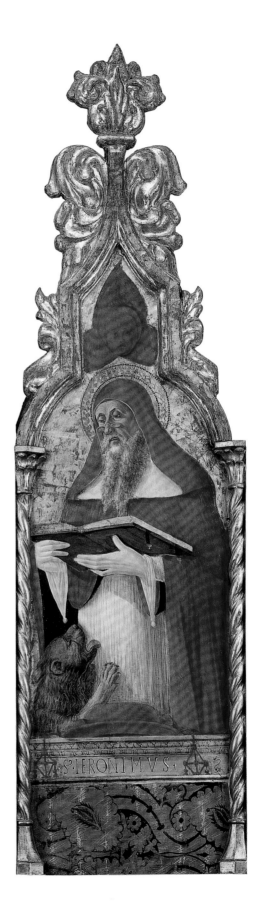

[36]

ANTONIO DA FABRIANO

Saint Jerome in His Study

Tempera on wood: (overall) 96 x 60 cm;
(painted surface) 88.4 x 52.4 cm
The Walters Art Museum, Baltimore (inv. 37.439)

When this picture was painted, the subject of Saint Jerome in his study was already an autonomous one in Flemish art. In accordance with Flemish practice, and as exemplified by a number of Jan van Eyck's works, Antonio da Fabriano painted his name "*antonio de fabr[ian]o*" on a fictive cartellino on the bottom of the frame, which is original, although it almost always appears cropped in illustrations of the panel. Another cartellino, its edges folded back and bearing the date 1451, is affixed to the edge of Saint Jerome's desk. While it is difficult to determine the original function of this painting, it is not a processional standard for a confrater-

nity—in fact, the panel was not included in Schmidt's 2003 survey of processional standards—even though, in Umbria and the Marches, these are typically on panel, similar in size, and in some cases perfectly square in format. It is, in any case, an autonomous work, intended for devotional use in a home or monastic institution. Paintings of this sort, free from the contemporary typologies of small Gothic altarpieces, began to gain popularity in the Marches in the course of the 1450s, although usually they are even more reduced in size (as, for example, the many versions of the Crucifixion, Giovanni Boccati's specialty, such as the one in the Ca' d'Oro in Venice that measures 71 x 52 cm, or Giovanni Angelo d'Antonio's *Madonna and Child with Saint John the Baptist and Saint Francis* in the Pinacoteca di Brera, Milan, which measures 49.7 x 38.2 cm). The Fabriano collector Romualdo Fornari purchased the present painting from a priest, Don Luigi Faustini, and it is possible that the Franciscan tertiaries of Fabriano were its intended audience: from 1407 they were established in the monastery of San Girolamo, whose name was changed in 1478 to

its current one of Sant'Onofrio (see Molajoli 1956 [1990 ed.], p. 151).

In the past, the domestic description of Jerome's study, which Antonio makes humbler and more real through such details as the veining and knots in the wood, the cardinal's hat hanging from a nail, and the small crucifix affixed to the keystone of a brick archway—prompted a comparison with Colantonio's *Saint Jerome,* painted as an altarpiece for San Lorenzo in Naples (about 1444–45; Museo Nazionale di Capodimonte, Naples), especially because of the still life of books randomly scattered on shelves together with a candlestick and an hourglass. For some time, in fact, the notion that Antonio's Flemish tendencies were the result of a journey to Naples in the 1440s (a thesis upheld, in particular, by Zeri [1948 b, p. 164]) found wide acceptance. A rival hypothesis posits a decisive journey to Genoa, which by the mid-fifteenth century had become among the principal exponents of the Flemish painting style in Italy and could boast that it was home to an artist of the stature of Donato de' Bardi (documented from 1426 to 1450/51)—one

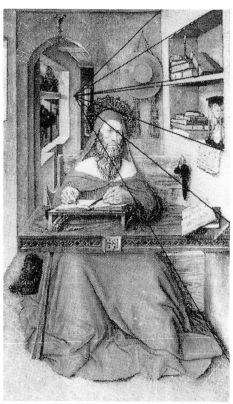
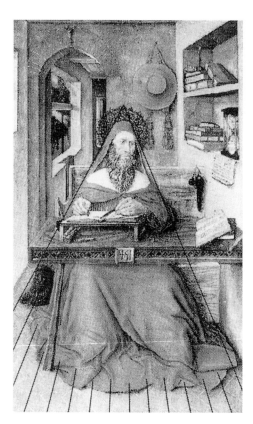

Reconstruction of the vanishing points of cat. 36

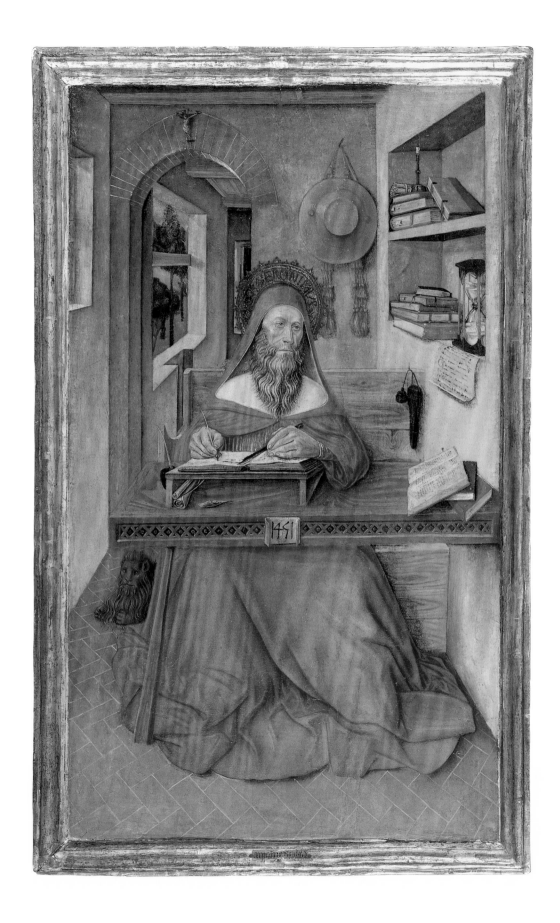

capable of inspiring the delicate pathos and employing the silvery light that constitutes the charm of Antonio da Fabriano's earliest works (see Urbani 1953, who nevertheless also gave credence to the Neapolitan theory; Reynaud 1989; Algeri in Algeri and De Floriani 1991; De Marchi 1994a; Cleri 1997a; Natale 2001). In further support of this hypothesis is the record of an "*Antonellus de Fabriano pictor*" (unfortunately without the patronymic) who was living in Genoa in 1447–48 and was married to an Albanian woman named Maria (Alizeri 1870–80, vol. I, p. 269). In Genoa, Antonio could have seen, either first hand or through copies, Jan van Eyck's *Saint Jerome in His Study* from a triptych that belonged to the Genoese merchant Battista Lomellini, and was later in the collection of Alfonso of Aragon in Naples. The affinities of the still-life objects in the background of Antonio's painting with those in Justus von Ravensburg's *Annunciation* of 1451 in the cloister of Santa Maria di Castello in Genoa (fig. 8, p. 72) are best explained by reference to a common prototype. By 1451 Antonio had already returned to the Marches, as is proven by the existence of a fresco of Saint Bernardino in the church of San Francesco at Gualdo Tadino—a work that bears that same date—and by two payments for the gilding of some candlesticks in San Venanzio, Fabriano, on January 31 and June 8, 1451 (Felicetti 1998, p. 221, docs. 228, 234). Moreover, the Eyckian character of von Ravensburg's *Annunciation* has long been recognized, although this painter—who also executed the cenotaph of Bishop Otto III von Hachberg in the cathedral of Constance and, later, an altarpiece formerly in Sant'Ambrogio at Brugherio as well as a *Mocking of Christ* at Chiaravalle, near Milan (Cavalieri 1998)—has more in common with Konrad Witz than van Eyck. What is strictly Eyckian in the Baltimore *Saint Jerome* is the articulation of the red cope spread out over the saint's feet. This may have been influenced by a specific work by van Eyck that was in Genoa: the triptych of 1437 owned by Michele Giustiniani and now in the Gemäldegalerie, Dresden, in which the elabo-

rate drapery folds were prompted by the protruding step in the foreground. In the present painting, an attention to the orchestration of light (somewhat diminished due to the abrasion of the paint surface) is Flemish—or, even more, de'Bardi-like in style. The effect is created by softly projected shadows and an overall impression of light filtering in through the windows and filling the room in an almost random fashion. Clearly, in this work Antonio is attempting a tight construction of space, but, at the same time, in contradictory fashion, he uses three distinctly different vanishing points (see ills.): for the floor, which is steeply sloped, and for the two side walls (see De Marchi 1994 a; and ills.).

During these same years, Fra Carnevale had returned to Urbino from Florence and taken his vows as a Dominican friar. There are precise indications of contact between the two artists—as, for example, in the realistic rendering of the arthritic hands of Saint Jerome and of the figures in Fra Carnevale's Franciscan polyptych (cat. 41 A–D), most likely dating to the early 1450s. The highly sensitive treatment of the skin of the elderly Jerome's emaciated face echoes the gaunt, wrinkled masks of the figures of Saint Peter and Saint John the Baptist in Fra Carnevale's polyptych, even though the fundamental temperaments of the two artists remain essentially antithetical. Rarely did Antonio's work attain a level of quality comparable to that of the *Saint Jerome*—perhaps only in the 1452 *Christ Crucified* (Museo Piersanti, Matelica). One strongly suspects, therefore, that his contact with the young Urbino painter, fresh from a decisive Florentine sojourn, stimulated him and provoked a more committed plastic and three-dimensional rendering of space. Thus, the comparison that can be made between the sharply foreshortened planes of the built-in bookshelves in the *Saint Jerome* and a similar detail in a drawing by Filippo Lippi for a *Saint Matthew* (The Pierpont Morgan Library, New York, inv. 1976.16) could be explained by a meeting between Antonio and Fra Carnevale—all the more probable as Antonio also worked in

Urbino, as attested by a recently discovered Crucifix in the church of Sant'Angiolino in Altavilla (now in the Museo Diocesano "Albani," Urbino; see Cleri 1997a, pp. 108–9).

ADM

PROVENANCE: Don Luigi Faustini, Fabriano (before 1834); Romualdo Fornari, Fabriano (by 1866–1910); A. S. Drey, Munich and New York (about 1911–12); Henry Walters, Baltimore (1911/12–31); The Walters Art Museum, Baltimore (from 1937).

REFERENCES: Ricci 1834, vol. I, pp. 176, 180 n. 5; Marcoaldi 1867, p. 9; Zeri 1948 b, p. 164; Bologna 1950, p. 97 n. 38; Urbani 1953, pp. 302, 306 n. 18; Donnini 1972, pp. 4, 9 n. 12; Zeri 1976, pp. 190–91, no. 125; Bologna 1977, p. 84; Reynaud 1989, p. 37; Algeri, in Algeri and De Floriani 1991, p. 165; De Marchi 1994a; Cleri 1997a, pp. 112–15; Natale 2001, pp. 39–40; Borchert 2002, no. 98; De Marchi 2002b, pp. 67–68.

[37]★

VARIOUS ARTISTS

Plutarch's *Lives* (*Vitae virorum illustrium*)

Manuscript containing portraits of: Brutus, f. 1;
Aratus, f. 16 v; Dion, f. 34 v; Mark Antony, f. 51;
Pyrrhus, f. 75; Sertorius, f. 87; Marcus Emilius, f. 96;
Cato the Elder, f. 107; Tiberius and Caius Gracchus,
f. 127; Lysander, f. 38 v; Sylla, f. 148 v; Lycurgus,
f. 165; Numa Pompilius, f. 177 v; Theseus, f. 189 v;
Romulus, f. 198 v; Alcibiades, f. 211 v; Phocion,
f. 214 v; Galba, f. 224 v; Otho, f. 233 v; and an
illuminated initial C, f. 225

Volume 2 of a three-volume manuscript: parchment
(binding restored, but with the original iron hinges),
66.2 x 24.7 cm
Biblioteca Malatestiana, Cesena (ms. XV 2)

Just as the Biblioteca Malatestiana, constructed
by 1452 next to the Franciscan convent in
Cesena by Matteo Nuti, is the chief architectural
monument of Malatesta Novello's court, so this
manuscript of Plutarch's *Lives* is its humanistic
and bibliographic masterpiece. Plutarch's
anthology was assembled with the help of the
humanist Francesco Filelfo, who had trans-
lated some of the *Lives* before 1454 and dedi-
cated them to Malatesta. The decision to make
this historical text a centerpiece of the library
was not an arbitrary one. As a youth, Novello,
together with his friend Lionello d'Este, had
studied with the great humanist and teacher
Guarino Veronese, who also had translated
Plutarch's writings. The *Lives* provided the
humanistically educated upper class with an
ideal repertory of ancient models of behavior
and culture, as exemplified by the dispute
between Guarino and Poggio Bracciolini over
the relative moral superiority of Caesar and
Scipio Africanus.

The model for Novello's library was the one
established by Cosimo de'Medici and designed
by Michelozzo at the Dominican monastery of
San Marco in Florence to house the collection
of the humanist Niccolò Niccoli. The San
Marco library consists of a single large hall
divided into three aisles, with a wide, barrel-
vaulted ceiling over the center one, and desks
to which the books were chained. There was a
steady correspondence between Malatesta
Novello and Cosimo, and sketches of the
library's floor plan may well have been sent to
Cesena from Florence (Volpe 1989, pp. 77–78).
The Biblioteca Malatestiana displays an obvious
architectural debt to Michelozzo in its columns,
with their Ionic and pseudo-Ionic capitals, and
tabernacle-style door topped by a tympanum—
a slightly more rustic version of the doorway to
Michelozzo's novitiate chapel in Santa Croce,
Florence (fig. 22, p. 61).

In recent decades the three Plutarch vol-
umes have been the subject of well-deserved
study and consequent fame. The first two vol-
umes (the second is exhibited here) and part of
the third were copied by Jacopo da Pergola, a
scribe whom Malatesta Novello employed fre-
quently in the 1440s and 1450s. It is not known
when the count actually commissioned this
ambitious project, although in 1453 he wrote to
Filelfo requesting a list of available Latin trans-
lations of Plutarch (Mariani Canova in Di
Lorenzo et al. 1991, p. 121). However, the task of
assembling the material had already begun in
the mid-1440s.

The first lives (those of Caesar and Alexander
the Great, in volume one) were decorated with
magnificent illuminations by a painter of the
School of Pisanello—identified by some schol-
ars as Matteo de'Pasti (Salmi 1961, p. 14;
Mariani Canova in Di Lorenzo et al. 1991, p.
124; Lollini 1995, p. 193) and by others as
Giorgio d'Alemagna (Boskovits 1995, pp. 457,
461 n. 15). As soon as fascicles of the *Lives* had
been transcribed, they were distributed to the
best masters available. The rest of the first vol-
ume was illustrated almost entirely by two
artists with a similar, local style that had a strong
Late Gothic flavor (Lollini 1995, pp. 194–95).
Boskovits has proposed identifying the second
master with Guglielmo Giraldi (1995, pp. 457,
460 n. 13).

The reader encounters a remarkably skilled
illuminator, who is responsible for some of the
last initials in the final volume and the first ones
in the second volume of the codex. He has
been identified as a member of the workshop
of Cristoforo and Lorenzo da Lendinara
(Salmi 1961, p. 15), a Paduan, Mantegnesque
master (Lollini 1995, pp. 196–97), or the
young Guglielmo Giraldi, whose pungent style,
bright colors, and awareness of the work of
Piero della Francesca made him a favorite both
at the Este court at Ferrara and the Gonzaga

1.
Taddeo Crivelli (?),
Initial *I* with a bust-length depiction
of Saint Augustine, from an illuminated
manuscript of Saint Augustine's
In Iohannis evangelium sermones.
Biblioteca Malatestiana, Cesena (ms. D.III.3, c. 7)

2.
Numa Pompilius, from an illuminated manuscript of
Plutarch's *Vitae virorum illustrium.*
Biblioteca Malatestiana, Cesena (ms. XV.2, c. 177v)

★ Shown only in Milan

court at Mantua during the 1450s and 1460s (Conti 1979a, p. 65 n. 1; Mariani Canova in Toniolo 1995a, p. 27; Boskovits 1995, p. 460 n. 13). The *Demosthenes* in the first volume (f. 319) is a memorable image: the figure's oversized head, crowned by a flame-like hood, is visible behind a little window, on the sill of which some small books are placed, without concern for their disproportionate size. This portrait bust demonstrates a better feeling for space than those on earlier pages, despite the fact that these last busts are more correctly proportioned in relation to their niches.

It is the fifth master that is of the most interest: a gifted artist, probably active in the mid-1450s, and identified by Salmi (1961) as the Camaldolese monk Fra Giuliano Amadei, an assistant to Piero della Francesca at Borgo Sansepolcro. Later, he had a brilliant career as an illuminator at the Roman Curia (see cat. 38). Although this identification is no longer tenable, the idea behind it is intelligent, since it takes into account some very evident borrowings from Piero. To varying degrees, historians have recognized the influence of Piero della Francesca (Lollini 1995, pp. 197–99; Mariani Canova in Di Lorenzo et al. 1991, pp. 127–28), if for no other reason than that the miniaturist displays a demonstrable ability to organize his compositions into perspective boxes and an often brilliant synthesis of volumetric forms of contrasting color. For a time his work was compared, generically, to the paintings of Piero's Ferrarese period, but recent attention has recognized in it a Central Italian component (Lollini in Toniolo 1998, p. 159), with certain Marchigian inflections. To the workshop of the "fifth master" (Lollini 1995, pp. 198–99) may be ascribed some of the most fascinating inventions in this volume: the *Alcibiades,* with his flared, Byzantine hat—like those worn by the figures in Piero's frescoes at Arezzo—and a background of roses against an intense blue sky, not too different from that in Fra Carnevale's *Saint John the Baptist* (cat. 41 A). Other examples are the *Galba,* copied from a Roman Imperial coin, but depicted beneath a courtly canopy, and the *Numa Pompilius,* shown in a study furnished with a still life of books (see fig. 2). The prototype for the *Numa Pompilius* is an initial on the frontispiece of Saint Augustine's *In Iohannis evangelium sermones* (ms. D. III.3, f. 7: see Mariani Canova in Di Lorenzo et al. 1991, pp. 325–29), another codex from the Malatestiana scriptorium. Inside a

feigned *spolia*—a marble enclosure with a double opening decorated with fusaroles and leaves—is a portrait of Saint Augustine within an initial decorated with gems, among the earliest examples of the type in Italian Renaissance miniatures (fig. 1). Eyes raised to the sky, his large head crowned by a subtly tooled gold-leaf halo that protrudes from the frame, Augustine occupies a small, austere cell containing a marvelous still life of a crucifix posed on a perspectively rendered, rustic console, on which is a Perugia-cloth canopy and a rosary of large coral beads that casts a clearly defined shadow on the wall. This miniature, the product of an artistic temperament clearly influenced by Piero della Francesca, seems to be recorded in the account book of the great Taddeo Crivelli in 1452 (Salmi 1931, pp. 61–62; Toniolo 1995b, pp. 146, 152 n. 9). Scholars have accepted this identification warily, more on the strength of the documentation than on the basis of style (Lollini and Conti have rejected the attribution: see Conti 1990, p. 9). Whatever the case may be, and while acknowledging that the illuminator of much of Borso d'Este's celebrated Bible created a similar initial, the expressive treatment of the face and the attention to realistic details cannot help but recall the work of the most brilliant Marchigian painters, such as the Franciscan polyptych (cat. 41 A–D) by Fra Carnevale, or the *Annunciation* (fig. 1, p. 66) by Giovanni Angelo d'Antonio.

The fifth master was certainly familiar with the illustrations in the beautiful Augustinian codex, since he borrowed its boxes shown in perspective, its distinctive sense of space and expressive treatment of physiognomy, and even its ancient-styled epigraphic characters, such as the graceful capital G with its horizontal cut and long descender leg (which is partly covered in the *Alcibiades*). That our master may have been from the Marches is suggested by the portrait of Galba (see ill.), with his unshaven face, dark-ringed eyes, and luminous hair, every lock of which is described: features that recall contemporary works by Giovanni Boccati (fig. 3) and Giovanni Angelo. If, in those still lifes of foreshortened books, we may detect the influence of Paduan art, it is of the sort that attracted the Camerino painters, whether Boccati, the Master of Patullo (the artist we now know as Gerolamo di Giovanni), or Giovanni Angelo.

The humanistic passion of Malatesta Novello was genuine, and he proved his competence in assembling his library by his care in

3.
Giovanni di Piermatteo Boccati, *Pergolato Altarpiece,* detail showing Saint Dominic. Galleria Nazionale dell'Umbria, Perugia

obtaining the least corrupt versions of the classics. He sought out numerous artists with differing backgrounds, including some from neighboring states. His close relationships with the Montefeltro were consolidated in 1442 by his marriage in Gubbio to Violante Montefeltro, the half sister of Federigo.

A decisive change in decorative style is evident in the work of the last master in the Plutarch volumes: the illuminator of the *Otho* (f. 233 v) and the *Crassus* (f. 19 v), first identified as Taddeo Crivelli by Salmi (1931, p. 66) and later as Giorgio di Alemagna or another anonymous Ferrarese master (Lollini 1996, pp. 105–6 n. 25). This shift in direction in the culture of post-1450 Ferrara is exemplified by the *studiolo* of Borso d'Este, the decoration of which involved Cosimo Tura and his workshop, Michele Pannonio, and Angelo Maccagnino. Nothing is more indicative of these new tendencies than the narrow, porcelain-like faces, elongated eyes, billowing garments, and *all'antica* armor, or the strange intertwining of letters with the figures within their niches.

M C

PROVENANCE: Biblioteca Malatestiana, Cesena.

REFERENCES: Salmi 1931; Salmi 1961, pp. 13–16; Conti 1979a; Todini in London 1984, pp. 116–17; Volpe 1989, pp. 75–99; Conti 1990; Mariani Canova in Di Lorenzo et al. 1991, pp. 121–28; Mariani Canova in Dal Poggetto 1992a, pp. 258–61; Boskovits 1995; Lollini 1995; Mariani Canova 1995; Mariani Canova in Toniolo 1995a, p. 27; Toniolo 1995b; Lollini 1996; Toscano in Marini 1996, pp. 136–37; Lollini in Toniolo 1998, pp. 158–59; Filippini 2001; Lollini 2002.

·GALBA· ROMANO·

Othon
Plutar
p
lu
qu
se
n
nunq
um fe
dente

[38]

GIULIANO AMADEI

Frontispiece to Lactantius's *Divinae institutiones*

Bound manuscript, 207 folios: tempera and gold on
parchment, 343 x 244 mm; leather-covered binding
with studs (spine restored in the 18th century)
Biblioteca Comunale degli Intronati,
Siena (ms. X.V.4)

The artist who decorated this manuscript by
Lactantius was initially thought to be
Ferrarese (Muzzioli 1953). Later, Salmi (1954)
ascribed this and some other codices by the
same hand to "Michele da Carrara." Without
doubt, the artist in question was by far the most
versatile and prolific miniaturist working for
the papal Curia during the three decades from
the pontificate of Pius II to that of Innocent
VIII, and although his oeuvre has been vari-
ously and partially reconstructed—and ascribed
to Michele da Carrara, Pseudo-Michele da
Carrara, the Master of the Missal of Innocent
VIII, or the Master of the Studioli—he should
be identified with the Camaldolese monk of
Florentine origin Giuliano Amadei (De Marchi
1995), who was educated as a miniaturist in the
circle of Fra Angelico and in the celebrated
school of Santa Maria degli Angeli. About 1460,
Amadei collaborated with Piero della Francesca
in Sansepolcro. He then moved into the local
Camaldolese abbey, and went on to launch a
career in Rome during the pontificate of Pius
II Piccolomini, perhaps with the help of Piero
himself as well as of the architect Francesco del
Borgo. The most probable date for the
Lactantius manuscript is the second half of the
1460s, when Giuliano Amadei was introduced
into the Curia of Paul II and undertook
numerous decorative projects of varying genres
for rooms in the Palazzo di San Marco. The
German scribe who signed the manuscript "*per
manus Petri de Middelburch*" (f. 206r) worked in

Rome during these years and copied another
codex decorated by Amadei, Cicero's *Orationes*
(Biblioteca Nazionale Centrale, Florence, ms.
Landau-Finaly 21), for the bishop of Padua
Jacopo Zeno; it was probably commissioned
when Zeno was living in Rome, between 1464
and 1469.

The frontispiece of the Lactantius is on folio
5r and follows a *Commendatio Lactancii per
Hieronimum*. It contains a vignette, rectangular
in format (100 x 77 mm), showing Lactantius
at work in his study. In many of the humanist
and patristic codices illustrated in the 1460s—
especially a large group decorated for the
Sienese doctor Sozino Benzi, chief physician to
Pius II (Dillon Bussi 1993)—Giuliano Amadei
amused himself by depicting the author of each
work in his study, but for the most part he rep-
resented them inside decorative initials or in
small pictures—never one so large as here. The
artist's perspective is empirical, but the scene
has an airy effect due to the vivid colors—the
violet walls, the starry blue vault, and pink-tiled
floor. An atmospheric sky—its obvious naïveté
notwithstanding—also contributes to the
charm of Amadei's predella to Piero della
Francesca's *Misericordia Altarpiece* (Pinacoteca
Civica, Sansepolcro), based on a drawing by
Piero of about 1459–60, and a similar sky also
appears as the backdrop for the three medal-
lions inserted in the borders of the frontispiece.
This device is characteristic of Amadei's codices
dating from the time of Pius II and Paul II. In
the medallion on the left is a head with a crown
of laurels, probably an imagined likeness of
Lactantius; the bust in the medallion at the top
of the page is probably that of Christ, although
without a halo. A struggle between a centaur
and a dragon—a subject hardly in keeping with
the book's religious content—is inserted, with
a nonchalance typical of the Camaldolese
monk, in the medallion on the right. The initial
M is inscribed inside a rectangular picture field
with a white vine-leaf pattern (a humanist dec-
oration known as *bianchi girali*). The margins are
adorned with a continuous trellis of blue,
green, and pink vines, with yellow roses, on a
black background. The medallion of intersect-

ing arches at the bottom of the page once con-
tained a coat of arms; this decorative motif,
which recurs in a 1485 codex by Amadei—an
edition of Pausanias (Biblioteca Medicea
Laurenziana, Florence, ms. plut. 56.11)—is typi-
cal of Roman illustration of the 1460s, and is
found, mutatis mutandis, in codices decorated
by, among others, Gioacchino de Gigantibus
and Andrea da Firenze.

In producing manuscripts dominated by the
use of *bianchi girali* for a library such as that of
Pius II, with its rather standardized conven-
tions, Giuliano Amadei distinguished himself by
the inclusion of the more imaginative and lively
blue, pink, and green vines set against the black
background. Over the course of the 1470s,
working alongside a scribe such as Bartolomeo
Sanvito and having the chance to train as a
miniaturist so talented an artist as Bartolomeo
della Gatta, Amadei perceptibly changed his
system of ornamentation, opting for more airy,
classicizing solutions that, in their details, never-
theless remain quite fanciful and chromatically
linked to his formative period with Fra
Angelico. Even the margins of this frontispiece
contain delightful little details, such as the two
leopards in the *bas-de-page* medallion or the
numerous putti, either perched in the branches
or frolicking, holding heavy festoons, playing
musical instruments, chasing butterflies, hug-
ging rabbits, or leading stags on leashes.

The incipit of the seven books that make up
the *Divinae institutiones* and the *Liber de ira Dei*
(f. 166v), the *De opificio Dei* (f. 183r), and the
Epitome divinarum institutiones (f. 198r) are deco-
rated with gold letters and tree branches in
three different colors (blue, green, and pink or
violet) on a black background, and vary in for-
mat (they measure between 45 to 78 by 62 to
70 millimeters).

ADM

PROVENANCE: Biblioteca Comunale degli Intronati,
Siena.

REFERENCES: Muzzioli 1953, p. 363, no. 571; Salmi
1954, pp. 99–100; Ruysschaert 1969, pp. 215–16;
Garosi 1978 (2002 ed.), pp. 40–41, no. 11; Dillon Bussi
1993, p. 766; De Marchi 1995, p. 154, no. 21.

LELII CELII FIRMIANI LACTANCII DE FALSA
RELIGIONE LIBER PRIMVS FOELICITER INCIPIT

AGNO ET EXCELLENTI
ingenio uiri cum se doctrine
penitus dedissent quicquid la
boris poterant impendi con
temptis omnibus, & priuatis
et publicis actionibus ad inq
rende ueritatis studium contu
lerunt existimantes multo ee
preclarius humanarum diui
narumq; rerum inuestigare ac
scire rationem q struendis opi
bus aut cumulandis honorib;
inhaerere. Quibus rebus quo
niam fragiles terreneq; sunt
& ad solius corporis pertinent
cultu nemo melior nemo iustior effici potest. Erant illi quidem uerita
tis cognitione dignissimi quam scire tantopere cupiuerunt atq; ita ut ea
rebus omnibus anteponerent. Nam et abiecisse quosdam rei familiaris
suas et renunciasse uniuersis uoluptatibus constat ut solam nudamq;
uirtutem nudi expediti; sequerentur tantu apud eos uirtutis nomen
et auctoritas ualuit ut in ipa ee summi boni predicarent. Sed neq; adepti
sunt id quod uolebant et operam simul atq; idustriam perdiderut quia
ueritas i archanum sumi dei qui fecit omnia ingenio ac propriis sensib;
no pot comprehendi. Alioquin nihil inter deum & hominem distaret si
consilia et dispositiones illius maiestatis eterne cogitacio assequeretur hu
mana.
Vod quia fieri non potuit ut homin per se ipm ratio diuina notesceret no
est passus hominem deus lumen sapientie requirentem diutius errare ac si
ne ullo laboris effectu uagari per tenebras in extricabiles. Aperuit oculos e
aliqu et notionem ueritatis munus suum fecit ut et humana sapientiam nul
lam ee monstraret. et erranti ac uago uiam consequende immortalitatis
ostenderet. Verum quomam pauci utuntur hoc celesti beneficio ac mu
nere quia ob uoluta in obsecro obscuro ueritatis latet eaq; uel cotemptui

[39]

AGOSTINO DI DUCCIO

Saint Bridget of Sweden Receiving the Rule of Her Order

Marble, 42.6 x 63.8 cm
The Metropolitan Museum of Art, New York.
John Stewart Kennedy Fund, 1914 (inv. 14.45)

This relief originally embellished the pre-della of an altar dedicated to Saint Lawrence in San Domenico, Perugia, commissioned in 1459 from Agostino di Duccio by the heirs of Lorenzo di Giovanni di Petruccio, who were represented by Lorenzo's sister Donna Brigida. The painter Bartolomeo Caporali witnessed the contract. The altar was completed in nine months. When it was refashioned in 1482, Donna Brigida gave the sculptures from the altar to the friars of San Domenico. Mercurelli Salari (1995) has demonstrated beyond doubt that this relief comes from the altar and that its subject is Christ presenting Saint Bridget (namesake of Donna Brigida) with a scroll containing the rule of her order, which was ratified by Urban V in 1370. Previously, the relief was believed to show another saint, to be an enigmatic rendering of the Virgin, or even to represent Christ returning to the Virgin after the dispute in the Temple (Bode 1914). Mercurelli Salari proved that Agostino took the scene of the order's bestowal from Book VIII of the *Revelations* of Saint Bridget. (For earlier renditions in illuminated manuscripts, see Aili and Svanberg 2003.) An illuminated initial in Palermo shows Bridget receiving a scroll from Christ on high with one hand and simultaneously passing it on to her novices with the other hand (Aili and Svanberg 2003, vol. 2, pl. 29). Angels sometimes assist in the scene (ibid., pl. 35), but not so prominently as here, where two, sinuously draped, enwreathe the presentation in laurel before a delicately sketched townscape and sky in which we detect a trumpeting angel and a zephyr-like head (that must represent the holiness of the discourse between Bridget and her extraordinarily youthful Savior—

at most, in his early teens) as well as a sun with a face and a crescent moon. The sphinx crouched at Bridget's feet endows her low throne with the authority of the Virgin Mary's *Sedes Sapientiae* (Seat of Wisdom).

The peripatetic Florentine Agostino di Duccio was one of the most imaginative and poetic talents operating in northern Italy during the years of Fra Carnevale's long sojourn in Urbino. The grace and the packed but animated surfaces of his reliefs surely impressed painters and sculptors alike. If the two artists did interconnect, Agostino would have reinforced Carnevale's Florentine roots. Agostino served as a carrier of the emotive facial types and energetic figures of Fra Filippo Lippi and of the Luca della Robbia of the *Cantoria*—the characteristics of which continued to distinguish and envigorate the productions of Florentines relocated farther north.

Having executed the reliefs in the Tempio Malatestiano in Rimini (1449–57), his most celebrated achievement, Agostino moved to Perugia. There, he began work on the façade of the Oratory of San Bernardino (1457–62) before taking up the lesser job of the altar of San Lorenzo in San Domenico, of which the present relief is the most exquisite remnant (for those sculptures still in situ in the chapel, see Cuccini 1990, plates 36, 37, 37, 39, 41, 43). His consistently well-organized workshop remained faithful even to his most ethereal concepts. That is not to imply that there was any intervention in this relief, whose curling folds and parenthetical rhymes are more personal than those in most of his standardized, tubular figures for Perugia, such as the ones on the façade of San Bernardino and those that still adorn the chapel in San Domenico.

JDD

PROVENANCE: Church of San Domenico, Perugia (1459–82; given by Donna Brigida di Giovanni di Petruccio to the friars of the church); London art market (1875); M. Châtel, Lyon (from 1875); Édouard Aynard, Lyon (sale, Drouot, Paris, December 8–11, 1913, no. 267); C. and E. Canessa, New York (until 1914); The Metropolitan Museum of Art, New York, 1914.

REFERENCES: Rossi 1875, pp. 79–81; Giraud 1878, p. xvi; Bertaux 1906, p. 93; Pointner 1909, pp. 179–82; Bode 1914, pp. 336–42; Gurrieri n.d., pl. 16; Santi 1961, pp. 162–63; Mercurelli Salari 1995, pp. 41–46.

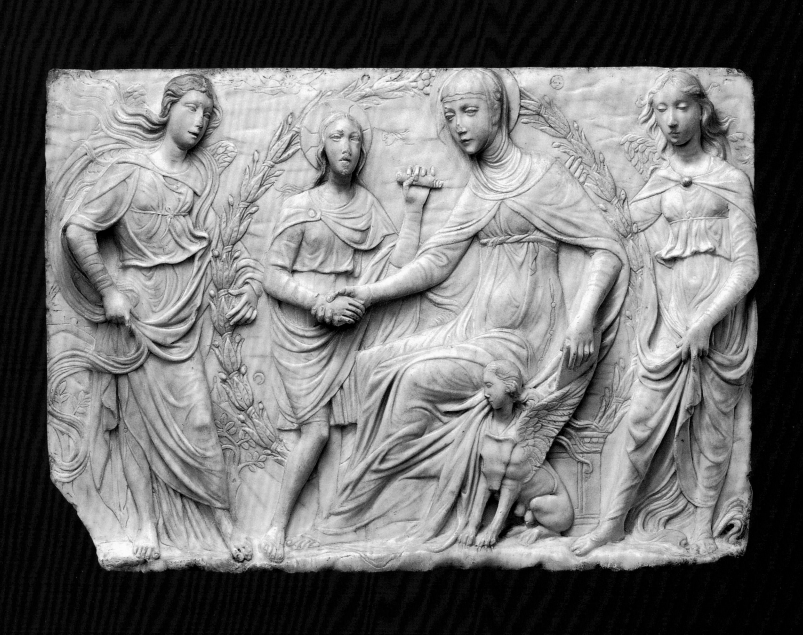

[40]

FRA CARNEVALE

The Annunciation

Tempera and oil (?) on wood, 87.6 x 62.8 cm
National Gallery of Art, Washington, D.C.
Samuel H. Kress Collection (1939.1.218)

The earliest reference to this enchanting picture is in a notebook of the great connoisseur and art historian Giovanni Cavalcaselle. Sometime between 1857 and 1858 he saw the painting, which he ascribed to Filippo Lippi, in the palace of Giuseppe Strozzi in Florence (see Boskovits in Boskovits et al. 2003, p. 185 n. 1). That it is by the Master of the Barberini Panels—that is, Fra Carnevale—was first recognized by Offner. Based on the resemblance of the figure types and landscape to those by Filippo Lippi, and the similarity of its architectural setting to works by Domenico Veneziano, he dated the picture to about 1448—now widely accepted. The painting must have been intended for private devotion.

The composition was inspired by two of Lippi's altarpieces: an *Annunciation* (fig. 13, p. 51) in San Lorenzo, Florence, usually dated to about 1440 (but see Merzenich 1997) and another (fig. 5, p. 43) in the Alte Pinakothek, Munich, that was painted about 1443–45 for the nuns of Le Murate in Florence (see cat. 5). From the first of these derive the pose and upward gaze of the angel, the solid halos with channeling, and the steep perspective of the buildings terminating in a salmon-colored wall with an open door (the *porta coeli,* an allusion to the Virgin as the gate of heaven). From the second, Fra Carnevale has taken the modest stance and gesture of the Virgin, whose heavy-lidded eyes and delicate features are typical of Lippi's figures in works from the mid- to late 1440s. What is completely original to this depiction is the idea of staging the Annunciation in a street bordered by elegant colonnades rather than in the Virgin's bedroom, a cloister, an enclosed garden, or a church-like interior space, as was traditional. The matter has not been commented upon, but it is the clearest indication of Fra Carnevale's primary interest in architecture and perspective and his willingness to dispense with conventional iconography. Are we to imagine

that the Virgin has just stepped out of a convent, the portico of which is behind her? The strangeness of finding a classical vase of roses on this luxuriously paved street could hardly be greater (the vase was painted over the completed pavement). Incisions in the surface reveal that originally Fra Carnevale planned a hexagonal-shaped well behind the angel—a detail that would have left no space for Gabriel, and that suggests that the scene initially was conceived in terms of an architectural view more common to the medium of intarsia than to painting (fig. 34, p. 86). If, mentally, we remove the vase and the angel, substituting the well, as had been planned, the *Annunciation* may be seen as a first step toward a painting in the Palazzo Ducale in Urbino—the great city view that, in the sixteenth century, bore a spurious attribution to Fra Carnevale.

The buildings, with their salmon and pink trim, are distinctly Florentine in style, although completely unlike those in Lippi's work. (Throughout his career Lippi avoided broad, flat walls, preferring surfaces articulated with rectilinear moldings, often inset with veined marble, such as are found in Masaccio's fresco in the Brancacci Chapel, Florence, of Saint Peter raising the son of Theophilus.) The unornamented arches of two of the buildings recall those in the background of Ghiberti's relief of Solomon and the Queen of Sheba on the *Gates of Paradise* of the Baptistery in Florence, and the Ionic portico is distinctly Michelozzan (as noted by Strauss, the Ionic capitals are virtually identical to those Michelozzo employed in the courtyard of the Palazzo Comunale in Montepulciano, begun in 1440). The picture is clearly earlier than the ex-Barberini Panels, from a moment when the memory of his Florentine training was still fresh and Fra Carnevale had not yet encountered the example of Piero della Francesca, whose shadow falls across his later work. (For an alternative view, see the essay by De Marchi.)

Whether the picture was actually painted in Florence prior to about 1450, possibly for a member of the Strozzi family, or whether it dates from a few years later, as the present writer is inclined to think, must remain conjectural. Although by late 1449 Fra Carnevale was again in Urbino, there is no reason to assume that he did not return to Florence, especially as he was involved with the building of the Renaissance portal on San Domenico in his

native city (see Strauss 1979, pp. 126–35: payments for the door were made to Maso di Bartolomeo and Luca della Robbia from 1449 to 1454; Fra Carnevale is first cited in December 1449, by which time he had become a Dominican friar: see the appendix by Di Lorenzo). There is, moreover, one non-Florentine feature in the picture that needs to be accounted for: the Gothic trilobate arch of the window in the background, which is distinctly Umbrian (we find examples in Benozzo Gozzoli's frescoes in San Francesco, Montefalco). This motif suggests that the *Annunciation* was painted after a trip to Perugia, and we must allow that Fra Carnevale closely studied the outstanding works to be seen there. The sharply incised folds of the angel's robe, the brilliant lighting, and the cloud-scudded sky are, indeed, even more strongly reminiscent of Fra Angelico's altarpiece for the church of San Domenico, Perugia, than they are of the work of Domenico Veneziano, who, prior to undertaking his frescoes (destroyed in 1594) in Sant'Egidio, Florence, of scenes from the life of the Virgin, painted a fresco cycle (1437–38; destroyed) in the Palazzo Baglioni, Perugia. While little has survived of Veneziano's work, we can nonetheless affirm that the delicate color harmonies of the present *Annunciation* reflect his paintings of the mid- to late 1440s, not those of the 1430s, and the sophisticated treatment of space—the asymmetric placement of the buildings and the syncopated rhythm they describe, with the right-hand loggia extending farther into the foreground than the left-hand one—is no less indebted to Veneziano's example (see cat. 22 B). Where Fra Carnevale differs so strikingly is in his lack of interest in using the perspective structure to reinforce the narrative: in his work the figures read as ancillary to the setting.

The perspective system is as rigorous as in the ex-Barberini Panels (cat. 45 A-B). A pinhole indicating the vanishing point has been made in the right doorjamb, eight centimeters from the base of the door; virtually all the orthogonals recede to this point (notwithstanding the analysis proposed by Roccasecca 2002). Pinpricks along the vertical edges of the panel indicate the placement of transversals for the perspective grid (clearly, the perspective system was studied separately, on a piece of paper, and transferred to the panel). Throughout the painting the architectural features are inscribed.

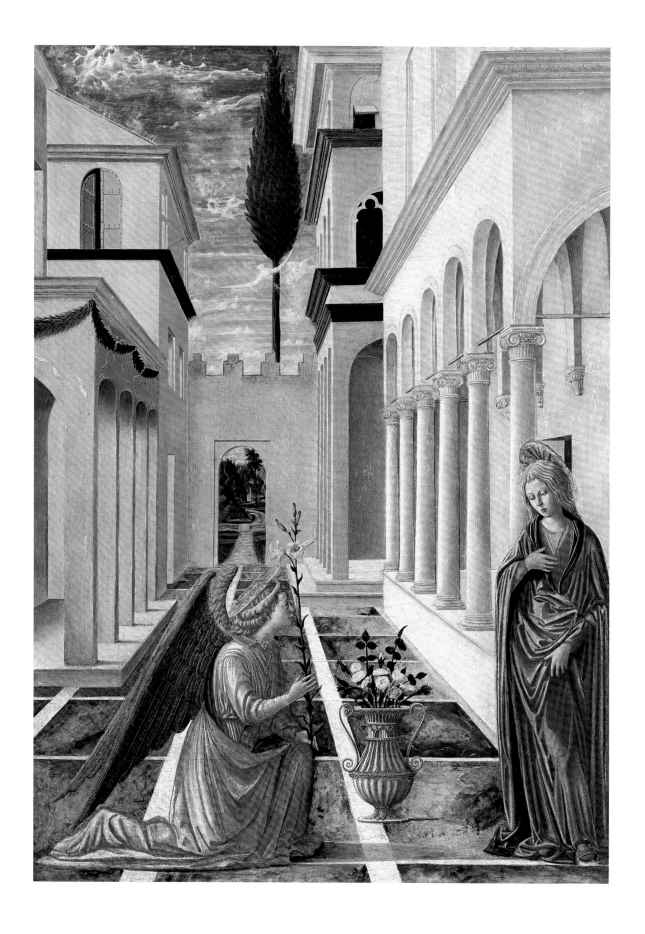

Some minor details, such as the angles at which the window shutters of the building at the left are open, seem to have been determined by drawing diagonals from the point where the horizon line intersects the vertical edges of the painting. Thus, even at this stage in his career Fra Carnevale reveals an interest in the geometry of perspective that aligns him with Uccello and even Piero della Francesca.

KC

PROVENANCE: Prince Ferdinando Lorenzo Strozzi, Florence (by 1857–58); Charles Timbal, Paris (until 1871); Gustave Dreyfus, Paris (1871–1914); his heirs (1914–30); Duveen Brothers, Inc., London and New York (1930–36); Samuel H. Kress Foundation, New York (from 1936).

REFERENCES: Crowe and Cavalcaselle 1864–66, vol. 2, p. 348; Offner 1939, pp. 236–46; Richter 1940, p. 313; Zeri 1953, pp. 130–31; Zeri 1961, pp. 29, 36–40, passim; Christiansen 1979, p. 200; Shapley 1979, pp. 309–11; Strauss 1979, pp. 41–56; Zampetti 1988, p. 394; Dal Poggetto 1992a, p. 307; De Marchi 1993a, pp. 90–91; Echols in Supplement to Millon and Magnago Lampugnani 1994; Boskovits in Boskovits et al. 2003, pp. 182–86.

[41 A]

FRA CARNEVALE

Saint John the Baptist

Tempera and oil on wood, 79.7 x 44 cm
Museo della Santa Casa, Loreto

[41 B]

FRA CARNEVALE

The Crucifixion

Tempera and oil on wood, 102.5 x 66.8 cm
Galleria Nazionale delle Marche, Urbino

[41 C]

FRA CARNEVALE

Saint Peter

Tempera and oil on wood, 140.5 x 45.7 cm
Pinacoteca di Brera, Milan

[41 D]

FRA CARNEVALE

Saint Francis

Tempera and oil on wood, 129 x 50 cm
Pinacoteca Ambrosiana, Milan

In 1979, Christiansen (p. 201 n. 8) suggested that these four panels, each with a different provenance and critical history, belonged to a single altarpiece, but it was Andrea De Marchi (1993, pp. 91–92) who insisted on the fact and provided the basis for a reconstruction by moving beyond the scattered, enthusiastic remarks and passing references—as well as the occasional, embarrassing silences—they have inspired. For some time a relationship between the *Saint John the Baptist* and the *Crucifixion* had been recognized, as had a connection between the *Saint Peter* and the *Saint Francis,* but the four panels had not been explicitly shown to be related (see, however, Dal Poggetto 1992a). The examination of the carpentry of the panels undertaken for this exhibition demonstrates that, despite discrepancies in the dimensions of the painted surfaces, the four works are, indeed, from a single polyptych that consisted of ten panels arranged in two registers (see the essay by Castelli and Bisacca).

With the exception of the *Saint John the Baptist,* which has suffered from a harsh cleaning that in some places removed almost all of the paint surface, the panels are in more than satisfactory condition. Unfortunately, the fact that so many of them are still missing, in addition to the loss of the frame (although parts remain on the *Saint Peter*), strongly limits our understanding of the altarpiece as a whole.

None of the panels can be traced back before the mid-nineteenth century. The *Saint Peter,* now the property of the Santa Casa in Loreto, bears the inventory number 71, but the date it entered the collection is unrecorded (I am most grateful to Msgr. Floriano Grimaldi for his assistance with the archives at Loreto). There is, however, a notice in 1853 that this panel was restored by an artist from Macerata named Giuliani, who worked at the Santa Casa in the 1850s. The losses the panel sustained—probably from Giuliani's intervention—led to another restoration in 1953, this time under the auspices of the Istituto Centrale per il Restauro in Rome, and to the one carried out for this exhibition by Barbara Ferriani, with funding provided by Bruno Munheim.

In the early twentieth century the *Crucifixion* belonged to a Roman dealer named Attilio Simonetti, who claimed that it came from the Marches (Vitalini Sacconi 1968, p. 250 n. 422). In the 1940s it was in the collection of Vittorio Cini in Venice, where it was noted by Zeri (1948a). Acquired by the Italian government, it was assigned to the Galleria Nazionale delle Marche in 1987, at which time it underwent a restoration, carried out by Anna Gasparini and Giuliano Rettori (Dal Poggetto 1988).

The *Saint Peter* was bequeathed to the Brera in 1903 by Casimiro Sipriot (Soprintendenza per il Patrimonio Storico Artistico e Etnoantropologico, Milan, Archivio Corrente 15/118), but nothing is known of its earlier history (Daffra in Zeri 1992).

In 1902, Toesca saw the *Saint Francis* in the town of Cagli, south of Urbino (Zeri 1961).

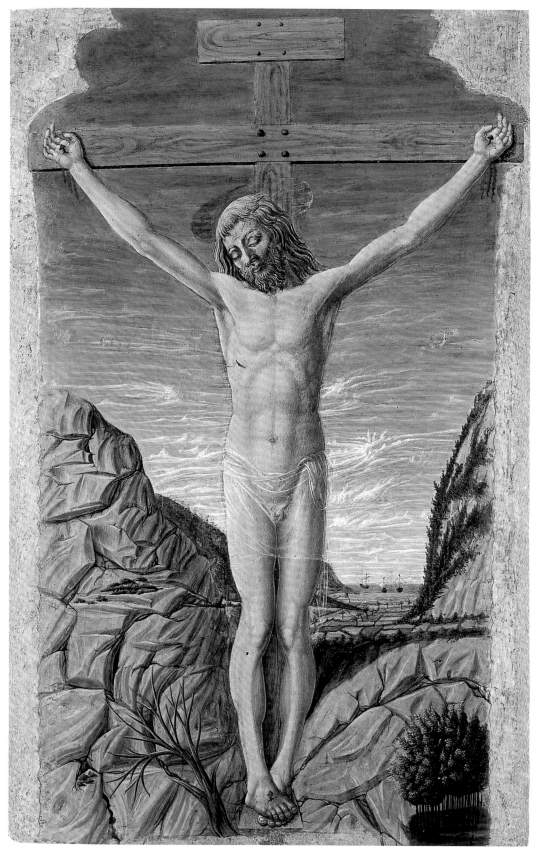

41 B

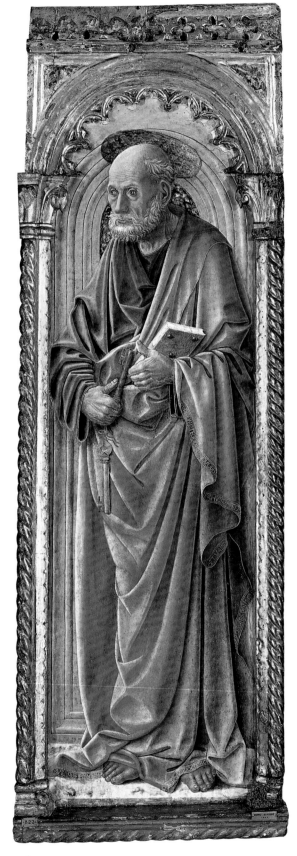

41 C

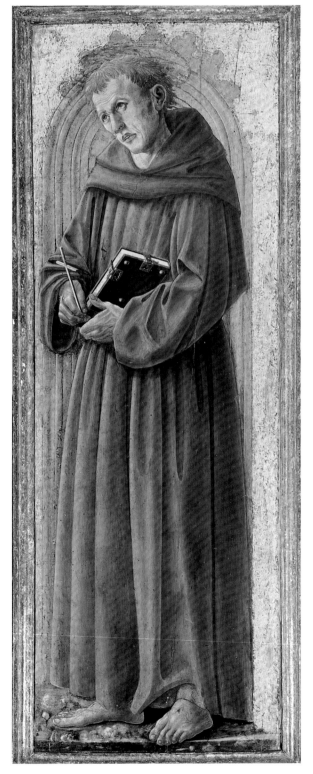

41 D

According to Fiocco, at some point it was in the Bruini collection in Modena before entering the Messinis collection in Venice (Zeri 1958), and then the Brivio collection (1954); Brivio left the picture to the Ambrosiana (1959).

There is a presumption that these panels, perhaps separated from one another as a result of a campaign of ecclesiastical modernization, were dispersed in the nineteenth century as a direct result of the vicissitudes that decimated the artistic patrimony of the church—both through the successive suppressions of ecclesiastical institutions and the revival of the art market. We can do little more than guess at the original location of the polyptych. However, recently two hypotheses have been put forward, albeit very cautiously. Tambini (2004) suggested that the altarpiece came from the basilica at Loreto, while Borsi (2003), who implicitly accepted a yet-to-be-proven relationship between the antiquarian Attilio Simonetti and the Simonetti family of Osimo, believed that the *Crucifixion* (and thus the entire polyptych) came from Osimo, which is not far from Loreto. Borsi further suggested that the work was commissioned by Gaspare Zacchi da Volterra, the vicar of Cardinal Bessarione, a friend of Leon Battista Alberti and, after 1460, Bishop of Osimo.

At first glance, the critical reception and attributional history of the four panels is remarkably varied. The marvelous *Crucifixion* was the first to be attributed to the artist then known as the Master of the Barberini Panels (Offner 1939); it had previously been assigned, variously, to Giovanni Boccati, Piero della Francesca, and Domenico Veneziano. Offner placed the *Crucifixion* after the Washington *Annunciation* (cat. 40) because it displayed a less exclusive debt to Florentine culture—exemplified in the work of Domenico Veneziano and of Filippo Lippi dating between 1455 and 1460—and combined echoes of Lombard art, especially the motif of the crucified Christ shown frontally, against a broad landscape. Although Richter (1940) accepted Offner's reconstruction of the oeuvre of the Master of the Barberini Panels, he nonetheless rejected the *Crucifixion*, identifying it as the work of a Paduan master. Roberto Longhi (1940) associated the *Crucifixion* with the *Saint John the Baptist,* but he ascribed both paintings to Ludovico Urbani, discarding Berenson's 1910 attribution to Marco Zoppo and Salmi's (1936, p. 91) to a

Domenico Veneziano,
Saint John the Baptist and Saint Francis.
Santa Croce, Florence

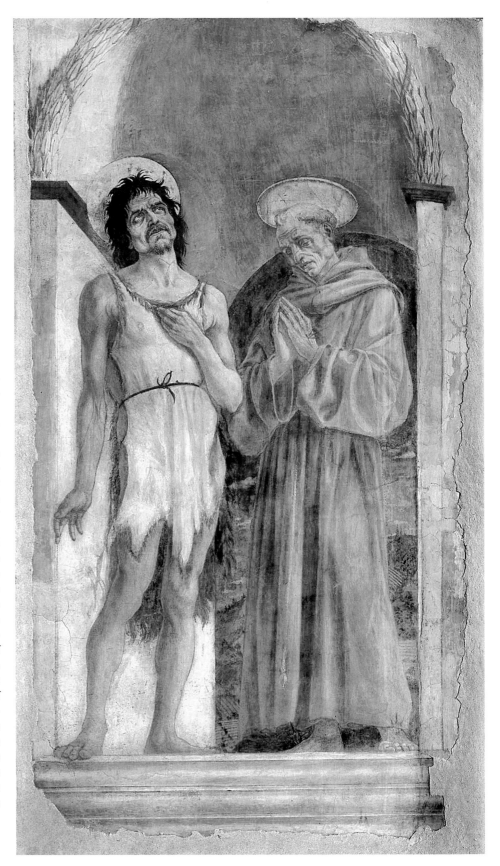

follower of Domenico Veneziano. Initially, Zeri (1948a) agreed with Longhi's assessment.

When the *Saint Peter* was left to the Brera, it was attributed to Masaccio, but that ambitious suggestion was quickly discarded (Malaguzzi Valeri 1904), and it was ascribed to an Umbro-Marchigian master and, more specifically, to a follower of Crivelli influenced by Piero della Francesca. Berenson (1936) and Fiocco (1955) favored Nicola di Maestro Antonio di Ancona, to whom Fiocco also attributed the *Saint Francis* (for which Adolfo Venturi [in a letter of 1932] had proposed the young Cosmè Tura, influenced by Piero della Francesca's work in Ferrara). Yet, as early as 1953, Zeri gave all four pictures to the Master of the Barberini Panels. He repeated this attribution in his 1961 book, dating them after the Barberini Panels, and this view has been widely accepted—except by Previtali (1970) and Conti (in De Angelis and Conti 1976), who ascribed the two panels in Milan to Giovanni di Piamonte, a follower of Piero della Francesca.

Reviewing these varied opinions, it is clear that they were based on the expressive tension of the four figures, with their remorselessly wrinkled and withered skin, lean faces, and swollen joints. These features have been interpreted as reflecting Ferrarese painting, the Paduan or Adriatic school of Squarcione, or the eccentricities of Marchigian art. From these traits derive the emotional tone of the paintings—a sort of dolorous concentration that reaches a subsiding climax in the figure of the crucified Christ, shown abandoned against the sky, his arms outstretched, the landscape seeming to bring him even closer to the viewer.

Domenico Veneziano,
Saint Lucy Altarpiece, detail.
Galleria degli Uffizi, Florence

The compressed space of the niches, entirely filled by the figures, contributes greatly to the impact the paintings make. However, the physical density of the figures is negated by the treatment of the drapery, whose deep shadows cut into the substance of the underlying body while the highlights are delicately brushed in. The self-contained pathos of the figures and the way they dominate the architectural setting are unique in Fra Carnevale's small oeuvre, and they make a comparison with his other work all the more difficult, despite the evident continuity in the artist's pictorial style. Still, we find here those liquid, transparent paint layers combined with other, thicker ones, almost possessing the tactility of a relief—as, for example, on the rosebush behind Saint John the Baptist. Note, too, that the architectural framework was painted with glazes through which the warm ground is visible.

That the panels made scholars uneasy is apparent from their often brief mention (in her excellent thesis, Strauss hardly dealt with them) or from the various dates assigned to them (for which, see Zeri 1961; De Marchi 2002b). This exhibition provides an opportunity for a direct comparison with the rest of the artist's surviving works. Nonetheless, when the panels are examined alongside the Washington *Annunciation,* it is evident that the artist has transferred his attention from Filippo Lippi to Domenico Veneziano. One sees this both in the limpid tonalities and motifs that derive from the *Saint Lucy Altarpiece* (ill.; fig. 21, p. 60) and, above all, in the artist's careful assessment of Domenico Veneziano's fresco of *Saint John the Baptist and Saint Francis* (ill.). The emaciated face of Fra Carnevale's *Saint John the Baptist,* his sunken eyes painted in perspective, derives from Veneziano's image of the saint, as does the concept underlying the positioning of the foot of Saint Francis projecting over the ledge (although in the opposite direction) and the tubular folds of his habit; his head is bowed in a like manner and is completed with an identically foreshortened halo, and the wounds of the stigmata emit the same short golden rays of light found in Domenico's fresco. The fact that the handling of the paint is harder and more concise, contained within more rigid and less articulated outlines, does not camouflage this debt to Domenico, but the relationship to him that is suggested is exactly the opposite of the one Zeri had mapped out: a solid formation with Lippi followed by a decisive turn toward Veneziano.

Domenico's work inspired Fra Carnevale toward the spatial rigor of the curved niches and the rosebush. It is as though the painter imposed on himself the task of creating a sense of depth separate from that of the architecture: hence the reflection of the heads in the foreshortened halos, and the book and cross held by Saint Francis at opposite angles, their volume defined by the judicious placement of light and dark, with the studs of the book casting precise shadows. Paradoxically, the Gothic frame would have emphasized these effects by making the figures emerge, like painted statues, without any surrounding atmosphere and would also likely have suggested a single, unified space across the polyptych. Although the pavement in the *Saint Francis* panel is partly covered by his habit, it seems to be foreshortened on the right, as if he were stepping back into a room—an effect emphasized by a shadow more intense than what is found in the *Saint Peter,* which must have been intended to indicate the distance of the saint from the center panel. For this reason, and also because of his larger proportions vis-à-vis the niche, the *Saint Francis* probably occupied a position at the extreme right of the polyptych and was conceived as closer to the viewer—forming a sort of semi-circle that would have been completed in the missing panels on the left. If this is so, we should discard the hypothesis that a *Saint Christopher* (fig. 13, p. 32), formerly in the Lanckóronski Collection, Vienna, might be one of these lost panels.

Although the date of Domenico Veneziano's fresco is uncertain, its strong influence on these panels suggests that they were painted no earlier than the mid-1450s, and it also implies that Fra Carnevale made a second, undocumented trip to Florence. The work of Antonio da Fabriano seems to confirm this chronology, since it is his paintings of the early 1450s that offered more than one hint to Fra Carnevale. This is especially true in what are perhaps the best of his paintings—the *Saint Jerome in His Study,* of 1451 (cat. 36), and the *Crucifix* in Matelica, of 1452 (fig. 31, p. 84)—closely related to another one in Urbino. Antonio may have conveyed to the Dominican painter certain North Italian iconographic motifs (one notes the similarity to Vincenzo Foppa's *Three Crosses* in the Accademia Carrara, Bergamo, and to Donato de'Bardi's *Crucifixion* in Savona). This dating would release Fra Carnevale's polyptych from the hypothetical, late commission in Osimo postulated by Borsi. The possibility that the altarpiece was painted for Loreto also deserves to be reconsidered, as it implies that an

elaborate altarpiece was commissioned at a time when the decoration of the basilica was still in its early stages (Grimaldi).

There remains the interesting connection with Cagli, where Toesca saw the *Saint Francis*. Cagli was one of the most important cities of Federigo da Montefeltro's state; Guido Bonclerici, Federigo's secretary, was born there, and we know he was acquainted with Fra Carnevale, since his name appears in legal documents that concern the artist. Bonclerici was also a canon of Urbino Cathedral, and beginning in 1470 he was syndic, procurator, and vicar-general of Bishop Giovanni Battista Mellini. He worked tirelessly to become bishop of his native city, eventually succeeding in 1478. He could certainly have recommended a trustworthy young artist from the court in Urbino to his compatriots in Cagli to undertake the painting of a large and complex work. Between 1446 and 1469 nine new chapels were built in the cathedral of Cagli, including one for the Tiranni family that, in 1590, was ceded to the Santa Casa in Loreto. This line of reasoning would overturn Anna Tambini's well-argued hypothesis by postulating a commission from the Tiranni and the subsequent dispersal of the altarpiece, with some part ending up in Loreto at a relatively late date. Such a hypothesis requires further proof, but it is worth recalling that Giovanni Tiranni was Federigo da Montefeltro's ambassador to the king of Naples and thus had frequent contact with the court. His sons were named Pietro Paolo and Pietro, and Saint Peter's presence in this polyptych, next to the central figure, suggests his role as the patron's protector saint. This conjecture seems all the more possible since an inscription on the hem of Saint Peter's robe alludes to Saint Paul. The inscription, written in beautiful capital letters that are partially obscured by the folds in the saint's mantle, reads (beginning at Peter's feet), "PETRVS APOSTOLVS SERV . . . /[ET] PAVLVS DOCTOR GE . . . /OPOS DIES PAVCOS." Another passage starts above, next to the wrist holding the book, "TOPISOMI ET EGO DISPONO VOBIS A/IFCC HIC SVNT DVC/ET VALIO."

The relationship of the Tiranni family with artists from Urbino has already been noted (Mazzacchera 1998; for a complete bibliography, see Varese 1999). For example, Pietro commissioned Giovanni Santi, Raphael's father, to fresco the funerary monument of his wife, Battista, in the church of San Domenico, and later to fresco the family chapel, again in San

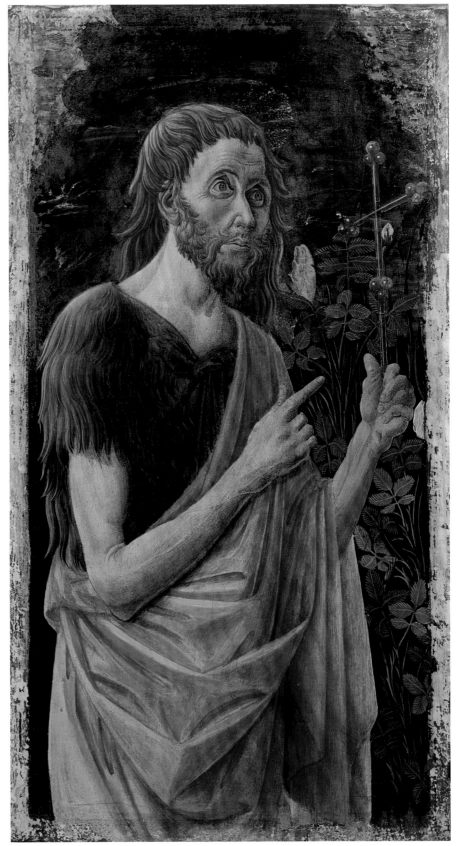

41 A

Domenico, where, in the principal scene, alongside the Madonna and in the company of Saint Thomas Aquinas, we find Saints Peter, Francis, and John the Baptist. Of course, these are commonly pictured saints, and their presence alone is not sufficient to establish an irrefutable link between the Tiranni and Fra Carnevale's dispersed polyptych. It does, however, suggest an avenue for future research.

A further observation relates to the iconography of the polyptych, although here, too, prudence is in order. The only words inscribed on Peter's mantle that seem to make direct reference to the Gospels ("et ego dispono vobis," Luke 22: 29) belong to a Eucharistic context and refer to the kingdom Christ is preparing for those who have persevered with him. This message ties in very neatly with the type of the crucified Christ, who wears no crown of thorns and is flanked by symbols of sin (the dead tree) and of new life (the luxuriant woods), suggesting that this is a work whose dense theological allusions surround a Christological theme.

ED

PROVENANCE: (A) Museo della Santa Casa, Loreto (before 1853); (B) Attilio Simonetti, Rome; Cini Collection, Venice; Galleria Nazionale delle Marche, Urbino (from 1987); (C) Casimiro Sipriot; Pinacoteca di Brera, Milan (from 1903); (D) Cagli (1902); Bruini Collection, Modena; Messinis Collection, Venice; Brivio Collection (by 1954); Pinacoteca Ambrosiana, Milan (from 1959).

REFERENCES: Longhi 1940; Richter 1940; Zeri 1948a; Zeri 1953; Fiocco 1955; Zeri 1958, especially p. 38; Zeri 1961; Vitalini Sacconi 1968; Previtali 1970; De Angelis and Conti 1976; Christiansen 1979, p. 201 n. 8; Dal Poggetto 1988; Daffra in Zeri 1992; Dal Poggetto 1992a; De Marchi 1992; De Marchi and Donnini 1994; Cleri 1997a; Tambini in De Marchi and Giannatiempo López 2002, pp. 256–57; Borsi 2003; Tambini 2003, pp. 823–38; Tambini 2004.

[42]

FRA CARNEVALE (?)

Portrait of a Man

Tempera on wood, 34.5 x 27 cm
Kunsthistorisches Museum, Vienna (inv. 7045)

Of the three portraits that have been ascribed to Fra Carnevale (see cat. 17, 28), this one, painted between about 1460 and 1470,

would be the latest and would document the artist's transformation into an exponent of a North Italian courtly style; there is, indeed, no hint of the Florentine training with Filippo Lippi we know Fra Carnevale to have received. At the Vienna museum the picture carries the generic attribution "North Italian School." The two attempts to give it more specific authorship are due to Heinz, who proposed the name of Marco Zoppo, and to Benati, who ascribed the picture to Fra Carnevale, emphasizing "the subtle abstraction of the taut profile of the sitter set against a copper resonate background, the attentive naturalism that records even the muscles and veins of the neck, and the luminosity of the colors." For a stylistic comparison he singled out the *Saint John the Baptist* (cat. 41 A) and, for the "typical metallic rendering of the hair," the relief of a Satyr in the *Birth of the Virgin* (cat. 45 A) and a painted frieze with cherub heads, universally recognized as by Fra Carnevale, that decorates an alcove in the ducal palace of Urbino (fig. 1, p. 22).

The comparison with the feigned marble reliefs in the *Birth of the Virgin* seems especially appropriate, for the portrait reads as a marble relief to which color has been added. In evaluating the picture, allowance must be made for the fact that the gray-blue background is damaged and has a mottled appearance while the face has lost much of its glazing. Yet, this does not fully account for the lapidary sharpness of the contours, the marmoreal hardness of the modeling, and the absence of Fra Carnevale's habitual delicacy of touch and preference for rich, jewel-like colors. Is Fra Carnevale intentionally working within the conventions of a sculptural relief such as that of Battista Sforza (cat. 43)? This exhibition presents a unique opportunity to resolve these issues, which have an importance well beyond that of merely attaching a name to an object, however desirable that may be. If the picture is by Fra Carnevale (this writer has reservations), it would provide a fascinating document of portraiture at the court of Urbino just prior to Piero della Francesca's diptych of Federigo da Montefeltro and his wife, Battista Sforza (Uffizi, Florence).

The vogue for profile portraits, with neutral, usually dark-colored backgrounds, continued into the 1470s at North Italian courts, encouraged both by the hierarchically formal character of the formula and by the prevailing

humanist-antiquarian taste for classical cameos and antique-inspired medals. We need only think of the profile depictions of Sigismondo Malatesta: on the medals by Pisanello and Matteo de'Pasti, the marble roundel in the Tempio Malatestiano, Rimini, and Piero della Francesca's votive fresco in the same building, as well as the small replica portrait in the Louvre of the tyrant (Laclotte 1984, pp. 77–102). At the same time, North Italian princes were avid collectors of Netherlandish painting and by the 1460s had become aware of a portrait tradition of far greater subtlety. In 1460 the duke of Milan, Francesco Maria Sforza, sent his court artist to Brussels to study with Rogier van der Weyden, and about a decade later Federigo da Montefeltro famously employed Joos van Ghent as well as another master in the Netherlandish technique of oil painting, the Spaniard Pedro Berruguete (see Marìas and Pereda 2004). Piero della Francesca's celebrated diptych showing Federigo and his wife in profile against a distant landscape is inconceivable without the example of Netherlandish painting and the new standard for naturalistic portraiture that it established. The date of Piero's diptych has long been the subject of controversy, but a general time frame can be established between about 1465 and 1472 (see Bellosi 1992b, pp. 51–52; Cecchi in Bellosi 1992a, pp. 139–44). For someone as keenly attuned as Fra Carnevale was to the evolving culture of Federigo's court and as closely associated as he seems to have been with the duke's cultivated kinsman and adviser Ottaviano Ubaldini, it is inconceivable that these transformations would have gone unnoticed. He had, after all, witnessed the first steps toward a more complex portrait style as a member of the workshop of Filippo Lippi (see cat. 4). Unfortunately, it is not possible to identify the sitter in the Vienna *Portrait of a Man,* although his plain black costume suggests he is a scholar or lawyer—someone like Guido Bonclerici, who was secretary to Federigo—rather than a courtier or merchant. If the portrait is, indeed, by Fra Carnevale, it is extremely unlikely to postdate about 1465/70.

KC

PROVENANCE: transferred from the Hofburg, Vienna.

REFERENCES: Heinz 1985, pp. 105–8; Ferino-Pagden, Prohaska, and Schütz 1991, p. 89; Benati 1996, pp. 25–28.

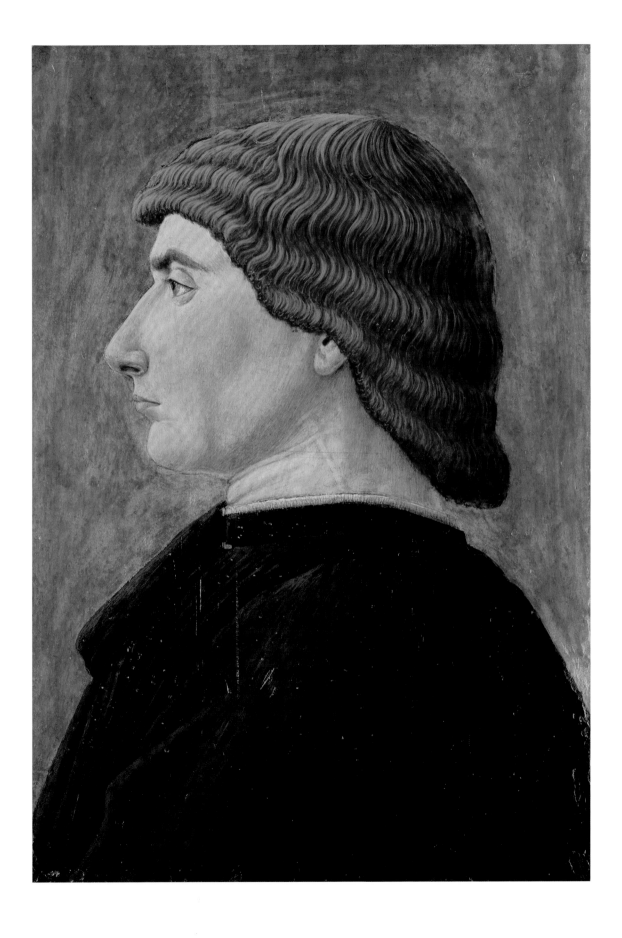

[43]

DOMENICO ROSSELLI (?)

Portrait of Battista Sforza (1446–1472)

Cesana stone, 45 x 39 cm
Museo Civico, Pesaro

This bas-relief entered Pesaro's Museo Civico as part of the collection of the erudite eighteenth-century collector Annibale degli Abati Olivieri Giordani. Adolfo Venturi (1908, p. 1044) attributed the relief to Laurana and discussed it in relation to the marble portrait of Federigo in low relief in the same museum. An inscription refers to the figure as "Duke," thus dating the work after 1474 (Sangiorgi 1982). That relief can be associated with the style of Gregorio di Lorenzo, also known as the Master of the Marble Madonnas. Lionello Venturi (1914, p. 439 n. 1) accepted his father's attribution of the relief of Battista Sforza to Laurana without reservation, although he rejected the same attribution for the portrait of Federigo—albeit primarily for reasons of chronology, as he believed that the portrait of Battista, who died in 1472, was made during her lifetime. In 1917 Adolfo Venturi (pp. 276–77) returned to this relief in an elegant discussion that is almost as much an exercise in literary style as a mark of his appreciation for the work ("dall'ampia occhiaia l'occhio turgido sboccia alla luce"). Such a characterization could not help but have an important impact on the critical history of the relief, which has been included in the catalogue of Francesco Laurana's works despite the evident doubts expressed by specialists: they repudiated the attribution without being able to offer a credible alternative. Kruft (1995, pp. 129, 218–19 n. 24) called the attribution to Laurana "willkürlich," or without foundation, and he rejected Venturi's pairing of the portrait of Battista with that of Federigo as well as Laurana as the author of that work. Damianaki (2000, pp. 65, 153–54 nn. 83–85), too, renounced the attribution of the Battista relief to Laurana and considered it to be based on Piero della Francesca's celebrated portrait (Uffizi, Florence) rather than on the famous portrait bust by Laurana in the Bargello, Florence. It is not surprising that scholars of Marchigian sculpture,

such as Serra, would support Venturi's attribution, but that someone of the caliber of Valentiner (1942, p. 280) would accept it testifies to the difficulty of giving it a proper context. More recent discussions of the attribution to Laurana are by Lightbown (1992, p. 235) and Valazzi (1996, p. 8).

Any attempt to make sense of this work must begin by affirming that it is, indeed, a portrait of Battista Sforza. Her long, aquiline nose; her high, rounded forehead; and her half-closed eyes beneath heavy, torpid lids correspond to the two known portraits of the countess of Urbino by Piero della Francesca and by Laurana. Nonetheless, despite the idealization of the work and the idiosyncrasies of the sculptor, she does seem younger here, and her jaw and facial features are less pronounced. Her coiffure—a veil that covers her forehead and her hair, which is swept up atop her head (Degli Abati Olivieri Giordani called it a *scufiocto*)—is less formal than in Piero's painted portrait, where her hair is decorated with jewels. Its matronly aspect brings to mind the coiffure of the queen of Sheba in Piero della Francesca's Arezzo fresco cycle as well as the *Madonna* in his altarpiece in Williamstown (cat. 47). It is a fashion difficult to date very precisely. The particular arrangement of the trailing end of the veil gathered on Battista's shoulders

1.
Francesco Laurana, *Battista Sforza.*
Museo Nazionale del Bargello, Florence

cannot help but recall the veil worn by one of the women in the foreground of Fra Carnevale's *Birth of the Virgin* (cat. 45 A). Given the high, rounded forehead, long nose, and lowered eyelids of Fra Carnevale's figure as well, we might suspect that she is an idealized representation of Battista (fig. 3, p. 252).

The old attribution to Laurana should be rejected not on the grounds of quality, but because of the profound stylistic differences between Laurana's marble bust of Battista Sforza in the Bargello (fig. 1, p. 250) and the present portrait. The former is worked with extreme precision: her skin seems as translucent as alabaster and her hair lacks accentuated linear definition and thus seems soft. The veil of her headdress is fine enough that we can almost see its weave while her dress appears to be made of a rougher, opaque material.

The relief in Pesaro is carved from a white, local stone. All areas are treated with equal emphasis and there is no attempt to render the tactile qualities of the different materials represented. The skin over the skull does not enhance the three-dimensionality of the form, as in Laurana's portrait bust in the Bargello, but rather appears as though molded from a soft substance and then smoothed over. The profile of the brow and lips does not exhibit the strong, funereal precision of Laurana's portraits but defines an attitude that is noble yet more approachable. The drapery, too, is very different from the high-necked garment worn by Laurana's *Battista,* and is similar to the attire of the women in Fra Carnevale's *Presentation of the Virgin in the Temple (?)* (cat. 45 B).

It seems certain that the marble bust by Laurana probably was made in Naples about the middle of the 1470s to commemorate the young countess, and was sculpted from a death mask, as evidenced by the elegant, classicizing, and celebratory inscription. From the very beginning, the work was likely meant to be displayed publicly, as part of Battista's tomb or in some equally prominent place in the Palazzo Ducale in Urbino, where it was listed in late-sixteenth-century inventories (Kruft 1995, p. 371; Damianaki 2000, pp. 55–65). Whatever other purpose the small relief in Pesaro might have served, it was intended to be seen at close range, and was perhaps also ornamented with colored details (as was the case, in all likelihood, with Laurana's portrait bust). Although it has no inscription, there may have been one on the wood frame that it certainly must once have had. In understanding its function we might

2.
Domenico Rosselli and Workshop, *Portrait of Federigo da Montefeltro*, from the architrave of a doorframe in the Sala degli Angeli, Palazzo Ducale, Urbino

recall a letter written from Naples by Ippolita Maria Sforza to her mother, Bianca Maria, in 1466. She asked for portraits of her family—of her father, mother, and siblings—declaring that "other than decorating my *studio,* seeing them [the portraits] gives me continuous solace and pleasure" (Damianaki 2000, p. 129 n. 81). This relief, too, was suitable for a private space, such as a *studiolo,* where it might be viewed through the perspectival opening of a frame, like the fictive one surrounding the small portrait of Federigo III (cat. 28). There is, however, no evidence that the relief was ever in Federigo's apartments in Urbino. In style it is very close to the portrait medallions of Federigo and the young Guidobaldo on the architrave of the doorway in the Palazzo Ducale leading from the Sala degli Angeli into the Throne Room (fig. 2, p. 252). It displays the same smooth surfaces within sharp, well-defined contours, as well as the identical way of modeling the skin to create a swollen effect in the face or body rather than one that is plastic and three-dimensional. Rotondi (1950, p. 257) was the first to attribute this architrave to the Florentine Domenico Rosselli, dating it to about 1478, based on the apparent age of Guidobaldo. Now that Pisani (2002, pp. 49–66) has studied the career of this artist, we may situate the portrait relief in the period between Rosselli's last Florentine works and those he made in Urbino—more specifically, during the time before 1476, when he was active in Pesaro working for Costanzo Sforza. The quality of the work surpasses that of the Urbino portrait medallions, which were created to serve a decorative purpose and to be seen from a distance, and were executed by a

large workshop (although they do reveal the same type of summary treatment in the spatially ineffective rendering of the shoulder). By way of compensation, the sculptor had a strong feeling for the profile and for delineation: in comparison we might cite—on the suggestion of Linda Pisani—a bas-relief of the *Madonna and Child* (Szépművészeti Múzeum, Budapest) as well as a fragmentary *Madonna and Child* (Galleria Nazionale delle Marche, Urbino) traditionally ascribed to Agostino di Duccio but clearly by Rosselli. Although the *Madonna and Child* in the Berenson Collection (Villa I Tatti, Settignano) is sculpted in the round, the Virgin has the same clean profile and idealized facial features. The handling of the drapery in the profile-portrait relief is equally Florentine, and the "wet cloth" appearance of the veil draped on the figure's shoulders is yet another of the many examples of Rosselli working to absorb the lessons of Donatello through the apparently more approachable example of Desiderio da Settignano. This stylistic detail is also close to that found in works by Pasquino di Montepulciano: one need only compare the latter's Madonna at the base of the Prato pulpit, dated to the late 1470s, which shares the same ennobling intention and the same orientation toward Desiderio as Rosselli's work, resulting in an idealized physiognomy with sharply defined eyelids beneath widely arched brows, and a veil that falls in wet folds across the shoulders.

In conclusion, it is possible that the portrait exhibited here was always intended for Pesaro (where it ended up in Degli Abati Olivieri Giordani's collection). Rosselli could have executed it between the end of 1472 and early 1473 —shortly after his arrival in Pesaro—possibly for Battista's grief-stricken father, Alessandro, who was to follow his daughter to the grave less than a year later (Degli Abati Olivieri Giordani 1785, p. 110), or for Battista's brother, Costanzo, as a personal, private record ("not as beautiful, but more alive," in Kruft's words, than Laurana's bust) of his young, departed sister. The work was not modeled from the startlingly realistic death mask (Louvre, Paris) but from a drawing—perhaps by Fra Carnevale (the image employed to render the countess's features in the Santa Maria della Bella altarpiece?)—that resembled Battista in general but lacked any naturalistic detail, and showed her younger and less marked by the cares of governing than she appears in both the portrait by Piero della Francesca and in the bust by Laurana. The face bears a stronger similarity to Battista's when, little more than a child, she left the Sforza court

at Pesaro for a marriage and a new life that would be short but would bring her immortal fame.

MC

PROVENANCE: Annibale degli Abati Olivieri Giordani (before 1785–89); bequeathed to the city of Pesaro; Museo Civico, Pesaro (from 1884).

REFERENCES: Degli Abati Olivieri Giordani 1785, p. 55; A. Venturi 1908, p. 1044; L. Venturi 1914, p. 439 n. 1; A. Venturi 1917, pp. 276–77; Serra 1934, pp. 149–50; Valentiner 1942, pp. 273–99; Polidori 1956, p. 27; Sangiorgi 1982; Lightbown 1992, p. 235; Kruft 1995, pp. 129, 218–19 n. 24; Giardini and Valazzi 1996, p. 8; Damianaki 2000, pp. 65, 153–54 nn. 83–84.

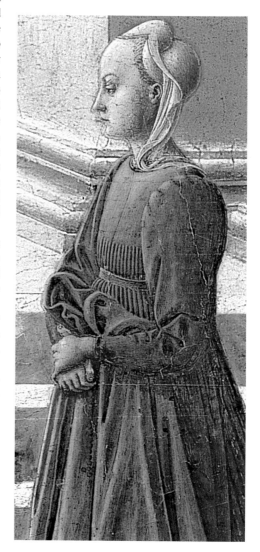

3.
Fra Carnevale, *The Birth of the Virgin*, detail showing an attendant tentatively identified as Battista Sforza. The Metropolitan Museum of Art, New York

[44]

FRA CARNEVALE

Heroic Figure Against an Architectural Backdrop

Oil on panel (unfinished), painted front and back,
45.8 x 32.7 cm
Villa Cagnola, Gazzada (Varese)

This small, enigmatic panel has always presented problems, made even more complicated because it was left unfinished and is in a poor state of preservation. The recent and very careful restoration by Sara Scatragli has largely corrected the shifts in the panel's tonalities, caused mainly by the glues and yellowed varnish applied to its surfaces. The original, pure colors have been recovered, and many of the decorative details of the architecture, just barely traced on the prepared ground with light touches of the brush, are again legible, offering us a more complete idea of the picture.

Guido Cagnola's archive is currently being reorganized to make it more easily accessible to scholars; until that project is finished it is very hard to reconstruct the circumstances under which this panel was acquired. Cagnola certainly owned it by the 1920s, and he considered it the work of an artist closely associated with the great architect from Urbino, Donato Bramante (Suida 1931b), or of his Milanese follower, Bartolomeo Suardi, known as Bramantino (Ciardi 1965). Suida was the first to publish the panel, attributing it to Bramante's circle because of the similarities between its heroic figure, those painted by Bramante for the palace of Gaspare Visconti (Brera, Milan), and those executed by an artist in the circle of Bramante for the residence of the Prinetti family in Milan. However, Suida also noted that the richly decorated architecture, with its figurative reliefs, had little connection with Bramante's Lombard style and more closely resembled the work of Francesco di Giorgio. Suida repeated his original observations in 1953, and again underscored the Sienese-Francesco di Giorgio sensibility of the architecture, adding a brief but definitive reference to the Barberini Panels. Berenson (1932 a, p. 109) ascribed the Cagnola panel to Bramantino and retained this attribution in his *Lists* of 1968. The catalogues of the Cagnola collection focus on two poles: the Montefeltro and Urbino, on the one hand, and Lombardy and Milan on the other. Ciardi attributed the painting to the Master of the Barberini Panels, also noting similarities with the work of Bramante and Bramantino, while Boskovits and Fossaluzza (1998, pp. 123–24) dated it to between about 1475 and 1485 and assigned it to an artist in Bramante's circle. They also noted affinities with Urbino and especially with the architectural culture of Florence, as well as of Leon Battista Alberti.

The fictive, geometric intarsia represented on the back of the panel has always been overlooked, even though it is key to understanding the work's function. The image imitates a decorative element of wood furniture and suggests that the panel was intended as a door on a piece of furniture or a *studiolo* cabinet (although Boskovits and Fossaluzza 1998, p. 124, are skeptical of its association with furniture). Similar examples of comparable furniture appear in contemporary inventories, such as that of the Palazzo Medici: "a small cabinet (*armadietto*) with a painted figure of a woman and two figures on the doors" (Müntz 1888, p. 63) that was in Lorenzo il Magnifico's large bedroom.

The geometric design consists of a double meander border that copies an intricate wood intarsia *alla certosina,* but with a strongly classical character quite unusual when compared with the geometric decorations by Florentine intarsia masters in the middle of the fifteenth century (see, for example, the magnificent benches in the Old Sacristy of San Lorenzo, created after 1451: Haines 1983, p. 60 n. 41). The motif occurs only rarely in fifteenth-century sketchbooks, although similar ones, derived from pavements, ancient altars, and trabeations (see, for example, the *Codex Escurialensis,* f. 66, in the Biblioteca dell'Escorial, Madrid), must have seemed excessively severe and condensed when compared with the banderoles painted by Andrea del Castagno in a room of the Villa Carducci in Legnaia. Yet, Fra Carnevale's geometric inventions must have triggered the young Bramante's interest in knots and intertwining—the *"gruppi di Bramante,"* as Leonardo da Vinci called them. It is probably not coincidental that there is a double meander pattern like Fra Carnevale's on the underside of the fictive arch that frames the fresco of the *Disputà* in the Vatican Stanze painted by that other great artist from Urbino, Raphael. The corner solution is especially surprising in the Cagnola panel: the most complicated part of the pattern is so poorly resolved that one can only conjecture that Fra Carnevale wanted to imitate the challenges an intarsia master faced when executing a very complex design.

The central star inscribed in a circle was originally intended to be larger and would have been contained only by the frame molding formerly applied to the periphery of the panel. The lines tracing the geometric design, drawn with a compass and incised into the painting's damp plaster with a metal point, are still easily visible. It seems that the actual representation is a corrected—and more geometric—version of the original, and is laid out with a more rationalized spacing and on a scale more typical of a flat bookbinding than of inlay work: star motifs, even if less complex, are common in Northern intarsias, as in that by the Cozzi in Venice, and are also present on the wood doors in the Iole wing of the Palazzo Ducale in Urbino.

On the front of the Cagnola panel is the figure of a youthful hero or young god on a podium made up of three polygonal plinths, one on top of the other, evidently meant to be finished with polychrome marble inlays. All that remains of this decoration are incision marks on the lowest podium. As noted in my essay, the geometry of this podium conforms closely with the methods put forth by Piero della Francesca in his *De prospectiva pingendi*: a system of projections not very different from those by contemporary intarsia masters and also analogous to the ones employed by Fra Carnevale himself in the wellhead he designed and then painted out in the final version of the Washington *Annunciation* (fig. 23, p. 326) and in his enigmatic drawing in Stockholm (fig. 68, p. 129)—perhaps a study for an image similar to that on the cabinet door.

The figure is the hardest part of the painting to interpret because it is the least finished, indicated only with thin brown lines—a working procedure in which the figure is left in reserve, similar to that employed by Piero della Francesca in the *Montefeltro Altarpiece* (cat. 46) and probably also in the *Nativity* (fig. 3, p. 26). Using this approach it was possible to establish the spatial context and light system so that the coordinates for the realization of each figure could be determined in both plastic terms and for chiaroscuro effect. This practice can be readily observed in the right-hand decorative relief on the arch, where the figure was inserted into a luminous background. The figure would have been painted according to its own chiaroscuro requirements, imitating the material of the background but with an added three-dimensional quality through subtle hatching, as in the finished figure on the left side of the arch.

In the preparatory drawing the central figure is represented nude but also draped with an ample mantle. It is impossible to say whether, when finished, he would have been clothed or not. Certainly, his legs were to be bare from the knees down, since they were left in reserve against the sky, and he was to have worn sandals. The figure's youthful face is crowned by a dense mop of curls held in place by a laurel wreath. He holds a staff with at least three gilded knobs, garnished with rosettes at the center; although the staff has been interpreted as Mercury's caduceus (Boskovits and Fossaluzza 1998), this reading is difficult to sustain, since its circular elements cannot in any way be interpreted as intertwined serpents. Thus, it offers us no help in identifying this figure, especially as we find in the small antiquarian dictionary Porcellio Pandoni prepared for Filarete the following comment: "ancient statues were dressed, holding a staff, or nude, with a staff in their hands" (Pfisterer 2002b, p. 133). Most similar to the decoration of the staff, and perhaps also its source, are the imperial devices found in the Aurelian reliefs on the Arch of Constantine: in the *Adlocutio, Lustratio,* and *Submissio* scenes the emperor is surrounded by soldiers carrying insignia that terminate in several small knob-shaped plates and other symbols. That Fra Carnevale must have studied the antique bas-reliefs that were readily visible in Rome and much frequented, during his probable but undocumented visit, is demonstrated also by the Cagnola hero's curls and his laurel-wreath crown, which derive from an ancient type and can be seen on the trumpet player or his companion in the scene of *Triumph* from the same series of reliefs. Such imperial devices, carefully derived from antique models, occur in a relief depicting Duke Federigo and Ottaviano Ubaldini, from the Palazzo Ducale, Urbino (Galleria Nazionale delle Marche, Urbino), as well as in the *Fregio della Guerra* by Ambrogio Barocci, after studies by Francesco di Giorgio.

Perhaps it was Fra Carnevale's intention to represent a young Caesar, probably the first in a series that was planned but never finished. The Cagnola panel thus becomes a link between the ancient warriors who dominate Boccati's imaginary theater in his frescoes in the Palazzo Ducale in Urbino (fig. 10, p. 48) and the "barons" Bramante painted in the house of his friend Gaspare Visconti in Milan. These references are reinforced by the similarity, already

1.
Giuliano da Sangallo, Arch of the Argentari, from the *Codex Barberiniano* (4424, f. 33). Biblioteca Apostolica Vaticana, Vatican City

noted by Andrea Di Lorenzo, between the pose of the Cagnola hero and Giovanni Santi's image of the *Muse Clio*, once in the Tempietto delle Muse in the Palazzo Ducale and now in the Galleria Corsini, in Florence. It is interesting that Santi remembered this invention, which he perhaps saw unfinished in Fra Carnevale's studio and found useful for his own composition.

Indeed, the elegant modeling of the limbs; the svelte subtlety of the hands and feet; and the dancing, contrapposto pose of the figure in this last work by Fra Carnevale reveal the impression made by Florentine artists from Verrocchio to Botticelli and Antonio del Pollaiuolo. These developments are comparable to the figures by Piero della Francesca, in his *Nativity* (National Gallery, London) and in the altarpiece in Williamstown (cat. 47), which are rendered with pointed faces, elongated eyes, and high, rounded foreheads as well as with slightly agile gracefulness in their postures. How can one not think of the transformation in taste at the Urbino court during these years? Gradually, an appreciation for Laurana and Piero was replaced by one for Francesco di Giorgio and the Florentine artists of the 1470s—a shift attested by commissioned works as well as by the visits to Urbino of important artists (Bellosi 1993, pp. 71–76). Examples include: the allegorical figures in the duke's *studiolo,* and the new doors with intarsia decorations executed by Giuliano da Maiano but based on cartoons attributed to Botticelli and, more recently, to

Baccio Pontelli (Benzi 2002, pp. 7–21); Antonio del Pollaiuolo, who visited Urbino in 1473; the magnificent books in Federigo's library, including the bible illuminated by a team of Florentine artists under the direction of Francesco d'Antonio (Garzelli 1977); and books illustrated by Botticelli—Cristoforo Landino's *Disputationes Camaldulenses* (fig. 5, p. 27) and especially a manuscript by Petrarch (Biblioteca Nacional, Madrid) copied by Matteo Contugi and magnificently illuminated in the 1470s by the baffling but elegant painter Bartolomeo della Gatta (a relative of Gentile Becchi, Bishop of Arezzo, and a naturalized Florentine originally from Urbino) (see, most recently, Alexander 1994, pp. 136–37 n. 60; Martelli [n.d.] forthcoming). On the one hand, the round face of our young hero, tilted to emphasize the expression in his large, languorous eyes, supports, as Andrea De Marchi has pointed out, the artist's early debt to Lippi, but, on the other hand, this sensitive roundness seems to me close to the florid beauty described by Fra Bartolomeo della Gatta and to the physiognomies of the ladies and young men riding in the allegorical chariots of the "Trionfi" conjured by the Florentine poet. Evidently, even the old friar, caught up in his own particular interests and by then not very active as a painter, was, in the 1470s, touched by these changes.

The perspective scheme was conceived to elicit the greatest sense of monumentality from the small panel. The low vanishing point dissolves the area in front of the triumphal arch and contrasts the arch with the figure, which thus seems colossal. If the panel were finished, this contrast would have been even more pronounced, although balanced by the clever design of the architectural background, where there is a vivid echo of the pose of the hero in the marble relief on the left pier of the arch.

The choice of the ancient ruin is no less sophisticated. It is a fairly faithful reconstruction of the Arch of the Argentari (ill.) near the church of San Giorgio al Velabro in Rome (De Maria 1988, pp. 307–9). Fra Carnevale has reconstructed the arch here in the same way that Giuliano da Sangallo did in the *Codex Barberiniano* (ff. 32v–33), where it is called the Arch of Decius (Borsi 1985, pp. 174–78). This monument was restored in 1469, under Pope Paul II (Lanciani 1989, p. 90). Although partially buried, it was carefully studied (Bober and Rubinstein 1986, pp. 213–14 n. 180). Among all the monuments in Rome, Leon Battista Alberti was probably most influenced by this one and

by the Arch of Constantine (Alberti 1912, p. 635 n. 12), as one can surmise from its precise citation by his associate, Bernardo Rucellai (1770, pp. 765–1131, especially pp. 925–26), who correctly recorded its inscription. It seems, however, that Fra Carnevale and Giuliano da Sangallo (in the *Codex Barberiniano*) alone document the fifteenth-century restoration of the tympanum: In the *Taccuino Senese* (f. 22) Sangallo offered a version of the arch without the crowning tympanum, as did Jacopo Ripanda (the so-called Master of Oxford) on folio 10 of a sketchbook in the Ashmolean Museum, Oxford (Cafà 2002, pp. 142–43) and then, later, in the *Codex Coner* on folio 60 (Ashby 1904, p. 36), followed by Sebastiano Serlio in his treatise (1540; edited by Fiore 2001, vol. 1, ff.108–9), and lastly Cassiano del Pozzo in his paper museum (Röll and Campbell 2004, vol. 1, pp. 244–47).

The unusual presence of the tympanum in Fra Carnevale's painting anticipates Giuliano da Sangallo's solution. If the attic the Florentine architect inserted onto the arch is an invention dictated by his specific interests, a tympanum nevertheless was a specialty of Fra Carnevale, beginning with the portal at San Domenico in Urbino (see my essay, above). However, the reintroduction of this solution in the Cagnola panel is chronologically close to Alberti's work in Mantua—the churches of Sant'Andrea and San Sebastiano—where this combination of ancient elements is developed in all its complexity for the creation of a Christian "temple" (Bulgarelli 2003a, pp. 9–35). As in the Barberini Panels, we have the impression that the antique-inspired ruins in the background of the Cagnola panel grew out of long evenings in the Palazzo Ducale, in the presence of Federigo, when the most difficult and salient passages of Vitruvius and of Alberti's *De re aedificatoria* were read aloud and discussed and when Alberti himself described the most important architectural monuments in Rome and how they should be restored.

The version of the arch in the *Codex Barberiniano* corresponds very precisely to that in Fra Carnevale's picture. Yet, instead of the pilaster in the intrados, found on the original arch as well as in Sangallo's drawing, the Cagnola panel shows the back side of the capitals on the rear face of the monument, from which one can imagine its isolated position. Fra Carnevale's reconstruction of the arch, like Giuliano da Sangallo's drawing and the Oxford sketchbook, shows garlands of leaves bound together with ribbons between the capitals of the paired pilasters. Curiously, though, instead of the Composite "*italico*" capital of the original, we find only a severe, exquisitely Brunelleschian, Corinthian capital, which seems somewhat archaic, although it was perhaps influenced by the Augustan arch in Rimini. Traces of the original color discovered during restoration demonstrate that Fra Carnevale also intended to depict the arch's inscribed tablet in the attic story—an element peculiar to the ancient arch that was carefully recorded in fifteenth-century drawings and that would prove influential in the next century. Drawings of the Severan arch always vary the subjects of the large reliefs, perhaps because the figures on the front of the monument had already been eroded in ancient times and were hidden by the later structures. However, Fra Carnevale was attentive to the original by including a single figure in the major panel, anticipating Giuliano da Sangallo's solution in the *Codex Barberiniano,* especially in the posture of the figure on the right pier—in Sangallo's drawing it is a Satyr—and in the idea of the small narratives below teeming with figures, which in the drawing illustrate the triumph of Titus and in the panel show scenes of Satyrs. One might wonder, then, if all these similarities in the layout and decorative details of the drawing and the panel do not indicate that Fra Carnevale and then Sangallo were both working, at least in part, from a common and preexisting drawing of the arch.

Finally, contrary to what is suggested in the *De re aedificatoria* (VIII, p. 6: "Carved narratives [*historie*] should be applied [to an arch] above [the halfway mark], the lower portion not being suitable because they would get dirty"), Fra Carnevale restores the lower zone of the arch —which is rusticated in antiquarian reconstructions and was, in any case, buried in the fifteenth century—with plinths decorated with pairs of putti that have become almost legible after the restoration of the panel. The richly carved plinths on the portal of San Domenico suggest that in practice Alberti's stricture seemed excessive; certainly in painted architecture it was not necessary to renounce figurative decoration. So little of the preparatory drawing in these areas is discernible that we cannot unequivocally identify the sources, although whether ancient or contemporary, they were doubtlessly transformed and manipulated in Fra Carnevale's usual fashion. A semi-recumbent figure leaning against a putto, his right arm raised, was planned for the plinth on the right, and it perhaps derived from the Adonis figure on the famous sarcophagus that belonged to Andrea Bregno in Rome (Bober and Rubinstein 1986, pp. 64–65, no. 21) or from a figure of Silenus, like the one surrounded by bacchants on the fireplace in the Sala della Iole in the Palazzo Ducale (fig. 31, p. 113). By contrast, on the left-hand plinth there was a seated figure with one leg extended—like that of the famous Ciampolini Jupiter—while at his shoulder is a winged putto with his legs crossed, according to a scheme devised for an allegorical figure of Sleep (Somnum) known from an altar much copied in the fifteenth century, in, among others, a drawing from the circle of Pisanello (Museum Boijmans Van Beuningen, Rotterdam). The comparison between the first figure and the fictive relief of Silenus holding the infant Bacchus, in the *Birth of the Virgin* (cat. 45 A), is significant, for although the position of the legs of the two figures is fairly close, the spatial implications of the pose in the Cagnola panel are more complex and calculated, as well as more fully developed.

Alongside the arch is a road and a vista with, on the left, only the vaguest trace of a foreshortened building: a very large house with a tympanum over a tall trabeation and perhaps a large arch. It is a great pity that the small bit of landscape visible through the barrel vault of the arch and between the legs of the hero will forever remain unfinished. Here, certainly, Fra Carnevale would have painted one of his blindingly brilliant skies and a small but precious recollection of Federigo's rugged countryside dotted with woods, castles, and mountains, of which nothing remains now but a ghostly outline.

M C

PROVENANCE: Guido Cagnola, Villa Cagnola, Gazzada (Varese) (1920s–1954); Cagnola collection, Villa Cagnola, Gazzada (Varese).

REFERENCES: Suida 1931b, pp. 340–48; Berenson 1932a, p. 109; Suida 1953, pp. 38–39; Ciardi 1965, pp. 35–36; Berenson 1968, p. 60; Boskovits and Fossaluzza 1998, pp. 123–24.

[45]

FRA CARNEVALE

A. *The Birth of the Virgin*

Tempera and oil (?) on wood, 144.8 x 96.2 cm
The Metropolitan Museum of Art, New York.
Rogers and Gwynne Andrews Funds, 1935 (35.121)

B. *The Presentation of the Virgin
in the Temple (?)*

Tempera and oil (?) on wood, 146.5 x 96.5 cm
Museum of Fine Arts, Boston. Charles Potter Kling
Fund (37.108)

Few paintings have elicited such sustained scholarly debate as these two spellbinding pictures from the Barberini Collection. Perhaps only Piero della Francesca's *Flagellation* (Galleria Nazionale delle Marche, Urbino) has provoked a similar degree of interpretive conjecture: in that work, too, the primary subject—the Flagellation of Christ or the Dream of Saint Jerome (Pope-Hennessy 1986)—is relegated to the background while the foreground is occupied by three commanding and enigmatic figures. Piero's celebrated masterpiece was unquestionably a major source of inspiration for the author of these two extraordinary paintings. Yet, Piero della Francesca certainly cannot be accused of having obfuscated an ostensibly religious subject with a plethora of detail taken, on the one hand, from contemporary life and inspired, on the other, by humanist-antiquarian interests.

At the heart of the debate is whether these two highly original pictures can be identified with an altarpiece painted by Fra Carnevale for a lay confraternity of flagellants in the hospital church of Santa Maria della Bella in Urbino. We know remarkably little about this altarpiece and those who funded it. On December 31, 1466, the syndics of the confraternity arranged that 144 florins due to the artist for his work on the altarpiece would be applied to his purchase of a house. Vasari attests that the altarpiece was studied by the young Bramante, and later sources assure us that in the seventeenth century it was confiscated by Cardinal Antonio Barberini. It was on this basis that, in 1893, Adolfo Venturi identified the New York picture (then still in the Barberini Collection) with the

Santa Maria della Bella altarpiece. He later retracted his view for lack of solid evidence. When, in 1939, Richard Offner created a corpus of works around the two ex-Barberini Panels, he conjectured that they possibly formed a larger cycle devoted to the life of the Virgin created to decorate a room or a large piece of furniture. This left the door open to the possibility of an alternative identification of their author, and in 1961 Federico Zeri provided one: Giovanni Angelo d'Antonio da Camerino. Two years ago a document was found that definitively disproves Zeri's thesis (see Mazzalupi 2003a). Despite this discovery, the debate about the authorship, subjects, and function of the panels shows no sign of abating, making it necessary to recapitulate what we actually know about the pictures.

The provenance of the two panels was a matter of conjecture until 1975, when Marilyn Lavin published a series of seventeenth-century Barberini inventories. The earliest is an inventory of Cardinal Antonio Barberini's possessions in the Palazzo Barberini, Rome, drawn up in 1644. Under numbers 13 and 14 are recorded: "a painting on wood that shows a perspective with some women who greet each other . . . by Fra Carnevale," and "a similar painting that shows a perspective with some women on their way to church . . . by Fra Carnevale." This inventory dates just thirteen years after Cardinal Antonio's tenure as papal legate to Urbino, at which time he is documented as having confiscated the Santa Maria della Bella altarpiece (the fact that this work was mentioned by Vasari must have whetted Cardinal Antonio's appetite as a collector). As established by Sangiorgi (1989, p. 19), the confiscation is first recorded in a pastoral visit of 1657 by the archbishop Ascanio Maffei, then by the Urbinate pope Clement XI Albani in his diary (1703), as well as, later, by the local historian Andrea Lazzari (1801). Clement XI and Lazzari also noted that Antonio Barberini substituted an altarpiece by Claudio Ridolfi showing the Birth of the Virgin (288 x 185 cm; now in the parish church of Groppello d'Adda). Fra Carnevale's altarpiece has been presumed to have depicted the same subject.

Carloni has uncovered a series of notices that add further evidence to the provenance of the Barberini Panels from Santa Maria della Bella (see the appendix). In 1632 the bishop of Urbino wrote to Cardinal Antonio to announce that the "*prospettivi*" had been sent to Rome in two crates; this clearly refers to the Barberini Panels. Three months later payment was made

to Claudio Ridolfi for a painting that can only have been the replacement of Fra Carnevale's altarpiece. With this information in hand, we may now firmly reject all attempts to associate these panels with the decoration of the ducal palace (Zeri; Strauss; Ciardi Dupré Dal Poggetto; Dal Poggetto). However, it may still be doubted that pictures treating their ostensible subjects in so ambiguous a fashion could have formed an altarpiece. For this reason some importance attaches to the fact that in 1565 the hospital buildings—including the small church of Santa Maria della Bella—were assigned to the nuns of the Convertite del Gesù, and it is possible that works of art were shifted about within the new convent (see Mazzini 1999, pp. 421–22), confusing their original function.

Creighton Gilbert has made an attempt to interpret the subjects of the pictures in terms of hospital decoration. As suggestive as this sounds, it remains a matter of pure speculation: apart from Claudio Ridolfi's replacement altarpiece, the only other work certainly from the church (which had three altars) is a fresco of the Crucifixion (Galleria Nazionale delle Marche, Urbino) painted by the Late Gothic Ferrarese artist Antonio Alberti in 1442. Moreover, the analogies Gilbert proposes with a fresco cycle in the Spedale di Santa Maria della Scala in Siena seem extremely tenuous as the two ex-Barberini paintings do not depict acts of charity or mercy. What deserves consideration is the probability that the secular slant of the paintings is related to their setting in a confraternity oratory attached to a hospital.

The compiler of the Barberini inventory was as puzzled as later, twentieth-century commentators about what the pictures show. A crucial point for any identification is that the woman reclining in a bed and the child standing in a washbasin in the New York picture have halos. The halos, of shell gold, were examined by conservators in 1994 and again for this exhibition and there seems no reason to question their authenticity since: 1) Where, in the case of the woman in bed, the halo has been partially cleaned off, it has left an impression due to its age; 2) In both instances the halos are executed in small, hatched strokes, completely in keeping with the painting technique of the artist; and 3) Had they been added at a later date, in an effort to clarify the subject, we would expect them to be larger and more conspicuous. They are remarkably discreet halos, but so, for that matter, is the one in Piero della Francesca's *Flagellation*. (Piero actually omitted halos in his *Senigallia Madonna* in Urbino, his *Montefeltro*

Altarpiece in Milan, his *Nativity* in London, and his altarpiece in Williamstown: cat. 47.)

The second point is that the infant in the New York picture is evidently a girl. Admittedly, the matter is not absolutely certain: in the infant's groin there is a small damage along with an adjacent brushstroke that at first glance might suggest a penis. However, in the reliefs that decorate the palace the artist is quite explicit about genitalia, and the child's is closer to that of the Nereid on the back of a sea centaur than to the male figures. It may seem remarkably indecorous to show the Virgin frontally as a naked baby standing in a basin, but Bicci di Lorenzo does precisely this in a scene of the Birth of the Virgin on the predella of an altarpiece in the Walters Art Museum, Baltimore.

Scarcely less notable is that the mother of the child—remarkably young for Saint Anne—is depicted lying in bed nude. Virtually every fifteenth-century scene of the Birth of the Virgin shows Anne reclining in bed, decorously dressed to receive visitors (on the clothes and rituals attending childbirth see Musacchio 1999, pp. 37–48). Fra Carnevale's departure from this convention (and social custom) would be inexplicable were it not that the three maids attending Saint Anne—unlike the woman seated alongside her—are clothed *all'antica*. Their peploi should be compared to those worn by the figures in the reliefs decorating the church façade in the *Presentation of the Virgin in the Temple (?)*. In other words, the birth has been imagined as a past event refracted through contemporary life. This was not an uncommon practice: it is also true of Ghiberti's *Gates of Paradise*, in which, in the story of Jacob and Esau, only the two youths are shown wearing contemporary clothes. In the *Flagellation* Piero della Francesca clothed two of the foreground figures and the judge on a throne in contemporary garb while the center figure is barefoot and wears a classicizing robe; this mixture of contemporary dress with classicizing costume was possibly for interpretive purposes rather than narrative strategy. The New York panel nonetheless remains unique for associating the haloed mother with a classical past rather than a fifteenth-century present. In sum, it would seem that the Metropolitan's painting is, indeed, a religious scene involving the birth of a girl, with well-wishers ceremoniously greeting each other in the foreground and men under the portico and in the background chatting, riding, or bringing home game. It is perhaps an indication of the religious theme that two of the women hold prayer beads.

If Fra Carnevale's approach to the subject in the New York panel may be described as oblique, in the Boston picture it is almost inscrutable. Despite the absence of any halos, the picture is most often described as showing the Presentation of the Virgin in the Temple, which, according to *The Golden Legend,* occurred when Mary was three years old. A good deal of license was taken in portraying the Virgin as a three-year-old: in Ghirlandaio's celebrated fresco cycle in Santa Maria Novella, Florence, she is about the same age as the young girl in blue that Fra Carnevale depicts at the head of the procession filing into the basilica-like temple, past three beggars—a common embellishment in the scene. A barely dissimilar approach to this subject was adopted by Jacopo Bellini in his celebrated albums (Louvre Album, ff. 23, 28), but those are private exercises exploring the notion of Albertian *historie*, not formal projects for altarpieces. Even so, Bellini invariably includes Joachim, the Virgin's father, who is nowhere in sight in Fra Carnevale's painting. Moreover, instead of the traditional Jewish priest officiating at the event, Fra Carnevale places three figures at the high altar—apparently a Franciscan, possibly a Dominican or a friar wearing priestly robes, and a hooded figure—while two pilgrims are seen against the right-hand entrance pier. (Is one of them sup-

1.

The Birth of the Virgin, detail, with incisions in the surface shown in raking light

posed to be Joachim or Joseph?) The remaining figures in the church are exclusively young males who chat, rest, or walk about. Two wear festive wreaths in their hair (one composed of roses, the other of leaves), while the coif of the young girl in blue is adorned with roses and a stem of rose leaves or myrtle. Kanter reasonably suggests that the scene may depict the marriage of the fourteen-year-old Virgin, with the prospective bride on her way to church, accompanied by her female relatives and two male guardians (once again, one of the women holds prayer beads). It is far easier to enumerate the anomalies in the depiction of this scene than it is to propose an alternative subject. For this reason it is important to point out that the decorative reliefs on the church façade clearly depict events in the Virgin's life—the Annunciation and the Visitation—and that the three marble steps the young girl is about to climb are shown with fissures, as though to denote the passage from one age to another. Typically, this would be the transition from the era under the Law to that of Grace, but there is also the suggestion of the transition from a pagan past, symbolized by the dancing maenad and Satyr with pipes on the bases of the columns and the classical urn with a branch protruding from its opening, to the Christian era, announced by the reliefs above the arches. As Stefano Borsi notes, the urn is reminiscent of the ancient vase, or cantharus, in the forecourt of Santa Cecilia in Rome as well as of ancient candelabra for balsam incense, as recorded by Alberti in the *De re aedificatoria* (VII.13). One wonders if, indeed, Fra Carnevale intended the Hebrew use of hyssop as an aspergillum. Thus there would seem to be no way around the religious content of both pictures, and the most probable identifications remain the Birth of the Virgin and the Presentation of the Virgin in the Temple or the Marriage of the Virgin. Once this is admitted, the case for accepting these idiosyncratic paintings as the documented altarpiece for Santa Maria della Bella seems overwhelming.

Yet, because of the competing theses that continue to be advanced, it needs to be emphasized that there is no basis for conjecturing that the pictures formed part of a larger series or cycle. Not only are the two panels virtually the same size, but the scenes are constructed on a precisely mirror-image perspective grid, with the vanishing point located along the left edge of the New York panel and the right edge of the Boston panel, sixty-two centimeters from the bottom edge. In both, three stairs divide a foreground space from an interior one, viewed

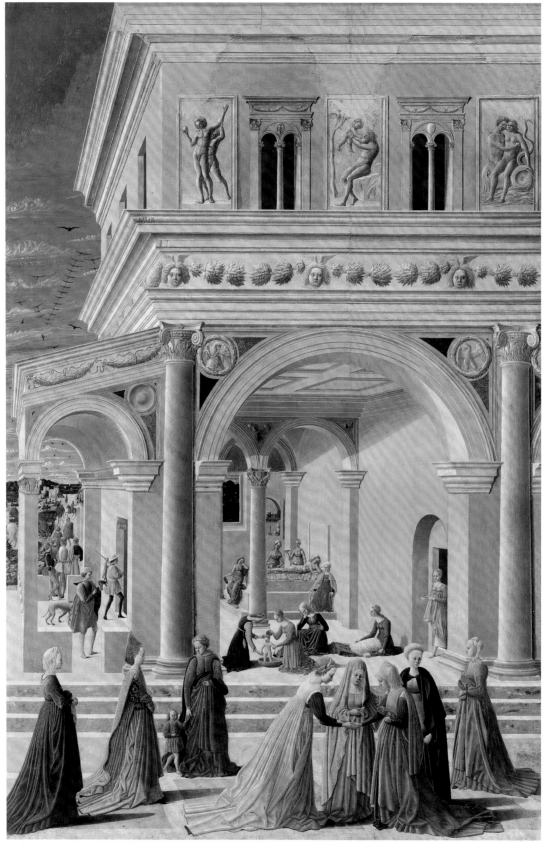

45 A

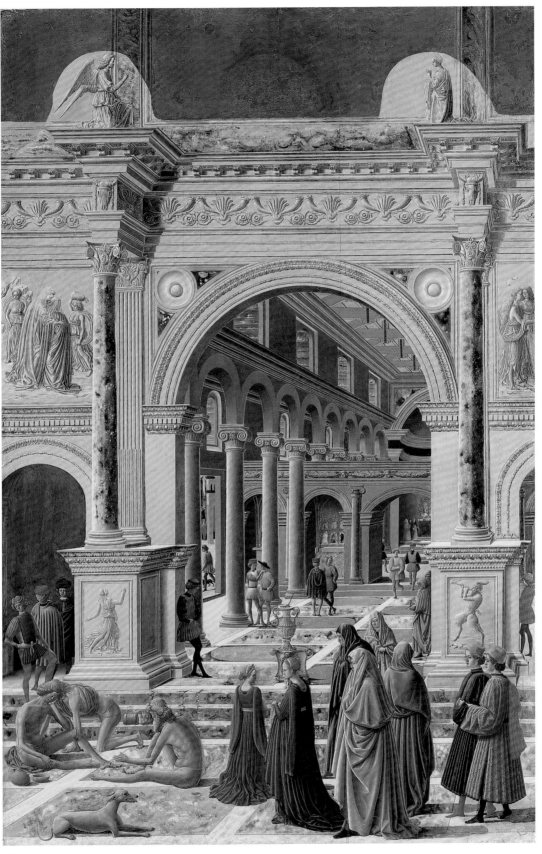

45 B

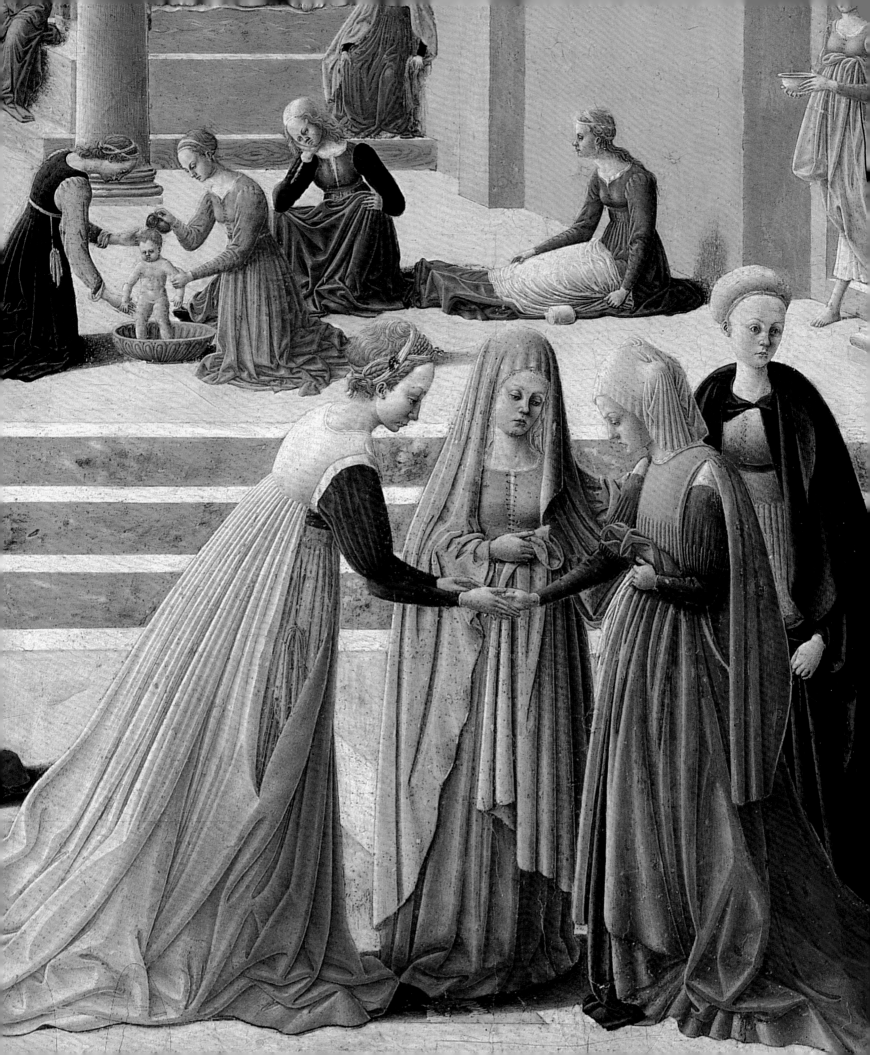

through a large, classical arch. The perspective must have been worked out on a separate piece of paper so that the results could be transferred to both panels by simply flipping the cartoon. The perspective grid was elaborated in greater detail in the New York panel—the incisions are clearly visible in the left background, where a mathematically determined diminution of the figures was desired (fig. 1, p. 259)—but in both, pinpricks along the vertical edges indicating the transversals were carefully transposed (the same technique was used in cat. 40). This sort of mirror-image type of construction would have made no sense if extended to further narrative panels, and it really only leaves open the possibility of a missing center element. There is also the matter that no extensive cycle of the life of the Virgin would have reduced the Annunciation and the Visitation to decorative footnotes, as is done in the Boston picture. As Belluci and Frosinini point out in their essay, the pavement divisions are larger in the Boston painting, but the rate of diminution and figure scale in both are consistent, and I do not believe the artist intended to suggest different distance points.

There remains the problem of suggesting the possible appearance of the altarpiece to which these two panels seem to have belonged. Both have incisions at the top marking off three arcs; in the Metropolitan panel these arcs are cusped. The frame thus had a Gothic profile, with small arches supported on consoles—a type found on numerous Marchigian altarpieces, including Fra Carnevale's one surviving polyptych (cat. 41 A–D). The difference here is that they are aligned horizontally, as in an altarpiece by Paolo da Viso (Pinacoteca Civica, Ascoli Piceno). Zeri (1961, p. 87) erroneously maintained that in the areas that would have been covered by the frame there is evidence of metal brackets and large nails for affixing the panels to a wall. This incorrect information became part of his argument that the panels were taken by Antonio Barberini from the Palazzo Ducale rather than from an altarpiece. X-rays (fig. 2, p. 263) do reveal a curious panel construction and small nail holes on the perimeter for some support system (see the essay by Castelli and Bisacca). The type of frame indicated could have extended over a center panel or a niche containing a sculpture. There is, however, one detail that cannot easily be accounted for in this reconstruction, and that is the fact that the series of incised arches on both panels drops to its lowest point on the left, presumably to allow for the capital of an abutting pilaster. We would expect a mirror arrangement

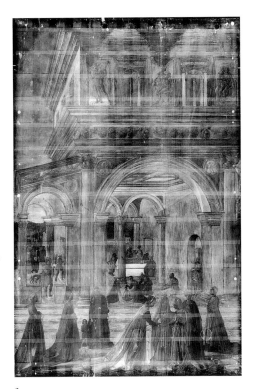

2.
X-radiograph of *The Birth of the Virgin*

in the framing, with a pilaster on the left side of one panel balanced by its counterpart on the right side of the other panel. The centers of the three arches do seem to be fixed symmetrically, approximately eighteen centimeters from the edges of the panel with about thirty centimeters between them.

As has long been acknowledged, architecture is the true protagonist of the compositions (see especially Strauss 1979; Borsi 1997; Bruschi 1996; and the essay by Ceriana). In the New York panel the setting is a grand, secular palace bearing affinities with the Palazzo Ducale of Urbino. In the Boston panel, by contrast, there is an impressive and remarkably innovative ecclesiastical structure, in which a Roman triumphal arch has been adapted as the façade of a basilica—a problem first essayed by Leon Battista Alberti for the Tempio Malatestiano in Rimini and then, more elaborately, on the church of Sant'Andrea in Mantua (designed in 1470). The interior of the temple or church has echoes of Early Christian basilicas in Rome but retains a Florentine, Michelozzan aspect. The Ionic capitals are identical to those in the *Annunciation* (cat. 40) and can be compared with the ones Michelozzo employed in the courtyard of the Palazzo Comunale in Montepulciano (Strauss 1979, p. 44). Similarly,

the frieze of the rood screen, or *tramezzo,* with its cherub heads from which swags bound with fluttering ribbons are suspended, derives from Michelozzo's door to the novitiate chapel in Santa Croce, Florence (on these see Bruschi 1998, p. 27; fig. 23, p. 63). The capitals of the projecting columns and pilasters repeat features of the entrance portal of San Domenico (fig. 1, p. 96), in the execution of which Fra Carnevale was personally involved (Strauss 1979, pp. 126–35). Notwithstanding these details, in the ex-Barberini Panels Carnevale has abandoned the strongly Florentine accent of his earlier architectural settings, with their brilliant local color, elongated proportions, and simple wall treatment, and aspired to a Roman grandeur reflecting his awareness of Alberti's treatise on architecture, the *De re aedificatoria.*

Key to their conception is the carefully articulated distinction between palace and ecclesiastical architecture, a central theoretical issue for Alberti (see Cieri Via 1999, pp. 237–40). "If I were to sum up the whole question," Alberti writes in the ninth book of the *De re* (Leach, Rykwert, and Tavernor 1988, p. 293), "I would say that sacred buildings ought to be so designed that nothing further may be added to enhance their majesty or cause greater admiration for their beauty; the private building, on the other hand, must be so treated that it will not seem possible to remove anything, because everything has been put together with great dignity." Fra Carnevale seems to have taken this admonishment as the leitmotiv of his panels, enriching the church façade with veined-marble columns and details such as the bucrania and paired cornucopias on the entablature and the inlaid marble pavement patterned on that of the Pantheon in Rome (on Alberti and pavements see Smith 1994, pp. 206–11). The entablature decoration is not dissimilar to the border of Piero della Francesca's votive fresco in the Tempio Malatestiano in Rimini, which, it has been conjectured, derives from a drawing by Ciriaco of Ancona (Simi Varanelli 1996, p. 143). At the same time, the palace, with its curious lean-to portico, is provided with a bona fide classical pedigree by the gems and sarcophagi on which the reliefs are based. (As noted by Strauss 1979, pp. 99–101, a similar portico is depicted in Lazzaro Bastiani's *Last Communion of Saint Jerome* [fig. 54, p. 123].) The relief of the drunken Bacchus is taken from an ancient cameo owned by Cardinal Francesco Gonzaga that was widely known through casts; that of Silenus with the infant Bacchus is based on a Roman sarcophagus (Museo delle Terme,

3.
The Birth of the Virgin, detail showing pinpricks

Rome); and the Nereid on a sea centaur reprised another sarcophagus motif that is also known from gems (see Thomas 1980, pp. 69–72; Strauss 1979, p. 90). Interestingly, Fra Carnevale has not slavishly copied his antique sources but freely transformed them (Bacchus holds a glass instead of his thyrsus and torch and his companion is no longer the fat Silenus). The reliefs have the same sort of anecdotal, genre-like slant found in the religious narratives that are the ostensible subject of the paintings.

This freely inventive spirit extends to details such as the Composite capitals in the New York panel, in which the volutes are interpreted as rams' horns, as though Fra Carnevale had taken to heart Alberti's remark (IX.1) that with private buildings, "it may be more delightful to stray a little from the dignity and calculated rule of lineaments. . . ." What we end up with is something very different from the erudite antiquarianism that informs Mantegna's frescoes in the Ovetari Chapel in Padua or his incomparable *Presentation of Christ in the Temple* (Uffizi, Florence), painted for Ludovico Gonzaga in Mantua: it is a piecemeal and even dilettantish approach, but extremely ambitious for all that. Bruschi (1996, p. 276) has defined the mind at work as notable less for practical competence than for an uncommon knowledge of architectural ideas that was among the most up-to-date in its day.

Even allowing for the possibility that Fra Carnevale went to Padua with his fellow Marchigian painters Giovanni Boccati and Girolamo di Giovanni, or possibly made a trip to

Rome (on the occasion of the 1450 Jubilee ?), the character of the two ex-Barberini panels can really only be explained by the culture of the court of Urbino: of Federigo da Montefeltro, whose keen interest in architecture as well as in perspective is well known, and of his counselor and relative Ottaviano Ubaldini, who, according to Giovanni Santi (Raphael's father), was looked upon as a father by painters and sculptors. (Recently discovered documents actually place Fra Carnevale in close touch with Ottaviano: see the contribution by Mazzalupi in the appendix.) It is in this regard that the similarities of certain details in the panels to decorative elements in the Palazzo Ducale become significant. The Montefeltro eagle that decorates the right-hand spandrel of the palace in the New York panel appears as though it were copied from the coat of arms above the fireplace of the Sala della Iole (fig. 31, p. 113). The pseudo-antique reliefs bear a close, stylistic affinity with the bacchic frieze on that same fireplace, while the dolphin capitals of the column within the palace in the New York panel reveal a striking resemblance to those actually framing the main door into the Sala della Iole (fig. 39, p. 116).

Fra Carnevale's name occurs on a sixteenth-century list of engineers who had been employed on the Palazzo Ducale, along with Luciano Laurana and Francesco di Giorgio, and it has been forcefully argued that, prior to 1468 and the appointment of Laurana as chief architect, the Dominican painter had a hand in the planning of the Sala della Iole (see the essay by Ceriana). There can be no question that Fra Carnevale was employed by the Urbino court—his painting of an alcove (fig. 41, p. 117) in the palace is proof of this—and the ex-Barberini paintings only make sense if we think of them as addressed not only to the confraternity members but to Federigo and Ottaviano as well.

It is worth reminding ourselves how advanced Fra Carnevale's paintings would have appeared in Urbino at this time, for too often Piero's work is taken as the sole yardstick of Federigo's patronage. Yet, aside from the *Flagellation,* Piero's paintings for the court date from the late 1460s on. (Piero is documented in Urbino in 1469, when he was engaged by the Compagnia del Corpus Domini to examine what needed to be done to their altarpiece, initially commissioned from Fra Carnevale and later brought to completion by Uccello and Joos van Ghent.) Sometime before 1467—perhaps as early as 1459—Giovanni Boccati was

hired to decorate a room adjacent to the Sala della Iole with a series of frescoes of *Famous Men* (fig. 9–10, p. 48): a cycle whose style is as far removed from the measured, solemn world of Piero and from the archaeological one of Mantegna as might be imagined. Compared to the chivalric, tapestry-like effect of this cycle, the style of the ex-Barberini Panels must have seemed to epitomize Alberti's ideals as expressed both in the *Della pittura* and the *De re aedificatoria*. Indeed, given Federigo's taste (which was not, however, immune to the luxuriant effect of Flemish tapestries, while relishing the detailed realism of Eyckian painting), we might well wonder why Fra Carnevale had not been engaged to carry out this task instead of Boccati. The answer must be that the artist was ill at ease working on a large scale and unpracticed in fresco. His approach was that of a miniaturist (in the Boston panel we can even make out the figures of the blessing Christ flanked by patriarchal saints in the small polyptych in the rood-screen chapel as well as the wrought-iron candlesticks with lit candles on the altar).

Boccati is only one of the artists against whose work Fra Carnevale's would have been measured. In 1465 Uccello had come to Urbino and in 1467–68 he was paid for painting the predella to an altarpiece for the Compagnia del Corpus Domini—an altarpiece with which Fra Carnevale had been involved a decade earlier. Both artists shared a common interest in perspective as a narrative device—Uccello, too, uses opposing vanishing points to divide the first two episodes of his tale—but there is no comparing their classical culture. The perspective structure of the panels demonstrates Fra Carnevale's awareness of Alberti's 1435 treatise on painting, for not only is he rigorous in laying in a grid for the composition but the figures positioned on that grid in the New York panel are approximately three times the height of the square on which they stand. This is in conformity with Alberti's desire to establish a proportional relationship of figure to setting that is premised on the *braccio*—"for as may be seen from the relationship of [a man's] limbs, three *braccia* is just about the average height of a man's body" (*Della pittura,* I.19). Thus, Fra Carnevale's fascination with perspective—evident in his earlier work—is now complemented by his knowledge of Alberti's architectural ideas.

In the 1460s Alberti made frequent trips to Urbino (he is documented there in 1464: on Alberti and Urbino see Borsi 1977, pp. 133–39;

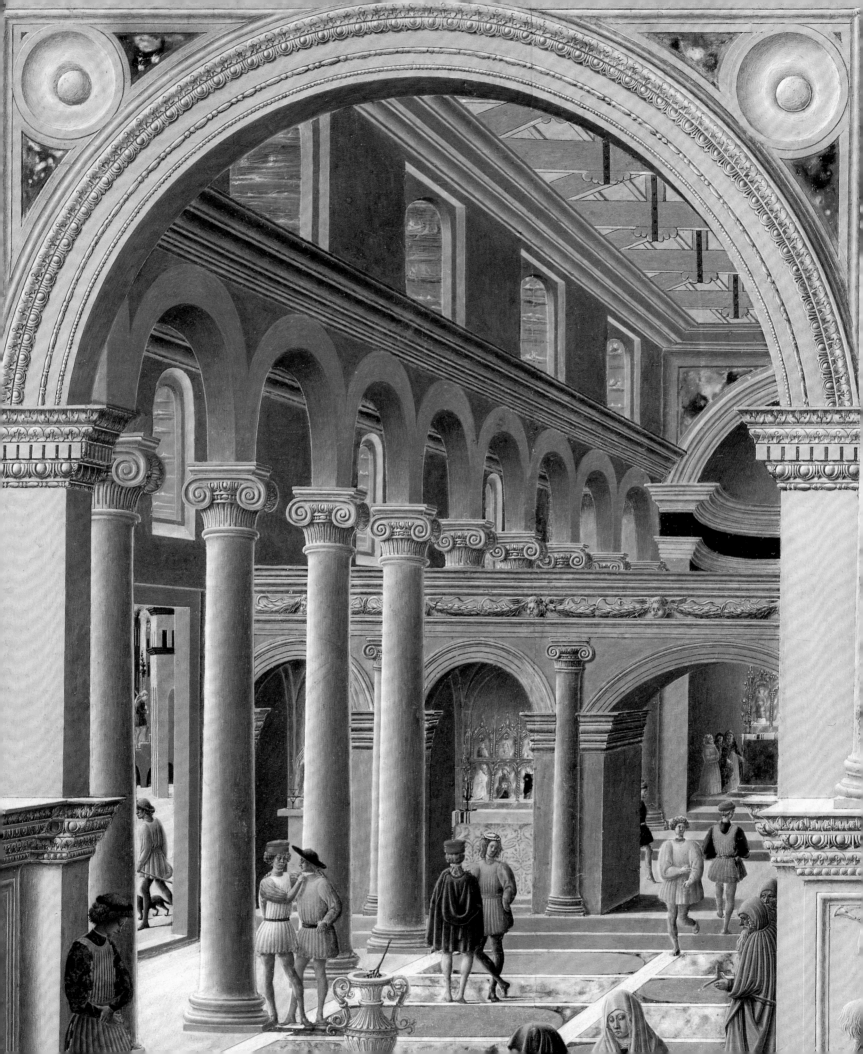

Pernis 1990, pp. 21–28). It is during such visits that Fra Carnevale may have had occasion to meet him and to acquaint himself with the ideas of the *De re*. The two cloud formations in the New York panel that take the form of dolphins (interpreted by Parronchi as Alberti's emblem of the winged eye) are erudite references to images made by chance, as mentioned by Pliny and Lucretius (see Janson 1961; Berra 1999, p. 375); they are the kind of detail Alberti would have approved of and that we also find in the work of Mantegna.

At Federigo's court Fra Carnevale must have met Piero della Francesca, who had a more profound but kindred interest in perspective and architecture. Every scholar has been struck by the echoes of Piero's cycle of frescoes in San Francesco, Arezzo, in the ex-Barberini Panels, but the culture Fra Carnevale shares with the great painter of Borgo Sansepolcro goes well beyond mere "influence." Needless to say, Fra Carnevale's work lacks the inner coherence and elevated vision of Piero: it remains a cornucopia of motifs rather than a synthetic statement. We might well view the ex-Barberini Panels as Fra Carnevale's attempt to maintain his position as architectural consultant to the duke at precisely the moment when Federigo was attempting to lure Laurana and Piero to his court. Although Lomazzo's treatise of 1584 (Book VI, chap. XLVI) lists Fra Carnevale alongside some of the greatest of architectural painter-designers, he could not compete with either Piero or Laurana. Yet, to an artist like the young Bramante, his paintings offered something just as important: a compendium of ideas that could serve as a catalyst rather than a model. The legacy of the ex-Barberini Panels can perhaps best be read in the image of a ruined temple engraved by Bernardo Prevedari in Milan in 1481 from Bramante's design.

K C

PROVENANCE: Oratorio di Santa Maria della Bella, Urbino (until 1632); Cardinal Antonio Barberini, Palazzo Barberini, Rome (1632–71; inv. 1644, 1671, 1672, as Fra Carnevale); Palazzo Barberini, Rome (1672–1934); (A) Marchesa Eleanora Corsini Antinori and Baronessa Giuliana Corsini Ricasoli, Florence (1934–35); M. Knoedler and Co., New York (1935) and (B) Principe Tomaso Corsini (1934–36).

REFERENCES: Lazzari 1801, pp. 73–74; Crowe and Cavalcaselle 1871, p. 350 n.; Venturi 1893, pp. 416–18; Venturi 1913, pp. 108–12; Wehle 1936, pp. 59–66; Cunningham 1937, pp. 46–50; Offner 1939, pp. 205–53; Zeri 1961, pp. 11–18, passim; Bruschi 1969, pp. 71–73 n. 43; Battisti 1971, pp. 501–3 n. 360; Conti in De Angelis and Conti 1976, pp. 105–9; Christiansen 1979, pp. 198–201; Strauss 1979, pp. 66–105; Zeri and Gardner 1980, pp. 36–40; Christiansen 1983, pp. 24–30; Ciardi Dupré Dal Poggetto in Ciardi Dupré Dal Poggetto and Dal Poggetto 1983, pp. 45–48; Zampetti 1988, pp. 393–96; Sangiorgi 1989, pp. 15–21; Dal Poggetto 1992b, pp. 304–5; Gilbert 1993, pp. 146–52; Strinati in Millon and Lampugnani 1994, p. 503; Echols in supplement to Millon and Lampugnani 1994, nos. 423–424; Kanter 1994, pp. 211–14; Bruschi 1996, pp. 275–85; Cleri 1996, pp. 354–58; Borsi 1997, pp. 14–60.

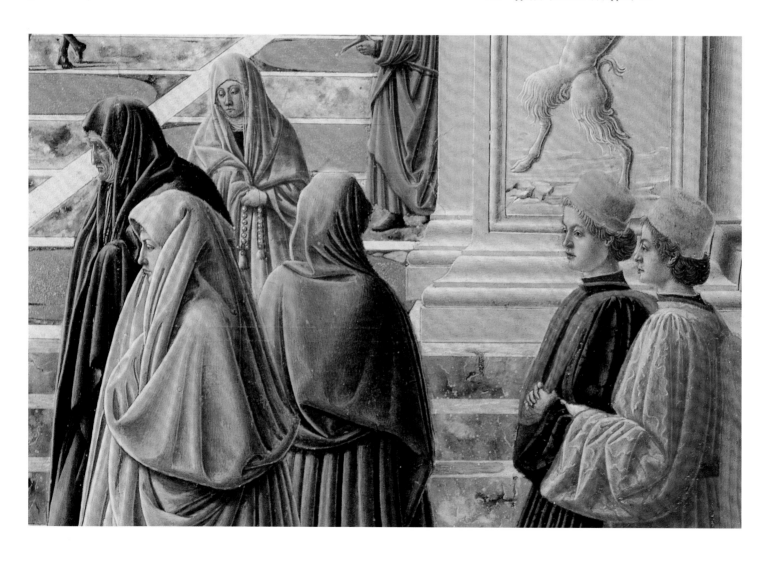

[46]*

P I E R O D E L L A F R A N C E S C A

Madonna and Child with Saints, Angels, and Federigo da Montefeltro (the *Montefeltro Altarpiece*)

Oil and tempera on panel, about 251 x 172 cm
Pinacoteca di Brera, Milan

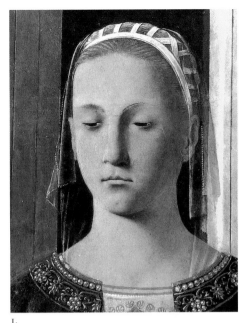

I.
Montefeltro Altarpiece, detail.
Pinacoteca di Brera, Milan

Although this painting was published, for the most part, after World War II, the critical literature is brief but also dense, and has led to an unusually close identification of the work with the museum where it is housed. The panel is often known as the "Brera Altarpiece," and its hypnotic, mysterious egg has come to symbolize the museum, like a hieroglyph (not coincidentally, designer Achille Castiglioni named his oval lamp suspended from a single wire the "Brera" lamp).

The altarpiece, which is in good condition, was restored by Pinin Brambilla from 1979 to 1981. The restoration project, supervised by Carlo Bertelli, not only addressed conservation issues—eliminating the thick layer of dust and varnish that had dulled the painting's colors and the complex, enchanting treatment of light—but was preceded by a detailed technical study (Bertelli 1981; Bertelli 1982). The panel consists of nine horizontal planks slotted together by means of wood rods and further reinforced by metal cleats with a ring-shaped center section, three for each join (the straight parts embedded in the panels, the ring part protruding). Two other works painted in Urbino during the 1460s and 1470s show this same unusual joining technique: Joos van Ghent's *Corpus Domini Altarpiece* (Galleria Nazionale delle Marche, Urbino) and his series of portraits of *Famous Men* in the *studiolo* of the Palazzo Ducale (Bertelli 1993; Trevisani 1996; Trevisani 1997; Castelli et al. 1997).

Vasari makes no mention of the altarpiece, which was taken from the church of San Bernardino in Urbino and arrived in Milan on June 10, 1811, with an attribution to Fra Carnevale. It was described as showing: "The Madonna, various Saints, with many portraits of the family of the Duke of Urbino" (*Inventario*

Napoleonico, Pinacoteca di Brera, Milan). As explained in my introductory essay, this description reflects a tradition dating back at least to seventeenth-century Urbino—a tradition that would endure until almost the end of the nineteenth century. Only a few dissident voices disputed the attribution to Fra Carnevale. The 1744 *Catalogo* prepared by Tosi contains the following annotation: "in the church of San Bernardino of the P[adri] Zoccolanti [the Observant Franciscans], the main altar, from the hand of Fra Carnevale, Dominican friar of Urbino, and others say by Luca [Pacioli] del Borgo." An anonymous source mentioned by Father Vincenzo Marchese (1845, p. 321) indicated without hesitation that the author was Piero della Francesca.

Cavalcaselle was the first reputable scholar to attribute the painting to Piero (Crowe and Cavalcaselle 1864–66, vol. 1, p. 554). Venturi (1893, pp. 415–16) made a stronger case, and although he later reconsidered his position, Piero's authorship was immediately accepted, particularly by the scholarly staff at the Brera (Calzini 1901, p. 370; Carotti 1901; Ricci 1904, 1910, pp. 317–18). Nonetheless, the idea that various artists had worked on the painting was slower to die. Van Marle (1929, pp. 8, 880–90) argued that Signorelli painted the figures, while several scholars have raised the possibility that Bramante or Fra Carnevale had a hand in the creation of the complex architectural setting (see Battisti 1971, 1992 ed.; Lightbown 1992; and, most recently, Bruschi 1996, for a more shaded analysis).

There is complete agreement that, as Longhi (1927) noted, the rough, almost realistic hands of Federigo da Montefeltro were painted by a Netherlandish-trained artist, one alternatively identified as Joos van Ghent (Aronberg Lavin 1967, p. 22; Aronberg Lavin 1969; Meiss 1971; Salmi 1979), or, more likely, Pedro Berruguete (Longhi 1927; Battisti 1971, 1992 ed.; Bertelli 1982; Dal Poggetto 2003c). The same artist is alleged to have painted the visor on the armor (Longhi 1963, p. 204; De Angelis and Conti 1976) and the Virgin's forehead, which initially had been decorated with a large diadem that is now hidden (Bertelli 1982). Direct study of these features, however, reveals them to be by Piero della Francesca himself (see fig. 1). Today, the altarpiece is regarded as a key work both in the oeuvre of Piero and in the history of art. It is a landmark *sacra conversazione,* whose vertical format required Piero to situate the figures within a deep, complex, and monumental space.

Remarkably, despite the important studies dedicated to this altarpiece, we know neither the circumstances of its commission or date nor its intended destination or significance. Even its spatial plan was long misunderstood. Many studies have now demonstrated that the group of figures in the foreground does not stand beneath the barrel-vaulted apse. Rather, as indicated by the plinth behind the elbow of Saint John the Baptist, the figures are positioned within the nave (Meiss and Jones 1966; Shearman 1968; Davies and Snyder 1970; Welliver 1973; Maltese 1974; Bertelli and Sorteni in Bertelli 1982; Ceriana [1997] gives a summary as well as a careful analysis of the architectural vocabulary). The egg, which seems to hang directly above the Virgin's head, actually is much farther back, as are the impassive angels, who at first glance seem aligned with the figures in the foreground.

Not only does Piero avoid furnishing the means that would make it possible to accurately reconstruct the ground plan of the building, but details important to an understanding both of the position of the figures and of the structure of the space occupy peripheral areas, so that a slow, attentive exploration of the entire picture field is required. The complexity of the cruciform building is suggested by the large arches of the transepts and the fragmentary cornices that support the vault of the nave, in which the viewer is imagined as standing. Contrary to recent assumptions (Bertelli, but also

Ragghianti as cited in De Vecchi 1967, p. 106), the panel does not appear to have been greatly reduced in size. It has probably been trimmed only a few centimeters—the difference between its current dimensions and its measurements when it first entered the Brera (258 x 176.5 cm) is perhaps accounted for by the unpainted support that originally was covered by the frame.

Thus, Piero intentionally created an ambiguous and difficult composition, as he also did in other works (for example, the Williamstown altarpiece [cat. 47]). Attempts to reconstruct the architecture have resulted in incongruities and gaps, demonstrating that Piero did not seek to accurately represent an actual interior but instead wanted to suggest an environment for the assembled figures: he strove for an optical rather than a geometrically based verisimilitude, evoking a believable setting through the light that outlines the architecture, enlivens the shadows with reflections, and delicately emphasizes the figures of the saints, the Virgin, and the donor, shown in a softly illuminated area (Hall 1992). To achieve this effect, he interweaves the colors, using a limited palette composed of pigments in various media (oil, egg, and oil-and-egg emulsion: Bertelli 1982; Trevisani 1997; Di Lorenzo 1996b), built up in varying, transparent layers.

Piero often leaves a thin strip of the pale ground exposed around the figures—something he learned from Netherlandish painting—so as to set up a vibrant luminosity that enhances their three-dimensionality. Although this feature, which is also found in the Barberini Panels, has been thought to indicate that the painting was unfinished (Bertelli), we now know that it was a device used by Piero in other, more or less contemporary works, such as the *Sant'Agostino Altarpiece* (Di Lorenzo 1996b).

The attention to the vivifying play of light on the most diverse materials—another lesson from Netherlandish painting—combined with the extraordinary command of color and geometric and spatial rigor indicate that this is a mature work by Piero. The exact date, however, is still a matter of controversy (hypotheses vary from "before 1466," as proposed by Shearman [1968], to the early 1480s, or even later: Rotondi [1947]; Venturi [1954]; Hendy [1968, p. 155]; Clough [1970]). The conclusion that has gained the widest consensus is that reached by Meiss (1954). He argued that the latest possible date for the altarpiece would be the summer of 1474, when Federigo was granted the title of

Duke, appointed *Gonfaloniere* of the Church, and decorated with the Collar of the Order of Ermine (the highest honor of the House of Aragon) and the Order of the Garter. Although these insignia appear regularly in his later portraits, he is not wearing them in the altarpiece. The earliest possible date would be July 6, 1472, when Federigo's wife, Battista Sforza, died, as she does not appear in the painting. The ostrich egg, an allusion to the Four Elements, Creation, and, above all, to the miraculous conception of Christ, would signify the birth of Federigo's son, Guidubaldo, the much-hoped-for male heir, in January of the same year (on the egg, see also Pozzi 1989).

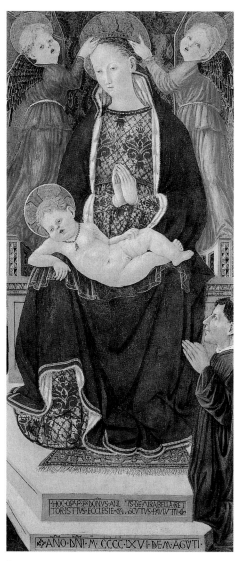

2.

Giovanni di Piermatteo Boccati, *Madonna and Child*. Santuario della Madonna delle Lacrime, Seppio di Pioraco

Even those who have interpreted the painting differently tend, for the most part, to agree on a dating between 1469 and 1475. Aronberg Lavin (1969) sees the work as a public oath of fealty to the pope; Bertelli (1982; 1992) offers a penitential, funerary reading; while Lightbown (1992) considers the altarpiece as the duke's invocation before the heavenly assembly for the salvation of his soul (for a summary of these viewpoints, with further observations, see Trevisani; Daffra in Trevisani and Daffra 1997; Bertelli 1998). If such private, personal readings of the painting are credible, the fact that Federigo does not wear his insignia would have no chronological significance, since worldly decoration would be out of place in such a context.

Disputes over the date and purpose of the painting are closely connected to the question of its original destination, since the church of San Bernardino—where the altarpiece was located in the sixteenth century and from which it was removed in the nineteenth—was probably not built until after the death of Federigo in 1482 (see Rotondi; Burns). Since the duke is portrayed in armor and the painting was eventually transferred to the place where Federigo was ultimately buried, the original location must have had dynastic significance. Two possibilities are the church of San Francesco (either the Cappella delli Conti or the Cappella dell'Assunta) and the reformed Franciscan church of San Donato, where Guidantonio da Montefeltro was buried and Federigo's body was temporarily laid to rest. A third possibility is the circular chapel—the "*tempio rotondo*"—which, while planned for the Cortile del Pasquino in the Palazzo Ducale, was never built (see Shearman 1968; Sangiorgi 1973; Parronchi 1976; Salmi 1979; Bertelli 1991; Battisti 1971, 1992 ed.; Clough [1970] proposes the Cappella del Perdono in the Palazzo Ducale).

No new, objective information has emerged that would answer these questions unequivocally. Some clues might be offered, however, by reflections on the Urbino context and on Fra Carnevale. If we compare the treatment of architecture in Fra Carnevale's *Annunciation* (cat. 40) with that in the Barberini Panels (cat. 45 A, B), it is difficult to escape the impression that the latter is a response to Piero, although less to the sumptuous and severe architecture of the *Montefeltro Altarpiece,* so different from the Dominican friar's varied and ornate settings, than to the Sansepolcro artist's extraordinary pictorial sensibility. The *Montefeltro Altarpiece*

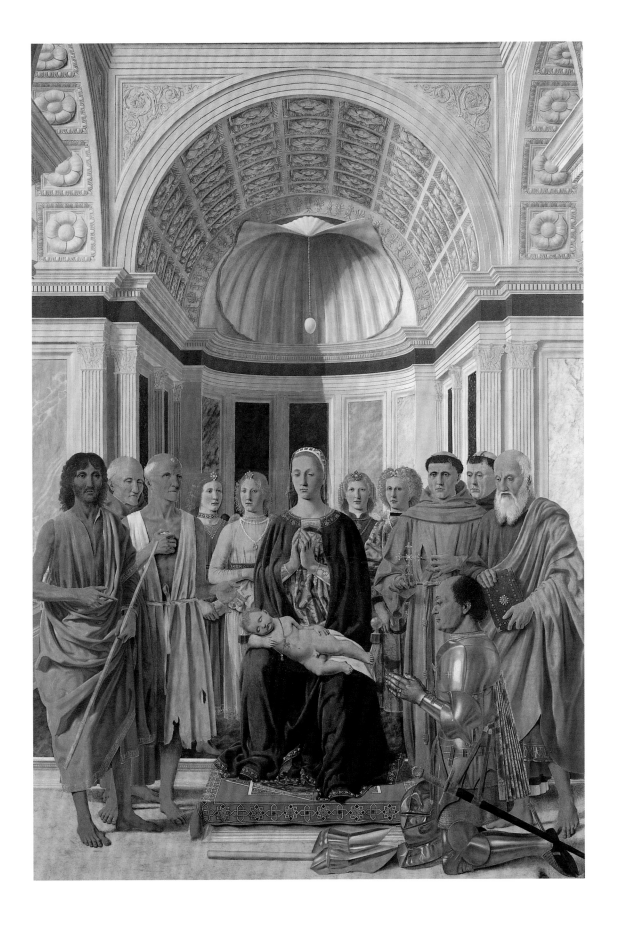

3.
Piero della Francesca, *Montefeltro Altarpiece*, detail.
Pinacoteca di Brera, Milan

4.
Nicola di Maestro Antonio, *Madonna and Child Enthroned with Saints,* detail. Carnegie Museum of Art, Pittsburgh

was probably also known to Giovanni Boccati. In the center panel of his triptych in Seppio di Pioraco (fig. 2), dated 1466 (see Minardi 2002a), the donor is depicted in full profile with his hands joined in prayer. The child is awake and animated, his legs crossed in aristocratic nonchalance, but he is holding his right arm at his side with the same gentle abandon as Piero della Francesca's sleeping infant. These details suggest that Boccati saw the *Montefeltro Altarpiece* while Piero was still working on it. These are, of course, motifs that he could have known indirectly (the type of the sleeping infant recurs in paintings by the workshop of the Vivarini: for example, in Bartolomeo Vivarini's triptych in the Museo Nazionale di Capodimonte, Naples), but Boccati's painting has even more significant resemblances, indicating direct knowledge of Piero's altarpiece. There is the unusual stiffness of the forms; the orderly arrangement of the drapery; the solemn Madonna, with her quiet, luminous face framed by a deep-blue mantle rather than by the customary brocade. The mantle stops at her shoulders, highlighting her forearms, as in the Brera Virgin, and it falls in folds more solid, sparse, and formal than the flat, angular pleats that fan out on the marble dais of Boccati's *Madonna of the Orchestra* (cat. 32).

Therefore, by 1466—much earlier than is usually believed—Piero must have begun the

altarpiece. Boccati, who had worked in the Palazzo Ducale, cannot have found it difficult to see the painting, admire it, and derive a strong but short-lived impression, since in his later altarpiece at Belforte (ill., p. 220) he reverted to his habitual sweet and exquisite type of the Madonna.

The impact of the *Montefeltro Altarpiece* would seem to have stopped with these examples, only to resume in the early 1470s. Subtle echoes can be seen in the *Coronation of the Virgin* by Francesco di Giorgio (Pinacoteca Nazionale, Siena), which can be dated between 1472 and 1474 (Di Teodoro 1996), and in the *Madonna and Child Enthroned with Saints* by Nicola di Maestro Antonio (Carnegie Museum of Art, Pittsburgh), dated 1472, in which the Virgin's hands (fig. 3, 4) are a fairly direct copy of those of Piero's Madonna (Trevisani 1997). Boccati seems, again, to have responded to the *Montefeltro Altarpiece* in his 1473 *Madonna and Child with Saints* (Szépművészeti Múzeum, Budapest; the head of the Virgin was repainted by Pastura), and Crivelli, too, appears to have known it, since his Saint Francis (fig. 5) in the *Montefiore Altarpiece* (dated by Zeri to the early 1470s) resembles a flatter, more elongated, and nervous recasting of Piero's representation of the same saint, with his extraordinarily foreshortened hands. That these were not casual repetitions of standardized poses is suggested by

the fact that the saints in the upper register of Crivelli's altarpiece—especially Saint Louis of Toulouse—betray the artist's knowledge of the fresco cycle of *Famous Men* in Federigo's *studiolo* and thus testify to an undocumented trip by the artist to Urbino.

This dense series of imitations could mean that in the early 1470s the *Montefeltro Altarpiece* was already installed in a place that was accessible to those who did not necessarily frequent the court. It seems puzzling that its innovative architectural setting did not leave a mark, but most painters, with the exception of Francesco di Giorgio, simply may have been uninterested in spatial and architectural issues.

Following an inductive line of reasoning, we could, therefore, propose that the altarpiece was begun in the mid-1460s and finished at the start of the following decade, according to the meditative process typical of Piero. Its chronological proximity to the panels of the *Sant'Agostino Altarpiece* for Sansepolcro, for which final payments were made in 1469 (Di Lorenzo 1996b), would support this hypothesis. So, too, does Piero's attention to those architectural works in Urbino with which Fra Carnevale can be linked: the portal of San Domenico (fig. 1, p. 96) and the plinths of the sleeping alcove (fig. 41, p. 117), which Piero updated (Ceriana 1997, p. 137; essay by Ceriana in this catalogue). Consequently, it seems reasonable to suggest that Federigo da Montefeltro commissioned the altarpiece for the "*tempio rotondo*" and that Piero was working on it at the same time that Fra Carnevale was painting the Barberini Panels— which, nevertheless, are quite distinct both in terms of the typology of the architecture and the crucial relationship between the human figures and the setting.

A final, secondary point: the only document that certifies the presence of Piero in Urbino is the reimbursement to Giovanni Santi for expenses sustained by the Sansepolcro artist, who had come to examine the still-unpainted panel of the altarpiece for the Confraternità del Corpus Domini in Urbino. This is the same panel that, in June 1456, Fra Carnevale had refused to "make, construct and paint." The panel was readied in the years immediately preceding Piero's arrival. The account books of the confraternity (Moranti 1990) record the expenditures relative to the carpentry work, which was paid for primarily between January and October 1468. As already noted, even in its altered state, this panel is of the same, unusual type as the *Montefeltro Altarpiece* and

the series of *Famous Men* for the *studiolo*. The shape, and especially the iron cleats, have been interpreted in different ways: as elements through which to pass iron reinforcement bars (Bertelli); as a system for securing the panel to a structure or frame (Trevisani); as the remains of a system for anchoring the boards according to models tried out in Florence by Fra Angelico and Lippi during the 1430s and 1440s (Castelli et al. 1997). The latter interpretation would seem to be supported by the meager book-keeping records, which mention large beams or planks "as an armature for the panel" with "metal bosses." If this is so, then it is tempting—although certainly not provable—to imagine that our multi-talented Dominican friar was appointed to supervise the construction of the panel supports for the new paintings in the city, and that in carrying out this task he proposed using a variant of the system he had seen during his youthful years as an apprentice in Florence.

ED

PROVENANCE: Church of San Bernardino, Urbino (until 1811); Pinacoteca di Brera, Milan.

REFERENCES: Crowe and Cavalcaselle 1864–66, vol. 1, p. 554; Venturi 1893, pp. 415–17; Clark 1951, 1969 ed., pp. 67–68, 231–32; Meiss and Jones 1966; Hendy 1968, pp. 143 ff.; Shearman 1968; Lavin 1969; Clough 1970, pp. 278–89; Davies and Snyder 1970, pp. 193–212; Battisti 1971, 1992 ed., vol. 1, pp. 263–68, vol. 2, pp. 504–12, 590–91; Meiss 1971; Sangiorgi 1973, pp. 211–16; Maltese 1974, pp. 283–92; Bertelli 1981, p. 11; Bertelli 1982; Orofino 1983; Alexander and Gallone 1987; Bertelli 1991, pp. 131–50, 212–13; Bertelli 1992, pp. 13–20; Hall 1992, pp. 79–84; Orofino 1992, pp. 174–81; Seracini 1992a, pp. 459–62; Bertelli 1993, pp. 51–55; Burns 1993a, pp. 240–42; Burns 1993b, pp. 230–38; Di Lorenzo 1996b; Di Teodoro 1996; Trevisani 1996, pp. 183–93; Castelli et al. 1997.

★ Shown only in Milan

5.
Carlo Crivelli, *Saint Francis*, from the *Montefiore Altarpiece*, detail. Musées Royaux des Beaux-Arts, Brussels

[47]

PIERO DELLA FRANCESCA

*Madonna and Child
Attended by Angels*

Oil (and tempera ?) on wood, transferred from
wood, 107.8 x 78.4 cm
The Sterling and Francine Clark Art Institute,
Williamstown, Massachusetts (inv. 948)

Quite apart from its intrinsic beauty, the Williamstown *Madonna and Child Attended by Angels* holds a special place in the reinstatement of Piero della Francesca as one of the great figures of the Renaissance. By the time the picture was published by Gnoli in 1930, it already had a long history, always as a work by Piero. It was purchased in Florence in 1837 by Sir Walter Trevelyan from a dealer whose name, Bicoli (common in the upper Valdarno region), suggests someone of Aretine origin. At the time, Piero was still a relatively undiscovered artist (see Cheles 1996, p. 586), and when we recall that well into the nineteenth century the *Senigallia Madonna* (fig. 2, p. 26), the *Montefeltro Altarpiece* (cat. 46), and parts of the *Sant'Agostino Altarpiece* (National Gallery, London, and Museo Poldi Pezzoli, Milan) were ascribed to Fra Carnevale, the fact that the work was attributed to the great Sansepolcro artist seems remarkable. The explanation for this is that the work remained in the same family for whom it was evidently painted and the name of the artist was passed down along with

6.
Piero della Francesca, *Montefeltro Altarpiece,* detail.
Pinacoteca di Brera, Milan

the picture: Trevelyan was told that it was "formerly in the gallery of Gherardi Christofori, of Borgo San Sepolcro, the native place of Pietro [*sic*]" (unpublished journals of Trevelyan).

Despite this early indication of authorship (which, prior to Battisti, remained largely unexplored), scholars have come to dispute the attribution, but all too frequently their opinions have been based on viewing photographs rather than the work itself. Indicatively, although exhibited in London in 1870 and again in 1892, Longhi was unaware of the picture when he wrote his groundbreaking monograph on the artist in 1927 (he included the painting in the 1942 edition). Even today, this is the least well known and studied of Piero's works, and this exhibition provides an exceptional opportunity to reconsider the issues surrounding it.

Its critical history may be summarized briefly. Gnoli (1930–31), Longhi (1942), Battisti (1971), and Lightbown (1992) all accept Piero's authorship. Frankfurter (1957) and Bertelli (1991) take a more shaded view: Bertelli considered it "close" to Piero, underscoring its high quality, but he also pointed out departures from the artist's norms, especially in the architecture (see below). Other critics (Clark 1951 [1961 ed.]; Robertson 1971; Gilbert 1968; Field [n.d.] forthcoming) have suggested that it is a workshop effort in which one or more of Piero's assistants employed the master's motifs or cartoons. Yet, the quality of the painting is such that these conjectures seem very implausible, especially if we consider those paintings of the Madonna and Child that are universally accepted as the products of Piero's workshop (now in the Cini Collection, Venice; Christ Church, Oxford; and the Museum of Fine Arts, Boston: see Kanter 1994, pp. 225–26). The attribution to Signorelli (Kury 1978) carries no weight. Kennedy (verbal opinion 1969) went so far as to suspect that the picture was a fake—an idea Longhi had already felt necessary to rebut in the 1942 edition of his monograph.

Given this checkered history, it is well to review what we know of the "Gherardi Christofori," for whom it was said to have been painted. As Battisti (1971 [1992 ed.], vol. 2, p. 523) pointed out, the Gherardi were rich merchants who resettled in their native Sansepolcro in the fifteenth century. They were to give birth to a number of painters, including Cristofano Gherardi, called Doceno—a collaborator of Vasari. Battisti (1971 [1992 ed.], vol. 2, pp. 408–9 n. 548) took up the problem of the patronage of the picture and its original desti-

nation, furnishing three hypotheses that should now be reconsidered in the light of the archival research undertaken for this exhibition by Frank Dabell, a summary of which follows.

Information on the Gherardi family, among the oldest in Sansepolcro, derives mostly from a family memoir (*Memorie istoriche della Famiglia Gherardi*), in the Biblioteca Comunale of Sansepolcro, which dates from the late eighteenth century but is copied from a manuscript composed about 1600. The most likely candidate for the patron of the altarpiece is Cristoforo (or Cristofano) di Gherardo di Cristoforo de' Gherardi or his father, Gherardo di Cristoforo. In 1500 Cristoforo held the public office of *gonfaloniere di giustizia*. He drew up three successive wills: in 1491, 1496, and 1502; those of 1491 and 1496, first cited by Franklin (1998, p. 46) refer to Cristoforo as Cristoforo di Gherardo Nardelli, Nardelli being the patronymic of Nardello and the diminutive form of Nardo, so that his full name would be Cristoforo di Gherardo di Nardello. In these wills Cristoforo provided for his burial alongside his ancestors in the Chapel of San Leonardo "del Monacato," adjacent to the principal religious establishment of the city, the Badia (in 1520 elevated to the status of cathedral by Leo X). The chapel of the Monacato was the most venerated shrine in Sansepolcro and was closely associated with the Gherardi family. They had been involved in its building (ascribed in the *Memorie* to Leonardo di Nardo Gherardi) and continued to embellish it (Cristoforo provided for its further decoration). Childless at the time of his death in 1502, Cristoforo named as the heirs of his entailed estate the three sons of his brother Leonardo and, in the case of their deaths without male issue, those of his other brother, Francesco. Interestingly, his sister, Mattia di Gherardo di Cristoforo Nardelli, funded the altarpiece for the high altar of the Badia, which was eventually painted by Perugino; she was an active member of the Confraternità della Madonna, which met in a chapel of the Badia where there was a much-venerated statue of the Virgin (Franklin 1998), and she was subsequently buried in San Leonardo. Thus, the devotion of the Gherardi was focused on the two most important, connected buildings in Sansepolcro.

Dabell points out that Mattia Gheradi's second husband was Niccolò di Marcolino Pichi, to whom Piero della Francesca would have

1.
X-radiograph of cat. 47 taken before the transfer of the panel (1950–51)

2.
Reverse of the original panel after removal of the cradle

3.
Panel support viewed in raking light, showing the joins

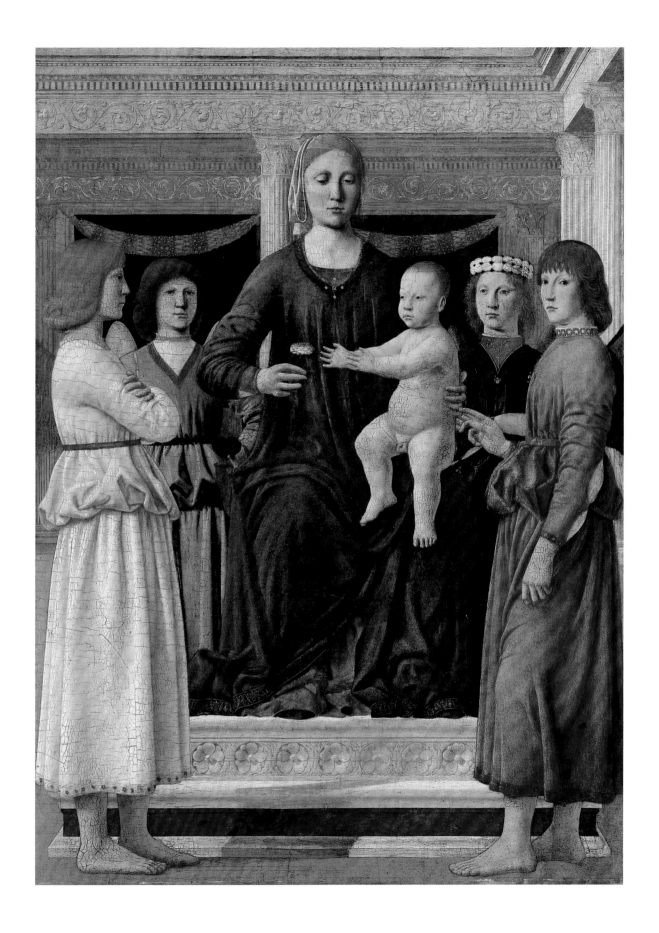

been related through the marriage of his niece Romana to Paolo di Meo Pichi in 1480. As is well known, a member of the Pichi family had funded Piero's *Misericordia Altarpiece* (Pinacoteca Comunale, Sansepolcro), and Piero's treatise on mathematics, the *Trattato dell'abaco,* was also dedicated to a member of the Pichi family. Nor do the relations between the two families stop here, for Piero elected to be buried in the Chapel of San Leonardo. It is therefore tempting to view the Williamstown painting as intended for an altar in San Leonardo, from which it was removed, as Battisti proposed, sometime in the sixteenth century—perhaps following the program of redecoration undertaken by Bishop Nicolò Tornabuoni (r. 1560–98). It is known, for example, that the chapel contained frescoes by the sixteenth-century painter Cherubino Alberti. The Gherardi would have appropriated their altarpiece and hung it in their palace. Indeed, the first probable reference to the painting is in a document of 1583 providing for the reframing of "*uno quadro di maestro Pietro di la Francesca*" (Battisti 1971; 1992 ed., vol. 2, p. 64). The document relates to the property of Giacomo di Bernardino Gherardi, Cristoforo's great-great-nephew (see Lightbown 1992, pp. 271–72). Whatever the destination of the altarpiece, the commission was clearly an important one.

Thirty-two years after Trevelyan purchased it, the picture was sold at public auction. Acquired by Sir Alfred Seymour, it was sold by his heirs in 1912 (Battisti 1971; 1992 ed., vol. 2, p. 523; Archives, The Sterling and Francine Clark Art Institute, Williamstown, Massachusetts); the New York collector Robert Sterling Clark bought it from Colnaghi in 1913, eventually transferring it to the museum he founded in Williamstown (opened to the public in 1955).

We know very little about the conservation history of the picture prior to its purchase by Clark. It was cleaned in Paris in 1934 by a Madame Coince, who was paid 7,000 francs (Archives, The Sterling and Francine Clark Art Institute). In 1950–51 the prominent restorer, William Suhr, transferred it from its much-deteriorated original wood support. Photographs of Suhr's intervention are on file in the museum (fig. 2–3), and when these are examined with the X-rays (fig. 1), they provide a partial basis for suggesting the nature of the original structure. Suhr also delivered a lecture on his restoration, and a manuscript copy of this, together with the author's handwritten notes, is preserved as well in

4.

5.

the Williamstown museum's archives.

Suhr reported that the picture's support, worm tunneled and impregnated with wax, had already been thinned and cradled. The condition of the support was so compromised by the infestation of wood-boring insects that it posed a danger to the stability of the paint surface. The transfer to a new support seems to have included both the destruction of the original panel and the bottom-most layer of the preparation (the so-called *gesso grosso*). The picture was reinforced with a layer of modern gesso and mounted on a composite support that was subsequently backed with wood.

Not surprisingly, these radical interventions have left their mark on the paint surface. The inevitable flattening that comes from a transfer is clearly evident, as is damage from over cleaning: in some areas the preparatory layer of paint is visible and in others—such as the brocade pattern of the virgin's dress, now barely discernible—the appearance of the painting has been seriously compromised. Actual losses, in the upper part of the picture and corresponding to the grain of the original support, must predate the transfer. (A long, *V*-shaped split extends through the Virgin's right temple, shoulder, and right hand; other local losses occur in the folds of the blue cloak below the Virgin's right knee.) Archival sources as well as a direct examination of the work provide crucial information about the technique and execution of the painting. Its support consisted of three poplar panels joined vertically. The picture has not been cut down at the top, although the other edges were trimmed, probably to regularize the panel after it was removed from its frame. The painting's dimensions are thus close to what Piero intended. There is, however, no

evidence to suggest that this panel was part of a larger and more complex structure, such as Parronchi (1984b) suggested when he argued that the Williamstown painting was the center panel of the disassembled *Sant'Agostino Altarpiece,* the four lateral panels of which survive.

An analysis of the paint layers reveals a proficient and complex technique. It is worth pausing here, since these observations provide information that may be useful in understanding the artist's creative process and the relative chronology of his work. First, there is the matter of the preparation he employs for the flesh tones, whether the traditional Florentine verdaccio (green) as in the *Baptism of Christ* (National Gallery, London) and the *Misericordia Altarpiece* (Museo Civico, Sansepolcro), or the gray preparation found in such works as the *Senigallia Madonna* (fig. 2, p. 26) and the *Montefeltro Altarpiece* (cat. 46). Second, there is the variation in craquelure visible in the painting. In parts of the Williamstown picture the wide craquelure is very conspicuous—almost disfiguring in places—but these passages are adjacent to others revealing a finer pattern (fig. 4). There are also areas of color slippage caused by an oil (or fatty) binder (fig. 5). Even taking into account the restoration history of the picture, it is clear that these three types of craquelure were caused by a variety of circumstances dating from the time of the work's execution. The least disfiguring of them, a mesh-like and fairly regular pattern, is seen in the architecture and in the red and green robes the figures wear, and was caused by the normal settling of the paint layers and the support. The slippage of color can be found almost exclusively in the Virgin's blue mantle. Prominent islands of color have been created—the typical result of the

swelling that takes place during the drying process. Frequently, this occurs in areas painted with lapis lazuli because of the higher percentage of medium necessary—a ratio that increases with the intensity of the dark tones. The third type of craquelure—creating islands of color irregular in shape, size, and patterning—happens mostly where lead white was used: that is, in the flesh tones, drapery, and in part of the base of the Virgin's throne, and includes highlighted areas, such as the dress of the angel at the left; those sections painted over *verdaccio,* as in the faces of the angels; and the warmer passages of the Virgin's skin.

As in his other works, Piero seems to have used various binders to achieve different effects. For the architectural portions, the pavement, and some of the costumes he employed a traditional tempera, with diluted colors laid on uniformly; he then returned to these areas to define the moldings, for example. By contrast, he used an oil medium for the flesh tones and to model the figures; for the Virgin's blue mantle; and to describe light playing on the drapery (especially, on the white robe of the angel at the left). Thus, there is a uniform craquelure over the whole of the picture that, in those areas where oil was used, interacts with the color slippage caused by the drying of the binder, creating the more conspicuous and disfiguring alterations. Finally, those passages painted with lapis lazuli bulged in the way that typically occurs with that pigment.

The technical peculiarities of the work no less than its quality and style attest to Piero's authorship. The question of its date, however,

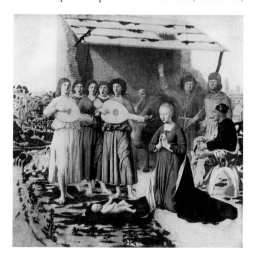

6.
Piero della Francesca, *The Nativity.*
National Gallery, London

remains an open issue. Indeed, the authors of this entry could not agree on a date. Depending on the reading of the technical findings and the way each author interpreted the artist's development, proposals ranged from the 1450s to the 1470s. Frosinini and Bellucci believe the evidence suggests that Piero had not completely mastered the technique of oil painting, and that the Williamstown altarpiece marks a transitional moment in the artist's involvement with that medium. Piero's earliest experiences with oil began during his sojourn in Ferrara, about 1450, when he began to employ a still-experimental *tempera grassa* (consisting of oil resins ?), as was used by the artists employed by Lionello and Borso d'Este in the decoration of the *studiolo* at Belfiore (Bellucci et al. 1992; Dunkerton 1997). This experimental period draws to a close with the technical perfection of the *Montefeltro Altarpiece* and other works painted in Urbino (Bellucci and Frosinini 1998). At this time Piero used a preparatory layer with an oil binder rather than the traditional gesso and glue—a technique that he probably adapted from his direct contact with Flemish artists. A good adhesion was obtained with the colors, also mixed with oil, because of the continuity and compatibility of the materials. Since Piero's working method seems to have developed in a linear fashion, it is difficult to imagine that he would have abandoned a technique he had learned in order to return to one that had already failed to give him satisfactory results. As Bertelli has already pointed out (1991, p. 228), the technical features of the altarpiece in Williamstown seem to refer to a period prior to the completion of the *Sant'Agostino Altarpiece,* which was commissioned in 1454 but only finished in 1469. Nonetheless, with the conspicuous exception of Hendy (1968), who considered this an early work, most scholars have interpreted the stylistic features as indicative of a late date (Clark 1969; Battisti 1971; and Lightbown 1992). Longhi (1942) argued that it preceded the *Montefeltro Altarpiece* and dated it to about 1460–65.

It is, however, difficult not to acknowledge a series of iconographical details that depend on the *Montefeltro Altarpiece,* while the emotional tenor is that of the *Senigallia Madonna* and the *Nativity* (fig. 6). The figure types of the Virgin and Child are also close to those in the *Nativity*: As in the *Nativity,* the child is inspired by Netherlandish painting and does not have the Herculean proportions found, for example, in

the *Sant'Antonio Altarpiece* in Perugia. As in the *Montefeltro Altarpiece,* the *Senigallia Madonna,* and the *Nativity,* there are no halos—another feature adopted from Netherlandish painting (earlier—with the single exception of the *Baptism of Christ*—Piero had preferred the reflective gold disks of Florentine tradition). Furthermore, the angel who interrupts the "*devota immobilità*" (Longhi) and looks out toward the viewer—something rather unusual in Piero's work but completely in keeping with Alberti's recommendation that "there be someone in the '*istoria*' who admonishes us and instructs us [as to] what is going on, or beckons us with his hand to look" (*Della pittura* II.42)—is perhaps most closely related to the shepherd in the London painting who fixes his gaze on the viewer while pointing to the sky. With this device Piero calls attention to the action that is at the center of the picture: the Virgin handing a rose to the Christ Child. This action has been endowed with a ritualistic importance.

In the Williamstown altarpiece, a fascination with Netherlandish painting is combined with an antiquarian-informed architecture of unusual character. Indeed, the architecture in the Williamstown painting poses difficulties of interpretation, and has raised doubts about the attribution to Piero. Yet, the description of space is among the most fascinating in fifteenth-century painting. The Virgin's throne is placed under the open sky in a courtyard, the plan of which is reconstructed by Battisti (1971; 1992 ed., vol. 1, pp. 385–87; see also Field forthcoming), and for which one is tempted to apply the exquisitely Albertian term "*xystus*" (*De re aedificatoria,* I.9, VIII.10). In itself, this spatial arrangement is not unusual; one need only recall the long series of Florentine *sacre conversazioni* by Fra Angelico and his followers (fig. 3, p. 41), which are situated in spaces enclosed by walls, beyond which we see a sort of paradisiacal garden. Domenico Veneziano's *Saint Lucy Altarpiece* (fig. 21, p. 60), which was certainly a point of reference for the young Piero, has a porticoed exedra behind which one can see the branches of citrus trees. In each of these examples, the perspectival depth of the scene becomes a signifier, since it is the means of linking, at a glance, the idea of salvation, access to Paradise (which comes from the Greek word for garden), and the figures of the Virgin and the infant Savior. Yet, in Piero's work there is no garden beyond the wall, unless we consider the fruit incised among the stone garlands sus-

pended across the marble panels or the spiraling acanthus sculpted in the frieze. This is "pure" architecture, in which the sole natural or fleeting element is the miraculous light, both reflected and raking, and the violet shadows beneath the portico.

So unusual are the iconographical and formal aspects of this building that the only true comparisons are with a later structure: the portico designed by Giuliano da Sangallo in the 1480s for Santa Maria Maddalena de' Pazzi in Florence (fig. 58, p. 125). Piero's painted building is not only foreign to, but seems to be an alternative to, Luciano Laurana's courtyard for the Palazzo Ducale in Urbino. The painter appears to have had Alberti's recommendations in the *De re aedificatoria* (VII.6) in mind: "The arch and the pier are appropriate for a theater, and even in a basilica the arch would not be amiss; but in a temple, the noblest work, nothing is found but the trabeated portico." At the same time, there are reasons to suspect an Early Christian source that Piero may have seen in Rome. Indeed, the rare type of frieze, perfectly modeled on ancient prototypes, is unique in Piero's work and only becomes common, especially in Northern Italy, in the 1470s (for example, in Amadeo's Colleoni Chapel in Bergamo and Pietro Lombardi's Malipiero Tomb in Santi Giovanni e Paolo, Venice). Its precise model was the four-sided Arco di Portogallo in Rome (fig. 7). Before its demolition in 1662, this monument was quite famous and was mentioned in all the *Mirabilia,* as well as by Poggio Bracciolini and Flavio Biondo (De Maria 1988, pp. 324–25). The drawing of the arch in the *Codex Destailleur* in Berlin has long been thought to be the only sure graphic evidence of what the arch looked like, but a second rendering reveals that not only the frieze but also Piero's Composite columns perhaps derived from that arch. It may be that the plinths, swollen like cushions, were copied into albums and passed from one workshop to another, accounting for the otherwise inexplicable amphora-shaped bases on the Virgin's throne in Giovanni Boccati's *Madonna* in Ajaccio and in Filippo Lippi's *Madonna* (formerly, Loeser collection, Florence). Such is the testimony to the fame of this arch. Perhaps the fragmentary state of its marble revetment made it easier for Piero to adapt the frieze while eliminating the architrave, thereby creating a late, retrospective homage to one of the architectural features of the portal of San Domenico in Urbino (fig. 1, p. 96). Whatever the case, this

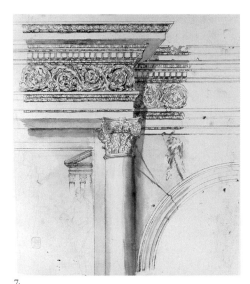

7.
Arco di Portogallo, detail of the trabeation.
Kunstbibliothek, Staatliche Museen, Berlin (inv. 60)

trabeation is so singular that it can hardly be ascribed to a mental lapse or to the intervention of a secondary artist, as Bertelli maintained.

The idea for the grandiose, fluted columns supporting a trabeation—as in the hall in the *Flagellation* or in Solomon's palace in the Arezzo fresco cycle—must derive from Alberti's Rucellai Chapel in San Pancrazio, which, in turn, was likely inspired by the interior of the Florentine Baptistery. This Albertian reference, which associates the motif with the key person for understanding Piero's architecture, is confirmed by the fact that a counterpart for the Williamstown portico can be found in the *Ideal City* (Gemäldegalerie, Berlin). This image, with its port scene, must be the earliest of the three ideal city views that have come down to us (the others are in the Walters Art Museum, Baltimore, and the Galleria Nazionale delle Marche, Urbino; see Krautheimer 1994); it shows elements taken from Alberti's Florentine work, including the pseudo-Doric capitals employed in the Rucellai commissions, thereby suggesting a date for Piero's panel no earlier than the 1470s.

Another feature of the decorative architectural ornament in the Williamstown panel is also surprising. On the one hand, Piero demonstrates his intuitive sense of proportion in the frieze and the way in which its spiraling vines are calibrated within the grid imposed by the columns. No less indicatively, the swags of fruit in his 1451 fresco of Sigismondo Malatesta (Tempio Malatestiano, Rimini) have been

reconceived in the spirit of an antique "*crusta,*" or embellishment. It is, therefore, notable that the rosettes on the base of the Virgin's throne are out of scale. Piero had a precise command of architectural decoration—one comparable only to that of Mantegna—as well as a knowledge of its morphology, uses, and placement. Yet, these rosettes—painted with a miraculous attention to light and shadow—are too large for a decorative motif that, within the classical lexicon of architecture, belonged to the torus or cyma bands of a complex molding. This is a unique ornamental device in Piero's work, and it can only refer to some ancient fragment, or *spoglia*—either a monumental Roman architectural form serving here as a footrest for the new King of the World, or perhaps an interpretation of a Romanesque decorative element. Indeed, we may wonder if, in fact, the figure group might not be a reference to the highly venerated, twelfth-century statue of the *Madonna and Child* (Staatliche Museen, Berlin) that was housed in the chapel of the Badia that served as a meeting place for the confraternity to which Mattia Gherardi belonged (see Teuffel 1999, p. 172). The statue depicts the Virgin as the *Sedes Sapientiae,* or the Seat of Wisdom (the inscription below the figure reads, "IN GREMIO MATRIS FULGET SAPIENTIA PATRIS": "In the Mother's lap shines the wisdom of the Father"). Piero knew this statue very well, as he had frescoed the chapel in 1474.

Piero's universe is pervaded by a steely logic and even a reference such as this one, however exiguous, leads us to speculate whether the portico might not have been intended to represent the Temple of Solomon. As such, it would refer to the replacement of ancient, Jewish wisdom and law with Christianity. Contemporary depictions of Solomon's temple presented it either as an enormous Gothic church, or were based on reports of the appearance of the Dome of the Rock in Jerusalem (Krinsky 1970). Although reading the Bible in the fifteenth century, especially the historical and prophetical books, was not common, Piero certainly did not lack the capability, and it is possible that he encountered the description of the great courtyard in front of the temple, which is mentioned in several places, as, for example, in Paralipomena [Chronicles] II: 3–4). There is no reason to assume that Piero was not interested in that archetype of all temples, and although Solomon's building is only cited in passing in Alberti's *De re aedificatoria,* it is, on the contrary,

treated at length in Giannozzo Manetti's life of Pope Nicholas V. Manetti's object was to demonstrate by means of pedantic comparisons that turn on the calculation of measurements or the form of the windows how the pope had not only equaled Solomon but surpassed him by providing new archetypes for the basilica and palace at the Vatican (Westfall 1984, pp. 222–27, 264–67). When Piero was in Rome, working in the Vatican apartments, such matters must still have been discussed. We might also recall that in the *De divina proportione* Luca Pacioli, Piero's best pupil in perspective and proportions, lays out a complete literary and graphic reconstruction demonstrating the perfect dimensions of the Beautiful Gate of Solomon's temple (Pacioli 1497; 1978 ed., p. 115, pl. V). If this reading of the enigmatic Williamstown painting is on the right track, it would provide yet another example of the way in which Piero presents a concept through his depiction of space and architectural typology. The painting would be nothing less than a figural expression of a doctrinal notion: the passage from the ancient biblical wisdom of Solomon to the new wisdom of Christianity— the *Sedes Sapientiae* alluded to by the inscription of the venerated statue in the Badia of Sansepolcro.

RB, CC, KC, MC, ED, CF

PROVENANCE: Gherardi family, Sansepolcro; Bicoli, Florence (1837); Sir Walter Trevelyan, Sixth Baronet of Nettlecombe (1837–69; sold, Christie's, London, May 29, 1869, lot 116); Arthur Seymour, Salisbury (from 1869); his daughter Jane Seymour (until 1912); Colnaghi, London (1912–13); Robert Sterling Clark (from 1913); The Sterling and Francine Clark Art Institute, Williamstown, Massachusetts.

REFERENCES: Phillips 1892, p. 158; Witting 1898, p. 58; Borenius in Crowe and Cavalcaselle, 1903–14, vol. 5, p. 28 n.; Gnoli 1930–31, p. 133; Longhi 1942, 1963 ed., pp. 222–23; Hendy 1968, pp. 61–63, 147, 157; Clark 1951, 1969 ed., p. 229; Battisti 1971, 1992 ed., vol. 1, pp. 384–89, 525–28, vol. 2, pp. 64–66; Salmi 1979, p. 136; Angelini 1985, p. 68; Parronchi 1985, pp. 41–42; Bertelli 1991, p. 228; Bellucci et al. 1992; Lightbown 1992, pp. 270–73; Bruschi 1996, p. 268; Ceriana 1997, pp. 138, 160; Dunkerton 1997; Bellucci and Frosinini 1998; Calvesi 1998, p. 226.

Cat. 47 (detail)

Biographies

AGOSTINO DI DUCCIO
(1418 – AFTER 1481)

Whether Agostino di Duccio was trained in Florence in the circle of Donatello and Michelozzo or received his training elsewhere has been debated. Accused of stealing silver from the Santissima Annunziata, he was forced to flee from Florence in 1441; his first documented work, a series of reliefs for Modena Cathedral (1442), already shows a keen interest in classical relief sculpture. From 1449 to about 1456 he was employed on the sculptural decoration of the Tempio Malatestiano in Rimini, the most singular project of the age (documents and Agostino's activity are reviewed by Turchini 2000, pp. 489–96, *passim*). It was there, working with Matteo de'Pasti, that his highly individual style, which has echoes of Attic relief sculpture, came into its own. It is this essentially linear style, with drapery arranged in windswept patterns, that has reminded more than one viewer of the fictive reliefs Fra Carnevale painted on the façades of the buildings in the *Birth of the Virgin* and the *Presentation of the Virgin in the Temple (?)* (cat. 45 A–B). Indeed, Zeri (1961, pp. 69–70) felt that the painted reliefs would be unthinkable without the artist having visited Rimini. No other sculptor of the day embraced such a self-consciously pagan style. Between 1457 and 1462 Agostino was in Perugia, where he designed the façade of an oratory dedicated to Saint Bernardino (1457–61) and also created an altar for the church of San Domenico (see cat. 39). He was in Bologna before returning to Florence in 1463. A number of exquisitely designed reliefs of the Madonna and Child (Bargello, Florence; Louvre, Paris) and some large statues seem to have been done at this time (see Bellosi 2001). In 1473 Agostino was again in Perugia, where he was employed both as a sculptor on the cathedral and as an architect (the Porta di San Pietro, commissioned in 1473). Among his last works are tombs in the cathedral and in San Francesco, Amelia (see Brunetti 1965).

KC

GIULIANO AMADEI
(ACTIVE BY 1447 – 1496)

A Camaldolese monk, Giuliano Amadei took his vows at the monastery of San Benedetto a Porta Pinti in Florence on March 12, 1447 (or 1446, according to the Florentine calendar), and was ordained in 1453. He was trained as a miniaturist in the circle of Fra Angelico, whose influence extended into the precincts of the celebrated scriptorium of Santa Maria degli Angeli in Florence. While still young he transferred to the Badia at Sansepolcro, in the upper Tiber Valley, the birthplace of his monastic order, where he met Piero della Francesca, under whose direction he completed the predella and pilasters of the *Madonna della Misericordia* (Museo Comunale, Sansepolcro); the polyptych was left unfinished after Piero departed for Rome in 1459 to fresco the apartments of Pope Pius II. Through Piero and perhaps also the architect Francesco del Borgo, Fra Giuliano found employment in the Roman Curia, becoming one of the city's most prolific and influential miniaturists in the Rome of Pius II, the great humanist pope. He had less of a talent for monumental painting, as can be seen in the signed triptych at the abbey of San Martino e San Bartoloméo in Tifi, near Caprese (Tuscany), and only on occasion did he execute such works for provincial centers. His reputation seems to have been established primarily in Rome, although he maintained ecclesiastic benefices from the Arezzo area (where he was the subject of much gossip as the abbot of Valdicastro, near Fabriano, and of Santa Maria d'Agnano, in Val d'Ambra). His remarkable business sense is apparent in the variety of his decorative work (ceiling panels, footstools, banners) while in the service of Pope Paul II at the Palazzo di San Marco (the present-day Palazzo Venezia). As late as the 1490s many miniaturists—such as Giovan Pietro Birago from Lombardy and Francesco Marmitta from Emilia—came to Rome to seek their fortune, working on manuscripts under Amadei's supervision. Fra Giuliano's codices were commissioned mainly by prelates associated with the Curia of Pius II and of his successors, Paul II, Sixtus IV, and Innocent VIII. Over a thirty-year period Fra Giuliano managed to ride the crest of the wave, visibly renewing his ornamental style, especially in the 1470s, when he was so fortunate as to have at his side the ingenious Bartolomeo della Gatta, another Camaldolese artist. His later miniatures, including the decorations for the now-dismembered missal of Innocent VIII, show a singular attempt to keep pace with the complex new style of the Sistine Chapel painters, particularly Ghirlandaio and Perugino, but his own artistic roots—indebted to the chromatic geometry of Fra Angelico and Piero della Francesca—are always evident. According to not completely reliable sources, Fra Giuliano died in Lucca in 1496, although no trace of the miniatures he supposedly painted there have been found.

ADM

ANTONIO DI AGOSTINO DA
FABRIANO (DOCUMENTED BETWEEN 1447 AND 1489)

Antonio da Fabriano is among the most fascinating Marchigian painters of his generation for the synthesis his work strikes between the perspective vision of Italian art and the optical tendency of Netherlandish painting. Two of his earliest dated paintings, a *Saint Jerome in His Study,* of 1451 (cat. 36), and a crucifix, of 1452 (fig. 32, p. 84), already attest to a precocious adoption of Netherlandish models. It has been thought that his knowledge of Netherlandish painting was the consequence of a sojourn in Naples, but recent scholarship (De Marchi 1994a) points, instead, to a trip to Genoa, where in 1447 and 1448 an Antonello da Fabriano is documented. Genoese collectors were avid patrons of Netherlandish painting, and in the Ligurian capital Antonio could have met both the Lombard Donato de'Bardi—one of the first Italians to respond to Netherlandish art—and the German Justus von Ravensburg, who in 1451 frescoed a loggia in the convent of Santa Maria di Castello. He would also have stopped in Florence, where the early work of Filippo Lippi would have been particularly important in confirming the direction of his interests. In the Marches the taste for Netherlandish painting was no less keen: Federigo da Montefeltro's adviser and kinsman Ottaviano Ubaldini owned pictures by Netherlandish artists (one by van Eyck is described by the humanist Bartolomeo Fazio in 1456), as did Alessandro Sforza, the ruler of Pesaro.

Antonio seems to have been in touch with Giovanni Angelo d'Antonio in Camerino and possibly with Fra Carnevale in Urbino; his triptych in Genga, of 1474, shows a greater simplification of form and a pearly light that must derive from the former. Although Antonio's most original work dates to the first decade or so of his career, when his contacts with major art centers were still fresh, his style continued to

develop. The frescoes in the refectory-library of San Domenico, Fabriano, which once bore the date 1480, are impressive for the unified, architectural conception of their layout and their treatment of light—whether an interior light filtered through a window or an early morning light playing on a glassy sea. Antonio is known to have designed sculptural projects: his signature appears on a Eucharistic tabernacle of Renaissance design in the cathedral of Fabriano.

K C

GIOVANNI DI PIERMATTEO BOCCATI
(DOCUMENTED BETWEEN 1440 AND 1486)

Together with his compatriot and sometime companion Giovanni Angelo d'Antonio, Giovanni Boccati was the chief representative of painting under the Da Varano rulers of Camerino. However, unlike Giovanni Angelo, Boccati enjoyed a success that extended over a much broader area. He was active in Perugia (1445–47; about 1454–60; 1479), Padua (1448), and Orvieto (1473), and was employed by Federigo da Montefeltro to fresco a room in a wing of his palace at Urbino (fig. 9, 10, p. 48)—possibly on the occasion of Federigo's marriage to Battista Sforza in 1459, but in any case prior to 1467. In this respect, his cultural background can be considered cosmopolitan, although he never had more than a superficial understanding of the basis of Renaissance art: his mastery of perspective was primitive at best and his figures show no interest in anatomy. He was a proponent of what Zeri has called the pseudo-Renaissance: someone who appropriated aspects of the work of the most avant-garde artists—Filippo Lippi, Domenico Veneziano, Piero della Francesca, Andrea Mantegna—without attempting to master the principles on which that art is based. The fascination—even modernity—of his style derives precisely from the tension between his cultural aspirations and the results he achieves. His art stretches any simple division between cosmopolitan and provincial, center and periphery, for it is both simultaneously. In this sense he is the quintessential Marchigian painter, and we need not be surprised that he was granted citizenship in Perugia in 1445 for his great expertise—*in arte pictoria expertissimus.*

Boccati's early training is a matter of conjecture (see Minardi 2002a, pp. 206–29, for an out-

line of his career). He arrived in Florence in 1443 and, like Fra Carnevale, joined the workshop of Filippo Lippi. This was the crucial, formative experience. His curiosity was enormous, and his earliest paintings show him to have been as attentive to Netherlandish painting as to that by Domenico Veneziano. The sunlit landscape settings of his early works, with their distant views, atmospheric effects, and curved horizons, are among the most innovative of the day (see cat. 31). Following a stay in Perugia (1445–47) and the completion of a major altarpiece (see cat. 30)—the first in Umbria to employ the new open-field, rectangular format of Renaissance painting—he moved to Padua, where he avidly studied the antiquarian-based art of Mantegna and that of Nicolò Pizzolo. The works he produced over the ensuing decade (see cat. 32) are among his most notable and show a growing awareness of the color harmonies of Fra Angelico and Piero della Francesca. Once he made his native Camerino the center of his activity (from 1461) and lost touch with the stimulus of major artists, a certain decline sets in, although there continue to be high points, such as the vast Gothic polyptych he painted in 1468 for Belforte sul Chienti (see cat. 33). In Camerino he was in close touch once again with Giovanni Angelo, with whom he occasionally collaborated (on a fresco of the *Crucifixion* [Pinacoteca e Museo Civici, Camerino]). There are dated works from 1466 (*Madonna and Child with Saint Sebastian* [Seppio]), 1468 (cat. 33), 1473 (the altarpiece from Orvieto [Szépművészeti Múzeum, Budapest]), and 1479 (the *Pietà* [Galleria Nazionale dell'Umbria, Perugia]). In his late paintings free rein is given to an expressionist vein that is one of the most compelling features of Boccati's hectic but fascinating art.

K C

BENEDETTO BONFIGLI
(ABOUT 1418/20 – 1496)

Together with his compatriot Bartolomeo Caporali, Benedetto Bonfigli was the key personality in Perugia prior to Perugino. His art combines reminiscences of the gilded, decorative splendor and attention to naturalistic details found in Late Gothic painting with the sunlit, perspectival treatment of space for which Fra

Angelico and Domenico Veneziano are noted. Veneziano painted a cycle of frescoes in Perugia in 1437–38 (destroyed) that has been thought crucial to Bonfigli's formation, while one of Angelico's most beautiful altarpieces was made for that city. Bonfigli was employed in the Vatican in 1450 by Pope Nicholas V, and he clearly studied Fra Angelico's frescoes there. Benozzo Gozzoli's extended presence in Umbria (1450–56) was also important for confirming the direction Bonfigli's art would take. His masterpiece, and one of the outstanding secular fresco cycles of the mid-fifteenth century, was the decoration of a chapel in the Palazzo dei Priori in Perugia (now the Galleria Nazionale dell'Umbria), painted in two phases, between 1455 and 1461 and 1461 and 1479 (see the contributions in Garibaldi 1996). Perugia was a cosmopolitan center with a university, and the priors stipulated that the frescoes were to be evaluated by either Fra Angelico, Domenico Veneziano, or Filippo Lippi. They were not to be disappointed: Lippi (the only one of the three Florentine painters still alive in 1461) deemed them "*bene factas.*" The cycle is replete with topographical views, portraits, and deep, perspectival interior settings that attest to Bonfigli's sophistication and his awareness not only of Florentine but also of Paduan painting. These frescoes mark the high point of his art, which by 1473 was superseded by that of the young Perugino, Pinturicchio, and a new generation of Florentine-oriented painters.

K C

FRA CARNEVALE (BARTOLOMEO DI GIOVANNI CORRADINI)
(ABOUT 1420/25 – 1484)

Although mentioned by sixteenth-century writers on art (Vasari, Lomazzo), only in the past thirty years has Fra Carnevale emerged as a historical personality—the author of a small but notable body of works. His birthdate is unknown, as are the circumstances of his early training, but it is possible that he studied with the Late Gothic painter Antonio Alberti, with whom he is associated in an undated document. When, in the spring of 1445, Fra Carnevale traveled to Florence and joined the workshop of Filippo Lippi, he was already an independent artist. He is documented with Lippi until

September 1446 but may have stayed in Florence longer, acquainting himself with other artists, sculptors, and architects. By late 1449 he had returned to Urbino, where he took orders as a Dominican monk, with the nickname of Fra Carnevale. He is cited in documents relating to the building of a new portal for the church of San Domenico, the first Renaissance monument in Urbino (fig. 1, p. 96). Was Fra Carnevale involved in the design of this work, which involved the Florentine sculptor and bronze founder Maso di Bartolomeo as well as Luca della Robbia? A newly discovered document informs us that in 1455 he designed capitals for the cathedral, and his name occurs in a sixteenth-century list of architects and engineers involved with the building of the Palazzo Ducale. Certainly, his paintings attest to a presiding interest in architecture. However, his only certain contribution to the palace is a painted alcove of advanced architectural design (fig. 41, p. 117).

In Urbino he would have met Leon Battista Alberti, a frequent visitor in the 1460s, and as a friend of Federigo da Montefeltro's adviser-kinsman Ottaviano Ubaldini—an executor of Fra Carnevale's will—he would have had access to the ducal library, with its copy of Vitruvius's treatise on architecture.

In 1456 Fra Carnevale was released from his contract to paint an altarpiece for the Confraternità del Corpus Domini. The predella was eventually undertaken by Uccello (1467–1468), while the task of painting the main panel, offered to Piero della Francesca in 1469, fell to the Netherlander Joos van Ghent. Fra Carnevale's most famous work was an altarpiece for the oratory of Santa Maria della Bella, which occupied him in 1466–67; its key elements can now, with confidence, be identified with two extraordinary panels in New York and Boston (see cat. 45 A–B).

In the 1450s Fra Carnevale became a parish priest at San Cassiano di Castelcavallino, near Urbino, and from this point on most documents relate to his ecclesiastical career. In his will he provided funds for preaching at San Domenico.

The main influences on Fra Carnevale's activity as a painter were Filippo Lippi, Domenico Veneziano, and Piero della Francesca, although he must have had prolonged contact with his Camerino colleagues, Giovanni Boccati and Giovanni Angelo d'Antonio, as well. He would have met Piero at Urbino, but was also familiar with the latter's frescoes at Arezzo. His

achievement as a painter was inevitably over-shadowed by that of Piero, just as his architectural ideas were superseded by those of Luciano Laurana and Francesco di Giorgio, but he is a crucial figure in the history of Renaissance painting in the Marches.

K C

LUCA DELLA ROBBIA
(ABOUT 1400 – 1482)

Luca della Robbia is one of the great masters of the Early Renaissance. Even before the completion of his first major commission—the *Cantoria* (or singing gallery) for Florence Cathedral—Alberti had included him in the dedication of the 1436 Italian edition of his treatise on painting; Luca's name appears alongside those of Brunelleschi, Donatello, Ghiberti, and Masaccio.

It remains uncertain with whom Luca trained. He enrolled in the Arte della Lana in 1427, at which time he was working as an assistant to Ghiberti on the *Gates of Paradise* for the Baptistery of Florence. His first independent works—among which are the *Cantoria* and five reliefs of the Liberal Arts for the Campanile of the cathedral—were in marble. Additionally, from 1445 he worked with the sculptor and bronze founder Maso di Bartolomeo on a set of bronze doors for the Sacrestia delle Messe of the cathedral. From about 1440, however, Luca's activity centered on the production of sculpture in glazed terracotta, a technique whose invention Vasari ascribes to him. At first Luca used glazed terracotta as a decorative embellishment on works in marble, but he was soon creating freestanding figural groups, complex figural reliefs, and compositions of the Madonna and Child for private devotion. The restrained naturalism and classical elegance of his figural compositions proved the perfect complement to Brunelleschi's architecture and was notably employed in the Pazzi Chapel, Santa Croce, Florence (1445–about 1470).

The partnership Luca formed in 1445 with both the sculptor-architect Michelozzo and Maso di Bartolomeo to produce the bronze doors for the cathedral of Florence led to other architectural endeavors, such as the ceiling for a study (or *studiolo*) in the Palazzo Medici (see cat. 25 A–B) and a tabernacle for a chapel in San

Miniato al Monte (1448; fig. 23, p. 61). Between 1450 and 1451, Luca completed a terracotta lunette of the *Virgin and Child with Saints* for the portal of San Domenico, Urbino (fig. 20, p. 109), collaborating with Maso di Bartolomeo, Michele di Giovanni, and Pasquino da Montepulciano—artists who seem also to have been employed in the Palazzo Ducale at Urbino. Maso di Bartolomeo's account books record Fra Carnevale's involvement with the portal of San Domenico. While his role in that project is not clear, Fra Carnevale certainly knew those artists from the time he spent in Florence and their work was important to the style that he developed.

K C

PIERO DELLA FRANCESCA
(ABOUT 1406/12 – 1492)

That Piero della Francesca was one of the greatest Renaissance artists would hardly be contested today, but he was not always viewed as such. Even in the Marches, where he might seem to have dominated the artistic landscape, his legacy did not long outlive him (see Christiansen 1993a). If we are to believe Giovanni Santi, the father of Raphael and the author of a long poem in praise of Federigo da Montefeltro, the artist the duke most admired was Andrea Mantegna. While Vasari makes Piero's association with the Montefeltro court a centerpiece of his biography of the artist, the bookseller-biographer Vespasiano da Bisticci notes only that the duke so admired oil painting that he summoned a Netherlandish painter—Joos van Ghent—to his court. This paradoxical situation must be borne in mind if we are to properly evaluate Piero's historical position and his impact on the artists in this exhibition, some of whom were as indebted to Paduan and Netherlandish painting as they were to Piero.

The first decade or so of his activity in his native Borgo Sansepolcro is still a mystery, although documents attest to his collaboration with the Late Gothic painter Antonio d'Anghiari (see Banker 2002, pp. 173–209). In 1439 he was working in Florence as an assistant to Domenico Veneziano, whose synthesis of light, form, and space would become central to Piero's art. His interests in mathematics and geometry—subjects he later wrote about (the *De prospectiva pingendi* and the *De quinque corporibus regularibus*: see Piero della Francesca 1984 and

Davis 1977)—found a creative outlet in perspective, composition, and architecture. Throughout his career—in Florence, Ferrara, Rimini, Urbino, and Rome—he had the opportunity to develop a friendship with Leon Battista Alberti, whose ideas were crucial to his development and particularly to his sophisticated understanding of architecture: He designed the family palace in Sansepolcro and was praised as a master of architecture as well as of painting by the mathematician Luca Pacioli. He was among the first Italian artists to take up oil painting—perhaps partly in response to the collecting interests of the Este and Montefeltro courts.

Like Vasari, we view his fresco cycle in the church of San Francesco, Arezzo (about 1452–58/66), as the centerpiece of his activity, but the character of his art was deeply indebted to the North Italian courts at Ferrara, Rimini, and Urbino (see Dal Poggetto 1992a; Cieri Via 1996). Indeed, to judge from the length of time he took to complete his various commissions in Sansepolcro—the *Madonna della Misericordia* (1445–62), the *Sant'Agostino Altarpiece* (1454–69), and the *Baptism* (finished by the Sienese painter Matteo di Giovanni)—he did not attach as much importance to the work he received from his fellow townsmen as he did to the requests by Borso d'Este, Sigismondo Malatesta, and Federigo da Montefeltro. He is first documented at the court of Urbino in 1469, when he stayed with Giovanni Santi and was offered the task by the Confraternità del Corpus Domini of painting the main panel of an altarpiece whose predella had been completed by Uccello; in the event, the painting was executed by Joos van Ghent. In all likelihood Piero had already been employed by Federigo, although for how long it is difficult to say: while the dates of his portraits of Federigo and of Battista Sforza (Uffizi, Florence), of the *Montefeltro Altarpiece* (cat. 46), and of the *Senigallia Madonna* (fig. 2, p. 26) are disputed, none of these works is likely to be earlier than about 1465 (see Bertelli 1991; Lightbown 1992; Cecchi in Bellosi 1992a). Whether the *Flagellation* (Galleria Nazionale delle Marche, Urbino)—the earliest of the works with a provenance from Urbino (about 1455–60, but proposed dates range from the 1440s to about 1465–70)—was in fact painted for Federigo has been questioned (Bertelli). Piero affirmed his admiration for Federigo in his dedication of the *De quinque corporibus.* The *Montefeltro Altarpiece,* with its grandiose architectural setting, and the *Senigallia Madonna*—a sophisticated interpretation of the kind of domestic devotional image popularized by Memling—would be incomprehensible without some knowledge of Federigo's tastes and character. Piero's periodic presence in Urbino was obviously important not only to Fra Carnevale but to other Marchigian painters.

KC

GIOVANNI ANGELO D'ANTONIO
(DOCUMENTED BETWEEN 1443 AND 1476)

In 1961, Federigo Zeri resurrected the name of Giovanni Angelo d'Antonio da Bolognola from a few archival notices, proposing him as the most likely candidate for the Master of the Barberini Panels. Although his hypothesis has proved incorrect—that artist is Fra Carnevale—Giovanni Angelo has scarcely been sidelined. Rather, he was the court painter of the Da Varano rulers of Camerino, an artist responsible for a fine body of work previously assigned to Girolamo di Giovanni, who was his frequent collaborator. The basis for these initially confusing shifts in identification were argued at length in a groundbreaking exhibition held in Camerino in 2002. However, it was only with the discovery of a document definitively assigning to Giovanni Angelo a work formerly ascribed to Girolamo di Giovanni that the case was proven (Mazzalupi 2003a). The result is a far clearer understanding of painting in the Marches at a crucial moment in the fifteenth century (see Di Lorenzo 2002 for an outline of his career).

Giovanni Angelo was born into a socially well-placed family in Bolognola, southeast of Camerino. He married the daughter of a Camerino merchant family, and it was perhaps through the business connections of his in-laws that he obtained a letter of introduction to the Medici in Florence (Di Stefano 2003). Sometime prior to January 1443 he went to Florence in the company of his compatriot Giovanni Boccati; Boccati joined the workshop of Filippo Lippi while Giovanni Angelo became a guest in the Medici palace (together with Fra Angelico, Lippi was the Medici's favorite artist). In March 1444 Giovanni Angelo's father-in-law (or future father-in-law: the matter is not altogether clear) sent a letter to the Medici palace urging the artist to return to Camerino to put his affairs in order; the letter also affirms that Elisabetta da Varano, the regent of Camerino, wished Giovanni Angelo to accompany her eleven-year-old son, Rodolfo, to Ferrara. Other letters reveal clearly that Giovanni Angelo had established a friendship with Giovanni de'Medici and that he was something of a courtier: he later attempted to arrange a marriage between Giovanni de'Medici and a cousin of the Da Varano. We also learn that he played the lute (music was among Giovanni de'Medici's passions). He probably made intermittent visits to Florence, although Camerino remained the center of his activity.

His close relationship with the Da Varano family is attested by two commissions, both of which resulted in masterpieces: an *Annunciation* (fig. 1, p. 66) and a *Saint John the Baptist* that includes a donor portrait of Giulio Cesare da Varano (Musée du Petit Palais, Avignon). Giovanni Angelo may also be responsible for the (now) heavily damaged frescoes in the vaults of a room in the ducal palace in Camerino, painted sometime after 1464, when Giulio Cesare da Varano assumed sole rulership of the Camerino state. These works demonstrate the artist's close study not only of the paintings of Filippo Lippi and Domenico Veneziano but of those by Mantegna and Piero della Francesca as well. To judge from his earliest dated work, a fresco from 1449 (Pinacoteca e Museo Civici, Camerino), Giovanni Angelo was among the first artists to respond to Piero's treatment of light. His subsequent trip to Padua (not documented, but probably undertaken about 1450, possibly with Girolamo di Giovanni) and his study of Mantegna's frescoes in the Ovetari Chapel in Padua formed his notion of the way in which architecture and perspective could be used to articulate a composition. Giovanni Angelo was a sophisticated artist and it is his work, much more than Giovanni Boccati's, that defined Renaissance painting in and around Camerino.

KC

GIOVANNI DI FRANCESCO DA ROVEZZANO
(1412/28 [?]–1459)

A document first published by Toesca in 1917 has made it possible to associate the name of Giovanni di Francesco del Cervelliera da

Rovezzano with a stylistically consistent body of works grouped around an altarpiece formerly in the Carrand Collection (now in the Bargello, Florence)—whence the name Berenson and other early critics assigned to the artist: the Master of the Carrand Triptych. Although the core group of works associated with him, all dating from the 1450s, is very homogeneous, attempts have been made to enlarge his oeuvre with other, far less certain paintings. Berenson at one time ascribed to him the Barberini Panels by Fra Carnevale and there has been a persistent confusion between his works and those of the Pratovecchio Master. Further complications arise from the fact that there was more than one artist named Giovanni di Francesco active in Florence at mid-century (for these issues, see the biography of the Pratovecchio Master).

Two insertions in his tax declarations (catasti)—those of 1435 and 1451—are fundamental for resolving the date of Giovanni's birth. Also crucial is the date of his matriculation in the Arte dei Medici e Speziali: January 26, 1442 (modern style); (for the documents, see Fredericksen 1974, pp. 34–35; Bellosi 1990b, p. 17 n. 7; Levi D'Ancona 1962, pp. 146–47). The contradictions in the tax declarations pose problems that cannot be easily resolved, but that must be touched upon here. Examination reveals that they contain information that has been copied from one to the other: the 1435 document may well record Giovanni's own declaration, while the later one would be another version kept in the official registers. In the event that a transaction of 1449 is cited in 1451, there can be no doubt that what we possess are documents gathered for that declaration, in which Giovanni di Francesco states that he is twenty-three years old; this would put his birth in 1428 and his age at fourteen when he matriculated in the guild. As Annamaria Bernacchioni has pointed out, this is a very young age for a man to have become an autonomous painter. Indeed, even allowing for Giovanni di Francesco's possible precocity, it appears highly unlikely.

What seems probable is that something of the 1435 declaration made its way into the one from 1451: there is no other apparent reason for backdating the information. Perhaps Giovanni's birth date can be resolved through documents relating to his father, but for the time being the matter must be left open, especially as it is difficult to account for an additional twenty years of activity: the two decades that would fall between his execution of the Nativity now in Berea College, Kentucky (Bellosi 1990b, p. 24), and his later, certain paintings of the 1450s. Of course, this is supposing that the style of the Berea Nativity really should be interpreted in neo-Gothic terms, in line with Paolo Uccello's work of the 1430s. Surely, we cannot fill this twenty-year void with the Madonna and Child at Fucecchio, as Salmi tried to do, or with the paintings by the Pratovecchio Master, as Fredericksen attempted. In 1439 Giovanni was employed by his uncle Giuliano di Jacopo in one of the busiest workshops on the Corso degli Adimari, near Florence Cathedral, but it is far from certain that he remained in his uncle's workshop for any length of time, especially as there are documents associating Giovanni di Francesco with Filippo Lippi in 1440 and 1442 (for these, see the biography of the Pratovecchio Master). In 1445 he is recorded as owing money to the church of Santa Maria degli Angeli—a debt incurred by his father; a payment was to be made to Giovanni by the church in 1451, probably for work he had done there. He died in 1459 (see Fredericksen 1974, pp. 33–35).

Giovanni di Francesco's accepted corpus is marked by an elegant but taut draftsmanship, brilliant color, and a mastery of perspectival composition, leading Bellosi (1990b) to include him among the pittori di luce. His primary debt is not to Filippo Lippi but to Andrea del Castagno, Domenico Veneziano, and Piero della Francesca. Indeed, he seems to have been among the first artists to respond to Piero's frescoes at Arezzo: his predella panel with scenes from the life of Saint Nicholas (Casa Buonarroti, Florence) was once installed below Donatello's Annunciation in Santa Croce (on this, see, especially, Bellosi [1990b, pp. 14–15]). As noted above, although there is still some confusion regarding Giovanni di Francesco's early activity, and the surprising affinities of his work with that of Paolo Uccello, the concerns reflected in his mature paintings—a fastidious attention to detailed description sometimes tending toward schematization and an almost lapidary effect—closely parallel the work of Baldovinetti. A marvelous panel of a hunting scene (Musée des Augustins, Toulouse) has been ascribed to both and is of particular interest because it was painted for Federigo da Montefeltro (Callman 1991; see the discussion in the essay by De Marchi, in this catalogue).

KC, MC

FRA FILIPPO LIPPI
(1406 – 1469)

Filippo Lippi is one of the presiding geniuses of Florentine art. No other fifteenth-century painter was so varied and consistently inventive, yet he has not always enjoyed the esteem he commanded among contemporaries. In his celebrated essay on Florentine painting, first published in 1896, Bernard Berenson sounded some of the themes that have been repeated in one manner or another: "If attractiveness . . . sufficed to make a great artist, then Filippo would be one of the greatest, greater perhaps than any other Florentine before Leonardo. . . . That he became more [than an illustrator]—very much more—is due rather to Masaccio's potent influence than to his own genius; for he had no profound sense of either material or spiritual significance."

Lippi certainly watched Masaccio and Masolino at work in the Brancacci Chapel in Santa Maria del Carmine, Florence, where in 1421 he took holy orders. However, his earliest paintings reveal someone looking beyond the austere gravity of Masaccio's work. His presence in Siena in 1428 and in Padua in 1434 enlarged his cultural horizons. The sculptures of Donatello and Luca della Robbia and the descriptive naturalism of Netherlandish painting proved more compelling than Masaccio in shaping a style remarkable for its unorthodox compositional solutions, its interest in problems of light and color, and its emphasis on artifice and improvisation. With the single exception of Leonardo da Vinci, no other fifteenth-century painter was so open to revising his work—of maintaining an improvisatory approach to the act of painting. During the course of execution his compositions invariably become more complex, the space less clear, and the decorative elements dominant. His emphasis is on those critical indicators of artistic genius in the fifteenth century—invention, fantasy, and artifice (invenzione, fantasia, artificio). This approach places him at odds with the grand tradition extending from Giotto and Masaccio through Piero della Francesca to Andrea del Sarto and Raphael. He belongs, instead, to a no less vital line extending from Lorenzo Monaco to Botticelli and Pontormo.

What stands out in Lippi's work is the way he consciously plays with elements of both traditions and incorporates naturalistic details into his art of the imagination: it is this that makes him a key figure in the history of Florentine painting.

During the 1440s Lippi became the preeminent painter in Florence. Indeed, with Donatello's move to Padua in 1444 and Fra Angelico's transfer to Rome in 1445, only Domenico Veneziano and Andrea del Castagno offered a real challenge to his supremacy. He became the favorite painter of the Medici and received numerous commissions from them and their associates. In the paintings included in this exhibition he responded to the new courtly taste promoted by the Medici by reinterpreting the terms of Gothic art without relinquishing the naturalism inherent in his earlier work. Among the array of artists who passed through his shop at this time were Giovanni di Francesco, Giovanni Boccati, Fra Carnevale, Pesellino, the anonymous Pratovecchio Masters, and the Master of the Castello Nativity.

In 1452 Lippi received the commission (previously offered to Fra Angelico) to decorate the choir of the cathedral at Prato with a cycle of frescoes of scenes from the lives of Saints Stephen and John the Baptist. Completed in 1465, these frescoes are among the masterpieces of Italian art. Their lively narrative quality, richly ornamented surfaces, imaginative architectural settings, and rocky landscapes—used to enhance the storybook-like action—stand at the opposite pole to the detached grandeur of Piero della Francesca's almost exactly contemporary fresco cycle of the Legend of the True Cross, in Arezzo. That Lippi's powers of invention did not diminish is demonstrated by his frescoes in the cathedral of Spoleto, painted between 1466 and 1469 with the aid of his long-standing assistant, Fra Diamante, and, possibly, Botticelli, who—together with Lippi's son Filippino—were his greatest artistic heirs. That Leonardo also studied Lippi's paintings (those of the late 1430s) should serve as a warning against taking at face value his irresistibly pleasing style. "The most singular master of his time" is how his work appeared to one informed critic at the end of the fifteenth century. (The three most recent studies on Lippi are those of Ruda 1993, Mannini and Fagioli 1997, and Holmes 1999.)

K C

MASO DI BARTOLOMEO
(1406–1456)

Maso di Bartolomeo, one of the most respected bronze casters of his day, was an indispensable collaborator on complex architec-tural projects. Between 1434 and 1438 he worked with Michelozzo and Donatello on the pulpit on the exterior of Prato Cathedral, and was responsible for the balcony on the cathedral's interior façade (1434–39) that connected with it. His bronze grille enclosing the Cappella della Cintola (Chapel of the Virgin's Girdle)—a masterpiece of decorative bronze work incorporating classically derived acanthus vines and architectural motifs (ill., p. 182)—was carried out between 1438 and 1443; his exquisite casket for the relic of the Virgin's girdle dates from 1446 (see cat. 20). Maso's monumental, multi-branched, bronze candlestick for the cathedral of Pistoia, documented to 1440, was followed by a smaller one for Prato Cathedral and another (now lost) for the church of the Santissima Annunziata in Florence; as with the grille for the Cappella della Cintola, their superlative execution and design, which has much in common with the antiquarian spirit of Alberti (De re aedificatoria, VII.13), established precedents for Verrocchio's work in this vein.

Maso's capabilities as a sculptor are perhaps best judged from the brass eagles he created for the tabernacle designed by Michelozzo in San Miniato al Monte (1449). This was but one of several projects that brought Michelozzo and Maso together with Luca della Robbia; of these, the most important one was their collaboration on the bronze doors of the Sacrestia delle Messe of Florence Cathedral (for his collaboration, see Caplow 1998, pp. 231–36). Maso and Luca both contributed to the Renaissance portal of San Domenico in Urbino (1449–51). Work on the portal (fig. 1, p. 96), which involved Fra Carnevale, is recorded in Maso's account book (see the appendix by Di Lorenzo in this catalogue); he is usually credited with its design but may, instead, have been acting more as foreman. His role in the Palazzo Ducale in Urbino is a matter of speculation (see Höfler 1998, pp. 249–55; see also the essay by Matteo Ceriana in the present catalogue). Contemporaneously with his work in Urbino Maso was casting cannons for Federigo da Montefeltro and was employed, as well, by Sigismondo Malatesta in the Tempio Malatestiano in Rimini, for which he made a bronze grille (1452–53; see Turchini 2000, pp. 574–76).

Maso's achievement as a Renaissance artist has been unjustifiably marginalized. He was a brilliant bronze founder, with a fine sense of design, and his association with Fra Carnevale was to prove crucial for the development of Renaissance art in Urbino. (It is just possible that he is the Masaccio mentioned in the dedication of Alberti's Della pittura, as was first proposed by Janitschek in 1877.) He died in Dalmatia (for his work there, see Höfler in Dempsey 1996).

K C

MASTER OF THE CASTELLO NATIVITY (ACTIVE 3RD QUARTER OF THE 15TH CENTURY)

About thirty paintings can confidently be ascribed to the Master of the Castello Nativity, whose eponymous work, showing the Virgin adoring the Christ Child in a landscape (Galleria dell'Accademia, Florence), was until 1961 in the Villa Reale di Castello. Essentially, the artist is a minor master who specialized in the production of devotional paintings of the Madonna and Child. Cerretelli (1998, no. 21) has argued that his most ambitious work (Museo dell'Opera del Duomo, Prato; see cat. 8A–C), an altarpiece painted for the parish church of Santi Giusto e Clemente at Faltugnano, near Prato, was completed prior to January 1450, but this remains uncertain. With its delicate figures placed within an imaginative architectural setting, this impressive picture was manifestly inspired by the example of Filippo Lippi, with whom the Master of the Castello Nativity must have worked during the 1440s. Some of the backmost angels in Lippi's great altarpiece of the Coronation of the Virgin (fig. 2, p. 40) have been ascribed to him, as well as secondary passages in other paintings by Lippi of the mid-1440s. On this basis it has been proposed that the Master of the Castello Nativity may be the Piero di Lorenzo who is cited in a 1440 document related to the Coronation of the Virgin—presumably (but not necessarily) the same Piero dipintore who was paid again in 1447 for gilding (see Ruda 1993, pp. 421, 426, 513; Lachi 1995, pp. 17–21; and Di Lorenzo in the appendix). Annamaria Bernacchioni has been able to demonstrate that the Piero di Lorenzo cited in the documents as "dipintore in Por' san Piero" was an artisan who took on rather minor tasks: he should not be confused with Piero di Lorenzo di Pratese, who was born between 1410 and 1414 and joined the painters' guild of the Arte dei Medici e Speziali in 1440. In 1453 Piero di Lorenzo di Pratese formed a business partnership with Zanobi di

285

Migliore and the younger and vastly more talented Francesco Pesellino; he died in 1487.

For the time being, then, the Master of the Castello Nativity must remain anonymous. Although his uncomplicated, if pleasing, style is readily identifiable, the Faltugnano altarpiece stands out for its quality. It exhibits a parallel culture to that of the young Fra Carnevale, making a confusion between their early works possible: indeed, in an article of 1981, Parronchi went so far as to identify the Master of the Castello Nativity with the Master of the Barberini Panels (Fra Carnevale), and for this reason he appears in this exhibition.

KC

PESELLINO (FRANCESCO DI STEFANO) (1422–1457)

Pesellino remains one of the more elusive masters of the Early Renaissance. This is partly due to Vasari, whose joint biography of the prodigiously gifted artist and of his grandfather, Giuliano d'Arrigo, known as Pesello, is filled with misinformation and misattributions. Vasari nonetheless recorded that Pesellino painted the predella of Filippo Lippi's altarpiece (fig. 20, p. 59) for the novitiate chapel in Santa Croce, and noted that "had death not carried him off at so tender an age [Pesellino] would have surpassed [Lippi] a great distance."

Lippi's altarpiece for the novitiate chapel (fig. 4, p. 42) usually is dated to the mid-1440s, and it was therefore assumed that Pesellino began his career as Lippi's pupil. It is far more likely that he was trained in his grandfather's highly successful Corso degli Adimari workshop, which he in fact inherited following his grandfather's death in 1446 (Procacci 1961, pp. 30–34). According to recent scholarship (Fahy in Di Lorenzo 2001, pp. 71–72; Angelini in Bellosi 1990a, pp. 125–27), Pesellino's earliest certain work—one of a series of panels depicting the Journey of the Magi (The Sterling and Francine Clark Art Institute, Williamstown, Massachusetts)—was carried out in collaboration with Zanobi Strozzi (1412–1468), a pupil of Fra Angelico, who excelled as a manuscript illuminator: the two worked together on the illumination of a manuscript of Silius Italicus's *Bellum Poenicum* (Ferro in Bellosi 1990a, pp. 128–32). Like the pair of cassone panels with scenes of the Triumphs of Petrarch (Isabella Stewart Gardner Museum,

Boston), the illuminations owe a profound debt to the example of Fra Angelico, especially to the predella panels of his *San Marco Altarpiece* (fig. 24, p. 62) and *Perugia Altarpiece* (Galleria Nazionale dell'Umbria and Pinacoteca Vaticana). The cassone panels, which were probably painted for the marriage of Piero de'Medici to Lucretia Tornabuoni in 1448 (Hendy 1974, pp. 176–78), show a growing command of anatomy and an increasing understanding of perspectival space.

Only about 1450 did Pesellino become associated with Fra Filippo Lippi. Whether he was subcontracted by Lippi to paint the predella for the novitiate chapel or was brought in by the Medici to complete it is unknown. This experience with Lippi opened a new chapter in Pesellino's activity, and it was only in the last three or four years of his short life that he became one of the leaders of artistic innovation in Florence: his *Altarpiece of the Trinity* (fig. 19, p. 58), commissioned in 1455 by the Compagnia dei Preti della Trinità in Pistoia and left unfinished at his death in 1457, is one of the landmarks of Renaissance painting. His mastery of anatomy, foreshortening, and perspective, and his grasp of light as a means of creating a strong sense of sculptural form set the stage for the next generation of artists: Pollaiuolo, Verrocchio, Botticelli, and Leonardo da Vinci. Like Leonardo, Pesellino looked beyond contemporary Florentine painting to Lippi's achievements of the late 1430s and early 1440s. To an unusual degree, his extraordinary paintings of the 1450s are based on a retrospective evaluation of Renaissance art.

Like his grandfather Pesello, Pesellino specialized in small-scale pictures of extraordinary refinement—another reason his importance has frequently been undervalued. Only two large-scale works survive: the great *Trinity* and a fascinating but still experimental altarpiece now in the Louvre, Paris. His paired panels with the story of David (National Gallery, London), possibly painted for a member of the Medici family (Gordon 2003, p. 292), give the fullest measure of his brilliance.

KC

THE PRATOVECCHIO MASTER (ACTIVE BETWEEN ABOUT 1435 AND 1455)

The Pratovecchio Master is the creation of Roberto Longhi, who, in a brilliant article

of 1952, reconfigured the terrain of mid-fifteenth-century Florentine painting. Removed from center stage were Fra Angelico ("from 1438 onward cloistered in San Marco, aided by angels and never again to descend from the ether of his devout paradise") and Fra Filippo Lippi ("in 1438, having accomplished the great work of the Barbadori altarpiece, already stubbornly descending on a downhill slope of coarse academicism"). In their vacated places—at the very center of artistic innovation—he placed Domenico Veneziano.

Longhi's bold reinterpretation of painting in mid-century Florence was an outgrowth of his notion of criticism as the art historian's most important tool, and just as his vision of Piero della Francesca as the presiding genius of Renaissance painting has gained wide acceptance, so has the position he accorded Domenico Veneziano, rightly or wrongly, shaped much subsequent writing. Yet, the very scarcity of Veneziano's work made it necessary to examine the paintings of those artists who worked in his shadow, and it is in this context that Longhi put forward the Pratovecchio Master as "the first to hear [Veneziano] and, for twenty years . . . [the artist who] almost represented the most secret conscience of Florentine painting during a period of crisis that runs from the beginnings of Andrea del Castagno to the emergence of Pollaiuolo."

While we might harbor reservations about the elevated position Longhi assigned the Pratovecchio Master, the consistency of the group of paintings he assembled has not been questioned. They reveal an artist who began painting about 1440 under the aegis of Domenico Veneziano and Filippo Lippi, but who also had a keen interest in the sculptural production of Donatello as well as, later, in the paintings of Andrea del Castagno. If his two key altarpieces do not attain the level of his chosen mentors, they are nonetheless remarkable for their inventiveness and expressivity. What remains problematic is their artist's historical identity. His eponymous work is a polyptych from the Camaldolese monastery of San Giovanni Evangelista, Pratovecchio, midway between Florence and Arezzo; the center panel is an *Assumption of the Virgin* (ill., p. 172); the lateral panels, pilasters, and pinnacles are in the National Gallery, London (see cat. 14 A–B). In this altarpiece the twin influences of Andrea del Castagno and Donatello are in the ascendance: the center panel clearly was painted after Castagno's *Assumption of the Virgin* (Gemäldegalerie, Berlin), which is documented to 1449. Another major

altarpiece (J. Paul Getty Museum, Los Angeles) can, with a high degree of probability, be associated with a work commissioned in 1439 for the Bridgetine convent at Pian di Ripoli, south of Florence and near the town of Rovezzano. The artist mentioned in the 1439 document is Giovanni di Francesco del Cervelliera da Rovezzano (1412/28–1459), who Vasari records as a disciple of Andrea del Castagno. It was Fredericksen (1974) who first realized the documentary basis for associating the name Giovanni di Francesco with the Getty altarpiece, but he fully acknowledged the difficulty of reconciling the style of the two groups of works—and, indeed, their stylistic differences are so great that they are unlikely to be by the same artist. (This issue and a fuller reading of the documents is addressed specifically by Padoa Rizzo [1992a].)

Several solutions to this dilemma have been advanced. It has been denied, for example, that the altarpiece in the J. Paul Getty Museum is the one contracted for in 1439. This seems very unlikely, given the fact that Saints Bridget and Michael—both shown in the altarpiece—are specified in the 1439 memorandum. Whether the altarpiece was actually painted immediately after 1439 or was carried out at a later date, possibly by someone else, is another matter: Giovanni da Rovezzano does not seem to have remained in his uncle's workshop for long, and it was through his uncle that the order for the altarpiece was placed.

Carlo Ginzburg (1994, pp. 115–23) has raised the interesting possibility that we actually are dealing with two artists named Giovanni di Francesco. One would be the Giovanni di Francesco da Rovezzano mentioned in the 1439 agreement, while the other would be a Giovanni di Francesco designated simply as *dipintore* (painter), who was paid in 1458–59 to fresco a lunette on the Spedale degli Innocenti in Florence (Toesca [1917] published the payments for the lunette). It is around this fresco of God the Father blessing that the corpus of works currently associated with Giovanni di Francesco da Rovezzano is grouped, it having been assumed by most scholars that the two artists were one and the same. Ginzburg's solution would have the paradoxical effect of transferring the name of Giovanni di Francesco da Rovezzano from the works that have universally been associated with him to those assembled by Longhi under the name of the Pratovecchio Master. In view of the confusion that now surrounds the matter, Annamaria Bernacchioni has checked the various documents and has generously allowed her findings to be included here (see also Jacobsen 2001, pp. 566–67).

For Giovanni di Francesco da Rovezzano, see the separate biography. What about the person cited in documents simply as Giovanni di Francesco *dipintore*? In June 1440—two years before Giovanni di Francesco da Rovezzano matriculated in the painters' guild—a Giovanni di Francesco *dipintore* became associated with Filippo Lippi for the considerable salary of forty florins (see Ruda 1993, pp. 30, 121, 402, and documents 7 and 19, pp. 520–23, 534–36), in an arrangement that seems to have been one of an assistant rather than a pupil. Two years later Giovanni formed an association with Lippi—apparently a sort of *compagnia*—which was dissolved after only two months, in November 1442. In 1450 there was an initiative to settle outstanding payments from this association (spurred, perhaps, by Giovanni's financial needs); this led to court proceedings in 1455, as Giovanni attempted to recover money still owed him. The witness to this affair was the painter Ventura di Moro, who, as it turns out, was a partner of Giuliano di Jacopo, Giovanni da Rovezzano's uncle. There follow the already mentioned payments in 1458–59 for the frescoed lunette on the Innocenti. In 1462—three years after the death of Giovanni da Rovezzano—a Giovanni di Francesco *dipintore* decorated the Cappella dell'Annunziata in Santa Maria dei Servi with gold and silver (see Tonini 1876, pp. 89, 295–96, document LI).

When these documents are analyzed together, it seems highly probable that, with the sole exception of the one from 1462, all the references are to a single artist—Giovanni di Francesco da Rovezzano: they dovetail perfectly, and one involves a partner of Giovanni's uncle. Nonetheless, that there were two or more painters with this name is clear from the fact that one was still alive in 1462, after the death of Giovanni da Rovezzano (see also Jacobsen 2001, pp. 168–70). Significantly, that artist was paid for gilding and is likely to have been either a mere artisan or the miniaturist Giovanni di Franco di Piero. (Bernacchioni notes that the Giovanni di Franco di Piero dealt with by Levi D'Ancona [1962, pp. 147–48] is probably the same one referred to by Jacobsen [2001, pp. 559, 568]. Born in 1426—not 1428, as affirmed by Levi D'Ancona—he was still learning to paint in 1442, and his name was inscribed in the Arte dei Medici e Speziali in 1444. Bernacchioni has been unable to trace the Giovanni di Francesco di Piero mentioned by Fredericksen [1974, p. 35 n. 56]). On purely documentary grounds we may thus eliminate Giovanni di Francesco da Rovezzano from consideration as the Pratovecchio Master.

Anna Padoa Rizzo has suggested as an alternative candidate Giovanni's cousin Jacopo di Antonio (1427–1454), who, like Giovanni, was employed in their uncle's shop, working there until his death. On the surface, there is much to recommend Padoa Rizzo's solution, except that what is presumed to be Jacopo's one documented work—cherub heads added in 1451 to an altarpiece by Giotto (Uffizi, Florence)—seems to be by a painter distinct from both the Pratovecchio Master and the artist currently identified as Giovanni da Rovezzano. The cherubs' strongest stylistic affinity is with Pesellino—so strong, indeed, that they have been ascribed to that artist, whose workshop was also on the Corso degli Adimari and who became closely allied with Giuliano di Jacopo. (For the documents regarding Jacopo d'Antonio's work on Giotto's altarpiece, see Procacci [1962, pp. 16–20]; Boskovits [in Boskovits et al. 2003, pp. 572–74 n. 11] suggests that Procacci may be wrong in assuming that the work in question by Giotto is the polyptych from the Badia, now in the Uffizi, further speculating that Jacopo di Antonio must have received payment for work done by Pesellino).

The difficulty in providing the Pratovecchio Master with a historical identity and even a universally accepted corpus of paintings reminds us how little we actually know about those artists who worked in the shadow of the dominant masters, and how often individual identities were lost in the collaborative workshops, or *compagnie,* to which they belonged. Yet, recognition of this reality of fifteenth-century practice should not diminish interest in the works of the Pratovecchio Master, which—as Longhi saw so clearly—document the great shifts in Florentine painting at mid-century. The Pratovecchio Master's early paintings show a culture parallel to that of Fra Carnevale. It is for this reason that he is included here.

K C

DOMENICO ROSSELLI
(1439–1497 [?])

In his classic survey of Italian sculpture, John Pope-Hennessy referred to Domenico Rosselli

only in passing, citing him among those Florentine sculptors who established their careers outside their native Tuscany. In the case of Rosselli the reasons for this are quite clear: in Florence he was a minor figure, dependent on the example of his illustrious compatriots Antonio Rossellino and Desiderio da Settignano. Although the sculptural decoration attributed to him on the exterior of San Petronio, Bologna (1460–61), suggests an artist of some refinement, his subsequent accomplishments in Pisa (decorative work on the cathedral in 1462); in Scarperia, near Florence (a tabernacle in the collegiate church, in 1463); and in the town of Monte, near Fucecchio in the Valdarno (a baptismal font in the church of Santa Maria, signed and dated 1468), rarely rise above the merely competent. Only occasionally, as in the tabernacle and pulpit (1465) ascribed to him in the cathedral of Colle Val d'Elsa, midway between Florence and Siena, or the coat of arms of the Arte della Seta on the Palazzo di Por Santa Maria in Florence, do we detect a hint of that refined sense of ornamentation that characterizes his best work in the Marches (see Pisani 2001, p. 53).

In Pesaro, where he moved about 1473, he earned the praise of the local ruler, Costanzo Sforza, but it is in Urbino that he seems to have been active from at least 1476 and to have come into his own. Although Rosselli's work in the Palazzo Ducale is not documented, it is certainly to him that we owe the sculptural decoration of some of the most prominent rooms, including the Sala degli Angeli (Rotondi 1951, pp. 243–51). Crucial to his achievements in the Palazzo Ducale must have been the designs supplied to him under the supervision of Francesco di Giorgio, who had succeeded Luciano Laurana as Federigo da Montefeltro's architect and adviser. Nonetheless,

his contributions could not compete with the exquisite antiquarianism of the Sienese Giovanni di Stefano and the Lombard Ambrogio Barocci. Following completion of the tomb monument to Calapatrissa Santucci in San Francesco, Urbino (about 1478–80), Rosselli moved his family and activity to Fossombrone, where he continued to work until his death in about 1497.

K C

DOMENICO VENEZIANO
(ABOUT 1410–1461)

Of the great painters active in Florence in the middle years of the fifteenth century Domenico Veneziano is easily the most enigmatic. His name is conspicuously absent from Cristoforo Landino's list of famous artists, part of his 1480 commentary to Dante, and Vasari's biography of him seems almost an afterthought (it is combined with that of Andrea del Castagno). Domenico signed his name "de Venetiis" (of Venice), but his art is Florentine, not Venetian in character, and although the first documentary reference to him is a letter of 1438 written from Perugia to Piero de' Medici, he must have been active in Florence from the early 1430s. Adding to the paucity of documents is the loss of his major fresco cycles: for the Baglioni palace in Perugia (about 1437–38); for the church of Sant'Egidio in Florence (1439–45); and, possibly, for a sacristy in the pilgrimage church at Loreto, in the Marches (1447/51?). (Piero della Francesca was an assistant at Sant'Egidio and is reported to have collaborated with Domenico at Loreto.) Yet, so remarkable are his seven surviving works that he is assured a key place in the

history of Renaissance art. Indeed, in a groundbreaking article of 1952 Roberto Longhi argued that he was the key artist at mid-century and the exemplar of the Albertian ideals of painting.

The centerpiece of his career is the *Saint Lucy Altarpiece* (fig. 21, p. 60), a landmark of altarpiece design painted in the mid-1440s. The elegant, inlaid-marble architectural setting is of unprecedented complexity, and the figures reveal a command of anatomy that looks ahead to the work of Antonio Pollaiuolo. Perspective and light are manipulated so as to enhance the impression of a space conterminous with that of the viewer. The five predella scenes, two of which are in this exhibition (see cat. 22 A–B), are no less remarkable for the way in which the perspective is adjusted to enhance the narrative. Only in Donatello's stucco roundels in the Old Sacristy of San Lorenzo do we encounter anything comparable: Donatello was clearly one of the key influences on Veneziano's art, together with Luca della Robbia. Scarcely less important as inspiration was Netherlandish painting, especially for Veneziano's early landscapes (for example, the tondo of the *Adoration of the Magi* in the Gemäldegalerie, Berlin, probably dating from the late 1430s). Here, too, Domenico was an innovator, creating quasi-plein-air effects (the predella of the *Saint Lucy Altarpiece* and the background of his late fresco of *Saints John the Baptist and Francis* [ill., p. 245]).

Without Veneziano's synthesis of light, color, and space it is doubtful that Piero della Francesca's art would have developed as it did. While his pupil Baldovinetti responded to the aristocratic side of his art, based on an exquisitely refined sensibility, Pollaiuolo—preceded by the Pratovecchio Master—best understood its expressive component.

K C

Documentary
Appendices

DOCUMENTS IN THE FLORENTINE ARCHIVES

Andrea Di Lorenzo

Our knowledge of Fra Carnevale's earliest artistic activity comes essentially from two archival sources in Florence. The first is an account book, the *Libro delle entrate e delle uscite del podere della Piacentina,*[1] and the second is Maso di Bartolomeo's *Libro di conti e ricordi.*[2] The account book records the income and expenses generated by a plot of land just outside the city walls of Florence acquired in 1438 by Francesco d'Antonio Maringhi, a canon of the Florentine church of San Lorenzo as well as chaplain, rector, and procurator of the Benedictine convent of Sant'Ambrogio. When Maringhi died on August 15, 1441, he left this farm to the convent on the condition that the revenue it earned be used to fund the altarpiece, already begun by Filippo Lippi, for the high altar of the church—that is, the famous *Coronation of the Virgin* (fig. 2, p. 40) now in the Uffizi. The religious community of Sant'Ambrogio divided the account book into two parts: the first was used to record the rental income from the land, and the second to note the expenses incurred in realizing the altarpiece (Maringhi himself made the first payments directly to Filippo in 1439). The numerous later payments to Lippi as well as to other artists who assisted him with the painting were made either by the convent itself or through the banker Giovanni di Stagio Barducci.[3] It was pointed out some time ago that Fra Carnevale, referred to by his secular name, Bartolomeo di Giovanni Corradini da Urbino, and described as "*dipintore e disciepolo di frate Philippo,*" appears twice on folio 51v of this manuscript; in both instances he is recorded as having received two payments, on November 28, 1445, and January 20, 1446 (modern style), on Lippi's behalf.[4] It has not, however, been noted before that two additional payments, dated September 6 and 7, 1446, are listed on folio 52v; they were made to Corradini by a certain "Madonna"—that is, by the abbess of the convent. Thus, there are four autograph receipts that preserve the Marchigian artist's handwriting and, despite their brevity, reveal something of his education, since he wrote his master's name in its Latin form ("Philippo")—an exceptional feature among the many instances of the Carmelite painter's name (see fig. 1). The fact that Corradini collected an additional two payments for Lippi in September 1446 also demonstrates his long-term presence in the artist's workshop and suggests that he had a much more prominent role in the execution of the Sant'Ambrogio altarpiece than has previously been thought.[5] Indeed, Corradini came to Florence to work with the Carmelite friar on the Sant'Ambrogio altarpiece well before November 28, 1445. Folios 81r–83r in the account book of the Piacentina farm record a series of payments made by the banker Giovanni Barducci between April 9, 1440, and January 7, 1447. These five pages, dense with entries written in a precise and regular hand,[6] have never been completely transcribed before, and contain some interesting surprises.[7] The entries always record the names of the individuals who received money on Lippi's behalf as well as of those who were the final recipients. In a number of cases the Carmelite painter used these payments to satisfy his own debts, often to people who had nothing directly to do with the execution of the altarpiece; some, as we shall see, are certainly worthy of our attention.

The name Bartolomeo Corradini, of the most interest to us here, appears in the accounts for the first time on April 17, 1445: *On the 17th of said month, to Fra Filippo, taken by Bartolomeo of Urbino.*[8] We learn that Corradini had come to Florence expressly to work with Filippo Lippi on the Sant'Ambrogio altarpiece in an entry dated a few days later: it records that the convent paid a certain "Boscho," a carter, to transport Bartolomeo's effects ("[le] *cose . . . di Bartolomeo*") from Urbino to Florence. The entry also notes that Bartolomeo "*sta cho'llui*"—that is, that he was staying with Fra Filippo.[9] On May 10 of the following year the convent also paid the tax, or *gabella,* owed for bringing Bartolomeo's possessions to Florence;[10] the *gabella* and the carter were paid again on May 29 and June 18.[11] The convent also subsidized the painter's clothes; payments were made on May 15 and 22 for two articles of clothing, a "*giornea*" and a "*guarnello,*" intended for Bartolomeo.[12] The fact that the convent of Sant'Ambrogio also took care of the painter's personal expenses confirms his involvement in the execution of its altarpiece. Bartolomeo's name appears regularly in the account book with the notation "*a fra'Filipo portò Bartolomeo*": in 1445, on April 17, 23, and 30; May 10 and 17; August 27 and 28; and December 28; and in 1446, on January 22; February 8, 11, 17, and 26; March 5; April 16 and 23; May 6, 7, and 14; July

1.
Fra Carnevale's autograph receipt of payment on Lippi's behalf. Archivio di Stato, Florence, Corporazioni religiose soppresse dal governo francese, 79, n. 155, f. 51v

9, 16, and 30; and September 6. The payment to our artist made on December 28, 1445, is for "*chamosci*," evidently for tools to make "*camos-ciatura*," a particular kind of very fine tooling of the gold.[13] An entry on July 23, 1446, records the disproportionate payments, based on a ratio of 2:1, made to the master and his pupil: "And on the 23rd of said month, to Fra Filippo, 8 lire and to Bartolomeo 4 lire."[14] As is readily apparent, there are interruptions—sometimes of several weeks—in the payments Bartolomeo Corradini received for Lippi, as, for example, between May 17 and August 27, and August 28 and December 28, 1445, and between May 14 and July 9, 1446. These may correspond to periods when Bartolomeo was away from Florence—perhaps returning temporarily to Urbino—but from April 1445 to September 1446, Corradini was employed in Florence in Lippi's workshop. This period corresponds, as well, to the time when the master was at work on the Sant'Ambrogio altarpiece. That there are interruptions in the payments to Fra Filippo is not surprising, since he was occupied with several important commissions simultaneously. Bartolomeo Corradini's name appears in the account book until the beginning of September 1446, but then the citations suddenly stop, despite the fact that this was well before the altarpiece was finished.[15] It is possible that he left Florence to return to Urbino shortly after he is last mentioned, perhaps in pursuit of his own commissions. As Bartolomeo is never referred to as a monk in the account book, he must have joined the Dominican order sometime between the fall of 1446 and December 1449, when "frate Bartolomeo" first appears, as we shall see, in Maso di Bartolomeo's *Libro di conti e ricordi*.

Folios 81r–83r in the *Libro delle entrate e delle uscite del podere della Piacentina* contain much interesting information, permitting us to reconstruct the artistic, cultural, and social context of Filippo Lippi's workshop, where our artist was empoyed. Among the individuals listed is another Marchigian artist, "Giovanni di Matteo da Chamerino," who, on January 31, 1443 (modern style), received 4 lire and 16 soldi from Giovanni di Stagio Barducci on behalf of Fra Filippo Lippi.[16] The artist referred to is Giovanni di Piermatteo Boccati, and this is the first dated documentary notice attesting to his presence in Florence. It confirms the stylistic evidence in his early paintings of his familiarity with Florence. The first known painting by Boccati, the *Adoration of the Magi* (Ulkomaisen Taiteen museo Sinebrychoff, Helsinki), can be dated to the early 1440s and clearly reveals a Florentine influence—in particular, that of Domenico Veneziano, Ghiberti, and Donatello—as well as an explicit debt to the *Strozzi Altarpiece,* executed in Florence twenty years earlier by another great Marchigian artist, Gentile da Fabriano. The extraordinary bird's-eye view in the Helsinki painting surprisingly also echoes the work of Jan van Eyck, which could be seen in Florence at that time.[17] Furthermore, the principal

model for the 1447 altarpiece for a confraternity in Perugia (fig. 17, p. 56; cat. 30), Boccati's first important public commission, is Filippo Lippi's Sant'Ambrogio *Coronation of the Virgin.*[18] Thus, it is not unusual to find Boccati's name in the account book of the Piacentina farm.[19]

Boccati cashed the payment he received for Lippi rather than simply "taking" (*portò*) it to him—evidence that he was working for the master, most likely on the Sant'Ambrogio altarpiece, and that he must have spent some time in Fra Filippo's shop as well. Boccati's presence in Florence in January 1443 also coincides perfectly with the dates of four letters regarding Giovanni Angelo d'Antonio da Camerino that are now in the Archivio di Stato in Florence.[20] In a letter addressed to his son-in-law, Giovanni Angelo, who was then living in Florence in the palace of Cosimo de'Medici, Ansovino di maestro Piero, wrote, "When you and Giovanni Boccati left here [Camerino], you said you had the means to make a great deal of money. I don't know what you've earned. From what we gather, there's not even a farthing."[21] This letter is dated March 17, but with no indication of the year; from circumstantial evidence it appears to have been written in 1444.[22] In an earlier letter from Giovanni Angelo to Cosimo de'Medici, dated July 2, 1443, the artist writes to say that he regrets not having been able to visit his benefactor and that he hopes to be able to return to Florence soon; the tone of the letter suggests that although the two had known each other for some time, they had not seen one another for some months.[23] Thus, Giovanni Angelo and Giovanni Boccati's departure from Camerino in search of their fortunes in Florence must have occurred some months before July 1443—a time frame that coincides with Boccati's presence in Lippi's shop the previous January. We do not know how long Boccati stayed in Florence, but it seems highly likely that he had the opportunity to meet Bartolomeo Corradini there. Certainly, he knew of the Sant'Ambrogio altarpiece, which was still not finished in 1446 and would not be installed on the high altar of the church until the following year. As for Giovanni Angelo, the documents in the Medici archive together with the artist's own increasing knowledge of Florentine art suggest that he must have returned to Florence several times; he began by exploring Lippi's style, then those of Fra Angelico and Domenico Veneziano.[24] It was just possibly Giovanni Boccati who introduced Carradini to Lippi; in any event, Boccati and Corradini stayed in touch until at least the late 1460s, when Boccati executed a cycle of frescoes of Famous Men in a room in the Palazzo Ducale in Urbino, where he perhaps went at the insistence of Corradini himself.[25] (The frescoes may already have been completed in 1459.)

Among the artists and artisans mentioned on folios 81r–83r of the Piacentina account book we find "Domenicho di Domenicho lengnaiuolo," who was paid 8 lire on November 6, 1441;[26] this is

Domenico di Domenico di Pagnio da Prato (about 1401–after 1487), whose activity has been noted in other archival sources.[27]

A certain "Piero di Lorenzo dipintore" was paid 14 lire on November 10, 1441.[28] Lachi has suggested that he should be identified with Piero di Lorenzo di Pratese di Bartolo, and has proposed to identify this latter with the Master of the Castello Nativity.[29] The matter is complicated by the fact that another Piero di Lorenzo, referred to as "*dipintore in Por' san Piero,*" is listed repeatedly in May and June 1447 in the *Libro delle entrate e uscite del podere della Piacentina,* where he is credited with gilding "*le colonne della tavola.*"[30] He is undoubtedly Piero di Lorenzo di Niccolò di Martino (the son of the painter Lorenzo di Niccolò)—a minor artist specializing in the skilled craft of gilding picture frames, and not Lorenzo di Piero di Pratese.[31] The "Piero di Lorenzo dipintore" mentioned six years earlier, in November 1441, must, instead, have been a young painter in Lippi's shop, and I do not think one can exclude the possibility that he was, indeed, Piero di Lorenzo di Pratese and not Piero di Lorenzo di Niccolò; in other words, the Piacentina manuscript may simply list two different artists with the same name.[32]

A "Domenico di Francesco," who was given 2 lire to take to Lippi on January 10, 1442,[33] is most likely the painter known as Domenico di Michelino (he took this nickname after his apprenticeship with Michele di Benedetto, who specialized in the making of coffers).

The "Donatello" who received 14 lire on October 15, 1443, probably to satisfy a debt Lippi owed him, is certainly the famous sculptor;[34] one can thus presume that Donatello had some relationship with Fra Filippo (an assumption never documented until now) and that he was still in Florence at that date, not yet having left for Padua, where his presence is recorded from January 1444.

The "Andreino" who brought 9 lire to Lippi in May 1445 is Andrea del Castagno;[35] he is commonly referred to by that nickname in documents.[36]

The entry on April 12, 1442, which notes that a certain "Piero di Benedetto" received 2 lire for Fra Filippo is very intriguing.[37] His profession is not listed, but as was the case with several other individuals mentioned about this time (Piero di Lorenzo, Domenico di Michelino, Giovanni Boccati) he was likely an artist then associated with Lippi's workshop. That he was Piero della Francesca is doubtful, since foreign artists are generally identified by their native city (as we have already seen in the case of "Giovanni di Matteo da Chamerino" and "Bartolomeo da Urbino"), and, furthermore, the celebrated painter generally is referred to in documents as Pietro rather than Piero.[38] Nevertheless, I do not think such an identification can be wholly discounted. If, in 1439, Piero was in Florence working with Domenico Veneziano, then perhaps in 1442 he was no longer considered a "foreigner" in the artistic community—which might account for the omission of his city

of origin from the list of names of those who received payments; such mentions are often a summary and sometimes consist only of nicknames. Nor is Piero documented in his native Borgo Sansepolcro in this period: one might speculate that he was elsewhere, completing his education and artistic training, with Florence being the most likely place.[39]

Another bit of interesting historical and artistic information in the Piacentina manuscript is the record of a payment of 11 lire and 5 soldi that Fra Filippo returned to Giovanni di Stagio Barducci on April 16, 1445, described as a "*resto di ragione,*" or leftover balance, for the "panel for Giovanni Benci." This is a reference to the *Annunciation* (fig. 5, p. 43) Benci commissioned from Lippi for the high altar of the convent of Le Murate in Florence (it is now in the Alte Pinakothek, Munich).[40] Thus, the date of this payment constitutes an important *terminus ante quem* for the execution of an important work, the chronology of which is not precisely documented.[41]

The "Mateo degl'Organi" who was paid 2 lire, 13 soldi, and 4 denari, on September 15, 1446, endorsed to him by Fra Filippo,[42] is clearly Matteo di Paolo di Piero da Prato, a famous organ maker and a friend of Donatello.[43]

Several *speziali* (spice sellers) are also mentioned in this list of payments, including a "Bonifazio";[44] a Michelino, called "Affinalazzurro" or "Falazzurro";[45] a "Lionardo"; and a "Franco." These merchants furnished the colors and the varnish for the execution of the altarpiece.

Others are listed who were not directly tied to the art world, but were the recipients of payments Lippi signed over to them that initially were meant for him. It seems likely that Fra Filippo used the regular salary Giovanni di Stagio Barducci paid him to satisfy his personal obligations—such as those to Donatello and to Matteo degli Organi—and that the others, such as Alessandro degli Alessandri,[46] were members of prominent Florentine families and had a close relationship with the Carmelite painter but had nothing to do with the execution of the Sant'Ambrogio altarpiece. Indeed, in the 1450s, Alessandri commissioned an altarpiece for the chapel of his villa at Vincigliata (fig. 15, p. 54), which Vasari mentioned in his biography of Filippo Lippi; the painting includes portraits of the patron and his two sons.[47] Also listed are Tommaso di Neri di Gino Capponi,[48] Piero Pecori,[49] and Filippo di Branchazio Rucellai,[50] as well as Girolamo di Soletto Baldovinetti—perhaps a relative of the painter Alesso[51]—who was paid 7 lire and 15 soldi on July 24, 1445.[52]

As mentioned above, there is a second archival source in Florence that sheds light on Bartolomeo di Giovanni Corradini: Maso di

2.

Fra Carnevale's autograph receipt of payment on Lippi's behalf. Archivio di Stato, Florence, Corporazioni religiose soppresse dal governo francese, 79, n. 155, f. 52*v*

Bartolomeo's *Libro di conti e ricordi.*[52] This is a small volume in which the Florentine bronze founder and sculptor kept notes on the works he made from 1449 to 1455,[54] including, in a separate list, all the monies he took in and spent. The book opens with a description of the commission Maso received from the governors and procurators of the convent of San Domenico in Urbino for the portal of their church (fig. 1, p. 96). Maso moved to Urbino with some of his assistants in September 1445[55] and remained there until June 1451; while in Urbino he also cast several cannons for Federigo da Montefeltro. Maso kept a very precise account in his manuscript of all the payments he received as well as of the salaries he paid to his collaborators. Bartolomeo di Giovanni Corradini, by then a friar at the convent of San Domenico, is often mentioned as assisting with these payments (or making them himself); he is cited in sixteen passages throughout the book.[56] The first of these is dated December 9, 1449, when Antonio di Simone dal Monte dei Corvi, a stonecutter working at the quarry at Piobbico, was paid 15 *bolognini* to quarry stones for the portal.[57] The entry specifies that the payment was made in Fra Carnevale's cell: "*in ciella di frate Bartolomeo in San Domenicho,*" and serves as a *terminus ante quem* for the artist's entry into the

Dominican order. In June 1451, Fra Carnevale also provided Maso with the money to pay Luca della Robbia for the glazed terracotta relief for the lunette on the (fig. 20, p. 109) portal.[58] It is also worth noting that in February 1451 Corradini entrusted Giovanni di Bartolomeo, who had come to Urbino to help his brother cast cannons for Federigo da Montefeltro, with the task of traveling to Florence to seek out a gilder, "*un garzone che mettessi d'oro,*" providing him with a letter of credit for 5 florins.[59] However, since this "*garzone*" did not wish to go to Urbino, Giovanni spent the money on himself, and Maso was forced to reimburse Bartolomeo Corradini, subtracting the sum from what his brother had earned as the latter's assistant. The money returned to Corradini came from the sale of a vineyard owned by the convent of San Domenico that was acquired by Giovanni di Sabatino on June 12, 1451.[60]

In conclusion, it seems that Fra Carnevale may have known Maso di Bartolomeo while he was in Florence, and may also have been responsible, in part, for the sculptor being summoned to Urbino. What a reading of the manuscript makes certain, however, is that Fra Carnevale played an important role in formulating and then supervising the project to construct the portal at San Domenico.

I would like to thank Annamaria Bernacchioni, Matteo Ceriana, Andrea De Marchi, Cecilia Frosinini, and Matteo Mazzalupi for their assistance and valuable advice.

1. Florence, Archivio di Stato, Corporazioni religiose soppresse dal governo francese, 79, n. 155. This manuscript was noted by De Angelis and Conti 1976; see also Borsook 1981, pp. 158–64, 193–95, nn. 84–127.

2. Florence, Biblioteca Nazionale Centrale, Baldovinetti archive, n. 70. Gaetano Milanesi published a number of excerpts from this manuscript in *La porta* 1874, including several regarding Fra Bartolomeo Corradini, as did Yriarte, in his 1894 edition of Maso di Bartolomeo's account books—the one now in the Biblioteca Comunale, Prato, and the one in the Biblioteca Centrale, Florence. See the reservations expressed by Fabriczy 1895. See also Strauss 1979, pp. 152–54 doc. 2 (transcribed by H. McNeal Caplow); Höfler 1988.

3. For a description of the contents of the manuscript, see the careful account by De Angelis in De Angelis and Conti 1976, pp. 97–102. See also Borsook 1981, pp. 158–64, 193–95, nn. 84–127.

4. See Conti in De Angelis and Conti 1976, pp. 103–9.

5. Eve Borsook, who was aware only of the payments Bartolomeo Corradini received in November 1446 and January 1446, dismissed the possibility that he had any important role in the execution of Lippi's altarpiece. See Borsook 1981, p. 194, n. 196.

6. The name of the scribe appears earlier, on folio 86v, "ebe da me ser Ghuido nostro chapellano." He can be identified with "ser Guido di Simone, sindaco e procuratore di Sancto Ambruogio," whose writing appears on folio 54r in May 1447.

7. So far, this long list of payments has been used primarily to calculate the overall cost of the altarpiece. See De Angelis in De Angelis and Conti 1976, pp. 99–100; Borsook 1981, p. 164.

8. Fol. 81v.

9. Fol. 82r. This is the same wording used to express the relationship between Piero della Francesca and Domenico Veneziano in the famous payment dated September 12, 1439, for the frescoes in the choir of Sant'Egidio, "E de' dare adì XII di settembre f. 2 s. XV a oro, portò Pietro di Benedetto dal Borgho a San Sipolchro sta co'illui, in grossi—f. 2, l.3" (see Wohl 1980, p. 341).

10. Fol. 82r.

11. Ibid.

12. Ibid. A mysterious collaborator of Lippi's, referred to as Lo Spangnuolo, received the same treatment during this period. On May 22 and June 19, 1445, the convent paid for a "*farsetto*" and a white "*giornea*" for him; ibid. On March 12, 1446 (modern style), Lippi was reimbursed the cost of other small dressing accessories, such as the "soling of a pair of stockings" and "a pair of shoes"; see fol. 82v.

13. See Cellini's *Trattato dell'oreficeria* ([1568] 1857, chap. XII, p. 92): "To finish draperies I also used a very fine steel tool, exquisitely tempered and then broken off, for the broken end gives a very delicate texture. With this tool you go over all the draperies with a small hammer weighing about two scudi or less. This is what is called *camosciare* [matting the surface]. Another method may be employed for larger draperies, and this is called *granire* [graining]. This is done with a small, sharply pointed steel tool that is not broken like the other one. And these two methods are very different from one another."

14. Fol. 82v.

15. Fol. 52v, 83r, 84r.

16. Fol. 81r.

17. De Marchi in De Marchi and Giannatiempo López 2002,

pp. 173–75, no. 22; De Marchi 2002a, pp. 230–33, no. 1; De Marchi 2002b, pp. 44–46; Minardi 2002, pp. 206–9.

18. Minardi 2002, p. 209.

19. Mauro Minardi's suggestion (2002, p. 226 n. 30) that Boccati "could have seen the [Sant'Ambrogio] altarpiece while it was being painted in Lippi's shop" can now be confirmed by documentary evidence.

20. Florence, Archivio di Stato, Archivio Mediceo avanti il Principato (henceforth ASF, MAP), file 5, n. 480, file 9, n. 565, file 9, n. 553, file 6, n. 709. See Di Lorenzo 2002.

21. ASF, MAP, file 9, n. 565. See Di Stefano and Cicconi 2002, p. 453, n. 56; Di Lorenzo 2002, pp. 296–98; Di Stefano and Cicconi 2002, pp. 452–53, 455–56, nn. 52, 56, 57, 78 (transcribed by Andrea Di Lorenzo).

22. This letter has, in the past, been incorrectly dated to 1451 (see Feliciangeli 1910a, p. 367; Zeri 1961, p. 93), but see also Feliciangeli 1910a–11, p. 210, n. 4, for a correction of his own error.

23. ASF, MAP, file 5, n. 480. See Di Lorenzo 2002, p. 296; Di Stefano and Cicconi 2002, pp. 452–53, n. 52.

24. See De Marchi 2002a, pp. 46–48; Di Lorenzo 2002, especially p. 299.

25. F. Marcelli in De Marchi 2002a, pp. 257–63, no. 13; Minardi 2002, pp. 220–21.

26. Fol. 81r.

27. See Merzenich 2001, pp. 125, 157–58, doc. 12.14.

28. Fol. 81r. See Borsook 1981, pp. 163, 194 n. 97.

29. Lachi 1995, p. 22.

30. See, for example, folios 54r, 54v, 56r, 56v, 65r. See also De Angelis in De Angelis and Conti 1976, p. 101; Borsook 1981, p. 194 n. 106, p. 195 n. 113.

31. As Annamaria Bernacchioni has also pointed out; oral communication.

32. For Piero di Lorenzo di Niccolò di Martino, see Jacobsen 2001, pp. 621–22; for Piero di Lorenzo di Pratese di Bartolo, see Colnaghi 1928, p. 213 n. 83; Jacobsen 2001, p. 622.

33. Fol. 81r.

34. Fol. 81v. In Florence at that time the name "Donatello" could only mean the famous sculptor. Eve Borsook (1981, p. 195 n. 120), who came across this passage in the Piacentina manuscript, discusses him as an "otherwise unidentified 'Donatello.'"

35. Fol. 82r.

36. See, for example, Horster 1980, pp. 204 doc. 7, 206 doc. 17; Jacobsen 2001, pp. 491–92; Spallanzani and Gaeta Bertelà 1992, p. 26; Fabriczy 1893, p. 79. Borsook (1981, p. 195 n. 120) correctly identified "Andreino" as Andrea del Castagno.

37. Fol. 81r.

38. In the payments to Domenico Veneziano in 1439 for the frescoes in the choir of Sant'Egidio he is referred to as "Pietro di Benedetto dal Borgho a San Sipolchro." (See note 9, above.)

39. In Jacobsen's index there is only one other listing for a painter named Piero di Benedetto (the brother of Michele di Benedetto, Domenico di Michelino's first master), although he had died in 1433. See Jacobsen 2001, p. 617.

40. Giovanni d'Amerigo Benci (1394–1455) amassed a great fortune as the director general of all the Medici's business interests, and his family became the wealthiest in Florence, after the Medici themselves. See Renouards 1966.

41. Usually the *terminus post quem* for this panel is assumed to be 1443, the year work began (thanks to the bequests of Giovanni Benci) on three altarpieces for the convent of Le Murate: those of the *Annunciation* (for the high altar), the *Crucifixion*, and Saint Bernard; see Ruda 1993, pp. 411–12, cat. 29.

42. Fol. 83r.

43. For Matteo degli Organi, see Guasti 1865 (especially pp. 53–55, for his relationship with Donatello); Bacci 1904.

44. For Bonifazio di Donato di Bonifazio, see Guidotti 1984, pp. 239, 244 n. 8.

45. For Michele di Ramondo "*qui laborat de azurro*," see ibid., pp. 239–40; Bellucci and Frosinini 1998, pp. 30, 61 n. 9.

46. His name appears on folios 81r and 82v, on January 10, 1443 (modern style), February 5, 1446 (modern style), and May 7, 1446. For Alessandro di Ugo degli Alessandri (1391–1460; the uncle of, among others, Ginevra degli Alessandri, who was Giovanni di Cosimo de'Medici's wife), see Litta 1876–78, pl. XXV; Pampaloni 1960.

47. "Messer Alessandro degl'Alessandri, allora cavaliere e amico suo, gli fece fare per la sua chiesa di villa di Vincigliata nel poggio di Fiesole, in una tavola, un S. Lorenzo et altri Santi, ritraendovi lui e due suoi figlioli" (Vasari 1568 [1971 ed.], p. 338).

48. Fol. 81v (October 28, 1443). For Tommaso di Neri di Gino Capponi (1417–1444), see Litta 1870, pl. XI; For his father, Neri, one of the most prominent individuals in Florence during the first two decades of the Medici's rule, see Mallett 1976. In the sixteenth century the Capponi possessed a work by Lippi, which Vasari described as "*una Nostra Donna bellissima in casa Ludovico Capponi*" (Vasari 1568 [1971 ed.], p. 338).

49. Fol. 81v (November 19, 1443). For Piero di Bartolomeo Pecori (died 1465), see Passerini 1868, pp. 13–14.

50. Fol. 81v (November 7, 1444). For Filippo Rucellai (1405–1464), see Passerini 1861, p. 67, pl. IX, n. 1; for his father, Pancazio, called Brancazio, see ibid., p. 62, pl. VIII, n. 2.

51. There is no one with this name in Alesso's branch of the Baldovinetti family tree prepared by Gaetano Milanesi (see Vasari [1568 ed.] 1906, vol. 2, p. 601).

52. Fol. 81v.

53. See note 2, above.

54. Another of the sculptor's account books, encompassing the years 1448 and 1449, is in the Biblioteca Comunale, Prato, cod. 388, R-V-14.

55. These assistants were Cantino di Lazzaro da Settignano, Domenicho di Niccolò da Settignano, and Luigi di Romolo da Fiesole, all of whom were talented stonecutters whose specialized skills apparently were not available in Urbino.

56. McNeal Caplow transcribed fifteen of these passages in which Fra Bartolomeo Corradini is mentioned (the citation on folio 19v, dated November 17, 1450, is omitted); see Strauss 1979, pp. 152–54. They are, however, out of context, and the date transcribed is sometimes erroneous (the passages on folios 2v and 23v do not take into account the old Florentine calendar, according to which the new year began on the feast of the Annunciation, March 25). The correct dates are thus January 2, 1450, and after March 1451, rather than January 2, 1449, and more generally 1450, as Strauss reported. The loose page inserted between folios 12v and 13r is also dated June 20, 1451, and not June 20, 1449, given that it refers to the same payment as that listed on folio 8v. Sometimes the dates are simply not recorded (the passage on folio 11v dated December 9, 1449).

57. A second stonecutter from Montecorvi, Francesco di Matteo, was employed in 1455 to sculpt the bases for the columns or pilasters in the cathedral of Urbino according to drawings provided by the same Fra Bartolomeo Corradino; see doc. 8 in Matteo Mazzalupi's documentary appendix in this catalogue.

58. Fol. 25v.

59. It seems most likely that this master gilder was engaged to decorate the stones of the portal with gold.

60. Fols. 8r and 23v. See also doc. 4 in Matteo Mazzalupi's documentary appendix in this catalogue.

ENTRATA E USCITA DEL PODERE DELLA PIACENTINA LASCIATO DA MESSER FRANCESCO MARINGHI

Archivio di Stato di Firenze, Corporazioni religiose soppresse dal governo francese, 79, n. 155

f. 51v MCCCCXLV

E a dì 28 di novembre 1445 ricievate io Bartolomeo di Giovanni Coradini da Urbino, dipintore et disciepolo di frate Philippo, fiorini quatro larghi, a soldi 17 l'uno, et doi strecti, per quindici soldi l'uno, per tucto lire ventocto et so[l]di diciocto, ricieve' per frate Philippo
l. XXVIII s. XVIII

Et a dì 20 di gienaio ebb'io Bartolomeo sopradecto fiorini dua larghi, a soldi 17 l'uno, in tucto lire nuove et soldi 15, i quali tolsi per portare a frate Phillippo [sic]
l. 9 s. 15

f. 52v MCCCCXLVI

A dì 6 di setembre 1446
Io Bartolomeo di Giovanni Coradini da Urbino ò riciuto per frate Philippo dipintore sopra la tavola di Santo Ambrogio lire quatro da madonna
l. 4 s.

[Below, in another hand—that of the sacristan Lionarda, who compiled this part of the codex]:
Et dicti danari furono di quei di Nofri prestati

A dì 7 di sectembre 1446
Io Bartolomeo sopradecto ebbi per frate Philippo lire cinque et soldi quatordici da madona [sic], in presantia di Lorenzo di Giovanni Barducci et Antonio di Gherardo di Lamanato, lavoratore de decto monistero di Santo Ambrogio
l. 5 s. 12 [sic]

f. 81r

Qui si serva chopia de' danari paghati Giovanni di Stagio Barducci a fra' Filipo per la tavola di Santo Ambruogio al tempo di messere Francescho e poi per lo munistero

1440
Giovanni di Stagio Barducci debe avere per una ragione schritta in messere Francescho Maringhi a dì 9 d'aprile 1440 per lui a fra' Filipo e per lui a Bonifazio speziale
f(iorini) l(ire) II s(oldi) X d (anari)

Et a dì 12 d'aghosto per lui a fra' Filipo e per lui a Michele di Simone linaiuolo per panno lino per la tavola
f l. XXVII s. XIIII° d.

Et a dì XXIII di settembre per lui a fra' Filipo per lui a Stefano Lenzi per panno per vestire uno fanciullo chessì [sic] fe' frate
f. l. XXII s. V d.

Et a dì 31 d'ottobre a fra' Filipo portò chontanti
f. l. V s. d.

Et a dì III di novembre 1441 a fra' Filipo per lui a Francescho vinattiere per vino ebe dallui
f. l. III s. VI d.

Et a dì VI di novembre a fra' Filipo a Domenicho di Domenicho lengnaiuolo [sic]
f. l. VIII s. d.

Et a dì X di novembre per lui a Piero di Lorenzo dipintore
f. l. XIIII° s. d.

Et a dì 10 di giennaio portò Domenicho di Francescho
f. l. II s. d.

Et a dì detto per lui a Michelino Falazurro per oncie 1 1/2 d'azurro
f. l. X s. X d.

Et a dì 12 d'aprile 1442 a fra' Filipo portò Piero di Benedetto
f. l. II s. d.

Et a dì 9 di dicembre portò fra' Filipo chontanti
f. IIII° l. s. d.

Et a dì 10 di gennaio a fra' Filipo per lui Alesandro deli Alesandri
f. l. LXVIIII° s. X d.

Et a dì 31 detto per lui a Giovanni di Matteo da Chamerino
f. l. IIII° s. XVI d.

Et a dì 16 di febraio portò Benedetto
f. l. XIIII° s. VIII d.

Et a dì 13 di marzo a fra' Filipo portò Benedetto
f. l. III s. d.

Et a dì 16 di marzo a fra' Filipo portò Benedetto
f. l. III s. d.

Et a dì 22 detto a fra' Filipo portò Benedetto
f. l. III s. d.

Et a dì 29 di marzo 1443 a fra' Filipo portò Benedetto
f. l. III s. d.

Et a dì 5 d'aprile a fra' Filipo portò Benedetto
f. l. III s. d.

Et a dì 13 d'aprile a fra' Filipo portò Benedetto
f. l. III s. d.

somma
f. IIII° l. CCIII s. XVIIII° d.

f. 81v

Et a dì 26 d'aprile a fra' Filipo portò Benedetto
f. l. III s. d.

Et a dì 4 di maggio a fra' Filipo portò Benedetto
f. l. III s. d.

Et a dì 11 di maggio a fra' Filipo portò Benedetto
f. l. III s. d.

Et a dì 18 detto a fra' Filipo portò Benedetto
f. l. III s. d.

Et a dì 24 di maggio a fra' Filipo portò Benedetto
f. l. III s. d.

Et a dì 31 detto per una pezza di saia nera
f. l. XXX s. d.

Et a dì 7 di gignio [sic] a fra' Filipo portò Benedetto
f. l. III s. d.

Et a dì 22 di gignio a fra' Filipo portò Benedetto
f. l. III s. d. 6
Et a dì 28 detto a fra' Filipo portò Benedetto
f. l. III s. d. 6

Et a dì 13 di luglio a fra' Filipo portò Benedetto
f. l. III s. d.

Et a dì 27 di luglio a fra' Filipo portò e' detto
f. l. III s. d.

Et a dì 19 d'aghosto a fra' Filipo portò Benedetto
f. l. VI s. IIII° d. 4

Et a dì 3 di settembre a fra' Filipo portò e' detto
f. l. V s. d.

Et a dì 7 di settembre a fra' Filipo portò Benedetto
f. l. I s. X d.

Et a dì 20 detto a fra' Filipo portò Benedetto
f. l. V s. d.

Et debe avere detto Giovanni per una ragione schritta nel chapitolo e munistero di Santo Ambruogio Addì 15 d'ottobre per loro a fra' Filipo e per lui a Donatello
f. l. XIIII° s. d.

Et a dì 28 d'ottobre a fra' Filipo per lui a Tommaso di Neri di Gino Chapponi
f. XVIII l. s. d.

Et a dì 19 di novembre a fra' Filipo per lui a Piero Pechori
f.V l. s. d.

Et a dì 23 detto a fra' Filipo portò e' detto
f. l. III s. d.

Et a dì 14 di diciembre a fra' Filipo portò e' detto
f. l. III s. d.

Et a dì 24 detto a fra' Filipo portò e' detto lire V soldi
f. l.V s. d.

Et a dì 22 di febraio portò e' detto chontanti
f. l. II s. d.

Et a dì 28 di marzo 1444 per lui a Salvestro di Giovanni linaiuolo
f. l.VI s. d.

Et a dì 29 d'aprile per lui a Lionardo speziale
f. l. I s.VII d.VI

Et a dì 15 d'ottobre a fra' Filipo portò chontanti
f. l.VIII s. d.

Et a dì 5 di novembre per lui a' Monticiellii linaiuli
f. l.VI s. d.

Et a dì 7 di novembre per lui a Filipo di Branchazio Ruciellai
f. l. XLI s.XVII d.

Et a dì 16 d'aprile 1445 a fra' Filipo per lui a Giovanni di Stagio Barducci et chonpagnia. Furono per resto di ragione di detto fra' Filipo per ragione tenuto [sic] per la tavola di Giovanni Benci
f. l. XI s.V d.

Et a dì 17 detto a fra' Filipo portò Bartolomeo da Urbino
f. l. II s. IIII° d.

Et a dì 23 d'aprile portò Bartolomeo
f. l. IIII° s. d.

Et a dì 24 d'aprile a fra' Filipo per lui a Lipo vinattiere
f. l. X s. X d.

somma
f. XXIII l. CLXXXXV s. XVIII d. X

f. 82r

Et a dì 27 detto a fra' Filipo per lui a Nanni Bello lanaiuolo
f.VIII l. s. d.

Et a dì 27 d'aprile a fra' Filipo per lui a Boscho vetturale per chose rechò da Urbino di Bartolomeo sta cho'llui
f. l. II s. d.

Et a dì 30 detto a fra' Filipo portò Bartolomeo
f. l.V s. d.

Et a dì 10 di maggio a fra' Filipo portò Bartolomeo
f. l. IIII° s. d.

Et a dì detto per ghabella di chose di Bartolomeo
f. l. s.VI d.
Et a dì 15 di maggio per lui a fra' Filipo e per lui a Bartolomeo da Urbino per fattura d'una giornea e altre chose
f. l. IIII° s. d.

Et a dì 17 di maggio a fra' Filipo portò Bartolomeo
f. l.V s. d.

Et a dì detto a fra' Filipo per lui a Luigi Bartolii
f. l.VIII s. XII d.

Et a dì di maggio [sic] a fra' Filipo portò per dare Andreino
f. l.VIIII° s. d.

Et a dì 22 detto a fra' Filipo per lui Antonio d'Andrea linaiuolo per ghuarnello e altre chose per Bartolomeo
f. l. X s. d.

Et a dì 22 di maggio a fra' Filipo per lui a Mariotto di Ronne per chose per uno farsetto per lo Spangnuolo [sic]
f. l. IIII° s. III d.

Et a dì 28 di maggio a fra' Filipo per lui a Bonifazio speziale per chose aùte dallui
f. l. XIIII° s. XVIIII° d. III

Et a dì 29 di maggio per ghabella d'una chassa di chose di Bartolomeo da Urbino
f. l. s. XVIII d.

Et a dì 18 di giungnio [sic] a fra' Filipo per lui a Boscho vetturale per chose di Bartolomeo rechò da Urbino
f. l. s.V d.

Et a dì 19 di giungnio a fra' Filipo per lui Andrea righattiere per una giornea biancha per lo Spagniolo
f. l.VI s. I d.

Et a dì 24 di luglio a fra' Filipo per lui a Piero di Pace per lui a Girolamo di Soletto Baldovinetti
f. l.VII s. XV d.

Et a dì 27 d'aghosto a fra' Filipo portò Bartolomeo
f. l. IIII° s. d.

Et a dì detto a fra' Filipo per lui a Michelino Affinalazurro per oncie ½ d'azurro tolto dallui
f. l. III s. d.

Et a dì 28 d'aghosto a fra' Filipo portò Bartolomeo
f. l. IIII° s. d.

Et a dì 13 di novembre per oncie 2 d'azurro venne da Virgo
f. l. XXVI s. d.

Et a dì detto a fra' Filipo portò e' detto
f. l. s. XVI d. 6

Et a dì 28 di diciembre a fra' Filipo portò chontanti
f. l. II s. d.

Et a dì 28 detto a fra' Filipo per resto di chamosci e altre spese, portò Bartolomeo
f. l. II s. X d.

Et a dì 21 di gennaio a fra' Filipo per portatura della tavola da cha' al muniste [sic] di Santa Apollonia
f. l. II s. IIII° d.

soma [sic]
f.VIII l. CXXXI s. IIII° d.VIIII°

f. 82v

Et a dì 22 di giennaio a fra' Filipo portò Bartolomeo
f. l. s. XI d.

Et a dì detto a fra' Filipo per lui a Domenicho di Chonte linaiuolo per una tovaglia chomperò dallui
f. l.VII s. d.

Et a dì 5 di febraio a fra' Filipo per lui Alessandro dell'Alesandri [sic]
f.I l. s. d.

Et a dì 8 di febraio a fra' Filipo per Bartolomeo
f. l. IIII° s. d.

Et a dì detto per ghabella di farina
f. l. I s. 4 d.

Et a dì 11 di febraio portò Bartolomeo
f. l. IIII° s. d.

Et a dì 12 di febraio a fra' Filipo per lui a Simone Formichoni per staia 12 di grano chomperò dallui
f. l.VIII s. d.
Et a dì 15 detto portò fra' Filipo chontanti
f. l. s. X d.

Et a dì 17 di febraio a fra' Filipo portò Bartolomeo
f. l. IIII° s. XVII d.

Et a dì 21 di febraio a fra' Filipo portò e' detto
f. l. I s. d.

Et a dì 26 di febraio a fra' Filipo portò Bartolomeo, disse per dare a quello del vino
f. l. IIII° s. XVII d.

Et a dì 5 di marzo a fra' Filipo per oncie ½ d'azurro chomperò
f. l. IIII° s. XVII d.

Et a dì detto a fra' Filipo portò et [sic] detto
f. l. IIII° s. XVII d.

Et a dì 5 di marzo a fra' Filipo portò Bartolomeo, disse per suo bisognio
f. l. II s. d.

Et a dì 9 di marzo a fra' Filipo per oncie 5 di vernice
f. l. s. XIIII° d.

Et a dì detto per resto d'una choltrice
f. l.VIII s. III d.

Et a dì 12 di marzo a fra' Filipo per solatura d'uno paio di chalze
f. l. I s. d.

Et a dì detto a fra' Filipo per uno paio di scharpette per sé
f. l. I s. d.

Et a dì 24 di marzo portò fra' Filipo chontanti
f. l. II s. XV d.

Et a dì 9 d'aprile 1446 a fra Filippo [sic] chontanti
f. l. II s. d.

Et a dì 16 detto a fra' Filipo portò Bartolomeo
f. l. II s. d.

Et a dì 23 d'aprile a fra' Filipo portò Bartolomeo
f. l. II s. d.

Et a dì detto a fra' Filipo per lui a Niato d'Ugholino tintore di setta [sic]
f. II l. I s.VIII d.

Et a dì 6 di maggio a fra' Filipo portò Bartolomeo
f. l. I s. II d.

Et a dì 7 detto a fra' Filipo per lui Alessandro degli Allesandri [sic]
f. I l. s. d.

Et a dì detto a fra' Filipo portò Bartolomeo
f. l. IIII° s. d.

Et a dì 14 di maggio a fra' Filipo portò Bartolomeo
f. l. I s. II d.

Et a dì 28 di maggio a fra' Filipo portò et [sic] detto
f. l. I s. II d.

Et a dì 9 di luglio a fra' Filipo portò Bartolomeo
f. l. XII s. d.

Et a dì 16 detto a fra' Filipo portò Bartolomeo
f. l. XII s. d.

Et a dì 23 detto a fra' Filipo lire 8 e a Bartolomeo lire 4
f. l. XII s. d.

soma
f. IIII° l. CXI s. XVIIII° d.

f. 83r

Et a dì 30 di luglio a fra' Filipo portò Bartolomeo
f. l.VII s. d.

Et a dì 6 d'aghosto a fra' Filipo portò e' detto
f. l. XIIII° s.VIII d.

Et a dì 13 detto a fra' Filipo portò e' detto
f. l. IIII° s. d.

Et a dì 20 d'aghosto a fra' Filipo portò e' detto
f. l. XII s. d.

Et a dì 3 di settembre a fra' Filipo portò e' detto
f. l. XII s. d.

Et a dì 6 detto a fra' Filipo portò Bartolomeo dal munistero
f. l.VIIII° s. XII d.
Et a dì 15 di settembre a fra' Filipo per lui a Mateo degl'Orghani
f. l. LII s. XIII d. IIII°

Et a dì 17 detto a fra' Filipo portò et detto
f. l. XII s. d.

Et a dì 24 detto a fra' Filipo portò e' detto
f. l. XII s. d.

Et a dì 24 di settembre a Francho speziale per vernice aùta da lui
f. l. s.VII d.VIII

Et a dì primo d'ottobre a fra' Filipo portò e' detto
f. l. XII s. d.

Et a dì 29 detto a fra' Filipo portò Forzerino
f. l. II s. d.

Et a dì 19 di novembre a fra' Filipo portò e' detto
f. l. II s. d.

Et a dì 3 di dicembre a Renzo chalzaiuolo
f. l. IIII° s.VI d.VI

Et a dì 10 detto a fra' Filipo per lui a Giovanni del Zacheria
f. l. II s. d.

Et a dì detto a fra' Filipo portò chontanti
f. l. II s. d.

Et a dì 11 d'ottobre a fra' Filipo ebe dal munistero ed èmme chreditore detto munistero nella ragione di Giovanni
f. l. XII s. d.

Et a dì 18 d'otobre [sic] rechò Lorenzo ebe fra' Filipo, e m'è chreditore el munistero chome di sopra
f. l.VIII s. d.

Et a dì 24 d'ottobre rechò Lorenzo ebe fra' Filipo, m'è chreditore el munistero chome di sopra
f. l. IIII° s. d.

Et a dì 17 di dicembre a fra' Filipo per lui a ser Bartolomeo di don Tomaso per uno libro avea pegnio da Lorenzo di Bartolomeo
f. l. II s. XV d.

Et a dì 24 detto a fra' Filipo portò e' detto
f. l. II s. d.

Et a dì 5 di genaio per 10 peze d'ase [sic] d'abete lire II, soldi 5, e soldi XXXIII a' portatori portorono la tavola a Santo Ambruogio, e soldi 7 per aghuli e bullette, e soldi 10 per due pezetti d'ase d'abeto
f. l. IIII° s. XV d.

Et a dì 5 di gienaio per uno lenzuolo per dinanzi a la tavola
f. l. IIII° s.V d.

Et a dì 7 di gennaio a fra' Filipo portò chontanti
f. l.II s.X d.

somma
f. l.CC s.XII d.VI

la prima somma
f.IIII° l.CCIII s.XVIIII° d.

la sechonda somma
f.XXIII l.CLXXXXV s.XVIII d.10

la terza somma
f.VIII l.CXXXI s.4 d.VIIII°

la quarta soma [*sic*]
f.IIII° l.CXI s.XVIIII° d.

somma in tutto
f.XXXVIIII° l.DCCCXLIII s.XIIII° d.I

f. 84r

Et a dì 6 detto [September 1446] dettono a Bartolomeo in vuolte
f. l.VIIII° s.XII d.

f. 85r
Fra' Filipo di Tomaso dipintore de' dare per danari aùti da messer Francescho e dal munistero, com'apare per una schritta di mano di messer Giovanni Manfredi priore di Santo Ambruogio, ebe da messer Francescho, 1439
f.35 l. s. d

Et a dì 27 di novembre 1445 portò Bartolomeo
f. l.XXVIII s.XVIII d

Et a dì 20 di giennaio [1446 modern style] portò Bartolomeo fiorini 2 larghi
f. l.VIIII° s.XIIII° d.

LIBRO DI CONTI E RICORDI DI MASO DI BARTOLOMEO DA FIRENZE

Florence, Biblioteca Nazionale Centrale, fondo Baldovinetti, n. 70

f. 2v † MCCCCXLVIIII

E de' avere a dì 2 di giennaio [1450 modern style] fiorini tre e bolognini 25, ebbi da ser Vangielista in chamera di fra' Bartolommeo

f(iorini) 3 b(olognini) 25

f. 7v † MCCCCLI

E déono avere e' sop[r]a decti sindachi a dì 13 d'aprile fiorini tre d'oro, che fu un viniziano, uno romano e uno fiorentino, chee [*sic*] ne cambiai 2 che furono peggio uno grano per uno, cambiòmegli Tommasso [*sic*] di Simone bolognini octantasei, e' quali danari detti a Pasquino [di Matteo da Montepulciano] che ne facessi le spese che bisognavano ala cava. Ébbigli da frate Bartolomeo in ciella sua

f. 3 b. 11

E de' avere a dì 13 detto ducati quttro [*sic*] vinziani [*sic*], e per me a Luigi di Romolo sta co'meco, e per Luigi a Baldo horafo, e' quali danari pagò detto frate Bartolomeo

f. 4 b. 20

E de' avere a dì 28 d'aprile un fiorino, cioè bolognini quaranta, e' quali ebbi da frate Bartolommeo di Giovanni Curradini, che gl'achattò dal priore per dare a Pasquino per fare le spese ala chava

f. 1

f. 8r † MCCCCLI

E de' avere a dì 22 di maggio fiorini uno, cioè bolognini 40, e' quali mi diè frate Bartolommeo in su la pancha fuori del choro in San Domenicho, e' quali portai al Piobicho

f. 1

E de' avere a dì 7 di giugno bolognini otto, e' quali s'ébbono da ser Vico, chavalieri del Podestà, dièmmegli in piaza, presente frate Bartolommeo

f. b. 8

E de' avere a dì 12 di giugno ducati cinque, e' quali furono danari che s'ébbono da Giovanni di Sabatino per parte di pagamento d'[u]na vigna

comperò da' frati; e' sopradecti danari si prese frate Bartolommeo per ischonto di fiorini 5 che Giovanni mio fratello aveva speso del suo in Firenze, che furono fiorini 4 larghi di Firenze e grossi 8 e soldi 3, e frate Bartolommeo detto si prese ducati 5 viniziani [see f. 23v]

f. 5 b. 25

f. 8v † MCCCCLI

E de[o]no avere e' sopra decti sindachi a dì 20 di giugno fiorini ventiquattro a bolognini 40 per fiorino, che furono pezi 17 d'oro, e' resto [*sic*] furono grossi e bolognini, e' quali ebbi da frate Bartolommeo di Giovanni Qurradini [*sic*] in cella sua in Urbino insieme col priore

f. 24

f. 11v † MCCCCXLVIIII

E de' dare [Antonio di Simone dal Monte dei Corvi] a dì 9 detto [December 1449] bolognini quindici, cioè bolognini 15, ebbe contanti in ciella di frate Bartolomeo in San Domenicho

f. b. 15

f. 12r † MCCCCLI

El sopra detto Antonio [Antonio di Simone dal Monte dei Corvi] venne a lavorare e aiutarmi digrossare e' resto delle pietre della porta a dì 23 di maggio, che fu in domenicha. Cominciò a lavorare e' lunedì mactina, e lavorò per infino a venerdì a ore 20. Fu finoto [*sic*] ogni chosa ed ebbe per me da frate Bartolomeo un fiorino a 40

f. 1 b. 7

[On a loose piece of paper inserted between folios 12v and 13r:]

Ricordo che oggi questo dì 20 di giugno [1451: see f. 8v] ricevetti fiorini 24 a 40 bolognini per fiorino, e' quali mi diè el priore e frate Bartolommeo

f. 14v

E de' dare [Luigi di Romolo da Fiesole] ducati quattro viniziani, e' quali danari furono di Baldo horafo, e frate Bartolomeo gli pagò per me a detto Baldo a dì 13 d'aprile 1451

f. 4 b. 20

f. 19v † MCCCCL

E de' dare [Pasquino di Matteo da

Montepulciano] a dì 17 di novembre duchati quattro, e' quali gli mandai per Lorenzo di Piero da Fabbriano, presente frate Bartolommeo di Giovanni Qurradini [*sic*] et Bartolommeo di messere Andrea. Valsono bolognini 46 l'uno

f. 4 b. 20

f. 23r † MCCCCL

E de' dare [Giovanni di Bartolomeo, the brother of Maso] a dì 9 di settembre duchati due viniziani, e per me da frate Bartolommeo di Giovanni Churradini, valsono bolognini 46 l'uno, sono in tutto bolognini 92

f. 12 b. 12

f. 23v † MCCCCL

E de' dare [Giovanni di Bartolomeo] a dì 22 detto [February 1451, modern style] fiorini uno e mezo in bolognini quando volle andare a Firenze

f. 1 b. 20

Partiti d'Urbino martedì a dì 23 di febbraio per andare a Chapannole e a Firenze, portonne ~~uno~~ 2 schoppietti, valse fiorini 2 l'uno

f. 4

Tornò a dì ultimo di marzo 1451. Non volle lavorare infino a dì 14 d'aprile, che andò ala cava

E de' dare fiorini cinque di Firenze, che fu una lectera di pagamento che lui [Giovanni di Bartolomeo] portò quando andò a Firenze, che furono danari di frate Bartolommeo, e doveva menare un garzone che mettessi d'oro, e perché 'l garzone non volle venire, si spese e' danari, e io gli rende' a detto frate [see f. 8r]

f. 5 b.

f. 25v † MCCCCLI

Lucha di Simone della Robbia de' dare a dì 29 di giugno fiorini quattro d'oro, valsono lire 18 soldi 8, e per me da frate Bartolommeo da Urbino. E questi furono per parte di pagamento di certe figure che detto Lucha mi debba fare per mettere nella porta d'Urbino, cioè una Nostra Donna, San Piero Martire e San Domenicho, e di sopra, in uno frontone, uno Idio Padre in uno tondo, per prezo di fiorini quaranta, cioè fiorini XL

l(ire) 18 sol(di) 8

DOCUMENTS IN THE URBINO ARCHIVES

Matteo Mazzalupi

Documents 1–6, 11, 12, 15, 22, 23, 26, 27, 36, 37, and 39 were tracked down by Don Franco Negroni and cited or published in recent years (see Negroni 1993; 2002; 2004); documents 9, 14, 18, 20, 21, 24, 25, 28–35, and 40 were already known from the studies of Lazzari (1797), Pungileoni (1822), Marchese (1878–79), and Schmarsow (1886). In all cases the location of first publication or citation is provided in parentheses after the archival information. All documents have been checked against the originals—except for numbers 14, 29, and 35. Documents 7, 8, 10, 13, 16, 17, 19, and 38, herein distinguished by asterisks, are unpublished. I would like to thank Don Franco Negroni for generously making his unpublished work available to me, thus facilitating my task.

Abbreviations:

ACCDU Archivio della Compagnia del Corpus Domini di Urbino

ACSCU Archivio della Confraternita della Santa Croce di Urbino, at the Archivio della Cura Vescovile di Urbino

ANU Archivio Notarile di Urbino, at the Sezione di Archivio di Stato, Urbino

1. JANUARY 4, 1434, URBINO

Don Felice di Petruccio, Canon of Urbino and rector of the church and hospital of San Sergio in Urbino and the hospitals of Santo Spirito and San Lazzaro in Fermignano, renews in perpetuity to Nanni d'Antonio alias Barocci da Pomonte, acting also on behalf of his brother Bartolomeo, the lease on a house formerly granted to Francesco da Scotaneto, located in the city, in the quarter [*quadra*] of Posterula and the district [*borgo*] of San Bartolo and bordering the street on two sides, with "*Iohannes Bartoli Cilli alias Coradine*" (Fra Carnevale's father) and Gregorio di Sabatino da Colonna, both on behalf of the church and hospital of San Sergio (ANU, Quadra Santa Croce, 27, ff. 5*v*–6*r*: copy belonging to the notary Nicola di ser Giovanni di maestro Cola, February 4, 1434. Cited in Negroni 2004, p. 17).

2. UNDATED (1436–37?)

On behalf of Don Sperandeo, Don Leonardo pays 35 *bolognini* to maestro Antonio da Ferrara through the intermediary of Bartolomeo di Giovanni della Corradina (ANU, 27, notary Simone Vanni [Simone d'Antonio], parchment cover. Published in Negroni 2002, p. 57 n. 24). The parchment on which the

document appears was a safe-conduct from the count Guidantonio di Montelfeltro (died 1443) for his agent ser Paolo di ser Benedetto, dated February 12 of the eleventh indiction [*indizione*], therefore either 1418 or 1433.

Expendit dompnus Leonardus pro domno Sperandeo bononenos XXXV missis (!) magistro Antonio de Feraria per Bartolomeum Iohannis Coradine.

The first of the two priests mentioned is Don Leonardo di Sabatino, Canon of the cathedral and witness to a 1455 document (ANU, 23, notary Simone Vanni [Simone d'Antonio], f. 64*v*, August 9) together with Don Sperandeo di Giovanni, who for some forty years was parish priest of San Cipriano, just outside Urbino (I am indebted to Don Franco Negroni's kindness for this information; in the documentation I was able to consult, the post of parish priest is documented from 1451 to 1456: compare respectively ANU, Quadra Posterula, 42, f. 122*r*–*v*, December 8, and ANU, 24, notary Simone Vanni [Simone d'Antonio], f. 33*r*, October 2). The name of Don Sperandeo also appears in an inscription on a triptych of the *Madonna and Child with Saints Catherine of Alexandria, Crescentinus, Cyprianus (?), and Jerome*, from the church of San Cipriano (today in the Galleria Nazionale delle Marche, Urbino), attributed by Roberto Longhi (1934 [1956 ed.], p. 12) to the workshop of Antonio Alberti da Ferrara: "*Hoc opus fatu[m] fuit te[m]pore doni [!] Sperandei 1436.*" It is not ruled out that the payment of 35 *bolognini* might have been in connection with this work.

3. OCTOBER 31, 1450, URBINO

To avoid a potential dispute with the brotherhood of Santa Maria dell'Umiltà over the bequest of Magia, the deceased mother of Fra Giovanni Battista di Bartolomeo, the Urbino chapter of the Preaching Friars of San Domenico, where we also find "*frater Bartolomeus Iohannis,*" grants to Angelo di Benedetto da Urbino and to maestro Benvenuto di maestro Giovanni, of Ancona (but living in Urbino)—both syndics [*sindaci*] of the brotherhood—the monastery's rights to a house in the district of San Bartolo, formerly belonging to Fra Giovanni Battista, against a payment of 25 ducats (ANU, Quadra Posterula, 41, f. 95*v*: copy of the notary Antonio di Giovanni di Piero, November 12, 1450. Cited in Negroni 2004, p. 18).

4. JUNE 12, 1451, URBINO

Maestro Marco d'Antonio, *sindaco* of the convent of San Domenico in Urbino, and the brothers of

the same monastery, gathered at a meeting of the chapter that included "*frater Bartolomeus Iohannis,*" to sell for a price of 20 ducats, to maestro Giovanni di Sabatino, a property with vineyard and canebrake, situated in a place called *de Guerinis,* which had been left to the convent by Agnese, widow of ser Filippo Catoni, for the masses in the chapel of the same ser Filippo in San Domenico (ANU, Quadra Posterula, 42, f. 75*r*–*v*: copy of the notary Nicola di ser Bonaiuto di ser Giovanni, July 6, 1451. Cited in Negroni 1993, p. 35 n. 7).

5. AUGUST 31, 1451, URBINO

As the convent of Preaching Friars of San Domenico at Urbino has pledged a shop, located in the quarter of the bishopric in the district of Porta Maia, to Niccolò d'Onofrio Benini of Florence "*pro fabrica porte maioris ecclesie dicti conventus,*" but does not have enough money to manage it, the convened chapter, among whom figures "*frater Bartolomeus Iohannis de Urbino,*" sells of a plot of cultivated land, with threshing floor and brick oven, in the villa of San Simeone in the district [*vocabolo*] of Palazzetto, half *pro indiviso* to Baldo di Benedetto da Castelboccione and half to Antonio and Andrea di Ugotto, to Evangelista [son] of said Antonio and Arcangelo di Benedetto di Bartolo di Ugotto, all of them of Santa Croce and represented by the same Baldo, for a price of 45 ducats (ANU, Quadra Posterula, 42, f. 98*v*: copy of the notary Matteo di ser Bartolomeo, September 13, 1451. Cited in Negroni 1993, p. 35 n. 7).

6. DECEMBER 14, 1454, URBINO

Giovanni, son of the late Piero di maestro Andrea Cionetti of Urbino gives, by barter agreement, to Oddone, son of the deceased physician maestro Antonio da Primicilio, citizen of Urbino, a house in the Porta Maia *contrada* of the city. The deed is notarized in the canons' chapter house [*capitolo della canonica*] of the cathedral. Figuring among the witnesses are the "*eximio legum doctore domino Matheo de Cathaneis*" and "*fratre Bartolomeo Iohannis Bartoli ordinis predicatorum de Urbino*" (ANU, 5, notary Simone Vanni [Simone d'Antonio], ff. 49*v*–50*r* = 23, same notary, ff. 37*v*–38*r* = Quadra Porta Nuova, 45, f. 38*r*–*v*. Cited in Negroni 2004, p. 18).

7. AUGUST 16, 1455, URBINO*

Don Valentino di Tommaso, prior and rector of the hospital of San Sergio in Urbino, issues a receipt to the notary Simone d'Antonio, who is

representing the heirs of Marco di Guido of Montefabbri, for the sum of 5 florins left by said Marco to the hospital and already paid out by Antonio di Giovanni *Giagii* of Petriano. The deed is drawn up and notarized in Pian di Mercato, in front of the warehouse of Bartolomeo and Ludovico of signor Andrea Paltroni, one of the witnesses (?) being "*fratre Bartolomeo Iohannis Bartoli Coradine*" (ANU, 23, notary Simone Vanni [Simone d'Antonio], f. 65v).

8. December 30, 1455, Urbino*

The stonecutter Francesco di Matteo of Montecorvi promises Don Bartolomeo di Cristoforo of Urbino, member of the cathedral administration (the *fabbrica*), that he will sculpt the bases of the columns and pilasters of the church as well as the blocks necessary for the keystones of the vaults, using material provided by the *fabbrica*, and that he will, moreover, at his expense have brought all the stone necessary for the construction of the *nodi* of the capitals of all the *exetre* (that is, apses or windows?) constructed, both in the main chapel and in the rest of the church, and will sculpt them and have them sculpted with foliage and other decorations in accordance with the design provided either by the same Don Bartolomeo or by Fra Bartolomeo di Giovanni di Bartolo, present as a witness to the signing (ANU, 23, notary Simone Vanni [Simone d'Antonio], f. 83v; for a dating in the manner of the Nativity, see doc. 20).

For the possible meaning of *nodi*, see the essay by Matteo Ceriana in this catalogue. The alternate meaning of "window" for *exetra* was suggested to me by a Camerinese document dated December 21, 1439 (Sezione di Archivio di Stato di Camerino, Notarial archive of Esanatoglia, 2, notary Matteo di maestro Marano, ff. 141v–143r), where one reads the phrase "*fenestras seu exetras.*"

M°CCCCLVI, indictione IIII, die XXX mensis decembris. In civitate Urbini et in domo domini Matei de Cataneis sita in quatra Pusterule iuxta stratam publicam, res heredum Francisci Vagnini et res dicti domini Matei, presentibus dicto domino Mateo, fratre Bartolomeo Iohannis Bartoli et Tomasso Dominici Honesti de Urbino testibus etc.

Magister Francisscus Matei de Monte Corvorum, magister lapidum, per se et suos heredes promixit et convenit domno Bartolomeo Christofori de Urbino operario fabrice katredalis ecclesie Urbini, stipulanti nomine et vice dicte fabrice, ex lapidibus dicte fabrice facere, construere et incidere bages pro columnis sive pilastris dicte ecclesie inceptis et incipiendis, quatenus capit corpus dicte ecclesie que noviter construitur, usque ad campanile, et lapides necessarios pro seraturis voltarum dicte ecclesie, quatenus capit dictum corpus. Item conducere et conduci facere omnibus expensis ipsius magistri Francisci omnes lapides necessarios pro constructione nodorum capitellorum construct[arum] exetrarum omnium dicte ecclesie,

tam capelle maioris quam residui dicte ecclesie, quatenus capit dictum corpus, et ipsos lapides bene per se et magistros per eum ducendos incidere, construere cum foliamentis, ornamentis pro (?) secundum desingnum sibi datum sive dandum per dictum domnum Bartolomeum sive fratrem Bartolomeum predictum.

9. June 25, 1456, Urbino

Dionigi di maestro Guido di Ludovico, syndic of the confraternity and of the flagellants [*disciplinati*] of Corpus Domini of Urbino, frees Fra Bartolomeo di Giovanni of Urbino, of the order of Preachers, from the obligation of making and painting a panel for the main altar of the confraternity, for which the friar had already received 40 gold ducats, spent in part on the colors. Baldo di Vico, goldsmith of Urbino, pledges to return to the syndic of the confraterniy 24 of the 40 ducats within a year (ANU, 5, notary Simone Vanni [Simone d'Antonio], f. 157r–v. Partially published in Pungileoni 1822, p. 55, with the date of June 5).

In nomine Domini, amen. Anno Domini a Nativitate eiusdem millesimo CCCCLVI°, indictione quarta, tempore domini Calisti pape tertii, die XXVᵃ mensis iunii. In civitate Urbini et iuxta et ante fundicum Iohannis Luce alias Zacaglie de Urbino situm in quatra Episcopatus iuxta stratam publicam et res fraternitatis Sancte Marie de Misericordia ab aliis, presentibus egregio legum doctore domino Matheo de Cathaneis, ser Matheo Bartolomei et ser Francissco Tome Lodovici de Urbino testibus ad hec vocatis, habitis et rogatis.

Cum inter disciplinatos fraternitatis Corporis Christi dicte civitatis et eorum sindicum ex una parte et venerabilem virum fratrem Bartolomeum Iohannis de dicta civitate ordinis predicatorum ex altera fuerint et sint quedam conventiones, pacta, promissiones et obligationes quibus dictus frater Bartolomeus se obligavit, promixit et convenit dictis disciplinatis et eorum sindico facere, edificare et pingere pro dicta fraternitate unam tabulam pro altari maiori dicte fraternitatis pro certo pretio inter ipsum et dictos disciplinatos et eorum sindico convento, et habuerit et receperit dictus frater Bartolomeus, pro parte pretii inter eos conventi, a dictis disciplinatis et eorum sindico ducatos quatraginta auri, ut asseruerunt dicte partes coram dictis testibus et me notario, et cum dictus frater Bartolomeus causa adimplendi per eum promissa dictis disciplinatis partem dictorum XL ducatorum auri iam expendiderit in coloribus sibi necessariis pro pictura dicte tabule; et cum dicte partes, propter multas alias occupationes et alias causas inter eos superventas, recesserint et recedere intendant a dictis promissionibus, conventionibus et obligationibus inter eas factis et se ipsas ad invicem liberare et in pristinum statum reponere, venerunt dicte partes unanimiter et concorditer ad infrascripta pacta, promissiones et conventiones, videlicet quia egregius vir Dionisius magistri Guidonis Lodovici de Urbino, sindicus et procurator dictorum fraternitatis et disciplinatorum predictorum, de cuius mandato dixit constare manu [* **

* *], *sindicario et procuratorio nomine predicto liberavit et absolvit dictum fratrem Bartolomeum presentem et acceptantem a promissione, conventione et obligatione per ipsum factis de faciendo et pingendo tabulam predictam, et pro liberato et absoluto ipsum habere voluit ipsumque fratrem Bartolomeum in pristinum statum reposuit prout erat ante dictam conventionem. Et hoc fecit dictus sindicus quia Baldus Vici aurifex de Urbino, sciens se aliter non teneri nec obligatum esse ad infrascripta sed obligari et teneri velle, promixit et convenit sibi Dionisio sindico et procuratori predicto presenti, stipulanti et recipienti nomine et vice dicte fraternitatis et disciplinatorum eiusdem, sibi dare, solvere et numerare, reddere et restituere hinc ad unum annum proxime futurum, hodie inceptum et ut sequitur finiendum, et abinde in posterum ad omnem dicti sindici et disciplinatorum predictorum petitionem et terminum, ducatos XXIIIIᵒʳ auri de summa dictorum XL ducatorum auri perventorum ad manus dicti fratris Bartolomei pro pictura dicte tabule, per se et suos heredes se et sua bona obligando, de quibus XXIIII ducatis auri dictus Baldus promixit dicto sindico ut supra stipulanti facere bonam, veram, interam et effectualem solutionem et restitutionem in civitatibus Urbini, Calii, Eugubii, Forosinfronii, Fani, Pisauri, Arimini et generaliter in qualibet alia civitate, terra, castro et loco in quibus dictus Baldus inventus fuerit et dicta quantitas XXIIII ducatorum auri ab eo petita fuerit per dictum sindicum vel alium eius nomine, in quibus locis et aliis quibuscumque dictus Baldus se constituit debitorem et solutorem dicti sindici et voluit et pacto convenit se posse realiter et personaliter conveniri, cogi, capi, detineri et carcerari usque ad integram solutionem dictorum XXIIII ducatorum auri et expensarum. Renumptians dictus Baldus privilegio fori incompetentis iudicis, feriis et diebus feriatis quibuscumque et maxime occasione extatis et vindemiarum, salviconductibus, bulletinis, rescriptis, statutis, reformationibus et dirictis et quibuscumque aliis inmunitatibus et securitatibus tam sibi concessis quam in futurum concedendis, exceptioni doli mali, conditioni sine causa in factum, actioni fictionis et simulationis erroris iuris et facti et omni alii legum et iuris auxilio. Cui Baldo debitori presenti et acceptanti precepi et mandavi ego Simon notarius infrascriptus, ex auctoritate et licentia michi concessa per formam statutorum Communis Urbini, facta prius cautione predicta, quatenus dictos XXIIIIᵒʳ ducatos auri daret, redderet et restitueret dicto sindico dictis nominibus in termino predicto et, eo elapso, ad omnem eius petitionem et terminum. Qui Baldus sic facere promixit, asigna[n]s contrascriptum de suis propriis bonis dicto sindico in tenutam et pro tenuta dicte quantitatis ducatorum IIIIᵒʳ staria grani boni et nicti ad mensuram Communis Urbini pro quolibet ducato, que tenuta de voluntate dicti sindici remansit penes dictum Baldum, promictentem dicto sindico ut supra stipulanti dictam tenutam sibi reasignare in termino predicto vel dictos XXIIIIᵒʳ ducatos auri solvere et restituere et expresse (?) […].*

10. January 9, 1458, Urbino

Appearing before Bishop Andrea, the "*venerabilis vir frater Bartolomeus Iohannis de Urbino,*" parish priest of San Cassiano di Castelcavallino, sells to Giovanni di

Biagio di Simonetto of the villa of San Leo, now living in Urbino, two plots of land in the said villa, previously sold without notarial documentation by the prior parish priest Don Valentino di Tommaso, for the price of 28 florins. The sum is deposited with Giovanni di Giampaolo di Diotallevi, parishioner and syndic of the church, and will be spent to purchase a house for the parish priest within the confines of the castle (ANU, 6, notary Simone Vanni [Simone d'Antonio], ff. 5*v*–6*r* = 24, same notary, f. 81*r*).

11. DECEMBER 6, 1459, URBINO

The church buildings being in need of restoration, and having obtained to this end the permission of Count Federigo da Montefeltro, after the latter was solicited in a papal brief from Pius II, to demand payment for several plots of land sold fourteen years earlier by the prior parish priest Don Valentino di Tommaso, "*Frater Bartolomeus Iohannis*," archpriest of the parish church of San Cassiano di Castelcavallino, sells to Bartolomeo di Domenico of Urbino a plot of land located in the villa *Vallis Roveti* estate, previously sold without notarial deed to the deceased Angelo da Vigliano, for the price of 10 florins (ANU, 6, notary Simone Vanni [Simone d'Antonio], ff. 119*v*–120*r*. Cited in Negroni 2004, pp. 19–20).

12. JANUARY 10, 1461, URBINO

"*Frater Bartolomeus Iohannis*," archpriest of the parish church of San Cassiano di Castelcavallino, and Don Niccolò di Paolo of Fermignano, resident of Urbino, procurators for the clergy of the diocese of Urbino, issue a receipt to Giovanni di Niccolò di Stefano of Urbino, who is acting on behalf of the successors of Don Niccolò di Francesco, former rector of Sant'Agata and collector of the fees imposed on the Urbino clergy, for all the money collected by said Don Niccolò (ANU, 22, notary Simone Vanni [Simone d'Antonio], f. 22*r* = 7, same notary, f. 5*r*. Cited in Negroni 2004, p. 20).

13. MARCH 2, 1461, URBINO*

Biagio di Matteo of Rancitella receives from Vico and Piero di Paolo di Stefano of Montecalende the residual of the dowry of Evangelista, daughter of the late Sante di Giovanni di Stefano (cousin of said Vico and Piero) and wife of Matteo, the son of Biagio. The deed is drafted in the canons' chapter house of the cathedral, with, as witness, "*domno Bartolomeo Iohannis plebano Cavalini*" (ANU, 22, notary Simone Vanni [Simone d'Antonio], f. 28*v* = 7, same notary, f. 12*r*–*v*).

14. AUGUST 22, 1461, URBINO

The commune of Urbino donates 4 pounds of wax (*cera lavorata*), for a value of 4 soldi, to Father Bartolomeo, parish priest of San Cassiano di Cavallino, in celebration of the victory of Federigo da Montefeltro over Sigismondo Pandolfo Malatesta (Pungileoni 1822, p. 56, from Archivio comunale di Urbino, "Libro del Camarlingo segnato A" ["Book of the Chamberlain marked A"] [so described in Pungileoni], f. 117).

15. DECEMBER 15, 1461, URBINO

With the parish church and the priest's house in need of renovation, and having obtained to this end from Count Federigo da Montefeltro, after the latter was solicited by a papal brief from Pius II, the permission to demand payment for several plots of land sold fourteen years earlier by his predecessors, Fra Bartolomeo di Giovanni, parish priest of Castelcavallino, issues a receipt to Giovanni di Paolo *Badarelli* of Castelcavallino for the sum of 28 florins, which the latter had received in his capacity as syndic for the parish church from Giovanni di Biagio di Simonetto in payment for certain plots of land sold to him (ANU, 22, notary Simone Vanni [Simone d'Antonio], ff. 65*v*–66*r* = 7; same notary, ff. 56*v*–57*r*. Cited in Negroni 2004, p. 20).

16. DECEMBER 19, 1461, URBINO*

The bishop Andrea, with the consent of Benedetto di Vanni Mazzanti, renews in perpetuity the lease on a plot of land located in the *curtis* of Colbordolo in the *Vallis Brancutii* area, to Giovanni and Matteo di Baldo of Petriano, who represent as well their brothers Antonio and Battista. The deed is drawn up in the bishop's room, with, as witness, "*frate Bartolomeo Iohannis de Urbino*" (ANU, 22, notary Simone Vanni [Simone d'Antonio], f. 66*v*–67*r*).

17. JUNE 12, 1462, URBINO*

Present, as witness, at the drafting of the will of Niccolò d'Antonio of Monfalcone, dictated in the canons' chapter house of the cathedral, is "*frate Bartolomeo Iohannis plebano Cavalini*" (ANU, 22, notary Simone Vanni [Simone d'Antonio], f. 88*r*).

18. MARCH 31, 1465, URBINO

The Confraternità del Corpus Domini in Urbino pays out to Giovanni di Luca, known as Zacagna, two sums of money: 67 florins and 2 soldi, which said Zacagna turns over to the same confraternity as change for the amount promised by him for the panel [*tavola*]; and 60 florins, 17 soldi, and 7 denarii, as the residual for the 36 florins promised by him to Dionigi di maestro Guido (syndic of the confraternity: see doc. 9) on behalf of Fra Bartolomeo Carnevale, debtor of the confrater-

nity (ACCDU, book B, 1, ff. 4*v*, 11*r*. Partially published in Pungileoni 1822, pp. 64–65; partial publication in Moranti 1990, p. 206).

Note that the drafter of the document indicates sheet 4*v* with a "5."

(f. 4v) Giovanni de Luca altramente Zacangna [sic] de' dare adì ultimo de marzo fiorini sesantasette, soldi doi de bolognini, per lui a la fraternita del Corpo de Cristo, per resto de la promessa lui fe' a la detta fraternita per la taula, a lei; in questo a f. 11
f. 67 s. 2 d. –

E adì detto fiorini sesanta, soldi dicesette, denari sette de bolognini sonno per resto de fiorini 36 lui promise a Dionigi de mastro Guido per fra Bartolomeo Carnoale per denari ditto fra Bartolomeo avea a dare a la fraternita del Corpo de Cristo, posto debba avere; in questo a f. 11
f. 60 s. 17 d. 7

(f. 11r) Fraternita del Corpo de Cristo de' avere adì ultimo de marzo per l'infrascritti debitori [. . .]
[. . .]
E adì detto fiorini sesantasette, soldi doi per Giovanni de Lucha Zacangna, a lui; in questo 5
f. 67 s. 2 d. –

[. . .]
E adì detto fiorini sesanta, soldi dicesette, denari sette per Giovanni de Luca, a suo conto; in questo 5
f. 60 s. 17 d. 7

19. JULY 27, 1465, URBINO*

Gentilina, daughter of the late Niccolò Passarini da San Giovanni, with the consent of her husband the late Tommaso di Giovanni da Castelcavallino, in order to put an end to the dispute with Pierantonio del signor Paolo over the dowry, cedes to him, in the name of his wife, Cangemia, daughter of the late ser Acquisto (Cangemia possesses the property of said Niccolò), all claim to these properties, against payment of 11 florins. Serving as witness to the deed, drawn up in the shop of the spice vendor Giovanni di Vincenzo in Pian di Mercato, is "*fratre Bartolomeo Iohannis plebano Cavalini*" (ANU, 27, notary Simone Vanni [Simone d'Antonio], f. 34*r*).

20. DECEMBER 31, 1466, URBINO

Tommaso d'Antonio Torelli sells to Fra Bartolomeo di Giovanni della Corradina of Urbino a house located in town, in the *contrada* of Pozzo Nuovo, for the price of 144 florins. The sum is paid out to the seller by Antonio d'Alessandro and Andrea di Nicola *Ciarle,* syndics of the confraternity and flagellants of Santa Maria della Bella, as payment owed to Fra Bartolomeo for the painting of a panel for the main altar of the

confraternity, in large part already painted by the friar (ANU, Quadra Santa Croce, 57, f. 5r: copy of the notary Bartolomeo di ser Pietro, January 14, 1467. Partial publication in Lazzari 1797, pp. 31–32, with the date October 31, 1467; reproduced in Sangiorgi 1989, p. 16, fig. 1. We are indebted to Negroni [2004] for determining the precise year of this document, which is not 1467 but 1466, since the deed is dated in the manner of the Nativity, which moves the beginning of the year up to December 25).

In nomine Domini, amen. Anno a Nativitate eiusdem MCCCCLXVII, indictione XV, tempore domini domini Pauli divina providentia pape secundi et die ultima mensis decembris. In civitate Urbini et in domo spectabilis et eximii legum doctoris domini Mathei de Cataneis de Urbino, posita in quatra Pusterule iuxta vias publicas, res Facini de Facinis et alia latera, presentibus Marcho Bartolomei Simonis, Arcangelo Mathei alias Ciuffole et Blaxio Vici olim de Durante civibus Urbini testibus ad hec vocatis, habitis et rogatis.

Tomas Antonii de Torellis de Urbino per se et suos heredes iure proprio, ad proprium et in perpetuum dedit, vendidit et tradidit venerabili viro fratri Bartolomeo Iohannis Coradine de Urbino presenti, ementi et recipienti pro se et suis heredibus unam domum positam in dicta civitate et quatra et in contrata Putei Novi burgi Evaginis, iuxta viam publicam, res Agustini Iacobi Ciarlini, res monialium et monasterii Sancte Agate mediante androna et furnum sive clibanum heredum Antonii Biachini mediante androna, ad habendum, tenendum et possidendum et quicquid deinceps dicto emptori et suis heredibus placuerit perpetuo faciendum, cum omnibus et singulis que infra predictos continentur confines vel alios siqui forent veriores, cum adcessibus et egressibus suis usque in vias publicas et cum omnibus et singulis que dicta res vendita habet supra se, infra seu intra se in integrum cum omnique iure et actione, usu seu requisitione dicto venditori ex ea, pro ea re vendita aut ipsi rei vendite modo aliquo pertinente sive spectante, pro pretio et nomine pretii centum quatragintaquatuor florenorum ad rationem XL bononenorum pro floreno. Quos Antonius Alexandri et Andreas Nicolai Ciarle de Urbino, sindici fraternitatis et disciplinatorum Sante Marie de Bella civitatis predicte, de mandato, comissione et voluntatis (!) dicti fratris Bartolomei et eius nomine presentis et mandantis, impresentia dictorum testium et mei notarii infrascripti, dederunt, solverunt et nominaverunt integre dicto Tome venditori presenti et recipienti pro mercede et de mercede sibi fratri Bartolomeo debita per dictos homines et disciplinatos fraternitatis predicte pro pictura tabule maioris altaris dicte fraternitatis per ipsum fratrem Bartolomeum picte pro maiori parte et pingende et perficiende per ipsum fratrem Bartolomeum de propriis peccuniis, ut asseruerunt, fraternitatis et disciplinatorum predictorum. Constituens se dictus venditor dictam domum venditam dicti emptoris nomine tenere et possidere donec ipse emptor eiusdem tenutam et possessionem acceperit corporalem, quam accipiendi eius auctoritate propria et rectinendi deinceps eidem emptori licentiam omnimodam

contulit atque dedit. Promictens dictus venditor per se et suos heredes dicto emptori, pro se et suis heredibus stipulanti et recipienti, de dicta re vendita ullo unquam tempore litem, questionem, molestiam aut controversiam aliquam non inferre nec inferrenti consentire, sed potius legitime deffendere, auctorizare et disbrigare in iuditio et extra ab omni homine, persona, communi, collegio et universitate omnibus ipsius venditoris sumptibus et expensis, et ipsum emptorem semper impossessione facere potiorem. Et predictam vendictio (!) et tradictionem et omnia et singula impresenti instrumento contempta promixit dictus venditor per et suos heredes dicto emptori, pro se et suis heredibus et subcessoribus stipulanti et recipienti, et promictendo iuravit ad sancta Dei evangelia, manu corporaliter tactis Scripturis, fuisse et esse vera et ea semper et perpetuo firma et rata habere, tenere et observare et in nullo contrafacere vel venire per se veal alium seu alios aliqua ratione vel causa de iure vel de facto, sub pena dupli valoris dicte rei vendite. Qua soluta vel non, firma et rata omnia et singula suprascripta. Item refficere et restituere eidem emptori omnia dampna, expensas ac interesses litis et extra. Pro quibus omnibus et singulis firmiter observandis et adimplendis obligavit dicto emptori omnia sua bona presentia et fuctura.

Et ego Stefanus Antonii de Urbino, habitator quatre Sancte Crucis, publicus imperiali auctoritate notarius, predictis omnibus et singulis presens fui et ea rogatus scribere scripsi et publicavi signumque meum apposui; auctenticavi die X sequentis mensis ianuarii et restitui.

Antonio d'Alessandro, one of the two syndics mentioned in this document, had sold, three weeks earlier, on December 10, 1466, a plot of land belonging to the confraternity of Santa Maria della Bella for the price of 90 florins (ANU, 27, notary Simone Vanni [Simone d'Antonio], ff. 97v–98r), a sum probably intended to be used to pay Fra Bartolomeo. In the December 10 deed, the seller is described as "*sindicus fraternitatis et hospitalis Sancte Marie de la Bella*," confirming the fact, handed down by later sources, of the existence of a hospital managed by the confraternity (an earlier deed dated July 10, 1456, already mentions the "*res hospitalis Sancte Marie Belle*": ANU, 24, notary Simone Vanni [Simone d'Antonio], f. 27r).

21. OCTOBER 24, 1467, URBINO

Giacomo, son of the late Matteo Biachini, sells to the "*venerabili viro fratri Bartolomeo Iohannis de Urbino*" an *androna* (or entrance passage) situated in the Lavagine quarter in the *contrada* of Pozzo Nuovo for the price of 16 florins (the *androna* bordered on the house acquired by the friar a year earlier: see doc. 20). The deed is drawn up in the garden of the bishop's residence. The witnesses include the "*egregio decretorum professore domino Guidone de Bonclericis de Callio vicario domini episcopi Urbini*" (ANU, Quadra Posterula, 56, f. 112r–v: copy of the notary Bartolomeo di ser Piero da Urbino, November 16, 1467. Published in part in Lazzari 1797, p. 31).

22. MARCH 1, 1471, URBINO

Last will and testament of the doctor of law Matteo *de Cathaneis* of Urbino, with bequests to, among others, the church of San Domenico, the Chapel of Santa Maria in the same church, the confraternity of flagellants of Santa Maria della Bella, and the parish church of Castelcavallino. Fra Bartolomeo di Giovanni della Corradina is named fideicommissary together with Ottaviano degli Ubaldini and Taddeo Cataldi, and is present as witness (ANU, Quadra Santa Croce, 61, f. 9r–v: copy of the notary Tommaso di Ludovico Oddoni da Urbino, March 16, 1471. Cited in Negroni 2004, p. 21).

In Christi nomine, amen. Famossisimus ac spectabilis legum doctor dominus Matheus de Cathaneis de Urbino, sanus per gratiam Domini nostri Yhesu Christi mente, sensu et intellectu, licet corpore languens, timens mortis periculum et nolens intestatus decedere, suarum rerum et bonorum omnium per presens suum nuncuptivum testamentum quod dicitur sine scriptis in hunc modum dispositionem facere procuravit et fecit, habita prius licentia a venerabili decretorum doctore domino Guidone de Bonclericis de Callio, sindico episcopatus Urbini, testandi de bonis emphiteoticis pro suo libito voluntatis, ut patet manu mei notarii infrascripti etc. videlicet:

In primis quidem reliquit, voluit et mandavit, cum ipsum mori contigerit, corpus suum sepelliri apud ecclesiam Sancti Dominici de Urbino, ubi suam et suorum maiorum habet sepulturam, cui ecclesie reliquit amore Dei et pro eius anima florenos decem pro fabrica et concimine capelle Sancte Marie in dicta ecclesia ad rationem XL bononenorum pro quolibet floreno.

Item reliquit dicte ecclesie pro dicta capella unum calicem valoris sex seu otto florenorum ad rationem predictam.

Item reliquit dicte capelle unum piviale veluti cremixini iam traditum et concessum fratribus dicte ecclesie.

Item reliquit dicte capelle unum fregium pro dicto piviali valoris tredecim florenorum ad dictam rationem.

Item reliquit nobili domine Mathee uxori ipsius testatoris iure restitutionis florenos quingentos quinquaginta ad rationem XL bononenorum pro floreno, quos dixit, asseruit et confessus fuit habuisse et recepisse pro suis dotibus tempore contracti matrimonii inter eos, presente dicta domina Mathea et dictam confessionem acceptante.

Item reliquit eidem omnes et singulas massaritias ipsius domine Mathee que sunt in domo ipsius testatoris, que olim fuerunt suorum fratrum et patris et matris sue, de quibus voluit stari simplici verbo ipsius domine Mathee etiam sine iuramento aliquo.

Item reliquit iure legati eidem domine Mathee florenos vigintiquinque ad rationem predictam.

Item reliquit iure legati dicte domine Mathee eius uxori possessionem cum columbari (!) positam extra portam Evagenis dicte civitatis in vocabulo [* * * *] iuxta stratam publicam, vias publicas et alia latera.*

Item reliquit pro eius anima ecclesie catredali civitatis Urbini et pro eius fabrica florenos sexaginta ad dictam rationem, quos mandavit deponi per eius heredes infrascrip-

tos apud rectores fraternitatis Sancte Marie de Misericordia civitatis predicte, per ipsos tenendos tenendos (!) donec et quousque dabitur operam fabrice dicte ecclesie et demum et tunc solvendos per eos pro fabrica predicta et operariis ipsius fabrice cum dabitur operam fabrice dicte ecclesie.

Item reliquit iure legati et pro eius anima fraternitati disciplinatorum Sancte Marie de la Bella florenos decem pro concimine dicte fratenitatis ad rationem predictam.

Item reliquit ecclesie Sancti Francisci de Urbino florenos decem pro reparatione et concimine ipsius ecclesie et conventus eius ad rationem predictam.

Item reliquit dicto iure ecclesiis Sancti Bartoli et Sancte Aghate et Sancti Angeli in Salsula insimul unitis florenos decem, videlicet dicte ecclesie Sancti Bartoli, et florenos decem dictis ecclesiis Sancte Agate et Sancti Angeli, pro omni eo quod deberent habere eorum rectores et recipere ab ipso domino testatore.

Item reliquit dicto iure plebi Sancti Iohannis de Firmignano florenos decem ad rationem predictam et pro omni eo quod eius rector deberet habere et recipere ab ipso domino testatore.

Item reliquit iure legati Matheo Simonis Centii de Columna florenos vigintiquinque ad dictam rationem pro omni eo quod ab eo pectere (!) posset et habere deberet dictus Matheus.

Item reliquit ecclesie Sancti Augustini de Urbino dicto iure florenos quinque ad rationem predictam.

Item reliquit dicto iure ecclesie Sancti Donati et monasterio Sancte Clare de Urbino pro fabrica florenos decem pro qualibet ipsarum ecclesiarum ad rationem predictam.

Item reliquit iure legati heredibus Brandani Bartolomei de Brandanis de Urbino omne ius et actionem omnem quod et quam haberet et habet ipse dominus testator in quadam petia terre quam habuit una cum ser Iohanne domini Mathei a dictis heredibus, ut patere dixit publico instrumento manu ser Pierhyeronimi ser Nicolai notarii de Urbino, que petia terre sita est in curte [* * * *] et vocabulo Mortule.*

Item reliquit monasterio Sancte Agate de Urbino florenos quinque ad dictam rationem pro fabrica dormitorii dicti monasterii, et totidem plebi Sancti Cassiani de Cavalino pro fabrica pro omni eo quod eius rector habere deberet ab ipso testatore.

Item reliquit iure legati ser Pierhyeronimo et Iohanmario fratribus et filiis ser Nicolai condam ser Iohannis de Urbino unam petiam terre vineate positam in curte civitatis et vocabulo de Guerinis iuxta viam, res domini Antonii de Raneriis, res heredum Iohannis Sabatini et alia latera.

Item reliquit dictos ser Pierieronimum, Iohanmarium, Nicoloyam et Pieram eorum sorores vestiri et indui vestibus lugubribus et funeralibus tempore mortis ipsius testatoris, si eos vivere contigerit tempore predicto, videlicet de bonis ipsius domini testatoris.

Item reliquit iure legati heredibus Blaxii Poli de Urbino calzolarii florenos tres ad rationem predictam.

Item reliquit pro eius anima iure legati conservatoribus Montis Pietatis civitatis predicte florenos tres ad rationem predictam.

Item reliquit Lodovice filie Dominici Arcangeli habitatoris castri Gengharum et Catarine sclave pedissequis

ipsius domini testatoris florenos decem pro qualibet earum et vestimenta funeralia et lugubria tempore sui funeris.

Item reliquit iure legati et pro eius anima rectoribus fraternitatis Sancte Marie de Misericordia dicte civitatis omnes et singulas terras et possessiones ipsius testatoris sitas in villa Salsule infra quecumque latera, que hic haberi voluit pro expressis etc. cum hoc quod ipsi rectores teneantur annuatim dare et tradere supradicte eius uxori salmas sex vini de vino pustitie, et si non esset tanti redditus dicta pustitia, supleri voluit de residuo alterius vinee.

Item reliquit iure legati supradicte domine Mathee eius uxori omnes et singulos pannos laneos et lineos et sirici et omnes alios quoscumque, tam ad dorsum et usum ipsius domini testatoris quam ipsius domine Mathee, et omnes perlas, zoias et iocalia et ornamenta ad eorum usum et omnes et singulas massaritias et peccunias que reperiantur in hereditate ipsius testatoris cum onere tamen solutionis legatorum de quibus supra et infra fit mentio.

Item reliquit iure legati et pro eius anima dictis rectoribus fraternitatis Sancte Marie de Misericordia omnes et singulos libros ipsius testatoris, per ipsos rectores vendendos et distribuendos, videlicet pretium ipsorum, amore Dei et pro eius anima inter pauperes Christi secundum quod videbitur dictis rectoribus, dummodo non vendantur alicui ex dictis rectoribus, cum hoc etiam addito quod ipsi rectores teneantur vendere de dictis libris, videlicet iuris canonici, venerabili viro domino Guidoni de Bonclericis de Callio quos ipse maluerit et pro congruo pretio et pari pretio quod ab aliis repetatur, et pretium distribuere ut supra.

Item reliquit pro male ablatis incertis florenos quinque ad rationem predictam.

Item reliquit restitui domino Thadeo de Cataldis Baldum super sexto Codicis.

Item reliquit restitui heredibus domini Hyeronimi de Stacholis omnes libro quos haberent comodatu, ut patet in scripta que est penes Marcum Bartolomei Simonis, cui scripte voluit et mandavit plenam fidem adhiberi.

In omnibus autem aliis suis bonis mobilibus et immobilibus, iuribus et actionibus tam presentibus quam futuris, propriis et emphiteoticis, ubicumque sunt et reperiri poterunt dominam Matheam predictam eius domini testatoris uxorem sibi heredem universalem instituit et fecit pleno iure, in vita eius tantum et done[c] vitam vidualem honestam castamque servaverit, et post eius mortem substituit ey supradictos rectores fraternitatis Sancte Marie de Misericordia pleno iure absque detractione alicuius trebeleanice, quam expresse prohibuit, cum hoc quod teneantur ipsi rectores annuatim facere celebrari unum obsequium seu offitium et missas mortuorum pro anima ipsius testatoris.

Suos autem fidei commissarios et huius sui testamenti executores pleno iure fecit magnificum dominum dominum Octavianum de Ubaldinis etc., dominum Thadeum de Cataldis et fratrem Bartolomeum Iohannis archipresbiterum Sancti Cassiani predicti, quibus dedit et concessit plenam auctoritatem predicta omnia exequendi prout et sicut eis videbitur.

Et hanc suam ultimam voluntatem asseruit dictus testator esse et esse velle, quem valere voluit iure testa-

menti, et si iure testamenti non valeret, valere voluit iure codicillorum vel alterius cuiuscumque ultime voluntatis quo vel qua melius de iure valere potest, possit et poterit ac tenere. Cassans, irritans et cancellans omne aliud testamentum et ultimam voluntatem siquod et siquam hactenus condidisset etc.

Actum, factum, condictum et affirmatum fuit dictum testamentum per dictum dominum Matheum testatorem predictum in domibus sue solite habitationis, sitis in civitate predicta et contrata Cortilis sive Platee iuxta vias publicas, res Fazini de Fazinis et alia latera, et scriptum, lectum et publicatum per me Stefanum Antonii notarium infrascriptum sub annis Domini a Nativitate millesimo CCCC°LXXI°, indictione quarta, tempore domini domini Pauli divina providentia pape secundi et die prima mensis martii, presentibus supradictis domino Guidone, fratre Bartolomeo Iohannis Coradine, spectabili milite et eximio legum doctore domino Thadeo de Cataldis, Antonio Peri Guidi de Bonaventuris, ser Nicolao ser Bonaiuti, Urbano Sanctis Mercedis, Gabrielle Nicolai Ciarlini de Urbino et Marcho Georgii de villa Montis Corvorum testibus ad predicta vocatis, habitis et a dicto testatore rogatis ore proprio etc.

Et ego Stefanus Antonii de Urbino, habitator quatre Sancte Crucis, publicus imperiali auctoritate notarius, predictis omnibus et singulis presens fui et ea rogatus scribere scripsi et publicavi singnumque meum apposui; die vero III^a dicti mensis martii decessit dictus testator me vidente, et die XII^a eiusdem mensis autenticavi et restitui dicte domine Mathee.

23. DECEMBER 23, 1472, URBINO

The *"venerabilis vir frater Bartolomeus condam Iohannis de Coradinis de Urbino,"* archpriest of the parish church of San Cassiano di Castelcavallino, renews in perpetuity the lease on a plot of land located in the *curtis* of Schieti in the *Mazelini* area to Anastasia, wife of Bartolomeo di Giacomo of Urbino and daughter of the late Massino *Parlani* of Schieti, for the sum of 40 *bolognini* and an unspecified annual rent. The deed is drawn up *"in domibus illustrissimi et excelsi domini nostri, in quibus impresentiarum habitat magnificus dominus Ottavianus de Ubaldinis"* (ANU, Quadra Vescovado, 56, f. 7r: copy of the notary Tommaso di Ludovico da Urbino, January 8, 1473. Cited in Negroni 2004, p. 21).

24. DECEMBER 19, 1474, URBINO

The *"venerabilis vir frater Bartolomeus alias dicto Fratecarnovale,"* parish priest of San Cassiano di Castelcavallino, and Battista di Simone di Bertola of the villa of Cavallino, procurator for his father, submit to the arbitration of Guido di Mengaccio and Girolamo di Serafino, merchants, their disputes over the earnings [*frutti*] received by the friar from the lands of the church of San Paterniano in the years 1473 and 1474, and over the damages caused to these lands by same Simone and others of his family. The document is drafted *"in domibus Antonii quondam Benedicti de Benedictis [. . .] et in*

quodam studiolo dicte domus ressidentie eximii legum doctoris domini Luce de Pretiosis de Callio, presentibus dicto domino Luca et ser Lodovico [* * * *] de Mercatello cancelario illustrissimi domini nostri"* (ANU, 59, notary Antonio Vanni [Antonio di ser Simone], f. 108r–v. Partially published in Lazzari 1797, p. 32).

25. FEBRUARY 10, 1476, ROME

Fra Niccolò di Giovanni *de Lanne* of Fano obtains from the Superior General of the Dominicans permission to reside outside of the order *"propter artem picture"* with Fra Bartolomeo of Urbino, both in Urbino and elsewhere (Archivio generale dell'ordine dei predicatori [General Archive of the Preaching Friars], IV.3, f. 162v. Published in Marchese 1878–79, p. 529, under the date of 1475).

Frater Nicolaus Iohannis de Lanne de Fano habuit licentiam standi extra ordinem propter artem picture cum fratre Bartholomeo de Urbino vel alibi, et potest interim officiare ecclesias et cappellas, elemosinas recipere et bis in anno confiteri etc. Datum Rome X februarii.

Fra Niccolò is perhaps the same *"fratrem Nicolaum de Fano"* mentioned on the same page in a register from January 31, 1476, according to which the prior of the monastery of Urbino was instructed to force him to give back 2 ducats and 27 *bolognini* to *"magistro Casparo Maschalco de Roberti de Arimino."*

26. FEBRUARY 15, 1476, URBINO

"Frate Bartolomeo de Giovanni," archpriest of Castelcavallino, deposited a fringed crimson belt as a pledge to the Monte di Pietà in return for 40 *bolognini,* which he receives from the consignee, Giovanni di Luca (Sezione di Archivio di Stato di Urbino [State Archives Department of Urbino], *Monte di Pietà,* I, f.n.n., number 1548. Partially published in Negroni 2004, pp. 21–22).

27. MARCH 27, 1478, URBINO

Lante [son] of the late Bartolomeo di Lante, gonfalonier; Domenico di maestro Antonio, prefect; Simone d'Antonio, alias *Brochole*; and Crescentino di Bartolo, barber, priors of the Commune of Urbino, called upon to settle the dispute between *"fratrem Bartolomeum,"* parish priest of Castelcavallino, and Simone della Bartola over a road that the former wants to replace with a recently opened one, grant the friar permission to close the old road so long as he maintains the new one in good condition (ANU, 62, notary Antonio Vanni [Antonio di ser Simone], f. 21v. Cited in Negroni 2004, p. 22).

28. DECEMBER 1, 1481, URBINO

The *decretorum profexor* Teseo [son] of the late Giampietro da Fermignano, on behalf as well of his brothers Sforza, Giambattista, Bernardino, and Piermatteo, and of their mother, Bartolomea, sells to Don Melchiorre Foschini of Auditore a house with a garden located in Urbino on the slopes of Monte San Sergio, in the quarter of the bishopric, for the price of 105 florins. The deed is drawn up in the cloister of San Francesco with, as witness, *"fratre Bartholomeo Iohannis de Coradinis plebano Sancti Casciani de Cavalino"* (ANU, 44, notary Antonio Vanni [Antonio di ser Simone], f. 433r–v. Cited in Pungileoni 1822, p. 56).

29. FEBRUARY 23, 1482, URBINO

In a book belonging to the "Fraternita" (of Santa Maria della Misericordia ?), mention is made of a "frate Bartolommeo archpriest of Cavallino" (Pungileoni 1822, p. 56, from "Libro G della Fraternita dal 1479 al 1488" [so cited in Pungileoni], f. 60).

30. SEPTEMBER 1, 1483, URBINO

"Fra Bartolomeo de Giovanni" (this is followed, in a contemporaneous hand, by the additional words "de la Coradina") is the first name to appear on the list of clerics who must pay the membership dues for the confraternity of Santa Croce for the last four months of 1483 (ACSCU, *Ufficiali,* book A, f.n.n. Cited in Pungileoni 1822, p. 56).

31. JANUARY 1, 1484, URBINO

"Fra Bartolomeo de Giovanni de la Coradina" is the first name to appear on the list of clerics who must pay the membership dues for the confraternity of Santa Croce for the first four months of 1484 (ACSCU, *Ufficiali,* book A, f.n.n. Cited in Pungileoni 1822, p. 56).

32. MARCH 19, 1484, URBINO

"Frate Bartolomeo alias Fracarnovale," "preite de Cavallino," pays out to Francesco di Cristoforo, syndic of the Confraternità del Corpus Domini of Urbino, 13 florins and 10 soldi for the acquisition of three bushels of wheat to donate to the poor (ACCDU, book B, 1, ff. 113v, 114v, 115r. Cited in Schmarsow 1886, p. 362, with the date of March 19, 1482; partially published in Moranti 1990, p. 220).

33. FIRST THIRD OF 1484, URBINO

"Frate Bartolomeo de la Coradina" pays 9 *bolognini* to the brotherhood of Santa Croce as alms to give to the poor on Holy Thursday (ACSCU, *Ufficiali,* book A, f.n.n. Cited in Pungileoni 1822, p. 56).

34. MAY 1, 1484, URBINO

"Frate Bartolomeo de Giovanne de la Coradina" appears first on the list of clerics having to pay their membership dues for the confraternity of Santa Croce for the second quadrimester of 1484 (ACSCU, *Ufficiali,* book A, f.n.n. Cited in Pungileoni 1822, p. 56).

35. JULY 1, 1484, URBINO

"Frate Bartolomeo de Giovanni de la Coradina" is registered first among the members of the confraternity of Santa Croce who died between July 1 and August 1 (Schmarsow 1886, p. 362, from ACCDU, *"Libro nel quale sono scripti quelli de la fraternita de Santa Cruce quali sonno morti dal 1349 (!) insino al presenti tempo,"* f. 7v).

36. 1490, URBINO

The most illustrious signor Ottaviano degli Ubaldini, having determined that the house that Fra Bartolomeo di Giovanni left to the convent of San Domenico does not yield rent sufficient to pay a preacher in accordance with the friar's will and testament, together with Antonio di Fazzino Fazzini, syndic of the convent, sells the house to Piergiovanni di Cione Landucci, citizen and merchant of Urbino, for the price of 400 florins, to be paid within three years with an annual interest of 25 florins (ANU, Quadra Vescovado, 79, ff. 4v–5r: copy of the notary Giacomo di Luca de Benis, February 22, 1496. Cited in Negroni 2004, pp. 23–24).

37. NOVEMBER 18, 1501, URBINO

The will of Bernardina, daughter of the late *signor* Piero degli Ubaldini and wife of the physician maestro Francesco d'Antonio di Guido Giordani of Urbino, is dictated *"in civitate Urbini in burgo Vaginis in quatra [* * * * *] in domo ecclesie Sancti Dominici que dicitur domus fratris Carnovalis, iuxta stratam a primo latere, magistrum Firmum [* * * * *] de [* * * * *] a secundo, monasterium Sancte Agate a 3° et alia latera"* (ANU, 111, notary Oradeo Sassi, f. 128v–129r. Cited in Negroni 2004, p. 24).

38. JUNE 10, 1506, URBINO*

The brothers and syndics of the convent of San Domenico of Urbino, deciding it advisable to sell some possessions *"pro liberatione et consequutione bonorum dicto conventui debitorum sive domus relicte dicto conventui per fratrem quondam Bartholomeum Ioannis de Coradinis olim presbiterum sive archipresbiterum plebis Sancti Casciani de Cavalino, que dettinetur per filios et heredes olim Perioannis Cioni de Landutiis de Urbino pretextu quinquaginta florenorum dictis heredibus debitorum pro melioramento et expensis factis in dicta domo per dictos filios et heredes dicti olim Perioannis, videlicet pro ressiduo, iuxta quandam extimationem alias factam de dicta domo, ad effectum concordie habende per dictos fratres cum dictis heredibus, cum quibus litigatum fuit pro consequutione dicte domus sive pretii, et quamdam*

concordiam seu tractatum concordie inter dictos fratres et cinves deputatos et ellectos ad id et filios et heredes predictos et dominam Martiam matrem," sell a plot of land with a house situated in Castelboccione to Giambattista and Girolamo, sons of the late Pietro Vagnarelli of Urbino, for the price of 42 florins of old currency (ANU, 169, notary Lorenzo Spaccioli, f. 544*r–v*. I thank Vincenzo Mosconi for bringing this document to my attention).

39. JANUARY 23, 1520, URBINO

The Preaching friars of San Domenico, at a meeting of the chapter in the sacristy, having obtained permission from Superior General of the order, Fra Tommaso de Vio, on October 17, 1510, sell to Bernardino, son of Baldo the goldsmith, for the price of 520 florins, a house in the Posterula quarter in the *contrada* of Pozzo Nuovo, near the public street, the possessions of the monastery of Sant'Agata, the possessions of Giacomo Biachini, and the possessions of the heirs of Agostino Ciarlini, and today the possessions of Giacomo Ciavaterii.

This house was left to the convent "*per bone memorie fratrem Bartolomeum quondam Iohannis de Coradinis ordinis predicatorum* [added between the lines in another hand: *alias fra Carnuale] in suo ultimo et solemni testamento amore Dei et pro salute anime sue hac conditione et pacto, quod dicta domus non possit vendi aliquo tempore nec alienari nisi modo infrascripto, videlicet quod dicta domus deberet locari ad pensionem et quod pensio ipsius deberet per illustrem dominum Octavianum de Ubaldinis expendi et dispensari in salario et mercede alicuius dotti seu peritissimi viri magistri in sacra theologia dicti ordini predicatorum, qui haberet stare et morari in dicto conventu Sancti Dominici Urbinati ad predicandum in dicta ecclesia Sancti Dominici singulis annis, aut singulo tertio anno si salarium sive pensio anualis dicte domus non esset tanti quod supeteret pro salario dicti magistri elligendi pro singulo anno, et prout videretur melius prefato illustri domino donec ipse illustris dominus viveret, post vero eius mortem voluit dictam ellectionem et dispensationem fieri per quatuor cives dicte civitatis de dignioribus qui habeant sepulturas eorum in dicta ecclesia Sancti Dominici, et quod si videbitur aliquo tempore prefato illustri domino*

seu, post eius mortem, dictis quatuor civibus, elligendis ut supra per fratres dicti loci, utilius esse dictam domum alienari, reliquit et voluit quod pretium ipsius domus converteretur in rebus stabilibus utilioribus ad dictum effectum pro obtinendo dicto magistro predicatore in dicto conventu ad predicandum, alias et aliter et alio modo ex tunc alienari promovit, licet eam perpetuo stare ad dictum effectum voluit" (ANU, 235, notary Federico Guiducci, ff. 364*r–*361*r*. Cited in Negroni 2004).

40. FEBRUARY 23 AND 26, 1584, URBINO

The Council of Forty of the Commune of Urbino elects four deputies to take action, with the help of the duke, against the friars of San Domenico, to make the latter provide the city with an orator who will preach in their church every year or at least every three years in accordance with the will and testament of "*fratris Bartholomei alias fra Carnevale*" (Biblioteca Universitaria di Urbino, *Fondo comunale di Urbino*, Consigli comunali dei Quaranta, III, ff. 225*r*, 226*r–v*. Partially published in Lazzari 1797, p. 30).

DOCUMENTS IN THE BARBERINI ARCHIVES

Livia Carloni

WHAT WE KNOW thus far of the famous Barberini Panels comes from reliable, but not contemporary, sources. They all recount how, by order of Cardinal Antonio Barberini the Younger, nephew of Pope Urban VIII, the celebrated altarpiece by Fra Carnevale was taken from the church of Santa Maria della Bella in Urbino, annexed to a fifteenth-century hospital run by a confraternity of *Disciplinati*. Cardinal Antonio's assignment there as papal legate began in the summer of 1631; it was supposed to last until the beginning of 1633, but, in fact, ended that October. It was during this period that the confiscation would have taken place. In the documents transcribed below, the panels are not specifically identified by subject matter or by function but are, instead, listed as "perspectives"— thereby associating them with the kind of painting that was frequently hung over a door or window. As such, they appear in the first inventory of Antonio Barberini's collection in Rome, that of April 1644 (see Lavin 1975, p. 158 nos. 13–14; BAV Arch. Barb. Indic II, b. 2439). Eighteenth- and nineteenth-century sources (including early guidebooks to Urbino), ranging from Pungileoni to Lazzari and Lancisi-Origo, all make reference to the events surrounding the transfer of these pictures to Rome, as contained in the record of a pastoral visit of Bishop Ascanio Maffei (preserved in the Archivio Arcivescovile in Urbino). Dated July 7, 1657, this record was published by Baldelli in his 1977 monograph on Claudio Ridolfi, who, at the expense of Cardinal Antonio, painted a *Nativity of the Virgin* for the high altar of the church of Santa Maria della Bella to replace what had been removed by the papal legate (see Doc. 5 below). (Following the Napoleonic requisitions of 1811, Ridolfi's painting was moved to Groppello d'Adda in Lombardy.) Taken as a whole, the other reports of pastoral visits that survive in Urbino are not very informative (and here I want to thank Don Negroni for his kind assistance). No less brief and disappointing are those preserved in the Archivio Segreto at the Vatican (the *Sacrae Congregationis Concilii Relationes,* Urbin. Fasc. 839A, with A. Maffei's visit on June 8, 1648 [f. 510r.], or that in fasc. 839B., and others in fasc. 41). The report of the pastoral visit of Bishop Maffei in 1657 is the only one that recounts the event in any detail, and it insists that Ridolfi's painting, a gift from the cardinal, was a dignified replacement for the older altarpiece removed by the aforementioned Cardinal Antonio. These seventeenth-century documents are important because they confirm that the Barberini Panels did, indeed, come from the church of Santa Maria della Bella

and that they are by Fra Carnevale. Vasari, who was in Urbino in 1548, noted that Fra Carnevale was Bramante's master, but it is from documents first published by Lazzari in *Antichità picene* in 1797 that Fra Carnevale is documented as having painted the altarpiece for the high altar of Santa Maria della Bella for the Confraternità dei Disciplinati in 1466–67.

It is clear that in taking the panels the young Antonio, perhaps advised by someone older and more knowledgeable than himself, was inspired by Vasari's mention of the paintings, but the notice that he took the paintings has entered the literature rather uncritically, without proper verification or contextualization. Thus, it is of some interest that there exists confirmation of this meager evidence and incontrovertible proof that (unlike Fra Carnevale's painted alcove; fig. 41, p. 117) the Barberini Panels had not been left in the Palazzo Ducale by Vittoria della Rovere, who brought her inheritance of movable paintings to Florence in 1631. This confirmation is in the form of the papal chirograph signed by Urban VIII on January 17, 1632 (Doc. 3), in which he conceded to his nephew Antonio everything the cardinal had removed from the palace, amounting to forty-one paintings (this document, although often ignored or incorrectly cited, was already known by Oskar Pollak in 1928). These consisted of twenty-nine large pictures—the series of *Famous Men* that decorated the walls of the *studiolo* on the piano nobile (fourteen are now in the Louvre, Paris, and fourteen have been restored to the Palazzo Ducale in Urbino) and probably the *Portrait of Federigo and Guidobaldo* (now also in the Palazzo Ducale, Urbino). There were also twelve smaller paintings from the Tempietto delle Muse on the ground floor of the palace (seven Muses and Apollo, now in the Galleria Corsini, Florence, and two Muses and two female divinities, possibly Pallas and Venus, that are missing: see Lavin 1975, p. 173, nos. 401–8, p. 161, no. 53, p. 174, nos. 429–51, respectively).

Conversely, a "perspective" panel— *"anthica ma bella"* ("old but lovely")—that was ascribed to Fra Carnevale in the 1599 inventory of the palace must, instead, have been sent to Florence in 1631 with Vittoria's inheritance. Perhaps the panel can be identified with the painting in the Walters Art Museum, Baltimore, of an ideal city (see Sangiorgi 1976, p. 63, nos. 1, 27). Antonio must have found the Palazzo Ducale essentially emptied of the treasures he had thought to find there, and thus turned to the old and valuable furnishings, detaching paintings from the walls or from their marble surrounds without any feeling for the con-

text he was destroying. The same logic, driven by the collector's impulse, must also have dictated the dismembering of the original structure of which the Barberini Panels were a part, as can be seen from the traces along the top of each panel of an elaborate frame with arches, perhaps disguised as early as the seventeenth century.

Those who have consulted Antonio Barberini's personal account books seem to have forgotten that in 1564, at the behest of Vittoria Farnese, the wife of Guidobaldo II della Rovere, the old hospital of Santa Maria della Bella was renovated and then occupied by a group of nuns, known as the Convertite del Gesù and later as the Convertite di Santa Maria della Bella, or della Maddalena. It is this fact that enables us to connect a further notice with the Barberini Panels. On September 16 and October 1, 1632, a payment of 77.30 scudi was made, via a complicated path, to Mons. Emilio Santorio, Archbishop of Urbino, for the execution of a painting, complete with its frame, for the high altar of the Convertite (Docs. 1, 2). This is evidently the payment for Claudio Ridolfi's picture of the *Nativity of the Virgin* for Santa Maria della Bella rather than an offering to the nuns, such as occurs in the same volumes to the Franciscan convent of Santa Chiara (an institution very important to the dukes of Urbino and to which they had perhaps left the obligation of a pious bequest). It is also the only donation Antonio personally made to a church in Urbino; the other expenses in the account book have to do with his trip to and from the city. The payments do not specify the subject of the painting, which must have been selected by Santorio or the nuns themselves. Viewed in this light, we are bound to say that the subject chosen may have nothing to do with the *Birth of the Virgin* in the Metropolitan Museum, as its Marian theme was not even noted in the 1644 Barberini inventory. Thus, it is possible that the subject of the original, fifteenth-century altarpiece was not, in fact, the *Birth of the Virgin,* although it most likely did treat a Marian theme. The Biblioteca Apostolica Vaticana offers another bit of very interesting documentary evidence in the form of a letter written by Santorio to Antonio, *"mio Padrone colendissimo,"* on July 30, 1632 (Doc. 4), just a few months before the payment for Ridolfi's picture and that seems to explain the motivation for the execution of the new altarpiece. There can be little doubt that the person in question was the papal legate, the political authority in Urbino through 1632 (this letter is preserved in Barb. Lat. 8927, which is erroneously indexed as containing letters only to Carlo Taddeo and Francesco Barberini). The letter expressly discusses the

prospettive sent to Rome by mule, packed in two chests. The delivery was made somewhat furtively, but with an ostentatious display of servility by the elderly archbishop, who was not himself from Urbino and owed his career to the Barberini: they had transferred him from Caserta to Urbino in 1623, when the question of the succession of the duchy first arose, following the death of its hereditary prince.

The fact that the Barberini Panels were sent by the archbishop directly to the cardinal legate, his administrative rather than religious superior (although Cardinal Antonio was also one of the papal nephews), seems to leave no doubt that these pictures came from an ecclesiastical setting in the city of Urbino, and that the church was then quickly compensated with another altarpiece a few months later. Clearly, Antonio personally ordered the confiscation of the works of art, with the complicity of the archbishop, and followed this almost immediately by restitution in the form of the commission for another painting. Despite the fact that the letter is rather vague about the "perspectives," which were sent as two separate and distinct objects, the documents support both the traditional hypothesis that the Barberini Panels came from Santa Maria della Bella and the identification of the artist as Fra Carnevale.

Although it now seems certain that these paintings were from that church, I would like, nonetheless, to suggest, very tentatively, an alternative to the idea that they were part of a complicated altarpiece—a hypothesis that, in truth, has never resulted in a fully credible reconstruction. This suggestion is based on a reference found in the reports of two pastoral visits made before 1631 (Visito O. Accoramboni, on November 26, 1622 [f. 36], and Visita G. Ferrerio, on May 14, 1608 [f. 185], in the AAV). These two notices mention an *armadio,* or reliquary cupboard, placed *"in cornu evangelii"*—to the left when facing the high altar. This *armadio,* of obvious importance for the cult, was protected with a green or red curtain. I am perfectly aware of the danger of making too much of this archival notice, but it is worth remarking that in both Barberini Panels the light falls from the left. Should further documentary evidence about this cupboard come to light, it might just prove that the panels have a close analogy with the celebrated series of panels, dated 1473, in the Galleria Nazionale dell'Umbria in Perugia, which framed some sort of a niche.

The following register thus offers useful evidence—some of it published and some not—relating to the removal of works of art from Urbino by Cardinal Antonio Barberini the Younger during the time that he was papal legate to the former Della Rovere states, then under the control of the papacy. More precisely, they document the choices the cardinal made during, or as a result of, his stay in Urbino from the summer of 1631 through October of the same year. If a document transcribed here has already been published,

the relevant publication is cited in parentheses; however, each document has been checked against the original. In transcribing the unpublished documents, words indicated by contraction marks have been spelled out completely, while abbreviated words have been left as they appear in the manuscript.

Abbreviations:

AAV Archivio Arcivescovile di Urbino
ASR Archivio di Stato di Roma
BAV Biblioteca Apostolica Vaticana

Document 1 1632

"Detto Siri / piacciale pagare à Francesco e Gio. Bernardino / Butillio cento due e 30 moneta per altresì / sborsati à loro conto dal Signore Gio. Rossi D'Urbino / al Signore Alessandro Marinucci il quale ne há pagato scud / 77.30 à mons. Arciv. D'Urbino per l'ornamento / di un quadro, che stà nell'altare maggiore della / Chiesa delle Monache Convertite d'Urbino, e scudi 25 pagati all'Abbadessa di Santa Chiara / di detto luogo per elemosina di nostro ordine che con ricevuta.
Di Palazzo li 16 settembre 1632–scudi 102,30 /"
(BAV, Archivio Barberini. Computisteria, vol. 232. Registro de mandati dell'Eminentissimo Cardinale Antonio Barberini. B. XII [1632–1635], f. 18r)

Document 2 1632

"[. . .] e à di detto [October 1] scudi 102 e 30, moneta pagati / à Butelli per tanti sborsati à loro conto Giovanni Rossi / d'Urbino al Signor Alessandro Marinucci per tanti / che hà pagati a Mons. Arciv. di detta Città / in scudi 77.30 per un ornamento di un quadro fatto / per le Monache Convertite di detto luogo e scudi / 25 pagati alle Monache di Santa Chiara per / elemosina conforme alle Giustificazioni / mandate - scudi 102,30 /"
(BAV, Archivio Barberini. Computisteria, vol. 241. Entrata e uscita B. X. Note in the accounts of the Signori Siri—from January 1632, f. 7v)

Document 3 January 17, 1632

"Monsignore Durazzo nostro Tesoriere Generale. Essendo stati ritrovati quando fu preso il possesso in nome / della nostra Camera degli Stati ad essa a Santa Sede Apostolica devoluti et incorporati per la morte di francesco Maria / Montefeltro della Rovere ultimo duca di Urbino nel Palazzo di detta Città di Urbino in alcuni stantiolini / d'esso l'effigie de' dottori sacri e profani, doratori, e di poeti, e dodeci piccoli con l'effigie delle / muse et altro che erano in detti stantiolini foderati de taole diverse pitture fatte nelle medesime / taole che erano affisse et inchoate nelli muri di detti stantiolini In pezzi n° 41 cioè 29 grandi / con l'effigie delle prenominate persone, quali tutte d'ordine / del Reverendissimo Cardinale Antonio Barberini nostro / nepote legato in detto Stato sono stati levati li detti stantiolini, e mandati a Rome ad effetto / che da noi se ne disponesse secondo la nostra volontà. Volendo noi disporre delle dette pitture / approviamo primieramente l'ordine dato dal detto Reverendissimo Cardinale Antonio di levare et haver poi

levato dalle predette stanze le dette Tavolee pitture mandate a Roma, e poi con questo chirografo ne facciamo a detto Reverendissimo Cardinale Antonio, per se e suoi heredi donatione libera perpetua et irrevocable etc.
Data nel nostro Palazzo Apostolico in Vaticano li 17 gennaio 1632
Urbano Papa VIII"
(ASR, Camerale I. Chirografi reg. 159, v.VII [1630–1632], f. 229–230; see Pollak 1928, reg. 967).

Document 4 July 30, 1632

"Eminentissimo et Reverendissimo Signor mio Padrone colendissimo / Con l'occasione che mi si rappresentò / di un mulettiere di quà, che / partì a cotesta volta Martedì passato di questa settimana / invai a Vostra Eminenza le prospettive rinchiuse in due casse / ove furono accommodate con diligenza, giovandomi di / credere. Che siano per giongerle all'arrivo della presente, / et Vostra Eminenza le dovrà ricevere ben condition ate. / Io riputarò à mia particolare fortuna, di haver conseguito in / ciò quel che hò preteso, che è l'intiero gusto di lei, desì / derando che ella si degni di continaur à favorir la / mia humilissima servitù con suoi commodi in orni nova occasione. / Si come me la supplico et qui himilissimamente me l'inchino, et mi / raccomando sempre nella sua benignissima gratia. Urbino 30 luglio / 1632.
Di Vostra Eminenza Humilissimo divotissimo et obligatissimo Servitore, P. Emil. Arciv. D'Urbino"
(BAV, Barb. Lat. 8927 [letters of P. E. Sartorio, Archbishop of Urbino], f. 102)

Document 5 July 7, 1657

"Altare Maius invenit. Decore excultum, in quo perspicuous pulcherrima tabula Vernonensis sepius nominati, ortum Deiparae Virginia exprimens; tam pictura quam ornatus ligneus circa eam in¹ pia largitione Eminentissimi Cardinalis Antonii Barberini emanatio, qui in possessione huiusce status, sublata quadam antiqua licet Formosa specula, haec moderna pictura formosior, tam in magnitudine quam in ornate aureo finitam Ecclesiam hanc non parum decorat"
(AAV, Visite pastorali. Visite mons. A. Maffei, vol. 1, fasc. 4 [1656–1657], f. 174; see Baldelli 1977, pp. 146–47 n. 8).

Technical Essays

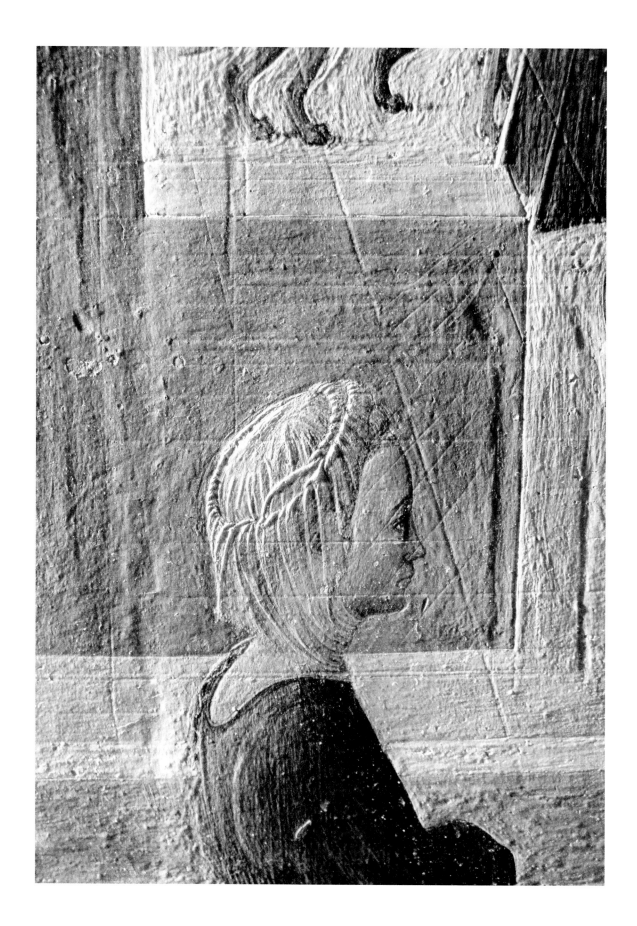

Roberto Bellucci and Cecilia Frosinini

OBSERVATIONS ON THE TECHNIQUE AND ARTISTIC CULTURE OF FRA CARNEVALE

"Ma il modo di ridurre l'arte a perfectione s'ha da guadagnare co' diligenza, con studio e con assiduità . . . imparando prima il contorno de la superficie, come elementi de la pittura, et ancho le connessioni de la superficie." (LEON BATTISTA ALBERTI)

IN ATTEMPTING A HISTORICAL RECONSTRUCTION of the oeuvre of an artist, one of the most difficult tasks resides in the discussion of his technique, and when the period under examination is the fifteenth century, all too often the social context in which the transmission of technical knowledge occurred is not sufficiently taken into account. We are still too heavily dependent on a Vasarian ideology, with its notions of affiliations and schools based on sixteenth-century practice, while discussion of earlier periods was premised largely on imagination.[1]

At least in Florence there are rich archival sources and a long tradition of historical accounts available for study, but in the case of Fra Carnevale the situation is even more complex, for we are dealing with a non-Florentine artist. In addition, we were faced with the tricky matter of assigning a name to a body of works, but with the recent discovery of new, definitive documents, we are able to examine the historical evidence alongside the works themselves.[2]

For now, the study of Fra Carnevale begins with the visual evidence of a handful of works about whose attribution a consensus now exists, although their relative chronology remains a matter of debate. Such is the case with the fragmentary Franciscan polyptych (cat. 41 A–D), which Andrea De Marchi argues is the earliest of the master's post-Florentine paintings. In it Fra Carnevale reveals himself as a fully developed artist with a fine pictorial technique that unites a traditional approach, seemingly derived from an initial apprenticeship in the Marches, with other innovative elements that are more Renaissance in character. For example, the absence of verdaccio as a ground for flesh tones suggests that Fra Carnevale employed a technique distinct from the traditionally Florentine one, as seen in the work of Filippo Lippi.[3]

The question of the use of verdaccio (described by Cennino Cennini, chap. LXVII) as a base for flesh tones is a more delicate one than is generally thought. We are so accustomed to regarding Cennini's treatise as a reliable reflection of Florentine practice in the fourteenth and fifteenth centuries that we have overlooked its true significance, accepting the equation of verdaccio with flesh tones as though it were fact. In reality, a careful reading of Cennini reveals that he was negotiating an equivocal territory at a time when there were a variety of traditions, among which he selected one, presenting it as if it were the

1.
Fra Carnevale,
The Birth of the Virgin (detail), viewed in raking light, showing incisions.
The Metropolitan Museum of Art, New York

norm—an approved text for the guild of the Arte dei Medici e Speziali—with a view to prohibiting newer tendencies.[4] The truth is that even Giotto's followers employed diverse working methods. For example, despite the fact that Cennini refers to Giotto, proclaiming him as the master in the use of verdaccio, in the Giottesque crucifix in the church of San Felice in Florence the flesh tones are painted a pale ocher,[5] with no verdaccio base. Later—although not only—Florentine painting attests to the principal use of a green preparation, perhaps of Byzantine origin. One possible explanation is that this occurred with the prevalence, introduced by Cimabue, of large-scale crucifixes which attempted to represent the flesh of the dead Christ naturalistically—an effect much enhanced by the use of green. Although Cennini displays some difficulty in advancing his argument and indicates alternatives that he is quick to condemn ("this is a method of those who know little about the profession"), he also ascribes to Giotto what he considers the best technique for employing green in the flesh tones: "But you follow this method . . . for Giotto, the great master, followed it."[6]

As far as is known, in the early Quattrocento only Masolino did not employ verdaccio,[7] preferring instead a mixture of white (biacca), vermilion or cinnabar, and ocher, using terra verde only for shadows. This is certainly a non-Florentine technique that probably reflects Masolino's training away from Florence (or by a non-Florentine),[8] although this does not mean that it occurred outside Italy; the fifteenth-century polyptych in the cathedral of Monza[9] might suggest Lombardy as a possibility. Another hypothesis worth pursuing involves Gentile da Fabriano: a recent, careful analysis of his pictorial technique[10] (with special attention to the flesh tones) enables us to conclude—at least pending research on his entire corpus—that he employed a very pale base over which he painted successive transparent layers of pink-tinted colors, with shadowed areas tending toward warm brown tones rather than cool greens. This is a technique quite similar to that of Fra Carnevale.

It is well known that artistic development transpired through the transmission of a craft from master to pupil, as befitted an artisanal society.[11] This may seem an obvious statement, but it must be repeated in order to avoid reconstructing such apprenticeships according to modern notions. With regard to Bartolomeo di Giovanni Corradini (later Fra Carnevale), a newly discovered document sheds light on the early phase of the artist's career. The Urbino archives contain a record of Corradini collecting money owed to the painter Antonio Alberti da Ferrara,[12] and although the payment is not dated, we may assume that this took place in 1436. Apart from its relationship to other documents in the volume containing this record, 1436 is the year inscribed on Antonio Alberti's triptych (Galleria Nazionale delle Marche, Urbino), and the name inscribed on the altarpiece—Don Sperandeo—is that of the individual on whose account the above-mentioned payment was made.

Among the few certain facts in the life of Bartolomeo Corradini is that, beginning in 1445, he spent time in the Florentine workshop of Filippo Lippi. That he joined Lippi as a trained artist seems evident from the language of the Florentine documents, which refer to him as *dipintore*, and from the sort of position he assumed: even if we only judge from the few surviving records, theirs appears to have been a relationship of near equals—of master and young colleague—rather than one in which Corradini functioned in the subordinate role of *garzone*, or salaried employee.

The period that Fra Carnevale spent with Filippo Lippi thus seems to have been one of true study, as codified by statutory regulations: he was financially dependent on his teacher, even for the arrangements to receive his belongings from Urbino and for acquiring clothing,[13] as documented in other cases of this kind—for example, that of Neri di Bicci and Cosimo Rosselli.[14] Moreover, it is recorded specifically that Fra Carnevale "sta cho'llui" ("is with him"), which defines an association within Lippi's workshop rather than an episodic or external one.

Many other Marchigian artists passed through Lippi's workshop in these years,[15] yet we do not know whether this was due to some special relationship between the former Carmelite friar and the Marches,[16] or through word of mouth within that milieu after an initial, fortuitous encounter with one such painter.[17] We should not overlook the fact that Filippo Lippi enjoyed extraordinary prestige in Italy: in the words of an agent of Ludovico il Moro, he was considered "the most singular master of his time."[18]

As noted elsewhere in this catalogue, it is likely that Fra Carnevale came to Florence to perfect his artistic training—which he may have felt to be somewhat lacking, or in any case to be provincial. Another plausible hypothesis—advanced by Matteo Ceriana[19]—is that he may have been encouraged by the court at Urbino to travel to Florence for exposure to the latest architectural practices: above all, joining a painter's workshop constituted an obligatory step in enlarging one's artistic horizons. Where else in the 1440s could one learn perspective in Florence, if not in a painter's workshop?[20] Indeed, perspective (alternatively called *perspectiva pingendi, artificialis* or *pratica*—to distinguish it from the science of vision, the so-called *perspectiva communis* or *naturalis*) developed as a science of representation, and for that reason was aimed at artists; it was not by chance that Brunelleschi presented his celebrated small perspective views of the Baptistery and the Palazzo Vecchio in Florence in pictorial form, for he considered perspective an instrument for painters.[21]

The Franciscan Polyptych: Underdrawing and Drawing from Life

Although our knowledge of the Franciscan polyptych (cat. 41 A–D) is incomplete, what is certain is that it has a traditional wood structure of the Adriatic type, with two, superimposed registers, and four lateral compartments (pl. 9, p. 342) and is constructed according to a local carpentry tradition.[22] X-radiography provides clear indications that the wood to be painted was planed down to obtain an even surface; so far, this evidence has not been found on other panels, which serves as confirmation that these come from a single ensemble.

Along the edges of the painted surface are incisions that must have delimited the area of the panel to be covered by the arched frame, which would have been applied after the painting was completed. The differences are particularly striking in the *Crucifixion* (cat. 41 B), where incisions extend halfway into the nailed hands of Christ (fig. 2–3). This curious discrepancy must indicate a change made during the execution of the work, one presumably related to the artist's decision to give greater breadth to his treatment of the subject. At the same time this peculiarity raises the age-old question of the relationship between the various craftsmen involved in the creation and execution of a polyptych. The extremely specialized nature of professions in artisanal societies in medieval Italy was

also reflected in the distinct phases of work associated with an altarpiece: painters were not necessarily involved in its design and construction (the form of the wood structure was usually determined by the carpenter),[23] and in some cases did not even gesso the panels in preparation for painting.[24] Generally, on a gold-ground painting in Florence and elsewhere in Tuscany the frame, with its arches and pinnacles, would be attached directly to the panel (an engaged frame) so that there was no need for the incised line that, in the Adriatic region, for example, would be employed to outline the framing elements for the painter: these frames were produced separately and only added when the painting was finished. The discrepancies seen in the Franciscan polyptych, which seem to indicate a change in the framing imposed by Fra Carnevale, concern only the interior space, for the remains of the original frame on the *Saint Peter* (cat. 41 c) testify that it was a Marchigian Gothic type.[25] Such alterations during the course of work have been observed fairly often, especially during restoration campaigns. Among the most well-known changes of this kind is that of Giotto's painted crucifix in Santa Maria Novella, where almost twenty centimeters of additional panel were added to accommodate the enlarged body of Christ.[26]

The Franciscan polyptych offers clear evidence of the artist's wish to display the important knowledge he gained during his Florentine sojourn: the updated architectural motifs (note the fictive marble and the *pietra serena* of the saints' niches), naturalistic description (the extraordinary and unusual marine landscape in the *Crucifixion*,[27] and the flowering shrubs behind the Baptist), and aesthetic heterodoxy were typical of artists in Lippi's milieu. To a certain extent these characteristics also coincided with local Marchigian tastes, which had always been based on dual influences—Umbrian art and the Paduan circle of Squarcione and, later, Crivelli.

2.-3.
Fra Carnevale, *The Crucifixion*, detail of Christ's hands, shown in an infrared reflectograph.
Galleria Nazionale delle Marche, Urbino

4.
Fra Carnevale, *Saint Peter*, detail.
Infrared reflectograph showing the
underdrawing of the drapery, done with
a brush. Pinacoteca di Brera, Milan

5.
Fra Carnevale, *Saint Peter*, detail.
Infrared reflectograph showing the
underdrawing of the drapery, done with
a brush. Pinacoteca di Brera, Milan

Infrared reflectography has revealed a detailed preparatory drawing (or underdrawing)[28] applied with a brush that not only precisely outlines the figures but also defines areas of shadow by building up volumes with a system of hatching (fig. 4–5).[29] The three saints (Peter, Francis and John the Baptist)[30] are drawn with a confident sense of volume and space, even though the actual space they are imagined as occupying is almost non-existent—or at any rate, extremely compressed: reduced by the foliage behind Saint John the Baptist, and scarcely hinted at in the niches with Saints Peter and Francis, the space functions more as a framing element than an architectural form. However, that the artist possessed a modern conception of space, although apparently limited in this instance by the need to respect traditional iconography, is demonstrated by his depiction of the marble dais on which the saints stand: the perspective is emphasized by Saint Francis's left foot projecting over its edge and by his toes, which are bent as if to grasp the marble (fig. 6). The concentric moldings of the arched niches are carefully modeled by the play of light and dark, as actual architecture, with the gray suggesting the characteristic Florentine *pietra serena*. In addition, there is the emphatical three-dimensionality of the saints' attributes: the studs on Saint Peter's book and his keys, and the crosses held by Saint Francis and Saint John the Baptist (fig. 7–8).

An analysis of the underdrawing of the individual figures has proved extremely informative, as it indicates careful preliminary planning. There are few variations in the final painted images, and these relate almost exclusively to adjustments in the position of the arms of the three saints (fig. 9–11) and in the head of Christ (fig. 12). Christ's halo was also modified, probably in an attempt to render a *di-sotto-in-sù* foreshortening in accordance with his higher position within the polyptych. This is further evidence of Fra Carnevale's attentiveness to the study of the human figure in space. A similar adjustment occurs in the underdrawing of the panel with Saint Peter, where infrared reflectography has revealed another molding in the niche. Infrared- and X-radiography suggest a likely repositioning during the painting phase of a passage of Saint Peter's robe, near his hands: this area appears lighter under X-ray and darker under infrared reflectography, indicating thicker layers of paint probably caused by substantial reworking.

Fra Carnevale's study of the human figure is especially evident in that of the crucified Christ, whose body is nude (fig. 13) except for the transparent loincloth that allows the anatomy to be seen. The anatomical treatment is closely analogous to that in an intriguing drawing in Stockholm (fig. 14 and fig. 33, p. 86) that has been ascribed to the Master of the Barberini Panels.[31] Christ's torso is also constructed according to a traditional tripartite division, that is Byzantine—and ultimately, classical—in origin (fig. 15), with a strong, almost caricature-like emphasis on musculature, the kneecaps, and the bowed legs (fig. 16). The strongly defined anatomy of the crucified Christ is tempered, in part, by the pictorial handling and is less overstated than in the drawing stage; however, this softer approach is probably a result of the shift from the chiaroscuro of the study to the tonal modulations of the painting. There is a close connection of the infrared images to the Stockholm sheet; this underscores the importance of analyzing underdrawings, as painting inevitably was preceded by these preparatory drawings on paper, which served as the artist's indispensable point of departure. The same approach to anatomy can be seen in the feigned figurative reliefs in the Barberini Panels (fig. 17) and in the Cagnola *Heroic*

Figure (fig. 18), while legs of the figures in the bacchic relief in the *Birth of the Virgin* are treated in the same way.

The Stockholm drawing attests to the kind of preparatory study—of which only isolated examples survive—that must have been employed in Florentine workshops in the fifteenth century, comprising as it does a virtual repertory of nude models based on anatomical observation. The process of studying poses and anatomy from life, as documented in independent drawings, was not only applied to paintings in which the iconographical subject (whether sacred or secular) required such knowledge.[32] It is a

6.
Fra Carnevale, *Saint Francis*, detail.
Pinacoteca Ambrosiana, Milan

practice that has been associated with Alberti's recommendation in the *Della pittura* (II.36): "Before dressing a man we first draw him nude, then we enfold him in draperies. So in painting the nude we first place his bones and muscles which we then cover with flesh so that it is not difficult to understand where each muscle is beneath."[33] Until now, this association with Alberti was based only on the exceptional quantity of surviving workshop drawings of nude models, and on the evidence of an ever-increasing interest in the human figure and the nude displayed in Quattrocento painting, beginning with Masaccio's truly creative and experimental *Adam and Eve* in the Brancacci Chapel. Now, however, we have an extraordinary example of this kind of exercise, based almost literally on Alberti's text, in the anatomy of the *Three Archangels* in Berlin (cat. 10): in the preparatory drawing rendered visible by infrared reflectography (fig. 19).[34] Their anatomy is so explicitly depicted that one can hardly avoid thinking of those theologians who were

7.
Fra Carnevale,
Saint Francis, detail.
Pinacoteca Ambrosiana, Milan

8.
Fra Carnevale,
Saint Peter, detail.
Pinacoteca di Brera, Milan

9.
Fra Carnevale,
Saint Francis, detail.
Infrared reflectograph.
Pinacoteca Ambrosiana, Milan

10.
Fra Carnevale,
Saint Peter, detail.
Infrared reflectograph.
Pinacoteca di Brera, Milan

11.
Fra Carnevale,
Saint John the Baptist, detail.
Infrared reflectograph.
Museo della Santa Casa, Loreto

12.
Fra Carnevale,
The Crucifixion, detail.
Infrared reflectograph,
showing changes.
Galleria Nazionale delle
Marche, Urbino

hopelessly debating the gender of angels during the Fall of Constantinople in 1453. Yet, even more than demonstrating an awareness of Alberti's text, the underdrawing by this still-anonymous painter—the Pratovecchio Master—attests to a spirit that pervaded contemporary Florentine workshops: one of diversion on the part of the artist, since, even today, the drawing can only be appreciated with the aid of reflectography. A much more functional attitude toward the pictorial construction of the human form, in the true Albertian sense, is found in the right knee of Saint Peter, which is visible beneath the saint's robe in the infrared reflectograph. As Ames-Lewis has stated: "Those studies done with a view to 'perceiving the positions of the muscles' become ever more numerous in the second half of the century, indicating that the problem assumed a determining role in the activity of an artist. Vasari affirmed that Antonio Pollai[u]olo undertook dissections to better understand the anatomy of the muscles: *He had a more modern grasp of the nude than the masters before his day, and he dissected many bodies in order to study their anatomy. He was the first to demonstrate the method of searching out the muscles, in order that they might have their due form and place in his figures.* And yet, the evidence for direct study of cadavers is not clear [in the work of Pollaiuolo]."[35] Evidence for the increasingly widespread practice of studying models from life, and subsequently clothing nude figures, appears to be demonstrated by the fact that when, in the 1470s, Piero della Francesca painted the Virtues on the triumphal chariot of Battista Sforza (on the reverse of the portrait, now in the Uffizi, Florence), he began by drawing them nude.[36] There existed also more realistic representations of anatomical peculiarities, usually reserved for emaciated or sick figures, as in Donatello's wood sculptures of *Saint John the Baptist* (Church of the Frari, Venice) and of the *Penitent Magdalene* (Museo

13.
Fra Carnevale, *The Crucifixion*, detail.
Galleria Nazionale delle Marche, Urbino

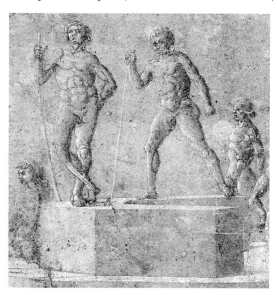

14.
Fra Carnevale, *Allegorical Scene*, detail.
Nationalmuseum, Stockholm

15.
Fra Carnevale, *The Crucifixion*, detail of
Christ's torso. Infrared reflectograph.
Galleria Nazionale delle Marche, Urbino

16.
Fra Carnevale, *The Crucifixion*,
detail of Christ's legs. Infrared reflectograph.
Galleria Nazionale delle Marche, Urbino

17.
Fra Carnevale,
The Birth of the Virgin, detail.
Infrared reflectograph.
The Metropolitan Museum
of Art, New York

18.
Fra Carnevale, *Heroic Figure Against
an Architectural Backdrop,* detail.
Infrared reflectograph.
Villa Cagnola, Gazzada (Varese)

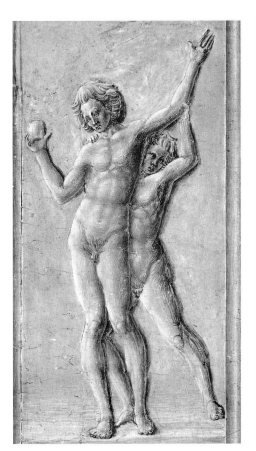

dell'Opera del Duomo, Florence), with their prominent tendons and veins, which seem to have been based on dissected cadavers, as described by Vasari. The same impression is conveyed by the arms and hands of Fra Carnevale's *Saint John the Baptist* (fig. 20), for which the influence of Donatello is perhaps the best explanation, especially now that the relationship between Lippi and Donatello in 1443, within the same workshop in which Fra Carnevale was trained,[37] has been documented. Another example is offered by the extreme attention to details in the musculature and bone structure of the legs of the Crucified Christ, where kneecaps, tibiae, fibulae, and metacarpal bones are all perfectly identifiable.

It may be Donatello's realistic portrayals that explain the expressionistic quality of the gnarled hands (fig. 21–22), arthritically deformed fingers, and portrait-like features of the *Saint Francis*, who stoops so that he can contain his height within the niche, as he looks up at the *Crucifixion*, with bovine-like eyes and half-open lips that reveal protruding teeth—characteristics certainly far removed from the customary iconography of the saint.

FRA CARNEVALE AND PERSPECTIVE

Returning to the earlier question of where one could study perspective in Florence during the 1440s, we must modify our answer, for perspective was not only part of the training

of a painter but also that of a woodworker, since intarsia masters had become the natural heirs of advances in perspective, and were designated simply as "*maestri di prospettiva*." When Benedetto Dei compiled his list of Florentine artisans about 1470,[38] he included a group of these "masters of perspective," comprising no fewer than fourteen woodworker-intarsia makers, after the painters and sculptors (he left nineteen spaces empty for later additions). Even Vasari gives pride of place to *maestri di tarsìa* for being the inheritors of Brunelleschi's legacy of perspective,[39] and in his life of Uccello he has Donatello dismissively assess the excesses of perspectival virtuosity, defining it as "only useful to men who work at the inlaying of wood, seeing that they fill their borders with chips and shavings, with spirals both round and square, and with other similar things."

The connection between the art of intarsia and architecture is clear in the context of Vasari's *Lives,* even if the Aretine biographer characteristically discriminates between theory and technique in such a way that "upward mobility is systematically superimposed on the multi-form technological culture of the Florentine workshops. . . . Wood carving and inlay thus are too often inevitably identified with the youthful phase of artists destined for greater responsibilities"[40]—as in the case of Benedetto da Maiano and Baccio d'Agnolo.

Perhaps one could hypothesize that Fra Carnevale actually did spend time in a workshop that produced intarsia, given his subsequent achievements and such works as the duke's sleeping alcove (fig. 41, p. 117) or the panel in the Cagnola Collection (cat. 44), the verso of which is a painted version of intarsia. Florentine workshops of the time often required of their members the most wide-ranging talents, and the matriculation registers of the Arte dei Legnaioli (the Woodworkers' Guild) record the names of numerous painters who joined this guild as well, doubtless in part to legally sanction their activity in an area governed by a separate corporation.[41] Thus, we find, among others, Giovanni di ser Giovanni (called Scheggia), Masaccio's brother, whom we know provided drawings for the intarsia decoration of the Sacrestia delle Messe in Florence Cathedral, where he worked alongside Agnolo di Lazzaro d'Arezzo (called Agnolo "de' Cori").[42] Other minor figures in this category include Mariotto di Cristofano[43] and Smeraldo di Giovanni, a long-term colleague of Giovanni dal Ponte.[44] Finally, in the exact years of Fra Carnevale's Florentine training in Lippi's shop, the matriculation registers of the *legnaioli* list another artisan from Urbino, for the moment completely unknown, yet whose presence not only further reinforces the Montefeltro–Florence connection but may also prove significant in establishing Fra Carnevale's biography.[45]

Suggesting that Fra Carnevale trained in a workshop engaged in the production of inlaid wood decoration could provide the link between his two areas of interest—painting and architecture—and explain the insistence on perspectival constructions in his paintings, as well as the unusual, and even obsessive, preponderance of painted architecture he chose to depict.

However, insofar as the profession of architect is concerned, there was no true *cursus studiorum*—not even a specific course of apprenticeship.[46] The architect evolved out of the Late Medieval craftsman's workshop, and well into the fifteenth century artists like Giuliano da Maiano and Michelozzo often were defined in contemporary documents in terms relating to such typical workshop members as *lastraioli* (flagstone workers) or

19.
Fra Carnevale, *The Three Archangels*, detail. Infrared reflectograph. Gemäldegalerie, Berlin

20.
Fra Carnevale, *Saint John the Baptist*, detail. Infrared reflectograph. Museo della Santa Casa, Loreto

21.
Fra Carnevale, *Saint Francis*, detail.
Infrared reflectograph.
Pinacoteca Ambrosiana, Milan

22.
Fra Carnevale, *Saint Peter*, detail.
Infrared reflectograph.
Pinacoteca di Brera, Milan

maestri di scalpello (stonecutters). Explaining Brunelleschi's work in the Palazzo dei Priori, Manetti relates that he was "summoned as architect, to design and carry out the plan,"[47] thus disclosing that the architect's task consisted of designing and construction, combining the originator of the idea with the practical function of the engineer.

From newly discovered documents[48] and a reexamination of Fra Carnevale's activities it seems possible to situate him, on the one hand, in the tradition of the medieval monk-architect (such as Fra Sisto Fiorentino and Fra Ristoro da Campi, who were involved in the building of Santa Maria Novella in Florence). On the other hand, his personality and multi-faceted skills justly place him in the context of the artist as intellectual, whereby a cultured friar or a prince with the proper instincts could pass as a *"mirabile architettore"* (as Vespasiano da Bisticci defined Federigo da Montefeltro).[49] It is possible that Fra Carnevale should also be considered in this category, as he employed his artistic culture and intellect to provide designs for architecture, sculptural decoration, stained-glass windows,[50] and paintings, and even gave general artistic advice to the ruler of Urbino.[51] As is well known, Alberti theorized about what sort of person constituted an artist: "It would please me if the painter were as learned as possible in all the liberal arts, but first of all I desire that he know geometry" (*Della pittura*, III.53).

Fra Carnevale's cultural background no doubt encompassed time spent in a *scuola dell'abaco*[52]—a secondary school with an emphasis on mathematics. He could perhaps have attended such a school in Urbino before 1445, and almost certainly in Florence, where, as noted, he frequented one of the most advanced workshops of the period and encountered an environment of keen experimentation and interest in the application of the new science of perspective, an environment dominated by Donatello, Maso di Bartolomeo, and Luca della Robbia. On his return to Urbino he could have broadened his cultural awareness, for it was then that he served his novitiate with the Dominican order, which traditionally afforded its members ample formative opportunities.[53] Fra Carnevale's knowledge of applied geometry, which one can infer from the perspectival constructions and the rendering of objects in his paintings, attests to the fact that he deeply assimilated all that he learned—an experience far removed from that of a neophyte astonished after suddenly being thrust into an intellectual climate governed by a totally foreign language.

The *Annunciation* in Washington (cat. 40) has long attracted scholarly attention because of its perspectival construction.[54] The discovery of a Strozzi provenance (albeit only dating as far back as the nineteenth century) has strengthened the hypothesis that it was executed during the artist's Florentine period: indeed, an undeniable Florentine quality pervades the work, its palette, and the porticoed structures that provide the stage for its subject, while the overall composition is clearly derived from works by Filippo Lippi. Yet, the architectural elements, which seem almost old-fashioned for Florence in the 1450s, are obviously closer to those seen in the Brancacci Chapel, although combined

with an unquestionable awareness of the art of Michelozzo (see the essay by Ceriana). This approach should be understood as a precise and deliberate reiteration or reevocation. If we also bear in mind Christiansen's emphasis in his catalogue entry on the innovative iconography of an *Annunciation* that takes place at the side of a road and the initial idea (never completed) to include a polygonal well in the center (its presence indicated by incised lines visible only with infrared reflectography [fig. 23])—indubitably suggesting a drawing from Piero della Francesca's treatise on perspective, as well as the most advanced perspectival constructions in the well-known paintings of ideal cities—what springs to mind is that Fra Carnevale was recycling the knowledge he gained in Florence and creating a new vision of geometrical perspective, devoid of Lippi's adaptations and pictorial fantasies, and restated with a theoretical purity that seems rooted in the ideal world of Piero della Francesca.[55] In any case, the *Annunciation* and the Barberini Panels share a maniacal approach to perspective rarely found in the work of other artists. The only difference is that the *Annunciation* displays less maturity; a less allusive, hidden content; and a less advanced antiquarian culture than the Barberini Panels, suggesting a fairly substantial gap both in dating and in overall refinement.

23.
Fra Carnevale, *The Annunciation* (detail), viewed in raking light, showing the wellhead placed where the angel is now.
National Gallery of Art, Washington, D.C.

Infrared reflectography and an analysis of the incised lines reveal how Fra Carnevale began with a precise and painstaking preliminary study of the architectural plan, an approach almost like that of Aristotele da Sangallo, in his perspectival stage sets, *avant la lettre* (plates 1, 2).[56] The gesso preparation bears the marks of every orthogonal and every calibration, so that each element within this dense network can be precisely constructed, from the most general to the tiniest detail: specifically, not only the portico, the squared sections of fictive marble paving, the alignment of the capitals toward a vanishing point, and the bases and cornices of the buildings, but even the depth of the imposts of the windows. This rigidly geometric construction is based on a single vanishing point, located on the right side of the doorframe leading into the garden and toward which all the lines of the architecture converge. The vanishing point itself is slightly to the left and below center with respect to the central axis of the painting (which does not appear to have been cut down). This arrangement serves to highlight the central position of the angel, which is further emphasized by the sense of *horror vacui* produced by the vase and the Virgin, which entirely fill the right side of the composition.

Although Vasari attributes this type of perspectival construction—"*disegnare per mezzo della pianta e del prospetto e per via della intersecazione*"[57]—to Brunelleschi,[58] it is, in fact, the method described by Piero della Francesca for designing complex objects and buildings ("*Da l'ochio dato nel termine posto il piano asignato degradare*").[59] This fact might, indeed, provide additional support for the hypothesis that the Strozzi *Anunciation* was an outgrowth of a relationship between Fra Carnevale and Piero della Francesca.[60]

Logic would dictate that Fra Carnevale conceived and planned out the perspective grid on paper, but if that is so he did not transfer the design summarily but drew it afresh on the gesso ground. There are no traces of a transfer—only of the construction, which takes the form of small holes pricked along the edge of the painting and calibrations marked in a variety of places, even under the body of the Virgin (fig. 24); these would then be used as points from which to extend the lines. This was to remain a typical facet

24.
Fra Carnevale, *The Annunciation*, detail.
Infrared reflectograph.
National Gallery of Art, Washington, D. C.

of the artist's working method, even in the Barberini Panels. Although the placement of the figures must have been planned, specific areas were not held in reserve. It is not easy to explain the initial inclusion of the wellhead within the perspectively arranged scene of the *Annunciation*, which was so meticulously studied; if everything were plotted out in advance, how was it possible to contemplate including an element so invasive in its dimensions that it would have precluded finding adequate space for the angel and the Virgin? It is as if the figures and, consequently, even the subject of the Annunciation were merely accessories, or even afterthoughts to fill the empty space.

THE BARBERINI PANELS AND ARCHITECTURAL SCENES WITH SMALL FIGURES

While the documentary evidence makes it clear that the Barberini panels (cat. 45 A–B) once belonged to the Santa Maria della Bella altarpiece, they continue to be extraordinarily problematic. This circumstance is probably due, in part, to our lack of a complete understanding of the variety of furnishings for churches and oratories before the uniformity introduced by the Council of Trent, but it also stems from the difficulty of deciphering the iconography without knowledge of the expectations of the patrons and the public for whom the pictures were painted.

Unfortunately, in addition to these difficulties in interpreting the images there are others arising from a technical examination of the paintings, for although such technical analyses may augment our knowledge, they do not automatically resolve our questions and often result in fewer certainties. In the case of the Barberini Panels, it is the cumulative weight of the questions touched on below rather than the decisive presence of one detail or another (none of which, in any case, allows for an alternative hypothesis) that forces us to review, in general terms, the problems connected with them. (This circumstance is not unusual, especially when radical physical alterations to the work under examination have destroyed important evidence of how it was put together.) What follows is an offering to those who will tackle these challenges in the future: an invitation to study the Barberini Panels bearing in mind technical issues (whose absence has been lamented)[61] but also giving due respect to their physical characteristics, without dismissing the accumulation of technical data as merely a passing obsession instead of a means toward arriving at a plausible reconstruction.[62]

THE PERSPECTIVAL STRUCTURE

Studying the two panels side by side, one immediately notices that the pavement in the foreground of each painting and the three steps are perfectly aligned, so as suggest a continuous space, with or without any intervening elements. Moreover, both images reveal the same perspectival construction, with the vanishing point at the edge of each panel: at the extreme right in the *Presentation of the Virgin in the Temple (?)* and the extreme left in the *Birth of the Virgin*. Likewise, the adjacent areas bear traces of a series of vertically aligned, pinpricked holes (fig. 3, p. 264), which served as guides in drawing the lines that define the perspectival construction of each composition (we shall return later to this point).

Both vanishing points are on the same horizon line (that is, they are placed at the same height)—further proof that both paintings belong to a single ensemble.

Yet, the first dissonant element arises if we imagine the paintings as the lateral panels of a diptych or triptych, since, logically, the *Birth of the Virgin* would constitute the left wing and the *Presentation of the Virgin in the Temple (?)* the right wing of an altarpiece. However, viewed in this sequence, the perspective of the panels diverges rather than converges, creating an unusually centripetal, disruptive effect (see plates 3–4). Another important factor that differentiates the two panels with regard to their perspectival construction is the division of the pavement, which, in the *Presentation of the Virgin in the Temple (?),* is composed of rectangular marble slabs as opposed to squares in the *Birth of the Virgin.* In addition, the bases of the rectangular divisions are greater than that of the squares.[63] When we consider that the vanishing point is fundamental to the creation of a perspectival composition—indeed, it is the basis of Brunelleschi's geometrical perspective—this observation becomes potentially important. According to Manetti's description of Brunelleschi's famous perspective view of the Florence Baptistery, "The painter must assume one single point from which his painting should be seen in relation to both the upper and lower limits and the lateral boundaries of the picture, so that it is not possible to err, since from every other position the appearance [of the picture] will change."[64] Alberti also insists on the need to determine the viewer's distance from the picture *before* painting begins: "Know that a painted thing can never appear truthful where there is not a definite distance for seeing it."[65] The same opinion was held by Piero della Francesca.[66]

The distance from the eye to the painting was conceived as proportional to the actual distance in nature, since it was calculated using the same theory of triangulation that provided the basis of medieval measuring techniques and the underlying principle of painting as the intersection of the visual pyramid.[67] The viewing or distance point and the vanishing point thus together determine the precise height at which the painting should be placed and its distance from the viewer (the painting being conceived as a window); the distance is determined by the projection of diagonals.[68] When we compare the perspectival construction of the Barberini Panels, we discover that each has a different distance point: a diagonal drawn through the rectangular sections of the floor results in a greater viewing distance than one drawn through the square sections of the floor in the other panel. The horizon line in both pictures is equivalent to 170 centimeters above the base line (or about three Florentine *braccia*). This constitutes an extremely important element in Alberti's theory, since he bases his entire method of construction for painters on this very point: the proportional relationship of three *braccia* (considered the average height of a man) according to which the rectangular panel to be painted must be constructed.[69] Yet, as noted—contrary to fifteenth-century principles of construction—the distance from the viewer differs for each panel: 240 centimeters (over four Florentine *braccia*) for the *Presentation in the Temple (?),* and 180 centimeters (almost exactly three *braccia*) for the *Birth of the Virgin* (see pl. 4); this disparity is not affected by the order in which the panels are viewed.

One wonders whether Fra Carnevale erred in calculating the distance point of one of the paintings (even if this seems improbable, given the painstaking perspectival and

pictorial construction), or whether he deliberately wished them to be seen from two different distances. Apart from the visual dissonance created by the square slabs in one painting and the rectangular ones in the other, the appearance of the two paintings must reflect a precise decision on the part of the artist and an acknowledgment of the consequences of a different distance point for viewing each picture, but his intention remains unclear.

Assuming that we are not dealing here with artistic license, stemming from a desire to avoid an effect of monotony and (as Christiansen suggests in his entry) to enhance the impression of Roman *maiestas* at the expense of mathematical clarity, we must assume that the two panels were conceived to be placed at the same height, but at two different distances from the viewer. We might, for example, imagine that they decorated a structure around an altar or a room in a confraternity whose walls were hung with pictures.[70] If, in addition, Fra Carnevale had experience as a master of intarsia, the Barberini Panels could represent the pictorial transposition of a decorative technique utilized for wood panels. As is evident from the recent technical examinations of the wood supports, the Barberini Panels had a perimeter framework—possibly consisting of metal bands to anchor them to a wall; that there was no batten or crosspiece was unusual for a conventional altarpiece, but reinforces the theory that they were somehow arranged against a wall: we should interpret the terms of the 1466 document, *tabule maioris altaris,* more loosely.[71]

Among the information gleaned from the careful technical examination of the paintings is that originally there was a crowning frame element with small arches, which was typical of Gothic polyptychs in the Adriatic region. Even if the panels were part of a wall decoration they might still have had such a frame, especially if they occupied a sacred space.[72] In the *Birth of the Virgin*, the incisions in this crowning section indicate traces of multi-lobed arches, but the *Presentation of the Virgin in the Temple (?)* did not have this additional internal decoration and bears signs only of simple arches. Furthermore, the incisions that define the arches do not describe a symmetrical pattern (as might be expected on the lateral panels of a triptych), but in each panel the incised lines descend slightly lower along the left edge than along the right one. These technical features have not yet been explained but appear somehow to be connected, even if we take into account that such incisions were perhaps carried out by the individuals who would have prepared the panel[73] rather than by the painter; thus, the incisions might have been present before Fra Carnevale became involved, added without consideration of his subsequent participation and ideas. In this case, he would have had to make adjustments during the final stages of execution.[74]

THE INCISED LINES

What we may unquestionably ascribe to the painter is the conception and realization of the images, achieved not only by means of the perspectival structure discussed above but by the obsessive use of incised lines. Their quantity is truly astounding in the Barberini Panels, even as compared with the Washington *Annunciation* (cat. 40), which also is characterized by a meticulous, almost excessive approach. Many of the incised lines were not even necessary for the perspectival construction (their principal function) and probably

were used by Fra Carnevale solely to elaborate his personal vision of receding space (fig. 25). What appears to be exceptional here is that Fra Carnevale drew directly on the preparatory gesso layer,[75] incising his entire scheme rather then copying only the essential elements (vanishing points and dimensions) from an earlier and separately prepared study on paper, which is what Alberti advised: "When we have an *istoria* to paint, we will first think out the method and the order to make it most beautiful; we will make our drawings and models of all the *istorie* and every one of its parts first of all; we will call our friends to give advice about it. We will force ourselves to have every part well thought out in our mind from the beginning, so that in the work we will know how each thing ought to be done and where [it is] located. In order to have the greatest fidelity we will divide our models with parallels [for example, square the drawing] so that in the public work we will be able to take from our drawings just as we draw maxims and citations from our private commentaries" (*Della pittura*, III.61).

In the *De prospectiva pingendi* Piero della Francesca also implied the necessity of extensive preliminary work, when the author assigned an infinite number of exercises to his putative pupil. This is what can be deduced from a drawing attributed to Signorelli in the Metropolitan Museum (fig. 26)[76]—evidently the preparatory study for a head that was proportionally reduced ("*proporzionalmente digradata*"). We do not know why, but Fra Carnevale skipped over this preliminary planning stage involving the spatial setting—or if he did address it, he decided to redo it totally on the final support.

The numerous incisions also disturb the quality of the painted surface (especially since, with age, they have become more visible), since the painter did not spare the areas reserved for the principal figures, as exemplified by the incised lines that cross the face of the Virgin in the *Presentation of the Virgin in the Temple (?)*. Rarely—if ever—has there been such widespread use of incisions on a painted surface, whether in fresco (where this would perhaps be more necessary in order to calibrate a larger space) or on panel: not even in the case of Masaccio's *Trinity*, where traces of direct and indirect construction of the perspective scheme (and of the figure of the Virgin) have often been noted.[77] In the *Trinity*, the signs of incisions are numerous on the left side of the painted architecture but limited on the right, where there are just enough lines to repeat those devised for and applied to the opposite side.

THE BINDER

There are further striking technical peculiarities relating to the way color is used: the handling of paint has the quality of a relief, with loaded strokes of the brush applied to describe the light on the figures. These light areas are executed in relief (plates 5–8), as if they were literal interpretations of Alberti's teachings, with the obvious intention of conveying illusionistic effects: "and that which the painter should desire above all else, is that his painted figures should appear to be in good relief.... I praise those faces which, as though carved, seem to issue out of the panel" (*Della pittura*, II.46).

Fra Carnevale's use of this expedient was surely not casual but deliberate. Indeed, the artist had to devise a precise technical strategy to achieve his desired aim: a binder that

was different from the usual one—probably composed of an oil emulsion with thixotropic properties[78]—which would allow for a traditional application of pigment in certain areas and passages in relief in others. Considering the fact that this surface relief is still perceptible today—notwithstanding aging, shrinkage, and thinning of the material— one can only imagine how much greater the effect must have been when it was newly created. Moreover, this approach yields the most minute pictorial details and requires an attentive, miniaturist's touch that is commensurate with the skill and technical prowess Fra Carnevale exhibited on this occasion. The painter was already seeking effects of this kind in the Washington *Annunciation*, where the surface exhibits a similar relief-like quality, albeit one achieved in a less virtuoso manner.

A secondary effect resulting from the type of binding medium employed is the fact that the brushstrokes are perfectly visible upon close examination of the surface of the picture under raking light. This also allows us to follow and reconstruct some phases in the execution of the painting: for example, it is clear that, contrary to what one would expect, the figures were painted first, followed by the surrounding areas and the background. The execution is quite remarkable and almost obsessively accurate in the depiction of minute details. One hypothesis is that this rich binding medium, which was particularly well suited to creating relief effects and, therefore, to filling in any surface irregularity, must have been regarded by Fra Carnevale as a way of compensating for the excessive use of incisions during the planning stage.

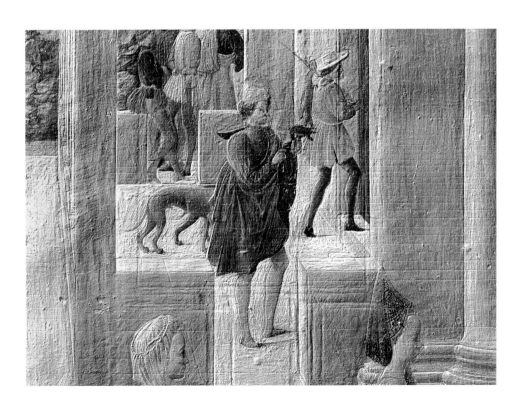

25.
Fra Carnevale, *The Birth of the Virgin* (detail), viewed in raking light, showing the incised lines of the perspective scheme.
The Metropolitan Museum of Art, New York

ARCHITECTURAL SCENES WITH SMALL FIGURES

Our continuing examination of the two pictures affirms that their aesthetic appearance (if we set aside questions of their iconography, iconology, or ultimate destination) would seem to designate them as architectural scenes with small figures—a category that occurs throughout the history of art without ever having been satisfactorily defined. Perhaps this is not only because so much painted decoration has been lost but because of our inability (as noted) to think beyond the customarily encountered types of altarpieces, altar frontals, dossals, or processional banners and standards when faced with a painting of a sacred subject or one from a religious site. Some of the most striking examples of a work of this type are the *Annunciation* by Leonardo da Vinci, the *Thebaid* now attributed to Fra Angelico (both in the Galleria degli Uffizi, Florence), or the series of small panels depicting miracles of Saint Bernardino (Galleria Nazionale dell'Umbria, Perugia), which are invariably cited as parallels to the Barberini Panels and were long believed to be part of an altarpiece. Technical and archival investigations have since shown that the latter were part of the decoration of a niche or tabernacle.[79] Would we not think we were looking at fragments of an altarpiece if we had only parts of Orcagna's revetment for one of the piers in Orsanmichele with scenes from the life of Saint Matthew (Galleria degli Uffizi, Florence),[80] or the individual figures from the Spanish paschal candlestick now in The Cloisters Collection at The Metropolitan Museum of Art?[81]

A work such as *The Healing of a Possessed Man* by Francesco d'Antonio (fig. 27)[82] perfectly illustrates the iconographic type of an architectural painting with small figures, which apparently became widespread in Florence during the 1420s, and (not by chance) especially in the circle of Masaccio. Even the Masacciesque *desco da parto* in the Gemäldegalerie, Berlin, could serve as an example of the evolution from scenes situated in an architectural setting for reasons of iconographical necessity to scenes in which the study of architecture and its inclusion in a painting become the principal subject, and, thus, where the iconography becomes a pretext for a form of cultivated *divertissement*. The subsequent popularity of painting as a form of domestic adornment favored the creation of this genre, as Vasari recounts in the life of Dello Delli (a text that actually reads like a general treatise on the birth of secular painting presented in the guise of a biography).[83] Vasari locates the origin of this type of painting in predella scenes, often referred to in the *Lives* as "*quadri di figure piccole*."[84] At a later point in the *Lives,* when writing of Bachiacca or Piero di Cosimo, he implies the presence of "*figure piccole*" as typical of works for domestic decoration, such as *spalliera* panels and paintings on furniture.

In the context of Urbino in the 1460s, however, it seems significant that Vasari should have credited Piero della Francesca with "many very beautiful pictures with little figures"painted for the duke of Urbino, although he was not able to describe them; surmising that they were lost, he attributed their destruction to chance political events:"for the most part ruined on the many occasions that state [Urbino] has been harassed by wars." Until now, scholars believed that the only surviving work of this type was the *Flagellation*,[85] but whether Vasari's statement was right or wrong, it is telling that he would have considered that Piero was behind these "*quadri di figure piccole*."[86]

26.
Luca Signorelli, *Study of a Head*, detail. The Metropolitan Museum of Art, New York

1. Procacci 1974; Panichi 1991.

2. For a discussion of the identification of Fra Carnevale and the Master of the Barberini Panels, see the essay by Daffra in this catalogue.

3. For the Florentine tradition of using verdaccio for flesh tones, see Bellucci and Frosinini 2002, pp. 32–33.

4. For a new interpretation of Cennini's treatise, see Baroni 1996, pp. 143–44 n. 30; Bellucci and Frosinini 2002, pp. 30–31; Frezzato 2003.

5. See Scudieri 1992, pp. 125, 181–84.

6. See Cennini 2003 ed., chap. lxvii–lxviii (pp. 110–17); chap. cxlvii (p. 172). A green ground for flesh tones is recommended in almost all medieval treatises: see for example, the *De arte illuminandi,* chap. xxviii, copied in the second half of the fourteenth century (see Brunello 1975, pp. 132–35); the manuscript of Jean Le Begue, dated about 1431 (Merrifield 1849 [1967 ed.], vol. 1, pp. 300–301); the Mount Athos manuscript, copied about 1730, but based on a Byzantine tradition that probably dates back to the fourteenth century (Dionysios of Fourna 1971, pp. 27–28). A treatise that illustrates a technique for creating flesh tones without a green base is the so-called Bolognese Manuscript of the first half of the fifteenth century (Guerrini and Ricci 1969, p. 156); the formula is in chapter seven, and seems to have come from Jacopo da Toledo—another demonstration that the technique is not Italian. We also find a recipe without green in the Strasbourg Manuscript from the fourteenth/fifteenth century—the principal treatise from north of the Alps (Borradaile and Borradaile 1966, pp. 57–58).

7. Bellucci and Frosinini 2002, p. 39.

8. Ibid., pp. 34–40.

9. Lucchini 1997.

10. Lucarelli 1998.

11. On the artistic development of painters in Florence, see Conti 1979b; Guidotti 1986; Padoa Rizzo 1992b; Thomas 1995, pp. 66–88; Jacobsen 2001.

12. Negroni 2002, p. 57 n. 24. See the comments by Mazzalupi in the documentary appendix in this catalogue.

13. See the documentary appendix by Di Lorenzo in this catalogue.

14. Similar arrangements are noted in Neri di Bicci's *Ricordanze* (1453–75 [1972 ed.], *ricordanza* no. 17, pp. 9–10, and *ricordanza* no. 236, p. 281) regarding the salary between master and disciple (for example, in the case of Cosimo Rosselli).

15. See the documentary appendix by Di Lorenzo.

16. In his life of Filippo Lippi, Vasari recounts that after abandoning his Carmelite habit, the painter went to the "Marca d'Ancona."

17. Giovanni Boccati is documented at the court of Cosimo, and Lippi was one of Cosimo's favorite artists: see Christiansen's essay in this catalogue.

18. Baxandall, as cited in the essay by Christiansen, note 32.

19. See the essay by Ceriana in this catalogue.

20. "From that time [following Brunelleschi's experiments], the term '*prospettiva*' entered into common usage to indicate the science of representation, sometimes accompanied by the adjectives '*pingendi*,' '*artificialis*' or '*pratica*,' to distinguish the new discipline from what had been the object of study by philosophers: the science of vision, of Greek origin (*optikè*), known in the Middle Ages as '*perspectiva communis*' or '*naturalis*.' . . . The principles of Euclidian optics had become part of the curriculum even in secondary schools—the *scuole dell'abaco*—where, as part of the application of mathematics, a '*perspectiva pratica*' was taught according to which actual objects were then 'represented' in order to arrive at a true measure of an inaccessible size" (Camerota in Camerota 2001a, pp. XV–XVI).

21. Manetti 1992 ed., pp. 55–57.

22. See the essay by Castelli and Bisacca in this catalogue.

23. Among the most famous documented cases of a wood structure pre-prepared for painting are: Pietro Lorenzetti's polyptych in the Pieve, Arezzo (Guerrini 1988); the *Sant'Agostino Altarpiece* of Piero della Francesca (Battisti 1971 [1992 ed.], vol. 2, pp. 611–12); and Masaccio's Pisa polyptych (Teuffel 1977). See also Gilbert 1977 and Bomford et al. 1989, for this division of labor, as well as Merzenich [1996] and Frosinini 1999. As for documented cases of collaboration on the architectural structure of an altarpiece, there is the example of Neri di Bicci, who commissioned from Giuliano da Maiano "1 *tavola d'altare . . . fatta e formata al'anticha . . . chome apare per uno disegnio fatto al detto Giuliano di mia mano*" (Neri di Bicci 1453–75 [1972 ed.], *ricordanza* no. 111, pp. 57–58); or Piero della Francesca, who assigned the *Misericordia Altarpiece* (Museo Civico, Sansepolcro) "*cum toto suo lignamine.*" Piero was responsible for any damages to the altarpiece that might result "*propter defectum lignaminis vel ipsius Petri*" (Banker 1995, pp. 21–35).

24. On the task of gessoing, see Thomas 1995, pp. 155–57; Bellucci and Frosinini 2002, p. 30.

25. See the essay of Bisacca and Castelli.

26. See Castelli, Parri, and Santacesaria 2001.

27. In this regard it is interesting to recall that a marine landscape also occurs in the *Birth of the Virgin* and, that, according to the *Vita Anonima*, in Rome Alberti demonstrated some exercises in perspective using what seem curiously like the Barberini Panels: they "*mostravano altissime montagne e vasti paesaggi marini intorno a grandi insenature*" (Fubini and Menci Gallorini 1972). This passage almost appears to be a description of the landscape in the Crucifixion. Fra Carnevale's marine backgrounds reveal an obvious echo of Netherlandish painting, as has been hypothesized for Antonello da Messina's *Crucifixion* (now in Bucharest) (biographical elements have also been detected in this landscape, as it seems to depict the Bay of Messina). It is also possible that the seascape in the *Crucifixion* was intended as a comment on a (lost) panel of the Madonna and Child, situated directly below in the polyptych, which perhaps represented the Madonna as the *Stella Maris.*

28. A high-definition INOA infrared scanner was used: for its various attributes see Bertani et al. 1990; Materazzi, Pezzati, and Poggi 2002; Fontana et al. 2002, pp. 113–15.

29. Fischer 1994.

30. Another lateral panel, depicting Saint Christopher, formerly in the Lanckorónski Collection, Vienna (fig. 13, p. 32), is known from a photograph in the Berenson library. It was attributed to Fra Carnevale by Luciano Bellosi, who proposed that it was part of the Franciscan polyptych (Bellosi 1990b, p. 36, fig. 30). The photograph cannot be traced, but Fiorella Gioffredi Superbi and Giovanni Pagliarulo made a microfilm available to us, which is published here. Despite the poor quality of the image, it is possible to see that the panel originally had an arched top without subdivisions into small arches. Moreover, the proportions are not compatible with those of the Franciscan polyptych—even allowing for the possiblility that it was cut down (an unlikely one, given that the saint appears intact).

31. Meller and Hokin 1982.

32. Ames-Lewis 2002.

33. Alberti 1950, p. 88, cited by Ames-Lewis 2002, p. 112.

34. The angel at the right wears a robe that the infrared videocon cannot penetrate (the pigment is possibly a copper resonate), so the underdrawing is not visible.

35. Ames-Lewis 2002, p. 112.

36. Caneva in Forlani Tempesti 1986, pp. 386–90; the reflectograph is published in Seracini 1992b.

37. See the documentary appendix by Di Lorenzo.

38. Dei 1984.

39. The life of Filippo Brunelleschi: "*né restò ancora di mostrare a quelli che lavoravono le tarsie, che è un'arte di commettere legni di colori: e tanto gli stimolò ch'e' fu cagione di buono uso e molte cose utili, ché si fece di quel magisterio et allora e poi molte cose eccellenti che hanno recato e fama et utile a Fiorenza per molti anni.*" See also the technical section of the life, in which it is said that "*Questo lavoro ebbe origine primieramente nelle prospettive. E perché tale professione consiste solo ne' disegni che siano atti a tale esercizio, pieni di casamenti e di cose che abbino i lineamenti quadrati e si possa per via di chiari e di scuri dare loro forza e rilievo, hannolo fatto sempre persone che hanno avuto più pacienza che disegno. E così s'è causato che molte opere vi si sono fatte e si sono in questa professione lavorate storie di figure, frutti et animali, che invero alcune cose sono vivissime.*"

40. Ferretti 1982, p. 462.

41. On this practice, see the contributions of Gilbert 1977, pp. 9–28; Frosinini 1989; Thomas 1995; Merzenich 1996.

42. Haines 1983; Haines 2001.

43. Frosinini 1987.

44. Frosinini 1989, pp. 139–50.

45. The person in question was a certain Bartolomeo di Cecchino "*torniaio*" (ASF, Arte dei Legnaioli, vol. 6). I would like to thank Annamaria Bernacchioni for this information.

46. Ackerman 1954; Lamberini 1994; Kimpel 1995; Baragli 1998; Galluzzi 1998.

47. Manetti 1992, p. 53.

48. See the documentary appendix by Mazzalupi. Fra

Carnevale furnished drawings for architectural elements for the cathedral of Urbino in December 1455.

49. Vespasiano da Bisticci 1970.

50. Marchese 1845, vol. 1, pp. 350–58. See the essay by Daffra.

51. See the essay by Ceriana.

52. For education during this period, see Grendler 1995, especially p. 171 nn. 6, 12; Ames-Lewis 2000; Camerota 2001 b. The importance of the *scuole dell'abaco* for the formation of artisans in Florence has been clarified in studies with a historical and economic slant: Arrighi 1965; Baxandall 1972 [1988 ed.]; Goldthwaite 1972; Zervas 1975. According to Giovanni Villani, in 1338 a very high number of Florentine youths—between 9,950 and 11,800—attended schools.

53. In 1450 Fra Carnevale is documented among the friars of San Domenico: see the documentary appendix by Mazzalupi. For his investiture in the Dominican order, see Gilbert 1984.

54. Bruschi 1996; Cleri 1996; Roccasecca 2002; Borsi 2003; Boskovits in Boskovits et al. 2003, pp. 182–86.

55. Roccasecca 2002, p. 169, established a parallel with the *De prospectiva pingendi*, chap. XXIV ("*Al quadrilatero degradato dato altri quadrilateri simili accrescere mediante le diagonali*").

56. According to Vasari, Aristotele da Sangallo gave up painting and "*si risolvé di volere che il suo esercizio fosse l'architettura e la prospettiva, facendo scene da commedie.*"

57. See Vasari's life of Brunelleschi.

58. By the sixteenth century, perspective had become a mathematical and theoretical exercise rather than a discipline critical to painters (as Brunelleschi had conceived it, according to Manetti's account, and as suggested by Brunelleschi's evident collaboration on the architecture in Masaccio's *Trinity* in Santa Maria Novella, Florence). Vasari himself does not leave in doubt his feelings on the matter ("*Ma del modo di tirarle [le linee della prospettiva], poiché ella è cosa fastidiosa e diffiicile a darsi ad intendere, non voglio io parlare altrimenti. Basta che le prospettive son belle tanto quanto elle si mostran giuste alla loro veduta e sfuggendo si allontanano dall'occhio, e quando elle son composte con variato e bello ordine di casamenti*").

59. Piero della Francesca 1984 ed., book 1, chap. XII, p. 75; Camerota 2001 c, p. 31.

60. See the essay by De Marchi, who hypothesizes contacts between Piero della Francesca and Fra Carnevale beginning in 1451, at the time of Piero's fresco in the Tempio Malatestiano, Rimini.

61. Gilbert 1993.

62. See the documentary appendix by Carloni.

63. This disproves the hypothesis of a mirror-image construction, since it would only allow for the completion of the series with a central element, and would make no sense if extended to other panels.

64. Manetti 1992, p. 56.

65. Alberti 1950 ed., 1.19, p. 38.

66. Piero della Francesca 1984 ed., book 1, chap. XII, p. 75.

67. Camerota 2001b, p. 19.

68. Piero della Francesca 1984 ed., book 1, chap. XXIV ("*Al quadrilatero degradato dato altri quadrilateri simili accrescere mediante le diagonali*"), pp. 87–88. See, above all, Field 1995.

69. Roccasecca 2002, p. 67.

70. Gilbert 1993; Gilbert 2000; Sebregondi 1991.

71. See the essay by Castelli and Bisacca.

72. Dal Poggetto (1992 b) has reiterated the claim that the panels served as decoration in the Palazzo Ducale, Urbino.

73. Thomas 1995, pp. 155–57; Bellucci and Frosinini 2002 c, pp. 56–57.

74. For other such cases, see our comments on incisions in the Franciscan polyptych.

75. Gesso preparation is extremely delicate and the secret of the success of a painting is linked to it: see Bellucci and Frosinini 2002 a, p. 44.

76. Bambach 1994, fig. 1.

77. See Danti 2002 (with earlier bibliography).

78. A thixotropic substance or fluid does not stick and maintains its form perfectly, even when applied to a vertical object.

79. Garibaldi and Mancini 2004, p. 184 (with earlier bibliography) See also the reconstruction proposed for the two scenes by Sano di Pietro of Saint Bernardino preaching: Freuler and Mallory 1991; see the contrary comments in Christiansen 1991.

80. Although Berti (1979, p. 396, no. P 1120) calls it a triptych, the painting was not necessarily an altarpiece. See, for example, the case of the Opera of Florence Cathedral, which provided for paintings for piers or walls separate from altars (Frosinini 1995).

81. Baetjer 1995, pp. 150–51.

82. See Berti and Paolucci 1990, p. 201.

83. "*Dello, dunque, essendo molto pratico e buon pittore, e massimamente come si è detto in far pitture piccole con molta grazia, per molti anni con suo molto utile et onore ad altro non attese che a lavorare e dipignere cassoni, spalliere, lettucci et altri ornamenti della maniera che si è detto di sopra, intantoché si può dire ch'ella fusse la sua principale e propria professione.*"

84. Since predelle were reserved for narrative scenes and were less rigorously subject to iconographic considerations than the main panels of altarpieces, they quickly became an area for compositional and aesthetic experimentation.

85. Castelli 1992.

86. From a technical point of view the *Flagellation* seems to have been constructed with a perimeter support, as were the Barberini Panels: see the Archivio Radiografico dell' Opificio delle Pietre Dure, Florence.

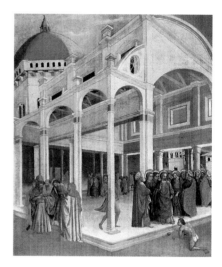

27.
Francesco d'Antonio,
The Healing of a Possessed Man.
Philadelphia Museum of Art

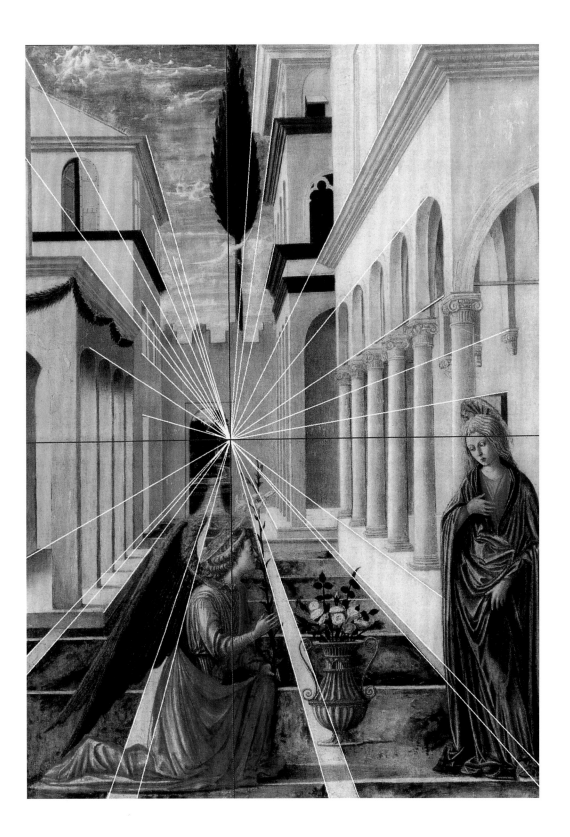

Plate 1.
Fra Carnevale, *The Annunciation*,
showing single-point perspective
construction. National Gallery of Art,
Washington, D. C.

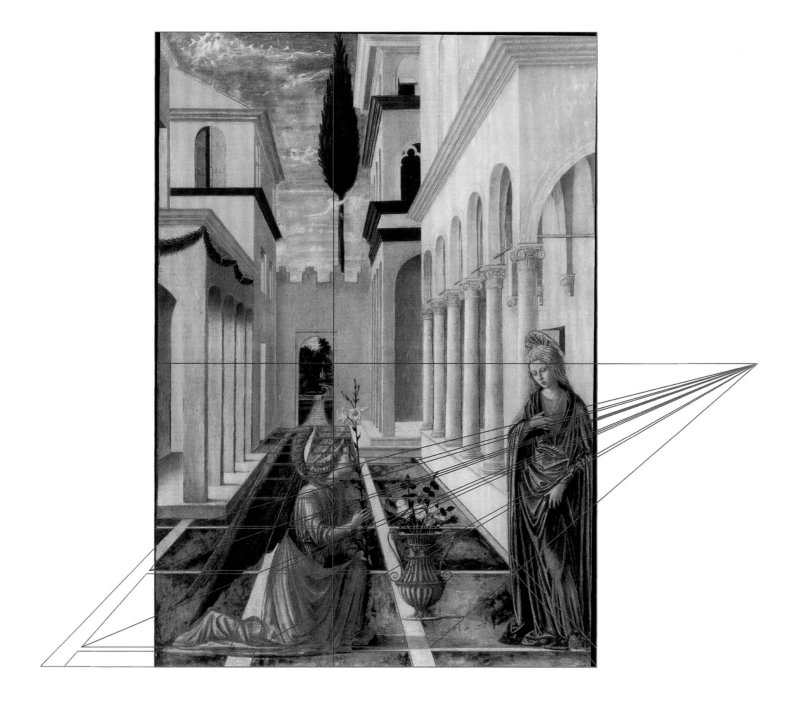

Plate 2.
Fra Carnevale, *The Annunciation*,
showing perspective construction.
National Gallery of Art, Washington, D.C.

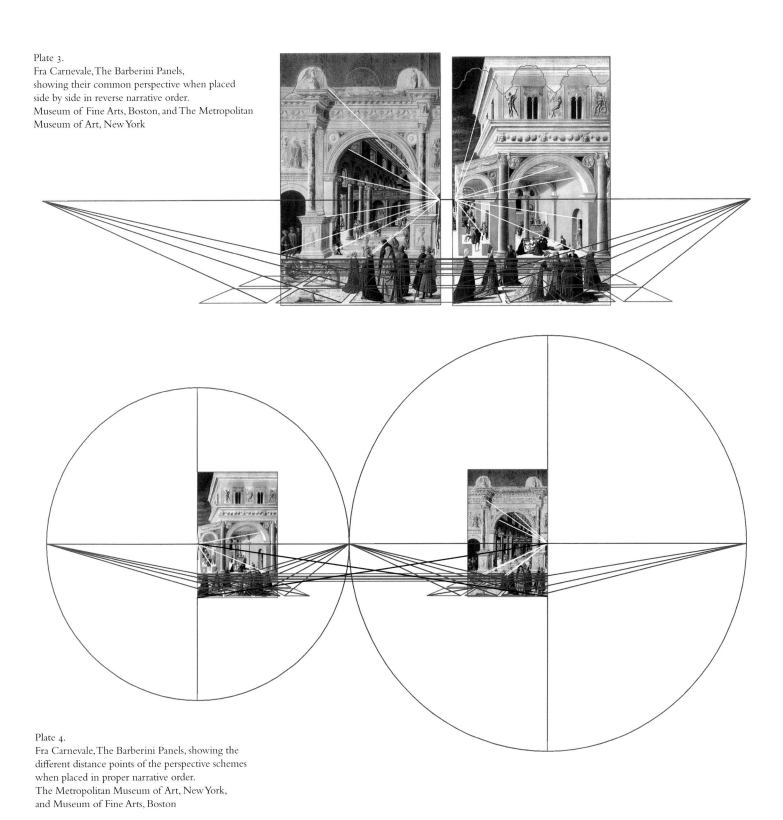

Plate 3.
Fra Carnevale, The Barberini Panels,
showing their common perspective when placed
side by side in reverse narrative order.
Museum of Fine Arts, Boston, and The Metropolitan
Museum of Art, New York

Plate 4.
Fra Carnevale, The Barberini Panels, showing the
different distance points of the perspective schemes
when placed in proper narrative order.
The Metropolitan Museum of Art, New York,
and Museum of Fine Arts, Boston

Plate 5.
Fra Carnevale, *The Birth of the Virgin* (detail),
showing part of a capital viewed in raking light.
The Metropolitan Museum of Art, New York

Plate 6.
Fra Carnevale, *The Birth of the Virgin* (detail),
showing a female figure viewed in raking light.
The Metropolitan Museum of Art, New York

Plate 7.
Fra Carnevale, *The Birth of the Virgin* (detail), showing an architectural frieze viewed in raking light.
The Metropolitan Museum of Art, New York

Plate 8.
Fra Carnevale, *The Birth of the Virgin* (detail), showing an inner chamber viewed in raking light.
The Metropolitan Museum of Art, New York

Plate 9.
Reconstruction of
the Franciscan polyptych
(cat. 41 A–D)

Plate 10.
Fra Carnevale,
Saint Peter, X-radiograph.
Pinacoteca di Brera,
Milan

Plate 11.
Fra Carnevale,
Saint Francis, X-radiograph.
Pinacoteca Ambrosiana, Milan

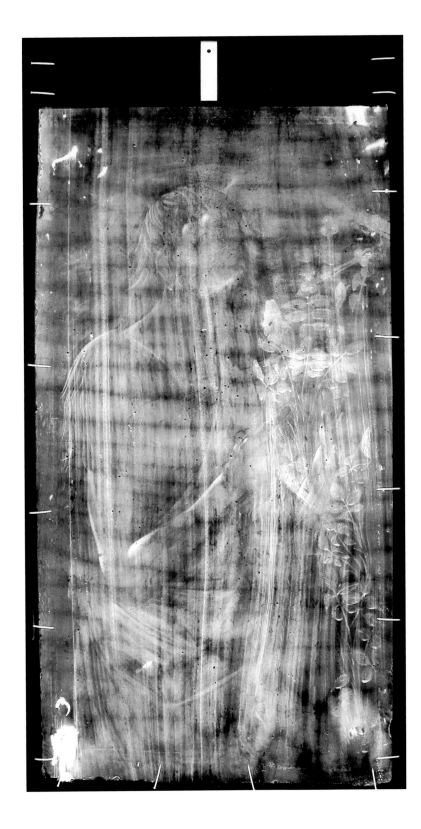

Plate 12.
Fra Carnevale,
Saint John the Baptist, X-radiograph.
Museo della Santa Casa, Loreto

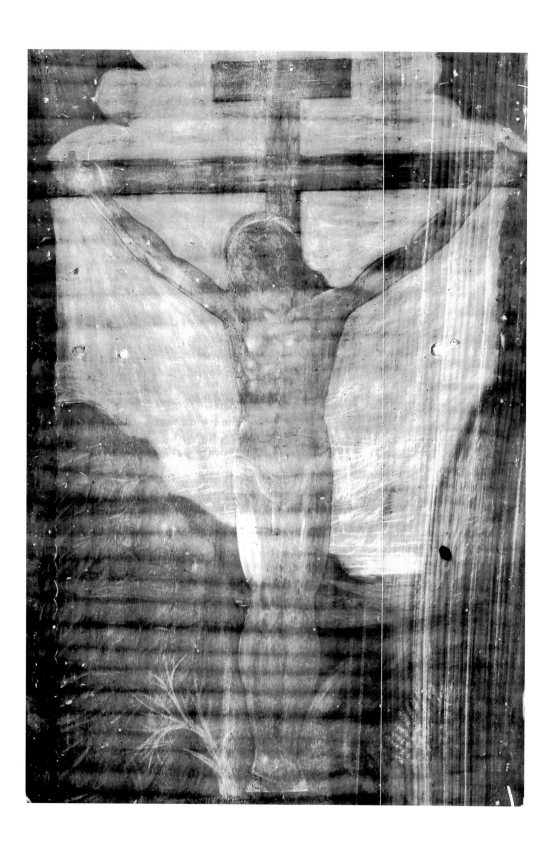

Plate 13.
Fra Carnevale, *The Crucifixion*,
X-radiograph. Galleria Nazionale
delle Marche, Urbino

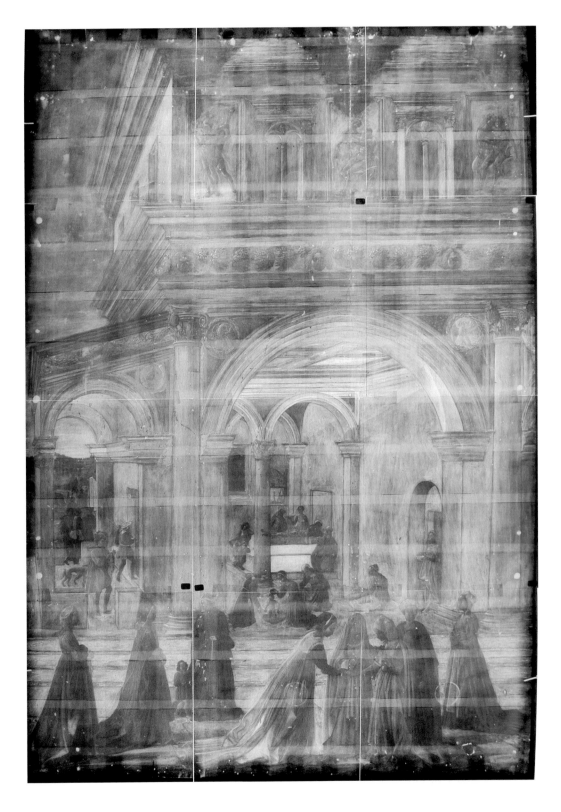

Plate 14.
Fra Carnevale,
The Birth of the Virgin, X-radiograph.
The Metropolitan Museum
of Art, New York

Plate 15.
Fra Carnevale,
The Presentation of the Virgin in the Temple (?),
X-radiograph. Museum of Fine Arts, Boston

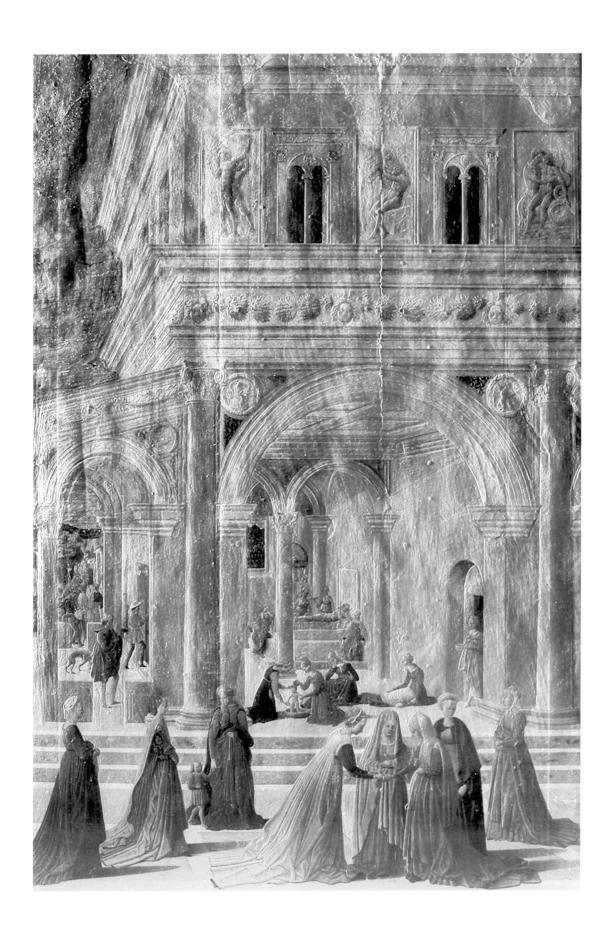

Ciro Castelli and George Bisacca

CARPENTRY AND PANEL CONSTRUCTION

This exhibition centering on Fra Carnevale, planned and organized by the Pinacoteca di Brera and The Metropolitan Museum of Art, has provided an opportunity to perform technical examinations on many paintings by the artist in various international collections and to conduct further research on a number of them.[1] In general, the new information that results from this type of exploration of works of art serves to clarify the cultural and technical evolution of various forms and working methods that have developed over the centuries, often between different cultural centers, and contributes to the body of knowledge available to all who study and care for artistic patrimony. Deeper knowledge of materials and fabrication techniques, and cooperation among art historians and conservators, have led to a heightened awareness of procedures and ultimately to better and more accurate restoration treatments, avoiding the often overly invasive interventions of the past. If, as Cesare Brandi wrote, it is the materials and not the image that is the object of any restoration, then it follows that the less we manipulate the materials, the more we guarantee a better state of preservation over time. In this case our observations were directed toward the study not only of the materials and techniques but also of the possible relationship between the painted panels, which often originally formed parts of a single nucleus that was later disassembled. Such occasions, aside from enriching our technical and professional knowledge, provide precious opportunities to study and verify the regional differences in the design, planning, and construction of Italian panel paintings. Comparing the different construction methods that existed among the major medieval and Renaissance cultural centers not only allows us to understand the level of workshop organization *in loco* but it can also suggest avenues of research regarding the movements of artists within the various territories. The carpentry of panels that functioned as supports for paintings in the twelfth through the fifteenth century might seem, in a cursory examination, not to be particularly sophisticated technically nor to represent refined methods of preparation and assembly. In fact, the first impression one has is that these works were of a simple and basic construction, made up of one or more boards joined, reinforced, and held together by one or more crosspieces, depending on the overall dimensions, fixed to the reverse. These restraint systems change over the course of the centuries for reasons of function and application. In the earliest examples, the crosspieces were nailed to the support, giving way, over time, to anchoring systems that better responded to the specific characteristics of the materials.

Even though they are generally well known, it may be worth reviewing here, however briefly, some of the principal characteristics of Italian panel carpentry.[2] These structures

1.
Fra Carnevale,
The Birth of the Virgin, viewed in raking light.
The Metropolitan Museum of Art,
New York

343

are usually made of poplar, a wood species generally considered to be of low quality; a relatively soft material, poplar does not age well and is easily attacked by wood-boring insects. The same material was also used for any framing and architectural elements that may have embellished the painted surface. The low level in which the wood components of these constructions have been regarded in past centuries has certainly contributed to many extensive and improvident interventions, including the alteration of forms, the dismemberment of architectural ensembles (triptychs and polyptychs), and the partial or even total demolition of panel supports and framing elements. The nineteenth century, with its embrace of technology in many aspects of productivity and cultural life, certainly contributed in a negative way: crosspiece systems, in particular, have suffered from this quest for renovation, and often were subjected to modifications or outright removal. To add to the reasons for detrimental interventions, one could cite changes in taste as well as neglect, but also an excessive desire to intervene in these wood constructions by inappropriately attempting to resolve conservation problems related to the preparation and paint film. As one might intuit, in reality the situation is completely different: carpentry techniques changed over the centuries and evolved differently in each region of Italy (as well as across the Alps) and are a testimony to an ancient understanding of wood and woodworking, of the methods of construction and assembly, and of the behavior of wood, both during the working phase and in the inevitable deformations that occur during aging. The type of wood used, as noted, often had negative properties in terms of resistance and durability, but technical solutions adopted in the construction phase made it more appropriate than it might appear. Its properties of easy and quick seasoning and workability and its homogeneous grain structure and porous surface lend themselves particularly well to the adhesion of the preparatory layers; furthermore, the low density of the material reduces the force of movement with respect to other wood types considered superior in quality.

The carpentry in the panels by Fra Carnevale analyzed for this essay corresponds, in materials and techniques, to the general characteristics described above. Our observations, for the most part, attempt to shed light on the working methods in the area around Urbino, although many of the problems that emerged had, at least in part, already been resolved in Tuscany. These differences are certainly tied to a local artisanal tradition influenced by the Venetian school.

I. THE FRANCISCAN POLYPTYCH

These observations on the techniques of construction, the criteria for the choice of materials, and the successive modifications and dismemberment have to do primarily with four painted panels from an altarpiece that, for simplification, we will call the Franciscan polyptych. At present, only four panels are known, representing Saint John the Baptist, the Crucifixion, Saint Peter, and Saint Francis (cat. 41 A–D). Some hypotheses have been advanced regarding a fifth panel representing Saint Christopher, but that panel is currently missing and is known only from a photograph.[3]

For each of the panels we examined (see plates 10–13, pp. 337–39) there follows a description of the type and quality of wood, the dimensions, the construction techniques, the

2.
Fra Carnevale, *Saint Peter*, reverse, showing the holes left by nails.
Pinacoteca di Brera, Milan

3.
Fra Carnevale, *Saint Peter* (detail),
showing the remaining framing elements.
Pinacoteca di Brera, Milan

4.
Fra Carnevale, *Saint Peter*,
reverse, showing marks made with
a saw blade.
Pinacoteca di Brera, Milan

characteristics of the workmanship, the state of conservation, and a record of the marks that could be considered useful in the hypothetical reconstruction of the original format. A careful reading of this data will help form a hypothesis for the composition of the polyptych, the type of mechanism that kept the individual parts together, and, even though approximate, the overall dimensions of the altarpiece.

Saint Peter (Pinacoteca di Brera, Milan)

SPECIES AND CHARACTERISTICS OF THE WOOD AND TECHNICAL ASPECTS OF THE CONSTRUCTION OF THE SUPPORT

The painting measures 140.5 centimeters in height, 45.7 centimeters in width, and 2.6 centimeters in thickness. The support is a single plank of poplar 136 centimeters high, oriented vertically. The wood is of medium quality, with a relatively homogeneous grain. The cut is subtangential and presents a slightly convex warp. Currently there are no crosspieces present, but a slight chromatic shift located at the extremities of the panel, as well as the holes left by nails (fig. 2), clearly indicates that, originally, the panel had a system of crosspieces made up of two elements.

The preparation and paint layers are spread on the internal surface of the board (that facing toward the pith), and original ornamental elements remain fixed to the borders of the panel: a small base, pilasters at the sides with small spiral columns nailed to the surface, and finally, capitals. In the upper area, the frame includes a rounded compass arch, refinished with a wide molding under which are seven small trilobed arches, somewhat Gothic in style. A lighter molding follows the upper perimeter of the panel, touching the compass arch at three points and thereby enclosing it.

One final element, a frieze 8.5 centimeters high, composed of a perforated quadrilobe form that is repeated nine times, completes the architecture at the top. All of the ornamental elements are fixed to the support by tapering rectangular-section iron nails with faceted heads (fig. 3).

TECHNICAL CHARACTERISTICS OF THE WORKMANSHIP

There are evident marks, slightly inclined and nearly horizontal, on the reverse, made by a saw blade (fig. 4).

On the right margin is an area that was partially leveled with an adze; this indicates that when the plank was being worked it had already been seasoned, and therefore warped,[4] making it necessary to re-flatten the surface. The surface of the board prepared for painting[5] was planed with a "*sgrossino*,"[6] the traces of which can be read in an X-ray (plate 10, p. 337) in the rippling effect of the gesso. The marks are regular, perfectly horizontal, and impart a slight undulation, visible even on the painted surface in raking light. This particular working method is common to all four panels and is another factor in the argument that they formed parts of the same complex of paintings. This detail adds to our knowledge of the working methods for constructing panel-painting supports in the workshops around Urbino.

INTERVENTIONS AND STATE OF CONSERVATION

The original dimensions of the panel do not seem to have been altered, but the original crosspieces that connected it to the adjacent panel have been removed. Wedge-shaped inserts are present at the sides, near the upper and lower edges—the result of an effort to repair the damage inflicted by the careless removal of the nails that once held the original crosspieces.

The state of the panel's conservation is consistent with the wood type and the natural aging process: there is a certain warp, a central split open at the top, and damage by wood-boring insects (not currently active) that has eroded the wood in some areas but not enough to seriously compromise the stability of the support. On the upper margin, in the middle of the panel, is a series of holes visible both with the naked eye and in X-radiograph, which are traces of the probable connection of this panel and the one that would originally have been placed above it (see fig. 5). Most of the architectural construction is currently shifted toward the left, protruding from the panel on the lower left by approximately 1.5 centimeters. Considering that the incisions in the preparation beneath the carved arches are completely exposed on the right (see fig. 6), we can deduce that the positioning of these was corrected at the moment of dismemberment, when they were centered instead on the support, thereby sacrificing the original pictorial composition and altering one aspect of its function of covering the joint and linking the panel to the one next to it.

USEFUL DETAILS FOR STUDY AND RECONSTRUCTION

1. As previously stated, the frame has been partially removed and shifted to the right to center it on the support. In fact, if the architectural elements were now moved farther to the left, the image of the saint would then be centered within the arch.

2. The upper frieze, which protrudes at the top by approximately 4 centimeters, confirms the theory that the polyptych originally was composed of two tiers, since the overhang served as a link to the panel in the upper register.

3. As stated, there are no evident traces of original crosspieces on this panel, but their presence can be deduced from the holes at the edges of the panel for the nails that would have anchored them to the panel. The nail holes (described in the section on construction techniques), which appear at the upper center of the panel, because of their number and distribution cannot have had any relation to the crosspieces; instead, the nails anchored an element that connected the panel to the corresponding panel in the upper register.

4. The architectural elements were applied to the panel after the ground was already prepared. This apparently insignificant detail underlines the many ways in which panels could be constructed, not only in different geographic zones, but also within the same region.[7] We know that these procedures underwent changes over time—not only stylistically but also in terms of technical execution, both with respect to the support as well as to the preparatory layers. The construction of panel supports, though, has always followed criteria compatible with the characteristics of wood, whereas, in the buildup

5.
Fra Carnevale, *Saint Peter*, reverse,
showing marks from nails that indicate how the panel
was connected to the upper register.
Pinacoteca di Brera, Milan

6.
Fra Carnevale, *Saint Peter* (detail),
showing the original incisions in the gold background
and the framing elements clearly shifted to the right.
Pinacoteca di Brera, Milan

of the preparatory layers, there has been a tendency to simplify the procedures, eliminating the canvas interlayer and reducing the number of gesso coats—a fact that has proven to be a weak point for the future conservation of these works.

The traditional fabrication of polyptychs and altarpieces in Tuscany, through the middle of the Quattrocento, always involved using the panel support as a primary structural element. Most of the wood accessories (inscriptions predella, spandrels, cusped arches, frame moldings) were attached first, then the ground was applied (either with or without a canvas interlayer) by spreading gesso over the entire assembly. In the Venetian and Lombard schools, polyptychs were predominantly made up of panels that were inserted into the openings of a wood framework or carrying structure, which was decorated with pilasters, half columns, and other framing elements.[8] The panels themselves were generally thinner than their Tuscan counterparts and the relationship between height, width, and thickness was proportional to the dimensions of each individual panel. Fra Carnevale's Franciscan polyptych mixes traditional Tuscan and Venetian practices. The assembly of the panels is more closely aligned with Tuscan practice, but differs in a series of simplifications: for example, in the fabrication of separate panels, which were fitted together later (rather than rigidly joined at the outset), and in the preparation of framing moldings as separate elements, rather than attaching them to the panel before gessoing. These factors certainly facilitated the tasks of the various specialized craftsmen who worked on different phases of the polyptych—phases that could be carried out contemporaneously due to the separation of the various elements. This type of construction undoubtedly helps to avoid future maintenance problems by limiting the interaction and movement of the different wood sections.

Saint Francis (Pinacoteca Ambrosiana, Milan)

SPECIES AND CHARACTERISTICS OF THE WOOD AND TECHNICAL ASPECTS OF THE CONSTRUCTION OF THE SUPPORT

The poplar support is composed of a single board oriented vertically; an edging strip was added around the entire perimeter. The current measurements, with the edging strip, are 129 centimeters in height by 50 centimeters in width; the thickness varies between 2.6 centimeters and 2.7 centimeters. The wood is of medium quality; the board was cut from a subtangential section, and the grain is relatively homogeneous. The panel has assumed a uniform, convex warp.

No other anomalies seem significant enough to have any bearing on the preparatory layers. As is usual, the preparation has been spread on the inner surface of the board. A lighter band, clearly visible on the reverse at the upper border, indicates the former presence of a crosspiece; this is further confirmed by the holes in the same area of the support, which were formed by square section nails placed at the upper and lower margins.

TECHNICAL CHARACTERISTICS OF THE WORKMANSHIP

Two types of toolmarks are visible on the reverse: there are slightly oblique saw marks toward the middle of the panel, which indicate that the cut was made in single strokes beginning at the bottom (with respect to the image). On the reverse, the sides—especially the right one—have been refinished with a "*sgrossino.*" The characteristic undulations left by that tool are, in this case, fairly regular, and follow a slight incline from outside to inside and from top to bottom. The X-radiograph shows that here, also, the surface of the board to be painted has been worked with a "*sgrossino*" with a slight curve, in regular, perfectly horizontal strokes (see plate 11, p. 337).

INTERVENTIONS AND STATE OF CONSERVATION

The panel has been reduced on all four sides and an edging strip has been fixed around the perimeter with glue and modern nails. The face of the edging strip is shaped into a frame profile. The original crosspieces that connected the various panels have been removed. The state of conservation is generally good, although there is a split along the entire length of the panel that penetrates only partway through it.

 Woodworm infestation has been minimal and is irrelevant to the conservation of the panel. The original frame is missing.

USEFUL DETAILS FOR THE RECONSTRUCTION

1. As described in the section on the technical aspects of the support, across the entire width of the panel there is a lighter band, whose location (at the border of the end grain), width, and remaining nail holes clearly indicate that a crosspiece was present in the past (see fig. 7).

2. Dowel holes: the X-radiograph shows two cavities approximately in the middle of the left edge whose size and shape suggest that they were made to receive dowels (fig. 8). The proximity of the dowels to each other is unusual and no explanation of their function can be made; whether they served as a connection between the panels or as any other type of bond is unclear. Three hypotheses can be proposed: the first, that the dowels are so close together because of an error made during construction (possibly in the positioning of the dowel in relation to the height of the panel); second, that the panel is composed of reused material; and third—and the most plausible—that early in the fabrication the entire assembly process was completely rethought, and in reconsidering the dimensions of the panels, their thickness, and the distance between the upper and lower crosspieces, it was decided that the use of dowels as reference elements for connecting the panels would be superfluous.

3. The characteristics of the supports of the *Saint Peter* and the *Saint Francis* in terms of grain orientation and distribution of annual growth rings, would seem to indicate that these panels were cut from the same trunk, even though they are not consecutive boards, as demonstrated by the growth rings and the knot in the *Saint Francis* panel not present in the *Saint Peter* panel.

7.
Fra Carnevale, *Saint Peter*, reverse, showing traces of the position of the original crosspiece, nail holes, and the chromatic alteration of the wood.
Pinacoteca Ambrosiana, Milan

8.
Fra Carnevale, *Saint Francis*, detail of the X-ray showing the presence of dowel holes.
Pinacoteca Ambrosiana, Milan

9.
Fra Carnevale, *Saint John the Baptist*,
detail of the reverse, showing traces of
the crosspieces and the chromatic
alteration of the wood.
Museo della Santa Casa, Loreto

10.
Fra Carnevale, *Saint John the Baptist*,
detail of the X-ray showing the nails, which
indicate the position of the original crosspieces.
Museo della Santa Casa, Loreto

Saint John the Baptist (Museo della Santa Casa, Loreto)

Species and Characteristics of the Wood and Technical Aspects of the Construction of the Support

The support is made of poplar and measures 79.7 centimeters in height and 46 centimeters in width; the grain is oriented vertically. The panel is composed of two boards: the width of the main one is 39.6 centimeters at the top and 39 centimeters at the bottom; the smaller board measures 4.1 centimeters at the top and 4.7 centimeters at the bottom. The two elements are butt joined with glue only and without any dowels or nailed reinforcements. The average thickness of the panel is between 2.6 and 2.7 centimeters. The quality of the wood is poor, and the grain is not homogeneous: the principal board is a subtangential cut, and the grain follows a slight curve; the smaller board is a tangential cut. The preparation layers have been spread on the inner surface (with respect to the tree trunk) of the board. On the reverse, at the upper and lower extremities, discolored bands are clearly visible, caused by the presence of crosspieces (see fig. 9). In the lower part of the panel, in the area corresponding to the chromatically shifted band, some wood has been planed to accommodate the crosspiece. From these marks, the dimensions of the crosspiece can be estimated: the lower one is approximately 10.5 centimeters, while the upper one is 7.5 centimeters. That discrepancy is not due to the crosspieces being different sizes but is because the panel has been cut at the top, interrupting the crosspiece track. Also present on the reverse, on the right edge of the base, are the tips of nails: on the left there is a very old nail hole, and at the top, at the edges of both sides, are the tips of original nails clinched over (see fig. 9 and 10).

Technical Characteristics of the Workmanship

On the reverse, toward the middle of the panel, there are saw marks made with nearly horizontal strokes, beginning at the top and progressing to the bottom. The left and right sides, on the reverse, have been further worked with an adze. As previously stated, because the boards tend to warp during seasoning, additional reworking is required to obtain a flat surface. The carpenters limited themselves to reworking the borders because obtaining a completely flat surface would have left the panel excessively thin. As in the case of the *Saint Peter* panel, the workmanship is not very accurate.

The reverse of the panel has, on the right side and at the bottom edge, routed tracks 8 millimeters wide and 2 millimeters deep, which served as thickness guides so that each panel could be worked individually while maintaining a reference for the desired thickness.[9] Before the advent of machines, this system of working wood simplified and improved the process, quickly establishing the correct thickness of only the small portion of the boards that needed to be prepared for connecting to others—either to be simply abutted (as in triptychs and polyptychs) or to be solidly glued (as in altarpieces). The remaining surface on the reverse could then be planed more quickly and with less precision.[10]

349

INTERVENTIONS AND STATE OF CONSERVATION

The support has been reduced in size: on the left side by about 2 centimeters and at the top by at least 3 or 4 centimeters—the amounts necessary to have completed the interrupted arch. The state of conservation is good, revealing a minimal attack of wood-boring insects. The small fissures at the bottom are attributable to the removal of the crosspiece. All the ornamental parts of the frame are missing.

USEFUL DETAILS FOR THE RECONSTRUCTION

1. There are many marks on the reverse, including those left by the crosspieces (the nails that secured them are still in place) (see fig. 11), and by the routed channels at the sides, which served as thickness guides. This last detail is very interesting for the study of the working methods employed.
2. The tips of the nails still visible at the bottom and at the top right are not only evidence of the presence and positioning of crosspieces but, if we combine this information together with the remnants of the tip of a nail along the cut on the upper left side, we can deduce that it must have been included within the plane of the support—and, thus, the panel must have been reduced by 1.5 to 2 centimeters.
3. Another interesting detail useful for the reconstruction of the polyptych is gained by comparing the three panels. The figure of Saint John is not complete although it has not been cut at the lower edge. This must have been an iconographic choice given its probable positioning in the upper register. However, if we superimpose this figure over those of the Saint Peter and Saint Francis, we find that they are practically identical in scale, which would indicate that the width of the panels in the upper and lower registers was also very likely identical.

The Crucifixion (Galleria Nazionale delle Marche, Urbino)

SPECIES AND CHARACTERISTICS OF THE WOOD AND TECHNICAL ASPECTS OF THE CONSTRUCTION OF THE SUPPORT

The support is made of poplar and the grain is oriented vertically. The current measurements are 102.5 centimeters in height by 66.8 centimeters in width by 2.8 centimeters in thickness. The panel is composed of two boards, which are butt joined only; there are no other connecting elements within the joint. The larger board is 47.2 centimeters wide and the smaller one 19.6 centimeters wide. The quality of the wood is not especially good, as the main board is a subtangential cut; otherwise, there are no knots or other defects that might affect the preparatory layers. The painting has been realized on the inner surface of the board (as described above). Two pairs of holes—one larger and one smaller—are visible on the reverse, located 61.8 centimeters from the bottom, 40.9 centimeters from the top, 12.1 centimeters from the right edge, and 7.8 centimeters from the left edge. One can also detect the mark left by a crosspiece, which would very likely have been fixed by nails in the above-mentioned holes, hammered from the front toward the back (see fig. 12 and plate 10, p. 337).

11.
Fra Carnevale, *Saint John the Baptist*, detail of the reverse, showing traces of the nails and adze marks for the further thinning of the panel, in order to position the crosspiece.
Museo della Santa Casa, Loreto

TECHNICAL CHARACTERISTICS OF THE WORKMANSHIP

The panel had been planed on the reverse using a "*sgrossino*" of fairly narrow width and with a slightly curved blade, leaving small, wave-like horizontal marks over the entire surface. As stated with regard to the previously described panels, X-rays reveal the same marks on the panel below the preparation.

INTERVENTIONS AND STATE OF CONSERVATION

The painting has been cut at the top and bottom but is intact on the sides. The panel is 66.8 centimeters wide and is taller at the top by about 37 to 38 centimeters with respect to the *Saint John*. The state of conservation is good, with few insect holes. The panel has a convex curve measuring 2.6 centimeters deep in the center; this pronounced deformation is in large part caused by the tangential cut of the wider board.

USEFUL DETAILS FOR THE RECONSTRUCTION

The particular type of planing of the reverse differs from that of the other panels—a fact that might be explained by the involvement of more workers or workshops in the overall realization of the project. However, a unifying common aspect among the panels remains the final planing of the front surface (underneath the preparation), to which all the panels were subjected, using the same method and with the same technical skill. The form of the holes left by the nails of the crosspiece, visible also in a radiograph (fig. 12), leads us to conclude that the nails were inserted from the front before the application of the ground and the paint layers. This would seem to indicate that the panel was fabricated separately from the others in which the nails that fixed the crosspieces were inserted from the reverse.

CONCLUSIONS

As often happens when works painted on wood panels are studied, the results differ: they generally are fruitful and informative with regard to the construction of the wood elements, the execution of the preparation layers, and the state of conservation, but much more problematic and sometimes disappointing on matters relating to the reconstruction. In the study of the reconstruction of physically compromised works, one can also hypothesize about why modifications have been made: the loss of entire sections is often due to removal of the work from its original site and to the adaptation of parts to fit smaller spaces, with consequent dismemberment, which may result in the work being placed on the art market. Within the logic of profit, artworks have suffered everything imaginable: aside from being disassembled, they have been reduced in size to adapt to new ways of exhibiting them; often, in order to regain a planar surface on panels warped over time, original crosspiece systems have been removed, the panels radically thinned, cradles applied, and so on, frequently with a disregard not only for the material but also for the work of art itself. Our artistic patrimony thus has suffered terrible losses, and even

12.
Fra Carnevale, *The Crucifixion*, detail of the reverse, showing the crosspiece track and the chromatic alteration of the wood. Galleria Nazionale delle Marche, Urbino

when it might have been possible to salvage a picture, it comes down to us stripped of the traces of its history.

The Franciscan polyptych is a case in point. As indicated above, it has been dismantled, many panels (including the central one) are missing, and those that survive have been compromised, with all decorative framing elements lost (except those on the *Saint Peter* panel). Moreover, nearly all the information that the wood construction might have transmitted was obliterated long ago. The few elements that can still be identified by specific examination and technical research lead us to conclude that the four panels once formed part of a polyptych with two registers structured in the following way: the first register consisted of four lateral panels representing full-figure images of saints, and the second register contained four lateral panels with three-quarter-length figures of saints. These were connected to a larger, central panel that probably continued through both registers, likely representing the Madonna and Child and, in the upper part, the Crucifixion. The various parts were divided by decorative framing elements (see the proposed reconstruction in plate 10, p. 337).

The information leading to the formulation of this reconstruction is as follows:

1. The criteria used in the fabrication of the four surviving panels, along with the unusual method of planing the surfaces that were to receive the preparatory layers, are similar enough to affirm that they once belonged to the same complex.

2. The panels of both registers shared the same width, as proven by the fact that all the painted figures are in the same scale. In the case of the *Saint John* (and of all the figures in the second register), the figure is truncated only because of an iconographic and compositional choice, but its proportions are identical with those of the two full-figure saints.

3. The *Crucifixion,* which has been cut at the top and bottom but is intact at the sides, measures 66.8 centimeters in width, compared to the approximately 45-centimeter width of the lateral panels. This would be an adequate measurement for a central panel, according to traditional proportional relationships between central and lateral panels.

4. The only original framing elements remaining are those on the *Saint Peter* panel, but the upper part has been shifted to the right (although only by about 2 centimeters) in order to center it according to the current dimensions of the support, following the dismemberment of the polyptych. In fact, the niche enclosing the saint is off-center with respect to the framing elements. This type of intervention indicates that the left side of the frame was at least 1.6 centimeters wider and, therefore, one can hypothesize that it protruded over the surface of the adjacent panel to mask the joint between them. This modification, dating from the time of the disassembly, left the small predella untouched; it still protrudes by 1.6 centimeters on the left, while the pilaster and the architectural member containing the arch were moved to the right until they were flush with the panel's edge. This would indicate that the *Saint Peter* was most probably the outermost of the two right lateral panels; it was customary for the central panel to have been contained within its own framing elements and not to have been enclosed by the lateral panels. Similar works display various solutions, and so our hypothesis for reconstruction is only partially binding. It does not appear as though the upper part of the panel, or the framing has been altered : the 4 centimeters of frieze that protrude from the support at the top hid the connection between the upper and lower registers.

5. If the position of the upper crosspiece of the *Saint John* panel is perfectly aligned with the crosspiece of the central *Crucifixion* panel, one might propose that the *Crucifixion* extended about 37 or 38 centimeters above the *Saint John* panel. These proportions would be perfectly plausible for the construction of a polyptych, from an architectural point of view.

6. The overall measurements, after this reconstruction, are 253 centimeters (height) by 250 centimeters (width), which does not take into consideration the possible pilasters, piers, or architectural elements at the sides, or other parts of the frame.

7. The most difficult problem is to identify the way in which these five sections were connected. Following the traces of the connecting systems (marks from crosspieces and evidence of the distance between the nails and the margins of the panels), we can deduce that the two pairs of lateral panels were constructed as linked elements: that is, the *Saint Francis* and *Saint Peter* were connected by a single crosspiece above and a single one below (the same would hold true for the other pair of saints on the left). The upper register would have been constructed in the same manner (as pairs with two crosspieces for each pair). Information is lacking as to how the lateral sections were connected to the central section, mostly because of the missing lower central section (the *Madonna and Child*). The *Crucifixion* contains evidence of only one crosspiece placed at a level at two-thirds of its height, which corresponds to the upper crosspiece of the *Saint John* panel. If, at some point, the *Crucifixion* panel were, indeed, separated from the *Madonna and Child* below, there could only have been two possibilities for a secondary support: the first is that the *Crucifixion* had a second crosspiece at the bottom (in the area that was likely cut off), at the same height as the lower crosspiece of the *Saint John* panel, but this would mean that the missing *Madonna and Child* would have been the same height as the lateral panels (an extreme rarity). Furthermore, the framing of the central panel (perhaps with a baldachin, a typical device) would have had to have been lodged on the upper panel. If, instead, we hypothesize that the baldachin was part of the *Madonna and Child,* then we would be left with the incongruous probability that the *Crucifixion* had only one crosspiece. According to an alternative hypothesis, the two central elements (the *Madonna and Child* and the *Crucifixion*) could have been constructed as a single panel, intact over its entire length. This explanation can be confirmed by the direct correspondence of the crosspiece tracks of both the *Crucifixion* and *Saint John* panels, and follows the traditional methods of construction in that region of Italy (the Marches and the Veneto). The crosspieces of the four pairs of lateral panels, in line with those of the central panel, would then have been able to be connected by some kind of joint in the crosspieces, creating a sort of "component" structure.[11] The linkage point between the upper and lower panels could have been achieved simply with small pieces of wood to join them together.

8. Additionally, one could envision the four groups of lateral panels (as pairs, with two crosspieces for each pair) connected to the central panel by means of two vertical posts anchored to the altar and positioned at the margins of the central panel (these posts could even have terminated in decorative pinnacles). At the outside, the cross-

pieces could have been joined to the lateral pilasters or piers. This type of structure would have been very strong, rendering superfluous any structural connection between the upper and lower registers, which would have been supported independently. A small connection between the panels on the reverse, in order to maintain the surface level, would explain the holes at the top center of the *Saint Peter* panel.

9. It is worth considering that a structure of these dimensions and this articulation undoubtedly would have had some type of stabilizing structure attached to the altar to hold the polyptych upright—perhaps one of the so-called *capsae* referred to in many contemporary documents.[12]

10. In conclusion, an example of our hypothetically reconstructed polyptych is found in the *Presentation of the Virgin* panel in Boston, where, on an altar in the background, in the interior of the temple, there is a very similar triptych with two registers (fig. 13).

2. THE BARBERINI PANELS

Deciphering the methods of constructing the actual panels and proposing hypotheses regarding their original collocation on the basis of the carpentry techniques employed is not an easy undertaking. The current condition of both supports provides little information beyond a description of the basic characteristics and the state of conservation, as well as evidence of past restorations whose consequences, in particular, must be examined more closely, as their methods of execution, and the reasons for them, can furnish useful information about the original procedures used in the realization of the works themselves.

NOTES ON THE PREVIOUS RESTORATION

In the first half of the twentieth century, both panels underwent extensive restorations (the New York panel, by Stephen Pichetto in 1935).[13] As was customary at the time, both supports were reduced in thickness by approximately half, the panels were then flattened by pressure, and cradles were applied (fig. 14 and 15). This type of intervention was common in the past (and, unfortunately, still occurs today) for panels that—because of natural aging, neglect, and poor environmental conditions—developed accentuated warping, causing further disjoins and splits along the wood fibers. Naturally, over time, this damage affects the paint film, not only aesthetically but also in terms of its conservation, provoking lifting paint and loss of color, and the presumed remedy is, as stated, an invasive intervention on the support and the application of a cradle. The practice of cradling was initiated in nineteenth-century Europe,[14] as evidenced by the *Manuale* by Giovanni Secco Suardo,[15] that of Ulisse Forni,[16] and by the successive diffusion of this technique, almost as a matter of course, as a presumed solution not only for problems relating to the wood, but also for those involving the stability of the preparation. The technique is based on the concept of deflecting the deformations caused by warping and transforming them into linear movements of dilation and contraction; it also depended on a strong aesthetic preference for an absolutely planar surface. In order to achieve the flattening of the panel and the cradling, many invasive side effects occur—from the disruption of the equilibrium of forces within the panel to the loss of traces of the original construction. The process obviously

13.
Fra Carnevale, *The Presentation of the Virgin in the Temple (?)*, detail, showing a polyptych on an altar in the background. Museum of Fine Arts, Boston

14.
Fra Carnevale, *The Presentation of the Virgin in the Temple (?)*, reverse.
Museum of Fine Arts, Boston

15.
Fra Carnevale, *The Birth of the Virgin*, reverse.
The Metropolitan Museum of Art,
New York

involves the removal of the original system of control (crosspieces), a reduction in the thickness of the wood, and often the routing or sawing of channels along the longitudinal axis, whether closer together or farther apart depending on the degree of deformation. The panel is then forced (with humidity and/or pressure) to conform to a planar surface.

This, then, is what the Barberini Panels were subjected to: the consequences, in terms of conservation, that are evident today are serious, and range from multiple deformities that have produced new fractures and accentuated existing ones, to the creation of a situation of traction of the reverse and contraction of the front, with the consequent crushing of the wood fibers. The front surface of the support (which carries the paint layers) has, as a result of the forced straightening, been compressed, causing tenting and overlapping of the paint film.

With regard to the Metropolitan Museum's panel, about which we have more information, the original support has been thinned by more than fifty percent. There are no longitudinal cuts; the flattening was certainly achieved by pressure and humidity because the deformations are such that considerable force would have been necessary for the cradle to hold the panel flat; in fact, the vertical and horizontal members are very close together, some of them wider in order to cover the joints in the panel. A full coat of beeswax is spread over the surfaces of the entire panel and cradle.

Construction Techniques

The two supports are similarly constructed, although their measurements are not identical: the *Presentation of the Virgin in the Temple (?)* measures 146.2 centimeters in height and 96.6 centimeters in width; its current thickness is approximately 1.5 centimeters. The *Birth of the Virgin* is 145 centimeters in height, 96.7 in width, and 1 centimeter in thickness. The height and width measurements do not take into account a mahogany edging strip around the entire perimeter, applied during the thinning and cradling operations. The difference between the two panels, then, is 1.2 centimeters in height. The edges of the Boston panel are intact: gesso, continuous with the preparation, dripped over the sides and, at the top, the boards of the support have not been trimmed, but differ slightly in length, making each board easy to recognize. The New York panel, as mentioned, has an edging strip, 1 centimeter by 1 centimeter, around the perimeter, which was applied during the Pichetto intervention.

Each of the supports is composed of three wider boards with a narrower one added at the sides.[17] These boards, with the grain oriented vertically, are of fairly mediocre quality, as deduced from examining the surface in raking light, from X-rays, and from certain details visible on the reverse (fig. 16 and plates 14, 15, pp. 340–41). It could be stated generally that the main boards of both supports have some characteristics in common: a subradial cut, with the grain so markedly inclined that it appears to have come from the lowest part of the tree trunk. The boards are butt joined only, with dowels for alignment (as indicated by the presence of two wood inserts placed perpendicular to the grain on the reverse of the New York panel, which seem, by their form and position, to fill the cavities left by the original dowels. These are situated in the central area over the joints, but they are not perfectly aligned (see fig. 17).

355

16.
Fra Carnevale, *The Birth of the Virgin*, photograph in raking light of the upper part of the surface, showing the low quality of the wood and permitting the identification of the joints between the boards.
The Metropolitan Museum of Art, New York

17.
Fra Carnevale, *The Birth of the Virgin*, detail of the reverse showing evidence of dowels.
The Metropolitan Museum of Art, New York

When the panel is viewed in strong raking light, many small, circular wood inserts, perpendicular to the grain, are visible protruding from the surface (because of shrinkage over the centuries) (see fig. 18). These inserts fill preexisting holes and seem to indicate the repair of the boards' surfaces prior to their use as paint supports; they appear to be logically distributed, but are wholly unrelated to any construction detail or design feature of the panels.

THE FRAME

If little useful information exists for a plausible reconstruction of the supports, there is even less for the reconstruction of the framing elements. Whatever can be said about the architectural elements derives solely from examining the surfaces in raking light. Because of a difference in the quality of the surfaces of the preparation layers and extensive overpainting, one discerns a slight level difference as well as small incisions in the gesso, which form a series of three regularly spaced rounded arches. Inside the three arches on the New York panel are two different series of marks, one involving the thickness of the preparation layers and the other, very fine incisions that describe small internal polylobed arches (see fig. 19). Along the vertical edges are various abrasions and a straight, incised line, which seems to indicate the area that would have been covered by the framing elements. On the lower horizontal edge, the paint surface is abraded and largely reconstructed, as though it had been damaged by the removal of an overlying element. In fact, old nail holes present in this area have been filled with gesso (see fig. 20). The X-ray also reveals a regular distribution of nail holes around the perimeter (different from a group of larger nail holes likely to have connected the panels to a perimeter strainer), which must have fixed the ornamental elements on top of the paint surface.

18.
Fra Carnevale, *The Birth of the Virgin*, photograph in raking light of the painted surface, showing the wood inserts used to repair the support and circular marks of uncertain origin.
The Metropolitan Museum of Art, New York

STATE OF CONSERVATION

Raking-light photographs of the *Birth of the Virgin* display slight level differences along the joints and various splits along the wood fibers: these are more prevalent on the boards' ends, especially the upper ones, and extend toward the center. Such splits along the wood fibers result from the tension that developed between the original crosspiece system and the warping of the boards during aging. There are other deformations of the paint film caused by past restorations, especially from the planing and straightening of the boards and the application of the cradle (see fig. 19). Another detail difficult to explain is

19.
Fra Carnevale, *The Birth of the Virgin*, photograph in raking light, showing evidence of the polylobed arches visible on the surface of the painting; the results of the flattening of the panel; and the consequent movement of the wood under stress from contraction.
The Metropolitan Museum of Art, New York

20.
Fra Carnevale, *The Birth of the Virgin*,
X-ray showing marks left by nails
from the frame along the bottom edge.
The Metropolitan Museum of Art, New York

the presence of a number of large circular marks, approximately 4.5 centimeters in diameter, visible on the paint surface with the aid of raking light. The marks are aligned at nearly regular intervals, and in three rows (see fig. 21). In the Boston panel there are nine, located on the three principal boards and evenly distributed with respect to the height and width of the support. The *Birth of the Virgin* has only six circular incisions, or marks (they do not appear in the first wide board on the left), which follow the same pattern already described. Curiously, these rows of marks only align perfectly from panel to panel if one panel is inverted and the marks are superimposed over each other. By examining the degree of radiopacity around these marks, it becomes clear that the internal surface of the circles is not the result of a plug or of any other manipulation (see fig. 22). There is, though, a slight level difference visible in raking light, perhaps caused by the strong pressure of some instrument (possibly a type of clamp). It is clear that these are not pieces of wood inserted into the thickness of the panel, and that they are not related to the repair of defects in the wood either during the original construction or a later restoration. The characteristics of the marks, especially their linear distribution over the surface of the support, could seem, on first examination, to be related to an innovative system for anchoring crosspieces, but this hypothesis falls apart upon closer examination. In fact, if these marks were anchoring points, the lack of three of the marks in the left-hand board of the *Birth of the Virgin,* as well as the absence within any of the marks of evidence of nails, glue, or other elements that could constitute a connection between the support and the crosspieces, would be very difficult to explain.

The only possible hypothesis is that the supports of the Barberini Panels were prepared only after assembly (and not as single boards) for some other purpose. We must also

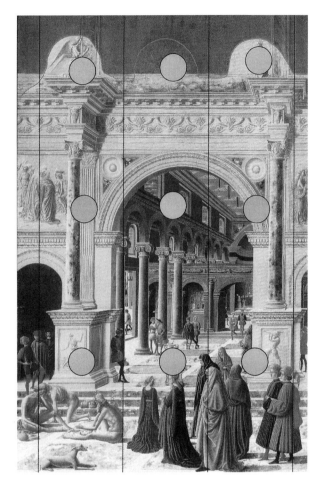
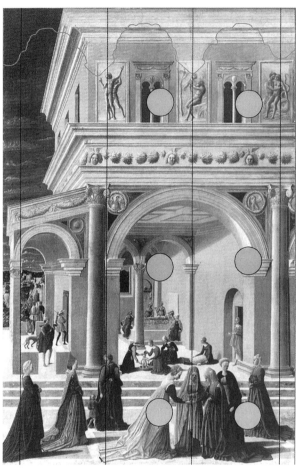

21.
Fra Carnevale, the Barberini Panels, graphic
view showing the distribution of the circular
marks and the panel joints.
Museum of Fine Arts, Boston,
and The Metropolitan Museum of Art,
New York

take into account that the marks are regularly distributed and that the dowel holes corre-
spond to two different board joints. What other use could they have had? It does not
appear that they would have been employed for another altarpiece. If we consider,
instead, the circular marks, the regular distance between them, and their even distribution
on the panels, we might think, for example, of a structure decorated with metal bosses, of
which these marks would be a trace. Yet, even in this case, some kind of anchoring—even
a simple point—would be necessary to connect the bosses to the support, and no such
traces can be found in either panel.

Even without a valid hypothesis for the previous use of these supports, we should bear
in mind the practical procedures of woodworking shops. Among the wealth of material
that exists about artisan workshops,[18] evidence shows that it was possible to work on various
undertakings contemporaneously, so that some supports could have been used for exper-
imentation or to develop a particular project that may or may not have been completed.
Thus, having already prepared some supports, a woodworker might employ them for
another project and once that was finished, the materials would become available for yet
another use. The current state of our research precludes following up other hypotheses

regarding the circular marks on the supports of the Barberini Panels, and, for now, we can only attempt to define the original construction techniques of the supports, and, in particular, the possible solutions for their structural reinforcement. Our information is deduced primarily from studying the radiographs, which reveal marks of varying radiopacity and forms that correspond to the original nailheads:[19] these are distributed around the entire perimeter, with those on the vertical edges in pairs and fairly close together (plate 12, p. 338). From a map of the positions of these marks, it appears that the most logical explanation is that they were the anchoring points of a perimeter strainer that may have had internal cross members connected to the lateral members but were not themselves fixed to the panels (there is no radiographic trace of a nail ever having been driven into the central part of the panel).[20] The pairs of nails on the vertical sides may have had something to do with the fixing of the cross members by metal brackets, but the presence of a perimeter strainer would seem instead to imply that the cross members were attached by joinery and not nails. Another plausible hypothesis is that some of the nails were used to attach metal brackets for anchoring the panel to the wall.

HYPOTHESES

Among the useful bits of information to emerge from the examination of these works, the most important may be those that indicate the original presence of a perimeter strainer to control the eventual movements of the panel, instead of the usual crosspieces that would be expected if the panels formed part of a polyptych or an altarpiece. The many questions that surround the critical history of the Barberini Panels, both of a historic and iconographic nature, as well as the doubts that have arisen about the original collocation, when taken together with the technical observations obtained in the present study, reinforce those hypotheses that take into account the evolution of techniques for panel construction during the period, and in the geographic area, in which Fra Carnevale lived. It would be interesting to discover whether those innovative elements already adopted in other regions may have been employed in these constructions as well. The question is even of greater interest since we know that Fra Carnevale was also an architect, and that he had direct experience in Florence in addition to Urbino, in the mid-Quattrocento. An artist as well prepared as he could also have made a theoretic contribution to the fabrication of a support for an altarpiece, possibly even exporting to the Marches the technical innovations he may have observed during his Florentine sojurn.

The years in which these works were produced were marked by sweeping cultural and technical changes that initiated the passage from fourteenth-century typologies to the rectangular altarpieces that predominated during the Renaissance.[21] First in Florence, then in Siena, and then in the area around Urbino, these changes modified wood constructions, leading to variations that took into account the characteristic behavior of wood. Works by Fra Angelico (*San Marco Altarpiece*; *Annalena Altarpiece*; Bosco ai Frati altarpiece; Montecarlo *Annunciation*), Fra Filippo Lippi (*The Coronation of the Virgin*; Uffizi, Florence), and Neri di Bicci (*Saint Felicita Enthroned*; Santa Felicita, Florence), as well as by Domenico di Michelino (in San Giovanni Valdarno), and Lo Scheggia (in the

22.
Fra Carnevale, *The Birth of the Virgin*, detail of the X-ray showing a circular mark and indicating that the area inside the circle has the same radiopacity as the area outside the mark.
The Metropolitan Museum of Art, New York

museum at Fucecchio), dating between 1438 and 1460, reflect the latest innovations in form and typology but, above all—and what interests us in this context—are the cross-piece systems used and the framing solutions adopted. It is probable that, during the time spent in Lippi's workshop (documented in 1445), Fra Carnevale would have seen the new forms of carpentry that were coming into use. Moreover, interesting technical solutions are apparent in the altarpieces painted by Giovanni di Paolo, Matteo di Giovanni, Vecchietta, and Sano di Pietro for the cathedral of Pienza, between 1460 and 1465, which are testimony to the rapid diffusion of new developments in construction.

While these advances took place in Tuscany, about 1460, in the *Montefeltro Altarpiece* (cat. 46),[22] Piero della Francesca employed a support that, in its method of assembly and its system of structural reinforcement, is procedurally unique:[23] the boards, placed horizontally, were not only butt joined, but, in order to obtain greater mechanical resistance and improved surface leveling at the edges, the carpenter cut a channel in the joint faces into which he inserted a wood strip; the resulting joint increased the glueing surfaces, achieving greater strength. Although this crosspiece system functions conceptually like the system used by Angelico, it differs in the anchoring elements. With this mechanism, the spaces that once served as the insertion points for the dowels to assemble the boards now become the anchoring points for the crosspieces as well, with the application of a round-section bar bent into an omega shape. This system was also adopted by other painters in contact with Piero, or who worked in that region.[24]

However, what differentiates the works by Piero from those by Florentine and Sienese painters are their frames. Unlike the Tuscan works mentioned above, which had already abandoned the practice, the *Montefeltro Altarpiece,* the *Flagellation,* and the *Senigallia Madonna* all have frames constructed contemporaneously with the support and attached before the preparation was applied.

Notwithstanding the innovations developing in the area where they were fabricated—nor the cultural contacts that Fra Carnevale established with the major painters of the period, and his exposure to the most up-to-date methods of panel construction—the Barberini Panels are structurally fairly traditional. Even though they were planned and constructed as independent panels not rigidly connected together or to other elements in an ensemble (but probably inserted into an overall framework), they were nonetheless not constructed according to the new systems employed for the "*pala unificata*" (or framed rectangular altarpiece). At the same time, there is no evidence of the crosspieces that panels of these dimensions usually would have had.

The hypothetical presence of a strainer, supporting the panel around the perimeter, would have been appropriate for contact against a wall. If, in addition, we interpret the pairs of nails along the vertical edges as the means to anchor metal bands to the panels in order to secure them to a wall, then we would have to reevaluate our knowledge of the way in which the furnishings of the altar of Santa Maria della Bella at Urbino were constructed.

1. It should be noted that, also in this section, single-plate radiographs were made of each of the panels of the Franciscan polyptych by the Opificio delle Pietre Dure. This system resolves the problem of the considerable optical distortions produced by the traditional method, which uses small, individual plates that are later pieced together into a composite whole. See Aldrovandi and Ciappi 1995, pp. 163–68. In the case of the Barberini Panels, it was only possible to study traditional radiographs; these were kindly furnished by the museums in which the works reside.

2. See Casazza 1992, pp. 9–34; Ciatti, Castelli, and Santacesaria 1999.

3. According to Bellosi (1990b, p. 36, fig. 30), the work had been in the Lanckorónski collection in Vienna, and, although known only from a photograph in the Berenson Library, must have been an element of the Franciscan polyptych. Despite the poor quality of the image, it is possible to see that, below a later alteration, which transformed the panel into a rectangle, the painting originally terminated at the top in a round arch without further subdivision into small polylobe arches. Moreover, the proportions of the work are not compatible with the measurements of the lateral panels (the individual saints) of the polyptych, even when taking into account the fact that the panel has been cut (given that the figure of the saint appears intact).

4. Considering that the boards were made from tree trunks by sawing parallel longitudinal planks, nearly all panels warp during seasoning; only radially cut boards remain relatively flat.

5. Normally, the ground and paint were applied to the inner surface of the board, the part closest to the pith. This guaranteed that, during aging, any eventual convex warping would create a larger surface area for the paint film with respect to the other, concave side. This property of wood was certainly known for millennia by woodworkers, who applied the knowledge to the type of object being constructed.

6. A tool consisting of a wooden block, like a plane, but with a slightly curved blade that could be adapted to the need at hand. The flat base enables the wood to be worked more accurately, while the curved blade allows material to be removed more quickly.

7. Fra Carnevale adopted this procedure in this polyptych, but Piero della Francesca, in the *Flagellation* and in the Brera panel, or Niccolò Liberatore in the pinnacle panels of the *Madonna delle Grazie* from Monteluco di Spoleto, apply the frame *before* the preparatory layers.

8. Examples of this type of structure are the polyptych for Olera by Palma Il Vecchio, the altarpiece for San Zeno in Verona by Mantegna, and the three altarpieces in the sacristy of San Zaccaria, Venice.

9. During the medieval period and the Renaissance, an organizational structure existed to control the quality and efficiency of the work. It was not only a master who developed a project and made drawings for its execution, but the operations were subdivided among other individuals: some selected and prepared the materials, others were responsible for the basic construction, and still others were involved in the refinishing details, the carving, and the frame moldings. The tools for the various phases were different: some roughed out surfaces and others refinished; the jack plane and the block plane were used for precise work, as, for instance, for preparing joint faces or final panel surfaces. Sometimes the carpenters preferred the "*sgrossino,*" a less-refined tool, which could work more quickly.

10. This technique was used more frequently for boards that were to be worked with an adze. Some examples of its use are found in the Gorgon on the large fourteenth-century cross from the church of San Marco in Florence; in the dismembered polyptych by Lorenzo di Niccolò di Martino, of 1409, now in the depositories of the Superintendency of Florence; and in the altarpiece (*Madonna and Child with Saints*) by Fra Bartolomeo, signed and dated 1509, in the cathedral of Lucca. This technical device is known to have been used on the *Madonna and Child with Saints* by Matteo di Giovanni (1460) for the cathedral of Pienza, as a refinished edge to fit into a U-section frame rabbet "*all'antica,*" and on the *Crucifixion* triptych by Domenico Beccafumi (1510), in the Pinacoteca, Siena, as a solution for insertion into a support structure.

11. Examples of this kind of structure are the polyptych by Antonio Vivarini in the Pinacoteca, Bologna, and the polyptych by Niccolò Liberatore, called L'Alunno, now in the Pinacoteca, Gualdo Tadino. See Saccuman 2004, pp. 489–97.

12. On "box" or "encasement" altars, see De Marchi 2004e, pp. 199–222, especially pp. 215–16; Teuffel 2001, pp. 113–64.

13. The information regarding conservation history contained in the archives of the two museums does not agree. The Boston archives do not mention Pichetto (and, in fact, note that both panels arrived in the United States already cradled). The Metropolitan's archives, instead, specifically mention the restoration by Pichetto, including cleaning and cradling. The two cradles are slightly different and may correspond to an early version of the type usually employed by that well-known American restorer; many examples can be seen in the Metropolitan and in the National Gallery of Art in Washington—museums for which he continually worked. Both cradles are made of mahogany, but on the New York panel the fixed members are more closely spaced—a detail more characteristic of Pichetto. The sliding members, though, are also of mahogany rather than the maple that was always employed later on. It should be noted that Pichetto himself did not execute the interventions on the support; he had a long association with a woodworker named Angelo Fatta, although it is not known at what date their collaboration began. This information is likely to be found in the archives of the Samuel H. Kress Foundation.

14. In Venice in 1778, Pietro Edwards, nominated by the Senate for the restoration of public works, instructed: "*Raddirizzeranno le tavole dipinte per quanto fossero curvate*" ("They will straighten the painted panels however curved they may be"). See Tiozzo 2002, documentary appendix, pp. 116–17.

15. Secco Suardo 1866.

16. Forni 2004.

17. The measurements of the boards of the *Birth of the Virgin* are (from left to right): 6, 28.2, 27.9, 28.5, and 6 centimeters, respectively. The boards of the *Presentation of the Virgin in the Temple (?),* measure 6, 29.5, 28, 27.2, and 6 centimeters, respectively.

18. Bonsanti 2000, pp. 55–73.

19. Either the original nails are still present, or thick fillings are present in the cavities left by extracted nails.

20. Even though the individual radiographic plates of the Boston panel partially crop the edges of the panel, it is possible to identify some holes at the top and the vertical sides, confirming the information revealed in the radiograph of the New York panel.

21. Castelli, et al. 1997, pp. 162–74; De Marchi 2002e, pp. 199–222.

22. See the proposal for circumstantial dating, given in this catalogue, by Emanuela Daffra.

23. Trevisani 1997, pp. 31–83; Castelli et al. 1997.

24. Joos van Ghent, in the panels representing the Liberal Arts (originally in the *studiolo* of Federigo di Montefeltro in Urbino; now in the National Gallery, London) and in the series of *Famous Men* (originally in the *studiolo* at Urbino; now divided between the Palazzo Ducale, Urbino, and the Louvre, Paris): see Campbell 1998, pp. 267–92; Reynaud and Ressort 1991, pp. 82–114.

Bibliography
Index
Photograph Credits

Bibliography

Ackerman, James S.
1954 "Architectural Practice in the Italian Renaissance." *Journal of the Society of Architectural Historians* 13, no. 3, pp. 3–11.

Agosti, Barbara, and Giovanni Agosti, eds.
1997 *Le tavole del Lomazzo: Per i 70 anni di Paola Barocchi.* Brescia.

Agosti, Giovanni, ed.
2001 *Disegni del Rinascimento in Valpadana.* Exh. cat., Gabinetto Disegni e Stampe degli Uffizi. Florence.

Agosti, Giovanni, and Vincenzo Farinella
1984 "Calore del marmo: Pratica e tipologia delle deduzioni iconografiche." In *Memoria dell'antico nell'arte italiana,* vol. 1, *L'uso dei classici,* ed. Salvatore Settis, pp. 373–444. Turin.

Agosti, Giovanni, Mauro Natale, and Giovanni Romano, eds.
2003 *Vincenzo Foppa.* Exh. cat., Museo della Città, Santa Giulia, Brescia, 2002. Milan.

Ahl, Diane Cole
1996 *Benozzo Gozzoli.* New Haven.

Aili, Hans, and Jan Svanberg
2003 *Imagines Sanctae Birgittae: The Earliest Illuminated Manuscripts and Panel Paintings Related to the Revelations of St. Birgitta of Sweden.* 2 vols. Stockholm.

d'Albenas, Georges
1914 *Catalogue des peintures et sculptures exposées dans les Galeries du Musée Fabre de la ville de Montpellier.* Montpellier.

Alberti, Leon Battista
1912 *Zehn Bücher über die Baukunst.* Ed. and trans. Max Theuer. Vienna and Leipzig.
1950 *Della pittura.* Ed. Luigi Mallè. Florence.
1966 *L'architettura [De re aedificatoria].* Ed. and trans. Giovanni Orlandi; notes by Paolo Portoghesi. 2 vols. Milan.
1972 *On Painting; and On Sculpture. The Latin Texts of De Pictura and De Statua.* Ed. and trans. Cecil Grayson. London.
1973 *De pictura.* In Leon Battista Alberti, *Opere Volgari,* ed. Cecil Grayson, vol. 3, pp. 7–107. Bari.
1975 *De pictura* [1435]. Ed. Cecil Grayson. Bari.
1986 *Momo; o, Del principe.* Ed. and trans. Rino Consolo. Genoa.
1988 *On the Art of Building in Ten Books.* Trans. Joseph Rykwert, Neil Leach, and Robert Tavernor. Cambridge, Mass.

Aldrovandi, Alfredo, and Ottavio Ciappi
1995 "La radiografia di grande formato: Problemi e soluzioni tecniche." *OPD Restauro* 7, pp. 163–68.

Alexander, Ingrid C., and Antonietta Gallone
1987 "A Study of Piero della Francesca's Sacra Conversazione and Its Relationship to Flemish Painting Techniques." In *Preprints of the Eighth Triennial Meeting of the ICOM Committee for Conservation,* pp. 9–12. Sydney and Los Angeles.

Alexander, Jonathan J. G., ed.
1994 *The Painted Page: Italian Renaissance Book Illumination, 1450–1550.* Exh. cat., Royal Academy, London; Pierpont Morgan Library, New York, 1994–95. London.

Algeri, Giuliana, and Anna De Floriani
1991 *La pittura in Liguria: Il Quattrocento.* [Genoa.]

Alippi, Alipio
1894 "Spigolature di alcuni frati scrittori, alluminatori e facitori di fenestre vetrate nel secolo XV." *Nuova rivista misena,* 1894, pp. 11–12.

Alizeri, Federigo
1870– *Notizie dei professori del disegno in Liguria dalle origini al secolo XVI.*
80 6 vols. Genoa.

Amadori, Maria Letizia
1985 "Studi e ricerche sulle pietre di palazzo Ducale." In *Il Palazzo di Federico da Montefeltro, restauri e ricerche,* ed. Maria Luisa Polichetti, pp. 709–29. Exh. cat. Urbino.

Ames-Lewis, Francis
1979 "Fra Filippo Lippi and Flanders." *Zeitschrift für Kunstgeschichte* 42, pp. 255–73.
1981 *Drawing in Early Renaissance Italy.* New Haven. Rev. ed., New Haven, 2000.
2000 *The Intellectual Life of the Early Renaissance Artist.* New Haven.
2002 "Il ruolo emergente della figura umana." In *Storia delle arti in Toscana: Il Quattrocento,* ed. Gigetta Dalli Regoli and Roberto Paolo Ciardi, pp. 111–28. Florence.

Angelini, Alessandro
1985 *Piero della Francesca.* Florence.
1986 as ed. *Disegni italiani del tempo di Donatello.* Exh. cat., Gabinetto Disegni e Stampe degli Uffizi. Florence.
1993 "Senesi a Urbino." In Bellosi 1993, pp. 332–45.

Antal, Frederick
1925 "Studien zur Gotik im Quattrocento: Einige italienische Bilder des Kaiser-Friederich-Museum." *Jahrbuch der Königlichen Preussischen Kunstsammlungen* 46, pp. 3–32.

Antaldi, Antaldo
1996 *Notizie di alcuni architetti, pittori, scultori di Urbino, Pesaro e de' luoghi circonvicini* [ca. 1805]. Ed. Anna Cerboni Baiardi. Pesaro.

Arasse, Daniel
2004 "La maniera di Botticelli." In *Botticelli e Filippino: L'inquietudine e la grazia nella pittura fiorentina del Quattrocento,* ed. Daniel Arasse, Pier Luigi De Vecchi, and Jonathan Katz Nelson, pp. 13–23. Exh. cat., Palazzo Strozzi, Florence. Milan.

Archivio di Stato di Firenze
1951 *Archivio mediceo avanti il principato: Inventario.* Vol. 1. Intro. Antonio Panella. Rome.

Arias, Paolo Enrico, Emilio Gabba, and Emilio Cristiani
1977 *Camposanto monumentale di Pisa.* Vols. 1, 2, *Le antichità: Sarcofagi romani, iscrizioni romane e medioevali.* Pisa.

Armellini, Luigi Maria
1989 *Il polittico di Giovanni Boccati: Un racconto per immagini.* Belforte del Chienti.

Arrighi, Gino
1965 "Il Codice L.IV.21 della Biblioteca degli Intronati di Siena e la 'Bottega dell'Abaco a Santa Trinita' in Firenze." *Physis* 7, pp. 369–400.

Ascani, Valerio
1997 *Il Trecento disegnato: Le basi progettuali dell'architettura gotica in Italia.* Rome.

Aschoff, Hans-Georg, and Anne Viola Siebert, eds.
2003 *Auf den Spuren von August Kestner.* Exh. cat., Kestner Museum. Hannover.

Ashby, Thomas, ed.
1904 *Sixteenth-Century Drawings of Roman Buildings Attributed to Andreas Coner.* Papers of the British School at Rome, 2. London.

Averlino, Antonio, detto Il Filarete
1972 *Trattato di architettura.* Ed. Anna Maria Finoli and Liliana Grassi. 2 vols. Milan.

Avril, François, ed.
2003 *Jean Fouquet: Peintre et enlumineur du XVe siècle.* Exh. cat., Bibliothèque Nationale de France, Richelieu. Paris.

Babelon, Jean-Pierre, et al.
2000 *Primitifs italiens.* Exh. cat., Musée Jacquemart-André. Paris.

Bacci, Mina
1969a "Il punto su Giovanni Boccati," part 1. *Paragone* 20, no. 231, pp. 15–33.
1969b "Il punto su Giovanni Boccati," part 2. *Paragone* 21, no. 233, pp. 3–21.

Bacci, Peleo
1904 "Nuovi documenti su Matteo degli Organi." *Bullettino storico pistoiese* 6, pp. 44–51.

Baetjer, Katharine
1995 *European Paintings in The Metropolitan Museum of Art by Artists Born before 1865: A Summary Catalogue.* New York.

Bagatin, Pier Luigi
1987 *L'arte dei Canozi lendinaresi.* Trieste.

Bairati, Eleonora
2000 "Attraverso il museo: Un consuntivo del patrimonio artistico gualdese." In De Vecchi 2000, pp. 39–64.
2003 "Girolamo di Giovanni per Gualdo Tadino." In De Marchi and Falaschi 2003, vol. 2, pp. 769–88.

Baldanzi, Ferdinando
1846 *Descritione della chiesa cattedrale di Prato corredata di notizie storiche e di documenti inediti.* Prato.

Baldelli, Marisa
1977 *Claudio Ridolfi Veronese, pittore nelle Marche.* Urbania.

Baldi, Bernardino
1859 "Descrizione del palazzo Ducale d'Urbino." In *Versi e prose scelte di Bernardino Baldi,* ed. and ann. Filippo Ugolini and Filippo-Luigi Polidori, pp. 538–90. Florence.

Baldinucci, Filippo
1845– *Notizie dei professori del disegno da Cimabue in qua. . . .* Ed. Fernando
47 Ranalli. 5 vols. Florence.

Baldwin, Robert
1986a "'Gates Pure and Shining and Serene': Mutual Gazing as an Amatory Motif in Western Literature and Art." *Renaissance and Reformation* 10, pp. 23–48.
1986b "A Window from the Song of Songs in Conjugal Portraits by Fra Filippo Lippi and Bartholomaeus Zeitblom." *Source* 5, no. 2, pp. 7–14.

Bambach, Carmen C.
1994 "On 'La testa proportionalmente degradata' – Luca Signorelli, Leonardo, and Piero della Francesca's 'De Prospectiva pingendi.'" In Cropper 1994, pp. 17–43.
1999 "The Early Italian Drawings in Berlin" *Master Drawings* 37, pp. 55–62.

Banker, James R.
1993 "Piero della Francesca as Assistant to Antonio d'Anghiari in the 1430s: Some Unpublished Documents." *Burlington Magazine* 135, pp. 16–21.
1995 "The Altarpiece of the Confraternity of Santa Maria della Misericordia in Borgo Sansepolcro." In Lavin 1995, pp. 21–35.
2002 *The Culture of San Sepolcro during the Youth of Piero della Francesca.* Ann Arbor.
2004 "Contributi alla cronologia della vita e delle opere di Piero della Francesca." *Arte cristiana* 92, no. 823 (July–August), pp. 248–58.

Baracchini, Clara, et al.
2004 *Matteo Civitali e il suo tempo. Pittori, scultori e orafi a Lucca nel tardo Quattrocento.* Exh. cat., Museo Nazionale di Villa Guinigi, Lucca. Cinisello Balsamo.

Baragli, Sandra
1998 "Il cantiere edile: Artefici e materiali." In *La grande storia dell'artigianato.* Vol. 1, *Il Medioevo,* pp. 237–56. Florence.

Barocchi, Paola
1958 "Il valore dell'antico nella storiografia vasariana." In *Il mondo antico nel Rinascimento: Atti del V convegno internazionale di studi sul Rinascimento, Firenze-Palazzo Strozzi, 2–6 settembre 1956,* pp. 217–36. Florence.

Barocchi, Paola, and Giovanna Gaeta Bertelà, eds.
2002 *Collezionismo mediceo e storia artistica.* Vol. 1, *Da Cosimo I a Cosimo II, 1540–1621.* 2 vols. Florence.

Baroni, Sandro
1996 "I ricettari medievali per la preparazione dei colori e la loro trasmissione." In *Il colore nel Medioevo: Arte, simbolo e tecnica; atti delle giornate di studi, Lucca, 5–6 maggio 1995,* pp. 117–44. Lucca

Bartoli, Roberta
2004 "Le fonti della scultura 'ficta' nelle tavole Barberini." In Cleri 2004, pp. 215–36.

Battisti, Eugenio
1971 *Piero della Francesca*. 2 vols. Milan.
1992 *Piero della Francesca*. Rev. ed. Ed. Marisa Dalai Emiliani. 2 vols. Milan.

Battistini, Rodolfo
1987 "La pittura del Quattrocento nelle Marche." In *La pittura in Italia: Il Quattrocento*, vol. 2, pp. 384–413. Milan.

Baxandall, Michael B.
1963 "A Dialogue on Art from the Court of Leonello d'Este: Angelo Decembrio's 'Politia Litteraria,' Pars LXVIII." *Journal of the Warburg and Courtauld Institutes* 26, pp. 304–26.
1972 *Painting and Experience in Fifteenth-Century Italy: A Primer in the Social History of Pictorial Style*. Oxford.
1974 "Alberti and Cristoforo Landino: The Practical Criticism of Painting." In *Convegno internazionale indetto nel V centenario di Leon Battista Alberti: Rome, Montova, Firenze 25–29 aprile 1972*, pp. 143–54. Rome.
1988 *Painting and Experience in Fifteenth-Century Italy: A Primer in the Social History of Pictorial Style*. 2nd ed. Oxford.

Bean, Jacob, with Lawrence Turcic
1982 *15th and 16th Century Italian Drawings in The Metropolitan Museum of Art*. New York.

Beck, James H.
1974 "The Medici Inventory of 1560." *Antichità viva* 13, no. 3, pp. 64–66; no. 5, pp. 61–63.

Belli, Gianluca
1996 "Forma e naturalità nel bugnato fiorentino del Quattrocento." *Quaderni di Palazzo Tè*, n.s., 4, pp. 9–35.

Bellosi, Luciano
1978 as ed. *I disegni antichi degli Uffizi: I tempi del Ghiberti*. Exh cat., Gabinetto Disegni e Stampe degli Uffizi. Florence.
1987 "Giovanni di Piamonte e gli affreschi di Piero ad Arezzo." *Prospettiva* 50, pp. 15–35.
1990a as ed. *Pittura di luce: Giovanni di Francesco e l'arte fiorentina di metà Quattrocento*. Exh. cat., Casa Buonarroti, Florence. Milan.
1990b "Giovanni di Francesco e l'arte fiorentina di metà Quattrocento." In Bellosi 1990a, pp. 11–45.
1992a as ed. *Una scuola per Piero: Luce, colore e prospettiva nella formazione fiorentina di Piero della Francesca*. Exh. cat., Uffizi, Florence, 1992–93. Venice.
1992b "Sulla formazione fiorentina di Piero della Francesca." In Bellosi 1992a, pp. 17–54.
1993 as ed. *Francesco di Giorgio e il Rinascimento a Siena, 1450–1500*. Exh. cat., Chiesa di Sant'Agostino, Siena. Milan.
2001 "Tre sculture di Agostino di Duccio." In *Opere e giorni: Studi su mille anni di arte europea dedicate a Max Seidel*, pp. 321–30. Venice.
2002 as ed., with Laura Cavazzini, and Aldo Galli. *Masaccio e le origini del Rinascimento*. Exh. cat., Casa Masaccio, San Giovanni Valdarno, Arezzo. Milan.

Bellosi, Luciano, and Giancarlo Gentilini, eds.
1998 *Una nuova Madonna in terracotta del giovane Donatello*. Exh. cat., Antichi Maestri Pittori. Turin.

Bellucci, Roberto, et al.
1992 "La scuola ferrarese: Indagini e confronti tecnici sulle Muse dello Studiolo di Belfiore." *OPD Restauro* 4, pp. 189–215.

Bellucci, Roberto, and Cecilia Frosinini
1998 "Piero della Francesca's Process: Panel Painting Technique." In *Painting Techniques: History, Materials and Studio Practice. IIC, Dublin Congress, 7–11 September 1998*, ed. Roy Ashok and Perry Smith, pp. 89–93. London.
2002 "Working Together: Technique and Innovation in Masolino's and Masaccio's Panel Paintings." In Frosinini and Strehlke 2002, pp. 29–67.

Benati, Daniele
1996 "Il 'Maestro delle Tavole Barberini': Un ritratto." *Nuovi studi: Rivista di arte antica e moderna* 1, no. 1, pp. 25–28.

Benazzi, Giordana, and Elvio Lunghi, eds.
2004 *Nicolaus pictor. Nicolò di Liberatore detto l'Alunno. Artisti e botteghe a Foligno nel Quattrocento*. Exh. cat. Foligno.

Benzi, Fabio
2002 "Baccio Pontelli, Francione e lo studiolo ligneo del Duca di Montefeltro a Urbino." *Storia dell'arte*, n.s., 102, pp. 7–21.

Berardi, Paride
1988 *Giovanni Antonio Bellinzoni da Pesaro*. [Bologna].

Berenson, Bernard
1896 *The Florentine Painters of the Renaissance*. New York.
1897 *The Central Italian Painters of the Renaissance*. New York.
1900 *The Florentine Painters of the Renaissance. With an Index of Their Works*. New York and London.
1903 *The Drawings of the Florentine Painters*. 2 vols. New York.
1905 "Una Annunciazione del Pesellino." *Rassegna d'arte* 5, pp. 42–43.
1907 "Gerolamo di Giovanni da Camerino." *Rassegna d'arte* 7, no. 9, pp. 129–35.
1909 *The Florentine Painters of the Renaissance. With an Index of Their Works*. New York and London.
1913 *Catalogue of a Collection of Paintings and Some Art Objects*. Vol. 1, *Italian Paintings*. Philadelphia: John G. Johnson.
1932a *Italian Pictures of the Renaissance. A List of the Principal Artists and Their Works with an Index of Places*. Oxford.
1932b "Quadri senza casa." *Dedalo* 12, pp. 512–41, 819–53. Reprinted in *Homeless Paintings of the Renaissance*, pp. 155–97. Bloomington and London, 1969.
1932c "Fra Angelico, Fra Filippo e la cronologia." *Bollettino d'arte*, ser. 3, 25, pp. 49–66. Reprinted in *Homeless*

Paintings of the Renaissance, pp. 199–234. Bloomington and London, 1969.
1936 *Pitture italiane del Rinascimento: Catalogo dei principali artisti e delle loro opere con un indice dei luoghi*. Milan.
1938 *The Drawings of the Florentine Painters*. 3 vols. Chicago. Amplified ed., New York, 1969.
1950 "Zanobi Machiavelli." *Burlington Magazine* 92 (December), pp. 345–49.
1963 *Italian Pictures of the Renaissance. A List of the Principal Artists and Their Works, with an Index of Places: Florentine School*. 2 vols. [New York.]
1968 *Italian Pictures of the Renaissance. A List of the Principal Artists and Their Works with an Index of Places. Central Italian and North Italian Schools*. 3 vols. London.

Berra, Giacomo
1999 "Immagini casuali, figure nascoste e natura antropomorfa nell'immaginario artistico rinascimentale." *Mitteilungen des Kunsthistorischen Institutes in Florenz* 43, no. 2–3, pp. 358–418.

Bertani, Duilio, Maurizio Cetica, Pasquale Poggi, Gian Piero Puccioni, Ezio Buzzegoli, Diane Kunzelman, and Stefano Cecchi
1990 "A Scanning Device for Infrared Reflectography." *Studies in Conservation* 35, no. 3, pp. 113–16.

Bertaux, Émile
1906 "Trois chefs-d'oeuvre italiens de la collection Aynard." *Revue de l'art ancien et moderne* 19, pp. 81–96.

Bertelli, Carlo
1981 "Un quadro difficile." *Alfabeta* 3, no. 29, p. 11.
1982 "La Pala di San Bernardino e il suo restauro." *Notizie da Palazzo Albani* 11, no. 1–2, pp. 13–20.
1991 *Piero della Francesca: La forza divina della pittura*. Cinisello Balsamo.
1992 "Lo spazio nella Pala dei Montefeltro." In Dal Poggetto 1992a, pp. 169–73.
1993 "Piero della Francesca's Cradle for the Montefeltro Altarpiece." In *Hulle und Fülle: Festschrift für Tilmann Buddensieg*, ed. Andreas Beyer, Vittorio Lampugnani, and Gunter Schweikhart, pp. 51–55. Alfter.
1998 "Modesto contributo all'ovologia braidense." In *Itinerari d'arte in Lombardia dal XIII al XX secolo: Scritti offerti a Maria Teresa Binaghi Olivari*, ed. Matteo Ceriana and Fernando Mazzocca, pp. 47–54. Milan.

Berthier, J.-J.
1910 *L'église de Sainte-Sabine à Rome*. Rome.
1912 *Le couvent de Sainte-Sabine à Rome*. Rome.

[Berti, Luciano, ed.]
1979 *Gli Uffizi. Catalogo generale*. Florence.

Berti, Luciano, and Antonio Paolucci, eds.
1990 *L'età di Masaccio: Il primo Quattrocento a Firenze*. Exh. cat., Palazzo Vecchio, Florence. Milan.

[Bertini, Giuseppe]
1881 *Fondazione artistica Poldi-Pezzoli: Catalogo generale*. Milan.

Biermann, Hartmut
2002 "War Leon Battista Alberti je in

Urbino?" *Zeitschrift für Kunstgeschichte* 65, no. 4, pp. 493–521.

Bittarelli, Angelo Antonio
1986 "Affreschi inediti a Piobbico e Sarnano." *L'esagono* 31, pp. 26–33.
1995 "Gli affreschi e il Maestro di Piobbico." In Giacinto Pagnani, *Storia di Sarnano, II: L'abbadia di Piobbico*, pp. 145–61. Macerata.

Bjurström, Per
2001 *Italian Drawings from the Collection of Giorgio Vasari*. Stockholm.

Bober, Phyllis Pray, and Ruth Olitsky Rubinstein
1986 *Renaissance Artists and Antique Sculpture. A Handbook of Sources*. London.

Boccaccio, Giovanni
1998 *Tutte le opere*. Ed. Vittore Branca. Vol. 2, *Filostrato*. Milan.

Bode, Wilhelm
1889 "Luca della Robbia ed i suoi precursori in Firenze." *Archivio storico dell'arte* 2, pp. 1–9.
1892– as ed. *Denkmäler der Renaissance-*
1905 *Sculptur Toscanas in historischer anordnung*. Text vol. and 11 portfolios of plates. Munich.
1914 "Marble Relief by Agostino di Duccio Recently Acquired by The Metropolitan Museum." *Art in America* 2, pp. 336–42.

Boissard, Elisabeth de
1988 "XIVe–XVIe siècles." In *Chantilly, Musée Condé: Peintures de l'école italienne*. Paris.

Bologna, Ferdinando
1950 "Il Maestro di San Giovanni da Capestrano." *Proporzioni* 3, pp. 86–98.
1977 *Napoli e le rotte mediterranee della pittura da Alfonso il Magnanimo a Ferdinando il Cattolico*. Naples.

Bombe, Walter
1912 *Geschichte der Peruginer Malerei bis zu Perugino und Pinturicchio auf Grund des Nachlasses Adamo Rossis und eigener archivalischer Forschungen*. Berlin.

Bomford, David, Jill Dunkerton, Dillian Gordon, and Ashok Roy
1989 *Italian Painting before 1400*. Exh. cat., National Gallery. London.

Bonaiti, Maria
2000– "Le architetture dipinte del
2001 Vecchietta: Castiglione Olona, Venezia e Siena." *La Diana* 6–7, pp. 27–43.

Bonsanti, Giorgio
2000 "La bottega di Giotto." In *Giotto, bilancio critico di sessant'anni di studi e ricerche*, ed. Angelo Tartuferi, pp. 55–73. Exh. cat. Florence.

Borchert, Till Holger
2002 *The Age of Van Eyck: The Mediterranean World and Early Netherlandish Painting, 1430–1530*. Exh. cat., Groeningemuseum, Bruges. London.

Borradaile, Viola, and Rosamund Borradaile, trans and eds.
1966 *The Strasburg Manuscript: A Medieval Painters' Handbook*. London.

Borsi, Franco
1977 as ed. *Leon Battista Alberti*. Trans. Rudolf G. Carpanini. New York.
1989 *Bramante*. Milan.

Borsi, Stefano
1985 *Giuliano da Sangallo: I disegni di architettura e dell'antico*. Rome.

1997 *Bramante e Urbino: Il problema della formazione.* Rome.

2003 "Fra Carnevale lettore di Alberti?" *Storia dell'arte,* n.s., 4–5, no. 104–5, pp. 33–64.

Borsook, Eve

1981 "Cults and Imagery at Sant' Ambrogio in Florence." *Mitteilungen des Kunsthistorischen Institutes in Florenz* 25, pp. 147–202.

Boskovits, Miklós

1986 "Fra Filippo Lippi, i carmelitani e il Rinascimento." *Arte cristiana* 74, pp. 235–52.

1990 *Early Italian Painting, 1290–1470: The Thyssen-Bornemisza Collection.* Contributions by Serena Padovani. London.

1995 "Mostre di miniature italiane a New York," part 2. *Arte cristiana* 83, no. 771, pp. 455–62.

1997 "Studi sul ritratto fiorentino quattrocentesco," part 1. *Arte cristiana* 85, no. 781, pp. 255–63.

Boskovits, Miklós, et al.

2003 *Italian Paintings of the Fifteenth Century.* Collections of the National Gallery of Art. Washington, D.C., and New York.

Boskovits, Miklós, and Giorgio Fossaluzza, eds.

1998 *La collezione Cagnola.* Vol. 1, *I dipinti dal XII al XIX secolo.* Busto Arsizio.

Boyle, Leonard E.

1991 "Sixtus IV and the Vatican Library." In *Rome. Tradition, Innovation and Renewal: A Canadian International Art History Conference (8–13 June 1987, Rome) in Honour of Richard Krautheimer and Leonard Boyle,* pp. 65–73. Victoria.

Brandt, Kathleen Weil-Garris, Cristina Acidini Luchinat, James David Draper, and Nicholas Penny

1999 *Giovinezza di Michelangelo.* Exh. cat., Palazzo Vecchio, Sala d'Arme, Casa Buonarroti, 1999–2000. Florence.

Braudel, Fernand

1949 *La Méditerranée et le monde Méditerranéen à l'époque de Philippe II.* Paris.

1953 *Civiltà e imperi del Mediterraneo nell'età di Filippo II.* Turin.

Breck, Joseph

1913 "A Double Portrait by Fra Filippo Lippi." *Art in America* 2 (December), pp. 44–55.

Bridgeman, Jane

2002 "'Troppo belli e troppo eccellenti': Observations on Dress in the Work of Piero della Francesca." In *The Cambridge Companion to Piero della Francesca,* ed. Jeryldene M. Wood, pp. 76–90. Cambridge.

Brown, David Alan, ed.

2001 *Virtue and Beauty: Leonardo's Ginevra de' Benci and Renaissance Portraits of Women.* Exh. cat., National Gallery of Art, 2001–2. Washington, D.C.

Brunello, Franco, ed.

1975 *De arte illuminandi e altri trattati sulla tecnica della miniatura medievale.* Vicenza.

Brunetti, G.

1965 "Sul periodo 'amerino' di Agostino di Duccio." *Commentari* 16, pp. 47–55.

Bruschi, Arnaldo

1969 *Bramante architetto.* Bari.

1973 *Bramante.* Bari. Eng. trans., London, 1977.

1983 "Corradini (Coradini o della Corradina), Bartolomeo, detto fra Carnevale." In *Dizionario biografico degli Italiani,* vol. 29, pp. 332–35. Rome.

1996 "Urbino, architettura, pittura e il problema di Piero 'architetto.'" In Cieri Via 1996a, pp. 265–300.

1998 "Qualche considerazione sul contributo di Michelozzo alla formazione del linguaggio architettonico rinascimentale." In Morolli 1998a, pp. 21–28.

2001 "Alberti e Bramante: Un rapporto decisivo." In *Leon Battista Alberti e il Quattrocento: Studi in onore di Cecil Grayson e Ernst Gombrich; atti del convegno,* ed. Luca Chiavoni, Gianfranco Ferlisi, and Maria Vittoria Grassi, pp. 351–69. Florence.

2002 "La formazione e gli esordi di Bramante: Ipotesi, problemi." In *Bramante milanese e l'architettura del Rinascimento lombardo: Atti del seminario del Centro Internazionale di Studi di Architettura "A. Palladio" (Milano–Vicenza 1994),* ed. Christoph Luitpold Frommel, Luisa Giordano, and Richard Schofield, pp. 33–66. Venice.

2004 "Le architetture nelle Tavole Barberini e la formazione di Bramante." In Cleri 2004, pp. 237–58.

Bulgarelli, Massimo

1998 "Gamberelli Bernardo, detto Rossellino." In *Dizionario biografico degli Italiani,* vol. 51, pp. 99–106. Rome.

2003a "Alberti a Mantova, divagazioni intorno a Sant'Andrea." *Annali di architettura* 115, pp. 9–35.

2003b "Caso e ornamento: Alberti e Mantegna a Mantova." *Casabella* 67, no. 712, pp. 42–53.

Buonocore, Marco, ed.

1996 *Vedere i classici: L'illustrazione libraria dei testi antichi dall'età romana al tardo medioevo.* Exh. cat., Vatican City. Rome.

Burckhardt, Jacob

1884 *Der Cicerone: Eine Anleitung zum Genuss der Kunstwerke Italiens.* 5th ed. 2 vols. Ed. Wilhelm Bode. Leipzig.

1904 *Der Cicerone: Eine Anleitung zum Genuss der Kunstwerke Italiens.* 9th ed. 2 vols. in 4 parts. Ed. Wilhelm Bode and Karl von Fabriczy. Leipzig.

Burns, Howard

1993a "Federico Barocci, veduta dell' interno della chiesa di San Bernardino a Urbino." In Fiore and Tafuri 1993, pp. 240–42.

1993b "San Bernardino a Urbino. Anni Ottanta del Quattrocento." In Fiore and Tafuri 1993, pp. 230–38.

1998 "Leon Battista Alberti." In *Storia dell'architettura italiana: Il Quattrocento,* ed. Francesco Paolo Fiore, pp. 114–65. Milan.

1999 "Antike Monumente als Muster und als Lehrstücke: Zur Bedeutung von Antikenzitat und Antikenstudium für architektonische Entwurfspraxis." In *Theorie der Praxis: Leon Battista Alberti als Humanist und Theoretiker der bildenden Künste,* ed. Kurt W. Forster and Hubert Locher, pp. 129–55. Berlin.

Busignani, Alberto

1962 "Maso di Bartolomeo, Pasquino da Montepulciano e gli inizi di Andrea del Verrocchio" *Antichità viva* 1, no. 1, pp. 35–38.

Butterfield, Andrew, and Anthony Radcliffe, eds.

2002 *Italian Sculpture from the Gothic to the Baroque.* Exh. cat., Salander-O'Reilly Galleries, 2002–3. New York and Florence.

Cafà, Valeria

2002 "I disegni di architettura del taccuino KP668 all'Ashmolean Museum di Oxford." *Annali di architettura* 14, pp. 129–61.

Caglioti, Francesco

1994 "Francesco Sforza e il Filelfo, Bonifacio Bembo e 'compagni': Nove prosopopee inedite per il ciclo di antichi eroi e eroine nella corte ducale dell'Arengo a Milano (1456–61 circa)." *Mitteilungen des Kunsthistorischen Institutes in Florenz* 38, pp. 182–216.

1995 "Donatello, i Medici e Gentile de' Becchi: Un po' d'ordine intorno alla 'Giuditta' (e al 'David') di Via Larga," part 2. *Prospettiva* 78, pp. 22–55.

2000 *Donatello e i Medici: Storia del David e della Giuditta.* 2 vols. Florence.

2001 "Nouveautés sur la *Bataille de San Romano* de Paolo Uccello." *Revue du Louvre* 4, pp. 37–54.

Callmann, Ellen

1991 "Lo sport aristocratico della caccia: Una 'spalliera' per Federico di Montefeltro." *Bollettino d'arte,* ser. 6, 77, no. 65, pp. 67–70.

Calvesi, Maruizio

1998 *Piero della Francesca.* Milan.

Calzini, Egidio

1897 *Urbino e i suoi monumenti.* Rocca S. Casciano.

1899 *Urbino e i suoi monumenti.* 2nd ed. Florence.

1901 "La Galleria annessa all'Istituto di Belle Arti di Urbino." *L'arte* 4, pp. 361–90.

Calzona, Arturo

2004 "Leon Battista Alberti e Luciano Laurana: Da Mantova ad Urbino o da Urbino a Mantova?" In Fiore 2004, vol. 2, pp. 433–92.

Camerota, Filippo

2001a as ed. *Nel segno di Masaccio: L'invenzione della prospettiva.* Exh. cat., Galeria degli Uffizi, 2001–2. Florence.

2001b "Perspectiva pratica." In Camerota 2001a, pp. 19–22.

2001c "L'esperienza di Brunelleschi." In Camerota 2001a, pp. 27–31.

Campbell, Ian, Arnold Nesselrath, and Johannes Röll, eds.

2004 *The Paper Museum of Cassiano del Pozzo: A Catalogue Raisonné, Series A, Antiquities and Architecture, IX, Ancient Roman Topography and Architecture.* 3 vols. London.

Campbell, Lorne

1998 *The Fifteenth Century Netherlandish Schools.* London: National Gallery.

Canali, Ferruccio

1992 "I tempietti della santissima Annunziata, di san Miniato al Monte e di santa Maria dell'Impruneta." In *L'architettura di Lorenzo il Magnifico,* ed. Cristina Acidini Luchinat, Gabriele Morolli, and Luciano Marchetti, pp. 32–36. Exh. cat. Cinisello Balsamo.

1999 "Michelozzo di Bartolomeo e Leon Battista Alberti a Firenze e in Adriatico. Addenda inedite di Corrado Ricci al suo Tempio Malatestiano (1924–1934): Nuove Marginalia sulle architetture." *Bollettino della Società di Studi Fiorentini* 4, pp. 9–37.

Caplow, Harriet McNeal

1974 "Sculptors' Partnership in Michelozzo's Florence." *Studies in the Renaissance* 21, pp. 145–75.

1977 *Michelozzo.* 2 vols. New York.

1998 "La bottega di Michelozzo e i suoi assistenti." In Morolli 1998a, pp. 231–36.

Cardona, Mario

1965 *Camerino: Un secolo e sei pittori.* Camerino.

Carloni, Livia

1998 "La Madonna di Filippo Lippi di Tarquinia." In *I Vitelleschi: Fonti, realtà e mito,* ed. Giovanna Mencarelli, with M. L. Perotti e S. Sabbatini, pp. 205–15. Civitavecchia.

Casalini, Eugenio M.

1995 *Michelozzo di Bartolommeo e l'Annunziata di Firenze.* Florence.

Casazza, Ornella

1992 "I dipinti su tavola: Storia e tecnica operativa." In *Conservazione dei dipinti su tavola,* ed. Luca Uzielli and Ornella Casazza, pp. 9–34. Florence.

Castelli, Ciro, Marco Ciatti, Mauro Parri, and Andrea Santacesaria

1997 "Considerazioni e novità sulla costruzione dei supporti lignei nel Quattrocento." *OPD Restauro* 9, pp. 162–74.

Castelli, Ciro, Mauro Parri, and Andrea Santacesaria

2001 "Tecnica artistica, stato di conservazione e restauro della Croce in rapporto con altre opere di Giotto. Il supporto ligneo." In *Giotto: La Croce di Santa Maria Novella,* ed. Marco Ciatti and Max Seidel, pp. 247–72. Florence.

Castelli, Maria Cristina

1992 "Flagellazione di Cristo." In Dal Poggetto 1992, pp. 118–21.

Casu, Stefano G.

1996 "Lazzaro Bastiani: La produzione giovanile e della prima maturità." *Paragone,* ser. 3, 8–10, nos. 557–61, pp. 60–89.

Cavalcaselle, Giovan Battista, and Joseph Archer Crowe

1886– *Storia della pittura in Italia dal secolo II*
1908 *al secolo XVI.* 11 vols. Florence.

Cavalcaselle, Giovan Battista, and Giovanni Morelli

1896 "Catalogo delle opere d'arte nelle Marche e nell'Umbria (1861–1862)." *Le Gallerie Nazionali Italiane: Notizie e documenti* 2, pp. 191–349.

Cavalieri, Federico

1998 "Una nuova presenza oltremontana

nella pittura milanese dell'età sforzesca." *Nuovi studi: Rivista di arte antica e moderna* 3, no. 5, pp. 29–37.

Cavallaro, Anna, and Enrico Parlato, eds.
1988 *Da Pisanello alla nascita dei Musei Capitolini. L'Antico a Roma alla vigilia del Rinascimento.* Exh. cat., Musei Capitolini, Rome. Milan and Rome.

Cellini, Benvenuto
1857 *I trattati dell'oreficeria e della scultura* [1568]. Ed. Carlo Milanesi. Florence.

Cennini, Cennino
2003 *Il libro dell'arte* [1437]. Ed. Fabio Frezzato. Vicenza.

Cerboni Baiardi, Giorgio, Giorgio Chittolini, and Piero Floriani, eds.
1986 *Federico da Montefeltro: Lo stato. Le arti. La cultura.* 3 vols. Rome.

Ceriana, Matteo
1997 "Sull'architettura dipinta della pala." In Trevisani and Daffra, 1997 pp. 115–66.
2002a "Note sull'architettura e la scultura nella Camerino di Giulio Cesare da Varano." In De Marchi and Giannatiempo López 2002, pp. 98–115.
2002b "Il portico rinascimentale e l'opera di Ambrogio Barocci a Spoleto." In *La Cattedrale di Spoleto: Storia, arte, conservazione,* ed. Giordana Benazzi and Giovanni Carbonara, pp. 288–303. Milan.

Cerretelli, Claudio
1995 "La pieve e la Cintola: Le trasformazioni legate alla reliquia." In *La Sacra Cintola nel duomo di Prato,* pp. 79–161. Prato.
1998 as ed. *I tesori della città: Pittura del Tre-Quattrocento a Prato.* Exh. cat., Museo di Pittura Murale. Prato.

Cheles, Luciano
1996 "Piero della Francesca e i Vittoriani." In Dalai Emiliani and Curzi 1996, pp. 569–92.

Cherubini, Giovanni, and Giovanni Fanelli, eds.
1990 *Il Palazzo Medici Riccardi i di Firenze.* Florence.

Chieli, Francesca
1998 "L'influenza di Michelozzo architetto sulla pittura coeva." In Morolli 1998a, pp. 309–14.

Chiesa di S. Domenico
1874 "La porta della chiesa di S. Domenico in Urbino." *Il Raffaello* 6, no. 7 (March 10), pp. 25–26.

Christiansen, Keith
1979 "For Fra Carnevale." *Apollo* 109, pp. 198–201.
1981 Review of Wohl 1980 and Horster 1980. *Apollo* 114, pp. 66–67.
1983 "Early Renaissance Narrative Painting in Italy." *Metropolitan Museum of Art Bulletin* 41, no. 2 (fall).
1990 Review of Bellosi 1990a. *Burlington Magazine* 132, pp. 736–39.
1991 "Some Observations on the Brancacci Chapel Frescoes after Their Cleaning." *Burlington Magazine* 133, pp. 4–20.
1991a "Sano di Pietro's S. Bernardino Panels." *Burlington Magazine* 133, pp. 451–52.
1993 "A Drawing for Fra Carnevale." *Master Drawings* 31, pp. 363–69.

1993a "Alcune osserfazioni critiche sulla pala di Perugia e sulla sua collocazione nella carriera di Piero della Francesca." In *Piero della Francesca: Il polittico di Sant'Antonio,* ed. Vittoria Garibaldi, pp. 117–24. Perugia.
1996 "Domenico Veneziano." In *The Dictionary of Art,* ed. Jane Turner, vol. 9, pp. 97–104. London and New York.

Ciardi, Roberto Paolo
1965 *La raccolta Cagnola: Dipinti e sculture.* Pisa.

Ciardi Dupré Dal Poggetto, Maria Grazia
2003 "Sulla probabile attività di Michelozzo e della sua cerchia per le Marche." In *Venezia, le Marche e la civiltà adriatica: Per festeggiare i 90 anni di Pietro Zampetti,* ed. Ileana Chiappini Di Sorio and Laura De Rossi, pp. 200–207. Venice.

Ciardi Dupré Dal Poggetto, Maria Grazia, and Paolo Dal Poggetto
1983 as eds. *Urbino e le Marche prima e dopo Raffaello.* Exh. cat., Palazzo Ducale, Urbino. Florence.
1996 "I dipinti di Palazzo Medici nell' inventario di Simone di Stagio delle Pozze." In *La Toscana al tempo di Lorenzo il Magnifico: Politica, economia, cultura, arte; atti del convegno di studi, 1992,* pp. 131–62. Pisa.

Ciatti, Marco, Ciro Castelli, and Andrea Santacesaria, eds.
1999 *Dipinti su tavola: La tecnica e la conservazione dei supporti.* Florence.

Cieri Via, Claudia
1996 "Ipotesi di un percorso funzionale e simbolico nel palazzo ducale di Urbino attraverso le immagini." In Cieri Via 1996a, pp. 47–64.
1996a as ed. *Città e corte nell'Italia di Piero della Francesca: Atti del convegno internazionale di studi (Urbino 1992).* Venice.
1999 "Ornamento e varietà: Riflessi delle teorie albertiane nella produzione artistico-figurativa fra '400 e '500." In *Leon Battista Alberti, architettura e cultura: Atti del convegno internazionale (Mantova, 16–19 novembre 1994),* pp. 235–50. Florence.

Cionini Visani, Maria
1973 "Un libro sul Boccati." *Arte veneta* 27, pp. 321–25.

Clark, Kenneth
1951 *Piero della Francesca.* London and New York.
1969 *Piero della Francesca; Complete Edition.* 2nd ed. London and New York.

Clementini, Cesare
1969 *Raccolto istorico della fondazione di Rimino e dell'origine e vite de' Malatesti.* Facsimile of the Rimini, 1617–27 ed. 2 vols. Bologna.

Cleri, Bonita
1996 "Fra' Carnevale e la cultura prospettica urbinate." In Cieri Via 1996a, pp. 347–59.
1997a *Antonio da Fabriano: Eccentrico protagonista nel panorama artistico del Quattrocento marchigiano.* Contributions by Fabio Marcelli. Cinisello Balsamo.
1997b "Ospedali e santi. Protettori per il corpo e per l'anima." In *Homo Viator nella fede, nella cultura, nella storia: Atti*

del convegno di studi (Abbazia di Chiaravalle di Fiastra, 1996), ed. Bonita Cleri. Urbino.
2004 as ed. *Bartolomeo Corradini (Fra Carnevale) nella cultura urbinate del XV secolo: Atti del convegno di studi (San Cassiano al Cavallino, Urbino 2002).* Urbino.

Clough, Cecil H.
1970 "Piero della Francesca: Some Problems of His Art and Chronology." *Apollo* 91 (April), pp. 278–89.
1973 "Federigo da Montefeltro's Patronage of the Arts, 1468–1482." *Journal of the Warburg and Courtauld Institutes* 36, pp. 129–44.

Colasanti, Arduino
1932 *La pittura del Quattrocento nelle Marche.* Milan.
1933 "Girolamo di Giovanni da Camerino." In *Enciclopedia Italiana,* vol. 17, p. 286. Rome.

Colnaghi, Dominic Ellis
1928 *A Dictionary of Florentine Painters from the 13th to the 17th Centuries.* London.

Coltrinari, Francesca
2004 *Tolentino: Crocevia di artisti alla metà del Quattrocento.* Ascoli Piceno.

Conti, Alessandro
1979a "Una miniatura ed altre considerazioni sul Pisanello." In *Itinerari (Contributi alla storia dell'arte in memoria di Maria Luisa Ferrari),* vol. 1, pp. 67–76. Florence.
1979b "L'evoluzione dell'artista." In *Storia dell'arte italiana,* vol. 2, p. 117–264. Turin.
1990 *La Biblioteca Malatestiana.* Milan.

Cordella, Romano
1992 "Nicola da Siena autore del polittico di S. Eutizio nel 1472." *Spoletium* 33–34, no. 36–37, pp. 106–7.

Cordellier, Dominique, et al.
1996 *Pisanello: Le peintre aux sept vertus.* Exh. cat., Musée du Louvre. Paris.

Corti, G.
1969 "New Documents Concerning Luca della Robbia's Federighi Tomb." *Mitteilungen des Kunsthistorischen Institutes in Florenz* 14, no. 1, pp. 24–32.

Crocetti, Giuseppe
1990 "Giovanni di Stefano da Montelparo intagliatore marchigiano del sec. XV," part 2. *Arte cristiana* 78, no. 736, pp. 15–30.

Cropper, Elizabeth, ed.
1994 *Florentine Drawing at the Time of Lorenzo the Magnificent: Papers from a Colloquium Held at the Villa Spelman, Florence, 1992.* Bologna.

Crowe, Joseph Archer, and Giovan Battista Cavalcaselle
1864– *A New History of Painting in Italy,*
66 *from the Second to the Sixteenth Century.* 3 vols. London.
1871 *A History of Painting in North Italy: Venice, Padua, Vicenza, Verona, Ferrara, Milan, Friuli, Brescia, from the Fourteenth to the Sixteenth Century.* Ed. Tancred Borenius. 2 vols. London.
1903– *A History of Painting in Italy, Umbria,*
14 *Florence, and Siena, from the Second to the Sixteenth Century.* 2nd ed. 6 vols. Ed. Langton Douglas, with S. Arthur

Strong (vols. 1–3); with G. de Nicola (vol. 4); and Tancred Borenius (vols. 5–6). London.

Cruttwell, Maud
1902 *Luca and Andrea della Robbia and Their Successors.* London.

Cuccini, Gustavo
1990 *Agostino di Duccio: Itinerario di un esilio.* Perugia.

Cunningham, Charles C.
1937 "A Great Renaissance Panel." *Bulletin of the Museum of Fine Arts, Boston* 35, no. 210, pp. 46–50.

Curzi, Valter
1987 "Girolamo di Giovanni." In *La pittura in Italia: Il Quattrocento,* vol. 2, p. 650. Milan.

Dabell, Frank
1984 "Antonio d'Anghiari e gli inizi di Piero della Francesca." *Paragone* 35, no. 417, pp. 73–76.
2003 "Riscoperte e dispersioni dell'arte marchigiana tra Ottocento e Novecento." In De Marchi and Falaschi 2003, pp. 895–901.

Dacos, Nicole
1961 "À propos d'un fragment de sarchophage de Grottaferrata e de son influence à la Renaissance." *Bulletin de l'Institut Historique Belge de Rome* 33, pp. 63–50.

Dalai Emiliani, Marisa, and Valter Curzi, eds.
1996 *Piero della Francesca tra arte e scienza: Atti del Convegno internazionale di studi, Arezzo, 8–11 ottobre 1992; Sansepolcro, 12 ottobre 1992.* Venice.

Dalli Regoli, Gigetta
1960 "Un disegno giovanile di Filippo Lippi." *Critica d'arte* 7, pp. 199–205.
1994 "Postille ai disegni dal modello: I temi e le forme della sperimentazione." In Cropper 1994, pp. 73–81.
2000 *Il gesto e la mano.* Florence.

Dalmasso, Franca, Giovanna Galante Garrone, and Giovanni Romano
1993 *Accademia Albertina: Opere scelte della Pinacoteca.* Turin.

Dal Poggetto, Paolo
1988 as ed. *Capolavori per Urbino: Nove dipinti già di collezione Cini, ceramiche roveresche, e altri acquisti dello Stato (1983–1988).* Exh. cat., Galleria Nazionale delle Marche, Urbino. Florence.
1991 "Ciò che era finora invisibile nella 'camera picta' del Palazzo Ducale di Urbino." *Bollettino d'arte,* ser. 6, 77, no. 65, pp. 71–78.
1992a as ed. *Piero e Urbino: Piero e le Corti rinascimentali.* Exh. cat., Palazzo Ducale. Venice.
1992b "Il maestro delle Tavole Barberini, chi era costui." In Dal Poggetto 1992a, pp. 301–5.
1998 as ed. *Fioritura tardogotica nelle Marche.* Exh. cat., Palazzo Ducale, Urbino. Milan.
2001 as ed. *Ricerche e studi sui 'Signori del Montefeltro' di Piero della Francesca e sulla 'Città Ideale.'* Quaderni Soprintendenza di Urbino, 5, III. S. Angelo in Vado.
2003a "Il punto sul 'Maestro delle Tavole Barberini.'" In De Marchi and Falaschi 2003, vol. 2, pp. 747–76.

2003b *La Galleria Nazionale delle Marche e le altre Collezioni nel Palazzo Ducale di Urbino.* Urbino and Rome.

2003c "Retrato de Federico de Montefeltro y de su Hijo Guidobaldo." In *Pedro Berruguete: El primer pintor renacentista de la Corona de Castilla,* ed. Pilar Silva Maroto et al., pp. 120–25. Palencia.

Damianaki, Chrysa

2000 *The Female Portrait Busts of Francesco Laurana.* Rome.

Danti, Cristina, ed.

2002 *La Trinità di Masaccio: Il restauro dell'anno Duemila.* Florence.

Darr, Alan Phipps, ed.

1985 *Italian Renaissance Sculpture in the Time of Donatello.* Exh. cat., Detroit Institute of Arts; Kimbell Art Museum, Fort Worth, 1985–86. Detroit.

Darr, Alan Phipps, and Giorgio Bonsanti, eds.

1986 *Donatello e i suoi: Scultura fiorentina del primo Rinascimento.* Exh. cat., Forte di Belvedere, Florence. Detroit and Milan.

Davies, Elton M., and Dean Snyder

1970 "Piero della Francesca's Madonna of Urbino: A Further Examination." *Gazette des Beaux-Arts,* ser. 6, 75 (April), pp. 193–212.

Davies, Martin

1961 *The Earlier Italian Schools.* The National Gallery Catalogues. London.

Davies, Paul, and David Hemsoll

1983 "Renaissance Balauster and the Antique." *Architectural History: Journal of the Society of Architectural Historians of Great Britain 26,* pp. 1–23.

Davis, Margaret Daly

1977 *Piero della Francesca's Mathematical Treatises: The Trattato d'abaco and Libellus de quinque corporibus regularibus.* Ravenna.

De Angelis, Laura, and Alessandro Conti

1976 "Un libro antico della sagrestia di Sant'Ambrogio." *Annali della Scuola Normale Superiore di Pisa, Classe di Lettere e Filosofia,* ser. 3, 6, no. 1, pp. 97–109.

Degenhart, Bernhard

1950 "Michele di Giovanni di Bartolo: Disegni dall'antico e il camino 'della Iole.'" *Bollettino d'arte,* ser. 4, 35, no. 3 (July–September), pp. 208–15.

1959 "Domenico Veneziano als Zeichner." In *Festschrift Friedrich Winkler,* pp. 100–113. Berlin.

Degenhart, Bernhard, and Annegrit Schmitt

1968 *Corpus der italienischen Zeichnungen, 1300–1450.* Part 1. 4 vols. Berlin.

Degli Abati Olivieri Giordani, Annibale

1785 *Memorie di Alessandro Sforza signore di Pesaro.* Pesaro.

Dei, Benedetto

1984 *La cronica dall'anno 1400 all'anno 1500.* Ed. Roberto Barducci. Florence.

Deiseroth, Wolf

1970 "Der Triumphbogen als grosse Form in der Renaissancebaukunst Italiens: Studien zur Entwicklungsgeschichte der profanen und sakralen Schaufront des 15. und frühen 16.

Jahrhunderts." Doctoral thesis, Ludwig-Maximilians Universität, Munich.

Del Bravo, Carlo

1973 "L'umanesimo di Luca della Robbia." *Paragone* 24, no. 285, pp. 3–34.

De Man, Hendrik

1950 *Jacques Coeur, der königliche Kaufmann.* Bern.

De Marchi, Andrea

1992 *Gentile da Fabriano: Un viaggio nella pittura italiana alla fine del gotico.* Milan.

1993 "Pedanterie pierfrancescane." *Prospettiva* 72, pp. 84–93.

1994a "Diversità di Antonio da Fabriano." In *Un testamento pittorico di fine '400: Gli affreschi restaurati di Antonio da Fabriano in San Domenico,* pp. [9–16]. Fabriano.

1994b "Domenico Veneziano alla mostra degli Uffizi." *Kermes* 7, no. 20 (May–August), pp. 30–40.

1995 "Identità di Giuliano Amadei miniatore." *Bollettino d'arte,* ser. 6, 80, no. 93–94, pp. 119–58.

1996a "Centralità di Padova: Alcuni esempi di interferenza tra scultura e pittura nell'area adriatica alla metà del Quattrocento." In Dempsey 1996, pp. 57–79.

1996b "Un raggio di luce su Filippo Lippi a Padova." *Nuovi studi: Rivista di arte antica e moderna,* 1, no. 1, pp. 5–23.

1998 "Ancora che l'arte fusse diversa." In Gentilini 1998, pp. 17–30.

2000 "Agenda per uno studio sulla pittura del Quattrocento a Camerino." In *Adriatico: Un mare di storia, arte, cultura; atti del convegno, Ancona, 20–22 maggio 1999,* ed. Bonita Cleri, vol. 2, pp. 63–82. Ancona.

2002a as ed., *Pittori a Camerino nel Quattrocento.* Milan.

2002b "Pittori a Camerino nel Quattrocento: Le ombre di Gentile e la luce di Piero." In De Marchi 2002a, pp. 23–99.

2002c "Viatico per la pittura camerte." In De Marchi and Giannatiempo López 2002, pp. 51–67.

2002d "Matteo di Giovanni ai suoi esordi e il polittico di San Giovanni in Val d'Afra." In *Giovanni di Matteo e la pala d'altare nel senese e nell'aretino 1450–1500: Atti del convegno internazionale di studi, Sansepolcro, 9–10 ottobre 1998,* ed. Davide Gasparotto and Serena Magnani, pp. 57–76. Montepulciano.

2002e "Norma e varietà nella transizione dal polittico alla pala quadra." In *Storia delle arti in Toscana: Il Quattrocento,* ed. Gigetta Dalli Regoli and Roberto Paolo Ciardi, pp. 199–222. Florence.

2003 "Camerino minore." In De Marchi and Falaschi 2003, vol. 2, pp. 369–406.

De Marchi, Andrea, and Giampiero Donnini

1994 *Un testamento pittorico di fine '400. Gli affreschi restaurati di Antonio da Fabriano in San Domenico.* Fabriano.

De Marchi, Andrea, and Pier Luigi Falaschi, eds.

2003 *I Da Varano e le arti: Atti del convegno internazionale, Camerino, Palazzo

Ducale, 4–6 ottobre 2001.* 2 vols. Ripatransone.

De Marchi, Andrea, and Maria Giannatiempo López, eds.

2002 *Il Quattrocento a Camerino: Luce e prospettiva nel cuore della Marca.* Exh. cat., Convento San Domenico, Camerino. Milan.

De Marchi, Andrea, Fabio Marcelli, and Mauro Minardi

2002 *Rinascimento a Camerino: Giovanni Boccati e la prospettiva ornata.* Exh. cat., Pinacoteca di Brera, Milan, 2002–3. Milan.

De Marchi, Andrea, and Franco Polcri

2003 *L'affresco riscoperto di Falcidiano e la questione di Antonio di Anghiari pittore.* Sansepolcro.

De Maria, Sandro

1988 *Gli archi onorari di Roma e dell'Italia romana.* Rome.

Dempsey, Charles

1996 as ed. *Quattrocento adriatico: Fifteenth-Century Art of the Adriatic Rim, Villa Spelman Colloquia, Florence 1994.* Bologna.

2001 *Inventing the Renaissance Putto.* Chapel Hill.

Dennistoun, James

1851 *Memoirs of the Dukes of Urbino, Illustrating the Arms, Arts, and Literature of Italy, from 1440 to 1630.* 3 vols. London.

De Ricci, Seymour

1931 *The Gustave Dreyfus Collection: Reliefs and Plaquettes.* Oxford.

Destrée, Jules

1900 *Sur quelques peintres des Marches et de l'Ombrie.* Brussels and Florence.

De Vecchi, Pier Luigi, ed.

1967 *L'opera completa di Piero della Francesca.* Milan.

2000 *Museo Civico di Gualdo Tadino. Rocca Flea 1. Decorazione murale, dipinti, materiali lapidei, sculture, arredo civile ed ecclesiastico, tessuti.* Milan.

Dillon Bussi, Angela

1993 "Pseudo-Michele da Carrara o Maestro degli studioli?" In *Studi di storia dell'arte sul Medioevo e il Rinascimento nel centenario della nascita di Mario Salmi: Atti del convegno, Arezzo-Firenze 16–19 novembre 1989,* vol. 2, pp. 751–72. Florence.

Di Lorenzo, Andrea, ed.

1996a *Il polittico agostiniano di Piero della Francesca.* Exh. cat., Museo Poldi Pezzoli, Milan. Turin.

1996b "Piero della Francesca nel Museo Poldi Pezzoli." In Di Lorenzo 1996a, pp. 121–31.

1998 "Sui due polittici di Girolamo di Giovanni da Camerino conservati nella Pinacoteca di Brera." In *Itinerari d'arte in Lombardia dal XIII al XX secolo: Scritti offerti a Maria Teresa Binaghi Olivari,* ed. Matteo Ceriana and Fernando Mazzocca, pp. 55–65. Milan.

2001 as ed. *Omaggio a Beato Angelico: Un dipinto per il Museo Poldi Pezzoli.* Exh. cat., Museo Poldi Pezzoli, Milan. Cinisello Balsamo.

2002 "Maestro dell'Annunciazione di Spermento (Giovanni Angelo d'Antonio?)." In De Marchi 2002a, pp. 294–301.

Di Lorenzo, Andrea, Alessandra Mottola Molfino, Mauro Natale, and Annalisa Zanni, eds.

1991 *Le Muse e il principe: Arte di corte nel Rinascimento padano.* Exh. cat., Museo Poldi Pezzoli, Milan. 2 vols. Modena.

Dionysios of Fourna

1971 *Ermeneutica della pittura.* Ed. Giovanna Donato Grasso. Naples.

Di Stefano, Emanuela

2003 "L'arte negli archivi: Il profilo di Giovanni Angelo di Antonio." In De Marchi and Falaschi 2003, vol. 1, pp. 261–80.

Di Stefano, Emanuela, and Rossano Cicconi

2002 "Regesto dei pittori a Camerino nel Quattrocento." In De Marchi 2002a, pp. 448–66.

Di Teodoro, Francesco Paolo

1996 *La Sacra Conversazione di Piero della Francesca.* Milan.

Dolci, Michelangelo

1933 "Notizie delle pitture che si trovano nelle chiese e nei palazzi d'Urbino, edizione integrale del testo originale curata da Luigi Serra." *Rassegna Marchigiana* 11, pp. 281–367.

Donnini, Giampiero

1972 "Sui rapporti di Antonio da Fabriano e di Matteo da Gualdo con Gerolamo di Giovanni." *Antichità viva* 11, no. 11, pp. 3–10.

Dragoni, Patrizia

2003 "Documenti sulla vendita del frammento di polittico di Girolamo di Giovanni a Gualdo Tadino." In De Marchi and Falaschi 2003, vol. 2, pp. 789–98.

Dunkerton, Jill

1997 "Modifications to Traditional Egg Tempera Techniques in Fifteenth-Century Italy." In *Early Italian Paintings: Techniques and Analysis; atti del convegno, Maastricht, 9–10 ottobre 1996,* ed. Tonni Bakkenist, René Hoppen Brouwers, and Hélène Dubois, pp. 29–33. Maastricht.

Eckert, Anja

2000 *Die Rustika in Florenz. Mittelalterliche Mauerwerks- und Steinbearbeitungstechniken in der Toskana.* Braubach.

Edgell, George Harold

1932 *A History of Sienese Painting.* New York.

Edgerton, Samuel Y., Jr.

1969 "Alberti's Color Theory: A Medieval Bottle without Renaissance Wine." *Journal of the Warburg and Courtauld Institutes* 32, pp. 109–35.

1987 "How Shall This Be?" *Artibus et historiae* 16, pp. 45–53.

Ercolino, Maria Grazia

2000 "Giorgio di Matteo da Zara." In *Dizionario biografico degli Italiani,* vol. 55, pp. 367–71. Rome.

Ermini, Giuseppe

1971 *La storia dell'Università di Perugia.* Vol. 1. Florence.

"Esposizione regionale marchigiana"

1905 *Catalogo della mostra di belle arti.* Exh. cat. Macerata.

Eubel, Conrad

1901 *Hierarchia Catholica Medii Aevi.* Vol. 2, *Ab anno 1431 usque ad annum 1503 perducta.* Monasterii.

Fabriczy, Cornelius von

1893 "Il codice dell'anonimo Gaddiano (Cod. Magliabechiano XVII, 17) nella Biblioteca Nazionale di Firenze." *Archivio storico italiano*, ser. 5, 12, pp. 15–94.

1895 "Recensione a Charles Yriarte: Journal d'un sculpteur florentin au XV siècle. Livre de souvenirs de Maso di Bartolomeo dit Masaccio. Manuscrits conservés à la Bibliothèque de Prato et à la Magliabechiana de Florence. – Paris, I. Rothschild, 1894. – 4°, pp. 96, con 47 fototipie." *Archivio storico italiano* 15, pp. 391–96.

1906 "Pasquino di Matteo da Montepulciano." *Rivista d'arte* 4, no. 7, pp. 127–31.

1907 "Ambrogio di Antonio da Milano." *Repertorium für Kunstwissenschaft* 30, no. 3, pp. 251–54.

Fairbairn, Lynda

1998 *Italian Renaissance Drawings from the Collection of Sir John Soane's Museum.* 2 vols. London.

Faré, Michel-A., and Henri Baderou, eds.

1939 *Les chefs-d'oeuvre du Musée de Montpellier.* Preface by Paul Valéry. Exh. cat., Musée de l'Orangerie. Paris.

Fausti, Luigi

1915 *Le pitture di fra Filippo Lippi nel Duomo di Spoleto.* Perugia.

Favière, Jean

1992 *L'hôtel de Jacques Coeur à Bourges.* Paris.

Federigo da Montefeltro

1978 "Patente a Luciano Laurana," ed. A. Bruschi; transcribed by Domenico De Robertis. In *Scritti rinascimentali di architettura,* ed. Arnaldo Bruschi et al., pp. 1–22. Milan.

Felicetti, Stefano

1998 "Documenti per la storia dell'arte medievale a Fabriano e nel suo contado." In *Il Maestro di Campodonico: Rapporti artistici fra Umbria e Marche nel Trecento,* ed. Fabio Marcelli, pp. 210–27. Fabriano.

Feliciangeli, Bernardino

1906 *Sulla vita di Giovanni Boccati da Camerino, pittore del secolo decimoquinto.* San Severino Marche.

1910a "Documenti relativi al pittore Giovanni Angelo d'Antonio da Camerino." *Arte e storia* 29, pp. 366–371.

1910b *Sulle opere di Girolamo di Giovanni da Camerino, pittore del secolo XV.* Camerino.

1910– "Notizie della vita di Elisabetta
11 Malatesta-Varano." *Atti e memorie della Deputazione di Storia Patria per le Marche* 6, pp. 171–216.

1912 "Un gonfalone sconosciuto di Girolamo di Giovanni da Camerino." *Atti e memorie della Deputazione di Storia Patria per le Marche*, n.s., 8, pp. 237–45.

1920 *Il "Chronicon de origine, situ et nobilitate Sarnani" di Archidoro Salimbeni, nozze Pasqualetti-Dal Pero.* San Severino Marche.

Ferino-Pagden, Sylvia, Wolfgang Prohaska, and Karl Schütz

1991 *Die Gemäldegalerie des Kunst-*

historischen Museums in Wien: Verzeichnis der Gemälde. Vienna.

Ferretti, Massimo

1982 "I maestri della prospettiva." In *Storia dell'arte italiana,* vol. 4, pp. 459–585. Turin.

Field, Judith V.

1995 "Piero della Francesca and the 'Distance Point Method' of Perspective Construction." *Nuncius* 10, pp. 509–30.

n.d. *Piero della Francesca: A Mathematician's Art.* New Haven, forthcoming.

Filippini, Cecilia

2001 "Le *Vite* alla Malatestiana di Cesena." In *Biografia dipinta: Plutarco e l'arte del rinascimento, 1400–1550,* ed. Roberto Guerrini, pp. 180–81. La Spezia.

Filippini, Francesca

1984 "Restauro di un mobile dipinto: L'alcova di Federico da Montefeltro." Doctoral thesis, L'Opificio delle Pietre Dure e Laboratori di Restauro, Florence; adv. A. Paolucci and C. Castelli.

Fiocco, Giuseppe

1937 *Andrea Mantegna.* Milan.

1955 "Un'opera di Nicola di Maestro Antonio d'Ancona." *Arte veneta* 9, p. 211.

Fiore, Francesco Paolo, ed.

2004 *Francesco di Giorgio alla corte di Federico da Montefeltro: Atti del convegno internazionale di studi; Urbino, Monastero di Santa Chiara, 11–13 ottobre 2001.* 2 vols. Florence.

Fiore, Francesco Paolo, and Manfredo Tafuri

1993 *Francesco di Giorgio, architetto.* Exh. cat., Palazzo Pubblico, Siena. Milan.

Fischer, Chris

1994 "Ghirlandaio and the Origins of Cross-hatching." In Cropper 1994, pp. 245–53.

Fontana, Raffaella, Marzia Materazzi, Luca Pezzati, and Pasquale Poggi

2002 "Uno scanner per riflettografia infrarossa e immagine a colori." In *Lorenzo Lotto: Il compianto sul Cristo morto; studi, indagini, problemi conservativi; atti della giornata di studio, Bergamo 14 dicembre 2001,* pp. 113–15. Milan.

Fontebuoni, Luisa, ed.

1985 "Regesto documentario." In *Il Palazzo di Federico da Montefeltro: Restauri e ricerche,* ed. Maria Luisa Polichetti, pp. 355–421. Exh. cat. Urbino.

Forlani Tempesti, Anna

1986 as ed. *Capolavori e restauri.* Exh. cat., Palazzo Vecchio, 1986–87. Florence.

1994 "Studiare dal naturale nella Firenze di fine '400." In Cropper 1994, pp. 1–15.

Forni, Ulisse

2004 *Manuale del pittore restauratore. Studi per la nuova edizione.* Ed. Giorgio Bonsanti and Marco Ciatti. Florence.

Franceschini, Gino

1970 *I Montefeltro.* [Milan.]

Franco, Tiziana

1998 *Michele Giambono e il monumento a Cortesia da Serego in Santa Anastasia a Verona.* Padua.

Frankfurter, Alfred

1957 "Now the Old Masters at Williamstown." *ArtNews* 56, pp. 28–31.

Franklin, David

1998 "Il patrocinio della pala del Perugino per l'altar maggiore dell'Abbazia di Sansepolcro." In *L'Ascensione di Cristo del Perugino,* ed. Casciu Stefano, pp. 43–51. Cinisello Balsamo.

Fratucello, Cinzia

1999 "Note sull'iconografia degli affreschi della Camera d'Ercole nel Palazzo del Paradiso di Ferrara." *Musei ferraresi* 18, pp. 18–39.

Fredericksen, Burton B.

1974 *Giovanni di Francesco and the Master of Pratovecchio.* Malibu.

Freuler, Gaudenz

1991 as ed. *"Manifestatori delle cose miracolose": Arte italiana del '300 e '400 da collezioni in Svizzera e nel Liechtenstein.* Exh. cat., Villa Favorita, Fondazione Thyssen-Bornemisza, Lugano-Castagnola. Lugano-Castagnola and Einsiedeln.

Freuler, Gaudenz, and Michael Mallory

1991 "Sano di Pietro's Bernardino Altarpiece for the Compagnia della Vergine in Siena." *Burlington Magazine* 133, no. 1055, pp. 186–92.

Frey, Carl

1885 *Die Loggia dei Lanzi zu Florenz: Eine quellenkritische Untersuchung.* Berlin.

Frezzato, Fabio

2003 "Introduzione. La 'questione cenniniana': Committenti e destinatari." In Cennini 2003, pp. 11–17.

Frick Collection

1968 *The Frick Collection: An Illustrated Catalogue.* Vol. 2, *Paintings: French, Italian and Spanish.* Ed. Bernice Davidson and Edgar Munhall. New York.

Frizzoni, Gustavo

1882 "Das neue Museum Poldi Pezzoli in Mailand." *Zeitschrift für bildende Kunst* 17, pp. 116–23.

1895 "Miscellanea: Notizie concernenti oggetti d'arte, musei e gallerie del Regno, ricavate dal Bollettino ufficiale del Minastero della pubblica istruzione." *Archivio storico dell'arte,* n.s., 1, pp. 393–407.

1905 Review of Georges Lefenestre and Eugène Richtemberger, *La peinture en Europe. L'arte* 8, pp. 391–95.

1910 "Girolamo di Giovanni da Camerino nel Museo Poldi Pezzoli in Milano." *Rassegna bibliografica dell'arte italiana* 13, no. 5–7, pp. 45–48.

Frosinini, Cecilia

1987 "Alcune precisazioni su Mariotto di Cristofano." *Rivista d'arte,* ser. 4, 39, pp. 443–55.

1989 "Appunti sui forzerai e i dipintori nella Firenze del Quattrocento." In *Legno e restauro,* ed. Gennaro Tampone, pp. 139–50. Exh. cat. Florence.

1995 "Testimonianze pittoriche e di arredo tra Duecento e Quattrocento." in *La Cattedrale di Santa Maria del Fiore a Firenze,* ed. Cristina Acidini Luchinat, vol. 2, pp. 193–232. Florence.

1999 "Il contesto storico nell'evoluzione tipologica della pala d'altare: Alcune

note." In Ciatti, Castelli, and Santacesaria 1999, pp. 29–36.

Frosinini, Cecilia, and Carl Brandon Strehlke, eds.

2002 *The Panel Paintings of Masolino and Masaccio: The Role of Technique.* Contributions by Roberto Bellucci et al. Milan.

Fry, Roger

1930 "Notes on the Italian Exhibition at Burlington House," part 2. *Burlington Magazine* 56, pp. 129–30.

Fubini, Riccardo, and Anna Menci Gallorini

1972 "L'autobiografia di Leon Battista Alberti: Studio e edizione." *Rinascimento* 12, pp. 21–78.

Fucili Bartolucci, Anna

2004 "La Pievania di Castel Cavallino." In Cleri 2004, pp. 25–44.

Fusco, Laurie

1982 "An Unpublished 'Madonna and Child' by Fra Filippo Lippi." *J. Paul Getty Museum Journal* 10, pp. 1–16.

Gaborit, Jean-René, and Marc Bormand, eds.

2002 *Les Della Robbia: Sculptures en terre cuite émaillée de la Renaissance.* Exh. cat., Musée National Message Biblique Marc Chagall, Nice, and Musée National de Céramique, Sèvres, 2002–3. Paris.

Gaeta, Franco

1954 "L'avventura di Ercole." *Rinascimento* [La rinascita] 5, no. 1 (December), pp. 227–60.

Galluzzi, Paolo

1998 "Dall'artigiano all'artista-ingegnere: Filippo Brunelleschi uomo di confine." In *La grande storia dell'artigianato,* vol. 1, *Il Medioevo,* pp. 285–94. Florence.

Garibaldi, Vittoria, ed.

1996 *Un pittore e la sua città: Benedetto Bonfigli e Perugia.* Exh. cat., Palazzo dei Priori, Galleria Nazionale dell'Umbria, Perugia, 1996–97. Milan.

Garibaldi, Vittoria, and Francesco Federico Mancini

2004 *Perugino il divin pittore.* Exh. cat., Galleria Nazionale dell'Umbria and Centro Espositivo Rocca Paolina, Perugia. Milan.

Garosi, Gino, ed.

1978 *Inventario dei manoscritti della Biblioteca comunale di Siena.* Vol. 1. Siena.

2002 *Inventario dei manoscritti della Biblioteca comunale degli Intronati di Siena.* Vol. 1. 2nd ed. Siena.

Garzelli, Annarosa

1977 *La bibbia di Federico da Montefeltro: Un'officina libraria fiorentina, 1476–1478.* Rome.

Gattucci, Adriano

1981 "Frate Giacomo della Marca bibliofilo e un episodio librario del 1450." In *Miscellanea Augusto Campana,* vol. 1, pp. 313–54. 2 vols. Padua.

Gemäldegalerie, Staatliche Museen zu Berlin

1978 *Malerei 14.–18. Jahrhundert im Bode-Museum, Staatliche Museen zu Berlin, Gemäldegalerie.* Ed. Irene Geismeier and Hannelore Nützmann. 3d ed. Berlin.

Gentilini, Giancarlo
1992 *I Della Robbia: La scultura invetriata nel Rinascimento.* 2 vols. Florence.
1998 as ed. *I Della Robbia e l'arte nuova della scultura invetriata.* Exh. cat., Basilica di Sant'Alessandro, Fiesole. Florence.

Ghiberti, Lorenzo
1998 *I commentarii: Biblioteca Nazionale Centrale di Firenze, II, I, 333.* Ed. Lorenzo Bartoli. Florence.

Giannatiempo López, Maria
2004 "Antefatti al palazzo di Federico: Ritrovamenti, ipotesi." In Fiore 2004, vol. 1, pp. 147–66.

Giardini, Claudio, and Maria Rosaria Valazzi
1996 *Pesaro Museo Civico-Pinacoteca.* Bologna.

Giglioli, Odoardo H.
1906 *Empoli artistica.* Florence.

Gilbert, Creighton E.
1968 *Change in Piero della Francesca.* New York.
1977 "Peintres et menuisiers au debut de la Renaissance italienne." *Revue de l'art* 37, pp. 9–28.
1980 *Italian Art, 1400–1500: Sources and Documents.* Englewood Cliffs.
1984 "The Conversion of Fra Angelico." In *Scritti di storia dell'arte in onore di Roberto Salvini,* pp. 281–87. Florence.
1993 "The Function of the Barberini Panels." In *Studi per Pietro Zampetti,* ed. Varese Ranieri, pp. 146–52. Ancona.
2000 "The Function of the Barberini Panels, Addenda." *Critica d'arte,* ser. 8, 63, no. 6, pp. 24–30.

Ginzburg, Carlo
1994 *Indagini su Piero: Il Battesimo, il ciclo di Arezzo, la Flagellazione di Urbino.* Rev. ed. Turin.

Giovannozzi, Vera
1934 "Note su Giovanni di Francesco." *Rivista d'arte,* ser. 2, 16, no. 6, pp. 337–65.

Giraud, Jean-Baptiste
1878 *Recueil descriptif et raisonné des principaux objets d'art ayant figuré à l'Exposition rétrospective de Lyon, 1877.* [Lyon.]

Giuliano, Carlo, and Daniele Sanguineti, eds.
2004 *Filippo Lippi: Un trittico ricongiunto.* Exh. cat., Accademia Albertina. Turin.

Glasser, Hannelore
1969 "The Litigation Concerning Luca della Robbia's Federighi Tomb." *Mitteilungen des Kunsthistorischen Institutes in Florenz* 14, no. 1, pp. 1–24.

Gnoli, Umberto
1908 *L'arte umbra alla mostra di Perugia.* Bergamo.
1930–31 "Una tavola sconosciuta di Piero della Francesca." *Dedalo* 11, p. 133.

Goldthwaite, Richard
1972 "Schools and Teachers of Commercial Arithmetic in Renaissance Florence." *Journal of European Economic History* 1, pp. 418–33.
1984 *La costruzione della Firenze rinascimentale: Una storia economica e sociale.* Bologna.

Gombrich, Ernst
1972 *Symbolic Images.* London.
1976 *The Heritage of Apelles.* Oxford.

Goodison, Jack W., and G. H. Robertson
1967 *Catalogue of Paintings.* Vol. 2, *Italian Schools.* Cambridge: Fitzwilliam Museum.

Gordon, Dillian
2003 *The Fifteenth Century Italian Paintings.* Vol. 1. National Gallery Catalogues. London.

Gosebruch, Martin
1958 "Florentinische Kapitele von Brunelleschi bis zum Tempio Malatestiano und der Eigenstil der Frührenaissance." *Römisches Jahrbuch für Kunstgeschichte* 8, pp. 63–193.

Grayson, Cecil, ed.
1957 *An Autograph Letter from Leon Battista Alberti to Matteo de' Pasti, November 18, 1454.* New York.

Grendler, Paul F.
1995 "What Piero Learned in School: Fifteenth-Century Vernacular Education." In Lavin 1995, pp. 161–74.

Grodecki, Louis
1975 Le "Maitre des vitraux" de Jacques Coeur." In *Études d'art français offertes à Charles Sterling,* ed. Albert Châtelet and Nicole Reynaud, pp. 105–25. Paris.

Grohn, Hans Werner
1995 *Die italienischen Gemälde: Kritischer Katalog.* Hannover: Niedersächsisches Landesmuseum.

Grossi, Carlo
1856 *Degli uomini illustri di Urbino. Commentario del P. Carlo Grossi con aggiunte scritte dal conte Pompeo Gherardi.* Urbino.

Guasti, Cesare
1862 "Inventario della libreria urbinate compilato nel secolo XV da Federigo Veterano bibliotecario di Federigo I da Montefeltro duca d'Urbino." *Giornale storico degli archivi toscani* 6, no. 1, pp. 127–47.
1863 "Inventario della libreria urbinate compilato nel secolo XV da Federigo Veterano bibliotecario di Federigo I da Montefeltro duca d'Urbino." *Giornale storico degli archivi toscani* 7, II, pp. 46–55; III, pp. 130–54.
1865 "Di un maestro d'organi del secolo XV nato in Prato e vissuto in Firenze." *Archivio storico italiano,* ser. 3, 2, no. 2, pp. 48–79.

Guerrieri, Ruggero
1933 *Storia civile ed ecclesiastica del comune di Gualdo Tadino.* Gubbio.

Guerrini, Alessandra
1988 "Intorno al polittico di Pietro Lorenzetti per la Pieve di Arezzo." *Rivista d'arte,* ser. 4, 40, pp. 3–29.

Guerrini, Olindo, and Carlo Ricci, eds.
1969 *Il libro dei colori segreti del secolo XV.* Reprint of 1887 ed. Bologna.

Guidotti, Alessandro
1984 "Battiloro e dipintori a Firenze fra Tre e Quattrocento: Bastiano di Giovanni e la sua clientela (dal Catasto del 1427)." In *Scritti di storia dell'arte in onore di Roberto Salvini,* pp. 239–49. Florence.
1986 "Il mestiere del 'dipintore' nell'Italia due-trecentesca." In *La pittura in Italia. Il Duecento e il Trecento,* vol. 2, pp. 529–40. Milan.

Guillaume, Jean
1990 "Désacord parfait: Ordres et mesurés

dans la Chapelle des Pazzi." *Annali di architettura* 2, pp. 9–23.

Gurrieri, Ottorino
n.d. *I tesori artistici di Perugia in Italia e nel mondo.* Perugia.

Haines, Margaret
1983 *La Sacrestia delle Messe del Duomo di Firenze.* Florence.
2001 "I 'maestri di prospettiva.'" In Camerota 2001a, pp. 99–104.

Hall, Marcia B.
1992 *Color and Meaning: Practice and Theory in Renaissance Painting.* Cambridge.

Hatfield, Rab
1970 "The Compagnia de' Magi." *Journal of the Warburg and Courtauld Institutes* 33, pp. 107–61.

Heinz, G.
1985 "Bemerkungen zu einem Quattrocento-Bildnis der Gemäldegalerie im Kunsthistorischen Museum." In *Festschrift Heinz Mackowitz,* ed. S. K. Moser and C. Bertsch, pp. 105–8. Innsbruck.

Hémery, Axel
2003 *La peinture italienne au Musée des Augustins: Catalogue raisonné.* Toulouse.

Hendy, Philip
1968 *Piero della Francesca and the Early Renaissance.* London and New York.
1974 *European and American Paintings in the Isabella Stewart Gardner Museum.* Boston.

Herald, Jacqueline
1981 *Renaissance Dress in Italy, 1400–1500.* London and Atlantic Highlands, N.J.

Herdejürgen, Helga, ed.
1996 *Stadtrömische und italische Girlandensarkophage. Part 1, Die Sarkophage des ersten und zweiten Jarhunderts.* Vol. 6, part 2 of *Die Antiken Sarkophagreliefs.* Berlin.

Herzner, Volker
1976 "Donatello und die Sakristei-Türen des Florentiner Domes." *Wiener Jahrbuch für Kunstgeschichte* 29, pp. 53–63.

Hessert, Marlis von
1991 *Zum Bedeutungswandel der Herkules-Figur in Florenz von den Anfängen der Republik bis zum Prinzipat Cosimo I.* Cologne, Weimar, and Vienna.

Heydenreich, Ludwig H.
1967 "Federico da Montefeltro as a Building Patron: Some Remarks on the Ducal Palace of Urbino." In *Studies in Renaissance and Baroque Art Presented to Anthony Blunt on His 60th Birthday,* ed. Samuel Courtauld et al., pp. 1–6. London and New York.
1977 "Baluster und Balustrade: Eine 'invenzione' der toskanischen Frührenaissancearchitektur." In *Festschrift Wolfgang Braunfels,* ed. Friedrich Piel and Joerg Traeger, pp. 123–32. Tübingen

Höfler, Janez
1984 "Maso di Bartolomeo in Dubrovnik (1455–1456): Zur Biographie des Florentiner Bronzegiessers." *Mitteilungen des Kunsthistorischen Institutes in Florenz* 28, no. 3, pp. 389–94.
1988 "Maso di Bartolomeo und sein Kreis." *Mitteilungen des Kunst-*

historischen Institutes in Florenz 32, no. 3, pp. 537–46.
1996 "Florentine Masters in Early Renaissance Dubrovnik: Maso di Bartolomeo, Michele di Giovanni, Michelozzo, and Salvi di Michele." In Dempsey 1996, pp. 81–102.
1998 "Maso di Bartolomeo e la sua cerchia a Urbino: Il portale di San Domenico e il primo palazzo di Federico da Montefeltro." In Morolli 1998a, pp. 249–55.
1999 "Novità sull'attività di Michele di Giovanni da Fiesole a Dubrovnik (Ragusa) e la paternità artistica dell'appartamento della Jole nel Palazzo Ducale di Urbino." *Territori e contesti d'arte* 3–4, pp. 11–32.
2004 *Der Palazzo Ducale in Urbino unter den Montefeltro (1376–1508). Neue Forschungen zur Bau- und Ausstattungsgeschichte.* Regensburg.

Holmes, Megan
1999 *Fra Filippo Lippi: The Carmelite Painter.* New Haven.
2000 "Giovanni Benci's Patronage of the Nunnery, Le Murate." In *Art, Memory, and Family in Renaissance Florence,* ed. Giovanni Ciappelli and Patricia Lee Rubin, pp. 114–34. Cambridge.

Horne, Herbert P.
1908 *Alessandro Filipepi, Commonly Called Sandro Botticelli, Painter of Florence.* London.
1980 *Sandro Botticelli, Painter of Florence.* Reprint of 1908 ed. with new introduction by John Pope-Hennessy. Princeton.

Horster, Marita
1980 *Andrea del Castagno. Complete Edition with a Critical Catalogue.* Oxford.

Humfrey, Peter
1985 "The Life of St. Jerome Cycle from the Scuola di San Girolamo in Cannaregio." *Arte veneta* 39, pp. 41–46.
1994 "The Bellini, the Vivarini, and the Beginnings of the Renaissance Altarpiece in Venice." In *Italian Altarpieces, 1250–1550: Function and Design,* ed. Eve Borsook and Fiorella Superbi Gioffredi, pp. 139–176. Oxford.

Hyman, Isabelle
1977 *Fifteenth Century Florentine Studies: The Palazzo Medici and a Ledger for the Church of San Lorenzo.* New York.

Iacobilli, Ludovico
1638 *Vite de' santi e beati di Gualdo e della regione di Taino nell'Umbria descritte. . . .* Foligno.

Jacobsen, Werner
2001 *Die Maler von Florenz zu Beginn der Renaissance.* Munich.

Janitschek, Hubert
1877 *Leone Battista Alberti's kleinere kunsttheoretische Schriften.* Vienna.

Jansen, Dieter
1987–88 "Fra Filippo Lippis Doppelbildnis im New Yorker Metropolitan Museum." *Wallraf-Richartz-Jahrbuch* 48–49, pp. 97–121.

Janson, Horst Woldemar
1961 "The 'Image Made by Chance' in Renaissance Thought." In *De artibus*

opuscula XL: Essays in Honor of Erwin Panofsky, ed. Millard Meiss, vol. 1, pp. 254–66; vol. 2, pp. 87–88. New York. Reprinted in *16 Studies,* pp. 53–69. New York, 1973.

Joannides, Paul
1989 "A Portrait by Fra Carnevale." *Source* 8, no. 3, pp. 7–10.

Kanter, Laurence B.
1994 *Italian Paintings in the Museum of Fine Arts, Boston.* Vol. 1, *13th–15th Century.* Boston.

Kemp, Martin
1977 "From 'Mimesis' to 'Fantasia': The Quattrocento Vocabulary of Creation and Genius in the Visual Arts." *Viator* 7, pp. 347–98.

Kennedy, Clarence
1932 "Il Greco aus Fiesole." *Mitteilungen*
34 *des Kunsthistorischen Institutes in Florenz* 4, no. 1, pp. 25–40.

Kennedy, Ruth Wedgwood
1938 *Alesso Baldovinetti: A Critical and Historical Study.* New Haven.

Kent, Dale V., and Francis William Kent
1979 "Two Comments of March 1445 on the Medici Palace." *Burlington Magazine* 121, no. 921 (December), pp. 795–96.

Kimpel, Dieter
1995 "L'attività costruttiva nel Medioevo: Strutture e trasformazioni." In *Cantieri medievali,* ed. Roberto Cassanelli, pp. 11–50. Milan.

Koch, Guntram, ed.
1975 *Die mythologischen Sarkophage.* Vol. 1, *Meleager.* Vol. 12 of *Die Antiken Sarkophagreliefs.* Berlin.

Kraus, K.
1971 "Jole." In *Enciclopedia dantesca,* vol. 3, p. 501. Rome.

Krautheimer, Richard
1956 *Lorenzo Ghiberti.* Princeton. Paperback ed., Princeton, 1982.
1994 "The Panels in Urbino, Baltimore and Berlin Reconsidered." In Millon and Magnano Lampugnani 1994, pp. 233–57.

Krinsky, Carol Herselle
1970 "Representations of the Temple of Jerusalem before 1500." *Journal of the Warburg and Courtauld Institutes* 33, pp. 1–19.

Kruft, Hanno-Walter
1995 *Francesco Laurana: Ein Bildhauer der Frührenaissance.* Munich.

Kuczman, Mazimierz, ed.
1998 *Donatorce – w Holdzie: Katalog wystawy odnowionych obrazów i rod zinnych pamiatek z daru Karoliny Lanckoronskiej* (To the donor in homage: A catalogue of restored paintings and family mementoes from Korolina Lanckoronska's donation). Exh. cat., Wawel Royal Castle. Krakow.

Kury, Gloria
1978 *The Early Work of Luca Signorelli, 1465–1490.* New York.

Labò, Mario
1907 *La mostra di antica arte umbra a Perugia.* Turin.

Lachi, Chiara
1995 *Il Maestro della Natività di Castello.* Florence.

Laclotte, Michel
1956 as ed. *De Giotto à Bellini: Les primitifs italiens dans les musées de France.* Exh. cat., Musée de l'Orangerie. Paris.
1978 "Une chasse du Quattrocento florentin." *Revue de l'art* 40–41, pp. 65–70.
1984 "Il ritratto di Sigismondo Malatesta di Piero della Francesca." In *Piero della Francesca a Rimini: L'affresco nel Tempio Malatestiano,* ed. Marilyn Aronberg Lavin, pp. 77–102. Bologna.
2003 "Un Crucifix peint d'Antonio da Fabriano." In De Marchi and Falaschi 2003, vol. 2, pp. 799–808.

Laclotte, Michel, and Elisabeth Mognetti
1976 *Avignon – Musée du Petit Palais: Peinture italienne.* Paris.

Lamberini, Daniela
1994 "Costruzione e cantiere: Le macchine." In Millon and Magnago Lampugnani 1994, pp. 478–90.

Lanciani, Rodolfo
1989 *Storia degli scavi di Roma e notizie intorno le collezioni romane di antichità.* Vol. 1, *1000–1530.* Ed. Leonello Malvezzi Campeggi. Rome.

Landucci, Giovanni
1976 "From 1439 to 1456. The Reform of Eugene IV." In *La Badia Fiesolana,* ed. Franco Borsi, Gabriele Morolli, Giovanni Landucci, and Ernesto Balducci, vol. 2, pp. 55–57. Florence.

Lankman, N.
1721– "Historia desponsationis et corona-
25 tionis Friederici III," sec. XV. In *Scriptores rerum austriacarum,* ed. Hieronymus Pez, vol. 2, cols. 570–605. Vienna.

Lanza, Maria Teresa
1998 *Le domande indiscrete: Saggi e note su Dante, Petrarca, Boccaccio, Belli, Pascoli, Piero della Francesca.* Milan.

Lanzi, Luigi
1795– *Storia pittorica della Italia.* 2 vols. in
96 3 parts. Bassano.
1797 *Storia pittorica della Italia.* Vol. 2. Milan. Reprint, 1824.

Lavin, Marilyn Aronberg
1955 "Giovannino Battista: A Study in Renaissance Religious Symbolism." *Art Bulletin* 37, pp. 85–102.
1961 "Giovannino Battista: A Supplement." *Art Bulletin* 43, pp. 319–26.
1969 "Piero della Francesca's Montefeltro Altarpiece: A Pledge of Fidelity." *Art Bulletin* 51, pp. 367–71.
1975 *Seventeenth-Century Barberini Documents and Inventories of Art.* New York.
1995 as ed. *Piero della Francesca and His Legacy.* Washington, D.C. Proceedings of the symposium "Monarca della Pittura: Piero and His Legacy," 1992.

Lawson, Jim
1979 "The Palace at Revere and the Earlier Architectural Patronage of Lodovico Gonzaga, Marquis of Mantua (1444–1478)." 2 vols. Ph.D diss., University of Edinburgh.

Lazzari, Andrea
1797 "Dizionario storico degl'illustri professori delle belle arti, e de' valenti mecanici d'Urbino del signor Andrea Arciprete Lazzari." In *Delle antichità picene,* ed. Giuseppe Colucci, vol. 31, pp. 29–32. Fermo.

1801 *Delle chiese di Urbino e delle pitture in esse esistenti.* Urbino.

Lelarge-Desar, P.
1913 "Galeries et collections: La collection Édouard Aynard." *Revue de l'art* 34, pp. 385–96.

Leonardi, Corrado
1970 *Il tempietto del riscatto di Urbania e altre opere. Contributo alla biografia giovanile di Donato Bramante.* Urbania.

Levi D'Ancona, Mirella
1962 *Miniatura e miniatori a Firenze dal XIV al XVI secolo: Documenti per la storia della miniatura.* Florence.
1977 *The Garden of the Renaissance: Botanical Symbolism in Italian Painting.* Florence.

Levi Pisetzky, Rosita
1964 *Storia del costume in Italia.* Milan.

Liebenwein, Wolfgang
1977 *Studiolo: Die Entstehung eines Raumtyps und seine Entwicklung bis um 1600.* Berlin.
1988 *Studiolo: Storia e tipologia di uno spazio culturale.* Ed. Claudia Cieri Via; trans Alessandro Califano. Modena.
1993 "Die 'Privatisierung' des Wunders: Piero de' Medici in SS. Annunziata und San Miniato." In *Piero de' Medici "il Gottoso" (1416–1469): Atti del convegno,* ed. Andreas Beyer and Bruce Boucher, pp. 251–90. Berlin.

Lightbown, Ronald W.
1980 *Donatello and Michelozzo: An Artistic Partnership and Its Patrons in the Early Renaissance.* 2 vols. London.
1992 *Piero della Francesca.* New York.

Ligi, Bramante
1937 *Le chiese di Urbino.* Urbino.

Lilii, Camillo
1835 *Istoria della città di Camerino (1649–52).* Camerino.

Lipman, Jean
1936 "The Florentine Profile Portrait in the Quattrocento." *Art Bulletin* 18, pp. 54–101.

Lisner, Margrit
1958– "Zur frühen Bildhauerarchitektur
59 Donatellos." *Münchner Jahrbuch d er bildenden Kunst,* ser. 3, 9–10, pp. 72–127.

Litta, Pompeo
1870 *Famiglie celebri italiane, disp. 164.* Milan.
1876– *Famiglie celebri italiane, disp. 180.*
78 Turin.

Lloyd, Christopher, comp.
1977 *A Catalogue of the Earlier Italian Paintings in the Ashmolean Museum.* Oxford.

Lochis, Guglielmo
1858 *La Pinacoteca e la Villa Lochis alla Crocetta di Mozzo presso Bergamo con notizie biografiche degli autori dei quadri.* 2nd ed. Bergamo.

Logan, Mary
1895 "Note sur les oeuvres de les maîtres italiens des musées de Province." *Chronique des arts,* ser. 2, 41 (December 28), pp. 396–97.

Lollini, Fabrizio
1995 "Le Vite di Plutarco alla Malatestiana (S.XV.1, S.XV.2, S.XVII.3): Proposte ed osservazioni per il periodo di transizione tra gotico e rinascimento nella miniatura settentrionale." In Lollini and Lucchi 1995, pp. 189–224.

1996 "Tre schede per l'arte in Romagna tra XIII e XV secolo." *Romagna arte e storia* 47, pp. 85–108.
2002 "Gusto malatestiano: Il decoro librario." In *Malatesta Novello magnifico Signore: Arte e cultura di un principe del Rinascimento,* ed. Pier Giorgio Pasini, pp. 59–65. Exh. cat. Bologna.

Lollini, Fabrizio, and Piero Lucchi, eds.
1995 *Libraria Domini. I Manoscritti della Biblioteca malatestiana: Testi e decorazioni.* Bologna.

Lomazzo, Giovan Paolo
1974 *Scritti sulle arti: Trattato dell'arte de la pittura.* Ed. Roberto Paolo Ciardi. Florence.

Lombardi, Francesco Vittorio
1992 "I simboli di Federico da Montefeltro." In Dal Poggetto 1992a, pp. 135–41.
1995 "Cataloghi settecenteschi inediti sulle pitture delle chiese di Urbino." *Studia picena* 60, pp. 267–306.

Londei, Enrico Ferdinando
1989 "Lo stemma sul portale di ingresso e la facciata 'ad ali' del palazzo ducale di Urbino." *Xenia* 18, pp. 93–117.
1991 "La scena della 'Flagellazione' di Piero della Francesca, la sua identificazione con un luogo di Urbino del Quattrocento." *Bollettino d'arte* 65 (January–February), pp. 29–66.

Londi, Emilio
[1907] *Alesso Baldovinetti, pittore fiorentino con l'aggiunta dei suoi "Ricordi."* Florence, n.d.

London
1930 *Exhibition of Italian Art, 1200–1900.* Exh. cat., Royal Academy of Arts. London.
1984 *From Borso to Cesare d'Este: The School of Ferrara, 1450–1628.* Exh. cat., Matthiesen Fine Art. London.

Longhi, Roberto
1927 *Piero della Francesca.* [Milan.] Reprinted in *Opere complete,* vol. 3. Florence, 1963.
1928 "Ricerche su Giovanni di Francesco." *Pinachoteca* 1 (July–August), pp. 34–38. Reprinted in *Opere complete di Roberto Longhi,* vol. 4, '*Me pinxit' e quesiti caravaggeschi, 1928–1934,* pp. 21–36. Florence, 1968.
1934 *Officina ferrarese.* Rome. Reprinted in *Opere complete di Roberto Longhi,* vol. 4, *Officina ferrarese, seguita dagli Ampliamenti 1940 e dai Nuovi ampliamenti, 1940–55,* pp. 7–122. Florence, 1956.
1940 "Genio degli anonimi: Giovanni di Piamonte." *Critica d'arte* 23, no. 2, pp. 97–101. Reprinted in *Opere complete,* vol. 8, *Fatti di Masolino e Masaccio e altri studi sul Quattrocento,* pp. 131–37. Florence, 1975.
1942 *Piero della Francesca.* 2nd ed. Milan.
1952a "Il 'Maestro di Pratovecchio.'" *Paragone* 3, no. 35, pp. 10–37. Reprinted in *Opere complete di Roberto Longhi,* vol. 8, *Fatti di Masolino e Masaccio e altri studi sul Quattrocento,* pp. 99–122. Florence, 1975.

1952b "Quadri italiani di Berlino a Sciaffusa (1951)." *Paragone* 3, no. 33, pp. 39–44. Reprinted in *Opere complete,* vol. 13, *Critica d'arte e buon governo,* pp. 311–17. Florence, 1985.

1963 *Piero della Francesca, 1927, con aggiunte fino al 1962.* 3rd ed. *Opere complete,* vol. 3. Florence.

Lorch, Ingomar

1990 *Die Kirchenfassade in Italien von 1450 bis 1527: Die Grundlagen durch Leon Battista Alberti und die Weiterentwicklung des basilikalen Fassadenspiegels bis zum Sacco di Roma.* Hildesheim, Zürich, and New York.

Lorentz, Philippe

2003 "Jean Fouquet et les peintre des anciens Pays-Bas." In *Avril 2003.*

Lorenz, Hellmut

1976 "Zur Architektur L. B. Albertis: Die Kirchenfassaden." *Wiener Jahrbuch für Kunstgeschichte* 29, pp. 65–100, pls. 20–52.

Lucarelli, Linda J.

1998 "La pulitura del polittico di San Niccolò Oltrarno di Gentile da Fabriano: Studio sull'utilizzo dei sistemi a base acquosa per l'intervento su materiali resinosi, oleosi e proteici." Doctoral thesis, Opificio delle Pietre Dure e Laboratori di Restauro, Florence.

Lucchini, Anna

1997 "Restauro del Polittico del XV secolo (ex-collezione Martello) di proprietà del Duomo di Monza." In *Monza: Il Polittico del Duomo. Un recupero, un restauro,* ed. Roberto Conti, pp. 43–67. Milan.

Lucchini, Flaminio

1996 *Pantheon.* Rome.

Luchs, Alison

1977 *Cestello: A Cistercian Church of the Florentine Renaissance.* New York and London.

Lunghi, Elvio

1996a "La cultura figurativa a Perugia nella prima metà del Quattrocento e la formazione di Benedetto Bonfigli." In Garibaldi 1996, pp. 31–47.

1996b "La perduta decorazione trecentesca nell'abside della chiesa inferiore del S. Francesco ad Assisi." *Collectanea franciscana* 66, no. 3–4, pp. 479–510.

1998 "Angelico, Benozzo e i pittori umbri." In *Beato Angelico e Benozzo Gozzoli: Artisti del Rinascimento a Perugia,* ed. Vittoria Garibaldi, pp. 81–91. Exh. cat. Cinisello Balsamo.

Luni, Mario

1992 "Ciriaco d'Ancona e Flavio Biondo: La riscoperta dell'antico a Urbino nel Quattrocento." In Dal Poggetto 1992a, pp. 41–45.

2000 *Studi sul Fanum Fortunae.* Contributions by Lucrezia Gallo and Vera Valletta. Urbino.

Luni, Mario, and Giancarlo Gori, eds.

1986 *1756–1986: Il Museo Archeologico di Urbino.* Vol. 1, *Storia e presentazione delle collezioni Fabretti e Stoppani.* Urbino.

Lutz, Werner

1995 *Luciano Laurana und der Herzogspalast von Urbino* Weimar.

Mackowsky, Hans

1899a "Jacopo del Sellaio." *Jahrbuch der Königlich Preussischen Kunstsammlungen* 20, pp. 271ff.

1899b "Die Verkundigung und die Verlobung der Heiligen Katharina von Francesco Pesellino." *Zeitschrift für bildende Kunst* 10, pp. 81–85.

Madiai, Francesco

1895 "Dei quadri tolti ad Urbino sotto il Regno Italico." *Nuova rivista misena* 8, pp. 84–88.

Malaguzzi Valeri, F.

1904 "La collezione Sipriot a Brera." *Rassegna d'arte* 4, no. 1 (January), pp. 3–10.

Mallett, Michael

1976 "Capponi, Neri." In *Dizionario biografico degli Italiani,* vol. 19, pp. 70–75. Rome.

Maltese, Corrado

1974 "Architettura 'Ficta' 1472 circa." In *Studi bramanteschi: Atti del congresso internazionale, Milano, Urbino, Roma 1970,* pp. 283–92. Rome.

Mancini, Francesco Federico

1992 *Benedetto Bonfigli.* Perugia.

Manetti, Antonio

1992 *Vita di Filippo Brunelleschi.* Ed. Carlachiara Perrone. Rome.

Mannini, Maria Pia, ed.

2004 *Filippino Lippi: Un bellissimo ingegno. Origini ed eredità nel territorio di Prato.* Exh. cat., Antiche Stanze di Santa Caterina and Museo di Pittura Murale, Prato. Milan.

Mannini, Maria Pia, and Marco Fagioli

1997 *Filippo Lippi: Catalogo completo.* Florence.

Mansuelli, Guido A.

1958– *Galleria degli Uffizi. Le sculture.*
61 2 vols. Rome.

Marcelli, Fabio

2002 "Giovanni Boccati, 1445–1460: Itinerari culturali e professionali." In De Marchi, Marcelli, and Minardi 2002, pp. 8–17.

2003 "Boccati 'umanista': Proposte intorno al soggiorno perugino." In De Marchi and Falaschi 2003, pp. 321–93.

n.d. *Osservazioni su alcuni soffitti del XIV e XV secolo nei palazzi umbro-marchigiani.* Forthcoming.

Marchese, Vincenzo

1845 *Memorie dei più insigni pittori, scultori ed architetti domenicani.* 2 vols. Florence.

1878– *Memorie dei più insigni pittori, scultori*
79 *ed architetti domenicani.* 2 vols. 4th ed. Bologna.

Marchini, Giuseppe

1952 "Di Maso di Bartolomeo e d'altri." *Commentari: Rivista di critica e storia dell'arte* 3, no. 2 (April–June), pp. 108–27.

1958 "Il palazzo ducale di Urbino." *Rinascimento* 9, no. 1 (June), pp. 43–78.

1960 "Aggiunte al palazzo ducale di Urbino." *Bollettino d'arte* 45, pp. 73–80.

1963 *Il tesoro del Duomo di Prato. Con documenti inediti ritrovati da R. Nuti e R. Piattoli.* Milan.

1968a "Maso di Bartolomeo." In *Donatello e il suo tempo: Atti dell'VIII convegno internazionale di studi sul Rinascimento, Firenze–Padova, 25 settembre–10 ottobre 1966,* pp. 235–43. Florence.

1968b "Per Giorgio da Sebenico." *Commentari: Rivista di critica e storia dell'arte,* n.s., 19, no. 3 (July–September), pp. 212–28.

1975 *Filippo Lippi.* Milan.

Marcoaldi, Oreste

1867 *Sui quadri di pittori fabrianesi raccolti e posseduti dal Sig. Romualdo Fornari.* Fabriano.

Mariani Canova, Giordana

1995 "La miniatura nella Biblioteca Malatestiana." In Lollini and Lucchi 1995, pp. 155–88.

Mariano, Fabio

1993 "Giorgio di Matteo da Sebenico in Ancona." In *Marche e Dalmazia tra umanesimo e barocco: Atti del convegno internazionale di studio, Ancona, 13–14 maggio, Osimo, 15 magio 1988,* ed. Sante Graciotti, Marina Massa, and Giovanna Pirani, pp. 61–84. Reggio Emilia.

Marias, Fernando, and Felipe Pereda

2004 "Petrus Hispanus in Urbino." In Fiore 2004, pp. 249–67.

Marini, Paola, ed.

1996 *Pisanello.* Exh. cat., Museo di Castelvecchio, Verona. Milan.

Mariotti, Filippo

1892 *La legislazione delle belle arti.* Rome.

Mariucci, Francesco

2001–2 "Una possibile traccia eugubina per Fra' Carnevale." *Notizie da Palazzo Albani* 30–31, pp. 69–71; documentary appendix ed. Cece Fabrizio.

van Marle, Raimond

1928 *The Development of the Italian Schools of Painting.* Vol. 10, *The Renaissance Painters of Florence in the Fifteenth Century: The First Generation.* The Hague.

1929 *The Development of the Italian Schools of Painting.* Vol. 11, *The Renaissance Painters of Florence in the 15th Century, the Second Generation.* The Hague.

1934 *The Development of the Italian Schools of Paintings.* Vol. 15, *The Renaissance Painters of Central and Southern Italy.* The Hague.

Marquand, Allan

1912 *Della Robbias in America.* Princeton.

1914 *Luca della Robbia.* Princeton.

1922 *Andrea della Robbia and His Atelier.* 2 vols. Princeton.

Martelli, Cecilia

n.d. "Bartolomeo della Gatta, Giuliano Amadei e Guglielmo Giraldi miniatori a Urbino: I corali quattrocenteschi del Duomo." *Prospettiva,* forthcoming.

Martineau, Jane, ed.

1992 *Andrea Mantegna.* Exh. cat., Royal Academy and The Metropolitan Museum of Art. London and New York.

Martines, Lauro

1963 *The Social World of the Florence Humanists, 1390–1460.* London.

Martini, Alberto

1960 "The Early Work of Bartolomeo della Gatta." *Art Bulletin* 42, no. 2 (June), pp. 133–41.

Materazzi, Marzia, Luca Pezzati, and Pasquale Poggi

2002 "La riflettografia infrarossa." In *Venere e Amore: Michelangelo e la nuova bellezza ideale,* ed. Franca Falletti and Jonathan Katz Nelson, pp. 244–48. Exh. cat. Florence.

Matz, Friedrich, ed.

1968– *Die dionysischen Sarkophage.* 4 vols.
75 Vol. 4 of *Die Antiken Sarkophagreliefs.* Berlin.

Mazzacchera, Alberto

1998 "Cagli." In *Palazzi e dimore storiche del Catria e del Nerone,* ed. Gianni Volpe. Cagli.

Mazzalupi, Matteo

2003a "Finalmente un'opera certa per Giovanni Angelo di Antonio." *L'Appennino camerte* 83, no. 32 (August 9), p. 2.

2003b "Giovanni Angelo d'Antonio 1452: Un punto fermo per la pittura rinascimentale a Camerino." *Nuovi studi: Rivista d'arte antica e moderna* 10, pp. 25–32.

2003–4 "Gli affreschi della cappella del Patullo e un nuovo profilo per Girolamo di Giovanni da Camerino." Doctoral thesis, Università degli Studi dell'Aquila.

Mazzini, Franco

1999 *Urbino, i mattoni e le pietre.* Pesaro.

Meiss, Millard

1954a "Ovum Struthionis: Symbol and Allusion in Piero della Francesca's Montefeltro Altarpiece." In *Studies in Art and Literature for Belle da Costa Green.* Princeton.

1954b "Addendum Ovologicum." *Art Bulletin* 36, pp. 221–22.

1961a "Contributions to Two Elusive Masters." *Burlington Magazine* 103, no. 695 (February), pp. 57–66.

1961b "'Highlands' in the Lowlands: Jan Van Eyck, the Master of Flemalle, and the Franco-Italian Tradition." *Gazette des Beaux-Arts,* ser. 6, 57, pp. 273–314.

1963 "Masaccio and the Early Renaissance: The Circular Plan." In *Studies in Western Art: Acts of the Twentieth International Congress of the History of Art,* vol. 2, *The Renaissance and Mannerism,* ed. Ida E. Rubin, pp. 123–45. Princeton.

1971 *La Sacra Conversazione di Piero della Francesca.* Florence.

Meiss, Millard, and Theodore G. Jones

1966 "Once Again, Piero della Francesca's Altarpiece." *Art Bulletin* 48, no. 2 (June), pp. 203–7.

Meller, Peter, and Jeanne Hokin

1982 "The Barberini Master as a Draughtsman?" *Master Drawings* 20, no. 3, pp. 239–46.

Melli, Lorenza

1995 *Maso Finiguerra: I disegni.* Florence.

2000 "Sui 'libri di disegni' di Benozzo Gozzoli: L'assedio di Perugia degli Uffizi e gli studi di teste dell'Accademia di Venezia." *Mitteilungen des Kunsthistorischen Institutes in Florenz* 44, no. 2–3, pp. 169–91.

Mendelsohn, Henriette

1909 *Fra Filippo Lippi.* Berlin.

Mercurelli Salari, Paola

1995 "L'altare di Agostino di Duccio in

San Domenico a Perugia: Una proposta di integrazione." *Commentari d'arte* 1, no. 2, pp. 41–46.

2001 "Girolamo di Giovanni da Camerino." In *Dizionario biografico degli Italiani*, vol. 56, pp. 560–64. Rome.

Merrifield, Mary P.

1849 *Original Treatises . . . on the Arts of Painting. . . .* London. Reprint, New York, 1967.

Merzenich, Christoph

1996 "Carpentry and Painting in Florentine Altarpieces of the First Half of the 15th Century." *Mededelingen van het Nederlands Instituut te Rome* 55 (pub. 1997), pp. 111–48.

1997 "Filippo Lippi: Ein Altarwerk für Ser Michele di Fruosino und die Verkündigung in San Lorenzo zu Florenz." *Mitteilungen des Kunsthistorischen Institutes in Florenz* 41, pp. 69–92.

2001 *Vom Schreinerwerk zum Gemälde. Florentiner Altarwerke der ersten Hälfte des Quattrocento: Eine Untersuchung zu Konstruktion, Material und Rahmenform.* Berlin.

Michelini Tocci, Luigi

1958 "I due manoscritti urbinati dei privilegi dei Montefeltro con una Appendice Lauranesca." *La bibliofilia* 60, pp. 206–57.

1986 "Federico da Montefeltro e Ottaviano Ubaldini della Carda." In Cerboni et al. 1986, vol. 1, pp. 297–344.

Middeldorf, Ulrich

1935 "Zu Goldschmiedekunst der toskanischen Frührenaissance." *Pantheon* 16, pp. 279–82. Reprinted in Ulrich Middeldorf, *Raccolta di scritti; That Is, Collected Writings*, vol. 1, *1924–1938*, pp. 211–15. Florence, 1979–80.

1956 "Su alcuni bronzetti all'antica del Quattrocento," paper delivered at the Convegno Internazionale di Studi sul Rinascimento, 5th, 1956, Florence. Reprinted in Ulrich Middeldorf, *Raccolta di scritti; That Is, Collected Writings,* vol. 2, *1939–1973*, pp. 243–55. Florence, 1980.

1976 *Sculptures from the Samuel H. Kress Collection.* London.

1978 "On the Dilettante Sculptor." *Apollo* 107, pp. 310–22. Reprinted in Ulrich Middeldorf, *Raccolta di scritti; That Is, Collected Writings,* vol. 3, *1974–1979*, pp. 173–202. Florence, 1981.

Millon, Henry A., and Vittorio Magnano Lampugnani, eds.

1994 *The Renaissance from Brunelleschi to Michelangelo: The Representation of Architecture.* Exh. cat., Palazzo Grassi, Venice, and National Gallery, Washington, D.C., 1994–95. New York. Also published in Italian.

Minardi, Mauro

1998 "Sotto il segno di Piero: Il caso di Girolamo di Giovanni e un episodio di pittura di corte a Camerino." *Prospettiva*, no. 89–90, pp. 16–39.

2002a "Giovanni di Piermatteo Boccati." In De Marchi 2002a, pp. 206–29.

2002b In De Marchi, Marcelli, and Minardi 2002.

2003 "Pittori camerinesi di metà Quattrocento e oltre: Bilancio di un'esperienza pierfrancescana." In De Marchi and Falaschi 2003, vol. 1, pp. 325–55.

Modigliani, Ettore

1914 "Un grande polittico del Quattrocento ricomposto a Milano." *Corriere della Sera*, June 20, 1914, p. 35.

Molajoli, Bruno

1956 *Guida artistica di Fabriano.* Fabriano. Reprinted 1990.

Molinier, Émile

1886 *Les bronzes de la Renaissance: Les plaquettes.* Paris.

Mollat, Michel

1957 "Les affaires de Jacques Coeur à Florence." In *Studi in onore di Armando Sapori*, pp. 761–71. Milan.

1988 *Jacques Coeur ou l'esprit d'entreprise au XVe siècle.* Paris.

Mongan, Agnes, and Paul J. Sachs

1940 *Drawings in the Fogg Museum of Art.* 3 vols. Cambridge, Mass.

Moranti, Luigi

1990 *La Confraternita del Corpus Domini di Urbino.* Ancona.

Morassi, Antonio

1936 *Antica oreficeria italiana.* Exh. cat., Triennale, Milan, 1937. Milan.

Morisani, Ottavio

1953 "Art Historians and Art Critics, III: Cristoforo Landino." *Burlington Magazine* 95, pp. 267–70.

Morolli, Gabriele

1979 "I Cantieri." In Franco Borsi, Gabriele Morolli, and Francesco Quinterio, *Brunelleschiani*, pp. 75–232. Rome.

1998 "'Sacella': I Tempietti marmorei di Piero de' Medici. Michelozzo o Alberti?" In Morolli 1998a, pp. 131–70.

1998a as ed. *Michelozzo: Scultore e architetto (1396–1472); atti del convegno ADSI, Associazione Dimore Storiche Italiane, Sezione Toscana.* Florence.

Mortier, Daniel Antonin, R.P.

1909 *Histoire des maîtres généraux de l'Ordre de frères prêcheurs.* Vol. 4, *1400–1486.* Paris.

Mottola Molfino, Alessandra

1982 "Storia del museo." In *Museo Poldi Pezzoli: Dipinti*, pp. 13–61. Milan.

Mottola Molfino, Alessandra, and Mauro Natale

1991 See Di Lorenzo et al. 1991.

Müntz, Eugène

1888 *Les collections des Médicis au XVe siècle: Le musée, la bibliothèque, le mobilier (appendice aux Précurseurs de la Renaissance).* Paris and London.

Musacchio, Jacqueline Marie

1999 *The Art and Ritual of Childbirth in Renaissance Italy.* New Haven.

Museo Poldi Pezzoli

1914 *Catalogo: Museo Artistico Poldi Pezzoli.* Milan.

1920 *Catalogo: Museo Artistico Poldi Pezzoli.* Milan.

Muzzioli, Giovanni, ed.

1953 *Mostra storica nazionale della miniatura.* Exh. cat., Palazzo della Venezia, Rome. Florence.

Nardini, Luigi

1912 "Un'alcova dei Montefeltro nel Museo della città di Urbino." *Picenum* 9, no. 11–12, pp. 270–71.

Natale, Mauro

1982 "Dipinti." In *Museo Poldi Pezzoli: Dipinti*, pp. 63–488. Milan.

2001 "El Mediterráneo que nos une." In *El Rinacimiento Mediterráneo: Viajes de artistas e itinerarios de obras entre Italia, Francia y España en el siglo XV*, ed. Mauro Natale, pp. 19–45. Exh. cat. Madrid.

Natali, Antonio

1990 "Gli anni Trenta: Un 'felicissimo istato': Cultura e scultura intorno a Cosimo il Vecchio." In Berti and Paolucci 1990, pp. 44–60.

1996 *L'umanesimo di Michelozzo.* Florence.

Nazzari, G. Ugo

1907 *L'antica arte umbra alla mostra di Perugia.* Perugia.

Negroni, Franco

1993 *Il duomo di Urbino.* Urbino.

2002 "Puntualizzazioni d'archivio sul pittore Antonio Alberti da Ferrara." *Accademia Raffaello: Atti e studi*, n.s., I, pp. 55–57.

2004 "Documenti negli archivi urbinati riguardanti Bartolomeo Corradini." In Cleri 2004.

Neri di Bicci

1972 *Le Ricordanze, 1453–1475.* Ed. Bruno Santi. Pisa.

Neri Lusanna, Enrica

1989 "Aspetti della cultura tardo-gotica a Firenze: Il 'Maestro del Giudizio di Paride.'" *Arte cristiana* 77, no. 735, pp. 409–26.

Nonni, Giorgio

1986 "Le rime di Angelo Galli e il codice Piancastelli 267 (Forlì, V 87)." In Cerboni Baiardi, Chittolini, and Floriani 1986, vol. 3, pp. 327–46.

1998 "Galli, Angelo." In *Dizionario biografico degli Italiani*, vol. 51, pp. 596–600. Rome.

Nuti, Ruggero

1939 "Pasquino di Matteo da Montepulciano e le sue sculture nel duomo di Prato." *Bullettino senese di storia patria*, n.s., 10, pp. 338–41.

Oertel, Robert

1942 *Fra Filippo Lippi.* Vienna.

Offner, Richard

1933 "The 'Mostra del tesoro di Firenze sacra.'" *Burlington Magazine* 63, no. 367 (October), pp. 166–78.

1939 "The Barberini Panels and Their Painter." In *Medieval Studies in Memory of A. Kingsley Porter*, ed. Wilhelm Koehler, vol. 1, pp. 205–53. 2 vols. Cambridge, Mass.

Orofino, Giulia

1983 "Piero della Francesca a Urbino e nelle Marche." In Ciardi Dupré Dal Poggetto and Dal Poggetto 1983, pp. 56–59, 68–70.

1992 "Piero della Francesca, la Vergine con il Bambino, quattro angeli e i Santi Giovanni Battista, Bernardino, Gerolamo, Francesco, Pietro Martire, Giovanni Evangelista(?)." In Zeri 1992, vol. 4, pp. 174–81.

Orsini, Baldassarre

1784 *Guida al forestiere per l'augusta città di Perugia.* Perugia.

Ottino Della Chiesa, Angela

1955 *Accademia Carrara.* Bergamo.

Paatz, Walter, and Elisabeth Paatz

1940–54 *Die Kirchen von Florenz.* 6 vols. Frankfurt am Main.

Pacciani, Riccardo

1996 "Orientamenti architettonici in Piero della Francesca: Vitruvio, i 'generi' degli ornati, gli edifici del primo Rinascimento fiorentino." In Cieri Via 1996a, pp. 301–18.

Paciaroni, Raoul

2001 *Lorenzo d'Alessandro detto il Severinate: Memorie e documenti.* Milan.

Pacioli, Luca

1978 "De divina proportione," (1497). In *Scritti rinascimentali di architettura*, ed. Arnaldo Bruschi, Corrado Maltese, Manfredo Tafuri, and Renato Bonelli, pp. 23–144. Milan.

Padoa Rizzo, Anna

1992a "Ristudiando i documenti: Proposte per il 'Maestro di Pratovecchio' e la sua tavola eponima." In *Studi di storia dell'arte sul Medioevo e il Rinascimento nel centenario della nascita di Mario Salmi*, vol. 2, pp. 579–99. Florence.

1992b "La bottega come luogo di formazione." In *Maestri e botteghe: Pittura a Firenze alla fine del Quattrocento*, ed. Mina Gregori, Antonio Paolucci, and Cristina Acidini Luchinat, pp. 53–59. Exh. cat. Florence.

2002 "L'educazione di Masaccio. Documenti, problemi, proposte." *Mitteilungen des Kunsthistorischen Institutes in Florenz* 46, no. 2–3, pp. 247–61.

Padovani, Serena

1975 "Pittori della corte estense nel primo Quattrocento." *Paragone* 26, no. 299, pp. 25–53.

Pagnani, Giacinto

1995 *Storia di Sarnano.* Vol. 2, *L'abbadia di Piobbico.* Macerata.

Pampaloni, Geno

1960 "Alessandri, Alessandro." In *Dizionario biografico degli Italiani*, vol. 2, pp. 161–62. Rome.

Panichi, Roberto

1991 *La tecnica dell'arte negli scritti di Giorgio Vasari.* Florence.

Paolucci, Antonio

1970 "Per Girolamo di Giovanni da Camerino." *Paragone* 21, no. 239, pp. 23–41, pls. 26–34.

1985 *Il Museo della Collegiata di S. Andrea in Empoli.* Florence.

Parlato, Enrico

1988 "Il gusto all'antica del Filarete scultore." In Cavallaro and Parlato 1988, pp. 115–34.

Parronchi, Alessandro

1962 "Leon Battista Alberti as a Painter." *Burlington Magazine* 104, pp. 280–86.

1964a "Leon Battista Alberti pittore," (1962). In *Studi su Lo dolce prospettiva*, pp. 437–67. Milan.

1964b "Luogo d'origine dell'Annunciazione Mond." *Paragone* 15, no. 179, pp. 42–47.

1974 "Prospettiva e pittura in Leon Battista Alberti." In *Convegno Internazionale indetto nel V centenario di Leon Battista Alberti, Accademia*

Nazionale dei Lincei, pp. 213–30. Rome.

1976 "Ricostruzione della pala dei Montefeltro." *Storia dell'arte* 28, pp. 235–48.

1981 "Paolo Uccello 'segnalato' 'per la prospettiva e animali.'" In *Michel-angelo* 10, no. 34, pp. 25–36.

1984a "L'emisfero della Sacrestia Vecchia: Giuliano Pesello?" In *Scritti di storia dell'arte in onore di Federico Zeri,* vol. 1, pp. 134–46. Milan.

1984b "Ricostruzione del Polittico di Sant'Agostino di Piero della Francesca." *Michelangelo* 13, no. 46–47 (January–June), pp. 29–37.

1985 "Per la ricostruzione del Polittico di Sant'Agostino." In *Piero, teorico dell'arte,* ed. Omar Calabrese, pp. 37–48. Rome.

1999 "Ancora sull'Alberti Pittore." In *Leon Battista Alberti: Architettura e cultura; atti del convegno internazionale, Mantova, 16–19 novembre 1994,* pp. 251–64. Florence.

Passerini, Luigi

1861 *Genealogia e storia della famiglia Rucellai.* Florence.

1868 *Memorie genealogico-storiche della famiglia Pecori di Firenze.* Florence.

1870 "Capponi di Firenze." In Pompeo Litta, *Famiglie celebri italiane,* disp. 164. Milan.

1876– "Alessandri, già Albizzi di Firenze."
78 In Pompeo Litta, *Famiglie celebri italiane,* disp. 180. Turin.

Pastor, Ludwig von

1944– *Storia dei papi dalla fine del Medio*
60 *Evo.* Ed. Angelo Mercati. 20 vols. Rome.

Perkins, Federico Mason

1907 "La pittura all'Esposizione d'arte antica di Perugia." *Rassegna d'arte* 7, pp. 88–95, 113–20.

Pernis, Maria Grazia

1990 "Ficino's Platonism and the Court of Urbino: The History of Ideas and the History of Art." Ph.D. diss., Columbia University, New York.

Pernis, Maria Grazia, and Laurie Schneider Adams

1996 *Federico da Montefeltro and Sigismondo Malatesta: The Eagle and the Elephant.* New York.

Perugia

1907 *Catalogo della mostra d'antica arte umbra.* Introduction by Giulio Urbini. Exh. cat., Palazzo del Popolo. Perugia.

Peruzzi, Piergiorgio

1986 "Lavorare a Corte: 'Ordine et offici.' Domestici, familiari cortigiani e funzionari al servizio del Duca di Urbino." In Cerboni Baiardi, Chittolini, and Floriani 1986, vol. 1, pp. 225–94.

Petrioli Tofani, Annamaria, ed.

1992 *Il disegno fiorentino del tempo di Lorenzo il Magnifico.* Exh. cat., Galleria degli Uffizi, Florence. Cinisello Balsamo.

Pfisterer, Ulrich

2002a *Donatello und die Entdeckung der Stile, 1430–1445.* Munich.

2002b "Filaretes Künstlerwissen und der wiederaufgefundene Traktat 'De Arte

Fuxoria' des Giannantonio Porcellio de' Pandoni." *Mitteilungen des Kunst-historischen Institutes in Florenz* 46, no. 1, pp. 121–51.

Pianazza, Muriel

1993 "Giovan Pietro Campana, collezion-ista, archeologo, banchiere e il suo legame con Firenze." *Mitteilungen des Kunsthistorischen Institutes in Florenz* 37, no. 2–3, pp. 433–74.

Piero della Francesca

1942 *De prospectiva pingendi.* Ed. Giusta Nicco-Fasola. Florence.

1984 *De prospectiva pingendi.* Ed. Giusta Nicco-Fasola. Florence.

Pignatti, Franco

1995 "Filelfo, Giovanni Mario." In *Dizionario biografico degli Italiani,* vol. 47, pp. 626–31. Rome.

Pisani, Linda

2002 "Domenico Rosselli a Firenze e nelle Marche." *Prospettiva* 102 (April 2001), pp. 49–66.

Pittaluga Mary

1949 *Filippo Lippi.* Florence.

Pius II, Pope, Enea Silvio Piccolomini

1984 *I Commentarii* [before 1464]. Ed. Luigi Totaro. Milan.

Pliny, the Younger

1972 *Letters and Panegyricus.* 2 vols. Ed. Betty Radice. London and Cambridge, Mass.

Pointner, Andy

1909 *Die Werke des florentinischen Bildhauers Agostino d'Antonio di Duccio.* Stras-bourg.

Polidori, Giancarlo

1956 *Musei Civici Pesaro: Catalogo.* Genoa.

Pollak, Oskar

1928 "Die Kunsttätigkeit unter Urban VIII." In *Quellenschriften zur Ges-chichte der Barokkunst in Rom,* vol. 1, ed. Dagobert Frey and Franz von Juraschek. Vienna.

Pope-Hennessy, John

1944 "The Development of Realistic Painting in Siena – I." *Burlington Magazine* 84 (May) pp. 110–19.

1950 *The Complete Work of Paolo Uccello.* London.

1964 *Catalogue of Italian Sculpture in the Victoria and Albert Museum.* London.

1965 *Renaissance Bronzes from the Samuel H. Kress Collection.* London.

1969 *Paolo Uccello; Complete Edition.* 2nd ed. London.

1980a *Luca della Robbia.* Ithaca, N.Y.

1980b "The Altman Madonna by Antonio Rossellino." In *The Study and Criticism of Italian Sculpture,* pp. 135–54. New York.

1983 "Some Italian Primitifs." *Apollo* 118, no. 257 (July), pp. 10–15.

1986 "Whose Flagellation?" *Apollo* 124, pp. 162–65.

1988 "Deux Madones en marbre de Verrocchio." *Revue de l'art* 80, pp. 17–25.

1993 *Donatello Sculptor.* New York, London, and Paris.

Pope-Hennessy, John, and Keith Christiansen

1980 "Secular Paintings in 15th Century Tuscany: Birth Trays, Cassone Panels, and Portraits." *The Metropolitan Museum of Art Bulletin* 38, no. 1 (summer).

Pope-Hennessy, John, and Laurence B. Kanter

1987 *The Robert Lehman Collection.* Vol. 1, *Italian Paintings.* New York.

Pozzi, G.

1989 "Maria Tabernacolo." In *Italia medievale e umanistica* 32, pp. 263–326. Reprinted in *Sull'orlo del visibile parlare.* Milan, 1993.

Previtali, Giovanni

1970 "Arte in Valdichiana." *Paragone* 21, no. 249, pp. 101–6.

Preyer, Brenda

1990 "L'architettura del palazzo mediceo." In Cherubini and Fanelli 1990, pp. 58–75.

Procacci, Ugo

1961 "Di Jacopo di Antonio e delle com-pagnie di pittori del Corso degli Adimari nel XV secolo." *Rivista d'arte* 35, no. 10 (1960), pp. 3–70.

1962 "La tavola di Giotto dell'altar maggiore della chiesa della badia fiorentina." In *Scritti di storia dell'arte in onore di Mario Salmi,* vol. 2, pp. 9–45. Rome.

1976 "Importanza del Vasari come scrit-tore di tecnica della pittura." In *Il Vasari storiografo e artista: Atti del con-gresso internazionale nel IV centenario della morte, Arezzo–Firenze, 2–8 set-tembre 1974,* pp. 35–64. Florence.

Pudelko, Georg

1934 "Studien über Domenico Venezi-ano." *Mitteilungen des Kunsthistorischen Institutes* 4, pp. 145–200.

1936 "Per la datazione delle opere di Fra Filippo Lippi." *Rivista d'arte* 18, pp. 45–76.

Pungileoni, Luigi

1822 *Elogio storico di Giovanni Santi, pittore e poeta, padre del gran Raffaello di Urbino.* Urbino. Reprint, ed. Ranieri Varese, Rome, 1994.

1836 *Memoria intorno alla vita e alle opere di Donato o Donnino Bramante offerte ad Antaldo Antaldi Patrizio Urbinate.* Rome.

Quaglio, Antonio Enzo

1986 "Donne di corte e di provincia." In Cerboni Baiardi, Chittolini, and Floriani 1986, vol. 3, pp. 273–326. Rome.

Ragghianti, Carlo Ludovico

1935 "Antonio Pollaiolo e l'arte fiorentina del Quattrocento." *Critica d'arte* 1, pp. 10–17, 69–84, 115–26, 157–65.

1938 "Notizie e letture. Intorno a Filippo Lippi. G. Pudelko." *Critica d'arte* 3, pp. xxii–xxv.

1949 "Studi sulla pittura lombarda del Quattrocento," part 2. *Critica d'arte* 8, pp. 288–300.

Ragghianti Collobi, Licia

1974 *Il libro de' disegni del Vasari.* Florence.

Raggio, Olga

1999 *The Gubbio Studiolo and Its Conser-vation.* Vol. 1, *Federico da Montefeltro's Palace at Gubbio and Its Studiolo.* Essay by Martin Kemp. New York: The Metropolitan Museum of Art.

Rearick, William Roger

2002 "The Dormitio Virginis in the Cappella dei Mascoli." In *De lapidibus sententiae: Scritti di storia dell'arte per Giovanni Lorenzoni,* ed.

Tiziana Franco and Giovanna Valenzano, pp. 343–62. Padua.

Relazione

1933 "*Relazione della città e diocesi di Urbino* fatta dal R.D. Brancaleone Fuschinio nell'anno 1597." *Urbinum* 6, no. 5–6.

Renouards, Yves

1966 "Benci, Giovanni." In *Dizionario biografico degli Italiani,* vol. 8, pp. 194–96. Rome.

Reynaud, Nicole

1989 "Barthélemy d'Eyck avant 1450." *Revue de l'art* 84, pp. 22–43.

Reynaud, Nicole, and Claudie Ressort

1991 "Les portraits d'Hommes illustres du Studiolo d'Urbino au Louvre par Juste de Gand et Pedro Berruguete." *Revue du Louvre* 41, no.1 (March) pp. 82–114.

Ricci, Amico

1834 *Memorie storiche delle arti e degli artisti nella Marca di Ancona.* 2 vols. Ancona.

Ricci, Corrado

1904 *La Pinacoteca di Brera.* Bergamo.

1906 "La pittura antica alla Mostra di Macerata." *Emporium,* 1906, pp. 200–215.

1910 "Piero della Francesca." In *L'opera dei grandi artisti italiani,* comp. Corrado Ricci. Rome.

Richa, Giuseppe

1754– *Notizie istoriche delle chiese fiorentine*
59 *divise ne' suoi quartieri. . . .* 8 vols. Florence.

Richter, George Martin

1940 "Rehabilitation of Fra Carnevale." *Art Quarterly* 3, pp. 311–24.

Richter, Jean Paul

1883 *The Literary Works of Leonardo da Vinci.* 2 vols. London.

Rinaldi, Rinaldo

2002 *"Melancholia Christiana": Studi sulle fonti di Leon Battista Albert.* Florence.

Robertson, Giles

1971 Review. *Art Quarterly* 34, pp. 356–58.

Roccasecca, Pietro

2002 "Not Albertian." *Center 22: Record of Activities and Research Reports. Center for Advanced Study in the Visual Arts,* 2002, pp. 167–69.

Romano, Giovanni

1981 "Verso la maniera moderna: Da Mantegna a Raffaello." In *Storia del-l'arte italiana,* vol. 2, *Dal Cinquecento all'Ottocento,* ed. Federico Zeri, pp. 5–85. Turin.

Ronen, Avraham

1998 "The Façade of Palazzo Rucellai and Its Classical Sources: New Proposals." In *Gedenkschrift für Richard Harprath,* ed. Wolfgang Lieb-enwein and Anchise Tempestini, pp. 402–12. Munich.

Rosand, David

1982 *Painting in Cinquecento Venice: Titian, Veronese, Tintoretto.* New Haven.

Rosini, Giovanni

1841 *Storia della Pittura Italiana.* Pisa.

Rossi, Adamo

1875 "Prospetto cronologico delle opere di Agostino di Duccio sculptore con la storia e i documenti di quelle da lui fatte a Perugia." *Giornale di erudizione artistica* 4, pp. 79–81.

Rossi, Francesco
1988 *Accademia Carrara: Catalogo dei dipinti sec. XV–XVI.* 5 vols. Milan.

Rotondi, Pasquale
1947 "Quando fu costruita la chiesa di San Bernardino in Urbino?" *Belle arti* 1, pp. 191ff.
1950 *Il Palazzo Ducale di Urbino.* 2 vols. Urbino.

Rowlands, Eliot Wooldridge
1983 "Filippo Lippi's Stay in Padua and Its Impact on His Art." Ph.D. diss., Rutgers University, New Brunswick, N.J.

Rubinstein, Ruth Olitsky
1975 "A Bacchic Sarcophagus in the Renaissance." *British Museum Yearbook,* vol. 1, *The Classical Tradition,* pp. 103–56. London.

Rucellai, Bernardo
1770 "De Urbe Roma," ed. D. Becucci. In *Rerum italicarum scriptores . . . ex florentinorum bibliothecarum codicibus,* vol. 2. Florence.

Ruda, Jeffrey
1984 "Style and Patronage in the 1440s: Two Altarpieces of the Coronation of the Virgin by Filippo Lippi." *Mitteilungen des Kunsthistorischen Institutes in Florenz* 38, no. 3, pp. 363–84.
1993 *Fra Filippo Lippi. Life and Work with a Complete Catalogue.* New York and London.

Ruysschaert, José
1969 "Le miniaturiste 'romain' de l''opus' de Michele Carrara." *Scriptorium* 23, pp. 215–24.

Rykwert, Joseph, and Anne Engel
1994 *Leon Battista Alberti.* Exh. cat., Palazzo Te, Mantua. Milan.

Saalman, Howard
1958 "Further Notes on the Cappella Barbadori in S. Felicita." *Burlington Magazine* 100, no. 665 (August), pp. 270–75.
1977 "Documenti inediti sulla cappella dell'Annunziata." In *Scritti di storia dell'arte in onore di Ugo Procacci.* 2 vols. Milan.
1993 *Filippo Brunelleschi: The Buildings.* London.

Saccuman, Roberto
2004 "Le grandi 'macchine' di Niccolò di Liberatore: Il caso del Polittico di Donna Brigida in San Niccolò a Foligno e il suo restauro." In Benazzi and Lunghi 2004, pp. 489–97.

Salis, Arnold von
1947 *Antike und Renaissance: Über Nachleben und Weiterwirken der alten in der neueren Kunst.* Erlenbach and Zürich.

Salmi, Mario
1925– "Cronaca delle Belle Arti: Il rinno-
26 vamento della Pinacoteca di Brera." *Bollettino d'arte,* ser. 2, 5, pp. 84–95.
1931 "La miniatura emiliana." In *Tesori delle biblioteche d'Italia: Emilia Romagna,* ed. Domenico Fava, pp. 65–68. Milan.
1934 "Paolo Uccello, Domenico Veneziano, Piero della Francesca e gli affreschi del Duomo di Prato." *Bollettino d'arte,* ser. 3 anno 28, pp. 1–27.

1936 *Paolo Uccello, Andrea del Castagno, Domenico Veneziano.* Rome.
1954 "Di Michele da Carrara, miniatore del Quattrocento." *Commentari: Rivista di critica e storia dell'arte* 5, pp. 95–102.
1961 *Pittura e miniatura a Ferrara nel primo Rinascimento.* Milan.
1979 *La pittura di Piero della Francesca.* Novara.

Salutati, Coluccio
1951 *De laboribus Herculis.* 2 vols. Ed. Berthold L. Ullman. Zürich.

Sangiorgi, Fert
1973 "Ipotesi sulla collocazione originaria della Pala di Brera." *Commentari: Rivista di critica e storia dell'arte* 24, pp. 211–16.
1976 as ed. *Documenti urbinati: Inventari del palazzo ducale, 1582–1631.* Urbino.
1982 *Iconografia federiciana.* Urbino.
1989 "Fra Carnevale e la tavola di Santa Maria della Bella di Urbino." *Notizie da Palazzo Albani* 2, pp. 15–21.
1992 as ed. *Una guida d'Urbino e dei luoghi limitrofi stilata da Clemente XI, con una relazione di mons Curzio Origo al Pontefice.* Urbino.

Santagata, Marco
1986 "La lirica feltresco-romagnola del Quattrocento." In Cerboni Baiardi, Chittolini, and Floriani 1986, vol. 3, pp. 219–72.

Santi, Bruno
1987 "Pittura minore in Santa Trinita: Da Bicci di Lorenzo a Neri di Bicci." In *La chiesa di Santa Trinita a Firenze,* ed. Giuseppe Marchini and Emma Micheletti, pp. 132–42. Florence.

Santi, Francesco
1961 "L'altare di Agostino di Duccio in S. Domenico di Perugia." *Bollettino d'arte* 46, pp. 162–63.
1985 *Galleria Nazionale dell'Umbria: Dipinti, sculture e oggetti dei secoli XV e XVI.* Rome.

Santi, Giovanni
1985 *La vita e le gesta di Federico di Montefeltro, duca d'Urbino: Poema in terza rima (Codice Vat. Ottob. lat. 1305).* Ed. Luigi Michelini Tocci. 2 vols. Vatican City.

Sapori, Giovanna, ed.
1997 *Museo Comunale di San Francesco a Montone.* [Milan] and Perugia.

Sartor, Lucia
1997 "Lazzaro Bastiani e i suoi committenti." *Arte veneta* 50, no. 1, pp. 39–53.

Sartore, Alberto Maria, and Pietro Scarpellini
1998 "L'Angelico a Perugia: Ancora sulla datazione del polittico Guidalotti." *Commentari d'arte: Rivista di critica e storia dell'arte* 4, no. 9–11, pp. 89–98.

Scalia, Fiorenza, and Cristina De Benedictis, eds.
1984 *Il Museo Bardini a Firenze.* Vol. 1. Milan.

Scalini, Mario
1995 "I maestri della cancellata della Cintola: Maso di Bartolomeo, Antonio di Ser Cola e Pasquino da Montepulciano." In *La Sacra Cintola nel duomo di Prato,* pp. 265–79. Prato.

Scardeone, Bernardino
1560 *De antiquitate urbis Patavii et claris civibus Patavinis.* Basilea.

Scarpelli, Giorgia, et al.
2003 *Scultura a Montepulciano dal XIII al XX secolo.* Montepulciano.

Scarpellini, Pietro
1988 "Note sulla pittura del Rinascimento nella Galleria Nazionale dell'Umbria (a proposito di un recente catalogo)." *Bollettino d'arte,* ser. 6, 73, no. 50–51, pp. 111–22.

Schiller Gertrud
1971– *Iconography of Christian Art.* 2 vols.
72 Trans. of 2nd ed. by Janet Seligman. Greenwich, Conn.

Schlegel, Ursula
1962 "Ein Madonnenbild des Francesco Pesellino." *Niederdeutsche Beiträge zur Kunstgeschichte* 2, pp. 172–78.

Schmarsow, August
1886 *Melozzo da Forlì: Ein Beitrag zur Kunst- und Kulturgeschichte italiens.* Berlin and Stuttgart.
1899 *Der Fortschritt des Meisters.* Vol. 5 of *Masaccio Studien.* Kassel.
1912 *Joos van Gent und Melozzo da Forlì in Rom und Urbino.* Leipzig.
1901 "Bayersdorfer Adolf e von Lützow Karl." *Kunsthistorische Gesellschaft für Photographische Publikationen, 1901.*

Schmidt, Victor M.
2003 "Gli stendardi processionali su tavola nelle Marche del Quattrocento." In De Marchi and Falaschi 2003, vol. 2, pp. 551–78.

Schubring, Paul
1905 *Luca della Robbia und seine Familie.* Bielefeld and Leipzig.

Schulz, Anne Markham
1977 *The Sculpture of Bernardo Rossellino and His Workshop.* Princeton.

Schulze Altcappenberg, Heinrich
1995 *Die italienischen Zeichnungen des 14. und 15. Jahrhunderts im Berliner Kupferstichkabinett.* Berlin.

Scudieri, Magnolia, ed.
1992 *La Croce giottesca di San Felice in Piazza: Storia e restauro.* Venice.

Sebregondi, Ludovica
1991 "Religious Furnishings and Devotional Objects in Renaissance Florentine Confraternities." In *Crossing the Boundaries: Christian Piety and the Arts in Italian Medieval and Renaissance Confraternities,* ed. Konrad Eisenbichler, pp. 141–60. Kalamazoo, Mich.

Secco Suardo, Giovanni
1866 *Manuale ragionato per la parte meccanica dell'arte del restauratore dei dipinti.* Milan.

Sella, Pietro
1944 *Glossario latino italiano. Stato della Chiesa, Veneto, Abruzzi.* Vatican City.

Seracini, Maurizio
1992a "Piero della Francesca, Pala Montefeltro." In Dal Poggetto 1992a, pp. 459–62.
1992b "Ricerche diagnostiche. Piero della Francesca, Dittico dei Duchi d'Urbino." In Dal Poggetto 1992a, pp. 456–57.

Serlio, Sebastiano
2001 "Il libro terzo . . . nel qual si figurano, e descrivono le antiquita di Roma, e le altre che sono in Italia, e fuori

d'Italia [Venezia 1540]." In Sebastiano Serlio, *L'architettura,* ed. Francesco Paolo Fiore. vol. 1. Milan.

Serra, Luigi
1921 *Il Palazzo Ducale di Urbino e la Galleria Nazionale delle Marche.* Milan.
1924– "Elenco degli oggetti d'arte
25a mobili della provincia di Macerata appartenenti ad enti pubblici." *Rassegna marchigiana* 3, pp. 114–22, 150–62.
1924– "Elenco delle opere d'arte
25b mobili delle Marche." *Rassegna marchigiana* 3, pp. 363–48, pls. 1–28.
1929– "Girolamo di Giovanni da
30 Camerino: Opere inedite o poco note." *Rassegna marchigiana* 8, pp. 246–68.
1930 *Il Palazzo Ducale e la Galleria Nazionale di Urbino.* Rome.
1932 as ed. *Urbino: Catalogo delle cose d'arte e di antichità d'Italia.* Rome.
1934 *L'arte nelle Marche.* Vol. 2, *Il periodo del Rinascimento.* 2 vols. Rome.

Servanzi Collio, Severino
1869 *Pittura in tavola di Giovanni Boccati da Camerino in Belforte del Chiento.* Camerino.

Settis, Salvatore, ed.
1984 *Camposanto monumentale di Pisa. Le antichità.* Vol. 2. Modena.

Sgarbi, Vittorio
1984 *La Fondazione Magnani-Rocca: Capolavori della pittura antica.* Milan.

Shapley, Fern Rusk
1979 *Catalogue of the Italian Paintings.* 2 vols. Washington, D.C.: National Gallery of Art.

Shearman, John
1962 "Leonardo's Colour and Chiaroscuro." *Zeitschrift für Kunstgeschichte* 25, pp. 13–47.
1968 "The Logic and Realism of Piero della Francesca." In *Festschrift Ulrich Middeldorf,* ed. Antje Kosegarten and Peter Tigler, pp. 180–86. Berlin.

Siepi, Serafino
1822 *Descrizione topologica-istorica della città di Perugia.* 2 vols. Perugia.

Sigillo, Antonio, ed.
1994 *Umanesimo e Rinascimento a Montepulciano.* Exh. cat. Montepulciano.

Simi Varanelli, Emma
1996 "Artisti, umanisti e viaggiatori alla riscoperta della grecità. Piero della Francesca e Ciriaco d'Ancona (1392–1452)." In Cieri Via 1996a, pp. 135–47.

Simons, Patricia
1992 "Women in Frames." In *The Expanding Discourse: Feminism and Art History,* ed. Norma Broude and Mary D. Garrard, pp. 2–54. New York.

Smith, Christine
1994 "Leon Battista Alberti e l'ornamento: Revestimenti parietali e pavimentazioni." In Rykwert and Engel 1994, pp. 196–215.

Spallanzani, Marco, and Giovanna Gaeta Bertelà, eds.
1992 *Libro d'inventario dei beni di Lorenzo il Magnifico.* Florence.

Spreti, Vittorio
1928– *Enciclopedia storico-nobiliare italiana.*
35 Bologna.

Steinberg, Leo
1987 "'How Shall This Be?': Reflections on Filippo Lippi's Annunciation in London." *Artibus et historiae* 16, pp. 25–44.

Stöckhert, Luise
1997 *Die Petrus- und Paulusmartyrien auf Filaretes Bronzentür von St. Peter in Rom.* Frankfurt am Main.

Strauss, Monica J.
1979 "The Master of the Barberini Panels: Fra Carnevale." Ph.D. diss., New York University.

Strehlke, Carl Brandon
2004 *Italian Paintings, 1250–1450, in the John G. Johnson Collection and the Philadelphia Museum of Art.* Philadelphia.

Strutt, Edward
1901 *Fra Filippo Lippi.* London.

Stuveras, Roger
1969 *Le putto dans l'art romain.* Brussels.

Suida, William
1931a "Das früheste Bildnis Friedrichs III." *Belvedere* 10, pp. 89–92.
1931b "Le pitture del Bramante sulla facciata del Palazzo del Podestà a Bergamo." *Emporium* 74, pp. 340–48.
1953 *Bramante pittore e il Bramantino.* Milan.

Swarzenski, Georg
1939– "The Master of the Barberini
40 Panels." *Bulletin of the Museum of Fine Arts, Boston* 38, no. 225, pp. 90–97.

Syndikus, Candida
1994 "Zu Leon Battista Albertis Studium der Basilica Aemilia auf dem Forum Romanum." *Zeitschrift für Kunstgeschichte* 57, no. 3, pp. 319–29.
1996 *Leon Battista Alberti: Das Bauornament.* Münster.

Syre, Cornelia
1990 *Frühe italienische Gemälde aus dem Bestand der Alten Pinakothek.* Exh. cat., Alte Pinakothek. Munich.

Tafuri, Manfredo
1993 "Il Duomo di Urbino, 1477–1478 circa e sgg." In Fiore and Tafuri 1993, pp. 186–207.

Tambini, Anna
2003 "Una congiuntura Crivellesca e camerte ad Ascoli Piceno." In De Marchi and Falaschi 2003, vol. 2, pp. 823–38.
2004 "Due polittici a confronto: Un contributo per fra Carnevale." In Cleri 2004, pp. 297–325.

Tavernor, Robert
1994 "Giovanni Rucellai e il suo complesso architettonico a Firenze." In Rykwert and Engel 1994, pp. 368–77.

Tenenti, Alberto
1998 "L. B. Alberti e le statue degli dei antichi." In *Artes atque humaniora: Studia Stanislao Mossakowski Sexagenario Dicata,* ed. Andrzej Rottermund, Jerzy Miziolek, Mieczyslaw Morka, and Piotr Paszkiewicz, pp. 45–49. Warsaw.
1999 "Il Tempio: Riflessioni sul pensiero religioso di Leon Battista Alberti." *Intersezioni* 19, no. 1, pp. 95–104.

Teuffel, Christa Gardner von
1977 "Masaccio and the Pisa Altarpiece: A New Approach." *Jahrbuch der Berliner Museen* 19, pp. 23–68.

1999 "Niccolò di Segna, Sassetta, Piero della Francesca and Perugino: Cult and Continuity at Sansepolcro." *Städel Jahrbuch* 17, pp. 163–208.
2001 "Perugino's Cassinese Ascension for San Pietro at Perugia: The Artistic and Musical Setting of a High Altarpiece in Its Cassa." *Städel Jahrbuch* 18, pp. 113–64.

Thomas, Anabel
1995 *The Painter's Practice in Renaissance Tuscany.* Cambridge.

Thomas, Troy M.
1980 "Classical Reliefs and Statues in Later Quattrocento Religious Paintings." Ph.D. diss., University of California at Berkeley.

Tietzel, Brigitte
1991 "Neues vom 'Meister der Schafsnasen' Überlegungen zum New Yorker Doppelbildnis des Florentiner Quattrocento." *Wallraf-Richartz-Jahrbuch* 52, pp. 17–42.

Tiozzo, Vanni, ed.
2002 *Dal decalogo Edwards alla carta del restauro: Pratiche e principi del restauro dei dipinti; atti del convegno, Venezia. 2000.* Padua.

Tissoni Benvenuti, Antonia
1993 "Antonia, il mito di Ercole: Aspetti della ricerca dell'antico alla Corte estense nel primo Quattrocento." In *Omaggio a Gianfranco Folena,* vol. 1, pp. 773–92. 3 vols. Padua.
1994 "L'antico a Corte: Da Guarino a Boiardo." In *Alla corte degli Estensi: Filosofia, arte e cultura a Ferrara nei secoli XV e XVI; atti del convegno internazionale di studi, 5–7 marzo 1992,* ed. Bertozzi Marco, pp. 389–404. Ferrara.

Toesca, Pietro
1917 "Il pittore del 'trittico Carrand' Giovanni di Francesco." *Rassegna d'arte* 17, pp. 1–4.
1932 "Una Madonna di Filippo Lippi." *L'arte* 35, pp. 104–9.

Tommasoli, Walter
1978 *La vita di Federico da Montefeltro (1422–1482).* Urbino.

[Tonini, Pellegrino]
1876 *Il santuario della Santissima Annunziata di Firenze: Guida storico-illustrativa compilata da un religioso dei Servi di Maria.* Florence.

Toniolo, Federica
1995a as ed. "Catalogo delle opere." In *Guglielmo Giraldi, miniatore estense,* by Giordana Mariani Canova. Modena.
1995b "Decorazione all'antica nei manoscritti per Malatesta Novello." In Lollini and Lucchi 1995, pp. 143–53.
1998 as ed. *La miniatura a Ferrara dal tempo di Cosmè Tura all'eredità di Ercole de' Roberti.* Exh. cat., Palazzo Schifanoia, Ferrara. Modena.

Torri, Alessandro, ed.
1827– *L'Ottimo Commento della Divina
29 Commedia: Testo inedito d'un contemporaneo di Dante citato dagli Accademici della Crusca.* 3 vols. Pisa.

Tory, Geofroy
1967 *Champ Fleury* [1927]. Ed. George B. Ives. New York.

Toscano, Bruno
1961 "Per la storia del San Salvatore di Spoleto." In *Scritti di storia dell'arte*

in onore di Mario Salmi, vol. 1, pp. 87–94. Rome.
1987 "La pittura in Umbria nel Quattrocento." In *La pittura in Italia: Il Quattrocento,* pp. 355–83. Milan.

Trachtenberg, Marvin
1996 "Perché la Cappella Pazzi non è di Brunelleschi." *Casabella,* no. 635 (June), pp. 58–77.
1997 "Michelozzo e la Cappella Pazzi." *Casabella,* no. 642 (February), pp. 56–75.
1998 "Michelozzo architetto della Cappella Pazzi." In Morolli 1998a, pp. 203–10.

Trevisani, Filippo
1996 "La Pala di San Bernardino: Indagini preliminari alla problematica della carpenteria." In Dalai Emiliani and Curzi 1996, pp. 183–93.
1997 "Struttura e pittura: I maestri legnaiuoli grossi e Piero della Francesca per la carpenteria della Pala di San Bernardino." In Trevisani and Daffra 1997, pp. 31–83.

Trevisani, Filippo, and Emanuela Daffra, eds.
1997 *La Pala di San Bernardino di Piero della Francesca: Nuovi studi oltre il restauro.* Florence.

Trudzinski, Meinolf
1986 *Beobachtungen zu Donatellos Antikenrezeption.* Berlin.

Tumidei, Stefano
1994 "Melozzo da Forlì: Fortuna, vicende, incontri di un artista prospettico." In *Melozzo da Forlì: La sua città e il suo tempo,* ed. Marina Foschi and Luciana Prati, pp. 19–81. Exh. cat. Milan.

Turcan, Robert
1966 *Les sarcophages romains à représentations dionysiaques: Essai de chronologie et d'histoire religieuse.* Paris.

Turchini, Angelo
2000 *Il Tempio malatestiano, Sigismondo Pandolfo Maltatesta e Leon Battista Alberti.* Cesena.
2004 "Sigismondo e Federico." In Fiore 2004, vol. 1, pp. 27–48.

Urbani, Giovanni
1953 "Leonardo da Besozzo e Perinetto da Benevento dopo il restauro degli affreschi di San Giovanni a Carbonara." *Bollettino d'arte,* ser. 4, 38, no. 9, pp. 297–306.

Urbino
1968 *Mostra di opere d'arte restaurate.* Exh. cat. Palazzo Ducale. Urbino.

Vaccari, Maria Grazia
1998 "Il restauro del San Giovanni Battista di Michelozzo." In Morolli 1998a, pp. 115–20.

Valentiner, Wilhelm R.
1942 "Laurana's Portrait Busts of Women." *Art Quarterly* 5, pp. 273–99.

Valeri, Stefano
1994 "Quattrocento pittorico marchigiano: Gli artisti di Camerino e le urbinati Tavole Barberini." In *Quattrocento in pittura nell'Italia centrale,* ed. Anna Cavallaro, Sergio Rossi, and Stefano Valeri, pp. 53–83. Rome.
1995 "Le Tavole Barberini e Fra Carnevale: Un maestro in prospettiva." *Arte e dossier* 10, no. 104, pp. 30–33.

1999 "Due dipinti per la concordia: Le Tavole Barberini." In *Sul Carro di Tespi: Studi in onore di Maurizio Calvesi.* Rome.
2000 "Le Tavole Barberini." *Ars* IV, 3, no. 27 (March), pp. 136–42.
2004 "Il tema della concordia nelle Tavole Barberini." In Cleri 2004, pp. 271–96.

Varese, Ranieri
1988 "La 'Cronaca rimata' di Giovanni Santi: Proposte di lettura." *Notizie da Palazzo Albani* 2, pp. 26–48.
1999 as ed. *Giovanni Santi: Atti del convegno internazionale di studi, Urbino, Convento di Santa Chiara, 17–19 marzo 1995.* Milan.

Vasari, Giorgio
1906 *Le vite de' più eccellenti pittori scultori e architettori* [1568]. Ed. Gaetano Milanesi. 9 vols. Florence.
1966– *Le vite de' più eccellenti pittori scultori e
76 architettori nelle redazioni affrontate del 1550 e 1568.* Ed. Rosanna Bettarini and Paola Barocchi. 7 vols. Florence.
1991 *Le Vite de' più eccellenti architetti, pittori, et scultori italiani, da Cimabue insino a' tempi nostri* [1550]. Ed. Luciano Bellosi and Aldo Rossi. 2 vols. Turin.

Vasoli, Cesare
2000 "Potere e follia nel Momus." In *Leon Battista Alberti; actes du congrès international de Paris . . . 10–15 avril,* ed. Francesco Furlan, Pierre Laurens, Sylvain Matton, et al., pp. 443–63. 2 vols. Turin and Paris.

Venanzangeli, Ado
1993 *Paolo da Visso pittore del '400.* Rome.

Venturi, Adolfo
1893 "Nelle pinacoteche minori d'Italia. I. Appunti e ricerche." *Archivio storico dell'arte* 6, pp. 409–18.
1908 *Storia dell'arte italiana.* Vol. 6, *La scultura del Quattrocento.* Milan.
1911 *Storia dell'arte italiana.* Vol. 7, *La pittura del Quattrocento.* Vol. 1. Milan.
1913 *Storia dell'arte italiana.* Vol. 7, *La pittura del Quattrocento.* Vol. 2. Milan.
1917 "L'ambiente artistico urbinate nella seconda metà del Quattrocento," part 1. *L'arte* 20, pp. 259–93.
1924 "Ancora una Annunciazione di Filippo Lippi." *L'arte* 27, pp. 167–68.
1927 *Studi dal Vero: Attraverso le raccolte artistiche d'Europa.* Milan.

Venturi, Lionello
1914 "Studi sul Palazzo ducale di Urbino." *L'arte* 17, pp. 415–73.
1915 "A traverso le Marche." *L'arte* 18, pp. 1–28, 172–208.
1954 *Piero della Francesca.* Trans. James Emmons. Geneva.

Venturini, Lisa
1994 *Francesco Botticini.* Florence.

Vespasiano da Bisticci
1892– *Vite di uomini illustri del secolo XV.
93 Ed. Ludovico Frati. 3 vols. Bologna.
1970 *Le vite.* Ed. Aulo Greco. Florence.

Vitalini Sacconi, Giuseppe
1968 *Pittura marchigiana: La scuola camerinese.* Trieste.
1972 "Due schede di pittura marchigiana. I. Un inedito di Girolamo di Giovanni." *Commentari: Rivista di critica e storia dell'arte* 23, no. 1–2, pp. 164–66.

1985 *Macerata e il suo territorio: La pittura.* Milan.

Viti, Paolo
1986 "Lettere familiari di Federico da Montefeltro ai Medici." In Cerboni Baiardi, Chittolini, and Floriani 1986, vol. 1, pp. 471–86.

Voll, Karl
1907 "Altfranzösische Bilder in der Alten Pinakothek." *Münchener Jahrbuch der bildenden Kunst* 2, pp. 41– 48.

Volpe, Carlo
1956 "In margine a un Filippo Lippi." *Paragone* 7, no. 83, pp. 38–45.

Volpe, Gianni
1989 *Matteo Nuti architetto dei Malatesta.* Venice.

Warburg, Aby
1914 "L'ingresso dello stile ideale anti-cheggiante nella pittura del primo Rinascimento." Reissued in *La rinascita del paganesimo antico,* ed. Gertrud Bing, pp. 283–307. Florence, 1966.
1922 "Piero della Francescas Constantinsschlacht in der Aquarellkopie des Johann Anton Ramboux." In *Atti del X Congresso internazionale di storia dell'arte: L'Italia e l'arte straniera,* pp. 326–27. Rome. Reprinted in *Gesammelte Schriften,* vol. 1, pp. 251–54. Berlin, 1932.

Watterson, Helen
1979 "The Romanesque Dolphin Capitals in the Cathedral of Viterbo." In *Itinerari (Contributi alla storia dell'arte in memoria di Maria Luisa Ferrari),* vol. 1, pp. 47–60. Florence.

Weddle, Saundra Lynn
1997 "Enclosing Le Murate: The Ideology of Enclosure and the Architecture of a Florentine Convent, 1380–1597." Ph.D. diss., Cornell University, Ithaca, N.Y.

Wehle, Harry B.
1936 "A Painting Attributed to Fra Carnevale." *Bulletin of The Metropolitan Museum of Art* 31, pp. 59–66.

Weisbach, Werner
1899 "Recensione a Piero dei Franceschi. Eine kunsthistorische Studie von Dr. Felix Witting Strassburg, Heitz 1898." *Repertorium für Kunstwissenschaft* 22, pp. 72–77.
1901a "Der Meister des carrandisschen Tryptychons." *Jahrbuch der Königlich Preussischen Kunstsammlungen* 22, pp. 35–55.
1901b *Francesco Pesellino und die Romantik der Renaissance.* Berlin.
1913 "Eine Darstellung der letzten deutschen Kaiserkrönung in Rom." *Zeitschrift für bildende Kunst* 24, pp. 255–66.

Welliver, Warman
1973 "The Symbolic Architecture of Domenico Veneziano and Piero della Francesca." *Art Quarterly* 36, pp. 1–30.

Wester, Ursula
1965 "Die Reliefmedaillons im Hofe des Palazzo Medici zu Florenz. I Teil, Die Tondi, ihre Vorbilder und die Meisterfrage." *Jahrbuch der Berliner Museen,* n.s., 7, no. 1, pp. 15–49.

Westfall, Carroll William
1984 *L'invenzione della città: La strategia urbana di Nicolò V e Alberti nella Roma del '400.* Urbino.

White, John
1967 *The Birth and Rebirth of Pictorial Space.* London. Reissued, New York, 1972.

Witting, Felix
1898 *Piero dei Franceschi.* Strasbourg.

Wohl, Helmut
1980 *The Paintings of Domenico Veneziano,*

ca. 1410–1461: A Study in Florentine Art of the Early Renaissance. Oxford and New York.

Wright, Alison
2000 "The Memory of Faces: Representational Choices in Fifteenth-Century Florentine Portraiture." In *Art, Memory, and Family in Renaissance Florence,* ed. Giovanni Ciappelli and Patricia Lee Rubin, pp. 86–113. Cambridge.

Yriarte, Charles
1894 *Journal d'un sculpteur florentin au XV siècle: Livre de souvenir de Maso di Bartolomeo, dit Masaccio. Manuscrits conservés à la Bibliothèque de Prato et à la Magliabecchiana de Florence.* Paris.

Yuen, Toby
1970 "The 'Bibliotheca Graeca': Castagno, Alberti, and Ancient Sources." *Burlington Magazine* 112, no. 812 (November), pp. 725–36.

Zampetti, Pietro
1961 as ed. *Carlo Crivelli e i crivelleschi.* Exh. cat., Palazzo Ducale. Venice.
[1969] *La pittura marchigiana del '400.* Milan, n.d.
1971 *Giovanni Boccati.* Milan.
1988 *Pittura nelle Marche.* Vol. 1, *Dalle origini al primo Rinascimento.* Florence.

Zannoni, Giovanni
1894 "I due libri della Martiados di Giovan Mario Filelfo," parts 1, 2. *Rendiconti della Reale Accademia dei Lincei. Classe di Scienze morali, storiche e filologiche,* ser. 5, 3, fasc. 8, pp. 557–72; fasc. 9, pp. 650–71.
1895a "Memoria felicissima de lo Ill. mo Sr. Duca Federico di Urbino et de la sua famiglia che teneva. Opera di Susek antiquo Cortigiano." In "I due libri della Martiados di Giovan

Maria Filelfo," *Rendiconti della Reale Accademia dei Lincei. Classe di Scienze morali, storiche e filologiche,* ser. 5, 3.
1895b "Porcellio Pandoni ed i Montefeltro," parts 1, 2. *Rendiconti della Reale Accademia dei Lincei. Classe di Scienze morali, storiche e filologiche,* ser. 5, 4, fasc. 2, pp. 104–22; fasc. 9–10, pp. 489–507.

Zeri, Federigo
1948a "A proposito di Ludovico Urbani." *Proporzioni* 2, pp. 167–70.
1948b "Me pinxit: Giovanni Antonio da Pesaro." *Proporzioni* 2, pp. 164–67.
1953 "Il Maestro dell'Annunciazione Gardner." *Bollettino d'arte* 38, pp. 125–39.
1958 "Qualcosa su Nicola di Maestro Antonio." *Paragone* 9, no. 107 (November), pp. 34–41.
1961 *Due dipinti, la filologia e un nome: Il Maestro delle Tavole Barberini.* Turin. Reprinted in *Diario marchigiano, 1948–1988,* pp. 132–97. Turin, 2000.
1976 *Italian Paintings in the Walters Art Gallery.* 2 vols. Baltimore.
1978 "An Annunciation by Benedetto Bonfigli." *Apollo* 103, no. 12, pp. 394–95.
1992 as ed. *Pinacoteca di Brera: Scuole dell'Italia centrale e meridionale.* Contributions by Luciano Arcangeli et al. Milan.

Zeri, Federico, and Elizabeth Gardner
1971 *Italian Paintings: Florentine School.* New York.
1980 *Italian Paintings: Sienese and Central Italian Schools.* New York.

Zervas, Diane Finiello
1975 "'The Trattato dell'Abbaco' and Andrea Pisano's Design for the Florentine Baptistery Door." *Renaissance Quarterly* 28, pp. 484–85.

Index

Note: Numbers in *italics* refer to pages with illustrations; numbers in **boldface** refer to pages with artists' biographies.

Agostino di Duccio (1418–after 1481), 252, **280**
Saint Bridget of Sweden Receiving the Rule of Her Order (cat. 39), 238, *239*, 280
Alberti, Antonio (documented 1418–47), 33, 49–50, 79, 94 n. 57, 97, 118, 258, 281, 312
The Crucifixion, *50*, 79
The Miracle of Saint Thomas (fig. 11), *49*, *50*
Alberti, Cherubino, 274
Alberti, Leon Battista, 27, 32, 34, 40, 46, 67, 69, 87, 97, 98, 99, 101, 106, 115, 119–22, 126, 128, 129, 218, 245, 253, 256–57, 263, 264, 276, 282, 283
Della pittura, 44–45, 54, 70, 71, 99, 143, 152, 156, 164, 178, 191, 202, 206, 214, 220, 264, 275, 285, 316–17, 321, 324, 326
De re aedificatoria, 44–45, 107, 257, 259, 263, 264–65, 275, 276–77, 285
Healing of a Man Possessed by Demons, from a design by (fig. 45), *119*, 120
influence of, in Northern Italy, 44–45
Palazzo Rucellai, Florence (fig. 44), 116, *118*
proposed as the Master of the Barberini Panels, 29
Alessandri Altarpiece (Lippi). *See Saint Lawrence Enthroned with Saints and Donors*
Alfonso of Aragon (Alfonso of Naples), 55, 147, 232
Amadei, Giuliano (active by 1147–1496), 234, **280**
frontispiece to Lactantius's *Divinae institutiones* (cat. 38), 236, *237*
Ambrosi, Pietro di Giovanni (documented 1428–49), 214–15
Angel (Michele di Giovanni) (fig. 19), 106, *108*
Angelico, Fra, 41, 42, 45, 47, 48, 54, 62, 69, 76, 88, 97, 144, 154, 188, 208, 212, 214, 236, 240, 271, 280, 281, 283, 285, 286, 291, 328, 359–60
The Adoration of the Magi (Cook Tondo) (with Lippi), 208, *209*
halo depiction, 138, 156, 208
Madonna of Humility images, 162
Saints Cosmas and Damian (fig. 24), *62*, 62, 286
San Marco Altarpiece. See Madonna and Child with Saints
Angelo Geraldini da Amelia, 215
Anghiari, Antonio di Giovanni da, 45, 46, 80, 282
Ansovino di Vanni da Bolognola, 216
Ansuino da Forlì, 72
Antaldi, Raimondo, 26
Antoninus, Saint (1389–1459), 147, 191
Antonio da Montecorvi, 104
Antonio da Rabatta, 207
Antonio di Agostino da Fabriano (documented 1447–89), 73, 83–85, 88, 222, 246, **280–81**
Crucifix (fig. 32), *84*, 85, 95 n. 75, 232, 246, 280
Saint Jerome in His Study (cat. 36), 83–85, 230–32, *231*, 246, 280; details, *73*, *83*
Arcangeli-Odasi house, Urbino, 120, 134–35 n. 155
Arcangelo di Cola da Camerino, 216

Arch of Constantine, Rome, 69, 257
Arch of the Argentari, Rome, 128, *256*, 256–57
Arco del Portogallo, Rome (fig. 7), 126, *276*, 276
Arrest of Christ, The (Boccati) (cat. 30), 81, 212, 214–15, *215*, 216
Augustine, Saint: *In Iohannis evangelium sermones* (fig. 1), *233*, 234

Baldinucci, Filippo, 24, 25
Baldovinetti, Alesso, 57, 180, 199, 207, 208, 209, 284, 288
baptismal font (Rossellino) (fig. 7), 101, *101*
Baptistery, Florence, 100, 110, 170, 276, 324
Gates of Paradise, 44, 61, 156, 174, 240, 259, 282
Romanesque marble altar, 186, *186*
Baptistery, Siena, 166, 168
Barbadori Altarpiece (Lippi). *See Madonna and Child with Two Saints*
Barberini, Cardinal Antonio, 23, 24, 26, 258, 306–7
Barberini Panels (Fra Carnevale) (cat. 45 A, B), 23, 24, 34–35, 39, 67–74, 86, 87, 176, 182, 223, 253, 258–66, *260*, *261*, 268
architectural settings of, 28, 32, 45, 61, 67, 69, 72, 99, 101, 104, 105–6, 111, 118, 119–24, 125, 127, 134 n. 150, 135 n. 166, 263–64, 268
archives related to, 306–7
attributed to Fra Carnevale, 26–27, 75
carpentry and panel construction of, 67, 263, 264, 325, 354–60, *355*–*59*
classicizing reliefs in, *34*, 37 n. 67, 61, 68, 72, 90, *100*, 101, 125, 248, 257, 259, 263–64, 280, 315–16, *319*
compositional devices in, 73–74
conjecture about appearance of overall altarpiece, 263
display of varied poses, 30, 37 n. 52, 68, 71
drapery treatment, 68, 82
figures' resemblance to fictive reliefs, 73–74
halos, 68, 258–59
identification of subject matter, 67, 258–59
light and color in, 27, 68, 71–72
perspective in, 30, 33, 62, 67, 68, 74, 121, 135 n. 159, 240, 259–63, 264, 322, 323–26, *333*
Piero della Francesca's influence on, 73–74, 125, 268
provenance, 29, 258. *See also* Santa Maria della Bella, Urbino
restorations of, 354–55
working procedures for, 323–28, 340–42
see also Birth of the Virgin, The; Master of the Barberini Panels; Presentation of the Virgin in the Temple (?), The
Bardi, Donato de' (documented 1426–50), 70, 85, 230, 232, 246, 280
Barducci, Giovanni di Stagio, 57, 290, 291, 292
Barocci, Ambrogio, 97, 288
Fregio della Guerra, 256
Bartolomeo di Cristoforo, 118
Bastiani, Lazzaro:
The Communion of Saint Jerome (fig. 54), *123*, 123–24, 263
Saint Jerome in His Study, Adored by a Patron, 124

Belforte Altarpiece (Boccati) (cat. 33), 70, 77, 93 n. 10, *220*, 220–22, 270; detail, *221*
Bellini, Gentile, 124
Bellini, Giovanni, 124, 138
Bellini, Jacopo, 107, 121, 124, 259, 263
Madonna and Child, 156
Bellum Poenicum (Silius Italicus), 188, 286
Bembo, Bonifacio (documented 1444–77), 76
Benci, Giovanni d'Amerigo (1394–1455), 43, 60, 154, 292, 293, 293 n. 39
Benzi, Sozino, 236
Berenson, Bernard, 31, 56, 75, 79, 81, 138, 144, 147, 158, 164, 166, 174, 176, 180–82, 188, 204–5, 207, 218, 223, 228, 245, 246, 253, 284
Bernaba di Giovanni, 56
Bernacchioni, Annamaria, 56, 57, 284, 285, 287
Berruguete, Pedro, 248, 267
Bertini, Giuseppe, 144
bianchi girali, 236
Biblioteca Malatestiana, Cesena, 233, 234
Bicci di Lorenzo, 45, 190, 259
Biondo, Flavio, 276
Boccati, Giovanni di Piermatteo (documented 1440–86), 26, 28, 29, 47–49, 71, 72, 75–77, 87, 88, 93 n. 33, 128, 164, 166, 180–82, 212, 214–22, 230, 234, 245, 264, **281**, 282, 283, 285, 291
The Adoration of the Magi, 81, 207, 214, 216, 291
The Arrest of Christ (cat. 30), 81, 212, 214–15, *215*, 216
Belforte Altarpiece (cat. 33), 70, 77, 93 n. 10, *220*, 220–22, 270; detail, *221*
The Blessed Guardato (cat. 33), 77, 220–22, *221*
The Crucifixion (Galleria Nazionale delle Marche, Urbino) (cat. 31), 214, 216, *217*
The Crucifixion (Galleria Sabauda, Turin) (fig. 10), 28, 30, *30*
Famous Men, fresco cycle of (fig. 9, 10), 48, 76–77, 109, 116, 218, 256, 264, 270, 271, 281, 291; details, *48*, *115*
Florentine sojourn of, 47–48, 56, 80, 281, 291
Fra Carnevale's connections to, 76, 77, 80–81, 82
Madonna (Ajaccio), 77, 276
Madonna and Child (Seppio di Pioraco) (fig. 2), *268*, 270
Madonna and Child Enthroned with Music-Making Angels (Madonna of the Orchestra) (cat. 32), 48, 71, 76, 212, 218–20, *219*, 270
Madonna and Child with Angels, 218–20
Madonna and Child with Saints (Budapest), 270
Pergolato Altarpiece. See Madonna and Child with Saints
The Pratovecchio Master and, 80–81
The Road to Calvary (fig. 23), *81*, 214
Saint John the Baptist and *Saint Sebastian*, 76
Bonamici, Gino di Lando, 160
Bonclerici, Guido, 34, 247, 248
Bonfigli, Benedetto (about 1418/20–1496), 33, 47, 210–14, **281**
The Adoration of the Magi, 211
The Annunciation (cat. 29), 211, 212–14, *213*, 216

The Annunciation of the Notaries, 214
Attila Taking Perugia, 212
Frederick III (attrib. [?]) (cat. 28), 30, 33, 210–12, *211*, 252
Life of Saint Louis of Toulouse, fresco cycle, Palazzo dei Priori, Perugia, 69, *210*, 211, 212, 214
The Nativity, 212
Portrait of Louis II d'Anjou, 210
Saint Peter, 210
Botticelli, Sandro, 26, 54–55, 188, 256, 284, 285
Federigo da Montefeltro (attrib. [?]) (fig. 5), *27*
Botticini, Francesco (1445/46–1497), 164
Braccio da Montone, 79
Bracciolini, Poggio, 233, 276
Bramante, Donato (1444–1514), 24, 25, 32, 39, 91, 253, 256, 258, 266, 267, 306
Bramantino, 24, 253
Brancacci Chapel, Florence, 240, 284, 321
Brunelleschi, Filippo, 43, 44, 53, 69, 97, 98, 101, 107, 120, 156, 282, 313, 320, 321, 322, 324
Florence Cathedral dome, 42, 55–56, 190
Old Sacristy, San Lorenzo, Florence, 44, 186, 198
Bruni, Leonardo, 104–5, 106
Buggiano (Andrea di Lazzaro Cavalcanti), 186

Cagnola, Guido, 227–28, 253
Calandrini, Cardinal Filippo, 228
Campana, Giovan Pietro, 207
Canozi da Lendinara, Cristoforo, 85, 233
Fountain (fig. 36), *87*
Canozi da Lendinara, Lorenzo, 85, 233
Caporali, Bartolomeo (documented 1442–92), 28, 71, 212, 238, 281
The Annunciation (fig. 5), *70*, 93 n. 24
Cappella dei Priori, Perugia, 211
Carnevale, Fra (Bartolomeo di Giovanni Corradini) (about 1420/25–1484), **281–82**
architectural interests of, 27, 32–33, 41, 44, 45, 61, 97–135, 184, 191, 240, 256–57, 263–66, 282, 320–21
architectural practice of, 32–33, 61, 78, 118, 119, 127–28, 264, 282, 292, 359
autograph receipts (fig. 1, 2), 290, *290*, *292*
carpentry and panel construction in works by, 343–61
color and light in works by, 27, 31, 68, 71–72, 74, 125
ecclesiastical career of, 30, 33, 63, 103, 282, 291, 292
expansion of oeuvre of, 30–32
expressive tension in works by, 82, 85, 88, 246
Florentine sojourn of, 39–41, 49, 50, 59–63, 97–102, 120, 240, 246, 281–82, 312–13, 314, 319–21
initial assessment of, 25–26
legacy of, 23–24
marine backgrounds in works by, 329 n. 27
nickname of, 34, 36 n. 29, 64 n. 1
oeuvre mistakenly associated with, 26–27, 28, 39
paint handling of, 125, 246, 326–27
personality of, 34

perspective and, 24, 33, 34, 35, 46, 61–62, 85–86, 90, 99, 128, 182, 184, 240–42, 256, 259–66, 313, 319–26
portrait of, 36 n. 7
provisional conclusions about, 33–35
Rome, possible visit to, 114, 120
training of, 25, 29, 32, 33, 49–50, 79–80, 97, 281, 312–13. *See also* Lippi, Fra Filippo: Fra Carnevale in workshop of
will of, 67–68, 282
working procedures for figures, 253–56, 311–12, 315–19
see also Allegorical Scene; Annunciation, The (two versions); Barberini Panels; *Birth of the Virgin, The; Crucifixion, The;* Franciscan polyptych; *Heroic Figure Against an Architectural Backdrop; Madonna and Child* (two versions); *Madonna and Child with Saints and Angels;* Master of the Barberini Panels; *Portrait of a Man; Presentation of the Virgin in the Temple (?), The; Saint Christopher; Saint Francis; Saint Jerome; Saint John the Baptist; Saint John the Baptist in the Desert; Saint Peter;* Scenes from the Life of Saint Nicholas; *Studies of Cupid and a Pluto; Study of David; Study of Putti; Two Figure Studies; Woman and a Kneeling Monk, A*
Carpaccio, Vittore, 124
The Vision of Doge Pietro Ottobon, 69
Carrand Triptych (Madonna and Child with Saints) (Giovanni di Francesco) (fig. 9), 102, *102,* 207, 209, 284
Castagno, Andrea del, 42, 116, 170, 172, 178, 207, 209, 253, 284, 285, 286, 287, 288, 291
Catanei, Matteo, 34, 118, 134 n. 140
Cavalcaselle, Giovanni, 26, 28, 82, 190, 218, 223, 240, 267
Cennini, Cennino, 202, 311–12
Chellini, Giovanni, 168
Ciampanti, Michele, 93 n. 34
Cicero, 44, 236
Cini, Vittorio, 242
Ciriaco of Ancona, 263
Clement XI Albani, Pope, 25, 258
Codex Barberiniano (Sangallo), 128, 256, *256,* 257
Codex Destailleur, 276
Coeur, Jacques (about 1395–1456), 62, 86, 88, 101, 164, 182–84
Colantonio: *Saint Jerome,* 230
Columella: *De re rustica,* 198
Confraternità del Corpus Domini, Urbino, altarpiece commission for, 25, 33–34, 62, 77, 264, 270–71, 282, 283
Contugi, Matteo, 256
Cook Tondo (The Adoration of the Magi) (Fra Angelico and Fra Filippo Lippi), 208, 209
Cori, Manno de', 55
Corradini, Bartolomeo di Giovanni. *See* Carnevale, Fra
Corvi, Francesco di Matteo di Monte, 118, 292
Crivelli, Carlo, 222, 314
Saint Francis, from the *Montefiore Altarpiece* (attrib. [?]) (fig. 5), 270, *271*
Crivelli, Taddeo, 234, 246
Saint Augustine (attrib. [?]) (fig. 1), *233,* 234
Crucifix (Antonio da Fabriano) (fig. 32), *84,* 85, 95 n. 75, 232, 246, 280

Da Varano family, 47, 48, 75, 77, 218, 281, 283
De Bosis, Antonio, 223, 226
De divina proportione (Pacioli), 277

Della Gatta, Bartolomeo, 236, 256
Della pittura. See Alberti, Leon Battista
Della Robbia, Andrea, 208
Della Robbia, Luca (about 1400–1482), 33, 42, 44, 53, 77, 100, 110, 114, 156, 158, 166, 194–99, 238, 240, **282,** 284, 285, 288, 292
drawings possibly by, 90, 199, 205, 206
Federighi tomb, Santa Trinita, Florence (fig. 26), *111*
Fra Carnevale's dealings with, 78, 199, 206
The Labors of the Months (cat. 25 A, B), 61, 198–99, *200, 201,* 205, 206, 282
Madonna and Child (cat. 23), 194, *195*
Madonna and Child ("Bliss Madonna") (cat. 24), 196, *197*
Madonna and Child with Saints (fig. 20), 105, *109,* 131 n. 62, 282
paintings and sculpture, portal of San Domenico, Urbino (fig. 1), 61, *96,* 105, 106, 131 n. 70, 240; detail, *109*
relationship with Domenico Veneziano, 198, 205, 206
replication techniques, 194
Resurrection, 42, 194, 196
and shared practices of painting and sculpture, 196, 198, 206
Shaw Madonna, 196
tabernacle, San Miniato al Monte, Florence (fig. 23), 61, *61,* 100–101, 105, 282
workshop practices, 199
Della Rovere, Vittoria, 306
Delli, Dello, 90, 328
Dell'Oro, Rinaldo, 144
De prospectiva pingendi. See Piero della Francesca
De re aedificatoria. See Alberti, Leon Battista
De re rustica (Columella), 198
Desiderio da Settignano, 106, 156, 252, 288
Diamante, Fra, 56, 178, 209, 285
Disputationes Camaldulenses (Landino), 256
Divinae institutiones (Lactantius), frontispiece to (cat. 38), 236, *237*
Doceno (Cristofano Gherardi), 272
Domenico di Bartolo, 180, 211, 214
Domenico di Domenico ("del Brilla"), 55
Domenico Veneziano (about 1410–1461), 47, 50, 56, 62, 65 n. 51, 71, 76, 80, 81, 82, 138, 147, 154, 178, 180, 184, 199, 207, 212, 214, 245, 281, 283, 284, 285, 286, **288,** 291
The Adoration of the Magi, 170, 191, 209, 214, 288
The Birth of the Virgin, 176
Carnesecchi Tabernacle, 170
drawings attributed to, 90, 91, 205, 206
Florentine sojourn, 45, 59–60, 97
influence on Fra Carnevale, 27, 28, 29, 30, 31, 59–60, 88, 148, 176, 191, 206, 240, 246, 282
Life of the Virgin fresco cycle, Sant'Egidio, Florence, 44, 45, 80, 208, 240, 288
light and color in works by, 31, 62, 64 n. 34, 288
Madonna and Child (Muzeul National de Arta, Bucharest), 166, 170
Madonna and Child (Villa I Tatti, Settignano), 156, 162
The Marriage of the Virgin, 208
A Miracle of Saint Zenobius (cat. 22 B), 190–91, *193,* 198, 206, 288
Piero della Francesca's contacts with, 45, 47, 49, 80, 282, 288
The Pratovecchio Master and, 164, 170, 172
relationship with Luca della Robbia, 198, 205, 206
Saint John in the Desert (cat. 22 A), 190–91, *192,* 198, 206, 288

Saint John the Baptist and Saint Francis, 172, *245,* 246, 288
Saint Lucy Altarpiece. See Madonna and Child with Four Saints
Dome of the Rock, Jerusalem, 276
Donatello, 44, 50, 54, 72, 82, 88, 97, 99, 100, 102, 105, 112, 115, 128, 138, 143, 144, 185, 191, 194, 208, 218, 252, 284, 285, 291, 292, 318–19, 320
The Annunciation, 42–43, 186, 208, 284
architecture and spatial manipulations in work of, 53, 62
Cantoria, Florence Cathedral, 42, 186
doors and reliefs, Old Sacristy, San Lorenzo, Florence (fig. 6), 44, *44,* 53, 143, 168, 172, 191, 288
The Feast of Herod, 166, 168
interrelationship of painting and sculpture, 168, 170
Filippo Lippi's relationship with, 98, 291, 319
Madonna and Child from the circle of (cat. 12), 166, 168, *169;* studies, *168*
Parte Guelfa tabernacle, Orsanmichele, Florence, 102, 156, 166, 186
Pazzi Madonna, 152, 166, 168
The Pratovecchio Master and, 166, 172, 286
Verona Madonna, 170
Dowdeswell & Dowdeswell, 228

Eleanor of Portugal, 210
Este, Borso d', 234, 275, 283
Este, Lionello d', 44, 47, 48, 233, 275
Eugenius IV, Pope (1383–1447), 41–44, 62, 118, 143, 146, 184
Eyck, Jan van, 51–52, 81, 83, 214, 216, 230, 280, 291
Lucca Madonna, 52
Saint Jerome in His Study, 232

Faltugnano Altarpiece (Master of the Castello Nativity) (cat. 8 A–C), 89, 158, 160, *160, 161,* 162, 285
Famous Men, fresco cycle, Palazzo Ducale, Urbino (fig. 9, 10), 48, 76–77, 109, 116, 218, 256, 264, 267, 270, 271, 281, 291, 306; details, *48, 115*
Fancelli, Luca, 115, 119
Faustini, Don Luigi, 230
Feast of Herod, The (Donatello), 166, 168
Federighi tomb, Santa Trinita, Florence (Luca della Robbia) (fig. 26), *111,* 198, 199
Federigo da Montefeltro (Botticelli [?]) (fig. 5), 27
Female Figure (Prophetess ?) (Workshop of Fra Filippo Lippi) (cat. 15), 58, 174, *175*
Ferrero, Giacomo, 150
Ferriani, Barbara, 242
Filarete, Antonio, 99, 105, 106, 112, 172, 198, 256
Filelfo, Francesco, 233
Finiguerra, Maso (1426–1464), 89, 199, 202
Flagellation, The (Piero della Francesca), 26, 74, 109, 258, 259, 276, 283, 328, 360
Flemish painting. *See* Netherlandish painting
Florence, 39–65
architectural trends in, 60–61, 97–102. *See also specific buildings*
cultural and artistic activity in (1434–50), 41–45
documents in archives of, 290–98
Fra Carnevale's sojourn in, 39–41, 49, 50, 59–63, 97–102, 120, 240, 246, 281–82, 312–13, 314, 319–21

influences beyond Lippi in, 61–62
Lippi's importance in, 50–55
Lippi's workshop in (1440s), 55–59
non-Florentine artists in, 45–48, 97
study of perspective in, 319–20
Florence Cathedral, 42, 97, 100, 110, 143, 166, 186, 190, 191, 285, 320
Brunelleschi's dome for, 42, 55–56, 190
Della Robbia's reliefs for, 42, 166, 194, 196, 198, 199, 282
figures on the Porta della Mandorla (fig. 32), 114, *114*
Uccello's clockface on (fig. 30), 110, *112*
foliate motifs, 69, 93 n. 10
Foppa, Vincenzo, 246
Fornari, Romualdo, 230
Francesco d'Antonio, 80, 256
The Healing of a Possessed Man (fig. 27), 328, *330*
Francesco del Borgo, 86, 236, 280
Francesco di Giorgio, 32, 40, 92, 118–19, 123, 128, 253, 256, 264, 282, 288
The Coronation of the Virgin, 270
Francesco di Matteo, 293 n. 57
Francesco di Stefano. *See* Pesellino
Franciscan polyptych (Fra Carnevale) (cat. 41 A–D), 82–88, 108, 182, 211, 242–48, 311
appearance of metal conveyed in, 70–71
arthritic hands depicted in, *83,* 85, 319, *320, 321*
carpentry and panel construction of, 70, 242, 313–14, *344–51, 344–54*
reconstruction of, 246, *336,* 352–54
working procedures for, 313–19, *314–18, 320, 321, 337–39*
see also Crucifixion, The; Saint Francis; Saint John the Baptist; Saint Peter
Frederick III (Bonfigli [?]) (cat. 28), 30, 33, 210–12, *211,* 252

Gaddi, Agnolo, 185
Galli, Angelo, 40, 107, 115, 120, 133 n. 115
Galli, Federigo, 107
Garelli, Tommaso, 172
Gaspare da Urbino, Fra, 103
Gaspare Zacchi da Volterra, 245
Gates of Paradise (Ghiberti), 44, 61, 156, 174, 240, 259, 282
Gatti, Francesco, 223
Gentile da Fabriano, 79, 180, 211, 214, 216, 222, 312
Madonna and Child, 166
Strozzi Altarpiece, 291
Valleromita Altarpiece, 70
Gentilini, Giancarlo, 194, 196, 198
Gerolamo di Giovanni, 234
Gherardi family, 272–74
Ghiberti, Lorenzo, 42, 44, 99, 100, 110, 114, 170, 191, 194, 291
Gates of Paradise, 44, 61, 156, 174, 240, 259, 282
Ghirlandaio, 178, 259, 280
Giachini, Antonio di Giovanni, 101
Giorgio d'Alemagna, 233, 234
Giotto, 57, 80, 284, 287, 312, 314
Giovanni Angelo d'Antonio da Camerino (documented 1443–76), 49, 71, 75–76, 77, 82, 83, 87, 88, 90, 93 n. 33, 164, 180, 212, 215, 216, 218, 222–29, 228, 230, 258, 280, 281, 282, **283,** 291
The Annunciation (two versions). *See Annunciation, The*
The Crucifixion (two versions). *See Crucifixion, The*
Florentine sojourn, 47–48, 56, 80, 283
The Lamentation (fig. 1), *66;* detail, *82*

Madonna and Child with Saint John the Baptist and Saint Francis, 230
proposed as the Master of the Barberini Panels, 29, 64 n. 20
Saint Jerome (cat. 35), 72, 227–29, *229*
Giovanni Antonio da Pesaro (about 1415–1474/78), 70
Giovanni d'Alemagna, 93 n. 10, 138
Giovanni da Pisa, 218
Giovanni da Ponte, 172
Giovanni di Bartolomeo, 78, 99, 106, 292
Giovanni di Francesco da Rovezzano (1412/28[?]–1459), 57–58, 65 n. 59, 71, 101, 110, 164, 170, 174, 178, 180, 182, **283–84,** 285
fresco backdrop for statue by Michelozzo, Santissima Annunziata, Florence, 207, *207*
The Hunt (fig. 18, 19), *78,* 78–79, *79,* 94 n. 53, 208–9
Madonna and Child with Saints (Carrand Triptych) (fig. 9), 102, *102,* 207, 209, 284
The Nativity and *The Adoration of the Magi* (cat. 27), 207–9, *208–9*
The Pratovecchio Master and, 284, 287
Giovanni di Piamonte, 83, 94–95 n. 74, 246
Giovanni di Ser Giovanni. *See* Il Scheggia
Giovanni di Stefano da Montelparo, 214, 227, 288
Giraldi, Guglielmo, 233–34
Girolamo di Giovanni di Marano (documented from 1450; died 1503), 29, 48, 72, 75, 180, 216, 223, 226, 227–28, 264, 283
Giuliano da Maiano, 199, 256, 320–21
Giuliano d'Arrigo. *See* Pesello
God the Father (Pasquino da Montepulciano) (fig. 15), 106, *106*
Gonzaga, Cardinal Francesco, 263
Gonzaga, Gianfrancesco, 44
Gonzaga, Ludovico, 44, 264
Gozzoli, Benozzo, 42, 48, 166, 191, 208, 212, 215, 240, 281
Bartolomeo Caporali's *Annunciation* based on drawing by (fig. 5), *70,* 93 n. 24
Greco, Il. *See* Michele di Giovanni
Gregorio di Lorenzo, 250

halos, depiction of, 68, 71, 138–43, 208, 258–59, 275

In Iohannis evangelium sermones (Saint Augustine) (fig. 1), *233,* 234
intarsia, 33, 199, 240, 253, 320

Jacob de Litemont, 184
Jacopo da Pergola, 233
Jacopo del Sellaio, 184
Jacopo di Antonio (1427–1454), 287
Joos van Ghent, 25, 77, 248, 264, 267, 282, 283
Jupiter Ammon, effigy of (fig. 14), *105,* 106, 131 n. 69
Justus von Ravensburg, 73, 280
The Annunciation (fig. 8), *72,* 232

Lactantius: *Divinae institutiones* (cat. 38), 236, *237*
Lancisi, Giovanni Maria, 25
Landino, Cristoforo, 50, 54, 55, 152, 256, 288
Lanzi, Luigi, 25
Laurana, Francesco, 250, 256, 266
Battista Sforza (fig. 1), 250, *250,* 252
Laurana, Luciano, 32, 36 n. 22, 99, 264, 282
Palazzo Ducale, Urbino, work on, 107, 123, 126, 127, 132 n. 83, 276, 288
Lazzari, Andrea, 26, 258

Leonardo da Vinci, 24, 52, 53, 147, 188, 202, 253, 284, 285, 328
Libro delle entrate e delle uscite del podere della Piacentina, 290–92, 294–97
Lippi, Filippino (1457–1504), 164, 204, 285
Lippi, Fra Filippo (1406–1469), 45, 49–60, 68, 72, 76, 77, 82, 97, 120, 121, 122, 130 n. 16, 138–56, 178, 182, 184, 188, 205, 207, 208, 209, 212, 238, 245, 256, 271, 280, 281, 283, **284–85,** 286, 287, 311, 359–60
The Adoration of the Magi (Cook Tondo) (with Fra Angelico), 208, 209
altarpiece for the novitiate chapel in Santa Croce, Florence. *See Madonna and Child with Saints*
The Annunciation (six versions). *See Annunciation, The*
architectural settings in works by, 53, 60, 98–99
Barbadori Altarpiece. See Madonna and Child with Two Angels
The Coronation of the Virgin (two versions). *See Coronation of the Virgin, The*
Donatello's relationship with, 98, 291, 319
drawings after works by (cat. 16), 30, 176, *177,* 182
Female Figure (Prophetess?) (Workshop of Fra Filippo Lippi) (cat. 15), 58, 174, *175*
Fra Carnevale in workshop of, 29, 31, 32, 33, 39, 41, 44, 47, 49, 55, 59–60, 62, 63, 80, 98, 99, 116, 154, 158, 174, 204, 248, 281–82, 290–91, 312–13
frames constructed for altarpieces by, 54
framing devices explored by, 121, 147
The Funeral of Saint Stephen, 69
gold leaf in works by, 52–53, 54, 156
halos in works by, 138–43
Head of a Monk (attrib. to Lippi) (fig. 42), 88, *90*
importance of, 50–55
influence on Fra Carnevale, 28, 29, 61, 76, 82, 83, 85–90, 99, 147–48, 154, 156, 166, 176, 240, 246, 282, 321
light and color in works by, 52–54, 64 n. 34, 147, 188
Madonna (formerly Loeser collection, Florence), 276
Madonna and Child. See Madonna and Child (eight versions); *Madonna and Child Enthroned with Two Angels; Madonna and Child with Saints; Madonna and Child with Two Saints*
Madonna del Ceppo, 150, 156
Master of the Castello Nativity and, 55, 56, 88, 158, 160, 162, 285
Medici Madonna, 196
The Meeting of Joachim and Anna at the Golden Gate (cat. 5), 52, 154, *155,* 240
Le Murate Altarpiece. See Annunciation, The
The Nativity, 154, 209
The Penitent Saint Jerome and Another Monk Pulling a Thorn from the Lion's Foot, 144–46
Pesellino and, 58–59, 188, 286
The Pietà (cat. 2), 144–46, *145;* detail, *146*
The Pietà with Saints Francis and Jerome, 144
Portrait of a Woman, 150
Portrait of a Woman and a Man at a Casement (cat. 4), 52, 147, 150–52, *151,* 166, 178; detail, *153*
The Pratovecchio Master and, 55, 164, 166, 170, 172
Sacra Conversazione, 98
Saint Lawrence Enthroned with Saints and Donors (Alessandri Altarpiece) (fig. 15), *54, 54,* 150, 156, 292

Saint Matthew, 232
Saints Augustine and Ambrose (cat. 1 A), 52–53, 138–43, *139,* 144, 188; detail, *142*
Saints Gregory and Jerome (cat. 1 C), 52–53, 138–43, *139,* 144; detail, *141*
Sant'Ambrogio Altarpiece. See Coronation of the Virgin, The
Sant'Egidio altarpiece and, 55, 64 n. 43
sculptural traditions and, 156, 170, 194, 196
shell motif in works by, 90, *92*
spatial ambiguities in works by, 53, 150–52
style of, adapted for commissions, 55, 60
Tarquinia Madonna. See Madonna and Child
vase depictions, 51, *51,* 162
workshop of, 55–59
Lochis, Guglielmo, 180
Lomellini, Battista, 232
Longhi, Roberto, 28, 29, 45, 50, 80, 81, 164, 166, 172, 212, 245–46, 272, 275, 286, 287, 288
Lorenzetti, Pietro, 214
Lorenzo d'Alessandro da Sanseverino, 223
Lorenzo di Giovanni di Petruccio, 238
Lorenzo di Pietro. *See* Il Vecchietta
Luca della Robbia. *See* Della Robbia, Luca

Maccagnino, Angelo, 234
Macchiavelli, Zanobi, 31, 180
Maffei, Ascanio, 258
Malatesta, Giovanna, 48, 218
Malatesta, Sigismondo Pandolfo (1417–1468), 44, 48, 72, 78, 98, 103, 105, 107, 111, 248, 283, 285
Piero della Francesca's fresco of, 73–74, 276
Manetti, Giannozzo, 277, 321, 324
Manfredi, Astorre, 103
Mantegna, Andrea, 24, 44, 48, 71, 72, 77, 81, 82, 116, 128, 138, 168, 218, 266, 276, 281, 282, 283
Madonna and Child, 170
The Martyrdom of Saint James, 223
The Presentation of Christ in the Temple, 264
Marinelli, Agostino, 223
Maringhi, Francesco d'Antonio, 76, 176, 290
Marsuppini, Carlo (1398–1453), 59, 60
Masaccio, 44, 50–51, 144, 147, 162, 240, 246, 284, 316, 328
The Trinity, 98, 102, 156, 326
Maso di Bartolomeo (1406–1456), 32, 33, 99–101, 107, 109, 110, 199, 240, 282, **285**
account book of, 78, 93 n. 39, 99, 104, 285, 290, 292, 298
grille and balcony for the Cappella del Sacro Cingolo, Prato Cathedral, 62, 99–100, 104, 106, 110, 115, 184, 185–86, 285; details, *100, 104, 182*
portal of San Domenico, Urbino (fig. 1), 61, *96,* 103–7, 240, 285, 292; details, *103, 104, 107, 182*
Reliquary for the Holy Girdle of the Virgin (cat. 20), *185,* 185–86, *187,* 285
tabernacle, San Miniato al Monte, Florence (fig. 23), 61, *61,* 100–101
tribune of the Sacro Cingolo, Prato Cathedral (fig. 12), *104*
Masolino, 184, 284, 312
Master of Patullo, 234
Master of the Barberini Panels, 27–30, 32, 81–82
artistic profile developed for, 28–29
attributions to, 27–29, 31, 86, 88, 164, 166, 170, 211, 240, 245, 246, 253
candidates proposed for, 26, 28–30, 36 nn. 20 and 22, 64 n. 20, 75, 81–82, 258, 283, 284, 286
creation of epithet, 27, 258
see also Carnevale, Fra

Master of the Bargello Judgment of Paris, 188
Master of the Bellpuig Coronation, 79, 94 n. 56
Master of the Carrand Triptych, 207, 284
Master of the Castello Nativity (active 3rd quarter of the 15th century), 55, 56, 88–89, 95 nn. 85 and 95, 158–62, 182, 184, **285–86,** 291
Faltugnano Altarpiece (cat. 8 A–C), 89, 158, 160, *160, 161,* 162, 285
Madonna and Child (attrib. [?]) (cat. 7), 62, 88–89, 95 n. 88, 158, *159,* 162
Madonna and Child with Two Angels (Madonna of Humility) (cat. 9), 162, *163*
Master of the 1454 Triptych, 216
Master of the Lanckorónski Annunciation, 196
Master of the Marble Madonnas, 250
Master of the Missal of Innocent VIII, 236
Master of the Studioli, 236
Matteo da Gualdo, 26, 227
Medici, Cosimo de' (1389–1464), 41–42, 43, 60, 98, 102, 103, 107, 115, 143, 144, 146, 207, 208, 233, 291
Medici, Giovanni di Cosimo de' (1421–1463), 40, 42, 47, 55, 75, 283
Medici, Lorenzo de', 253
Medici, Piero de', 42, 45, 55, 61, 101, 103, 115, 138, 143, 146, 156, 194, 207, 286, 288
Luca Della Robbia's roundels for the *studiolo* of (cat. 25 A, B), 61, 198–99, *200, 201,* 205, 206, 282
Medici family, 40–44, 45, 47, 76, 78, 123, 283, 285
Mellini, Bishop Giovanni Battista, 34, 247
Michael of Pfullendorf, 210
Michele da Firenze: *Madonna and Child, God the Father, and Six Angels,* 170, *170*
Michele di Giovanni (Il Greco), 104, 108, 282
angels, portal of San Domenico, Urbino (fig. 19), 106, *108,* 112
Madonna and Child (fig. 18), *108,* 112
stonework, Palazzo Ducale, Urbino, 108, 110–16, 112–14, 115
Michelele da Carrara, 236
Michelozzo, 32, 42, 44, 97, 103, 105, 107, 108, 110, 118, 120, 174, 184, 185, 188, 199, 233, 240, 282, 285, 320–21, 322
Giovanni di Francesco's fresco backdrop for the statue by, 207, *207*
influence on Fra Carnevale, 60–61, 98–102, 263
novitiate chapel, Santa Croce, Florence (fig. 22), 60, 61, *61,* 101, 105, 108, 115
Pazzi Chapel, Santa Croce, Florence, 101, 106, 109, 110, *111,* 131 n. 71
tabernacle, San Miniato al Monte, Florence (fig. 23), 61, *61,* 100–101, 102, 105
tabernacle, Santissima Annunziata, Florence, 60, 61, 100–101
Migliore, Zanobi di, 188, 285–86
Milanesi, Gaetano, 207
Milanesi, Niccolozzo, 185
Mino da Fiesole, 115
Monaco, Lorenzo, 147, 284
The Coronation of the Virgin, 172
Montano, Giovan Battista, 186
Montefeltro, Antonio da (died 1404), 79
Montefeltro, Federigo da (1422–1482), 23, 34, 35, 39–40, 44, 87, 104, 109, 122, 129, 216, 234, 247, 248, 256, 257, 264, 266, 280, 282, 283, 284, 285, 292, 321
architectural interests of, 46, 97–98, 104, 105, 107, 116, 127, 264
Famous Men, fresco cycle, for, 48, 76, 281
Fra Carnevale's position at the court of, 48, 77–79, 110–14

heraldic symbol of (fig. 42), 68, 116–18, *118, 264*
The Hunt and, 78–79, 94 n. 53
marriage to Battista Sforza, 48, 76, 116, 281
Montefeltro Altarpiece and, 268, 270
as Piero della Francesca's patron, 39–40, 46, 48–49, 97
portraits of, *27,* 30, 33, 46, 95 n. 76, 210–12, *211,* 248, 250, *252,* 256, 267, 283, 306
residences of, 100. *See also* Palazzo Ducale, Urbino
Montefeltro, Guidantonio da (1378–1443), 79, 97, 268
Montefeltro, Guidobaldo da, 252, 268
Montefeltro, Oddantonio da, 39

Negroni, Don Franco, 49, 79
Nelli, Ottaviano (documented 1400–1444), 79
Neri di Bicci (1419–1491), 132 n. 97, 164, 359–60
Netherlandish painting, 51–52, 70, 152, 188, 212, 230–32, 248, 268, 275, 280, 281, 284, 288, 329 n. 27
Niccoli, Niccolò, 233
Niccolò di Liberatore (Niccolò da Foligno), 216, 227
Nicholas V, Pope, 62, 88, 126, 210, 212, 228, 277, 281
Nicola di Maestro Antonio, 82, 87, 246
Madonna and Child Enthroned with Saints (fig. 4), 270, *270*
Nicola di Ulisse da Siena (documented 1442–72), 70
Novello, Malatesta, 233, 234
Numa Pompilius, from Plutarch's *Vitae vironum illustrium* (fig. 2), *233,* 234
Nuti, Matteo, 105, 115

Offner, Richard, 27–28, 29, 68, 69–70, 81, 85, 86, 87, 156, 240, 245, 258
Olivuccio da Ciccarello, 222
Oratorio di San Giovanni Battista, Urbino, 79, 94 n. 57
Salimbeni's fresco cycle in (fig. 12), 50, *50,* 79
Origo, Curzio, 25
Orsanmichele, Florence, 102, 156, 166, 174, 186, 206
Ovetari Chapel, Church of the Eremetani, Padua, 48, 69, 72, 77, 218, 223, 264, 283

Palazzo Comunale, Montepulciano, 240, 263
Palazzo Ducale, Urbino, 79, 97, 98, 99, 100, 127–28, 132–34 nn. 81–134, 208, 250, 257, 268, 276, 282, 285, 288, 306
Barberini Panels and, 30, 111, 122–23, 127, 258, 263, 264
courtyard, 107, 123, 126, 127, *128,* 132 n. 83, 276
Famous Men fresco cycle in (figs. 9, 10), 48, 76–77, 109, 116, 218, 256, 264, 267, 270, 271, 281, 291, 306; details, *48, 115*
Fra Carnevale as director of decorative program for, 110–14, 116
inventory of (1599), 24, 31, 306
Iole wing, 32, 77, 107–18, 122, 253; details, *109–18*
portrait medallions from the Sala degli Angeli, 252, *252*
Sala della Iole (fig. 31), 87, 110, 111, *113,* 114–15, 257, 264; details, *110, 111, 112, 114*
sleeping alcove (fig. 41, 43), 28, 29, 32, 77, 101, 105, 110, 116–18, *117, 118,* 248, 264, 270, 282, 320; details, *22, 118*

Palazzo Medici, Florence, 44, 47, 61, 102, 107, 108, 115, 198, 205, 208, 214
Luca della Robbia roundels for the *studiolo* in (cat. 25 A, B), 61, 198–99, *200, 201,* 205, 206, 282
Palazzo Rucellai, Florence (fig. 44), 116, *118*
Palazzo Staccoli, Urbino, 26, 36 n. 18
Pandoni, Porcellio, 112, 114–15, 121, 256
Pannonio, Michele, 234
Paolino da San Ginesio, 214
Paolo da Viso (documented 1438–81), 70, 263
Pasqua, Vincenzo di, 218
Pasquino di Matteo da Montepulciano, 108, 110, 112, 252, 282
grille, Cappella del Sacro Cingolo, Prato Cathedral, 110, *110,* 185
portal, San Domenico, Urbino, 104, *105,* 105–6, *106*
sphinx from the pulpit, Prato Cathedral, 106, *107*
Pasti, Matteo de', 77, 119, 121, 168, 233, 248, 280
Paul II, Pope, 160, 256, 280
Pausanias, 236
Pazzi Chapel. *See* Santa Croce, Florence
Perugino, Pietro, 23, 92, 218, 272, 280
Pesellino (Francesco di Stefano) (1422–1457), 56, 58–59, 138, 144, 158, 176, 199, 207, 208, 285, **286,** 287
The Annunciation (cat. 21), 120, 188, *189*
Lippi's relationship with, 58–59, 188, 286
The Miracle of the Miser's Heart (fig. 20), 58, 59, *59,* 158, 188, 286
The Trinity (fig. 19), 58, *59,* 188, 286
Pesello (Giuliano d'Arrigo) (1367–1446), 188, 198, 207, 286
Petrarch, 188, 256
Piero della Francesca (about 1406/12–1492), 23, 24, 29, 40, 62, 68, 70, 77, 83, 164, 184, 190, 191, 207, 208, 223, 228, 229, 233, 234, 236, 242, 245, 246, 248, 253, 256, 263, 267–77, 280, 281, **282–83,** 284, 286, 291–92, 318, 324, 328
The Annunciation (fig. 16), 74, *76,* 275
architectural settings in works by, 125–27, 268
Arezzo fresco cycle. *See* San Francesco, Arezzo
The Baptism of Christ, 274, 275
Barberini Panels and, 36 n. 20, 73–74, 264, 266, 268, 270
City View with Well by miniaturist from the circle of (fig. 35), 86, *87,* 95 n. 82
The Death of Adam, 125
De prospectiva pingendi (fig. 37), 46, 86, *87,* 91, 127, 128, 253, 322, 326
Domenico Veneziano's contacts with, 45, 47, 49, 80, 282, 288
The Flagellation. See Flagellation, The
Florentine sojourn, 42, 45–46, 47, 63
Fra Carnevale compared to, 35, 39, 125
Ideal City, 92, 276
influence on Fra Carnevale of, 27, 28, 73–74, 81, 86, 87, 124–29, 240, 266, 268, 282, 283, 322
Legend of the True Cross. See San Francesco, Arezzo
light and color in works by, 125, 127, 268
Madonna and Child (Christ Church, Oxford), 26
Madonna and Child by a follower of (*Villamarina Madonna*) (fig. 4), 26, *26*
Madonna and Child with Angels. See Madonna and Child with Angels
Madonna della Misericordia (*Misericordia Altarpiece*), 46, 229, 236, 274, 280, 283

The Meeting of Solomon and the Queen of Sheba (fig. 10, 12), *73, 74, 74*
Montefeltro Altarpiece. See Madonna and Child with Saints, Angels, and Federigo da Montefeltro
The Nativity. See Nativity, The
paint handling, 125, 268, 274–75
paintings by, once attributed to Fra Carnevale, 25, 26–27, 28, 39
perspective and, 35, 46, 53, 86, 91, 127, 128, 182, 253, 266, 282–83, 322, 326
portraits of Federigo da Montefeltro and Battista Sforza, 95 n. 76, 250, 252, 283
Rimini fresco of, 73–74, *75,* 276
Saint Jerome, 87
Saint Michael, 26, 39
Saint Nicholas of Tolentino, 26
Saint Sigismond and Sigismondo Malatesta (fig. 15), 73, 74, *75,* 125
Sant'Agostino Altarpiece, 268, 270, 271, 274, 275, 283
Senigallia Madonna. See Madonna and Child with Angels
training and early career, 45–46, 80
Trattato dell'abaco, 274
in Urbino, 46, 48–49, 124–27
Williamstown, Massachusetts, altarpiece. *See Madonna and Child Attended by Angels*
Piero di Lorenzo, 56, 188, 285–86, 291
Piero di Lorenzo di Pratese, 56, 95 n. 85, 285–86, 291
Pinturicchio, 210, 281
Pisanello, 40, 77, 168, 248, 257
Pius II, Pope (1405–1464), 72, 118, 210, 236, 280
Pizzolo, Nicolò (about 1421–1453), 48, 71, 72, 73, 82, 138, 218, 281
Saint Gregory (fig. 4), 70
Pliny, 44, 70, 112, 147, 152, 266
Pliny the Younger, 118
Plutarch's *Lives* (*Vitae vironum illustrium*) (cat. 37), *233,* 233–34, *235*
Pluteo (thirteenth-century sculptor) (fig. 27), *111*
Poldi, Gianluca, 146
Poldi Pezzoli, Gian Giacomo (1822–1879), 144
Pollaiuolo, Antonio del, 130 n. 16, 172, 188, 199, 256, 288, 318
Pontelli, Baccio, 256
Portigiani, Pagno di Lapo, 101
tabernacle, Santissima Annunziata, Florence (fig. 5), 100, 100–101
Portinari, Pigello, 101
Prato Cathedral, 69, 120, 178, 285
grille and balcony, Cappella del Sacro Cingolo, 99–100, 104, 106, 110, 115, 184, 185–86, 285; details, *100, 104, 110, 184*
Maso di Bartolomeo's reliquary for (cat. 20), *185,* 185–86, *187,* 285
Pasquino da Montepulciano's sphinxes on the pulpit (fig. 16), 106, *107*
The Pratovecchio Master (active between about 1435 and 1455), 28, 55, 71, 80–81, 88, 180, 182, 214, 284, 285, **286–87,** 288
architectural features in works by, 101–2
The Assumption of the Virgin, 172, *172,* 178, 286
Madonna and Child (cat. 11), 28, 30, 101–2, 148, 166, *167,* 168; detail, *80*
Madonna and Child with Six Angels (cat. 13), 80–81, 164, 170, *171*
The Three Archangels. See Three Archangels, The
The Virgin and *Saint John* (cat. 14 A, B), 172, *173*

Prevedari, Bernardo, 266
Pseudo-Michelele da Carrara, 236

Quintillian, 44, 152

Raphael, 23, 24, 25, 253, 284
Reliquary for the Holy Girdle of the Virgin (Maso di Bartolomeo) (cat. 20), *185,* 185–86, *187,* 285
Resurrection, The (Luca della Robbia), 42, 194, 196
Ricci, Corrado, 223
Ridolfi, Claudio, 27, 258, 306
Ripanda, Jacopo, 257
Rivanni, Abbate, 184
Road to Calvary, The (Boccati) (fig. 23), *81,* 214
Rosselli, Cosimo, 207
Rosselli, Domenico (1439–1497 [?]), **287–88**
Madonna and Child, 252
Portrait of Battista Sforza (attrib. [?]) (cat. 43), 248, 250–52, *251*
portrait of Federigo da Montefeltro (fig. 2), 252, *252*
Rossellino, Antonio, 156, 288
Rossellino, Bernardo, 102, 104–5, 108, 118
baptismal font (fig. 7), 101, *101*
Bruni tomb, Santa Croce, Florence, 104–5, *106*
Rotondi, Pasquale, 107, 108, 252
Rucellai, Bernardo, 257

Salari, Mercurelli, 238
Salimbeni, Lionardo di Bartolomeo Bartolini, 44
Salimbeni, Lorenzo (documented 1400–1416) and Jacopo (1400–1427), 98
The Birth of Saint John the Baptist (fig. 12), 50, *50,* 79
Salmi, Mario, 198, 199, 205, 234, 236, 245–46, 284
San Bernardino, Urbino, 24, 25, 26, 267, 268
San Bernardo, Arezzo, 55, 59
San Domenico, Perugia, 76, 215, 238, 240
San Domenico, Urbino, 50, 67–68, 79, 247–48
holy orders taken by Fra Carnevale at, 33, 34, 50, 63, 291
marble façade, 78, 87
portal (fig. 1), 32, 50, 78, 90, 94 n. 52, *96,* 103–7, 108, 112, 122, 131–32 nn. 46–79, 186, 199, 240, 257, 263, 270, 276, 282, 285, 292; details, *103–8, 124*
San Francesco, Arezzo, 45
Piero della Francesca's fresco cycle in (*Legend of the True Cross*), 42, 69, *73, 74, 74,* 83, 125, 250, 266, 282, 283, 284, 285
Sangallo, Giuliano da:
Arch of Septimus Severus (fig. 49), 121, *121*
Codex Barberiniano, 128, 256, *256,* 257
Santa Maria Maddalena de'Pazzi (Cestello), Florence (fig. 58), 125, 126, 135 n. 177, 276
Taccuino Senese, 257
San Lorenzo, Florence, 100, 107, 253
Brunelleschi's Old Sacristy, 44, 186, 198
Donatello's doors and reliefs for the Old Sacristy (fig. 6), 44, *44,* 53, 143, 168, 172, 191, 288
San Marco, Florence, 41, 42, 45, 99, 101, 103, 120, 208, 233
San Marco Altarpiece (Fra Angelico). *See Madonna and Child with Saints*
San Miniato al Monte, Florence:
Cappella del Crocifisso, 100–101, 102, 198, 199

tabernacle (Michelozzo, Maso di Bartolomeo, and Luca della Robbia) (fig. 23), 61, *61,* 100–101, 105, 282
Uccello's frescoes in (fig. 48), 120, *120*
Santa Croce, Florence, 42–43, 55, 208, 263, 284
 Bruni tomb, 104–5, 106
 Cavalcanti Tabernacle, 168, 186
 Lippi's altarpiece for the novitiate chapel. *See Madonna and Child with Saints*
 novitiate chapel (fig. 22), 43, 61, *61,* 101, 105, 108, 110, 115, 233
 Pazzi Chapel, 43, 101, 106, 109, 110, *111,* 131 n. 71, 282
Sant'Agostino, Montepulciano, 105
Santa Maria degli Angeli, Florence, 172, 236, 280, 284
Santa Maria della Bella, Urbino, 50, 68, 79, 306–7
 confraternity of flagellants associated with, 34–35
 identification of Fra Carnevale and the Barberini Panels with, 24, 25, 26, 27, 30, 34, 39, 67, 252, 258, 259, 282, 306, 323
Santa Maria Maddalena de'Pazzi (Cestello), Florence (fig. 58), *125,* 126, 135 n. 177, 276
Santa Maria Novella, Florence, 55, 61, 98, 106, 121, 314, 321
Sant'Ambrogio Altarpiece (Lippi). *See Coronation of the Virgin, The*
Sant'Angelo a Nilo, Naples, Brancacci tomb, 102, 105
Santa Sabina, Rome, 120
Santa Trinita, Florence, 55
 Federighi tomb (fig. 26), *111,* 198, 199
Sant'Egidio, Florence, 44, 45, 55, 60, 64 n. 43, 80, 208, 240, 288
Santi, Giovanni (1440/45–1494), 23, 247–48, 256, 264, 270, 282, 283
 Muse Clio, 256
Santissima Annunziata, Florence, 184, 209, 280, 285

Giovanni di Francesco's fresco backdrop for Michelozzo's statue, 207, *207*
tabernacle (fig. 5), 60, 61, *100,* 100–101
Santorio, Emilio, Archbishop of Urbino, 306–7
Sanvito, Bartolomeo, 236
Sapiti, Angiola di Bernardo, 150
sarcophagus, antique, figures copied from (Lombard master [?]) (fig. 33), *114,* 115, 133 n. 113
Sassetta (Stefano di Giovanni), 46
Il Scheggia (Giovanni di Ser Giovanni), 320, 359–60
 Madonna and Child, 150, 152, 166
Schiavo, Paolo, 80, 170
Schiavone, Giorgio (about 1436–1504), 71
Scolari, Lorenzo di Ranieri, 150
Serlio, Sebastiano, 257
Sforza, Alessandro, 48, 252, 280
Sforza, Battista (1446–1472), 48, 76, 77, 116, 268, 281, 318
 portraits of, 95 n. 76, 248, *250,* 250–52, *251, 252,* 283
Sforza, Costanzo, 252, 288
Sforza, Francesco Maria, 248
Sforza, Ippolita Maria, 252
Siena Cathedral, 121, 168
Signorelli, Luca, 267, 272
 Study of a Head (fig. 26), 326, *328*
Silius Italicus, 188, 286
Simonetti, Attilio, 242, 245
Sipriot, Casimiro, 242
Sperandeo di Giovanni, Don, 49–50, 79
Squarcione, Francesco (about 1394/97–1468), 28, 71, 211, 246, 314
Stefano di Francesco, 56
Stratonice Master, 93 n. 34
Strozzi, Giuseppe, 240
Strozzi, Zanobi (1412–1468), 59, 162, 188, 208
Studies of Cupid and a Putto (Fra Carnevale) (fig. 45), 89–90, *92*
Study of a Head (Signorelli) (fig. 26), 326, *328*
Study of David (Fra Carnevale) (fig. 44), 89–90, *91,* 95 n. 90, *202,* 204

Study of Putti (Fra Carnevale) (fig. 36), 115, *115*
Taliano di Lippo, 220, 221
Tempio Malatestiano, Rimini, 72, 78, 87, 98, 106, 111, 121–22, 218, 238, 248, 263, 280, 285
 Piero della Francesca's fresco, 73–74, *75,* 276
Temple of Minerva, Assisi, 105–6
Temple of Solomon, Jerusalem, 68, 276–77
Tiranni family, 247–48
Tornabuoni, Bishop Nicolò (r. 1560–98), 274
Tornabuoni, Giovanna degli Albizzi, 178
Trevelyan, Sir Walter, 271–72, 274
Tura, Cosimo (Cosmè), 234, 246

Ubaldini, Ottaviano (1423/24–1498), 34, 40, 46, 67, 97, 248, 256, 264, 280, 282
Uccello, Paolo, 25, 42, 44, 61–62, 77, 143, 242, 264, 282, 283, 284
 clockface, Florence Cathedral (fig. 30), 110, *112*
 figure studies, 89, 90, 199, 204–5
 The Flood (fig. 25), 61, *63,* 178
 frescoes, San Miniato al Monte, Florence (fig. 48), 120, *120*
 Madonna and Child, 166, 168, 178
 The Nativity, 62
 Portrait of a Woman, from the circle of (cat. 17), 30–31, 94 n. 72, 178, *179*
 Saint Monica and Two Youths, 178
Ugolino da Fiegni, Blessed, 222
Urban V, Pope, 238
Urban VIII, Pope, 306
Urbani, Ludovico, 82, 245
Urbino:
 architectural projects in, 103–18.
 art traditions in, 79–80
 court life in, 46
 documents from, 299–305
Urbino Cathedral, 33, 61, 78, 104, 118–19, 120, 247, 282

Vasari, Giorgio, 23–24, 30, 32, 39, 47, 50, 60, 89, 90, 91, 107, 110, 116, 128–29, 144, 146,

176, 190, 198, 199, 204, 205, 207–8, 258, 272, 282, 286, 287, 288, 306, 311, 318, 319, 320, 322, 328, 330 n. 58
Vatican, 69, 277
 Bibliotheca Graeca, 126, 135 n. 176
Il Vecchietta (Lorenzo di Pietro), 211, 214, 360–61
 The Miracle of Beato Sorore (fig. 51), 121, *122*
Veneto, Fra Jacopo, 25, 33
Veneziano, Domenico. *See* Domenico Veneziano
Venturi, Adolfo, 26–27, 29, 147, 207, 223, 246, 250, 258, 267
verdaccio, 311–12, 329 n. 6
Verrocchio, 23, 92, 147, 188, 285
 The Baptism of Christ, 147
Vespasiano da Bisticci, 41, 42, 116, 282, 321
Villamarina Madonna (Madonna and Child) (follower of Piero della Francesca) (fig. 4), 26, *26*
Virgin, The (The Pratovecchio Master) (cat. 14 A), 172, *173*
Visconti, Filippo Maria, 40, 215
Visconti, Gaspare, 253, 256
Vitelleschi, Cardinal Giovanni, 138, 180
Vittorino da Feltre, 44
Vivarini, Antonio, 93 n. 10, 138
Vivarini family, 144, 270

Williamstown, Massachusetts, altarpiece (Piero della Francesca). *See Madonna and Child Attended by Angels*
Witz, Konrad, 232
 Saint Mary Magdalene and Saint Catherine of Alexandria, 70

Zanolini, Paola, 227
Zeno, Jacopo, 236
Zeri, Federico, 23, 28–29, 30, 32, 70, 75, 82, 86, 88, 164, 166, 184, 211, 214, 216, 230, 242, 246, 258, 263, 270, 280, 281, 283
Zoppo, Marco (1433–1478), 26, 71, 82, 245, 248

Works of Art Cited

Abundance (early-fifteenth-century Florentine sculptor) (fig. 32), 114, *114*
Adoration of the Magi, The (Boccati), 81, 207, 214, 216, 291
Adoration of the Magi, The (Domenico Veneziano), 170, 191, 209, 214, 288
Adoration of the Magi, The (Fra Angelico and Fra Filippo Lippi) (*Cook Tondo*), 208, 209
Adoration of the Magi, The (Giovanni di Francesco) (cat. 27), 207–9, *208–9*
Allegorical Scene (Fra Carnevale) (fig. 68), 90, 128–29, *129,* 253, 315, 316; details, *86, 318*
Annunciation, The (Bonfigli) (cat. 29), 211, 212–14, *213,* 216
Annunciation, The (Caporali, based on a drawing by Gozzoli) (fig. 5), *70,* 93 n. 24
Annunciation, The (Domenico Veneziano) (from the *Saint Lucy Altarpiece),* 86, 190
Annunciation, The (Donatello), 42–43, 186, 208, 284
Annunciation, The (Fra Carnevale [?]) (cat. 19), 28, 29, 62, 86, 88, 101, 182–85, *183*

Annunciation, The (Fra Carnevale) (Washington, D. C. *Annunciation*) (cat. 40), *29,* 32, 62–63, 81, 85–87, 147–48, 152, 154, 174, 190, 240–42, *241,* 245, 246, 263, 268; details, *86, 120*
 architectural setting of, 32, 120, *120,* 240
 attribution of, 27–28, 240
 dating of, 86–87, 240
 homages to Lippi in, 85, 86, 87, 240, 321
 perspective in, 85–86, 87, 128, 184, 240–42, 253, 263, 321–23, *331, 332*
 unfinished wellhead incised in the ground of, 91, 240, 322, *322,* 323
 working procedures for, 321–23, *322, 323,* 325, 327, *331, 332*
Annunciation, The (Giovanni Angelo d'Antonio) (Sarnano) (cat. 34 A), 222–26, *224,* 228
Annunciation, The (Giovanni Angelo d'Antonio) (Spermento) (fig. 1), *66,* 72–73, 218, 223, 226, 228, 234, 283; detail, *71*

Annunciation, The (Justus von Ravensburg) (fig. 8), *72,* 232
Annunciation, The (Lippi) (The Frick Collection, New York) (cat. 3), 52, 147–48, *149,* 150, 152; detail, *148*
Annunciation, The (Lippi) (Galleria Doria Pamphilj, Rome), 55, 156, 162
Annunciation, The (Lippi) (Galleria Nazionale d'Arte Antica, Rome), 55, 150, 154
Annunciation, The (Lippi) *(Le Murate Altarpiece)* (fig. 5), 43, *43,* 55, 60, 62, 65 n. 69, 85, 147, 154, 158, 162, 184, 212, 292
Annunciation, The (Lippi) (National Gallery of Art, Washington, D.C.), 188
Annunciation, The (Lippi) (San Lorenzo, Florence) (fig. 13), *51,* 51–52, 54, 55, 86, 98, 138, 143, 154, 162, 174, 176, 212, 240; details, *51, 180*
 attribution of predella panels from, 58, 65 n. 59, 89, 180, 182
Annunciation, The (Pesellino) (cat. 21), 120, 188, *189*

Annunciation, The (Piero della Francesca) (fig. 16), 74, *76,* 275
Apostles Peter and Paul, The (Donatello) (fig. 6), 44, *44*
Arch of Septimus Severus (Sangallo) (fig. 49), 121, *121*
Assumption of the Virgin, The (The Pratovecchio Master), 172, *172,* 178, 286

Birth of Saint John the Baptist, The (L. Salimbeni and J. Salimbeni) (fig. 12), 50, *50,* 79
Birth of the Virgin, The (Fra Carnevale) (cat. 45 A) 27, *28,* 29, 67–70, 81, 89, 90, 152, 154, 164, 176, 258–66, *260;* details, *10, 34, 72, 77, 81, 88, 100, 127, 128, 252, 259, 262, 264,* 316
 architectural setting of, 99, 101, 104, 122–24, 127, *127,* 128, 135 n. 166, 263–64
 cloud formations in, 81, 266
 foreshortening of pilasters and capitals in, 74, *77*

DEMCO

ND 623 .C2865 A4 2005
Fra Carnevale.
From Filippo Lippi to Piero
della Francesca

WITHDRAWN

3 0311 00137 4409
CATHOLIC THEOLOGICAL UNION